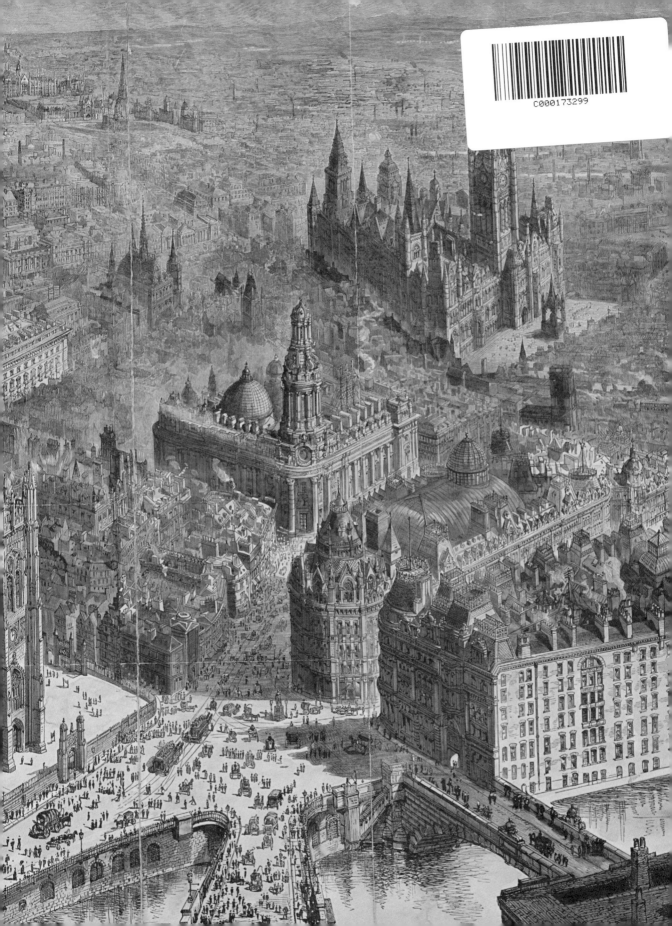

MANCHESTER

MAKING THE MODERN CITY

MANCHESTER

MAKING THE MODERN CITY

Edited by
Alan Kidd and Terry Wyke

LIVERPOOL UNIVERSITY PRESS

First published 2016 by
Liverpool University Press
4 Cambridge Street
Liverpool
L69 7ZU

British Library Cataloguing-in-Publication data
A British Library CIP record is available

ISBN 978-1-84631-878-8 softback
ISBN 978-1-84631-877-1 cased
ISBN 978-1-84631-838-2 cased with slipcase

Designed and typeset by BBR (www.bbr.uk.com)
Printed and bound by Gomer Press, Llandysul, Wales

Front cover image: The familiar shape of the clock tower of Manchester Town Hall, the city's most iconic building,
is paralleled by the most eye-catching of twenty-first-century landmarks, the glass sheerness of the 47-storey
skyscraper known as the Beetham Tower. Reproduced with the kind permission of William Rigby, photographer.

Back cover image: Manchester Central Library under construction, May 1933. The white Portland
stone of the nearly completed library half conceals the soot-darkened bulk of the Midland Hotel.
The buildings in the foreground were to be demolished to make way for the Town Hall extension.
Courtesy of Manchester Libraries, Information and Archives, Manchester City Council.

Front endpaper image: *A Bird's-Eye View of Manchester in 1889*, by Henry William Brewer (1836–1903). Brewer, who
specialised in drawing urban panoramas, provides a view of late-Victorian Manchester looking eastwards from a vantage
point at the top of Exchange Station, taking the eye from the medieval core (Cathedral and Chetham's) towards buildings that
symbolized commerce and industry (Exchange), medicine and science (Infirmary) and municipal independence (Town Hall).

Back endpaper image: An aerial view of the city centre, looking to the east, with the River Irwell just visible in the
immediate foreground. Although recently erected high-rise buildings catch the eye, the essential urban footprint is that
inherited from the Georgian and Victorian periods. Reproduced with the kind permission of Webb Aviation (ic15084).

Published in partnership with Corridor Manchester

Contents

Preface

Cities have done much to shape the modern world. This is a book about the making of one of the world's first truly modern cities, a process that began little more than two centuries ago and put a hitherto little-known Lancashire town on the global map. What historians sometimes call the 'first industrial revolution' began arguably the greatest historical transformation of all time and generated what we term 'the modern world'. It is difficult to tell the story of this transformation without mention of Manchester.

From the late eighteenth century onwards, the manufacture of cotton cloth in steam-powered factories made the Manchester region a centre of sustained economic growth the like of which the world had never seen. Cotton was central to British industrialization and cotton meant Manchester, or 'Cottonopolis' as the city became widely known. The roots of this revolution lay in the economy and culture that had grown up in the centuries before the coming of the first factories. Yet it was during the eighteenth century that a tipping point was reached and an unstoppable process began.

By the early nineteenth century Manchester had been transformed into the first industrial city, the heart of an industrial system. Yet it was also a great commercial centre, the hub of the world's trade in cotton goods. Pioneering transport developments during the canal era and the railway age involved innovative feats of engineering. Over time engineering became as important as cotton to the city's economy and the challenges facing the cotton industry produced the remarkable achievement of the Manchester Ship Canal, turning this inland city into an international port with its own docks and the world's first industrial estate at Trafford Park. These developments helped the city through the inter-war Depression but the demise of the cotton industry after the Second World War was soon followed by the closure of the docks and Trafford Park, turning this industrial giant into a pale shadow of its former self.

Manchester has been described as the quintessential innovative city of the first industrial revolution. It is well known how new factory-based machine technology revolutionized industrial production. But what is perhaps more significant is that the wave of invention and innovation was sustained as Manchester

developed a vigorous scientific and technical culture through its various societies and academies. The history of modern Manchester opens doors to an understanding of how science helped shape the modern world, from the discoveries of Dalton and Joule to Rutherford's splitting of the atom, and in a later era from the first stored-program computer to the invention of graphene.

The industrial revolution made the name 'Manchester' known across the world as a symbol of industrialism and modernity. It was one of those iconic cities that came to stand for something more than itself. In the event its global reach extended beyond industrialism as such and encompassed the political and economic ideas to which the industrial revolution had given birth. Manchester was simultaneously the home of the capitalist ideology of free trade, famously naming its chief public building in honour of this idea, and the place where Marx and Engels plotted the communist revolution.

Cities draw people to them; they cluster and gather and forge societies of great complexity and colour. The history of Manchester echoes with innumerable voices of individuals and groups, sometimes expressing affirmation, but equally questioning voices of dissent and protest. From the Peterloo protesters gathered to demand the right to vote in 1819 to the women's suffrage campaigners of nearly a century later and the gay and lesbian activists of more recent times, the city has been a forum for multiple voices. Moreover Manchester has long been a cosmopolitan city with a lively mix of ethnic groups that has added celebration and tension to its cultural and social life and increased the range and diversity of the voices expressed. Like all great cities, over time it has been challenged and ultimately strengthened by its vibrant and remarkably complex blend of peoples from near and far.

Cities have always been centres of cultural life. Manchester has long been associated with the performing arts, newspapers and the visual media. Musical production and performance has been particularly strong, from the world-renowned Hallé Orchestra to Manchester's contribution to popular music. The city was once the most significant newspaper centre outside Fleet Street and the eminence of its printed media connection was to be matched by a tradition of television production culminating in MediaCity. Today, it is sporting culture that reverberates the name 'Manchester' around the globe, through the prowess of its famous football teams.

Over time population growth in and around Manchester generated an urban sprawl that became a city region. 'Greater Manchester' has been a reality for over a century and along with Greater London it is the only metropolitan region to be named after its core city. The much denigrated 'suburbia' in which a majority of the people now live has come to characterize our cities as much as the urban core with its grand buildings and historic places. We cannot understand the one without the other.

As the industrial base on which the city and region had depended for two centuries collapsed in the later twentieth century, the city had to take another

path. This it has done with remarkable success and among former British industrial cities, twenty-first-century Manchester is regarded as having been most successful in reinventing itself. Understanding how that has been achieved is as much a part of appreciating what makes Manchester 'tick' as the all-important history of the city since it first trod the path to industrial greatness more than two centuries ago.

The chapters in this book cover some of the chief elements in the story of the making of modern Manchester. The book does not pretend to be comprehensive but sets out to offer key insights into a number of the main features of the history of the modern city from the roots of industrial revolution in the eighteenth century and before to the post-industrial regeneration of the late twentieth and twenty-first centuries. It tells the stories of the people as well as of the processes that made and are making the city.

Acknowledgements

This volume would not have been possible without drawing on the research completed by generations of historians who have explored and written about different aspects of the history of Manchester. Like them we have benefited from the printed and unpublished records that have been collected and carefully arranged in the libraries, archives, museums and galleries in and around Manchester. We have drawn heavily on Chetham's Library, the oldest of the country's public libraries, where Michael Powell and Fergus Wilde have been unfailingly helpful in their suggestions and in providing material from their splendid collection. Manchester Local History Library also has a long tradition of supporting researchers and in its new format of Archives+ it continues to encourage and assist all those who are interested in the history of the city and wider region. It has come a long way since Edward Edwards began stocking the shelves of what in 1852 was the country's first major municipal library. David Govier in particular has provided invaluable assistance in recommending and supplying illustrations from the superb Local Image Collection. The staff in the following libraries, archives, museums and galleries in and around Manchester have also been generous in providing information and illustrations: Greater Manchester County Record Office, Greater Manchester Police Museum, John Rylands Library, Manchester Art Gallery, Manchester Cathedral Archives, Manchester Museum, Manchester Museum of Science and Industry, Manchester Jewish Museum, Manchester Metropolitan University Library, National Archive for the History of Computing, National Cooperative Archive, People's History Museum, Portico Library, University of Manchester Library, University of Salford Archives, Salford Diocesan Archives, Salford Local History Library, Salford Museum and Art Gallery, Whitworth Art Gallery and the Working Class Movement Library, Salford.

At Manchester Metropolitan University we would like to thank the Manchester Centre for Regional History, which provides a forum for academics and students undertaking research on the history of the city and is a home for the *Manchester Region History Review*. We are also grateful to John Davis of the Visual Resources Unit at Manchester Metropolitan University, as well as to Ian Reid who drew the maps in the Introduction. Norman Redhead of the Greater Manchester

Archaeological Advisory Service supplied the county maps in Chapter 7. Graham Bowden drew most of the maps and diagrams in Chapter 8. Particular thanks are also owed to Stephen Yates who provided invaluable assistance in photographing many of the archive illustrations reproduced in the volume. Uncredited illustrations were supplied by the editors or contributing authors.

John Garrard read the manuscript and provided many useful corrections and suggestions. He was a most generous critic given our decision not to discuss in detail the changes occurring on the right bank of the Irwell.

Invaluable financial support for the publication has been provided by Corridor Manchester, an innovative partnership of knowledge-based public and private institutions located between St Peter's Square and Whitworth Park, which recognized that the business of increasing growth and employment in the present and future ought not to be carried out in a historical vacuum.

It is a pleasure to express our gratitude to Alison Welsby of Liverpool University Press who approached us with the idea for the volume and who commissioned it. She and her tireless crew in Liverpool have guided the text and its cargo of illustrations through the sometimes slack and at other times choppy waters that have turned a manuscript into this book. (Every effort has been made to identify the copyright holders of the illustrations reproduced in the volume. Should anyone have been inadvertently omitted then we will be pleased to provide an acknowledgement in future editions.)

We owe a debt to our contributing authors for their patience and understanding during a project that has taken longer to come to fruition than we had hoped. Its completion is tinged with sadness at the absence of two of our original team of authors. The untimely death of John Pickstone deprived us not only of his chapter but also of his boundless enthusiasm and shrewd insight. A notable historian of science, John was also one of the originators of the Manchester Histories Festival and did a good deal to increase participation in the history of the city and its communities. He is much missed. Also sadly absent from our original team is Bill Williams who through ill health was unable to write his chapter. We wish him well. We are grateful to the authors who stepped in to take up responsibility for the chapters John and Bill were to have written.

Finally, a single sentence will have to suffice to express our gratitude for the patience of our wives, who were led to believe that when pensions replaced salaries less time would be spent on talking and writing about the history of Manchester.

MANCHESTER DOCKS

FOR
MANCHESTER GOODS

Making the Modern City

ALAN KIDD and TERRY WYKE

Manchester Docks for Manchester Goods, c.1912. Numerous anti-suffragette postcards were published during the course of the Women's Social and Political Union's campaign of direct action, though few were as geographically specific as this one, which linked the Manchester-founded pressure group with a popular slogan promoting the city as an inland port.

© The March of the Women Collection / Mary Evans Picture Library

Towns and cities are the greatest works of humanity, the products of interaction between people that have produced a resource of great variety and density, in which buildings, monuments, topography, landscape character, street pattern, archaeological deposits and open spaces all interface to produce a distinct entity. Manchester is one such construct.[1]

Manchester is one of a select band of cities that have left their mark on human history. It has been inhabited for much of the last two thousand years, but its modern history began around two hundred years ago with the era of the industrial revolution. Any account of the making of the modern city must begin here, because without it nothing else in Manchester's story since then makes sense. It is a story of enterprise and innovation; of industry, science, technology and education; of music, performance and sport; of political ferment and popular protest; of urban growth and migration; of poverty and wealth; of slum and suburb. This is the story of a city. Every town and city has its story, but few have one that belongs to the world.

Manchester vaulted to the centre stage of world history during the industrial revolution. It was then that the modern world we inhabit began and Manchester played a part in its creation. Changes wrought by the industrial revolution caused unprecedented urban growth, ushered in new ways of living and working and generated new ideas of economy and society. The story of the making of modern Manchester is also the story of the making of the modern world.

Manchester is often referred to as the 'first industrial city', but this understates the significance of what occurred there during the first half of the nineteenth

century. The Manchester that had emerged by 1850 was an early and in some cases the first expression of certain key characteristics of modernity that were to change not just the face of this city but ultimately the world. There are other versions of modernity, but we are talking here about certain key characteristics of the modern world that first arose during the nineteenth century: sustained population growth and mobility; rapid and continued urbanization; new and transformational machine-powered technologies of manufacture, transportation and communication; new kinds of cities based on machine-powered industry.

The 'Malthusian' preventive checks (famine and disease) that had restricted population growth for millennia had ceased to operate by 1750. Sustained and apparently irreversible population increase was occurring for the first time in human history. Population growth was accompanied by population mobility. The consequent migration fed the growth of towns and cities. As early as 1851 Britain had become the world's first predominantly urban society in which over half the people lived in towns and cities. London was by far the largest city but it had not been the fastest growing. While between 1801 and 1841 the population of London doubled, that of Manchester more than trebled and by 1851 it was over four times larger than it had been fifty years before. This was a hitherto unprecedented rate of urban growth.

Manchester's fame as 'Cottonopolis' recognizes the town's singular importance in this staple product of industrialization. But it is not always understood that the historic world significance of the cotton industry lies in its role as the entry point to industrial growth. Ever since the British industrial revolution, textile and clothing industries have spearheaded modernization across the world, from Europe and North America in the early nineteenth century to Japan and the rest of Asia in the twentieth century.[2] Almost everywhere in the world, as mechanized industrial production has stimulated economic growth, the earliest factories have been in the cotton industry. This worldwide pattern was initiated in the world's first industrial nation and Manchester was the centre of the world's trade in cotton goods.

The steam engine was a dynamic force in the creation of the modern world. It converted heat (thermal energy) into controllable work (kinetic energy) and was the first technology to exploit the energy stored up in a natural earth resource. Prior to the steam engine, it was possible to harness heat by burning fuel and work by means of animal power, wind power and water power, but it was not possible to convert heat into usable work. The steam engine made this remarkable technological breakthrough possible, and what the steam engine began, the internal combustion engine was to continue. Without these technologies it is difficult to imagine the modern world.

In the half century following the 1780s, Manchester was transformed by the impact of the rotary steam engine on the mechanization of cotton spinning. These steam engines were housed in multi-storey factories with huge chimneys belching smoke. This was an entirely new urban environment. Water-powered production

of textiles had encouraged geographical diversity but the transition to steam power ensured the concentration of production in towns. Factories were built in groups. They shared the same infrastructure of canals and roads (and later railways) and had access to the same locally based workforce. The urban industrial age had arrived and Manchester was its prime example. The invention of the rotary steam engine transformed the topography of Manchester, and created the first industrial city.

Towns and cities were reshaped by industrialization and urban growth. They did not merely get bigger, but as their populations rose they changed their character. A key feature of this transformation was the growth of residential suburbs around an urban core with separate zones for industry and commerce. This became the template for innumerable modern cities around the globe. The modern residential suburb began life in London but it was not until suburban growth started around Manchester and other industrial towns that its true ability to reshape the urban environment was first realized.

During the nineteenth century Manchester became one of the most famous cities in the world: a pivotal site of the urban industrial revolution (some of the world's oldest surviving steam-powered factory buildings can be seen still) and the

City centre, 1930. This aerial view of the city centre shows Vincent Harris's Central Library under construction and to its immediate north the buildings that were to be cleared for his extension to the Town Hall.

Courtesy of Manchester Libraries, Information and Archives, Manchester City Council

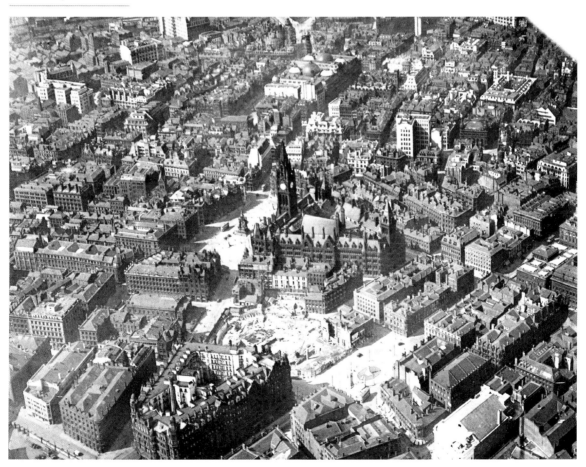

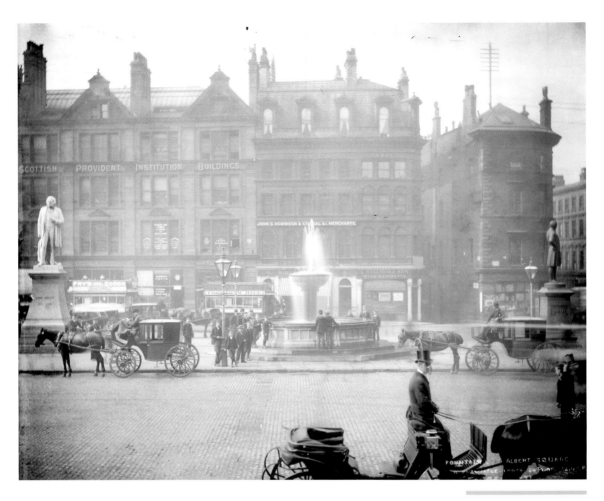

Albert Square, 1895.
Originally created as a site
for the Albert Memorial,
Albert Square became the
city's principal civic space
following the completion
of Waterhouse's Town Hall
in 1877. This photograph
shows the recently installed
fountain marking the
opening of the Thirlmere
Reservoir, between
the statues of John
Bright (left) and Bishop
James Fraser (right).

Courtesy of Manchester Libraries,
Information and Archives,
Manchester City Council

centre of the world's trade in cotton goods (many former cotton warehouses line the streets of the city centre). During the industrial revolution Manchester became a transport hub, first with canals creating an inland port at Castlefield and cutting through the centre of the town, and then as the site of the world's first railway station on the Liverpool and Manchester Railway of 1830. Both the canals and the Liverpool Road Station survive (the latter in the Museum of Science and Industry) as further reminders of Manchester's historic greatness.

Interest in Manchester began when the rest of the world realized that what was happening represented a vision of the future. The trickle of industrial tourists that had begun with the building of the Barton Aqueduct on the Bridgewater Canal grew to a persistent stream as the curious and concerned sought introductions to visit the town's mills and factories. The complexity of the vision of the future they witnessed, encompassing as it did the great wealth-creating possibilities of mass production but also the immense inequalities that the unrestrained free market can produce, instilled both a sense of awe and of dismay.

'Manchester' soon became a place name recognized across the globe. It was a symbol of industrialism and modernity, soon to be emulated by dozens of other 'Manchesters', which either called themselves the 'Manchester' of their country or region or actually adopted the name directly themselves. Manchester was one of those iconic cities that came to stand for something more than itself. Its global reach stretched beyond industrialism as such and encompassed the political and economic ideas that the industrial revolution spawned. Manchester was simultaneously the home of the capitalist ideology of free trade (famously naming its chief public building in honour of this idea) and the place where Marx and Engels plotted the world communist revolution.

The last hundred years have witnessed a dramatic decline from greatness with the disappearance of the industrial base upon which Manchester was built. The global cotton trade, which more than any other industry had made Manchester the powerhouse that it was, shifted first across the Atlantic to more technologically advanced American factories and eventually eastwards, back to the Asian producers from whom Manchester's machines had stolen it two centuries previously. The inexorable decline of Lancashire cotton during the first half of the twentieth century became a collapse after the Second World War. Today former cotton mills across the region have either disappeared or been converted to a variety of alternative uses. The once arrogant forest of chimneys is reduced to a memory.

Manchester today lives with the inheritance of that heroic era. But this is not to ignore the fact that Manchester has a much longer pedigree. However, we had better stop for a moment and explore some definitions. First, the issue of location: where was this 'Manchester' we are speaking about?

Where was Manchester?

It might seem straightforward to answer the question 'Where was Manchester?', but over time the name has been applied to various different parcels of land and administrative units. To find the first Manchester, one has to go as far back as 'Mamucium', the probable name for the Roman fort and civil settlement that nestled at the confluence of the rivers Irwell and Medlock (Castlefield) and lasted for around three centuries following AD 77. There is little archaeological evidence of settled occupation of the site after the Romans left and it was not until the tenth century that Manchester reappeared in the historical record in a brief reference to its fortification against the Vikings in the Anglo-Saxon Chronicle under the year 923. However, this makes no mention of a town. We have to travel forward to 1086 for a further reference to Manchester, or 'Mamecestre', this time in the Domesday Book. However, this is equally elusive, and rather than implying an urban settlement could refer either to the parish of Manchester or to the manor of Manchester.

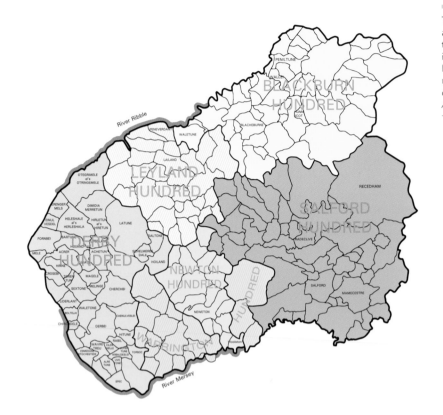

The land between the Ribble and the Mersey, indicating the hundreds and places identified in the Domesday Book, 1086, based on the map in W. Farrer, *Transactions of Lancashire and Cheshire Antiquarian Society* (1898).

Parish

The Domesday Book entry reveals that at the time of the survey the churches of St Mary and St Michael held land in Manchester. Most historians conclude, on the basis of their medieval dedications, that those churches were at Manchester and Ashton-under-Lyne, respectively. Thus at the time of the Norman Conquest of England, Manchester already had a church. We know from later evidence that its parish was extensive. In the medieval period it covered about 60 square miles, and lay between the parish of Prestwich-cum-Oldham in the north, Ashton-under-Lyne and the river Tame to the east, with Flixton and Eccles in the west and the river Mersey from Stockport to Urmston to the south. It embraced over two dozen separate townships, including Denton, Blackley, Stretford, Heaton Norris, Didsbury and Salford. But medieval Manchester was also a manor and this introduces its history as an administrative unit and political entity. It is not a straightforward history and it is one in which Salford plays a more prominent role.

Manor and township

One of the most curious anomalies of modern English local government is the separate existence of the cities of Manchester and Salford. For centuries they sat next to each other, divided only by the once clear waters of the Irwell. In more modern times they have been called 'twin cities' in the manner of Minneapolis St Paul or Newcastle/Gateshead, yet to the unwary visitor the distinction between the two is largely invisible. The origins of the separation of Manchester and Salford are political and date back around a thousand years. They reveal that although in the medieval ecclesiastical hierarchy Salford was part of the parish of Manchester, in political terms it was more important than its close neighbour.

Prior to the Norman Conquest in 1066, Manchester was merely a part of the royal manor of Salford, held directly by the king, Edward the Confessor. The royal manor of Salford was the most important place in the hundred of Salford, sometimes referred to as 'Salfordshire'. At this time there was not yet a county of Lancashire, and instead the territory between the rivers Ribble and Mersey was divided into six units of local administration known as hundreds, including the hundred of Salford. After the Norman Conquest the new king, William the

Parish of Manchester with townships, based on an index map in *Victoria History of the County of Lancashire*, vol. IV (1911).

Conqueror, granted this territory to Roger de Poitou, who had helped him to victory at the Battle of Hastings. Roger kept the manor of Salford for himself but divided other parts of the hundred into a number of fiefdoms, which he granted to lesser Norman knights in return for military service; among them was the barony of Manchester, which went to Albert de Gresle.

The de Gresle family held the manor of Manchester for two hundred years. Their patrimony included the growing township of the same name. Although the township grew gradually in size and importance, it could not escape the clutches of the lord of the manor. Whereas in the sixteenth and seventeenth centuries places such as Liverpool and Wigan, already royal boroughs, were granted charters of incorporation which made them fully self-governing, Manchester remained only a manorial borough and the townsmen (burgesses) had only basic rights and freedoms.

In 1301 the lord of the manor, Thomas Gresle, granted a charter confirming the existing customs and privileges enjoyed by the burgesses of Manchester. This was a landmark in the history of the township. It established the system of local government for Manchester that was to survive for over five centuries. Manchester was a manorial borough, governed by Court Leet and with a 'borough reeve' appointed by the burgesses. Manchester was not incorporated as a self-governing borough until the nineteenth century.

Over the centuries the manor passed through different hands, culminating in its purchase in 1596 by the prominent merchant clothier Nicholas Mosley. His descendants held the rights of lord of the manor of Manchester for over two centuries until they were bought out by the newly created Manchester Corporation in 1846. It was not unusual for smaller places to be thus governed, but the sheer size of Manchester made such a system seem anomalous. In 1726 Daniel Defoe in his tour of Britain referred to Manchester as 'one of the greatest, if not the greatest mere village in England'.[3] Manchester and Birmingham were the largest unincorporated towns in the eighteenth century. In Manchester the Court Leet remained the chief authority of local government, sharing responsibilities with church-wardens and overseers of the poor, the parish vestry and magistrates. This situation prevailed until the latter end of the century when statutory commissioners for particular purposes were appointed following police and improvement Acts of Parliament in 1765, 1776 and 1792.

Municipal borough and city

During the 1830s Manchester was brought into the national political arena. The Great Reform Act of 1832 gave the town its first Members of Parliament,[4] and the Municipal Corporations Act of 1835 led to the incorporation of the borough of Manchester in 1838, and confirmation of its powers by the Borough Charters Incorporation Act of 1842. Thus began the municipal management of a town hitherto run by manorial court and police commissioners. 'Manchester' could now mean a municipal borough with a mayor and corporation. As well as

the Manchester township, the original borough consisted of the townships of Chorlton-on-Medlock, Hulme, Ardwick, Beswick and Cheetham. By the mid-nineteenth century, as well as being a municipal borough, 'Manchester' was also a city. In 1847 the diocese of Manchester was formed and the Collegiate Church became Manchester Cathedral. Historically cities were places with an Anglican see, but none had been created since the sixteenth century. The new industrial towns of nineteenth-century England were often much larger and more important than the ancient cities. Manchester was to create a precedent when the borough petitioned for city status. Manchester's importance was officially recognized when in 1853 the borough was granted a Royal Charter authorizing it to bear the name 'the city of Manchester', and its inhabitants, most of whom had long been in the habit of calling it a city, could be referred to as 'citizens'.

Manchester's municipal boundaries were successively extended between 1885 and 1913. The area covered by the new borough created in 1838 had been 4,293 acres. By 1913 the area had increased fivefold, and corporation authority extended over 21,645 acres. In 1885 Harpurhey, Bradford and Rusholme were added, followed by Blackley, Moston, Crumpsall, Newton Heath, Openshaw, Kirkmanshulme and West Gorton in 1890. Moss Side, Withington, Burnage, Chorlton-cum-Hardy, Didsbury, Gorton and Levenshulme were incorporated in 1904 and 1909. The last phase of expansion was to come with the acquisition of Wythenshawe in 1931.

Manchester Corporation was an active agent in the development of the city's economy. It was the main investor in the Manchester Ship Canal Company as it later was to move Manchester into the aviation age with the foundation of

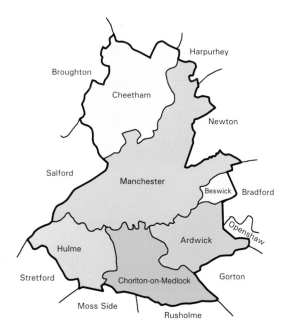

Municipal Borough of Manchester in 1838, based on a map in A. Redford, *The History of Local Government in Manchester*, vol. II (1940).

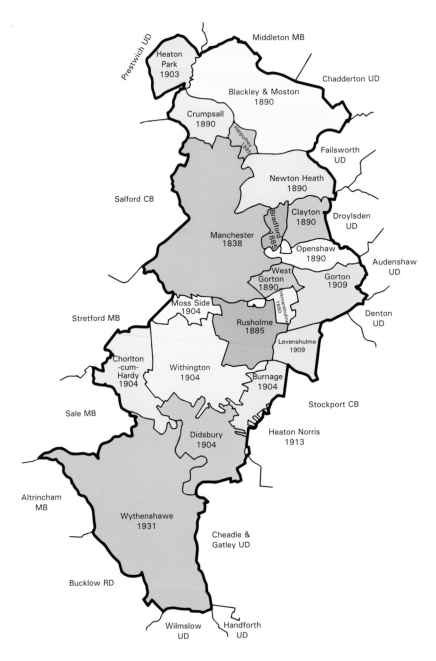

Manchester Airport (originally Ringway). Like some of the other great municipal corporations, Manchester had become a major employer of labour. Manchester City Council employed more than 25,000 people in 1926, and one-tenth of the city's population lived in the households of council employees. By 1939 annual expenditure topped £9 million and the corporation had assets in land, buildings, stocks and investments worth over £88 million.[5] Trading undertakings included

the city's waterworks, gas and electricity supply, transport (electric tramcars and motor buses) and markets. Over the last half century central government has consistently eroded local government independence and diminished its areas of responsibility. The powers of local elected authorities have been reduced and at the same time the need for co-operation between neighbouring municipalities has been enhanced. 'Greater' Manchester had walked on to the stage.

Greater Manchester

The idea of a larger 'Manchester' reaching far beyond municipal boundaries had emerged by the end of the nineteenth century due to the growth and movement of population, and it became conceptualized in the minds of town planners and government officials during the early twentieth century. Urban growth over the previous century had produced city regions of which the largest was Greater London. In the event, regional planning for urban development was to enjoy a varied history that began with co-operation between local authorities and ended with the diktat of central government.

The need for planning across some conception of a 'greater' Manchester first arose in the 1920s in the fields of transport and housing.[6] However, the ground rules for such local and regional planning were to be markedly changed by the strictures of the Town and Country Planning Act of 1947. This legislation set requirements on local authorities to plan, but also determined the limits and frameworks through which such planning was to take place. This ushered in an era of greater central control over regional planning.

Administrative reform follows economic reality tempered by historical precedent, but in a very real sense the lines on the map mean little. The various elements of the Manchester conurbation had grown into one another long before they were to be united by local government reform. Economic reality rarely balked at municipal boundaries. For example, 'industrial Manchester' could not be confined within the administrative areas shown on a map. This had the power to confuse the unwary. Thus the docks of the Manchester Ship Canal, the Port of Manchester, were in fact to be found in Salford, and Trafford Park industrial estate occupied land in Stretford and Urmston. Locating the physical 'heart' of Manchester has never been easy. The travel writer H.V. Morton commented in 1928 that 'Manchester is an elusive city; one is always searching for its centre and never finding it.'[7]

The 'twin cities', linked by more than the bridges across the Irwell, are divided by a boundary that seems to have little basis in reality. To the outsider amalgamation may seem rational, but Salford has nurtured its separate identity over the years and any prospect of absorption by its wealthier neighbour was effectively blocked when Salford became a city by letters patent in 1926. But the age-old sibling rivalry between Manchester and Salford perhaps matters less now than it has ever done as both have been subsumed into the 'city region' that takes its name from Manchester and of which Salford is now but a part.

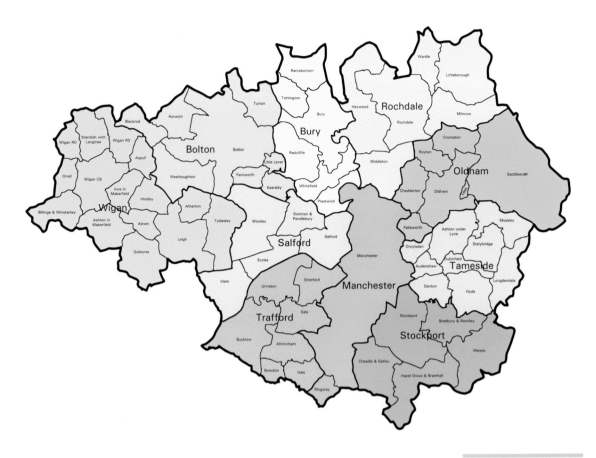

In terms of territorial expansion, municipal Manchester's 'imperial' phase was over by 1914, although the later addition of Wythenshawe accounts for the elongated shape of the borough. Despite economic interdependence within the region, and co-operation for planning purposes, surrounding towns such as Salford, Stockport, Oldham and Rochdale jealously guarded their independence and identity. Local government reform tended to strengthen their position while recognizing the dominance of Manchester. For example, the Local Government Act of 1972 created Greater Manchester as one of six new metropolitan counties. Following Greater London and the West Midlands it was the third largest of the new giants of local government and the only one in the provinces to be named after its core city.

Greater Manchester County stretched over almost 500 square miles and reorganized a population of 2.7 million into a cluster of newly created metropolitan boroughs. These included the city of Manchester at the centre, with the crescent of industrial towns to the north (Wigan, Bolton, Bury, Rochdale and Oldham) and the adjacent boroughs of Salford and Stockport, to which were added the new administrative inventions of Trafford to the south of Manchester and Tameside to the east.

Metropolitan County of Greater Manchester, 1974, based on a map in N.J. Frangopulo, *Tradition in Action* (1977).

As a unit of local government, the Greater Manchester County with its own county council was abolished in 1985, but the metropolitan boroughs survived and co-operated through a variety of joint boards and agencies until their continued interdependence was recognized in the creation of the Greater Manchester Combined Authority in 2011. This reflected central government conversion to the need to strengthen the former industrial centres of the north in an attempt to redress the north–south economic divide. In talk about a 'Northern power-house' attention has been focused on Manchester. As a first step, an elected mayor will run Greater Manchester from 2017. The mayor will oversee policies such as transport, social care and housing as well as police budgets, and will lead Greater Manchester Combined Authority, chair its meetings and allocate responsibilities to a cabinet made up of the leaders of each of the area's ten local authorities. 'Greater Manchester' marches on in a new incarnation.

What was Manchester?

Like any great city, Manchester had many layers of identity, often conflicting and contradictory. Its urban form was to change over time, most obviously with the onset of industrialization, though this is not to suggest a fossilized pre-industrial town. By the 1760s economic activity was already quickening, the Bridgewater Canal turning Castlefield, the site of the ancient Roman settlement, into a bustling canal port. New industrial, commercial and domestic buildings created an advancing frontier of development that was to obliterate ancient fields and eventually breach existing administrative boundaries. This new urban landscape was captured in William Green's large-scale town plan published in 1794, but that this was only the beginning of an urban revolution was evident by comparing it with the 62 sheets of the Ordnance Survey's first large-scale plan of the town published in 1850–51. Manchester was, as Elizabeth Gaskell informed her readers in the opening chapter of her novel *Mary Barton. A Tale of Manchester Life* (1848), a place in which today's countryside was tomorrow's streets.

A stranger visiting Manchester in the early eighteenth century would not easily have been able to distinguish industrial from residential buildings. Manchester had workshops and warehouses, but they were generally not separate buildings dedicated to their industrial or commercial purpose. By contrast a visitor in the early nineteenth century would have been confronted first and foremost by steam-powered cotton-spinning factories, the visible manifestation of the new economic order. Their size was inescapable. They dominated their environment in a manner unprecedented for any previous type of building, their smoking chimneys heralding the town long before any visitor reached it. Rather than being scattered across the town they formed groups in distinct factory districts. The main district was to the north and east of the township, focused on Ancoats, which included the huge factories of the Murray brothers and McConnel & Kennedy.[8] There was also a clutch of mills on the southern boundary of the township along Oxford Road and

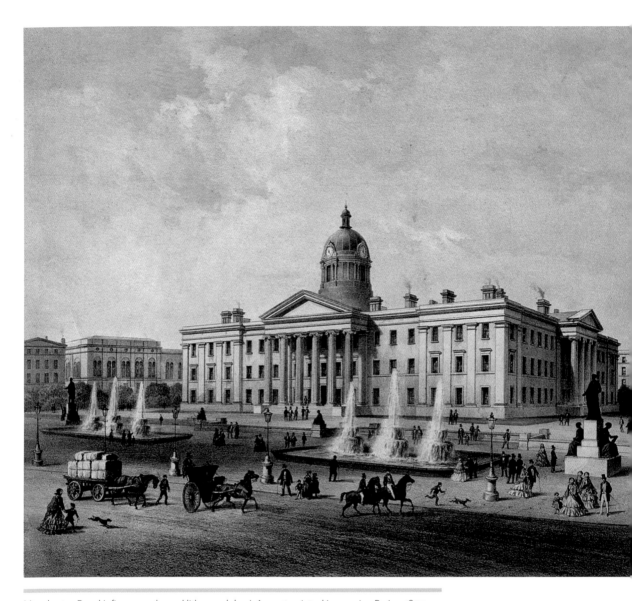

Manchester Royal Infirmary, coloured lithograph by J. Arnout, printed Lemercier, Paris c.1857. Creating a more formal space in front of the Infirmary was part of the wider project of Richard Lane's redesign of the original hospital building. In the early 1850s the Esplanade was created with fountains and monuments, including statues of John Dalton, James Watt and two Tory prime ministers, the Duke of Wellington and Sir Robert Peel.

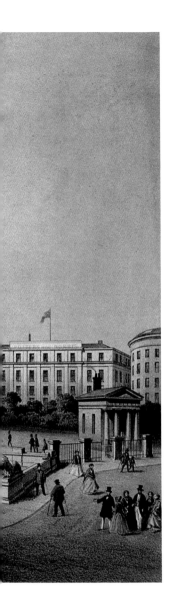

Cambridge Street by the river Medlock, including those of Hugh Hornby Birley and Robert Owen. During the 1820s, more factories were built in Ancoats and along the Medlock, and new industrial zones developed alongside the Rochdale and Ashton canals to the east and astride the Irk valley to the north of the town. As the Irwell wound its way through Salford it brought industry in its wake. The increasing complexity of the local canal network, and the advent of a rail network after the Liverpool to Manchester line was opened in 1830, further added to the industrial belt.

The earliest and most complete industrial district was Ancoats, which had pioneered a new kind of urban landscape: a dense and compact neighbourhood of steam-powered mills and industrial housing that provided a template for a myriad of other industrializing towns across the globe.[9] The Medlock industrial district along Oxford Road continued to grow. Here, gasworks, canal wharves, timber yards, sawmills, foundries, ironworks and cotton mills dominated an area entirely given over to manufacturing, and relieved only by pockets of back-to-back houses and courts. An industrial belt was encircling the town.

New forms of communication served the factories and workshops of Manchester, beginning with the Bridgewater Canal. The Rochdale canal, the first of the trans-Pennine waterways, had been completed in 1804 and a short cross-city section linked it to the Bridgewater Canal at Castlefield. The Ashton canal joined the Rochdale canal near Piccadilly. The canals played a vital part in the early phases of industrialization, turning Manchester into an inland port, with wharves and quays and the constant bustle of horse wagons and narrow boats at the Castlefield and Piccadilly canal basins.[10] Investment in new roads also changed the landscape, none more so than the opening of Oxford Road in the early 1790s, a catalyst in the development of the southern suburbs beginning with Chorlton-on-Medlock. The impact of roads on the landscape is generally underestimated and attention turns readily to the coming of the railways in 1830s. The Liverpool and Manchester railway heralded a revolution whose significance could not be measured solely in economic terms. By 1850 London Road (now Piccadilly) and Victoria stations saw the beginnings of railway warehouse and office developments, which were to swallow up entire areas of the city. Railway viaducts strode arrogantly across the urban landscape, providing in Castlefield a spectacular visual metaphor of the triumph of the Railway Age.

By contrast to the factory districts, public buildings, offices, warehouses, shops and hotels dominated the streets of the city centre. As the demand for commercial premises grew so the warehouses spread from King Street and St Ann's Square in the 1780s to the Cannon Street, High Street and Market Street area by the 1800s; thence they moved to the region of Mosley Street by the second quarter of the nineteenth century and later to Portland Street and Princess Street. Here lay the commercial heart of the city. On Cannon Street alone, in 1815, there were 57 warehouses occupied by 106 separate firms.[11]

The cotton trade gave Victorian Manchester's city centre its distinctive physical appearance, its warehouses replacing the factories as the city's leitmotif. Warehouses lined the main commercial streets or were gathered in rectangular blocks with innumerable back alleys for the loading and unloading of cotton. Manchester warehouses, particularly those involved in the home trade where buyers visited and examined goods before purchase, exhibited a new architectural style, that of the palazzi of Renaissance Italy but exploiting the latest construction methods and materials. These often palatial edifices were 'structures fit for kings ... which many a monarch might well envy',[12] the most imposing and showy being that of S. & J. Watts (now the Britannia Hotel) on Portland Street.

If Manchester's warehouses were the arteries of the Lancashire cotton trade, the Royal Exchange was its heart. The 'Change was rebuilt and enlarged several times during the nineteenth and early twentieth centuries. A visitor who entered the third building (completed 1874) at High 'Change, 2 p.m. each Tuesday and Friday, would encounter a dense mass of around 6,000 men engaged in myriad discussions and deals. The last extension was commissioned in 1913 to house the more than 10,000 subscribers. It finally closed for business in 1968, by which time the number of members had dwindled to 660. The last day's prices can still be seen on the display board in what now houses the Royal Exchange Theatre.

The head offices of the city's main banks and insurance companies were located in the streets close to the Exchange. The Manchester branch of the Bank of England was in Upper King Street and the Manchester Stock Exchange in Norfolk Street. Rising land prices in the financial centre were exemplified in the premium price that Lloyds Bank paid for the site occupied by Manchester's first Town Hall on the corner of Cross Street and Upper King Street. Other businesses such as Refuge Assurance developed larger, less expensive sites with slightly less prestigious addresses. But as in the case of the Co-operative Insurance Company whose main offices were in the community of buildings that housed the CWS at the northern end of Corporation Street, between Miller Street and Withy Grove, members of Manchester's financial community remained within walking distance of each other.

Retailing was another prominent feature of the commercial and business centre. By the late eighteenth century shops were already beginning to dominate the streets around the Market Place. Market Stead Lane (Market Street) was an important shopping street even before it was widened in the 1820s. Successive commercial directories provide the empirical data to support the pictorial evidence that begins with John Ralston's views of the street in Georgian times and goes on to include the first daguerreotypes of the city and some of the earliest moving images showing the pedestrians and traffic that clogged the street in Edwardian times.[13] The age of mass shopping can be dated from the opening of Lewis's Market Street store in 1880. Its success was immediate, and as new departments were added several building extensions were required, culminating in the seven-storey structure completed in 1885. One of the consequences of this long retail revolution

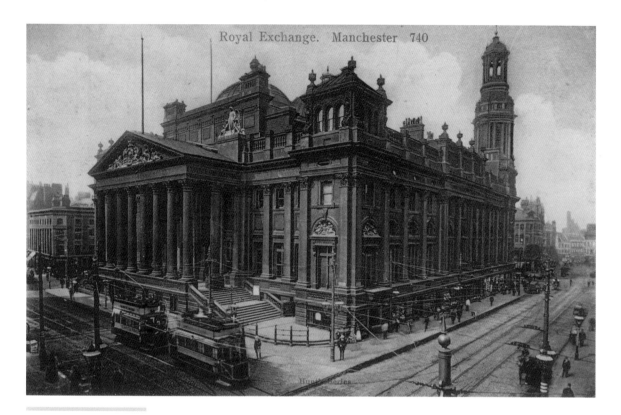

Royal Exchange. Manchester 740

Manchester Royal
Exchange, c.1910. The
Royal Exchange was a
popular Manchester
subject for Edwardian
postcard firms. This view
highlights the grandeur
of Mills & Murgatroyd's
Cross Street entrance,
demolished in the First
World War to make way
for a larger Exchange.

Courtesy of Chetham's Library

was the moving away of residents, a defining feature of city centres in the Victorian
period but one that was evident in the districts around Market Street as early as the
1820s.

A townscape created by private developers left few open spaces and even in
those schemes that did provide them they were spoiled by the rapidity of urbaniza-
tion. By the 1830s the absence of open spaces in the city centre was widely recog-
nized but little was done, and civic-minded schemes such as that proposed by
William Fairbairn to provide the city with more imposing public spaces remained
daydreams.[14] One of the few public spaces in the city centre was the Esplanade
(the former Daub Holes) in Piccadilly, a narrow strip of land in front of the Royal
Infirmary. When the plan to raise a memorial there to Prince Albert failed, this
triggered the creation of what eventually became the city's principal civic space,
Albert Square, though for many years it was little more than a large traffic island
enhanced by public statuary and overlooked by the Town Hall. Opened in 1877,
Waterhouse's glorious and expensive Gothic symphony became (and remains) a
symbol of the city. It was important on many levels and much has been written
about its brilliant architecture, especially its public and ceremonial spaces.[15] Less
consideration has been given to its offices, in what after all was a building that
accommodated the departments supplying services that were having an increasing
impact on the lives of ordinary citizens. This was a priority for the Town Clerk,

Joseph Heron, who was prominent in the small group of individuals who drove the project forward and whose arguments, no doubt, helped to ensure that although Waterhouse's design was not the first choice in the open competition, the extensive office accommodation it provided helped him win the commission.

Piccadilly's potential as a public space was boosted when, after decades of argument, the Infirmary finally decided to move to a new site on Oxford Road, selling the land to the council for £400,000. Interminable discussions on how the space could be best used continued, an art gallery and library being among the favoured ideas. Sculpture was promised for the site, and had the art gallery committee been more determined this might have included Rodin's *The Burghers of Calais*. But, like Fairbairn's plans, these all came to nothing, and in the end the land became, almost by default, a much-needed but unremarkable public space with a sunken garden. Providing even small open spaces in the inner city was, of course, expensive. An important source of public space arose from the closure and demolition of churches whose congregations had long succumbed to the lure of the suburbs. Redundant churchyards were transformed by the council into pocket parks and playgrounds.

If open spaces were not an important feature of its city-centre landscape, Manchester was far more successful in providing them in its suburbs, the city being in the forefront of the public parks movement. The opening in 1846 of Phillips Park and Queens Park in Manchester and Peel Park in Salford is generally regarded as one of the formative events in what became a significant change in land use in the Victorian city.[16] Parks became symbols of civic propriety, amenities to be praised in the local guidebook and celebrated in the jubilee essay on municipal achievements. By 1914 Manchester had no fewer than 70 parks and recreational areas covering some 1,480 acres, 6.8 per cent of land in the borough, a remarkable development given that the provision of parks was not a legal responsibility for councils. Public parks also proved to be dynamic institutions, the arguments and assumptions that had informed the first generation of their supporters and designers being revised, resulting in the emergence of landscapes with amenities that met more closely the needs of an enfranchised working class.[17] Equally important, due to the pressure brought by groups like the Committee for Securing Open Spaces for Recreation, was the establishment of small recreational grounds and play areas in the heavily populated working-class districts.[18]

Land for new parks continued to be acquired, and one of the appeals of extending the city's boundaries was the opportunity it provided of purchasing cheap land. On the very northern boundary of the city, Heaton Park was bought from the aristocratic Wilton family in 1902, its 600 acres making it easily the city's largest park.[19] Not all of the parks required the spending of ratepayers' money, the city being gifted Wythenshawe Park – an area of 250 acres – by Ernest and Shena Simon. Although fewer new parks were opened in the inter-war years, they were firmly fixed as important public spaces, the social characteristics of their users varying depending on which hour of the day or day of the week one visited. They

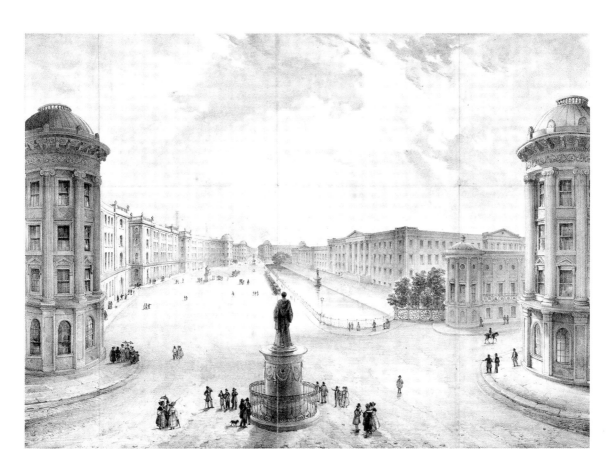

William Fairbairn's 1836 plan to provide Manchester with a large civic space worthy of the city – Bridgewater Crescent in front of the Infirmary – was a recognition that it lacked such public spaces and that it was falling behind improvement schemes in towns such as Liverpool. Over one hundred years later the *City of Manchester Plan* (1945) included an artist's impression of what a redesigned Piccadilly might look like in 2045.

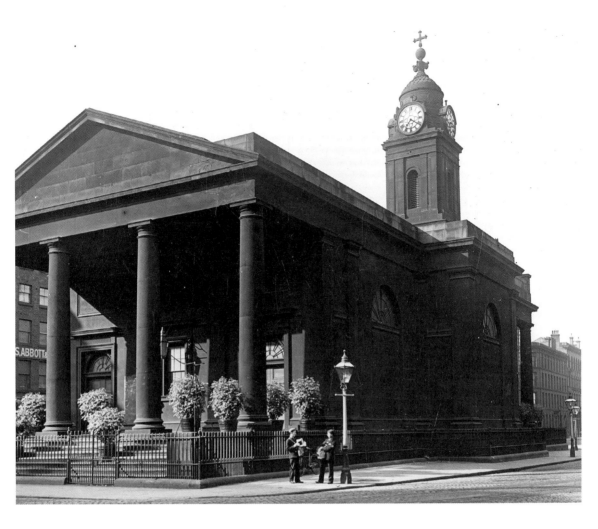

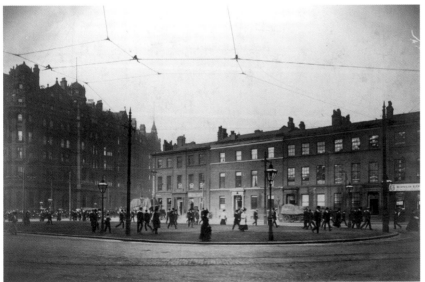

St Peter's Church, 1895. The church, consecrated in 1794, was demolished in 1906–07 to create an open space at the centre of St Peter's Square, captured in the 1907 photograph (below). A Gothic memorial cross, designed by the church architect Temple Moore, was unveiled in 1908.

Courtesy of Manchester Libraries, Information and Archives, Manchester City Council

were known for their floral displays, epitomized by the thousands who came to see the flowers on Tulip Sunday in Phillips Park, a small annual victory of colour for gardeners locked in what since the late eighteenth century had been a Sisyphean struggle to grow plants in Manchester's sooty atmosphere.[20]

Open spaces were a feature of the post-war plans for the city but little came of these. Significant improvements did not occur until the 1990s when open space provision became an integral part of redevelopment projects such as the Corn Exchange, Urbis and the Great Northern Warehouse. Piccadilly, however, continued to fulfil its historical role as a problematic space, a major re-landscaping scheme completed in 2002 having been preceded by the building of an office block on the south side of the gardens.[21]

The city centre did acquire new buildings in the early decades of the twentieth century but as its guidebooks suggest it was a place that was still dominated by its nineteenth-century architecture;[22] its distinctive commercial streets were 'canyons, walled in by cotton warehouses'.[23] The Blitz destroyed much of the Victorian character of the central business district. For two nights prior to Christmas 1940 the Luftwaffe dropped thousands of incendiary devices and high-explosive bombs on Manchester, Salford and Stretford. There were around 30 acres of damaged industrial and commercial property within one mile of the Town Hall alone.[24] Iconic buildings suffered: the Free Trade Hall and the Royal Exchange were gutted, the cathedral was hit, the Assize Courts damaged beyond repair and little was left of the city's ancient Market Place. As elsewhere in Britain, bombsites were to remain a potent reminder of the devastation that had been suffered for twenty and more years after the war was over.

From its construction in the 1890s onwards, the Manchester Ship Canal transformed Manchester into a port of international standing and gave Manchester and Salford their own docks. When completed, the Port of Manchester docks consisted of three main units. The main docks lay west of Trafford Road; on the opposite side of the canal was Trafford Wharf; and the shallower Pomona docks (on the site of the Pomona pleasure gardens) lay upstream to the south of the Irwell. The Trafford Park Industrial Estate, adjacent to the canal and designed to exploit its trading opportunities, effectively shifted the industrial focus of the city towards its south-western fringes. Trafford Park was entirely without cotton mills. Even in the 1890s it symbolized the alternative to 'Cottonopolis'. Its most characteristic industries were in the oil trade, engineering, chemicals and foodstuffs.

The Ship Canal and the Port of Manchester docks had been a vital success story for the city and of great significance for the economy of much of south Lancashire. But by the late twentieth century the Manchester docks had been reborn as Salford Quays, a complex of leisure facilities and commercial offices, and an example of the kind of dockland redevelopment scheme that had also been tried in the city's old rival, Liverpool. The availability of land so close to the city centre made it a suitable location for leisure and tourist attractions such as the Lowry Centre and the Imperial War Museum North.

During the 1960s and 1970s the final decline of Manchester as a great industrial centre was remarkably rapid. Following the loss of the cotton trade came the collapse of the docks in the face of containerization. As a consequence the inner industrial belt of factories, workshops, canals, railway depots and row upon row of terraced housing, which had long been a lively, dirty but exciting place, confronted the city with the characteristic problems of former industrial giants: loss of employment, urban decay and social deprivation. In addition to industrial decline, Manchester's central business district suffered from the decentralization of office development. Put off by the problems of inner-city parking and attracted by better motorway access and lower rents, new office blocks rose across the southern suburbs. The collapse of cotton meant not only redundant factory space but also empty warehouses of which Manchester's central streets had plenty.

The numbers of people employed in shop work grew while the warehouse sector contracted. Independent stores like Lewis's, Paulden's, Affleck and Brown's, and multiples like Marks and Spencer (which opened its Cross Street store in 1961), were joined in the 1960s by the supermarkets, which revolutionized British shopping habits in a generation. In the 1960s the most popular shopping areas were around Market Street and Oldham Street. Smaller retailers clustered in the side streets, spilling out along Princess Street and Cross Street. There was a degree of specialization: for example, car showrooms lined Peter Street while Tib Street was cluttered with the cages of its innumerable pet shops. Oxford Street displayed a characteristic mixture of cafés, restaurants, cinemas, newsagents and tobacconists. St Ann's Square and King Street remained fashionable shopping quarters, and Deansgate boasted the upmarket stores of Kendal Milne and Marshall and Snelgrove. The increasing relative importance of shopping to the local economy revealed itself in adventurous, if controversial, plans for a covered shopping centre for the city. The shopping streets of Manchester were transformed in the 1970s by the massive scale and indoor malls of the Arndale Centre, the city centre's answer to increasing competition from the region's other retail centres. This, plus pedestrianization, saved Market Street but at the expense of other traditional shopping thoroughfares like Oldham Street. Nonetheless it went some way to preserving Manchester's role as a retail centre. Initiatives in the wake of the 1996 IRA bomb involved a revamping of the shopping sector including the building of an entirely new thoroughfare, New Cathedral Street.

The now converted Daily Express building on Great Ancoats Street is a visible reminder of the city's former role as the newspaper capital of the north. The city's importance in other branches of the media seems more secure. Manchester has enjoyed a high profile in the fields of radio and television. The development of MediaCity UK since 2006, on former Port of Manchester land, is an endorsement of the major role the north-west continues to play in the history of British television.

Moreover, the industrial heritage of the region became a strength of the city's growing tourist trade. For example, the Museum of Science and Industry (MOSI)

is an attraction of international significance. Work was what once brought people to Manchester in their thousands; now it is leisure. Mills have been converted into museums and shopping outlets across the old industrial heartlands of the north, but the past need not be put into a museum to preserve it. MOSI was part of the reclamation of the formerly derelict Castlefield basin (the site of the Roman fort, the terminus of the Bridgewater Canal and once the cradle of Manchester's industrial revolution) as Britain's first urban heritage park. This historically important quarter of the city, with its canals, viaducts and derelict warehouses, was granted conservation area status in 1979. The renovation and conversion of historic buildings into residential accommodation and the transformation of the open space in the canal basin has converted this redundant industrial and commercial site into an exemplar of how sensitive regeneration can salvage historically important (and visually striking) locations.

Twenty-first-century Manchester has the single largest concentration in the north-west of offices, shops, warehouses, hotels and theatres. Part of the area's attraction is its built environment. It may seem odd to comment thus about 'sooty' Manchester, which until the 1950s was a byword for dreariness and gloom. The products of industrial pollution and the unrestricted use of the domestic coal fire were fog, smog and blackened buildings, which together with an infamous climate (more permanently damp than actually wet) contrived to give Manchester its grey visage. In the mid-twentieth century its image also had something to

John Harwood, *Market Street, from the Market Place, Manchester* (1829). The widening of Market Street, begun in the early 1820s, transformed it, confirming it as one of the main retail streets of the town. By 1830 the number of shopkeepers had trebled since the 1770s. Only the older inhabitants remembered it as the narrow and hazardous Market Stead Lane.

Courtesy of Manchester Libraries, Information and Archives, Manchester City Council

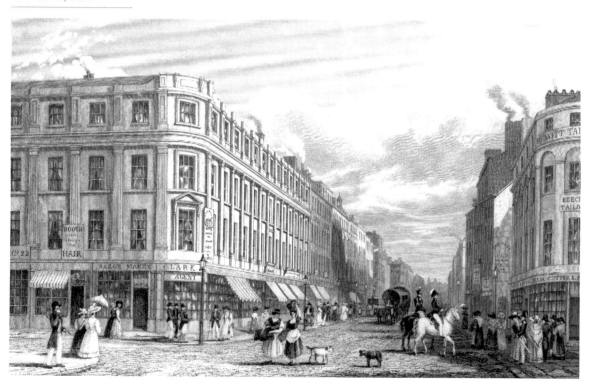

do with a prevalent distaste for all things Victorian. The Clean Air Act of 1956, which effectively doubled winter sunshine, and a policy of sandblasting in the 1970s dispelled much of the gloom, removing the grime from atmosphere and buildings alike to reveal the architectural flourish of the latter, now more readily appreciated.

When was Manchester?

Cities have identities created by an interaction of time and place. Although the place name 'Manchester' had an existence reaching across the centuries, its modern identity, known around the world, was the creation of a particular historical epoch. What happened here in the decades following the 1780s was a crucial staging post on the path to the modern world. This was Manchester's great moment on the stage of world history. Later generations had to struggle with the decline from these dizzy heights of significance. This was a challenge to the city's identity as much as to its economy. Civic and business leaders often responded to the challenge with great vision and bravura, no more so than in the enterprise and ingenuity that created the Manchester Ship Canal and saw the advent of the world's first industrial estate at Trafford Park. Such ventures were responses to the prolonged decline of the city's premier industry.

In more recent times the economy has shifted so firmly from manufacturing to service industries that regeneration initiatives have had to seek to reinvent Manchester as a 'post-industrial' European city, a new version of 'modernity' that seeks to respect but transcend the industrial past. That this has been done with imagination and a large degree of success does not surprise, but it does create something of an identity crisis for a city known throughout the world for its heritage as a great industrial city.

Manchester is here now, and is real and present, yet like many great cities around the globe it has a significant past that has an inevitable effect on how it conducts itself today and how it is viewed by many beyond its borders. One crucial attribute inherited from former times is a deep sense of confidence borne of an awareness of former greatness. Manchester saw and sees itself as a world city. In the nineteenth century it looked beyond national borders in its trading and cultural connections. Its scientists and industrialists were international names; its architects were visionaries who looked to historic civilizations for their inspiration as they sought to satisfy the aspirations of the city's merchant princes. The modern city has inherited this sense of ambition, this willingness to dare. The shadow cast by this history may be less important to more recent generations for whom Manchester's prowess in sport or popular music, or the bright glass buildings of its new city centre, may count for more, but its heritage of historic buildings and the momentous events that took place within and between them is a 'resource of great variety and density', which it is impossible to ignore.

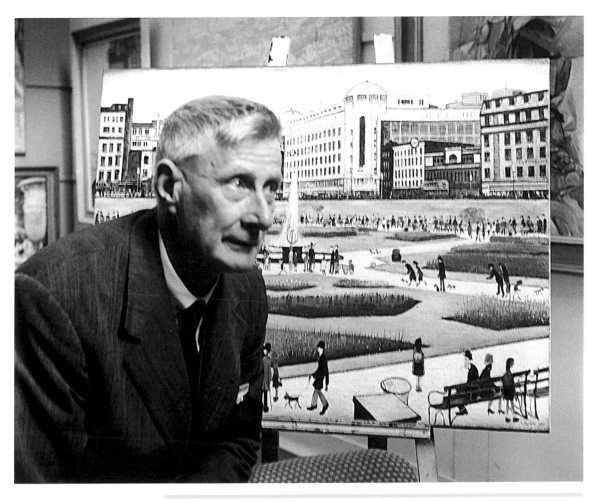

L.S. Lowry (1887-1976) created some of the most recognizable industrial urban landscapes of the twentieth century, works derived in part from a familiarity with Manchester and Salford resulting from his job as a rent collector. Here he is seen in front of his 1954 painting of Piccadilly Gardens, which was presented to the City Art Gallery by the Manchester Jewish retailers Henry's Stores, which also commissioned the Coronation fountain in the sunken garden which features in the painting.

© Mary Evans Picture Library/IDA KAR

The structure of this book

The chapters in this book cover some of the chief elements in the story of modern Manchester. The book does not pretend to be comprehensive but sets out to offer key insights into a number of the main features of the history of the modern city. Thus Geoff Timmins examines the Manchester that preceded the factory and asks questions about how the town grew and the roots of industrialism. Terry Wyke explores the phenomenon that was Cottonopolis and the extent to which this soubriquet explains or obscures Manchester's industrial importance. He also sheds

light on the decline from industrial greatness in the twentieth century. Science and technology have been close to the core of Manchester's being since the eighteenth century. It is no accident that statues of two of the city's greatest scientific names, Dalton and Joule, grace the entrance to the Town Hall. Manchester has always regarded itself as a city of science. The chapter by James Sumner surveys this tradition from the era of Dalton to that of graphene. Michael Rose considers Manchester's radical traditions and the many 'voices' that have been heard in the city from the politics of protest that resulted in the Peterloo Massacre to the struggles for political rights for women and civil rights for gay people. Modern Manchester is a multi-cultural city with a wide variety of ethnic and linguistic communities and traditions. This is nothing new. Mervyn Busteed explores the varied histories that the communities of the city have produced over the last two hundred years. Manchester has strong traditions in cultural and sporting performance, with significant contributions in the performing arts from music to drama and in media history from newspapers to television, and in numerous sports, as well as the city's world-famous football clubs. Dave Russell investigates this rich cultural and sporting heritage. Alan Kidd assesses the extent to which suburbs have influenced the growth and character of modern Manchester and examines the relationship between the city of Manchester and the conurbation of which it is the heart. Finally, Brian Robson brings the history right up to date with a detailed account of the contemporary city that in the wake of the challenges of industrial decline has done so much to reinvent itself.

Notes

1. R. McNeil, *Manchester – Archetype City of the Industrial Revolution: A Proposed World Heritage Site*, Manchester: University of Manchester Field Archaeology Centre, 2002, p. 39.

2. D.A. Farnie and D.J. Jeremy, eds, *The Fibre that Changed the World. The Cotton Industry in International Perspective, 1600–1990s*, Oxford: Oxford University Press, 2004.

3. Daniel Defoe, *A Tour Through the Whole Island of Great Britain* (1726), Harmondsworth: Penguin, 1971, pp. 544–5. Compare this with Stukeley's similar observation: 'Manchester … the largest, most rich, populous, and busy village in England'; William Stukeley, *Itinerarium Curiosum: Or, An Account of the Antiquities, and Remarkable Curiosities in Nature or Art, Observed in Travels through Great Britain*, London: Baker and Leigh, 2nd edn, 1776, p. 58 [first published in 1724].

4. Manchester had briefly been represented in Parliament during the Commonwealth in the 1650s.

5. E. Simon, *A City Council from Within*, London: Longmans, Green, 1926, p. 1; *How Manchester is Managed*, Manchester: Manchester City Council, 1926 and 1939.

6. The Manchester and District Joint Town Planning Advisory Committee was formed in the 1920s and proposed 65 projects for regional and main district roads (Manchester and District Joint Town Planning Advisory Committee, *Report on the Regional Scheme*, Manchester, 1926). Two years later a Manchester and District Regional Planning Committee was constituted to prepare a joint planning scheme for an area encompassing 14 local authorities. See R. Nicholas, *The Manchester and District Regional Planning Committee Report on the Tentative Regional Planning Proposals*, Norwich: Jarrold & Sons, 1945.

7. H.V. Morton, *The Call of England*, London: Methuen, 1928, p. 158.

8. I. Miller et al., *A & G Murray and the Cotton Mills of Ancoats*, Lancaster: Oxford Archaeology North, 2007.

9. M.E. Rose et al., *Ancoats: Cradle of Industrialisation*, Swindon: English Heritage, 2011.

10. The canal network of central Manchester can be followed in detail by using Joseph Adshead's *Twenty-Four Illustrated Maps of the Township of Manchester 1851*, available on CD ROM from Digital Archives Association (Warrington).

11. R. Lloyd-Jones and M.J. Lewis, *Manchester and the Age of the Factory: The Business Structure of 'Cottonopolis' in the Industrial Revolution*, London: Routledge, 1988.

12. *Bradshaw's Guide to Manchester*, 1857, cited in C. Stewart, *The Stones of Manchester*, London: Edward Arnold, 1956, p. 36.

13. J. Ralston, *Views of the Ancient Buildings of Manchester*, Manchester: D. and P. Jackson, 1823–25; 'Manchester street scenes (1901)', British Film Institute, Mitchell and Kenyon Collection.

14. W. Fairbairn, *Improvements of the town of Manchester. The chaste and beautiful, with the ornamental and useful*, Manchester: printed by Robert Robinson, 1836.

15. J.H.G. Archer, ed., *Art and Architecture in Victorian Manchester*, Manchester: Manchester University Press, 1985.

16. H. Conway, 'The Manchester/Salford parks', *Journal of Garden History*, 5 (1985), pp. 231–60; T. Wyborn, 'Parks for the people: the development of public parks in Manchester', *Manchester Region History Review*, 9 (1995), pp. 3–14.

17. H. Conway, 'Sports and playgrounds and the problems of park design in the nineteenth century', *Journal of Garden History*, 8.1 (1988), pp. 31–41.

18. *Illustrated Handbook of the Manchester City Parks and Recreation Grounds*, Manchester, 1915.

19. C. O'Reilly, 'From "the people" to "the citizen": the emergence of the Edwardian municipal park in Manchester, 1902–1912', *Urban History*, 40.1 (2013), pp. 136–55.

20. A.R. Ruff, *The Biography of Philips Park, Manchester 1846–1996*, Manchester: University of Manchester, 2000.

21. See Ian Nairn's discussion of Piccadilly Gardens in 'Nairn across Britain. London to Lancashire' (BBC TV, 1972) https://www.youtube.com/watch?v=eL95amUnQuc.

22. C. Reilly, *Some Manchester Streets and their Buildings*, Liverpool: Liverpool University Press, 1924.

23. 'A pictorial and descriptive guide to Manchester', *Manchester City News* (1937), p. 36.

24. 'Return as to damage to property directly consequent upon the bombardment or attack from the air', Manchester Emergency Committee Minutes, 9 January 1941, Manchester Archives, M564/1.

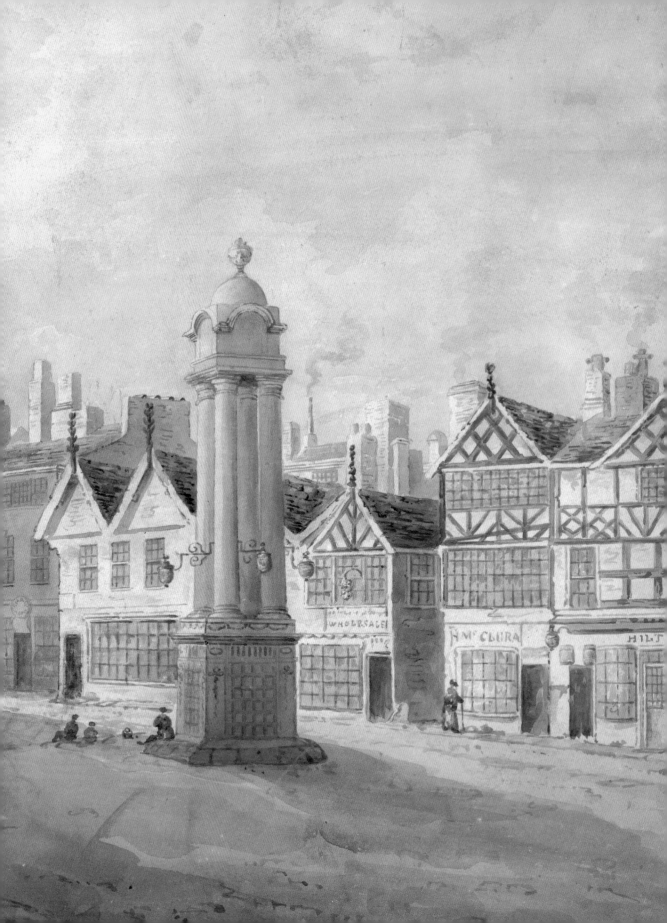

Roots of Industrial Revolution

GEOFF TIMMINS

The industrial revolution catapulted Manchester to world importance, but even before the first factory was built, the town was already the economic hub of the textile industry in the north-west of England. It was noted for its commercial and manufacturing activities alike; for the wealth of its leading businessmen; and for the impressive changes that were being made to its built environment. It had also become one of Britain's most populous towns. How had all this come about? How can the town's progress before the factory era be measured? What factors explain its rise to importance? Also, what sort of town was it: what did it look like, what was it like to live in and how did it change over the years? These are some of the questions addressed in this chapter.

It is surprising how much remains unknown about Manchester before the industrial revolution era, including its population growth. Yet numbers of inhabitants, along with physical expansion, are fundamental measures by which urban development can be assessed. Without such basic data it is hard to say exactly how Manchester progressed during the two centuries or so prior to the steam-factory age. In estimating population size before the late eighteenth century, historians have relied on indirect measures, that is, statistics gathered for other purposes, such as tax assessments. The evidence these sources provide is not always easy to interpret and has to be treated with caution. As an alternative, this chapter uses evidence from the town's parish registers to estimate population trends – whether numbers were rising, falling or stable over time – and to assess the pace at which population change occurred. Analysing these trends gives a clearer insight into how Manchester developed during the seventeenth and eighteenth centuries.

E. Hooson, *Market Place* (1807). The Market Place underwent many changes in the eighteenth century in response to the increase in trade and population. Following the demolition of the Exchange in 1792, a classically inspired obelisk, which included oil lamps and a clock, was built. Known as Nathan Crompton's Folly after the borough reeve who erected it, it was taken down in 1816, having become an obstruction to the movement of traffic.

Courtesy of Chetham's Library

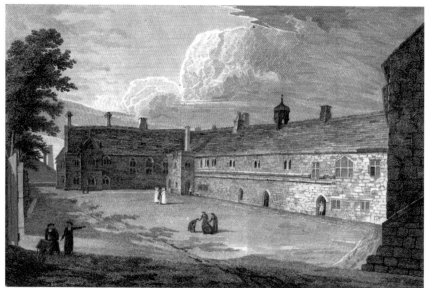

View of Chetham's School and Library from the schoolyard, c.1819. Chetham's School and Library was on the itinerary of most visitors to Manchester in the eighteenth century, and was regarded as an ancient foundation that was living proof of the philanthropic spirit existing in the town. Housed in one of the town's oldest and most historic buildings, a visit might include a tour of its museum of curiosities led by one of the charity scholars.

Courtesy of Chetham's Library

In 1801, as the first national census of population held in Britain revealed, the adjoining towns of Manchester and Salford formed the most populous urban concentration in provincial England. No fewer than 84,020 people were counted, of whom 70,409 (84 per cent) lived in Manchester. It is true that, if single towns are considered, Liverpool's population exceeded that of Manchester, its inhabitants numbering 77,653. But the more significant point is that, even allowing for some degree of error in counting, the populations of both Manchester and Liverpool greatly exceeded those of any other town in the north-west. Ashton-under-Lyne, the next most populous, had only 15,632 inhabitants, several hundred more than fourth-placed Chester.

As they rose to regional and national prominence, Manchester and Liverpool benefited appreciably from the connections they forged with one another. From a Manchester perspective, the proximity of emerging port amenities was particularly important. Yet Manchester acquired other locational advantages that helped to promote its economic growth. These included specialized labour skills, an improved transport system and the development of effective means of organizing and financing production. The town's economy also benefited from a rising demand for the products its inhabitants manufactured and the marketing services they provided, particularly in relation to cotton textile goods.

That Manchester had become prominent among English provincial towns by the early nineteenth century raises the issue of its relative importance in earlier times. To throw some light on the matter, size rankings prepared by historians of England's most populous towns can be considered. The rankings are based mainly on taxation records and are available for several years between the thirteenth and nineteenth centuries. Those compiled for years before 1600 do not mention any

town in north-west England. At the most, therefore, Manchester was a place of no more than regional importance during Tudor times.

Given this finding, what can be said about the timing and pace of Manchester's transformation into a town of national prominence by the early nineteenth century? Was the process a gradual and steady one, or was there an uneven rate of development, perhaps associated with a marked discontinuity in the expansion of the town's economy, population and built-up area? If so, when did this discontinuity occur? And though Manchester was not nationally significant in the Tudor period and perhaps beyond, were changes already occurring which, in the fullness of time, laid the foundations for the predominance it was eventually to achieve?

In addressing these questions, discussion is divided into three sections. The first examines changes in the rate of Manchester's population growth between the mid-sixteenth and late eighteenth centuries. The second considers the extent and nature of changes that were made to the town's built environment during this period. The findings in both these sections reveal that Manchester's expansion quickened markedly during the middle decades of the eighteenth century. This is not to argue, however, that progress was lacking in earlier times. Indeed, as will be seen, the new types of textile products being manufactured in the town from the late sixteenth century had a profound influence on its long-term prospects.

The third section considers why the middle decades of the eighteenth century were so crucial in Manchester's development. The impact of the rise of cotton manufacturing in Lancashire, an industry with which the town became so intimately connected and to the growth of which it made such a major contribution, is highlighted. From the end of the seventeenth century, official statistics are available relating to the import of raw cotton into Britain and to the overseas sales of cotton cloth. Both can be used to gauge trends in the industry's expansion during the eighteenth century and hence its impact on the likely course of Manchester's growth. Consideration is also given to developments occurring within Manchester and its environs that impacted on the cotton industry's growth, including the major improvements made to the transport network in conveying goods both by water and land.

Counting heads: population size and trends

Numerous estimates of the size that the populations of English provincial towns had reached before the nineteenth century have been made for selected years, usually with lengthy time intervals between them. They have often been used to show the rate at which towns grew and, in some cases, to indicate their national standing. Yet historians have often stressed the difficulties involved in calculating these estimates and in using them for comparative purposes.

For Manchester, the earliest of these estimates dates back to 1543. It draws on lay subsidy records. These were taxes levied nationally on the moveable property owned by lay people as opposed to clergymen. However, there is a general concern

The South West Prospect o[...]

as to how many people actually paid the tax, since certain types of goods were exempt. Moreover, in using the returns to estimate population size, assumptions have to be made about the probable number of people per household. In Manchester, 256 taxpayers were recorded in the 1543 returns and a multiplier of nine was used to allow for household size and exemptions. As a result, a figure of around 2,300 people for the township has been suggested.[1] Clearly, this figure may be wide of the mark.

Further estimates of Manchester's population size relate to the middle decades of the seventeenth century. They include one based on the 1642 Protestation Returns, which required people aged 18 or above to swear on oath that they would maintain and defend the established religion against 'popery and Popish innovations', the king's 'person, honour and royal estate', the powers and privileges of Parliament and the lawful liberties and rights of subjects. For the most part, only men were recorded, 1,157 of them being named in the Manchester township returns, along with one woman. Taking into account likely numbers of children and adult females, it has been suggested that Manchester's population in 1642 must have exceeded 3,000.[2] So, while it is hazardous to draw firm conclusions

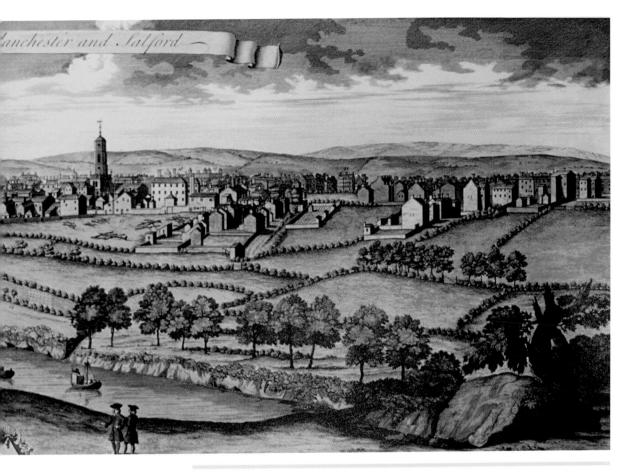

Robert Whitworth, *The South West Prospect of Manchester and Salford* (c.1734). One of the earliest pictorial representations of Manchester, Whitworth's *Prospect* (based on one published in 1728) provides important evidence of the physical appearance and extent of the town. Of the public buildings the two Manchester churches - the Collegiate Church and St Ann's - are clearly visible, as is Sacred Trinity in Salford. By the 1720s houses were encroaching on the land between Deansgate and the Irwell. The Exchange was among the buildings identified, but the more direct evidence of the quickening urban economy is the depiction of the Irwell as a working river.

Courtesy of Chetham's Library

based on such inadequate evidence, Manchester's population may have expanded by at least a third between the mid-sixteenth and mid-seventeenth centuries.

Other mid-seventeenth-century evidence on Manchester's population size has been derived from hearth tax returns. Introduced in 1662 to provided income for Charles II, this tax was levied on the number of hearths in each householder's dwelling.[3] Based on the returns for 1664, recent investigation has shown that at least 1,067 households were to be found in Manchester and Salford. The returns include the numbers of households that were exempt from the tax. Not all households may have been listed, however, the occupants of some being so poor that they were ignored by the tax collectors. A further uncertainty is the number of people who would have lived

in each household. In this case, two calculations are made, one assuming an average of 4.5 people per household and the other an average of 5.0 people per household. As a result, a total population for Manchester and Salford together of between 4,800 and 5,335 is obtained. Since not all households may have been included, a somewhat higher figure may be more appropriate.[4] Making calculations on a similar basis, the 820 households recorded in Manchester alone in 1664 would have had between 3,690 to 4,100 inhabitants.[5] Using hearth tax evidence, therefore, the best that can be said is that, in the 1660s, Manchester's population may have been around 4,000 and that of Manchester and Salford together around 5,000. Given the substantial loss of population that occurred in Manchester during the mid-1640s – a matter discussed below – it is highly unlikely that the growth implied by comparing the town's 1642 population estimate with that of 1664 would have occurred.

But what can be said about Manchester's regional and national standing during the mid-seventeenth century? The 1664 hearth tax returns provide some guidance, since they have also been used to compute household numbers in several other north-west towns. One set of results is shown in Figure 1.1.[6] As can be seen, Chester retained its status as by far the region's most populous town, with more than twice as many hearths as Manchester. However, though incomplete, the evidence shows that Manchester had achieved prominence over its satellite towns, as well as towns further afield. The number of hearths in Bolton and Preston, for example, was only around half those in Manchester.

As to establishing Manchester's national importance in the mid-seventeenth century, the evidence is far from clear cut. One calculation using the 1662 hearth tax lists places 42 provincial towns in rank order and only Chester, in nineteenth position, is mentioned in the north-west.[7] In contrast, a listing for c.1670 mentions only 13 provincial towns as having a larger population than that of Manchester. However, within this list, Manchester is included in a group of seven towns with a population of c.6,000, perhaps a larger total than the hearth tax returns suggest, even if Salford is included. The indications are, therefore, that while Manchester had achieved a degree of regional importance at this time, it had yet to attain significance at national level.[8]

For the post-1660s period, evidence on household numbers in Manchester is available from returns made to the Bishop of Chester around 1717 and from a survey undertaken by Dr Thomas Percival in 1773. The former gives a count of 2,006 families in the township, suggesting a population total of around 9,000–10,000. On this evidence, more than a doubling may have occurred since the 1660s.[9] The latter, a remarkably detailed house-to-house survey of Manchester and Salford, gives population totals as well as other demographic details. In Manchester, 22,481 people were enumerated and in Salford 4,765.[10] So, during the half-century after the Bishop of Chester's returns, the population of Manchester township may have again more than doubled.

Table 1.1 brings together the population totals discussed above. What stands out is the much quicker rate of growth that appears to have occurred between the

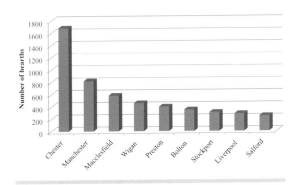

Year	Estimated population
1543	c.2,300
1642	c.3,000
1664	c.4,000
1717	c.10,000
1773	c.22,500

Figure 1.1 Numbers of hearths listed in selected north-west towns, 1664

Table 1.1 Estimates of Manchester's population for selected years

mid-seventeenth and mid-eighteenth centuries than between the mid-sixteenth and mid-seventeenth centuries. Comparing the 1664 figure with those of 1543 and 1773, so that almost the same time intervals are taken, the increases amounted respectively to 74 per cent and 463 per cent. However, given the limitations of the data on which most of them are based – that of 1773 being the exception – these percentage figures, as well as the growth pattern they reveal, should not be taken too literally. Checks against the findings from investigating other sources of evidence on Manchester's population growth are needed. So, too, are explanations as to why the changes were taking place.

Evidence to address these matters is to be found in the baptism, burial and marriage registers of the Manchester Collegiate Church, which date back to 1573. The entries relate mainly to Manchester township, but also to many of its neighbouring settlements, including Salford, Cheetham, Gorton, Chorlton Row, Bradford and Ardwick. Beginning with Gorton in 1599, some of these settlements acquired their own chapels of ease and accompanying sets of registers. Salford followed suit in 1616, as did Chorlton-with-Hardy in 1639, Blackley in 1655 and Newton Heath in 1665.[11] Further sets of local registers became available during the following century as nonconformist chapels were established, as were Anglican churches within and around Manchester. The earliest among the town registers are those for St Ann's, available from 1737, and for St Mary's, which date from 1756.

For most of the seventeenth century, the baptism and burial entries in the Collegiate Church registers note the places to which those recorded belonged. Exceptions arise during the first few years of the century and, though to an insignificant extent, during some of the later years. With all parish register evidence, however, there is concern as to how fully records were kept, not least because of the disruptions to normal life brought about by the Civil War (1642–51). However, the Collegiate Church registers were carefully compiled during this period, credit being due to the efforts of the Revd Richard Heyricke, who held the office of churchwarden from 1635 to 1666.[12] Furthermore, the virtual absence of monthly

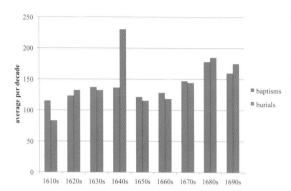

Figure 1.2 Average number of baptisms and burials per decade in Manchester during the seventeenth century

■ baptisms

■ burials

gaps in the registers throughout the seventeenth century at least shows that fairly regular recording took place. Annual baptism and burial totals for those living in Manchester at this time can be compiled, therefore, though allowance has to be made for the possibility of some under-recording.

These totals are set out as decennial averages in Figure 1.2. Comparing the numbers of baptisms and burials that occurred in each decade gives a strong indication of whether the town's population was rising (more baptisms than burials) or falling (more burials than baptisms) and of the course of change over the decades. However, they do not give the complete picture because migration must also be taken into account. Work opportunities would certainly have attracted people into the town. But acting against this was the growth of domestic textile production and of other types of work in rural districts around the town during the seventeenth century, as well as further afield, which would have lessened the appeal of urban life. The importance of this so-called proto-industrialization, which gave employment to both sexes, is evident from the occupations recorded in the marriage registers of the Collegiate Church during the 1650s. These reveal that domestic weaving had become widespread in the rural settlements around Manchester, sometimes forming a significant component of the economy.[13] It must also be realized that some people, perhaps many, would have left Manchester as occasion arose. Marriage is one possibility. When Ann Barber of Manchester married Edward Morecroft, a tanner from Ormskirk, in October 1657, who would have moved?[14] The question must also be asked as to whether rural people would have been attracted to living in Manchester given the health hazards associated with urban living. These are considered in the following section. The extent to which net migration influenced the population totals of early modern Manchester is unknown. However, its impact in promoting change in the town's population during the early modern period is likely to have been far less significant than changes in birth and death rates that occurred within the town.

Turning to the evidence shown in Figure 1.2, the most striking feature to emerge is the exceptionally high mortality of the 1640s. This resulted largely from an outbreak of plague in the middle of the decade; no fewer than 1,014 people – a

high proportion of the town's population – died in 1645. During the earlier decades of the century, baptisms were a little more numerous than burials, suggesting that the population was rising. And this was so despite a setback during the 1620s, when burials exceeded baptisms. Again, a particular 'crisis' year stands out, with 284 people dying in 1623. During the 1650s, 1660s and 1670s a return to rising population is evident. Baptisms not only exceeded burials, but, during the 1670s, they reached a total higher than had been achieved earlier in the century. However, a fall in population may have occurred during the 1680s and 1690s as burials exceeded baptisms, though without any very marked mortality peaks arising. Whether, as the estimates noted in Table 1.1 suggest, Manchester's population would have more than doubled between the mid-1660s and 1710s remains in doubt. But what needs to be recognized is that, in the wake of the massive loss of population in the 1640s, the growth that did occur during this period started from a reduced base and did not take place in a smooth progression.

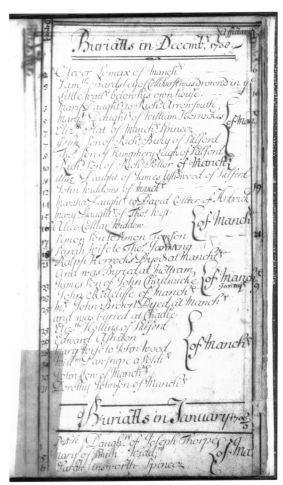

Burial register, Collegiate Church, December 1708. The parish registers kept by the Collegiate Church are among the most complete for any English parish, providing the raw data for charting demographic trends. As is commonly the case, entries in these registers frequently refer to 'son of' or 'daughter of'. Adults were given their full names. So, the entries shown on this page point to the high levels of child mortality, especially among infants, that prevailed before the twentieth century.

Manchester Cathedral Archives

Plague in Manchester

In early modern times, parents commonly outlived their children, as was the case with Richard Heyricke, the long-serving warden at Manchester Collegiate Church. His son William died in 1637, when just a few weeks old. In 1642 his first wife Ellin also died, followed barely a month later by their daughter Suzanna. She had recently reached her third birthday. Heyricke also lost at least four more of his children, namely Ann (1643), John (1647), Joan (1649) and a second Joan (1650).

In years of exceptionally high mortality – usually referred to as crisis years – such tragic experiences could occur within very short timescales. The demise of Hugh Travis's family during Manchester's 1645 mortality crisis illustrates the point. On 12 June his sons Edward and Thomas were buried, followed by his wife Jane the day after. The next day, Travis's own burial took place and three days later that of his daughter Marie. Other instances, equally heart-rending, appear in the burial lists for that year. Many involved young children, as checks against baptism register entries confirm.

Manchester's baptism and marriage registers mention the intensity of the 'sickness' that occurred during the late summer of 1645, and its impact is clearly revealed in Figure A, which shows that over half the deaths recorded during the year occurred in August and September. Such a seasonal pattern of deaths, coupled with the exceptionally high numbers who died, adult and children alike, is consistent with an outbreak of bubonic plague. Victims were removed to wooden cabins at Collyhurst, to the north-east of Manchester, and relief measures were implemented. Thus in December, a House of Commons ordinance directed churches and chapels in the metropolis to make collections for relieving Manchester's poor. The ordinance stated that the severity of the outbreak had prevented

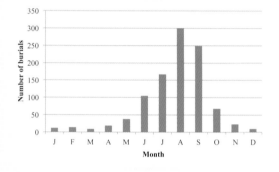

Figure A Monthly burial totals in Manchester, 1645

For the early decades of the seventeenth century, the Manchester trends broadly reflect national changes, with the growth rate of England's population slowing down from that achieved in the later Tudor period as fertility rates fell. However, a decline in England's population set in from the mid-1650s, a decade later than in Manchester, where the plague outbreak took severe toll. Moreover, whereas Manchester's population growth resumed during the 1660s, recovery at national level was delayed until the mid-1680s, by which time Manchester's population was showing another downturn. Further falls in fertility rates from 1650 to 1680, followed by a recovery thereafter, are seen to have influenced the national trends.[15]

During the eighteenth century, the Manchester Collegiate Church registers ceased to give places of residence. However, the great majority of people recorded

movement into and from the town for many months, greatly hindering the town's trade.[16]

Two other years of extraordinarily high mortality appear in Manchester's Collegiate Church registers. One was 1605, when 1,078 burials were recorded and plague mentioned. The monthly burial distribution was similar to that of 1645, although with an earlier peak (Figure B). Attempts were made to control entry into Manchester and relief measures were again introduced, funded partly by taxing those who left the town during the outbreak.[17]

The other mortality peak was in 1729, when 762 burials were recorded in the Collegiate Church register. However, the monthly burial pattern differed from those of 1605 and 1645,

with burial numbers rising during the summer and autumn to a peak in November (Figure C). In fact, mortality was generally high in southern Lancashire during the winters of 1728/29 and 1729/30, when outbreaks of fever occurred. High food prices also prevailed, so resistance to disease was perhaps weakened through inadequate nourishment.[18]

At national level, population crises have been graded according to their severity. That of 1729/30 was among the most severe, being 35 per cent above trend. However, despite their severity in Manchester, the 1605 and 1645 plague outbreaks were not of national significance; they did not occur in years when national death rates reached 10 per cent above trend.[19]

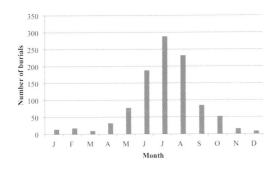

Figure B Monthly burial totals in Manchester, 1605

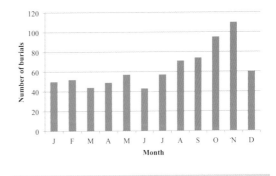

Figure C Monthly burial totals in Manchester and district, 1729

in them would undoubtedly have lived within the town itself, which, as the following section reveals, was expanding significantly. Weight is added to this point because the local chapels of ease mentioned above would have catered for much of the surrounding population. And even though the Collegiate Church registers note very few of the baptisms and burials held in other churches that were established within the town during the eighteenth century, they still record the great majority of those that took place there, as least before the 1780s.

Totals of the baptisms and burials noted in the Collegiate Church registers between 1700 and 1780 are presented in Figure 1.3 as decennial averages. As in the seventeenth century, the indications are that the registers were carefully kept. The only monthly gaps in the baptism records are for August 1760. Burial recording is a little less well served, with gaps appearing in November 1739, December 1742 and

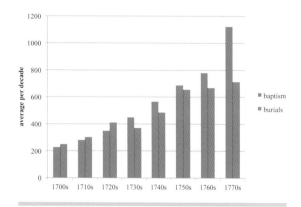

Figure 1.3 Average number of baptisms and burials per decade recorded at Manchester Collegiate Church during the eighteenth century

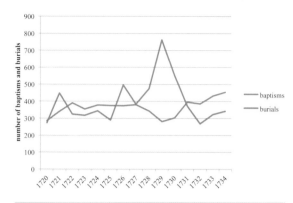

Figure 1.4 Manchester parish register counts, 1720-34
Source: Manchester Collegiate Church registers

January 1743. Accordingly, the baptism figure for the 1730s and the burial figure for the 1740s should be somewhat higher. Even so, the shortfalls are too small to have any significant impact on the trends that the figures reveal.

As can be seen, a strikingly different pattern of change emerges compared with that of the seventeenth century, with the 1730s marking a crucial turning point. From then onwards, the baptism counts began to exceed the burial counts consistently. And they did so with widening gaps during the 1760s and 1770s, indicating an accelerating rate of growth. This finding is consistent with the population totals given in Table 1.1, though it reveals that the population rise during the eighteenth century was uneven in pace.

Manchester's population growth during the eighteenth century reflected a national trend. Whether rising birth rates, associated with a fall in the age at which women married, had more influence on this trend than falling death rates is a matter of debate.[20] However, after the early 1740s, a significant change occurred in the nation's mortality pattern. Thereafter, years of exceptionally high mortality no longer occurred.[21] These are considered later, but it may be noted here that in Manchester, the last decade in which burials exceeded baptisms was the 1720s. The highest annual number of burials during this decade was in 1729, when 762 were recorded compared with 281 baptisms (Figure 1.4). In this year, burials were well above the average for the rest of the 1720s and, for that matter, for any year since the mid-seventeenth century. How far Manchester's eighteenth-century population growth was also influenced by net migration is unknown, although Thomas Percival, writing in 1773, argued that the health of the town's inhabitants had improved because of 'the large accession of settlers from the country', who were usually in the prime of life. But no numbers are cited.[22]

The sources and methods used to determine population change in early modern Manchester must be treated cautiously. However, they do give an indication of the numbers of inhabitants for benchmark years, as well as showing the

An Enumeration of the Houses and Inhabitants in the Town and Parish of Manchester, 1773-74. Manchester's first detailed census showed that the majority of the population in the parish lived in Manchester, in sharp contrast to the small number of inhabitants living in the outer townships, even those like Ardwick and Chorlton Row that were contiguous to Manchester.

Courtesy of Chetham's Library

	Houses	Families	Males	Females	Marr'd	Wid'd
Ardwick	47	53	115	127	00	6
Broughton	99	104	205	270	102	14
Bradford	13	17	44	55	32	—
Beswick	2	2	6	4	4	—
Burnage	54	55	147	150	93	3
Blakeley	240	270	692	702	469	13
Chorltonrow	46	49	103	123	70	7
Claddin	10	11	21	24	19	—
Cheetham	93	107	207	293	103	10
Crumpsall	57	63	160	101	116	6
Chorlton	71	75	176	202	120	11
Droylsden	107	111	376	323	210	0
Didsbury	84	86	260	239	150	7
Denton	111	116	318	279	107	10
Falowfield	15	15	26	34	23	—
Failsworth	223	242	609	664	413	24
Gorton	141	144	403	369	245	15
	1413	1520	4110	4127	2596	134

relative importance of Manchester regionally and nationally. They also enable the general pattern of the town's population change to be established, with some departure from national trends being evident, and give insights into the extent and causes of change. What emerges is that the growth evident in the early seventeenth century was reversed during the 1640s, when a plague outbreak brought exceptionally high mortality, and that the recovery occurring during the following three decades gave way to stagnation in the closing decades. The eighteenth century saw quicker and more sustained growth following another abnormally high mortality peak in 1729. By the 1760s, an ever-widening gap between baptisms and burials emerged as Manchester rose rapidly to prominence among Britain's provincial towns.

Development of the built environment

In 1751 John Berry advertised a new edition of the map of Manchester and Salford that, in association with Russel Casson, he had first published a decade previously. He described the map in an advertisement he took out in *The General Advertiser* on 24 June 1751, remarking on the following features: 'In this map is also a Plan of the Towns, taken about 1650, laid down by a Scale of ten Inches to a Mile, by which it appears, that there were not in the Town at that Time, above 24 Streets, Lanes, &c. ...'

A version of the 1650 plan is reproduced here. The scale is enlarged. It shows a clustering of streets around the parish church (now the cathedral), immediately

east of which can be seen the familiar triangle of land formed by Fennel Street, Hanging Ditch and Cathedral Street (formerly Half Street) that was eventually occupied by the town's Corn Exchange. Deansgate is shown as the southerly route to and from the town centre and Marketstead Lane (now Market Street) the easterly one. Also shown as part of the town's road network is a bridge over the Irwell linking Manchester and Salford, as well other bridges over the river Irk, only one of which facilitated an out-of-town route.

Who prepared the plan and for what purpose is unknown. Nor is it clear that it was drawn in the mid-seventeenth century. Perhaps it was extrapolated from the Casson and Berry map, the 1746 version of which (see below) shows the plan with the same unusual orientation as the map. Moreover, it seems more than chance that, having produced a 20-inches-to-the-mile map, Berry was able to find a much earlier map conveniently drawn at half that scale. If the map was not his, he certainly added to it by inserting letters to show features that he did not include on his maps. In advertising his map, Berry noted that buyers would receive a free copy of a 1650 description of Manchester and Salford and their inhabitants, 'just as it was then wrote'. No copy of this description appears to have survived; nor again is it clear who compiled it and why. And the question arises as to whether this description, whoever prepared it and at whatever time, formed the basis of the 1650 map. What is clear is that Berry was very much alert to the commercial opportunities that his map offered, his sales strategy including the introduction of additional features with each new edition, of which there were five. He advertised the 1751 edition widely, selling it from outlets in several major towns, including London, Birmingham, Leeds, Liverpool and Newcastle-upon-Tyne.[23]

The 1650 plan is the only map known to exist of early modern Manchester, but the uncertainties associated with it limit its use value as an historical source. However, much can be gleaned about the size and nature of the town during this period from other sources, some dating back to mid-Tudor times. It is to the evidence that these sources supply that discussion now turns, beginning with the brief and frequently cited accounts left by two visitors to the town, John Leland (c.1503–52) and William Camden (1551–1623).

Leland, an antiquary and poet, visited in 1536. He deemed the town to be 'the fairest, best builded, quickhest, and most populous tounne of al Lancastreshire ...' Given this pre-eminence, he was surprised to find only one church there – the parish church – though he noted it was a collegiate establishment, that is, a church administered by a group of clergymen and others, in this case comprising a warden, eight priests, four clerks and six lay choristers. He remarked, too, that the church was built of a hard, squared stone obtained from a nearby quarry and that, for most of its length, it had an aisle on either side. In addition to the church, he mentioned the 'fair buildid college' situated at 'the very point of the mouth' of the river Irk, in other words at the confluence of the rivers Irk and Irwell. This college provided domestic accommodation for those attached to the church and eventually became Chetham's school and library. Leland also drew attention to the town's two 'fair

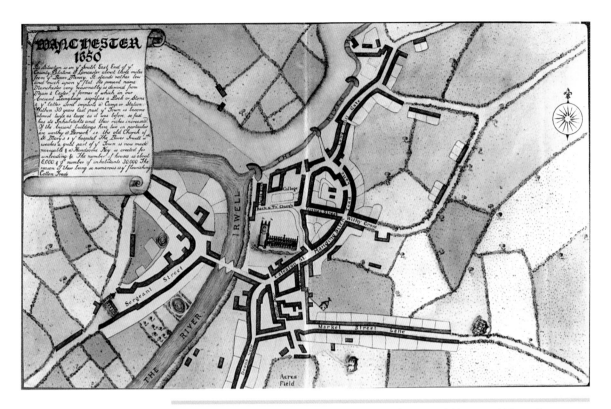

Map of Manchester, 1650. There is no known original version of this map, which was first published as part of the 1746 edition of Casson and Berry's map of Manchester and Salford, where it served to emphasize the growth of the towns over the previous hundred years. The built-up area of Manchester is shown concentrated around the Collegiate Church, with longer streets such as Long Millgate and Market Street ending abruptly in hedged lanes. Its uncertain provenance has not prevented different versions of the map being published, this one being drawn for the *City of Manchester Plan* and reorientated from the original (1945).

market placys' and the 'divers faire milles that serve the toune'. The mills were situated on the Irk and therefore water-powered. Additionally, he remarked on the 'divers stone bridges in the toune'. He mentioned that one crossed the Irk, but he considered that the best spanned the Irwell, joining Manchester to Salford. It had three arches and was surmounted by 'a praty little chapel'.[24]

The antiquary William Camden, who visited Manchester in the late sixteenth century, was equally complimentary about the town's appearance, remarking that it 'excelleth the townes lying round about it for beautifull shew it carieth, for resort unto it, and for clothing, in regard also of the marcate place, the faire Church, and Colledge'. However, he also remarked that 'in the foregoing age this towne was of farre greater account ... for certain woollen clothes there wrought and in great request, commonly called Manchester Cottons ...'[25]

Brief and impressionistic though these observations are, they nonetheless provide evidence of Manchester's prominence among neighbouring towns during the Tudor era, both in terms of the quality of its built environment and the

amount of trading that took place. The town's involvement with woollen textile production is also noted, albeit, according to Camden, concerning a branch that had experienced a considerable decline by the late sixteenth century. What is not mentioned, however, is that the production and sale of linens as well as woollens played a significant role in the town's economy. As elsewhere in Lancashire at this time, the weavers in and around Manchester generally worked on an independent basis. They bought and carried home the raw materials they needed, usually in small quantities, from dealers, and sold their unfinished cloth at weekly markets to other dealers, who arranged for the cloth to be finished. The weavers might have other occupations, farming among them. In linen weaving, much of the yarn used was imported from Ireland, mainly via Liverpool, but in woollen manufacturing the carding and spinning was probably done locally, sometimes by members of the weavers' families. In marketing the finished cloth, the dealers sold in various parts of the country, but mostly in London, to which the bulk of Manchester's cloth exports were sent. It seems probable that London was less important for sales of Manchester-made linens than of Manchester-made woollens and that the former were exported to a lesser extent than the latter.[26]

In commenting on Tudor Manchester's built environment, Leland and Camden presented very positive images. The church and college buildings certainly impressed them, though around the time of Camden's visit the church was seen to be in a state of some disrepair.[27] Under a licence granted by Henry V in 1421 to the cleric Thomas de la Warre, then the local lord of the manor, the church was given collegiate status and the college founded. Masses were to be held daily in the church for de la Warre, Henry V and others, the aim being to safeguard them while they lived and preserve their souls after death. Both buildings survive, having been restored and extended over the ages.[28]

Despite these fine stone buildings, it is clear from the Court Leet records of the manor of Manchester, which date back to 1552, that sanitation was a major problem in the town. The Court Leet, which proved to be a remarkably durable form of local government, dealt with a varied range of matters such as adulterated food sold at the market, the clearing of blocked watercourses and the control of farm and domestic animals in the streets.[29] But in relation to the built environment, it is about the condition of the town's streets that its records are particularly revealing.

Causing particular anxiety in this respect was the accumulation of animal and human ordure, an issue of general concern in early modern towns. Animal droppings inevitably fouled urban streets, but so, too, did human waste. The Manchester Court Leet records make numerous references to the problem and the attempts the court made to deal with it. Thus, in December 1554, the court ordered that all middens in the streets of the town, along with swine cotes, had to be removed before the following June and no more created.[30] Middens attached to individual properties, including that for which Thomas Jacson was responsible, also proved troublesome. In December 1556 Jacson was required to 'make or cause

to be made a sufficient Defence in the marketstead Lane wheare he hath now a donge hill with pale or otherwise so that the donge or mocke be no noyance nor evil sight in the streete'.[31]

Evidently, Jacson's dung heap bordered the road, offending both sight and smell. The requirement to erect a pale (a fence enclosing the heap) shows, for whatever reason, a policy of containment rather than removal, no doubt to prevent spillage. Yet some townsmen were required to adopt an alternative course of action. In May 1555, for example, Robert Cropper was ordered to keep a barrel under his privy in Hanging Ditch and to remove the contents 'privily awaye' whenever they 'may be or afore yt be noysom or hurtfull to the passers bye ...'[32] Under a court decree of October 1561, these requirements were to be met by emptying privies between 10 p.m. and 4 a.m.[33]

Also of concern during the mid-Tudor period was the practice of removing earth from the town's streets to make daub for building walls, pointing to the prevalence of timber-framed buildings. In March 1554 the Court Leet ordered that, in Marketstead Lane, earth should not be taken for this purpose within a rood (a quarter of an acre) of the causeway. As was common in the early modern period, Marketstead Lane probably comprised a narrow stone causeway alongside which ran an unpaved section of road useable when conditions allowed, the intention being to prevent wear and tear on the causeway.

Further insights into Manchester's built environment during Tudor times can be obtained from manorial records. They demonstrate how, by the later sixteenth century, the town was characterized by burgage holdings, that is, areas of land fronting on to a street. Their usage varied, providing space for houses, workshops, barns and gardens. For instance, at the end of the sixteenth century, Robert Langley's burgage in Millgate contained two tenements and two gardens, while Nicholas Hartley's two tenements and gardens, situated in the same street, occupied only a half-burgage. In addition to those situated in the streets adjacent to the church, burgages extended outwards along Millgate, Marketstead Lane and Deansgate, producing 'ribbon' development, beyond which was farmland.[34] In 1565 those owning tenements, burgages and other land in the town were required to lay paving in front of them.[35]

How did Manchester's built environment evolve as the early modern period progressed? For one thing, change was more marked in some respects than in others. With regard to sanitation, for instance, much remained amiss. The Court Leet records show that, until the early eighteenth century at least, problems arising from the disposal of ordure probably took up more time than any other group of problems.[36] And though they became of less concern to the court, they continued to be reported. Thus, in October 1769, John Smith was fined one shilling for emptying his privy tubs in a public street, while two years later Thomas Smith was ordered to remove a dunghill he had made near to a street, obstructing not only passers-by but also a public waterway.[37] Secondly, little change was made to the built environment prior to the late seventeenth and early eighteenth centuries. In

Overleaf: A plan of the towns of Manchester and Salford, 1746. Russel Casson and John Berry published the first modern plan of Manchester and Salford in 1741, with further editions in 1745, 1746, 1751 and 1755. The plan puffed the enterprise and dynamism of the expanding town, while the architectural elevations of the public and private buildings featured in the images that framed the plan proclaimed its prosperity, progress and taste, and reflected the fashion for classical revival architecture.

Courtesy of Chetham's Library

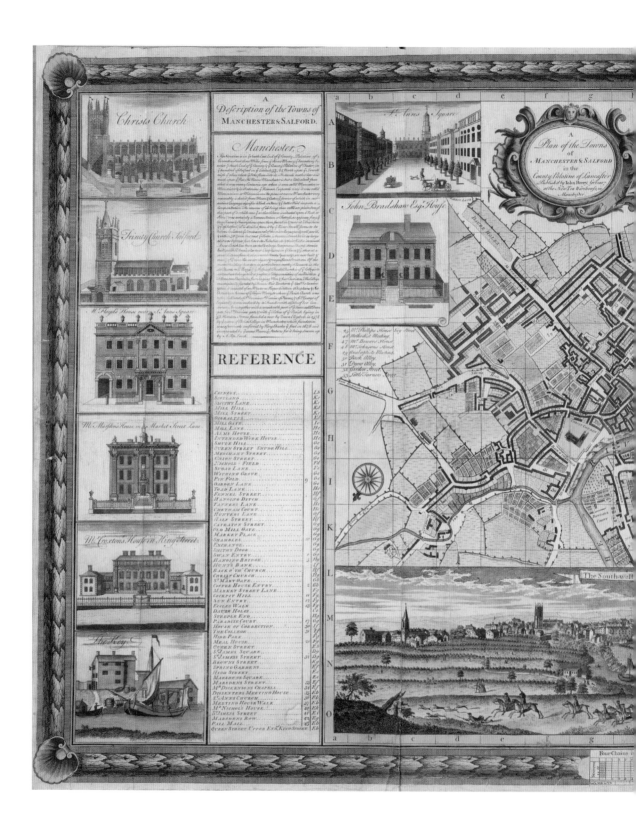

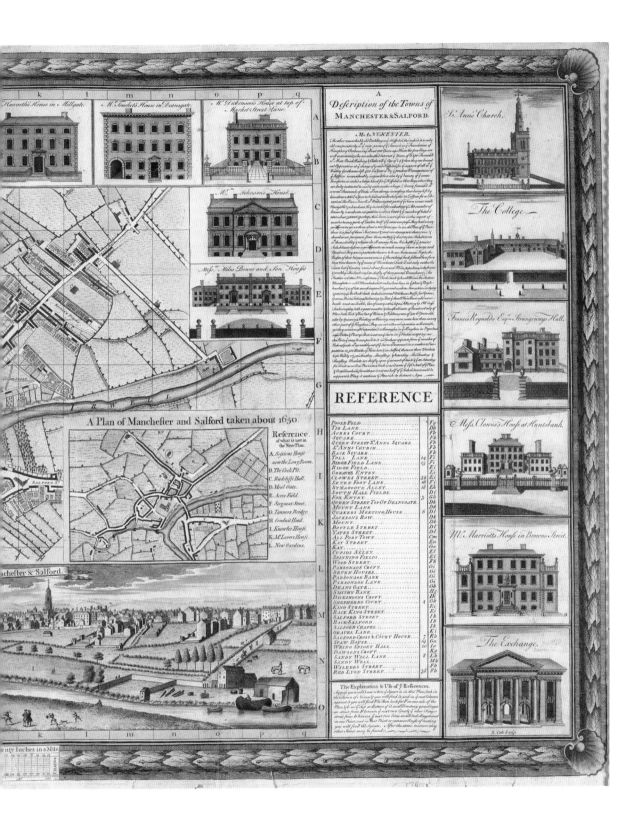

A Plan of Manchester and Salford taken about 1650.

Reference
of what is not in
the New Plan.
A. Sessions House
now the Long Room.
B. The Cock Pit.
C. Radcliffe Hall.
D. Meal Gate.
E. Acres Field.
F. Sergeant Street.
G. Tanners Bridge.
H. Conduit Head.
I. Knowles House.
K. Mr Lever's House.
L. New Gardens.

REFERENCE

fact, it was only in the mid-eighteenth century that changes gathered momentum. One result was that the town's built-up area was appreciably extended, especially southwards. Another was that new building-types and styles appeared, not all of which were confined to the newly developed areas.

In considering these changes, the Casson and Berry map of 1745 is a useful aid. The most notable area of eighteenth-century growth shown on the map lies to the south of Marketstead Lane and the east of Deansgate. Development here stemmed from an Act of Parliament secured in 1708 for erecting St Ann's church and square. The Act stipulated that the square was to be thirty yards wide and that it should provide space to accommodate the annual and long-established Acres Fair. The church was consecrated in 1712 and, according to John Aikin (1747–1822), the square and adjoining streets were built within a few years of the Act being passed. However, it may not have been until the mid-1730s that most of King Street was developed.[38] St James's Square (situated off what became John Dalton Street) was also created at this time, while Marsden Square, bounded by Market Street and High Street, had been formed by the early 1740s.[39] Both places were characterized by large terraced houses, though they comprised short, wide streets rather than fully formed squares with central gardens of the type found in London and other major towns. Only St Ann's Square provided a substantial amount of enclosed space, being wide enough to accommodate two rows of trees.

Two distinctive features of these developments are revealed by the Casson and Berry map. The first is their size. The space they occupied approximately doubled the size of the town's built-up area. Even so, it remained the case that only a short walk was required to reach the boundaries. Indeed, it was for this reason that an attempt made in 1750 to introduce Hackney coaches in the town was deemed to have failed, sedan chairs being seen as preferable.[40] The second is the ordered pattern of the street layout. The new streets were almost designed in grid-iron form; they were straight and quite short between intersections, though, for the most part, they did not meet at right angles. Even so, they contrasted sharply with the curvilinear street formation that characterized the old town. King Street stands out as the most spacious among the new thoroughfares, though it had yet to be linked directly with Deansgate.

As regards changes to the appearance of new buildings, some brief observations made by the intrepid traveller Celia Fiennes (1662–1741), who visited Manchester in 1698, are instructive. She remarked: 'Manchester looks exceedingly well at the entrance, very substantiall buildings. The houses are not very lofty but mostly of brick and stone, the old houses are timber work, there is a very large Church all stone and stands high soe that walking round the Church yard you see the whole town ...'[41] Plainly, the town did not reach out very far from the centrally placed churchyard. Yet some development was evident with new houses being built from brick and stone. In this matter, Manchester was following a national trend in that, given the fire hazards associated with timber-framed structures in urban areas, more fireproof building materials came into general use.[42] In fact, a serious

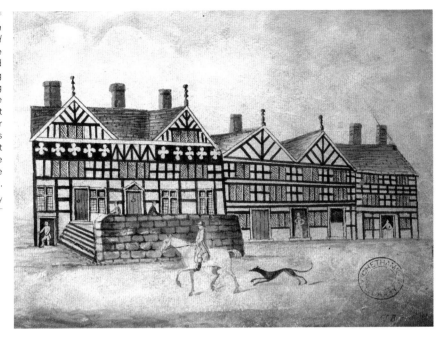

fire broke out in Manchester during 1616, prompting the Court Leet to require that a stock of 6 ladders, 4 hooks, 24 buckets and 4 ropes should be made available in order to cope with any other outbreaks that might occur. The purchase of these items was to be met by a local lay (tax) and they were to be 'kepte in some conveynient house for the common good and benefyte of all the inhabitants'.[43]

What Fiennes did not mention was that classical styles of architecture were adopted for the new buildings she observed. Again, this development was occurring more generally, forming part of what has been seen as an 'urban renaissance' dating from the later part of the seventeenth century.[44] In designing St Ann's church, the pointed arches that characterized the parish church were deemed inappropriate. Instead, the windows were formed from round-headed arches with keystones, while the doorways comprised pairs of Corinthian columns with a triangular pediment above. A tiered spire surmounted the tower. In domestic architecture, classicism also dictated the form of the large, brick-built houses that were increasingly provided for the better-off. These came to form a distinctive feature of Manchester's townscape, demonstrating the modernity and affluence of an emerging town.

Also adding to Manchester's classical-revival architecture was the first Exchange building, which was erected in 1729. The lower part of the Exchange provided space for traders to meet and conduct business, while the upper part was used by those attending sessions and manor court gatherings. However, it was not until the ensuing decades that the pace at which Manchester's more significant buildings were erected accelerated, appreciably extending the impact that

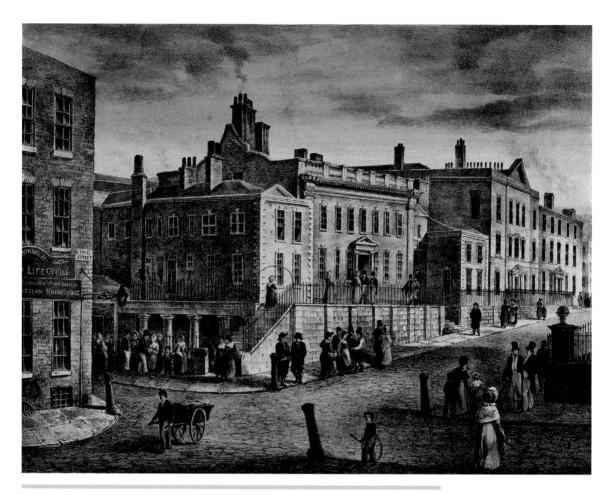

Dr White's house, John Ralston (1789–1833). By the middle of the eighteenth century King Street was a desirable address for the town's middling class. One of its most elegant houses, its symmetry and proportions reflecting contemporary architectural tastes, belonged to the surgeon Thomas White, and later to his son, Charles, an influential figure in Manchester's medical and scientific circles. The desirability of King Street as a residential address diminished as the town grew, and what had been described as 'quite the most handsome and conspicuous house in the street' was demolished a few years after Charles White's death, Manchester's first Town Hall being built on the sloping site.

Wellcome Images

classical-revival architecture was having on the townscape. As far as places of worship are concerned, the Baptist chapel situated off Withy Grove was completed in 1740, while, a decade later, the Methodists opened a chapel off Birchin Lane, their first in the town. In 1756 St Mary's church, situated on College Lane between the Irwell and Deansgate, was consecrated. It was described by one observer as a 'Doric edifice with a spire steeple 186 feet high' and was 'universally and deservedly admired'. Less spectacular was Cannon Street Independent chapel, erected in 1761. Opening directly on to Cannon Street, it featured a three-bay frontage with a central, arched doorway and first-floor windows crowned with pediments.

Two further churches were erected during the 1760s, St Paul's in Turner Street (1765) and St John's, Byrom Street (1769). Both were built in revived Gothic styles, however, serving as a reminder that, in Manchester as elsewhere, choice of architectural styles was a contested matter.[45]

The invasion of classical styles in eighteenth-century Manchester extended beyond the construction of new buildings; it was also associated with altering or demolishing existing ones. Writing in the late nineteenth century, the local architect Alfred Darbyshire (1839–1908) remarked with feeling on these matters. Regarding alterations to buildings, he fumed at what he saw as the 'ruthless manner in which the fine old timber-framed buildings were treated by the improver of the Georgian era'. Warming to his theme, he continued:

> The timbers were cut and hacked in all directions, the picturesque lattice windows were torn out, and the most unfortunate contrivance for an opening window (the modern sash) introduced in their place; the open shop front gave way to 'bows' or 'bays', and all sorts of windows occupying the entire front of the building.

As to demolition, Darbyshire regretted that 'a pile of 2 storey timber-framed gabled buildings' was taken down in 1776. This action had been permitted under the provisions of an Act of Parliament passed in that year to open up Exchange Street.[46] An alternative perspective on the quality of these buildings was offered, however. It came from the unnamed author of the *Manchester Historical Recorder*, who noted that the buildings were known as the 'Dark Entry' and that a narrow footpath led through them linking Market Street Lane with St Ann's Square. He noted, too,

Blackfriars bridge, Irwell. Looking downstream, this view of the Irwell provides one of the few images of the first Blackfriars bridge, a wooden structure built in 1761. It was replaced by a stone bridge in 1821. The spire of St Mary's church, the tallest in Manchester, is also prominent. St Mary's was supported by a congregation of middle-class businessmen and professionals. It was demolished in 1891.

Courtesy of Chetham's Library

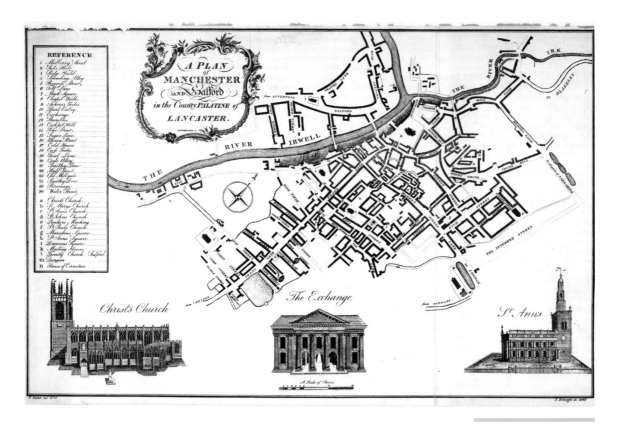

REFERENCE
1 Mulberry Street
2 Spits Hole
3 Ridge Field
4 Spinning Alley
5 Bywell Street
6 Toll Lane
7 Back Square
8 Chapel Walks
9 Arches Gates
10 Dark Entry
11 Exchange
12 Shambles
13 Cockpit Hill
14 Pope Street
15 Sugar Lane
16 Brown Street
17 Cold House
18 Cock Gates
19 Fowl Lane
20 Crofts Alley
21 Smithy Lane
22 Hall Street
23 Old Millgate
24 Smithy Row
25 Parsonage
26 Water Street

a Christs Church
b St Marys Church
c St Annes Church
d St Johns Church
e Quakers Meeting
f St Pauls Church
g Marsdens Square
h St Annes Square
i Dawsons Square
k Meeting House
l Trinity Church Salford
m Dungeon
n House of Correction

Christs Church

The Exchange

St Annes

Thomas Tinker's 1772 plan
of Manchester and Salford.
Courtesy of Chetham's Library

that the 1776 Act permitted the widening of several streets in the old town centre, namely Old Millgate, Cateaton Street and St Mary's Gate, and he expressed the view that these streets 'had long been a disgrace to the town. They had often doomed the unwary passenger to broken limbs, and sometimes to death, to say nothing of the unwholesomeness of the houses in them, from their confined situation.'[47]

The same author was also concerned about the hazards of crossing the road bridge between Salford and Manchester, improvements to which were also sanctioned by the 1776 Act. His particular concern was for less active pedestrians crossing the bridge who encountered carriages, a particular issue on market days. For them, he opined, much effort had to be expended by taking refuge in the angular recesses that had been provided in the parapets on either side of the bridge.

At the time they were built, as Tinker's 1772 map of Manchester demonstrates, St John's church and St Paul's church were respectively situated at the southern and eastern edges of the built-up area. Comparison of this map with that of the early 1740s shows that a measure of development had taken place in both parts of the town, centring on Deansgate and High Street. Even so, to reach either church from the market place scarcely involved a lengthy walk. Manchester remained a town of a pedestrian scale.

Quickening development: the mid-eighteenth century

The accelerating development of Manchester during the middle decades of the eighteenth century was strongly linked with growth in a broad range of manufacturing and service activities, but particularly with the rise of Lancashire's cotton textile industry.[48] Focusing on the Manchester area, this section examines the rise of the industry during these decades, and considers the importance it achieved in the economy of Manchester by the 1770s. Discussion then turns to the factors underpinning these developments, both within Manchester itself and more generally.

Precisely when the production of cotton goods began in Britain is uncertain. However, they formed part of the 'new draperies' introduced by Flemish refugees who settled in the eastern and south-eastern counties during the latter half of the sixteenth century. Their arrival coincided with new types of woollen and linen fabrics being woven in Lancashire, including bays – cloths with a worsted warp and a woollen weft – and smallwares – linens woven as tapes, garters, ribbons and the like.[49] The latter were manufactured on Dutch looms, a late sixteenth-century innovation that enabled several pieces to be woven at the same time, and they became an important component of Manchester's textile production. Of greater significance, however, were fustians. These were fairly coarse and cheap cloths comprising a linen warp and a cotton weft, the production of which gathered momentum in the county during the seventeenth century. In the Manchester area, weavers also incorporated varying amounts of cotton into their linen cloths to produce 'cotton-linens'. These were probably lighter cloths than fustians and were often woven with coloured or checked patterns. Independent domestic weavers were superseded as the merchants controlling the industry developed putting-out systems, as well as arranging for the cloth to be finished. They brought in raw cotton from London and returned finished cloth there. Their businesses were conducted on the basis of giving and receiving credit.[50] For those with a determined approach to business matters, including Manchester's Humphrey Chetham, large fortunes could be made.[51]

The cotton textile industry saw a more rapid growth during the middle decades of the eighteenth century than previously, and this is most clearly demonstrated by figures of raw cotton imports into Britain. They are shown in Figure 1.5 as average annual totals per decade. Raw cotton imports that were re-exported from Britain each year, and hence did not enter into cotton manufacturing in Britain, have been discounted from the totals, thereby giving retained import figures. As Figure 1.5 reveals, the decennial average figures increased in each decade, rising from an annual average of 1.48 million lb in the 1710s to 5.13 million lb in the 1770s. Moreover, they did so at an exponential rate. Thus, whereas the 1720s average was a mere 2 per cent higher than that of the 1710s, the 1740s figure was 24 per cent higher than that of the 1730s and the 1770s figure was 39 per cent above that of the 1760s. While the total figures pale into insignificance compared with

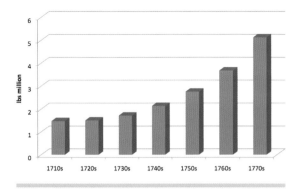

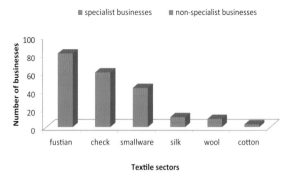

Figure 1.5 Raw cotton imports into Britain, 1710s–1770s

Source: A.P. Wadsworth and J. de Lacy Mann, *The Cotton Trade and Industrial Lancashire, 1600–1780*, Manchester: Manchester University Press, 1931, p. 170

Figure 1.6 Manchester textile manufacturers, 1773

Source: A.P. Wadsworth and J. de Lacy Mann, *The Cotton Trade and Industrial Lancashire, 1600–1780*, Manchester: Manchester University Press, 1931, pp. 254–60

those of later decades, they nonetheless demonstrate that the growth of cotton textile production in Britain quickened appreciably throughout the middle decades of the eighteenth century.

It is not known precisely how much the manufacturing and trading of fustians and cotton-linens grew in Manchester as raw cotton imports expanded during the middle decades of the eighteenth century. However, using trade directory evidence extracted by Wadsworth and Mann, the importance of these products in the town's textile sector by the early 1770s can be assessed. Figure 1.6 records the number of manufacturers engaged in the various branches of the town's textile industry, making a division in each case between specialist concerns and non-specialist concerns, that is, those engaging in at least one other activity. For example, nine fustian manufacturers also produced checks (commonly made from linen and cotton) and six others produced smallwares. In total, 207 concerns are noted, of which 81, the largest group, were fustian manufacturers. It was these businesses that organized the spinning and weaving of textiles, utilizing domestic workers within the town and the surrounding countryside. Additionally, 122 concerns were engaged in textile finishing, including 16 fustian cutters and 16 fustian dyers, with 37 others in associated industries, 21 of them being hatters. Given uncertainty about the directory's completeness and accuracy, the figures cannot be taken too literally. Nor is it clear how far the check and smallware businesses would have been concerned with cotton-linens rather than linens. Even so, the trade directory data reveal that manufacturing fustians and cotton-linens had certainly become a major component of Manchester's textile industry by the early 1770s.

But what of the importance of cotton goods in Manchester's commercial sector during the early 1770s? As far as businesses based in the town are concerned, assessment is hampered because the trade directory entries may again be incomplete. Also, they do not always state the economic sectors in which the traders operated. Nor do they do always draw a distinction between involvement in wholesale rather

Elizabeth Raffald

History rarely records the activities of women in business during the industrial revolution era, but it has been estimated from trade directory evidence that around 6 per cent of businesses in 1770s Manchester were in female hands, most typically in the clothing trade, food and drink, shopkeeping and dealing. A prime example is Elizabeth Raffald (1733–81). Born in Doncaster, as a young woman she spent about fifteen years in service, rising to become housekeeper at Arley Hall, Cheshire, to Lady Elizabeth Warburton. She married her employer's gardener, John Raffald, and bore him at least nine children. After leaving service, she moved to Manchester in 1763 and opened a shop in Fennel Street supplying 'Cold Entertainments, Hot French Dishes, Confectionaries, &c.' and in 1766 transferred her business to Exchange Alley by the Bull's Head in Market Place. This later became the Exchange Coffee House. From these premises she ran a school of cookery and domestic economy, and what was probably the first register office for servants in Manchester. She later turned her hand to the sale of cosmetics. She expanded further into catering and innkeeping and ran the King's Head in Chapel Street, Salford. The excellent food and her ability to converse in French were said to have attracted many foreign visitors. She was in a competitive business since the town had inns and taverns in profusion. A great publicist, Mrs Raffald recorded most of the highlights of her career by advertisements in the *Manchester Mercury* and she is reported to have assisted Joseph Harrop in its publication, both with money and with advice. She was instrumental in establishing a second Manchester newspaper, *Prescott's Manchester Journal*, in 1771. Today she is best remembered for her own ventures into publishing. Her *Experienced*

From *The Experienced English Housekeeper* (1769).
Courtesy of Chetham's Library

English Housekeeper, for the use and ease of ladies, housekeepers, cooks, &c., wrote purely from practice ... consisting of near 800 original receipts was first published in 1769. It sold well and ran to six editions. In 1772 she produced the first *Directory of Manchester and Salford*, and followed this with further editions in 1773 and 1781. These remain invaluable sources for students of the period.

than retail trade. Yet Wadsworth and Mann identified 102 businesses that they included in their 'dealers, etc.' category, among which the largest group, comprising 31 businesses, were warehousemen. The next largest group were linen drapers, of whom there were 21. Men of this description were engaged in both the manufacture and trading of textile goods and some of them assumed leading positions in Manchester's business community, acquiring considerable fortunes.[52]

Also forming part of Manchester's trading community were the so-called 'country tradesmen'. They were based in neighbouring towns and villages, but they had warehousing facilities in Manchester and visited the town on a regular basis to meet customers and suppliers. A 1773 trade directory lists 159 of them, of whom no fewer than 110 are given as fustian manufacturers, the great majority being specialists. The next biggest groups were check manufacturers and woollen manufactures, who respectively numbered 24 and 23. That among the fustian manufacturers were quite a number from Bolton points to a significant change that was occurring in Manchester's trading economy. During the middle decades of the

The *Manchester Directory* (1773). This extract identifies a number of individuals employed in the textile trades, including check-calenderers and fustian manufacturers. However, the publisher Mrs Raffald, who was involved in many business enterprises, omits her own name while including that of her husband ('John Raffald, inn-holder'), perhaps reflecting attitudes towards women in business. (She included entries for other women trading independently, but these were most probably widows or single women.)

Courtesy of Chetham's Library

eighteenth century, Bolton was the main centre for trading Lancashire fustians, with buyers from London and elsewhere attending the town's distinctive warehouses and salerooms, which still existed during the 1760s and 1770s. The 1773 directory listings suggest that Manchester was taking over from Bolton with regard to fustian trading, perhaps to an appreciable extent.

The evidence so far in this section suggests that cotton textile production expanded appreciably in Britain during the middle decades of the eighteenth century and that Manchester's economy became dependent on the manufacture and trading of cotton goods to a much greater degree. The question arises, therefore, as to why these developments came about. In addressing the issue, account must be taken of the growing demand for cotton goods, of which Manchester's business community was able to take considerable advantage. Additionally, consideration must be given to changes taking place that stimulated the production of cotton goods. Some of these changes, including technological innovation, related specifically to the textile industry. Others, however, transport improvements among them, had a more general impact, though they were still of considerable importance in stimulating textile production. In discussing these developments, there is need to recognize that cause and effect would both have operated. Thus, while advances in technology raised productivity and hence the output of textile manufactures, they were also influenced by the opportunities that an expanding industry offered for inventive minds to prosper. The advantages offered to the business community by the absence of a town corporation and craft guilds would still have applied. The consequent lack of regulation made for a relatively 'open society' in which newcomers could set up in business with few restrictions.[53] Also remaining important was the means of financing business activity through credit networks, with the town's first bank not being established until December 1771.[54]

As their compilers warn, the figures for the export of cotton goods (see Figure 1.7) need to be treated with care. Firstly, they relate to single years rather than to averages of say, three years, the years chosen being deemed to be 'less abnormal' that those in a ten-year sequence starting in 1710. Secondly, the figures after the mid-eighteenth century are probably more reliable than those for earlier years,

Figure 1.7 Exports of British cotton piece goods during the eighteenth century, derived from the customs accounts.

Source: A.P. Wadsworth and J. de Lacy Mann, *The Cotton Trade and Industrial Lancashire, 1600–1780*, Manchester: Manchester University Press, 1931, pp. 145–6

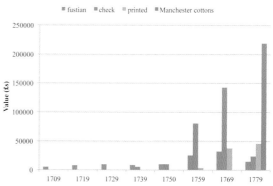

since the accounts were better kept. Thirdly, the fustian figures represent quantity rather than value – they were entered at £1 per piece – and do not take account of increases in the number of yards per piece that occurred as the century progressed. Nevertheless, the figures do suggest that a pronounced upward trend occurred in cotton goods exports during the middle decades of the eighteenth century, especially from the 1750s. They were exported to various parts of the world, but the amount dispatched to Ireland grew particularly rapidly; by 1769 they accounted for around four-fifths of the total. It should also be noted that the figures show much more rapid growth during these years in the export value of checks, with African sales achieving prominence by the late 1760s.

How far domestic demand for cotton cloths expanded during the middle decades of the eighteenth century can only be conjectured. One consideration relates to national population growth. This was no longer constrained after the early 1740s by major mortality crises. Potentially, therefore, a growing number of consumers were becoming available. But what was crucial was the purchasing power they could bring to bear. In the industrializing districts, large numbers of people were being drawn into manufacturing and commercial employment, including domestic textile production, in which women and children took part. Such employment may also have offered more regular work opportunities, especially when compared with pastoral agriculture. Accordingly, effective demand for consumer goods, including cotton textile goods, would have increased. Yet this line of argument cannot be taken too far. Consumer goods other than textiles, of which a wide and growing range existed – cast steel and silver-plated goods were introduced during the 1740s, for example – would also have been purchased. Moreover, some expenditure would have been directed to imported textiles, not least all-cotton cloths.

The issue of population growth also enters into the supply-side considerations of the cotton industry's expansion. Not until the late eighteenth century was powered machinery introduced into cotton goods production, so that manufacturing fustians and cotton-linens during earlier times was dependent on hand technology. To a degree, the productivity of hand spinners and weavers could be enhanced by improving this technology, and during the period in question the introduction of Kay's fly shuttle (1733) and Hargreaves' spinning jenny (1765) made significant contributions in this respect.[55] So, too, did the introduction of a new type of smallware loom, which produced finer tapes. Known as the swivel loom, it was adopted in Manchester around 1750.[56] Yet rising output in cotton manufacturing depended to a considerable extent on more people becoming available for work. Some could be attracted from other occupations or from part-time to full-time work within the industry. Even so, rising population helped to ease any problems that cotton manufacturers had in meeting their labour requirements, especially when trade was good.

Other supply-side developments also occurred. Among these was product innovation, including cotton velvets, the manufacture of which began in the

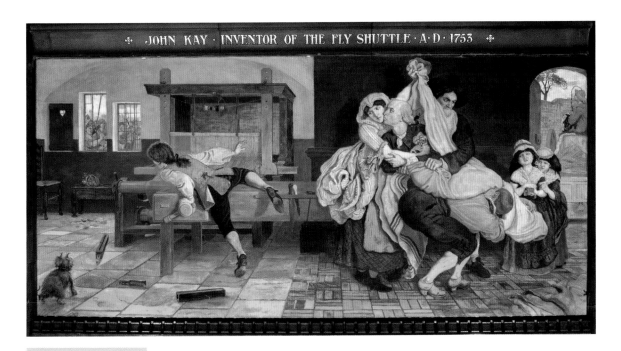

JOHN KAY · INVENTOR OF THE FLY SHUTTLE · A·D· 1753

Ford Madox Brown, *John Kay, Inventor of the Fly Shuttle A.D. 1753* (1888). Because of his invention Kay was purportedly subjected to attacks by weavers who felt their jobs threatened, incidents that were given a fuller treatment by Victorian writers, notably Francis Espinasse whose unsubstantiated account of Kay escaping from his home in a woollen blanket (*Lancashire Worthies* (1874)) informed Ford Madox Brown's memorable mural in Manchester Town Hall.
Courtesy of Manchester Art Gallery

mid-eighteenth century. In 1768 an Austrian visitor to Manchester expressed the view that cotton velvets were one of the town's most celebrated manufactures.[57] Additionally, important infrastructural improvements were made. The erection of the town's first Exchange building in 1729, which provided a facility for traders, has already been noted, although it is possible that traders still preferred to stand outside in the market place to conduct their business since the new building was too small and inconvenient.[58] Perhaps it quickly became so as the cotton industry began to grow at a more rapid pace. Additional warehousing space would have been required and, in an expanding town, for the storage and display of other goods as well as textiles. Existing premises might well have been converted or extended to meet growing needs; certainly the pressure on centrally located premises for commercial use would have intensified.

Of significance, too, were advances in the town's communications network which greatly enhanced Manchester's geographical advantage as a route centre, as well as helping to foster social networks. As far as water transport was concerned, the 1721 Mersey and Irwell Navigation Act, which was strongly backed by Manchester traders, permitted the rivers to be made navigable as far as Warrington. The river became navigable as far as Manchester during the mid-1830s, when a wharf and warehouse were built alongside the Irwell at the bottom of Quay Street.[59] By 1772 21 vessels were plying the navigation, providing a carrying service between Manchester and Liverpool.[60] Far more significant as a means of water transportation, however, was the Bridgewater Canal. Sanctioned by an Act of Parliament passed in 1760 and opened during the following year, the canal's function was to bring coal into Manchester from the Duke of Bridgewater's mines

at Worsley, which were located a few miles to the north-west. Its terminus, with associated warehouses, was established at Castlefield, close to the southern edge of the built-up area. An extension of the canal to Runcorn, on the Mersey, was permitted by another Act of 1762, creating an alternative waterway link between Manchester and Liverpool. Some 29 miles in length, it was partly opened in 1767 and completed in 1776.[61] According to John Aikin, the Duke's charge on his canal for carriage between Manchester and Liverpool was 6 shillings per ton, a sum that compared with 12 shillings per ton using the river navigation and 12 shillings per ton by road.[62] In 1772 the Duke of Bridgewater was operating from three to fifteen coal boats, each with a five-ton capacity, from Worsley to Manchester on a daily basis, Sundays excepted.[63]

Roads were also improved. By a 1724 Act the road to Buxton was turnpiked, thereby easing travel on the crucial route to London via Stockport and Derby. During the two subsequent decades, further Acts were secured to turnpike the roads between Manchester and Salford and each of their satellite towns. That for the Ashton-under-Lyne route was secured in 1732 and for the Oldham route in 1735. A further Act passed in 1753 permitted the roads from Salford to Bolton and to Wigan, as well as to Warrington, to be turnpiked. Two years later, Acts were obtained to create turnpike links between Manchester and Rochdale and Manchester and Bury.[64] How far road quality improved is unknown, but as wheeled vehicles were increasingly used in order to cope with rising amounts of traffic, this would have involved attempts to create wider and more durable carriageways and

'The Father of Inland Navigation'. By the time of his death in 1803 the contribution made by the third Duke of Bridgewater (1736–1803) to the ongoing industrial revolution within and beyond the region was widely recognized. His determination and wealth had built the Bridgewater Canal, providing Manchester with a more reliable and cheaper supply of coal and, equally important, providing a new water route to the Mersey.

Courtesy of Chetham's Library

maybe to realign routes in order to ease gradients and remove sharp bends. There is some evidence to show the rising traffic levels on London services, with the four per week in 1715 having increased to ten per week in the late 1750s. There was no further rise, though, until the mid-1770s.[65] No doubt traffic flows also rose along other routes to and from Manchester. By 1772 108 scheduled goods wagons were leaving the town each week. Of these, 40 per cent went to towns in Lancashire and a further 18 per cent to towns in Yorkshire. Apart from London, more distant places reached included Bristol, Newcastle-upon-Tyne and Birmingham.[66]

In John Aikin's view, the development of Manchester's turnpike road system encouraged a significant change in marketing practices which 'greatly pushed' trade during the middle decades of the eighteenth century. Prior to this time, he

Albert Dunington, *Barton Aqueduct* (1894). Opened in 1761, James Brindley's Barton Aqueduct carried the Bridgewater Canal over the Irwell. It was immediately recognized as an astounding feat of engineering, becoming a symbol of modernity which drew visitors from Europe and the United States. Dunington's painting presents a romanticized view of the aqueduct, which no longer existed, having been demolished in 1893 during the construction of the Manchester Ship Canal.

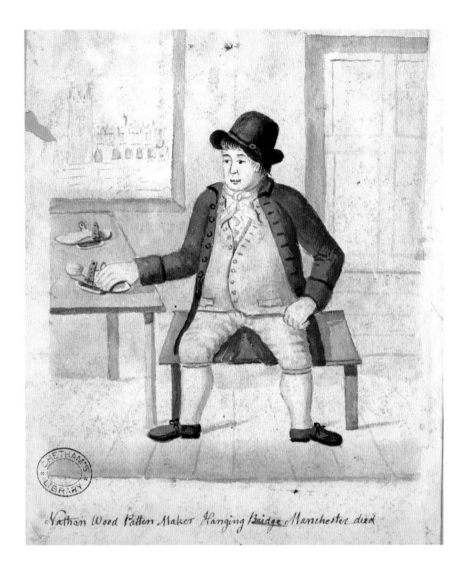

Nathan Wood Patten Maker Hanging Bridge Manchester died

maintained, local chapmen conveyed their goods on packhorses, concentrating on wholesalers and shopkeepers in several 'capital places', namely London, Bristol, Norwich and Newcastle, and on 'those who frequented Chester fair'. Unsold goods were stored at inns and sheep's wool was brought back to be sold in Manchester. With improved turnpike roads, however, packhorses were substituted by wagons and 'young adventurers' among the chapmen rode out to obtain orders carrying only samples (patterns) with them. Moreover, they travelled all over the country, supplying traders in those towns that had previously relied on wholesalers in the capital places.[67]

The remaining matter to consider relates to political developments. During the late seventeenth and early eighteenth centuries, Britain's woollen and silk manufacturers lobbied Parliament to secure a ban on imports of printed Indian calicoes. They succeeded in 1701, though plain calicoes could still be imported

and printed in Britain. However, a further Act, passed in 1721, extended the ban to the use and sale of 'any stuff made of cotton or mixed therewith ...', making an exception for fustians. Substantial fines were introduced for both buyers and sellers who broke the new law. Given the popularity of printed cotton cloths as dress and furnishing fabrics, both the manufacturing and printing of fustians in Britain received a powerful market advantage. Not surprisingly, the woollen and silk manufacturers sought to challenge the provisions of the Act, claiming infringements because it did not clarify what a fustian cloth actually was. The matter came to a head in 1736, following the presentation of a petition to Parliament from the Manchester manufacturers and dealers. The passage of the so-called 'Manchester Act' reaffirmed the legality of printing fustians, defining them clearly as cloths made in Britain from a linen warp and cotton wool. The competitive advantage gained by the fustian manufacturers was legally confirmed. In 1774 a further enactment legalized the production of all-cotton cloths.[68]

Manchester on the cusp

A visitor to Manchester in the opening years of the eighteenth century would not have seen a town that differed markedly in size and appearance from that reported by visitors in Tudor times. He or she would have still found only one church, the Collegiate Church, in the township itself, and would have been able to walk from the town centre to the edge of the built-up area within a short space of time, even allowing for inadequate paving. Narrow, winding streets rising up quite steeply

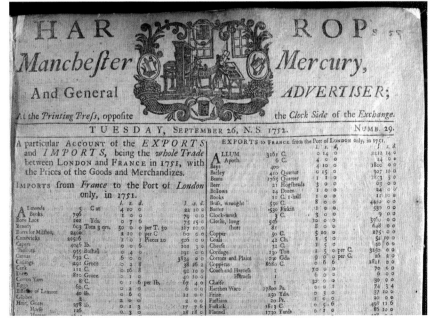

Harrop's Manchester Mercury and General Advertiser, 26 September 1752. First published by Joseph Harrop in 1752, the *Manchester Mercury* owed much of its longevity – it ceased publication in 1830 – to the support and advertising of the region's burgeoning business community, a concern evident in this front page of 1752 which was entirely given over to foreign trade.

Courtesy of Chetham's Library

from the Irwell valley and lined with timber-framed premises would have predominated, no doubt varying greatly in the quality of accommodation they offered. The unsavoury effects of domestic sanitation organized on a conservancy system, as well as animal droppings, might have assailed both eye and nostril. Had the visit occurred on a market day, the trade taking place in a wide range of goods would have impressed. Perhaps sight might have been obtained of cloth samples that local manufacturers and merchants had brought for sale, with the striking patterns and bright colours of printed fustians and cotton-linens particularly catching the eye.

Yet Manchester had changed in several notable respects since Tudor times. The rise of cotton cloth manufacture, especially fustians, was a major development in the town in the seventeenth century. It was accompanied by changes in the organization of domestic manufacturing in and around the town, as putting-out systems replaced those based on independent production. And in the linen industry, the rise of the smallware branch added another dimension to the town's textile manufactures. The development of these products also offered growing opportunities for

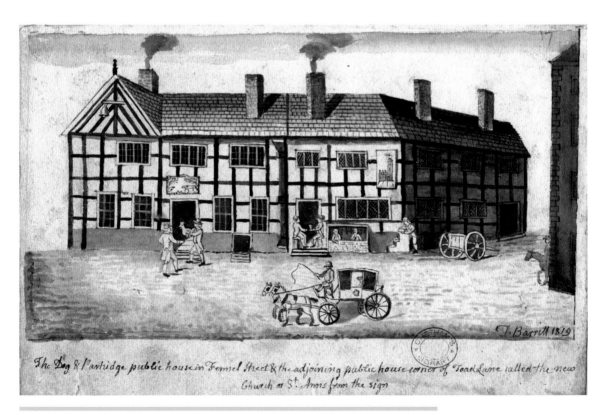

The Dog and Partridge public house in Fennel Street. The Dog and Partridge was remembered as one of the inns in the town centre where traders met to conduct their business. Unlike its neighbour, the New Church Inn, it continued to operate long into the nineteenth century.
Courtesy of Chetham's Library

the town's traders, many of whom were manufacturers as well, though Manchester did not supersede Bolton as the main centre for trading in fustians until the closing decades of the eighteenth century. So, even though the indications are that Manchester was not characterized by growth of population or physical size in the seventeenth century, it was already a place of innovation and enterprise. Additionally, it continued to occupy a leading position at regional level.

During the early decades of the eighteenth century, evidence of the town developing more rapidly can be found. The population may have started to expand and the erection of St Ann's church exemplified a new taste for neoclassical architectural styles. These were also evident at domestic level in the provision of sizeable, brick-built houses occupied by the town's wealthiest inhabitants, though precisely when they started to be built is unclear. During the 1720s, three important developments occurred that played a crucial role in laying the foundation for subsequent, more rapid expansion. All three required Acts of Parliament. In 1721 local fustian manufacturers were able to take advantage of a ban on imported printed cottons. In the same year permission was granted to improve transportation along the rivers Mersey and Irwell, thereby strengthening commercial links between Manchester and Liverpool. And in 1724 the turnpiking of the road from Manchester to Buxton was sanctioned, so that links with London, the main market for locally produced cloth and the source of raw cotton, were facilitated.

During the middle decades of the century, the pace of Manchester's development quickened considerably. Sustained growth of the town's population set in and the extent of the built-up area expanded appreciably, at first in the vicinity of St Ann's church and subsequently along Deansgate and High Street. Additionally, several visually impressive places of worship were constructed. Even so, problems remained, not least with regard to the town's sanitary conditions. Underpinning the quickening pace of development was an expansion of cotton goods manufacturing. It was in part stimulated by growing exports, but also by rising domestic demand triggered by a growing number of consumers with income to spend on consumer goods. The increase in Manchester's population provided the additional labour needed to expand manufacturing and service-sector activity, which remained largely dependent on hand technology, while well-established systems of granting credit continued to provide business finance. Further significant improvements were also made to the town's communications as the roads to neighbouring towns were turnpiked and the Bridgewater Canal was opened. Even so, problems remained, not least with regard to the town's sanitary conditions.

The generation of Mancunians born in the early part of the eighteenth century witnessed a much greater amount of change in their town than the generations they succeeded. Yet what was to come from the late eighteenth century onwards was of an altogether different dimension.

Notes

1. T.S. Willan, *Elizabethan Manchester*, Manchester: Chetham Society, 1980, p. 38.
2. Ibid., p. 39.
3. It was to be paid twice yearly and remained in force until 1689.
4. A.G. Crosby, 'The regional road network and the growth of Manchester in the sixteenth and seventeenth centuries', in C. Horner, ed., *Early Modern Manchester*, Preston: Carnegie, 2008, pp. 2–3.
5. The 1664 figure for Manchester hearths is given in P. Arrowsmith, 'The population of Manchester from c. AD 79 to 1801', *Greater Manchester Archaeological Journal*, 1 (1985), p. 99.
6. Crosby, 'Regional road network', p. 3. For a fuller listing of the rank order of north-west towns in 1664, along with population estimates, see J. Stobart, *The First Industrial Region*, Manchester: Manchester University Press, 2004, p. 37.
7. W.G. Hoskins, *Local History in England*, London: Longman, 1959, p. 177.
8. E.A. Wrigley, 'Urban growth and agricultural change: England and the continent in early modern England', in P. Borsay, ed., *The Eighteenth Century: A Reader in English Urban History, 1688–1820*, London: Longman, 1990, pp. 42–3.
9. F.R. Raines, *Notitia Cestriensis or Historical Notices of the Diocese of Chester*, Manchester: Chetham Society, 1845, vol. 2, pt. 1, p. 57; Arrowsmith, 'Population of Manchester', p. 99; A.P. Wadsworth and J. de Lacy Mann, *The Cotton Trade and Industrial Lancashire, 1600–1780*, Manchester: Manchester University Press, 1931, p. 509.
10. T. Percival. 'Observations on the state of population in Manchester, and other adjacent places', *Philosophical Transactions*, 64 (1774), p. 55. The Percival survey is kept in Chetham's Library. Pages from it can be viewed online at http://www.chethams.org.uk/treasures/treasures_census.html (accessed 31 December 2015).
11. The registers for these places have been published by the Lancashire Parish Register Society and can be viewed in local libraries.
12. *The Registers of the Cathedral Church of Manchester, 1653–1665/6*, Preston: Lancashire Parish Register Society, 1949, vol. III, pp. iv–v.
13. For example, 20 of the 39 bridegrooms from Blackley who were recorded in the registers between 1653 and 1660 were involved in textile-related work, mostly handloom weaving, the others being yeomen or husbandmen. For other figures based on these entries, along with discussion on proto-industrialization, see G. Timmins, *Made in Lancashire: A History of Regional Industrialisation*, Manchester: Manchester University Press, 1998, p. 73.
14. *Registers of the Cathedral Church of Manchester*, III, p. 85.
15. E.A. Wrigley and R.S. Schofield, *The Population History of England, 1541–1871: A Reconstruction*, Cambridge: Cambridge University Press, 1981, pp. 212–13.
16. E. Baines, *History, Directory, and Gazetteer, of the County Palatine of Lancaster*, vol. II (1825), Newton Abbot: David & Charles, 1968, p. 98; M. Mason, 'Manchester in 1645: the effects and social consequences of plague', *Transactions of the Lancashire and Cheshire Antiquarian Society*, 94 (1998), pp. 1–30.
17. T.S. Willan, 'Plague in perspective: the case of Manchester in 1605', *Transactions of the Historic Society of Lancashire and Cheshire*, 132 (1982), pp. 29–40.
18. J. Healey, 'Socially selective mortality during the population crisis of 1727–1739: evidence from Lancashire', *Local Population Studies*, 81 (2008), pp. 58–74.
19. Wrigley and Schofield, *Population History*, pp. 334–42.
20. Much depends on the completeness of recording in baptism and burial registers. See, for example, P. Razzell, 'An evaluation of the reliability of Anglican adult burial registration', *Local Population Studies*, 77 (2006), pp. 42–57, and E.A. Wrigley, R.S. Davis, J.E. Oeppen and R.S. Schofield, *English Population History from Family Reconstitution, 1580–1837*, Cambridge: Cambridge University Press, 1997, pp. 549 and 544.
21. Wrigley and Schofield, *Population History*, p. 334.
22. Percival, 'Observations', p. 58.
23. The 1751 version is described at length in J. Harland, 'Maps or plans of Manchester', in his *Collectanea Relating to Manchester and Its Neighbourhood at Various Periods*, Manchester: Chetham Society, 1866, pp. 100–9. See also T. Wyke, 'Mapping Manchester', *Historical Maps of Manchester: Maps from the Eighteenth Century*', Digital Archives Association, Warrington, CD-ROM, http://digitalarchives.co.uk.
24. *The Itinerary of John Leland the Antiquary*, vol. 5, 2nd edn, Oxford, 1744, pp. 88–9. The Collegiate Church served a large parish covering an area of nearly 60 square miles. See G.H. Tupling, 'Medieval and early modern Manchester', in C.F. Carter, ed., *Manchester and its Region*, Manchester: Manchester University Press, 1962, pp. 120–1.
25. R. Morden, S. Piggott and G. Walters, *Camden's Britannia 1695: A Facsimile of the 1695 Edition*, Newton Abbot: David & Charles, 1971, p. 788. Evidence that the 'cottons' to which Camden referred were likely to have been a type of woollen cloth is considered in G.W. Daniels, *The Early English Cotton Industry*, Manchester: Manchester University Press, 1920, pp. 6–8.
26. Willan, *Elizabethan Manchester*, pp. 51–63.
27. S. Bowd, 'In the labyrinth; John Dee and Reformation Manchester', in C. Horner, ed., *Early Modern Manchester*, Preston: Carnegie, 2008, p. 27.
28. For further details of the history and architecture of these buildings, see W. Farrer and J. Brownbill, *A History of the County of Lancaster*, vol. IV, London: Victoria County History, 1911, pp. 187–92, available at http://www.british-history.ac.uk/vch/lancs/vol4 (accessed 31 December 2015).
29. Further details of the Court Leet's procedures and concerns can be found in A. Kidd, *Manchester: From Roman Fort to 21st Century City*, Lancaster: Carnegie, 2016.

30. *The Court Leet Records of the Manor of Manchester*, vol. 1, Manchester, 1884, p. 15.
31. *Court Leet Records*, I, p. 30.
32. *Court Leet Records*, I, p. 18.
33. *Court Leet Records*, I, p. 69.
34. Willan, *Elizabethan Manchester*, pp. 4, 22, 106.
35. *Court Leet Records*, I, p. 71.
36. A. Redford, *The History of Local Government in Manchester*, vol. 1, London, 1939, p. 108.
37. *Court Leet Records*, VIII, pp. 107 and 141.
38. *The Manchester Historical Recorder*, Manchester: John Heywood, 1874, p. 32.
39. C. Chalklin, *The Provincial Towns of Georgian England: A Study of the Building Process, 1770-1820*, London: Edward Arnold, 1974, opposite p. 59. Marsden Square is marked on the first edition of the Casson and Berry map.
40. J. Aikin, *A Description of the Country from Thirty to Forty Miles around Manchester*, London, 1795, p. 191.
41. *The Journeys of Celia Fiennes*, London: McDonald, 1983, pp. 251-2.
42. E.L. Jones and M.E. Falkus, 'Urban improvement and the English economy in the seventeenth and eighteenth centuries', in P. Borsay, ed., *The Eighteenth Century: A Reader in English Urban History, 1688-1820*, London: Longman, 1990, pp. 116-27.
43. *Court Leet Records*, II, p. 308.
44. P. Borsay, 'The English urban renaissance: the development of provincial urban culture c.1680-c.1760', in P. Borsay, ed., *The Eighteenth Century: A Reader in English Urban History, 1688-1820*, London: Longman, 1990, pp. 159-87.
45. Details of these churches are taken from *Manchester Historical Recorder*, pp. 35, 42, 44 and 46.
46. A. Darbyshire, *A Book of Olde Manchester and Salford*, Manchester: John Heywood, 1887, pp. 53 and 60-1.
47. *Manchester Historical Recorder*, p. 51.
48. For details of the occupational structure within Manchester's 'middling' society during the first half of the eighteenth century, see C. Horner, '"Proper persons to deal with": identification and attitudes of middling society in Manchester, c.1730-1760', unpublished PhD thesis, Manchester Metropolitan University, 2001, pp. 60-99.
49. Wadsworth and Mann, *Cotton Trade*, pp. 11-23.
50. Wadsworth and Mann, *Cotton Trade*, pp. 36-47, 78-96, 98-106, 111-16.
51. S.J. Guscott, 'Merchants, money and myth-making: the life of Humphrey Chetham', *Transactions of the Lancashire and Cheshire Antiquarian Society*, 99 (2003), pp. 1-19.
52. Wadsworth and Mann, *Cotton Trade*, pp. 71-96.
53. For discussion of this matter, see Kidd, *Manchester: From Roman Fort to 21st Century City*.
54. These credit networks are discussed in Horner, 'Proper persons', pp. 117-25.
55. For details, see G. Timmins, 'Technological change', in M.B. Rose, ed., *The Lancashire Cotton Industry: A History Since 1700*, Preston: Lancashire County Books, 1996, pp. 37-9 and 40-1.
56. Wadsworth and Mann, *Cotton Trade*, pp. 287-8.
57. Wadsworth and Mann, *Cotton Trade*, p. 175. For a more general discussion, see B. Lemire, *Fashions' Favourite: The Cotton Trade and the Consumer in Britain, 1660-1800*, Oxford: Oxford University Press, 1991, pp. 77-114.
58. Darbyshire, *Olde Manchester*, p. 81.
59. For further details, see Wadsworth and Mann, *Cotton Trade*, p. 219; M. Nevell, *Manchester, The Hidden History*, Stroud: History Press, 2008, pp. 74-6; D. Vale, 'Connecting Manchester to the sea: the origins and early years of the Mersey and Irwell Navigation', in D. Brumhead and T. Wyke, eds, *Moving Manchester: Aspects of the History of Transport in the City and Region since 1700*, Manchester: Lancashire & Cheshire Antiquarian Society, 2004, pp. 51-68.
60. E. Raffald, *Directory of Manchester and Salford, 1772*, Swinton: Neil Richardson, 1981.
61. Wadsworth and Mann, *Cotton Trade*, pp. 220-3; Nevell, *Manchester*, pp. 76-92. For a detailed discussion of the development and impact of the canal, see M. Nevell and T. Wyke, *Bridgewater 250: The Archaeology of the World's First Industrial Canal*, Centre for Applied Archaeology, University of Salford, 2012.
62. Aikin, *Description*, pp. 112-16.
63. Raffald, *Directory*.
64. J. Whitely, 'The turnpike era', in A. Crosby, ed., *Leading the Way: A History of Lancashire's Roads*, Preston: Lancashire County Books, 1998, pp. 122-4.
65. G.L. Turnbull, *Traffic and Transport: An Economic History of Pickfords*, London: Allen & Unwin, 1979, pp. 60-4.
66. Raffald, *Directory*.
67. Aikin, *Description*, pp. 182-4.
68. Wadsworth and Mann, *Cotton Trade*, pp. 129-44 and 484-5; Lemire, *Fashion's Favourite*, pp. 12-42; P. O'Brien, T. Griffiths and P. Hunt, 'Political components of the industrial revolution: Parliament and the English cotton textile industry, 1660-1774', *Economic History Review*, 44 (1991), pp. 395-423.

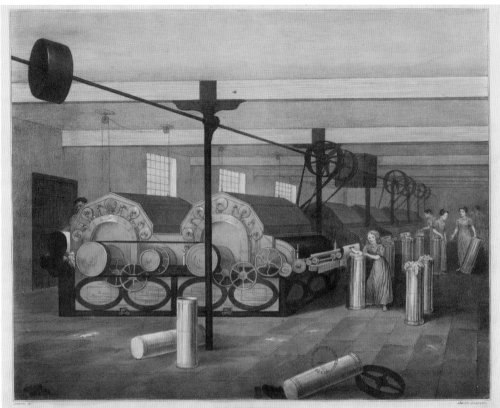

CARDING

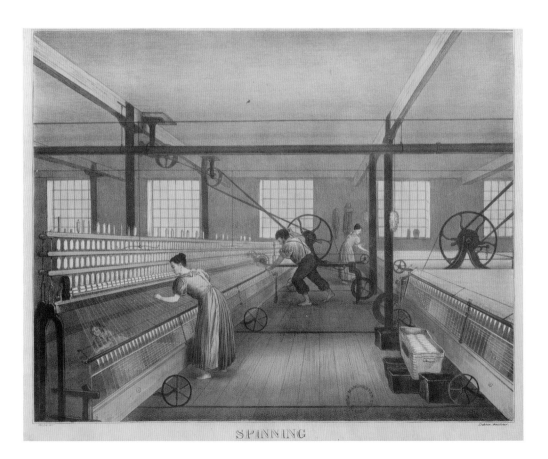

SPINNING

Rise and Decline of Cottonopolis

TERRY WYKE

James Richard Barfoot, *The Progress of Cotton* (1840). Barfoot's lithographs depicted the different processes involved in turning raw cotton into yarn and cloth. Featured are carding and spinning, the first to become part of Richard Arkwright's factory system of cotton production.

Courtesy of Manchester Libraries, Information and Archives, Manchester City Council

Arguments continue to rage about the nature, timing, causes and consequences of the world's first industrial revolution. Yet no convincing explanation of this, the most pivotal of all historical changes, is possible without reference to the cotton industry. 'Whoever says industrial revolution says cotton' was Eric Hobsbawm's aphoristic observation, to which one might add that whoever says cotton at that point in history has to be thinking about Manchester.[1] A revolution in the organization and technology of the cotton industry in the closing decades of the eighteenth century brought this middling market town in south-east Lancashire on to the stage of world history, making what was to become the Manchester city region one of the axes of an expanding global economy. It was all the more extraordinary as the nearest source of raw cotton was over two thousand miles away. Within a generation, Manchester became the centre of the world's cotton industry, occupying a commanding position on the fault line between the traditional and the modern world. This was not to last. Industrialization spread to other countries, and Manchester's pre-eminence was challenged. Its moment as one of the 'messianic cities of human history' passed.[2] Having been the cockpit of the modern industrial world, it was to be one of the first cities to face the problems posed by the loss of its dominant industry. This chapter examines these momentous changes. For convenience it is divided into two sections: the first from the 1780s, the decade in which the first cotton mill in the town was built, to 1914; the second from the First World War to the 1960s, the decade which ended with the closing of the Royal Exchange, the building that had come to symbolize Cottonopolis.

The rise of cotton

The industrialization and urbanization of Manchester is best regarded as not one but a cluster of interlocking changes, each of which can be considered revolutionary. These changes were evident by the 1780s. Writing in the town's first guidebook in 1783, James Ogden (1718–1802) captured Manchester on the edge of a great transformation, proud that the town – a place that had recently 'excited the attention and curiosity of strangers'[3] – was acquiring a new identity. Viewed from the tower of the Collegiate Church, the tallest building in the town, there was clear evidence of change. Old buildings were being pulled down in the centre while new streets were extending its urban frontier. Other pulses of economic activity were the construction of a toll bridge over the Irwell and the contentious attempt to open a new market in Pool Fold. New churches were highly visible markers of the growth in population: to the west of Deansgate, St John's (consecrated in 1769) was to be the centre of a new residential development of superior houses promoted by Edward Byrom (1724–73), while to the west of Piccadilly, St James's (consecrated in 1788), at the junction of the patriotically named George and Charlotte streets, looked to fill its pews from among those servant-keeping families who were moving into the new houses in the surrounding streets. Looking north-east from the church tower one could see the mass of Richard Arkwright's recently built cotton factory on Miller Street, a building in which he had tried unsuccessfully to drive his spinning machinery by steam power. Ogden enthused about the factory, probably unaware that around that time Arkwright was also purchasing property close to Market Street Lane with the intention of clearing the site and erecting a warehouse in what was to become Cromford Court.

Leaving the church to visit one of the many inns around the Market Place brought one closer to the commercial world of Manchester. Here was an opportunity to observe its businessmen at close quarters as well as to read the local newspapers. Charles Wheeler (1751–1827), the printer of Ogden's guide, began publishing the *Manchester Chronicle* in 1781, its advertising columns, like those of its rival, Joseph Harrop's *Manchester Mercury*, testifying to the town's quickening economy. Essential as these weekly newspapers were as sources of commercial information, some Manchester businessmen also purchased the London newspapers, preferring to read about the ongoing peace negotiations with the former American colonies and the most recent list of bankrupts before this news was recycled in the columns of the local press.[4] Yet for a commercial community other types of information were in short supply. One could not consult an up-to-date map of the town. It was not until 1787 that William Green began the survey that would produce the first large-scale plan of Manchester and Salford, a detailed and accurate plan that also recorded those streets that had been proposed but not yet built. Such was the pace of development that in the summer months Green had to carry out his surveying before 7 a.m. because after that time the streets became too busy.[5] In the inns one

also would have heard manufacturers and merchants discussing the state of trade, rumours of new taxes and the progress of the opposition organized by the local Committee for the Protection and Encouragement of Trade, the forerunner of the Chamber of Commerce, to confront Arkwright's efforts to protect the use of his cotton machinery.

Equally admired and disliked in Manchester, it was Richard Arkwright (1732–92), above all others, who started the revolution that moved spinning from an essentially home-based occupation into the factory, in which machines, powered at first by water and then by steam, produced yarn in quantities and of a quality previously unimaginable.[6] The hand-tool technologies by which spinning had been carried out for centuries were swept aside in a generation. The cotton factory had arrived in Manchester, a town that had long been one of the leading centres for the manufacturing, finishing and marketing of textiles. The existing expertise of Manchester manufacturers and merchants in organizing production gave the town an advantage over its competitors. It was a competence that supposedly stretched back to the arrival of Flemish weavers in the fourteenth century, a legend that Ford Madox Brown's mural in the Town Hall fixed even more firmly into the popular history of a city whose warp was textiles and whose weft was migrants. Cotton, of course, was only one of the textiles that Manchester dealt in, though by the early eighteenth century its merchants had established trading networks to import raw cotton which was used to produce the mixed-fibre cloths known as 'Manchester cottons', cloths increasingly popular in the London markets and at country fairs. 'Cotton in all its varieties' was responsible in Defoe's view not just for the growth of Manchester itself, but of the surrounding communities, a district that reached as far as Bury.[7] Consumers with rising incomes recognized that all-cotton cloths in particular were more comfortable to wear and easier to launder than woollens, while the relative ease with which they could be dyed and printed added greatly to their appeal. Cotton fabrics were in demand from every section of an increasing population. By the early nineteenth century the *Encyclopedia Britannica* was noting that Manchester cottons had 'acquired such celebrity, both in the scale of ornament and utility, as to spread in ten thousand forms and colours, not only in these kingdoms, but over all Europe, and even into the distant continents'.[8]

That Arkwright had set up a factory and warehouse in Manchester was recognition of its importance in the textile economy in the north-west of England. The carding and spinning machinery in his factory was powered initially by water pumped by a steam engine, but within a few years the problems of driving cotton machinery by steam were resolved and the decisive phase of the cotton factory began. Mills now no longer had to be anchored close to rivers and streams: 'instead of carrying people to the power, it was found preferable to place the power among the people' was cotton master John Kennedy's description of this decisive change in an essay read to the Manchester Literary and Philosophical Society.[9] Manchester seized the opportunity presented by the new machinery, quickly becoming a major cotton-spinning centre. Attracted by the large profits to be made from producing

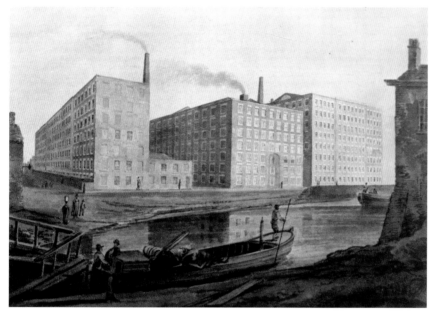

McConnel and Kennedy cotton mills, Ancoats. The building of these mills began in 1798, around the same time as the neighbouring mill of fellow Scotsmen, Adam and George Murray. These steam-driven multi-storey spinning mills came to symbolize the new industrial city, attracting visitors from across the world whose responses ranged from apprehension to amazement.

Courtesy of Manchester Libraries, Information and Archives, Manchester City Council

good-quality yarn and now free from the restrictions that Arkwright had placed on the use of his machines, existing manufacturers, merchants and new entrepreneurs began to build cotton factories in which the machinery was entirely driven by steam. In the north-west that industry was to be concentrated in the towns and villages of south-east Lancashire, but more particularly in Manchester where multi-storey cotton mills in Ancoats and on the boundary between Manchester and Chorlton-on-Medlock were brick behemoths in a new townscape that impressed and shocked contemporaries. By 1802 Manchester had over fifty cotton-spinning mills, and more were under construction.[10] Although the typical cotton master employed small numbers of workers, it was the larger mills employing hundreds of 'hands' that attracted most attention. In 1815 the major employers in Manchester and Salford were Adam and George Murray, Ancoats (1,215 employees); McConnel and Kennedy, Ancoats (1,020); Philips and Lee, Salford (937); Thomas Houldsworth, Manchester (622); and Birley and Hornby, Chorlton (549).[11]

The rising demand for cotton prompted continuing improvements to the cluster of inventions that had resulted in Arkwright establishing factory production. Eventually this was to include every stage of production from the opening of cotton bales to the bleaching, dyeing and printing of cloth. The structure of the industry, a large number of small firms, produced a competitive culture in which technical change became embedded, increasing productivity and lowering prices. Samuel Crompton's renowned spinning mule, for example, was to be significantly improved, notably by Richard Roberts (1789–1864). Initial efforts to develop steam-powered looms were disappointing and it was not until the 1820s that weaving began to move from the home and workshop into the factory, a change that

would see the handloom weaver go the way of the hand spinner. Production in the home and workshop only continued in trades like fustian cutting where processes remained difficult to mechanize. Technical improvements were to become less dependent on the inventions of semi-literate workmen, and more on understanding and applying specialized scientific and technical knowledge, subjects that came together in forums such as the Manchester 'Lit and Phil'. A closer relationship was developing between science and industry, John Dalton (1766–1844) being among the local chemists who conducted analyses for local textile firms.[12]

Cotton exports boomed. New markets for cotton goods opened up alongside those with which Manchester merchants already had trading links. By 1810 they exceeded woollen exports in value. This expansion was all the more remarkable in that it took place against a background of Britain fighting long and expensive wars which disrupted markets and increased prices and taxes. Beginning in Europe and the United States, Manchester cottons were soon wanted in all continents. Britain's dominance of world trade in the nineteenth century owed much to its cotton exports, and it was perhaps appropriate that, unlike most industries, cotton was not lost in a twilight zone of statistical guesswork. The most quoted and arguably the most important statistical tables in any discussion of Britain's first industrial revolution were those recording raw cotton imports and the exports of cotton goods. Caveats about the data aside, the gradient of the curves was impressively upwards (Figures 2.1, 2.2).

Ensuring a regular supply of cotton was, of course, essential to the industry. In the 1780s the West Indies and Turkey were the main suppliers, but this changed as cotton began to be grown in the newly independent United States. By the 1820s the United States had become the crucial link in the global supply chain of cotton, and was to remain throughout the century the largest supplier of cotton to Lancashire. In contrast to the early eighteenth century when most of the raw cotton worked in and around Manchester entered the country via London, cotton now came directly

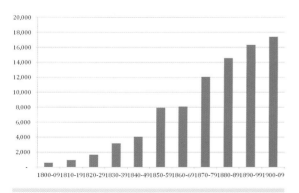

Figure 2.1 Imports: Raw cotton consumption (million lb) in Great Britain, 1770–1909

Source: B.R. Mitchell, *Abstract of British Historical Statistics* (1971).

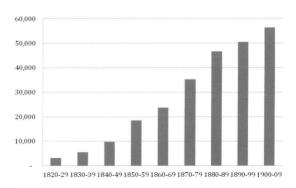

Figure 2.2 Exports of cotton piece goods (million yards), United Kingdom, 1820–1909

Source: B.R. Mitchell, *Abstract of British Historical Statistics* (1971).

through the port of Liverpool, a trade that was to bind the economies of the two towns ever more closely.

But in understanding Manchester's growth it is important to recognize that the cotton boom was not confined to the town. In his aptly entitled *A Description of the Country from Thirty to Forty Miles Round Manchester* (1795), John Aikin (1747–1822) indicated that the neighbouring smaller communities were also being transformed by cotton. Their pace of growth accelerated, transforming communities such as Ashton, Bury, Oldham and Stockport into major towns. Over the next half-century the cotton industry became ever more concentrated in and around south-east Lancashire – by the 1850s it was consuming over three-quarters of all cotton imports. Over the same period the business of turning raw cotton into yarn and cloth became ever more important to the towns around Manchester, specialization becoming more evident as they concentrated on producing particular types of yarn or piece goods. This challenged Manchester's position as the leading manufacturing centre, a shift that a sharp-eyed Disraeli noted in his 'condition of England' novel *Coningsby* (1844), when he had one cotton master tell his hero that if he wanted to see a truly modern cotton mill then Stalybridge not Manchester was now the place to visit.[13]

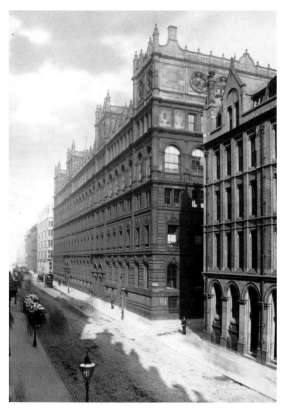

Watts warehouse, Portland Street, 1892. From its opening in 1858, the five-storey warehouse built for Samuel and James Watts was not only one of the largest but one of the most spectacular of the home trade warehouses built in mid-Victorian Manchester. It immediately became a landmark of Cottonopolis, added to the list of those buildings and works to be seen and visited by dignitaries, journalists and others.

Courtesy of Manchester Libraries, Information and Archives, Manchester City Council

Cotton spinning continued in Manchester, but it was the merchanting of cotton that became sovereign. Manchester's warehouses increased in number and size. Foreign merchants who had begun arriving by the late eighteenth century increased in number – Nathan Rothschild (1777–1836) being one of the best remembered of these early arrivals – developing new trading links as well as strengthening existing ones. The 1851 census counted over 1,600 foreign-born residents in Manchester and Salford, a figure only exceeded in Lancashire by Liverpool.[14] Over time the business of merchanting, like manufacturing, was to be transformed, becoming ever more specialized, though whether one operated a home or foreign trade warehouse, those fundamentals that had determined the fortunes of Manchester clothiers in earlier centuries – trust, reputation, access to credit and a knowledge of markets and customers – remained paramount. Warehouses came to be concentrated in particular in the streets between Piccadilly and Princess Street. They were as much working machines as the cotton mills, becoming ever more efficient in maximizing both space and natural light. Merchants, particularly those in the home trade who needed to display their extensive range of goods in larger and more attractive showrooms, began to employ architects to provide buildings that were more than functional brick boxes. S. & J. Watts's massive warehouse on Portland Street was among the grandest mid-Victorian examples, an architectural confection that prompted penny-a-line journalists to make comparisons with Italian merchant palaces. They became points of interest in a rapidly changing townscape, and were also welcomed because their construction frequently required the demolition of slum housing.

A noteworthy feature of the early part of the cotton revolution was the absence of a specialist textile Exchange. Manchester's first Exchange was closed in 1792, though around this time it is unclear to what extent textile traders preferred to conduct business in their own warehouses or in one of the local inns. Opened in 1809, the new Exchange became synonymous with cotton and such was the growth in business that it was extended twice before the end of the century (1847–49, 1867–74), each extension an expression of the rising wealth and confidence of the city. The number of members belonging to the Exchange described a similar trend to that of cotton imports (Figure 2.3).

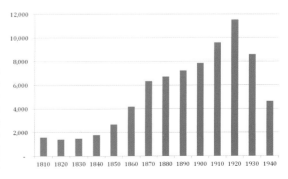

Figure 2.3 Annual number of subscribers, Manchester Royal Exchange, 1810-1940

Source: D.A. Farnie, 'An index of commercial activity: membership of the Manchester Royal Exchange 1809–1948', *Business History*, 71 (1979), p. 101

Just as the first generation of industrial tourists had been thrilled to travel on the Bridgewater Canal, now it was Manchester's cotton factories, printing works and warehouses which attracted the curious. No serious visitor could leave Manchester without seeing 'the parliament house of the Cotton Lords'. The spectacle and mystery of High 'Change – cotton was rarely seen on the trading floor – was frequently described, transactions in which merchants, manufacturers and their agents bought and sold on the strength of a handshake quantities of yarn and cloth that fifty years before would have represented a year's trade with a single country. For Mancunians there was a recognition that they were at the centre of a new industrial society in which their town was foremost. 'Cotton is Lord of the Ascendant in the Manchester house of destiny', cheered one local journalist in 1833, 'that creative, vivifying, radiating power from which emanates the suns and stars and comets, the life and light and being of the Manchester "system".'[15] Two years later, Edward Baines (1800–90) provided a more ordered account of the extraordinary changes that had already taken place in his *History of the Cotton Manufacture in Great Britain* (1835), the first detailed history to be published of any of the industries that were driving the industrial revolution. Such was cotton's importance in foreign trade and the empire that the town could not be ignored. Manchester was now listened to in the corridors of power, its economic muscle underpinning its voice. This was made clear in the 1840s, when following a business-like campaign in pressure group politics, free trade became the nation's economic creed; a momentous victory that ensured that the political as well as the economic history of modern Britain could not be told without reference to Manchester.

Canals and railways

A transport revolution was the second in the cluster of revolutions that made modern Manchester. Expanding urban economies depended on an efficient transport system capable of moving raw materials, finished goods, foodstuffs and fuel ever more quickly, cheaply and reliably. Manchester was special in that it was at the centre of the two most important developments in transport in the eighteenth and nineteenth centuries. First were the improvements in water transport.

Manchester's distance from the sea meant that it was not favourably located to become a major industrial and commercial city, least of all one whose essential raw material had to be imported. Although rivers defined the main boundaries of the township, with the exception of the Irwell they were of minor economic importance. The navigability of the Irwell had been improved in the second quarter of the eighteenth century, but it was not to become the great commercial artery of the town; rather it was investment in canals as well as roads that was to accelerate urban growth. The canal revolution began in the most spectacular manner with the building of the Bridgewater Canal – an improved ancient technology – which allowed coal from the Duke of Bridgewater's Worsley mines to reach Manchester in ever larger and cheaper amounts, guaranteed supplies of 'cheap energy' being a prerequisite for industrialization. Equally important, the canal provided a new

route between Manchester and the port of Liverpool. Although it is easy to exaggerate the inefficiencies of the existing road network, the Bridgewater confirmed the economic advantages of canals in transporting heavy, bulky, low-value goods as well as demonstrating that existing expertise, much of which was derived from river navigations, was capable of providing solutions to formidable engineering problems.

The Bridgewater Canal put Manchester on the national map, the Barton Aqueduct becoming one of the country's first industrial tourist attractions. Castlefield canal basin was prominent in James Ogden's rhetoric of industrial progress. Other canals followed, the risks now being spread among groups of businessmen, merchants and landowners rather than relying on one individual with bottomless pockets. Canal mania gripped Manchester in the 1790s, and by 1815 canals linked the town to major urban markets in England. Above all, the trade between Manchester and Liverpool continued to increase. After Castlefield, another sprawling canal basin of wharves and warehouses developed around the terminus of the Rochdale and Ashton canals, between Great Ancoats Lane and Piccadilly. Canals became important in determining industrial location. Nowhere was this more evident than in Ancoats where, in addition to its eye-catching cotton mills, there were firms working in metals, chemicals, glass and timber. The canal

Staffordshire Warehouse, Castlefield c.1890. Built in the 1790s, this was one of the earliest and largest of the warehouses in the Castlefield basin. Its design was unusual in that the two canal arms did not terminate inside the warehouse but passed through it, creating a small basin at the rear. A vitriol works was established behind the warehouse.

Courtesy of Chetham's Library

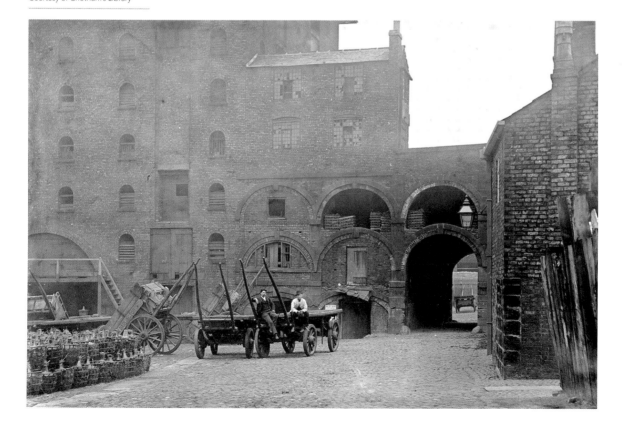

joining the Castlefield and Piccadilly basins bristled with factories and workshops, taking advantage of the cheap coal and other raw materials carried on it, while water from the canal filled the boilers of their steam engines. Canals carried a wide range of raw materials, foodstuffs and general goods, but for many businesses it was coal that was the backbone of their profits. The canals also provided farmers with easier access to urban markets, maintaining food supplies without which prices and wages would have fluctuated more widely. Manure pits in the canal basins were a reminder that the barges also carried animal and human waste out to the farms of Cheshire and Yorkshire. Canals were not cheap to build but there was no shortage of capital, a share market helping mobilize the savings of a wider group of investors. 'Lancashire claims special praise as having set the example to the country in the great modern arts of internal communication by land and water' was James Wheeler's short and accurate assessment of a revolution that had reduced distance, increased productivity by lowering costs and ensured that Manchester and its cotton towns never suffered a fuel famine.[16]

Canals have drawn attention away from improvements in road transport. Contemporaries frequently measured such improvements in terms of the journey times of stagecoaches to London, but this tends to understate the savings generated by local and regional turnpike trusts, whose investments included improving existing roads as well as building new ones. New and revised editions of county maps confirmed Manchester as the centre of an increasingly dense road network, connecting it to neighbouring towns whose economies were being pulled ever more closely within its orbit. The building of bridges was another consequence of the increase in road traffic. New and replacement bridges contributed to bolting together the economies of Manchester and Salford: Blackfriars Bridge (opened 1820) and Albert Bridge (opened 1844) replaced eighteenth-century bridges, while Victoria Bridge (opened 1839) replaced the ancient Salford Bridge.

Wednesday 15 September 1830 is rightly regarded as one of the most significant dates in the history of the modern world, as on this day the opening of the Liverpool and Manchester Railway marked the real beginning of the Railway Age. As with the Bridgewater Canal some seventy years before, the railway became an immediate symbol of progress, demonstrating to doubters that this entirely novel mode of land transport was a reliable and profitable way of moving merchandise and passengers at previously unimaginable speeds over long distances. It was, of course, to be of global significance, but more immediately it underlined the regional nature of the ongoing industrial revolution, strengthening the connection between the two largest urban communities outside London. Both Manchester and Liverpool businessmen had recognized the potential benefits of a new transport link, spurred on by their dissatisfaction with the costs and delays of canal transport. Liverpool merchants were especially prominent in promoting the railway, aware of the burgeoning trade centred in the Manchester district.

Funding the railways proved less difficult than funding the canals, and Manchester quickly became a major railway centre. Railways competed with the

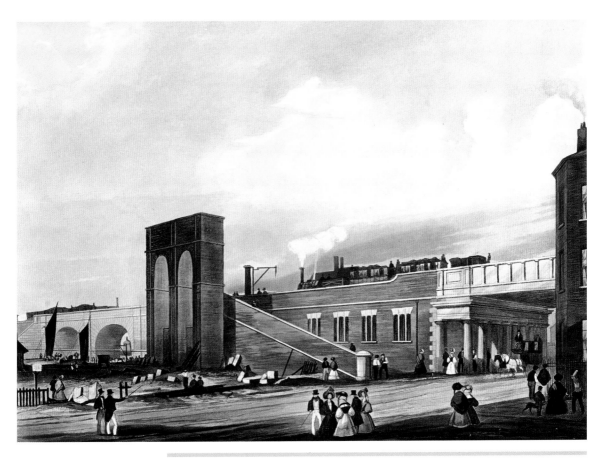

Thomas Talbot Bury, *Liverpool and Manchester Railway. Entrance into Manchester across Water Street*, from *Coloured Views on the Liverpool and Manchester Railway* (1831). Bury's drawings celebrated and publicized in Britain and abroad the great transformation that the railway represented. In this illustration a train has crossed the elegant Water Street bridge (right) which was built using a new type of cast-iron beam devised by Eaton Hodgkinson and manufactured by William Fairbairn in Ancoats.

Courtesy of Chetham's Library

canals, but the increasing volume of goods and raw materials that needed to be moved meant that the long-term decline in canal traffic was to be less evident in south-east Lancashire than in other regions. The growth of the railways also changed the face of the city. It was the inter-city lines, like the earlier long-distance turnpike roads, that attracted most attention, but equally important were those lines connecting Manchester to the neighbouring cotton towns, connections vital in the business that began with the placing of an order for raw cotton and ended with the despatch of yarn or piece goods from a Manchester warehouse. One indication of the profits to be earned in Manchester was its railway warehouses, beginning with the timber-frame warehouse at Liverpool Road station (1830), the world's first railway warehouse, and ending with the monumental and hugely expensive Great Northern Goods Station (1898) on Deansgate, the last major

goods station to be located in the centre of any Victorian city. Railways consolidated Manchester's position as a regional capital, driving changes in the economic and social geography of the city. Ambition was hardly lacking, but not even one of Manchester's shrewdest businessmen, Edward Watkin (1819–1901) – the 'Second Railway King' – could realize the dream of a through station. Railway companies established goods stations and depots – the large-scale Ordnance Survey plans recording acres of warehouses, workshops, sidings and marshalling yards. Liverpool Road and Oldham Road were among those closest to the city centre, both having been originally terminus stations for passengers and goods. Railways continued to be built into the early twentieth century and the Railway Clearing House map of Edwardian Manchester shows the city encircled by railway lines, terminating in four passenger and eight goods stations.

Manchester became the most railway-minded of cities. In 1847 it was among the first provincial towns to set its clocks by Railway (Greenwich) Time, the adjustment being made following a signal sent by the new electric telegraph. Few bemoaned the loss of 8 minutes 56 seconds, satisfied in the knowledge that it would be easier to plan journeys when consulting a railway timetable, of which the most successful were those compiled on behalf of the Manchester publisher George Bradshaw (1801–53).

Engineering

The steam-powered cotton factory would not have been possible without a complementary revolution in engineering, the interdependency of industries becoming a key feature of the new industrial urban economy. Continuous improvements in machinery and power systems in the cotton factory transformed engineering into a major sector of the town's and the region's economy. Textile engineering changed rapidly, the first generation of jennies and mules being soon replaced by superior all-metal machines. At the same time firms such as Bateman and Sherratt were competing with Boulton and Watt to meet the demand for steam engines. Manchester's expanding economy attracted young engineers who learned on the job and who, often after only a short apprenticeship, set up their own firms. The Welsh-born Richard Roberts (1789–1864), who came to Manchester in around 1815, was to be responsible for manufacturing machine tools and improving the design of many textile machines, most famously Crompton's mule. The Scots-born William Fairbairn (1789–1874) settled in the town around 1814 and was soon demonstrating that his problem-solving skills extended far beyond the making and powering of machinery in cotton mills. Contrary to the observation of James Nasmyth (1808–90) that engineering was 'common sense applied to the use of materials', there was a recognition that engineering solutions depended on a more scientific understanding of the properties and potential of metals, a need that encouraged closer links between local chemists and engineers. This was also evident in other areas of the Manchester economy such as its early adoption of gas lighting – another symbol of its modernity.

The popular history of engineering, like that of cotton, became a narrative dominated by the achievements of individuals whose inventiveness and expertise made them leaders in the industry. Sharp, Roberts and Nasmyth Wilson were among the first Manchester firms to respond to the technical challenges of Stephenson's locomotives, though it was to be the German-born Charles Beyer (1813–76), one of Sharp, Roberts' employees, who in partnership with Richard Peacock (1820–89) consolidated Manchester's reputation as a major centre of railway engineering. Engines from the company's Gorton works were to be found on railways from Belgium to Australia. Machine-tool engineering became another important part of the sector, led by the 'the great mechanician', Joseph Whitworth (1803–77), who having established his works in the town in 1833, soon set about pursuing that precision in measurement, standardization and interchangeability that placed him in the pantheon of Victorian engineers. Galloways, which was to be closely associated with improvements to the Lancashire boiler, contributed to the research that resulted in the development of Bessemer steel. Inevitably, the achievements of these engineering giants left others unrecognized, men like the Manchester blacksmith John Stanley, whose 'Stanley Stoker' improved the combustion efficiency of boilers by distributing coal within the grate, a modest empirical alteration but one that produced savings for a relatively small outlay. Stanley is also a reminder of the diversity of a sector in which, for every firm employing hundreds in vast works, there were scores with only a handful of workers, making everything from chains to files whose methods of manufacture would have been familiar to an earlier generation of toolmakers.[17] By 1851 Manchester and Salford's main engineering

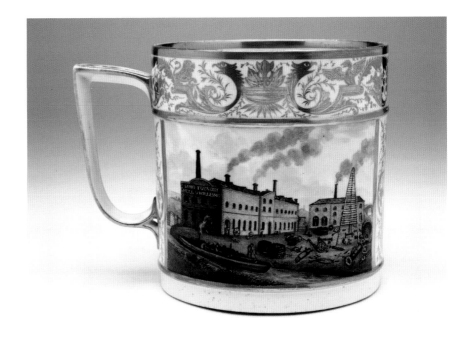

Peel, Williams and Peel, Soho Foundry, porter mug (c.1820). Established in the late 1790s, Peel, Williams and Peel was among the first generation of engineering firms to be established in Ancoats. Known particularly for manufacturing steam engines, the firm diversified into making other machinery, including boilers, axles and railway engines. It occupied the Phoenix Foundry on Swan Street before transferring to the Soho Foundry, located in Pollard Street and adjoining the Ashton canal, whose buildings and workyard are depicted on the mug.

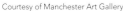
Courtesy of Manchester Art Gallery

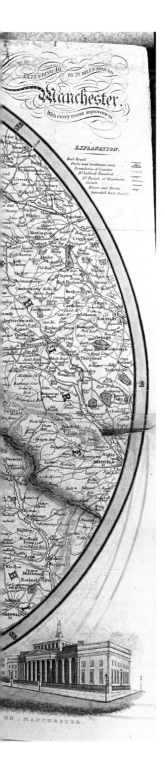

Map of the manufacturing district extending 40 by 28 miles around Manchester (*Pigot's Directory*, Manchester, 1838). By the 1840s it had become commonplace to discuss Manchester as the commercial centre of a vast region of towns and villages in which different branches of the cotton trade were carried out, an economic relationship that was especially evident in periods of depression. This map would have been helpful to businessmen as it included the majority of the region's cotton towns, with the exception of Preston.

Courtesy of Chetham's Library

trades employed over 5,500, a figure that excluded those working in the wider metal trades. By no means all those employed in engineering works were skilled workers, but the wages and security experienced by many provided conditions in which permanent trade unions were established, a force pressing for improvements in pay and working conditions.

By the late 1840s Manchester's engineering works had also become a must-see for the industrial tourist, the fortunate ones being taken to Nasmyth's works to marvel at the sight of his steam hammer cracking an egg. By this date, successful Manchester firms had outgrown their original central locations, moving to larger sites outside the city, exemplified in Nasmyth's decision to move his works to Patricroft next to the Bridgewater Canal and the Liverpool and Manchester Railway, and John Ashbury's removal of his railway rolling stock works next to the railway in Openshaw. The need for larger sites and access to superior transport facilities was also important in later removals, notably Whitworth's move to Openshaw in 1880, Craven Brothers to Reddish in 1900, and Mather and Platt's transfer of production to Newton Heath in 1912–13.

Manchester's claim to be the 'Metropolis of Manufactures' was not confined to the city. While firms such as John Hetherington & Sons were to maintain Manchester's prominent position in the textile engineering sector, this also became an important part of the economy of other towns in the city region. Howard and Bullough (Accrington), Dobson and Barlow (Bolton) and, above all, Platt Brothers (Oldham) were among Lancashire's largest employers, firms capable of equipping a cotton mill anywhere in the world. Salford was also a major centre of engineering and iron works. Mather and Platt, which was to be regarded in the twentieth century as one of the largest of Manchester's engineering firms, had its roots in Victorian Salford. This is not to suggest that the invention and manufacturing of textile machinery was limited to Lancashire, but almost everywhere the pull of Manchester was evident. Lancashire mechanics had been among those taking the secrets of its cotton machines abroad. Even before the industrial revolution John Kay (1704–c.1779), inventor of the fly shuttle, famously helped to mechanize the French textile industry. Foreign mechanics also came to Manchester to train and in some cases to spy. A well-known example was Josué Heilmann (1796–1848), the French inventor of the cotton-combing machine, who spent time in the city, in his case working with Sharp, Roberts.

By the time Manchester exhibits were being arranged at the Great Exhibition in London's Hyde Park, these interlocking revolutions in cotton, engineering and transport had created a dynamic city region. 'Tis coals and cotton boil the pot, sirs', ran one of the lines in Richard Baines's popular ballad 'Manchester's Improving Daily'.[18] Manchester was home to some of the region's largest spinning mills but, above all, it was the undisputed centre for the marketing of cotton yarn and cloth. The Royal Exchange, as it became following Queen Victoria's visit in 1851, and the great swathe of warehouses in the city centre announced its position at the heart of 'Cottonopolis'. Within living memory, the cotton spun and woven in its factories had come to dominate the world's cotton trade, thousands of men, women and children employed, directly and indirectly, in its factories. From Barmen in Germany to Lowell in the United States, cotton factories were driving change in economies desperate to catch up with Britain. New communities in other countries chose to call themselves Manchester, presumably hoping that some of its entrepreneurial magic would rub off on them.[19] Samuel Sidney, visiting the original Manchester in 1851, was unequivocal about its momentousness:

> Manchester is the greatest manufactory in the world. The cradle and metropolis of a trade which employs a million and a half of souls, beside the sailors, the merchants, the planters and the slaves, who grow or carry or buy the raw material, it is the second city in the empire, and perhaps, considered in relation to the commercial influence of Great Britain, scarcely second. Blot out the capital, the credit, the living enterprise, the manufacturing power of Manchester, and we have lost a century of commercial progress.[20]

Manchester had become the exemplar of the new industrial society. People continued to be drawn to a town that had become a byword for modernity, a place that intrigued yet perplexed visitors, a place that, like London, was large and continually expanding, a place that even more so than in Defoe's day could not begin to be understood within its conventional administrative boundaries. Its extraordinary growth defied easy explanation, contemporaries falling back on dull descriptions and generalizations about its polarities and its inhabitants' single-minded pursuit of money. Its sense of its own importance, compounded by the repeal of the Corn Laws, also brought it critics. To Thomas Carlyle, Manchester was 'quite puffed up, and fancies *it* can rule the world, ever since that Anti-Corn-Law achievement. One of the most palpable mistakes on the part of Manchester; which is, and will for a long time remain, a very dark, greasy-minded, and quite *limited* place, in spite of its skill in calicoes!'[21] Other observers looked beneath the smoking chimneys and noisy machinery to discern other meanings in an economic system which was redefining the nature of work and the relationship between masters and men. The young Friedrich Engels (1820–95), having lived and worked in Manchester from 1842 to 1844, explained to his German readers the contradictions within the factory system that was at the heart of what he, following other Continental writers, referred to as

the industrial revolution, a revolution that was fundamentally economic but also responsible for creating a new social structure.[22]

These decades of accelerating economic growth underpinned an equally astonishing increase in Manchester's population. That increase was underway by the middle of the eighteenth century, the rise in population prompting the first detailed census of the town and parish in 1773–74. The census was symptomatic of an inquiring spirit that was also evident in bodies like the Manchester Agricultural Society, founded in 1767, whose meetings were both serious and social. The census revealed that of the 36,267 inhabitants in the parish, the majority, 22,481 (62 per cent), were living in the Manchester township, most of whom were concentrated in and around the medieval centre, leaving outlying districts such as Ancoats distinctly rural. Salford (4,765) was the most populous of the parish's other townships, followed by Blackley (1,394), Failsworth (1,353) and Stretford (1,104).[23] Fifteen years later it was estimated that the population of the Manchester township had almost doubled.

Rapid as the increase in population during the second half of the eighteenth century was, it was merely a prelude to the unprecedented growth in the next half-century. Manchester's prominence in what was a new urban hierarchy was confirmed in the first national census in 1801. Whereas fifty years before it was little different from many other medium-sized market towns, industrialization had raised the township's population to 70,409, a figure that took no account of the population increase in adjoining districts. In the next half-century the pace of urbanization quickened. On any historical accounting the growth was astounding. By 1851 the township's population alone numbered 186,986, an increase of 265 per cent since 1801. Population densities were highest in the township, though there were wide differences between areas: the population of the central districts had been shrinking since the 1820s whereas the population in what had previously been an almost rural Ancoats numbered close to 50,000 in 1851. Comparing William Green's map of 1794 with the first large-scale Ordnance Survey plan of the borough published in 1851 it is evident that these decades of galloping urbanization saw the once thinly populated contiguous townships transformed into full-blown urban and suburban districts. The boundaries of the new municipal borough created in 1838 (comprising Ardwick, Beswick, Cheetham, Chorlton-on-Medlock, Hulme and Manchester) reflected this urban revolution. The borough's population in 1851 numbered 316,203, compared to 23,803 in 1773–74, an annual increase in absolute numbers of around 3,800 people, though this increase was not evenly spread, either chronologically or spatially. This was especially evident in Chorlton-on-Medlock and Hulme where new streets obliterated the old field boundaries, and where between 1801 and 1851 the population increased from 675 to 35,558 and 1,677 to 53,482, respectively, creating districts that would have ranked high in the national urban league tables had they not become part of the borough. In 1851 Hulme, whose population had increased by more than 30,000 in twenty years, easily exceeded the population of Chester.

Yet in economic terms Manchester was more than a single city. It was the centre of a city region, the rise of the steam-powered cotton industry having resulted in the equally rapid growth of satellite cotton towns. Salford's population numbered over 60,000 in 1851 as did those of Oldham, Preston and Bolton.[24] The population of Burnley, one of the smaller cotton towns, was greater than that of Lancaster. In the larger towns, as in Manchester, the growth in population breached existing administrative boundaries, with the result that the census figures without reference to specific boundaries could be misleading. Issues of comparability aside, what was clear was that this pace of urban growth made Lancashire one of the largest counties in terms of population, and south-east Lancashire one of the most densely populated areas in the country. Such numbers put pressure on the urban infrastructure, most obviously in the central districts of Manchester

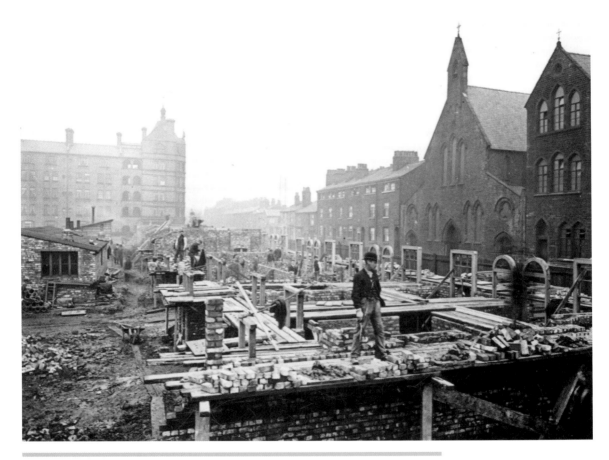

Building houses in Ancoats, 1898. House building was one of the key sectors of the urban economy, but it was not until the 1890s that Manchester Corporation began to build houses in the slum districts. This photograph shows some of the earliest corporation 'cottages' under construction in George Leigh Street, while in the background is the earlier municipal housing scheme of Victoria Square Dwellings, completed in 1894.

Courtesy of Manchester Libraries, Information and Archives, Manchester City Council

with its older housing stock, where a generation before the first cholera epidemic serious concerns were being raised about public health.[25] Sanitary and environmental problems intensified as the population increased. Beneath the political squabbling that surrounded the adoption of the Municipal Corporations Act there were concerns over Manchester's ability to provide essential services, not least an adequate water supply with which to fight fires and slake the thirsts of its industries and inhabitants.[26] It was not immediately evident from the published maps that brick was the dominant building material in a long building boom that had been underway since at least the 1780s. Brick crofts were a common (but now forgotten) feature of the landscape, the places where the millions of largely handmade bricks out of which the town was built were manufactured. Given its employment of casual labour and its cyclical and seasonal nature, measuring the importance of building to the economy is difficult. Certainly it is best to regard the 4.8 per cent of the male population employed in the main building trades in Manchester and Salford in 1851 as an approximate guide.

The rapid increase in population was driven by long-term movements in fertility and mortality rates, more particularly fertility. Charting these changes before the introduction of civil registration remained problematic, contemporaries turning to counting the entries in the Collegiate Church registers to provide a rough measure of the demographic revolution in which they found themselves. These revealed that between 1781 and 1800 there were 42,995 baptisms and 24,738 burials, compared to 104,592 baptisms and 53,316 burials in 1821–40.[27] Crude and limited as these numbers were, they did tend to support the view that in these years the birth rate was increasing, a trend that found further support in the rise in the number of couples whose names were entered in the marriage registers. In addition, the population was increasing as a result of what Thomas Percival (1740–1804) had referred to as those 'new settlers in the prime of life who annually pour into Manchester'.[28] Migrants continued to move into the town, attracted by the opportunities provided by an expanding labour market. The town also brought them into contact with new ideas and experiences. Urban life meant that there was more to do, more to talk about, more to read. One of the earliest inquiries conducted by the Manchester Statistical Society identified Charles Knowlton's *Fruits of Philosophy* as one of the most popular books read in the town, some forty years before its discussion of birth control made it the centre of the celebrated Bradlaugh–Besant trial.[29]

King Cotton

In the second half of the nineteenth century the cotton industry continued to expand, exports driving its growth. The potential of the Indian market for Lancashire piece goods – it had been on the agenda of the early meetings of the Manchester Chamber of Commerce – began to be realized, and by 1914 it was to be by far the industry's largest export market, having an apparently insatiable demand for cheaper low-quality cotton cloths. Working cotton mills were still to be found in and around the city centre of Manchester, but its importance as a spinning

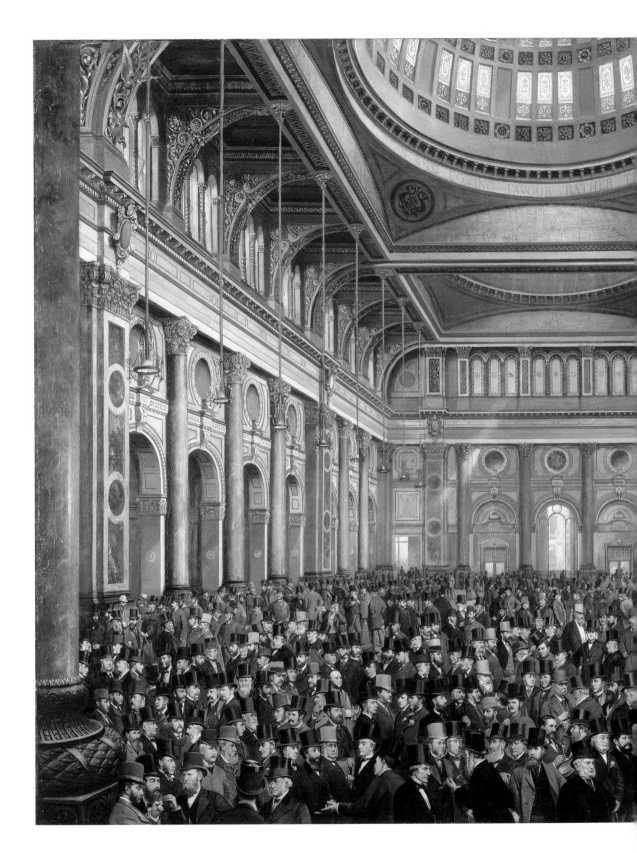

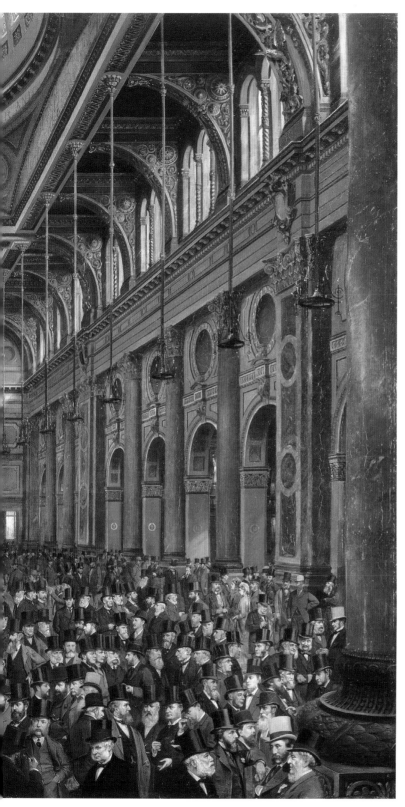

Frederick Sargent and H.L. Saunders, *Interior of the Manchester Royal Exchange* (1877). This oil painting of traders on the floor of the Exchange can be regarded as a statement of Manchester's supremacy in the world of cotton. It captures the scale and magnificence of the interior of Mills and Murgatroyd's building. Of the hundreds of traders on the main floor, 231 were identified in a key to the painting. Sargent was the main artist, large group portraits being a speciality of his. The painting was presented to the Exchange by the textile merchant and philanthropist Joseph Broome in 1885. 'Rather too much hat' was the droll comment of one observer.

Courtesy of Manchester Art Gallery

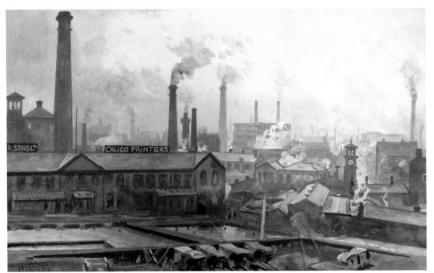

Henry E. Tidmarsh, *Mayfield printworks* (1894). The Mayfield printworks, originally established by Thomas Hoyle in the early 1780s, was the largest and the best known of the city's many calico printworks. Notable visitors included Prince Albert in 1857. Its importance meant that it was an essential subject in W. Shaw's multi-volume *Manchester Old and New* (1894). Tidmarsh's drawing, looking south from London Road railway station, records other smoking factory chimneys – the leitmotif of any prosperous nineteenth-century industrial town.

Courtesy of Manchester Art Gallery

centre was declining. Cotton spinning became more concentrated in the satellite towns: Oldham was famous for coarse spinning using mainly American cotton, while Bolton's reputation was based on spinning finer yarns using Egyptian cotton. Burnley and Blackburn were among the leading weaving towns. New cotton towns, exemplified by Shaw, near Oldham, and Nelson, near Burnley, were another feature of these years.

Manchester strengthened its position as the commercial centre of the industry. New warehouses were built in and around the main commercial district bounded by Piccadilly, Portland Street, Mosley Street and Princess Street. Improvements continued to be made in the design and operation of home and foreign trade warehouses. Only the unmindful observer could have mistaken an Edwardian warehouse for a mid-Victorian one. The same was true of cotton mills.

Reliable commercial information was essential in an industry where shifts in the price of raw cotton or yarn could bring difficulties to merchants and manufacturers. 'Margins', as the *Manchester Guardian* observed, were prone to 'disappear like snow in a frying-pan', resulting in thinner order books and harder times.[30] Cotton operatives knew only too well of the impact of poor cotton harvests and shifts in foreign markets due to political circumstances. The most serious downturn in the industry occurred when the American Civil War stopped supplies of cotton from the southern states reaching Lancashire. Initially, this did not have a major effect because raw cotton stocks were high, but by 1861–62 hundreds of Lancashire mills were on short time or completely stopped. The impact of the crisis on business, from the largest textile engineering company to the smallest shopkeeper, underlined the importance of the industry to the region's economy. The crisis overwhelmed the Poor Law authorities, and local relief committees were established as unemployment increased. Every cotton town felt the impact of the famine but the diversity

of Manchester's economy meant that it suffered less than many of its neighbours. A later Liberal narrative emphasizing the stoic sufferings and sacrifices of Lancashire's cotton workers for the abolitionist cause ignored the support that existed for the Confederate states, if not slavery, in the cotton towns. For Lancashire cotton men the war drew attention, once more, to their dependence on American cotton. However, the crisis came and went, and Lancashire workers, relieved to see the wagons carrying good-quality cotton arriving at the mill, appeared to take little interest in the lives of those now freed slaves who continued working on the cotton plantations.[31]

Banking and insurance

Manchester's industrial and commercial development would have slowed had it not developed a modern financial sector to provide access to the capital, credit and cash that was a necessary part of a growing economy. Credit was essential for the smooth running of the cotton industry, and over time the banks devised more sophisticated ways to meet the needs of different sections of the trade, eventually replacing the bills of exchange which had been an essential means of creating credit and settling accounts in Lancashire.[32] These were frenetic years, the timeline of which was marked by the failure of banks. Out of the 1825–26 financial crisis came the legislation that saw the beginnings of joint-stock banking. Manchester's

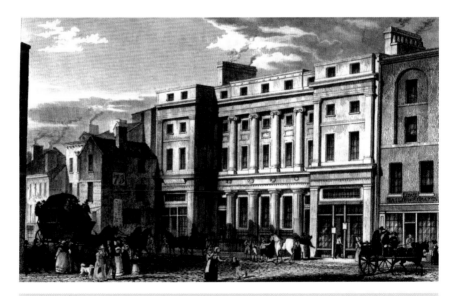

Thomas Allom, *Cunliffes, Brooks & Co. Bank, Market Street* (1829). Founded by Roger Cunliffe and William Brooks in Blackburn, Cunliffe, Brooks opened a Manchester branch around 1819. In spite of the volatile nature of banking during these years, new premises were opened in Market Street in 1827, a confidence-inspiring neoclassical building designed by Thomas Royle and Robert Unwin. William's son, Samuel, became a leading figure in the firm, consolidating its reputation as one of the region's main banks. In 1847 the bank occupied the premises recently vacated by the Bank of England branch in King Street, a move precipitated by a fire in Market Street.

Courtesy of Manchester Libraries, Information and Archives, Manchester City Council

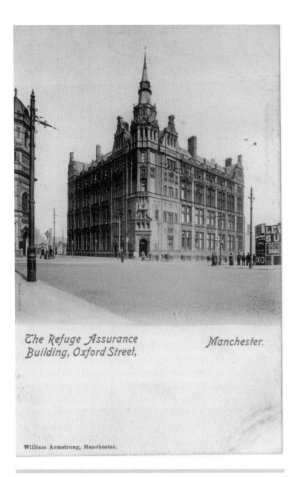

The Refuge Assurance
Building, Oxford Street,

Manchester.

William Armstrong, Manchester.

Refuge Assurance Office, Oxford Street (postcard, William Armstrong, Manchester). What was to be the first of the three sections of the Refuge building was completed in 1894, providing accommodation for 900 clerks. It was designed by Alfred Waterhouse, whose son, Paul, was the architect of the extension, including the clock tower, completed in 1909. A further extension completed in 1934 with a frontage on Whitworth Street doubled the size of the building.

Courtesy of Chetham's Library

[Supplement to "THE MILLER," December 4, 1882.

SIMON'S
IMPROVED
2- & 3- ROLLER MILLS,
With Rolls arranged vertically,

Take Less Floor Space,

Take less Power,

Cost much less in Repairs,

And are handier than others.

Instantaneous Stop Motion for Feed.

Prices from £60 upwards.

H. SIMON,
7, St. Peter's Square, Manchester.

Simon's Roller Mills (advertisement in *The Miller*, 1882). The German engineer Henry Simon, who came to Manchester in 1860, was responsible for the introduction of roller milling, a technology that revolutionized the grinding of grain into flour. It was to be the foundation of what became the Simon Engineering Group. Simon was a prominent member of Manchester's German community, taking an active part in movements ranging from the supply of pure milk to cremation.

importance as a financial centre was recognized by the opening of one of the first provincial branches of the Bank of England. By 1847, the year in which the Manchester branch of the Bank of England moved into impressive new premises on King Street, it was evident that the banks were becoming more effective in providing working and investment capital for the region's business community. Cunliffes, Brooks & Co., Heywood & Co., Jones, Loyds & Co., Manchester and Liverpool District Banking Co., Manchester and Salford Bank, and the Union Bank of Manchester were among the principal banks with their headquarters in Manchester. In addition to the banks, the Manchester Stock Exchange, established in the heady speculation of 1836, became a solid part of Manchester's financial

sector, its share-broking firms providing services that could not be supplied from London, even in an age of shrinking distance. The volume of business conducted between local banks resulted in the establishment of the Manchester Clearing House in 1872, itself another part of a more structured and integrated financial system centred on the city. It became the largest of the provincial clearing houses, the business transacted between its banks a gauge of the city region's economy.

Banking produced large fortunes, and bankers such as Sir William Cunliffe Brooks (1819–1900) and Oliver Heywood (1825–92) were to be numbered among Manchester's richest and most influential men. Manchester banks, once household names, continued to be absorbed by larger banks. Williams, Deacon had a typically complex genealogy that could be traced back to the bank of Raymond, Williams, Vere, Lowe and Fletcher in the 1770s, amalgamated in 1890 with the Manchester and Salford Bank, the latter having acquired the Manchester bank of Heywood Brothers in 1874, the Bolton bank of Hardcastle, Cross in 1878, and the Rochdale bank of Royds, Clement in 1881. Growth and amalgamations were the underlying trends. By the 1870s Manchester's business community was beginning to look back indulgently to the not too recent past when the shortage of small coin had caused tradesmen to issue their own tokens.

Insurance was another of the services that strengthened Manchester's reputation as one of the leading financial centres outside London. By the early 1800s Manchester firms had begun to challenge the London-based companies that dominated the profitable fire insurance market. Business increased in the long construction boom. Specialization was a feature of this sector, with engineering insurance becoming particularly associated with Manchester, a business that developed out of concerns over boiler explosions. Both of the leading firms in the sector, Vulcan Boiler (1859) and National Boiler (1864), had their head offices in Manchester, their expertise expanding into new areas such as gas engines and electrical plant.[33]

Life assurance companies also had a considerable presence in the city. Firms such as the Co-operative Insurance Society and the Refuge Assurance Society had their roots in the burial clubs and friendly societies formed during the industrial revolution. The Manchester Unity of Oddfellows had also prospered and at the time of its centenary conference in 1910 it had over one million members across the world, including Australia and South Africa. That this concentration of financial businesses in the city should have resulted in the formation of professional associations was unsurprising: the Institute of Manchester Insurance, for instance, founded in 1873, was the forerunner of the National Chartered Institute.

Markets and shops

Retailing was another important sector of the urban economy, driven in Manchester, as elsewhere, by the long-term rise in living standards which by the end of the century had reached the majority of the working class. Rising expenditure on food, drink and consumer goods in the early nineteenth century caused the

town's open-air markets to spill out beyond the traditional market places. This was a period of such rapid change that the removal of the market cross, the quintessential symbol of the pre-industrial town, appears to have aroused little comment. Control of the markets was one of the priorities of the new municipal council, and even before the purchase of the market rights from the lord of the manor – 'the last badge of feudalism' – new market halls were being planned. These markets principally met the needs of the city's growing population, before taking on the role of supplying the wider region. The construction of new market buildings was to continue in what became known as Smithfield while a modern municipal abattoir, located in Water Street, was an important step in dealing with the problems created by private slaughterhouses.

Manchester continued to be an important retail centre, its shopkeepers an economic and political force in the town. A hierarchy of shops reflected the class structure, ranging from purpose-built shops which met the demands of the expanding middle class to shops set up in the front rooms of terraced houses in working-class streets. Shopping had its temporal and spatial divisions, its weekly and seasonal rhythms. Market shopping on Saturday evenings remained important, not least for those on meagre incomes.[34] Retailing was highly competitive and success depended on location, stock, service and advertising. Purportedly, Arthur Brooke's decision to add the name Bond to his shop sign in Market Street proved to be a crucial marketing decision in the fortunes of his tea-dealing business, while shopkeepers like Benjamin Hyam spent heavily on press and poster advertising. Brighter and better-stocked shops attracted customers. 'Window gawking', noted in the 1850s, became ever more important, women in particular coming into the city from the surrounding towns, a trend that accelerated with improvements in transport and further reductions in working hours on Saturdays. In contrast, on weekdays St Ann's Square was the centre of a more socially exclusive form of retail promenading.

Decades before the multiples became a major presence in the city, Manchester shopkeepers faced competition from the new co-operative stores. With their roots in the northern textile communities, consumer co-operatives advanced within a single generation from selling a handful of unadulterated foodstuffs to offering cradle-to-grave provision of goods and services. Beginning with a store on Great Ancoats Street in 1859, the Manchester and Salford Equitable Society developed a retailing network which, if not as dominant as the co-ops in many of the cotton towns, attracted thrifty working-class families for whom dividend days were circled on their calendars. By the end of the century, its massive and architecturally distinctive flagship stores were as much a part of the landscape in working-class districts as the board schools. Manchester also became the administrative headquarters of the Co-operative Wholesale Society (CWS), a decision that was followed by it becoming a manufacturing centre for CWS foodstuffs and other goods that, because of rising real incomes, were no longer luxuries. Controlling retailing from production to sale generated positive synergies. One consequence was an increase

Golden Jubilee plate, Manchester and Salford Equitable Co-operative Society, 1909. The Co-operative Society's first store was opened in 1859 in rented premises on Great Ancoats Street. Thirty years later it had 21 stores, chiefly in working-class districts in the two cities. Its largest store and headquarters was in Downing Street, Ardwick, opened in 1864.

in employment, not least for women, whether as shop assistants working long hours or as factory workers packing biscuits into tins and cigarettes into packets.

The opening of department stores was another part of this retail revolution. In Manchester the most significant development came in 1880 when David Lewis (1823–85), drawing on his Liverpool retailing experience, opened a store in Market Street that offered the emerging mass consumer a vast range of priced merchandise in a spacious building that was to include a café and a skating rink. Lewis's flair for publicity became renowned, even extending to reprinting old Manchester maps and directories. Lewis's soon came to occupy a prominent place in the mental map of Mancunians. Other shops and stores responded. Kendal Milne gradually extended its 'bazaar' to both sides of Deansgate, but its focus remained firmly on 'carriage folk' rather than ordinary working families. Importantly, given the sheer size of Manchester it was possible to sustain shopping streets outside the city centre. Stretford Road, a convenient place for the working population of Hulme and Chorlton to shop, became an important shopping street with family-run shops, multiples, banks and even its own department store.

'The Big Ditch'

Explanations for the slowing down of the city's economy in the early 1880s saw an accusing finger pointed in particular at Liverpool. Gossip circulated about the disproportionate profits made by Liverpool merchants in the long supply chain of cotton, while those with longer memories recalled that Manchester Men had been more active than sweet-toothed Liverpool Gentlemen in petitioning for the abolition of slavery. Such dissatisfactions contributed to the resurrection of the cost-cutting idea of building a ship-carrying canal that would bypass Liverpool. It was a scheme that had all the entrepreneurial boldness of the Bridgewater Canal, except that the engineering and financial challenges were of a considerably higher

order. Raising the initial capital of some £8 million proved difficult. The idea of making the canal a grand project of popular capitalism by encouraging the working classes of Textile Lancashire to buy shares failed, and the company was compelled to turn to London banks to finance the project. Even then, the capital raised proved insufficient, and in 1891–92 Manchester Corporation provided two tranches of money, amounting to £5 million, to ensure that the 'Big Ditch' was completed. The Manchester Ship Canal was finally opened in 1894. Understandably puffed by the Manchester business community as evidence of the city's dynamism, no official visitors to the city were allowed to leave without seeing the new docks (the main ones being in Salford) and taking a boat ride to Leader Williams's swing aqueduct at Barton, as much an engineering marvel as Brindley's now demolished 'castle in the air'.

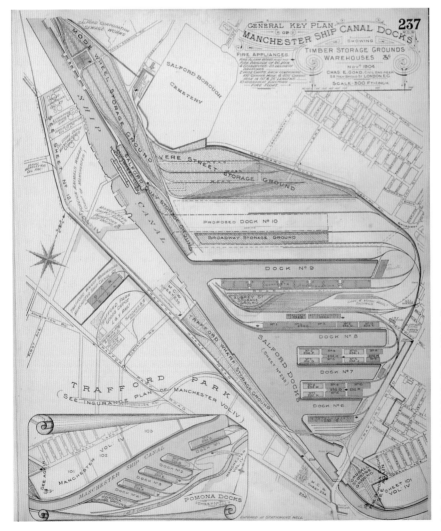

Manchester Ship Canal docks (Goad's Fire Insurance Plans). The Port of Manchester comprised two sets of docks: the main docks in Salford, and others in Trafford and Manchester on the site of the Pomona Gardens. The original Salford docks were extended by the building of No. 9 dock on the site of the Manchester racecourse. Opened in 1905 by Edward VII, its ferro-concrete transit shed and electric cranes struck a note of modernity.

Courtesy of Digital Archives

The economic benefits to industry and jobs in the city region that were expected to follow the opening of the Ship Canal were not immediate. Its economic impact would have been even less had it not been for the opening of Trafford Park, widely regarded as the world's first planned industrial estate. It opened in 1896 amid argument and bad feeling because the opportunistic financier Ernest Hooley had bought the estate from under Manchester Corporation's nose in circumstances that verged on the suspicious.[35] The decision to develop the 1,100-acre estate, located between the Ship Canal and the Bridgewater Canal, for industrial rather than the recreational purposes that the corporation had intended was to be one of the most far-reaching business decisions in the city's modern history. Hooley soon left the project, but not before persuading Marshall Stevens, the manager of the Ship Canal, to take charge of the new industrial estate. Under Stevens's management Trafford Park became home to engineering, chemicals and food processing firms, prominent among them being a number of leading American businesses, beginning with the Westinghouse Electrical and Manufacturing Company. Railway lines soon criss-crossed the estate, connecting firms directly to the region's markets. The estate's transport connections helped persuade Henry Ford to choose it as the site for his first European car assembly plant, and when, in 1908, Manchester United was searching for a site on which to build a new football stadium, the attractions of land on the doorstep of the docks and industrial estate with its superior communications and its thousands of workers (most of whom stopped work at Saturday dinner time) were equally convincing.[36]

Important as the Ship Canal was to be for the city's economy, the continuing improvements in land transport need to be recognized. This was most evident in rail travel. In 1830 the journey time from Liverpool to Manchester was a breathtaking 110 minutes, by 1900 ordinary express trains completed the journey in a

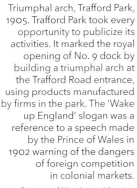
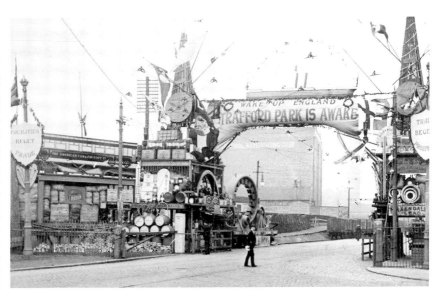

Triumphal arch, Trafford Park, 1905. Trafford Park took every opportunity to publicize its activities. It marked the royal opening of No. 9 dock by building a triumphal arch at the Trafford Road entrance, using products manufactured by firms in the park. The 'Wake up England' slogan was a reference to a speech made by the Prince of Wales in 1902 warning of the dangers of foreign competition in colonial markets.

Courtesy of Manchester Libraries, Information and Archives, Manchester City Council

mere 40 minutes, while the Manchester and Liverpool Electric Express Railway was promising a service travelling at over 100 miles an hour between the two cities. Efficient communications were significant in Manchester developing into the most important newspaper centre outside London, publishing and distributing newspapers within and well beyond the region. Its star if not best-selling title was, of course, the *Manchester Guardian*, which under the editorship of C.P. Scott (1846– 1932) established a reputation that made it one of the country's most admired and quoted newspapers, a conspicuous part of the city's identity. Manchester's position in the railway network also made it a convenient place to host meetings for politicians, church groups, trade unionists, professional associations and others. Its attractions could also be enjoyed on a day trip, whether that was to the zoo and gardens at Belle Vue or other entertainments. Of the 47 men arrested at a transvestite ball in Hulme in 1880, almost a quarter had travelled from Sheffield, while in another widely followed court case, a Birmingham businessman brought an action for robbery against the well-known Manchester courtesan Polly Chester, after visiting the brothel she kept in Chorlton-on-Medlock.[37]

Manchester in 1914

In 1914 Manchester continued to be at the centre of the world's cotton industry. Cotton manufacturing remained Lancashire's largest industry, employing over 500,000 people in 1911, most of whom were working in the factories that processed the bulk of the raw cotton imported into the country. Women workers were in the majority, a feature that was especially evident in the weaving towns. Cotton imports in 1912 had exceeded, for the first time, 2 billion lb, twice the weight imported in 1870. Cotton was still the largest of the country's export industries, piece goods exports reaching a record 7 billion linear yards in 1913, again over double the quantity in 1870. It was arithmetically inevitable that the rise of foreign competitors, led by France, Germany and the United States, would result in a relative decline in the British share of the world cotton trade, but this was in an expanding world market.

Manchester continued to attract visitors. These included Virginia Woolf, who mistakenly assumed that one of the statues in Piccadilly was that of 'the man who invented the spinning jenny'.[38] A more methodical visitor might have consulted their Baedeker and begun their tour of Cottonopolis not in Manchester – 'The chief industrial town of England, and the great metropolis of the cotton manufacture'[39] – but at Oldham Edge from where they would have seen an extraordinary industrial panorama comprising hundreds of factory chimneys, the majority being cotton-spinning mills which, as the commonplace had it, supplied the home market before breakfast before spending the rest of the day attending to export orders.[40] Oldham's spindles alone outnumbered those of France and Germany combined. Arguments that the industry was lagging behind its competitors and slow to innovate more profitable technologies did not always fully acknowledge the number of new mills that had been built since the 1870s, the improvements made

to their design and the machinery installed in them. The industry was aware of foreign competition but few considered it to be a serious threat.

Scratching beneath its patina of soot, one discovered in Manchester a modern city, an economy comprising both new and old industries, and dynamic commercial, financial and service sectors. Viewed from the clock tower of Waterhouse's Town Hall (completed in 1877), the sheer size of the city was impressive. By 1911 the city's population was 714,333, an increase due in part to the extension of its boundary to include Moss Side, Chorlton-cum-Hardy, Burnage, Didsbury, Withington, Heaton Park, Levenshulme and Gorton. As the Edwardian edition of the Ordnance Survey map revealed, the land in the ring of suburbs closest to the city centre was now heavily built up, its workers and residents finding it hard to imagine it as pasture land whose farmers once supplied the town market and attended meetings of the Manchester Agriculture Society. Not all of the contiguous townships had become part of the city. Salford remained separate, generally suspicious of arguments that its prospects and services would improve if it amalgamated with its larger neighbour. Its population in 1911 was 231,357, making it the third largest urban area in Lancashire. Salford was the site of the majority of the docks that made up the Port of Manchester.

The Ship Canal had been a declaration of the city's determination to defend its global position. Since its opening, a new dock had been built and such was the increase in trade that by 1914 there was an expectation that ordinary shareholders

Foreign challenges

My lad, never again let anybody in Lancashire hear you talk this childish stuff about foreign competition. It's right enough for Londoners and such like, but it puts a born Lancashire man to shame as an ignoramus. It's just twaddle. In the first place, we've got the only climate in the world where cotton piece goods in any quantity can ever be produced. In the second place, no foreign Johnnies can ever be bred that can spin and weave like Lancashire lasses and lads. In the third place, there are more spindles in Oldham than in all the rest of the world put together. And last of all, if they had the climate and the men and the spindles – which they never can have – foreigners could never find the brains Lancashire cotton men have for the job.

Ben Bowker, *Lancashire under the Hammer*, London: Hogarth Press, 1928

Ben Bowker (1894–1940) was born near Colne into a family of cotton weavers. He studied at the University of Leeds before going on to a career in journalism, working for newspapers in both Lancashire and Yorkshire. In his polemic, *Lancashire under the Hammer*, he recalled a pre-war conversation with a cotton manufacturer to whom he suggested that Japan's new cotton-spinning industry might pose a threat to the Lancashire industry. The response captures in its purest form the prevailing attitude in the industry. Changing trading conditions after the war challenged this belief in the innate superiority of the Lancashire industry.

might receive their first dividend. Looking from the Town Hall towards the east, beyond the factory chimneys of Ancoats one could see the winding gear of Bradford collieries, Manchester's voracious demand for coal having resulted in mining within a mile of St Ann's Square. Closer to the city centre the landscape became dominated by warehouses, offices and shops. These included the cotton-packing warehouses on Whitworth Street, a recent extension of the main commercial district. Also on Whitworth Street was the Manchester School of Technology (opened 1902), many of its departments closely tied to local industries. Similarly, courses in business skills and foreign languages provided at the neighbouring School of Commerce were directed at improving the productivity of the city's many office workers. In the city centre it was possible to identify numerous distinctive public and commercial buildings, as well as municipal buildings, emblazoned with the city coat of arms, that were clearly not the outcome of contracts written on paper watermarked 'Ratepayers' Economy'. Immediately by the Town Hall one could see the fountain that celebrated the municipal determination and engineering prowess that had led to the construction of the Thirlmere reservoir, its 96 miles of underground pipes providing the city with a new supply of water.

Looking along Cross Street, lined with banks and insurance companies, one reached the Royal Exchange, the commercial heart of Cottonopolis. Here the increase in business and rise in the number of members was such that work had begun on yet another extension, one that was to more than double the floor space. There was, as always on 'Change, a peppering of commercial and political issues – protectionism, metrication, bimetallism[41] – to discuss, salted with more immediate worries about the deterioration in industrial relations following the ending of the Brooklands Agreement, which had helped to smooth industrial relations since 1893.[42] But no one seriously suggested that the economy of Textile Lancashire was in a precarious, let alone a perilous state. No rational person was sketching out the industry's obituary. Manchester remained confident of its sovereignty in the world of cotton. When its businessmen met to toast the trade and commerce of the city, there was an underlying belief and pride, secure in the knowledge that, whatever Glasgow and Birmingham might claim, Manchester was the second city of the Empire.

1914 to 1968

Cotton in decline

Just as a convergence of epochal forces had made Manchester one of the centres of the first industrial revolution, a convergence of new economic forces in the international economy was responsible for its decline, a collapse that was as dramatic and unpredictable as its rise. Some of those forces can be traced back before 1914 but it was the First World War and its economic aftermath that brought them to the fore. The war disrupted the region's economy, particularly the cotton industry.

A shortage of shipping was the most obvious problem for an export-dominated industry that imported all of its raw material. Difficulties also arose as operatives left the mills to enlist.

Expectations that the cotton industry would re-establish its position in foreign markets after the war, as it had done after previous periods of instability, were not realized. An excessive optimism fuelled a post-war boom, which saw a reckless recapitalization of spinning firms in particular. Exporting cotton became increasingly difficult, as the disruption caused by the war had allowed countries to develop their own industries which were able to supply their home markets. India, Lancashire's largest export market, was to be the reef into which the industry crashed. Here the decline was swift and severe, cotton exports plummeting from 3 million to 1.5 million linear yards between 1913 and 1927. The Indian home industry benefited from tariffs and was further boosted by the nationalist campaign, led by Gandhi, that demanded the boycotting of foreign cotton goods and the wearing of home-made cloth, spun and woven by hand. The speed and scale of the loss of markets was also devastating in the Far East, exports of piece goods to Japan and China falling from 773,000 to 128,000 linear yards between 1913 and 1927. Japan's cotton industry was growing at a rate reminiscent of the British industry in the industrial revolution. Low labour costs and the introduction of 24-hour working increased its competitiveness which by the mid-1930s resulted in it replacing Britain as the world's largest exporter of cotton cloth.

Reductions in demand of this scale were especially severe for those cotton towns like Oldham and Blackburn that spun and wove lower value yarns and unfinished cloths from American cotton, while the impact was less in Bolton and Nelson which specialized in fine spinning and the weaving and finishing of cloths using higher-value grades of Egyptian cotton. Those contrasting fortunes could be read in the annual reviews of the cotton trade published in local newspapers and the specialist textile press. They could also be read in the census figures that showed that the long boom in population growth was coming to an end.[43]

The opening of the new Royal Exchange by George V in 1921 was, of course, an occasion for celebration, but it came at the very time that doubts about the industry's future were beginning to emerge. Manufacturers and merchants, indeed all sections of the industry, were bewildered by the speed of the loss of markets, a miasma of gloom descending over the Exchange. The industry's miseries intensified as the Great Depression saw a further contraction in trade, unemployment among insured workers in cotton reaching its inter-war peak of 43.2 per cent in 1931, a figure that was only exceeded in shipbuilding. The old pattern of the past in which lean years were followed by a longer run of fat ones was no longer occurring. The crisis spread throughout the region's economy. Textile engineering

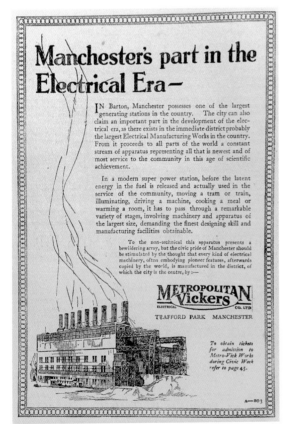

'Manchester's Part in the Electrical Era' (1926). The involvement of Manchester firms in the pioneering years of electricity continued in the inter-war years with firms like Metropolitan-Vickers at the forefront of manufacturing electrical plant. This firm supplied the turbines for Manchester Corporation's power station on the banks of the Ship Canal at Barton, which at its opening in 1923 was among the largest in the world.

firms suffered as did those businesses providing financial and legal services to the industry. Manchester banks which had lent heavily to the industry in the post-war boom found themselves in particular difficulty. Indeed, Williams Deacon's position proved to be so precarious that the Bank of England had to intervene and arrange for a takeover by the Royal Bank of Scotland.[44]

Finding solutions to the industry's problems proved more difficult than finding one's way through one of the city's notorious fogs, but as the diaries of the secretary of the Manchester Chamber of Commerce, Raymond Streat (1897–1979), reveal, the industry did not sleepwalk through the crisis.[45] Investigations into the industry identified fundamental weaknesses in its organization, shortcomings in both management and unions, a reluctance to invest in modern machinery and high labour costs. However, the different sides of the industry – manufacturers and merchants, employers and trade unions – could not agree on a way forward. Overcapacity had become a major problem but reorganizing and rationalizing an industry burdened by debt was a formidable undertaking. Initiatives were taken, none more singular than the 1932 Import Duties Act which saw Manchester forsake free trade for protectionism. Two years later quotas were introduced on Japanese cotton exports to the Empire countries. Both the manufacturing and merchanting sides of the industry suffered, though there were as always firms whose performance went against the general trend, none more so than John Rylands, which in the pit of the depression opened a colossal warehouse in Market Street.

Artificial fibres were one point of hope in a contracting industry, an optimism that J.B. Priestley expressed in his script for the film *Sing As We Go* (1934), in which artificial silk was cast as the solution to end the miseries of cotton. Efforts were also directed at boosting sales in the now threatened home market, but publicity-generating spectacles such as a grand cotton pageant at Belle Vue in 1932 and the annual competition to elect a millworker as cotton queen to promote the industry did not address the fundamental issues of restructuring and modernization. Reports from bodies such as the Cotton Trade Statistical Bureau made dismal reading, as did the returns issued by the Manchester Bankers' Clearing House (Figure 2.4). One has some sympathy for the *Manchester Guardian*'s industrial correspondent who

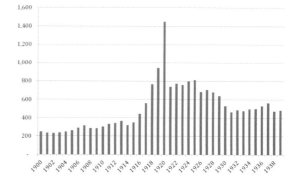

Figure 2.4 Manchester Bankers' Clearing House returns, 1900–38 (£ 000)

temporarily escaped the ongoing agonies of the trade by writing about an earlier, expansionist period of its history.[46] The trade continued its decline. By 1939 exports of cotton piece goods had fallen to 1,462 million linear yards, a quantity approaching one-fifth of the total in its zenith year of 1913.

A diverse economy

Whatever criticisms were directed at the institutional and managerial responses to the crisis in the cotton industry, other parts of the city's economy helped to mitigate the impact of the depression in the inter-war years. Investment in 'new' industries helped offset the contraction of those smokestack industries that had started the industrial revolution. Coal continued to be mined in Bradford, remaining profitable in spite of the great depths from which it was extracted. Trafford Park and the Port of Manchester remained key points of growth, strengthening and diversifying the manufacturing base, notably in engineering which continued to produce machine tools, railway engines, chains, wire and cable along with products from the newer electrical industries. By 1929 there were over 130 firms in the Park. Metropolitan–Vickers, National Gas Engine and Crossley Brothers were among the largest companies in a diverse engineering sector. Food-processing companies, including Hovis, Brooke Bond and Kemp's Biscuits, were also attracted to Trafford Park. Kellogg's established its European headquarters there towards the end of the 1930s, building a grain wharf on the southern side of the Bridgewater Canal. The Ship Canal strengthened the city's role in supplying markets across the region. In spite of Ford's move from Trafford Park to Dagenham, motor vehicles continued to be manufactured in the city. The city's promotional message was of a cost-saving transport infrastructure, pools of skilled labour, and over four million people living within a 25-mile radius of the city. Measured in terms of the value rather than the volume of goods carried, traffic on the Ship Canal continued to increase, its ships unloading foodstuffs and live animals, timber and oil. Raw cotton was also unloaded, though the hope that Manchester would free itself from the Liverpool Exchange was not to be realized. The opening of Manchester Corporation's Barton power station in 1923, its massive turbines manufactured by Metro–Vickers, marked a new chapter in the history of the canal. Built with a capacity far ahead of existing demand, it recognized a future in which electricity would become the major source of power, light and heat for industry and the home.

Manchester had also become the centre of a substantial clothing industry. This drew on a pool of unskilled and cheap labour, girls and women working at home or in workshops.[47] A small number of purpose-built clothing factories were also opened, though few matched in its scale, style and working conditions the Burtonville factory built by Montague Burton in Swinton. It was located by another symbol of progress in these years, the East Lancashire Road.[48] As in Leeds, the other important centre for ready-made clothing in the north, the tailoring and sewing trades in Manchester had close associations with Jewish immigrants. The making of waterproof clothing became particularly associated with the Jewish immigrants

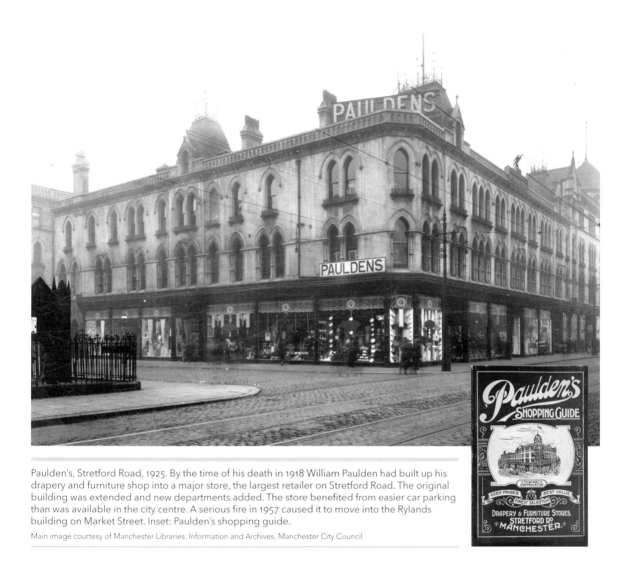

Paulden's, Stretford Road, 1925. By the time of his death in 1918 William Paulden had built up his drapery and furniture shop into a major store, the largest retailer on Stretford Road. The original building was extended and new departments added. The store benefited from easier car parking than was available in the city centre. A serious fire in 1957 caused it to move into the Rylands building on Market Street. Inset: Paulden's shopping guide.

Main image courtesy of Manchester Libraries, Information and Archives, Manchester City Council

who settled in Manchester in the closing decades of the nineteenth century. It had a long history in the city, and was usually connected to the Scottish chemist Charles Macintosh (1766–1843), who established a factory in Cambridge Street, Manchester for manufacturing his waterproof cloth in the 1820s. Clothing was a diverse industry, producing shirts, dresses, blouses and underwear (including corsets), products that were displayed and sold in the city's Home Trade warehouses. Although heavily concentrated in Manchester, clothing firms were also found in towns in the wider region, communities being associated with particular products such as hats (Denton and Stockport) and slippers (Waterfoot). In 1931 the numbers employed in the main clothing industries exceeded 20,000, some of whom were working in conditions and for wages that brought to mind the evidence collected by the factory reformers in the previous century.

Retailing showed a more vibrant side of the city's economy. Manchester's reputation as a regional retail centre remained strong, its shops becoming an ever more prominent part of the city centre. The sector remained diverse, ranging from the large stores and multiples to the smaller family-operated specialist shops. The city's markets had also continued to grow, the wholesale markets supplying food-stuffs and goods to shopkeepers and market traders across the north-west and into the midlands. Street sellers provided a link back to the pre-industrial world but municipal regulations made them less prominent than in the past. An exception was the bookstalls around Shudehill – the place 'where the literary trash of Manchester is chiefly congregated' – which continued to attract its book-hunters and those workers whose dinners were 'flag hash'.[49]

The face of retailing was also changing, shopkeepers ever more skilful at emptying the purses of their customers. What was described as a 'shopping centre' was part of the redevelopment of the Royal Exchange. Its importance was in providing shopping under cover, arcades being less evident in Manchester than in Birmingham and Leeds, in spite of the town's much-discussed rainfall. Lewis's remained the king of the popular department stores, continuing to invest in improving its premises. On Deansgate, Kendal Milne prospered, the depression having less impact on its suburban middle-class customers. Although taken over by Harrods it remained a thoroughly Manchester store. The rebuilding of the store in a modernist style at the end of the 1930s was a statement of its faith in the city as a regional shopping centre. Many of the new trends in retailing could be traced back to the United States, heralded by the opening of Manchester's first Woolworth's store just before the First World War. The national multiples continued to strengthen their presence in the city centre and suburban shopping streets. There were also regional chains, one of the best known being the shops and restaurants of the UCP (United Cattle Products) which sold tripe and other offal, foods that had long been part of the Lancashire working-class diet. But for retailers, as for other businesses, this was a period in which trading conditions were never easy.

Tentativeness about the economic future was apparent in the debates over establishing a municipal airport, in retrospect one of the most important developments of the inter-war years. Manchester's early enthusiasm for aviation was boosted in 1919 when two Manchester men, John Alcock (1892–1919) and Arthur Whitten Brown (1886–1948), piloted the first aeroplane across the Atlantic. However, as the economic uncertainties increased so did the doubts about developing passenger and commercial services. When the plan to replace the municipal aerodrome at Barton with one at Ringway was discussed it was only approved by the slimmest of majorities by the city council, many of whose members were not convinced by arguments that, if the city was to be at the forefront of this transport development and compete with Liverpool's Speke airport, they needed to be as bold as their predecessors who had invested in the Ship Canal. Ringway finally opened in June 1938. Its first international flight was a KLM plane to Schiphol, which completed the journey in 145 minutes. But by this date other considerations were

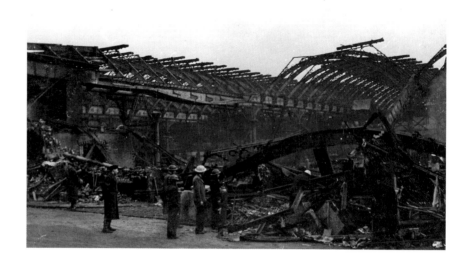

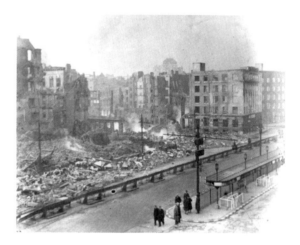

Manchester Blitz, 1940. The 'Christmas Blitz' destroyed or damaged many important buildings in the city centre including the Exchange, the Free Trade Hall, the cathedral and Cross Street chapel. Transport was also bombed (Victoria Station, top) as was the warehouse district to the west of Piccadilly Gardens (Parker Street, bottom).

Courtesy of Manchester Libraries, Information and Archives, Manchester City Council

to the fore: the airport at Barton was being used for RAF training, while the local aeroplane manufacturers, Avro in Newton Heath (Alliott Verdon Roe (1877–1958), had begun building planes in a former cotton factory in the city centre in 1910) and Faireys in Heaton Chapel, were working full time on rearmaments contracts.

Redirecting Manchester's industries towards the production of military goods was underway before the Second World War was declared. It was a reflection of the size and strength of the city's engineering sector that it was to make a significant contribution to the war effort. Trafford Park in particular became a major centre of military production. Metropolitan–Vickers manufactured specialized electrical and electronic equipment for the military, though it is now best remembered for its contribution in making Lancaster bombers; Glovers contributed to the manufacture of the Hais cable for PLUTO (Pipe Line Under The Ocean), while the engines

and pumps to operate this essential part of the infrastructure of the Normandy landings came from the Newton Heath works of Mather and Platt. Ford Motors returned to Trafford Park to manufacture Rolls-Royce Merlin aero-engines. In another government-built factory ICI established a plant for producing penicillin, the greatest of the war's silver bullets, the company having previously produced smaller quantities at its Blackley works. DDT, which proved especially effective against typhus, was produced at Geigy Colour Company's factory. Barrage balloons and other military equipment were produced at Dunlop's Manchester works. The cotton industry's contribution to the war effort was less spectacular, reflected in its late recognition as an essential occupation. The industry made much of cotton's use in the manufacture of planes, motor vehicles, submarines and bullet-proof material, though its main uses were in military clothing (including snow suits worn by Russian soldiers) and camouflage cloth.

Fortunately for the war effort, Manchester was not as heavily bombed as Liverpool. Raids on Trafford Park damaged only a relatively small number of factories. It was the physical destruction and loss of civilian lives in and around the city centre, particularly in the December Blitz of 1940, that came to dominate the narrative of Manchester's war.[50] The Cathedral, Royal Exchange and Free Trade Hall were among the prominent buildings severely damaged.

Manchester after the war

Manchester entered the post-war years more aware of the problems it faced than at any time in its recent past. There was a determination to improve the city, particularly the health, education and housing of the majority of its citizens. To provide the massive investment required to tackle these problems would need a strong economy. There were signs of progress in some sectors of the Manchester economy, the war having helped to boost research and development in areas such as telecommunications and electronics. The resources and expertise of the ICI works at Blackley, housing one of the country's largest research departments, was another point of growth.[51] Engineering remained strong, headed by firms like Mather and Platt which became leaders in manufacturing fire-fighting equipment, electric motors and food machinery, helping to offset the falling orders for textile machinery. Trafford Park remained the greatest concentration of industry in the region. It was a powerhouse, employing over 50,000, drawing its workers from a widening radius, including the old cotton towns. One of the estate's main problems was devising a road system to reduce congestion arising from lorries and buses, not least in the rush hours when tens of thousands of workers entered and left 'The Park'. AEI, formerly Metro–Vickers, was the largest employer, eventually being taken over by Arnold Weinstock's GEC in the rush of mergers that marked the 1960s. Demand from businesses seeking accommodation remained high and shareholders in Trafford Park Estates continued to receive healthy dividends.

Expectations had risen in the cotton industry in the immediate post-war years. However, recruiting new workers and persuading former workers to return

to the mills to help in the export drive proved difficult, a deaf ear being turned to the patriotic appeals of an advertising campaign which proclaimed that 'Britain's Bread Hangs by Lancashire Thread'. The post-war increase in trade went on longer than expected, but by the early 1950s it was clear that Lancashire firms, even those specializing in manufacturing higher-quality cotton goods, were struggling to maintain a margin of superiority over foreign competitors. Exports continued to haemorrhage as low-cost producers in Asia and Europe made further inroads into Lancashire's traditional markets. Different sides of the industry continued to report on the industry's problems, acknowledging factors outside their control rather than their own inefficiencies. As in the inter-war years, mergers and diversification became survival strategies for companies. Manchester's merchants and brokers were similarly challenged. The takeover in 1953 of Rylands by Isaac Wolfson's Great Universal Stores, best known for its mail order and furniture businesses, was an indicator that not even the largest of Manchester firms could guarantee survival. By the mid-1960s there was a glut of city-centre warehouses to let or for sale. Even so, it was still a surprise to read that the renowned Watts warehouse, which had survived the conflagration of the 1940 Blitz, was being considered as a site for a museum of science and technology.[52]

Efforts to convince the government to provide greater support for the industry were disappointing. Cotton was not included in the Labour government's nationalization programme, and the industry was to be all but sidelined by the following Conservative governments. Calls for protection against Asian imports went largely unheeded, Peter Thorneycroft (1909–94), the Conservative President of the Board of Trade, being dubbed the 'Hangman of Lancashire'. When the government did finally intervene, Manchester's and Lancashire's days as a textile superpower were coming to an end. The 1959 Cotton Industry Act which was aimed at modernizing the industry was cynically described by Harold Wilson (1916–95) not as offering the industry a future, but more a way of contributing towards its funeral expenses.[53] The numbers employed in the industry, directly and indirectly, continued to fall. One measure of the decline was the number of firms listed in Worrall's *Lancashire Textile Directory*, which fell from 2,011 in 1914 to 598 in 1963.[54] Worrall's itself would soon become another casualty along with other publications of a once vibrant cotton press: titles like the *Cotton Factory Times* had ceased publication in the 1930s, whereas the *Textile Mercury* struggled on, eventually closing in the 1960s. Just how low confidence in the industry had reached was evident in the investment portfolio of the Manchester Corporation pension fund in which the leading sectors in 1961–62 were insurance (13.3 per cent), industrials (9.6 per cent), drapery and stores (9.2 per cent) and engineering and metals (8.7 per cent). Investments in textiles represented a mere 0.7 per cent.[55]

By the 1960s Courtaulds and ICI, the dominant firms in the artificial fibres side of the textile industry, were not alone in picking over the bones of a vanishing industry.[56] Undervalued assets attracted property companies. In 1961 Charles Clore and Jack Cotton's City Centre Properties took over Cottonopolis's Royal Exchange,

Manchester Royal Exchange, 1968. Members gathered on the floor of 'Change on the final day of trading in December 1968. As recently as 1953 when the restored building was reopened, few members foresaw that the industry's decline would be so swift that Cottonopolis would no longer require a formal market place in which to conduct the buying and selling of cotton goods.

Courtesy of Manchester Libraries, Information and Archives, Manchester City Council

attracted by the site and its offices and shops rather than the vast trading floor. Membership of the Exchange continued to decline, attendances at High 'Change being numbered in the low hundreds. When trading on the floor of the Exchange finally ceased in 1968, the 'parliament of the cotton lords' had only 660 members, having lost over 1,400 members since 1962.

The decline of the cotton industry in the Manchester region was as startling as its rise. In the fifty years after 1918 all the key indicators of the industry followed the same gloomy trend. The advantages which had placed Manchester at the centre of the world's first industrial revolution and made it the world's cotton capital were gone. Industrialization, once underway, was a global revolution and other economies were to overtake Britain. The very industry that had been central in

creating the first industrial nation was now challenged by economies pursuing the holy grail of industrialization, in which cotton was the harbinger of their own modernities. It was a painful readjustment for a city that, while not having conquered the world, might lay claim to having clothed a great deal of it. There was, of course, a degree of inevitability about the industry's demise, though with the benefit of hindsight perhaps what was truly remarkable was not the speed of its decline but rather the length of time that Manchester had been at the centre of the industry, its name known across the globe.

The closing of the Cotton Exchange was only part of the economic gloom. The city's population had been in decline since the inter-war years and was continuing to fall. In 1961 the census recorded 661,791 inhabitants, 104,520 (15.8 per cent) fewer than in 1931, its highest recorded population. The volume of freight

'Ugly' Manchester

My point is that too much justice has been done to Manchester already. Too many polite things have been said about it, and believed. The reality, a reality shared with most other built-up areas in the industrial North, is of ugliness: forlorn, protracted, wilful ugliness. It is the ugliness of poverty and misplaced wealth, of darkness and dampness and dirt, of slimy streets, pollution, bad air, decay, monotony, mediocrity. Manchester is the ugliest, least congenial large city that I have ever seen. The city-centre has almost nothing to recommend it by day; by night it is gloomy and deserted. The only recourse for the native Mancunian is to shut his eyes to the pervasive grubbiness and cheerlessness, and to forget that any other existence is possible. For the visitor who has not had the chance to train himself in apathy, Manchester is a sad shock. As befits the dreary city-centre, Manchester's airport has also been worse than any that even a much-travelled visitor could have encountered. It is named Ringway and would have been better named Ringworm. The visitor will discover that there is only one large hotel (though another is being built, with unbelievable slowness), and a quantity of execrable small ones. If he has come to examine manufactured products on display in one of Manchester's two exhibition halls, he will be appalled by a decor that alternates between the glum and the tatty – especially if he happens to have been in, say, Dortmund, an uncompromisingly industrial city which has nevertheless erected an elegant modern hall, with two new nearby hotels, good enough to attract political party conferences as well as industrial fairs.

Marcus Cunliffe, 'Life in the Industrial North', *Encounter*, 1962.

At the time of writing this essay, the Rochdale-born Marcus Cunliffe (1922–90) was Professor of American History and Institutions at the University of Manchester. His castigation of Manchester as hapless, ugly and behind the times was denied by Lady Simon of Wythenshawe, Philip Gell, president of the Manchester Chamber of Commerce, and other public figures. 'Too ridiculous to need answering' was the riposte of the Labour Lord Mayor, Robert Thomas. Cunliffe, however, was not the only critic of Manchester. Eric James, the High Master of Manchester Grammar School, called it 'the most wilfully ugly city in the world'. Cunliffe and James were among the leading academics who left Manchester to take up positions in the new universities in the mid-1960s.

carried on the Ship Canal, for two generations a bellwether of the city region economy, had passed its peak. Amid the continuing announcements of companies merging, of mills and warehouses closing down, came the news of the closing of the Bradford collieries, itself part of the wider contraction of the Lancashire coalfield. Other sectors of the city's economy were also struggling. The celebrations of the centenary of the *Manchester Evening News* in 1968 were tinged with the awareness that the city's newspaper offices were becoming feeding stations for the London nationals. The removal of the *Guardian* (as the *Manchester Guardian* had become in 1959) to London in 1964 was the most discussed aspect of the decline of the city as a newspaper centre, not least for the traction it gave to Manchester's voice in the country. Amid the closures there were more positive signs in the city's economy, especially in its banking and financial sector, its continuing importance as a retail centre, and in newer industries such as television. Another positive was the

municipal airport at Ringway, where passenger numbers were increasing following the opening of a new terminal in 1962. Optimists could also point to the flush of new building in the centre, perhaps most notably the country's tallest skyscraper which housed the offices of the Co-operative Insurance Society.

Manchester in 1968

Looked at from the top of the CIS building in 1968, Manchester remained a city of contrasts and contradictions. On the edge of the city centre, one could see the impact of the slum-clearance programmes, the clearing away of a nineteenth-century landscape in the wide collar of working-class inner-city districts that included Ardwick, Chorlton, Gorton and Longsight. In districts like Hulme there was a sense of hopeful expectation as construction was about to begin on what was in all but name a New Jerusalem. Moving closer to the centre, the contrast between the new white concrete buildings and the older smoke-stained ones was striking. Manchester was in the forefront of clean air legislation – the city centre had been made a smokeless zone in 1952 – but scrubbing its soot-caked buildings clean was a slow and expensive undertaking. Some areas of the city remained industrial. Indeed, some of the oldest mills in Ancoats were still standing, their link to the cotton industry continuing in the form of sewing firms which made clothes from Lancashire and imported textiles.

Closer to the centre along Oxford Road one could see modernist-influenced buildings, most obviously in the concrete and glass Mathematics Tower of the University of Manchester campus. Increased investment in further and higher education was also evident closer to the city centre on the new campus of what in 1966 had become the University of Manchester Institute of Science and Technology (UMIST). In the city centre itself the Manchester Education Committee's new education offices were part of the development of Crown Square which, with the neighbouring square dominated by the Law Courts, provided a much-admired example of civic planning. Other new buildings also caught the eye. Overlooking Piccadilly on the site blitzed in 1940, a new hotel was part of another distinctive development. The city's banking and financial companies were continuing to commission and occupy new buildings.

Improvements to the city's transport infrastructure had been regarded as central to its post-war identity. Progress on a new road system had been slow, though much publicity was given to the Mancunian Way, one of the country's first 'aerial motorways', when it opened in 1967. The age of the steam railway had finally ended, and with an appropriate sense of history British Rail's final steam-hauled train ran from Manchester to Liverpool in 1968. A new railway station, Piccadilly, had replaced the London Road station, the electrification of the Manchester–London line having been finally completed, reducing journey times to London to 2.5 hours. Viewing the city from the CIS tower it was also clear that there was a huge legacy of largely redundant railway infrastructure. Similarly, the city's canals were no longer working machines, the exception being at Castlefield where barges

CIS building, topping-out ceremony, 1962. The CIS tower provides a view looking south-west across what was the medieval centre of the town, the soot-stained parish church (Cathedral) prominent. Later development largely followed the existing street pattern, evident in the triangular footprint of the Corn Exchange. New buildings are also visible – Longridge House (the offices of British Engine Insurance), opened in 1959, and the Marks and Spencer building, opened in 1962 – the first developments in the long-awaited rebuilding of this part of the bomb-damaged centre. To the middle left are the buildings fronting Corporation Street which would be demolished to build the Arndale Centre.

Courtesy of Manchester Libraries, Information and Archives, Manchester City Council

were still unloading coal as they had done for over 200 years. However, if the more fanciful transport visions of the *1945 City of Manchester Plan* were fading – it had discussed building heliports – the 1968 *City Centre Plan* envisaged improvement in terms of constructing a new rapid-transit route running north–south across the city, the line between Victoria Station and the university being underground. There was also recognition of the need to increase the number of people living in the city centre. The current population was around 4,000, similar in size to what it had been in the late seventeenth century. In 1968 the idea of reversing this long decline in population by building houses in or close to the city centre that could accommodate up to 10,000 people was being mooted. The pedestrianization of Market Street was also on the planners' agenda. All these projects, of course, depended ultimately on the strength of the city's economy.

From the CIS tower one could also observe that some of the larger bombsites were now finally beginning to be developed. These included the building of a new shopping centre around what had been the original Market Place. Looking down on the swathe of old buildings between Market Street and Withy Grove one could still make out streets and courts that had been on the eighteenth-century maps of the town. This part of the city centre was also to change, as approval was about to be given to build an enormous shopping centre (and market), which was to take the name of its developers, Arnold Hagenbach and Sam Chippindale.[57] Among the buildings to be swept away in this scheme were those in Arkwright's Cromford's Court. Their demolition, as had been the case with the knocking down of Arkwright's factory off Miller Lane, prompted little public comment. A

Ringway, 1970. In the 1970s Ringway (renamed Manchester International Airport in 1975) was investing in infrastructure in response to the continuing rise in annual passenger numbers, which amounted to over 2 million by 1973. A new intercontinental pier capable of handling the Boeing 747 Jumbo jets was opened. Freight facilities were also improved to meet the growth in cargo traffic.

Courtesy of Manchester Libraries, Information and Archives, Manchester City Council

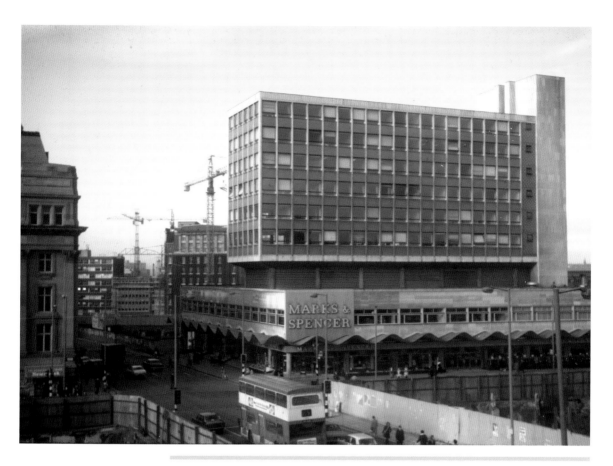

Junction of Market Street and Cross Street (c.1972), photographed by Margaret Newbold. The opening in 1962 of the Marks and Spencer store signalled the beginning of a major redevelopment of the retail centre. Ten years later work on what had been the old Market Place was finally underway, including the creation of a new open space, Shambles Square. The buildings on the north side of Market Street had also been cleared and work was in progress on the foundations of the Arndale Centre.

Courtesy of Chetham's Library

modern-day Coningsby visiting Manchester in 1968 would have noted all these pulses of change, signs of the city attempting to come to terms with its past, striving to develop a new identity. He would have discovered signs of both old and modern grandeur in its streets, but he would have puzzled over predicting what, if anything, was to be the 'immensity of its future'. The only thing that was certain was that the Age of Cotton had passed.

Notes

1. E.J. Hobsbawm, *Industry and Empire*, Harmondsworth: Penguin, 1999, p. 34.

2. W.H. Mills, '1729–1921, The story of the Exchange', *Manchester Guardian*, 8 October 1921.

3. J. Ogden, *A Description of Manchester* (1783), Manchester, 1887, p. 3.

4. Mrs Hibbert-Ware, *The Life and Correspondence of the late Samuel Hibbert Ware*, Manchester: J.E. Cornish, 1882, pp. 36–7.

5. C. Roeder, 'Maps and views of Manchester', *Transactions of Lancashire and Cheshire Antiquarian Society*, 21 (1903), pp. 153–71; see also *Manchester Maps*, Digital Archives Association, Warrington, http://digitalarchives.co.uk.

6. R.S. Fitton, *The Arkwrights. Spinners of Fortune*, Manchester: Manchester University Press, 1989.

7. D. Defoe, *Tour Through the Whole Island of Great Britain*, Harmondsworth: Penguin, 1968, pp. 545–6.

8. *Encyclopedia Britannica*, 4th edn, Edinburgh, 1810, p. 555.

9. J. Kennedy, 'Observations on the rise and progress of the cotton trade in Great Britain', *Memoirs of Manchester Literary and Philosophical Society*, vol. III (1819), pp. 115–37.

10. W.H. Chaloner, 'The cotton industry to 1820', in J.H. Smith, ed., *The Great Human Exploit*, Chichester: Phillimore, 1973, pp. 17–24.

11. *Select Committee on the State of the Children Employed in the Manufactories of the United Kingdom*, PP 1816 (397), pp. 374–5 (data collected by William Sanford).

12. J.J. Mason, 'A manufacturing and bleaching enterprise during the Industrial Revolution: the Sykeses of Edgeley', *Business History*, 23 (1981), pp. 59–83.

13. B. Disraeli, *Coningsby, or, the New Generation* (1844), Oxford: Oxford University Press, 1982, pp. 138–9.

14. British Parliamentary Papers, 1851 Census of Great Britain, 1852–53 (1691), p. 664.

15. *Wheeler's Manchester Chronicle*, 5 October 1833.

16. J. Wheeler, *Manchester: its political, social and commercial history, ancient and modern*, London: Whittaker, 1836, p. 275.

17. T.S. Ashton, *An Eighteenth-century Industrialist: Peter Stubs of Warrington, 1756–1806*, Manchester: Manchester University Press, 1961.

18. R. Baines, *The Budget of Comicalities* (1844), Manchester: Abel Heywood, 1851.

19. R. Cookson, *A World of Manchesters*, Didsbury: Castherman Books, 2002.

20. S. Sidney, *Rides on Railways*, London: W.S. Orr, 1851, p. 255.

21. Thomas Carlyle to W.B. Baring, 8 February 1848, *The Collected Letters of Thomas and Jane Welsh Carlyle*, vol. 22, Durham, NC: Duke University Press, 1993, p. 241.

22. D.C. Coleman, *Myth, History and the Industrial Revolution*, London: Hambledon Press, 1992, pp. 3–11.

23. Percival Census 1773–74, Chetham's Library (see chapter 1).

24. C.B. Phillips and J.H. Smith, *Lancashire and Cheshire since AD 1540*, London: Longman, 1994, p. 229.

25. E.P. Hennock, 'Public health a generation before Chadwick?', *Economic History Review*, 2nd series, 10 (1957), pp. 113–20.

26. J.A. Hassan, 'The impact and development of Manchester's water supply, 1568–1882', *Transactions of the Historic Society of Lancashire and Cheshire*, 133 (1984), pp. 25–46.

27. R. Parkinson, 'On the origin, custody, and value of parish registers, with an abstract of the registers of the Collegiate Church of Manchester', *Journal of the Statistical Society of London*, 5 (1842), p. 260; M. Powell and C. Hunwick, 'The Manchester Cathedral Sextons' Register', *Local Historian*, 39.4 (2009) pp. 300–13.

28. T. Percival, 'Observations on the state of population in Manchester ...', in *Philosophical, Medical, Experimental Essays*, London, 1786.

29. 'Report from the committee appointed to enquire into the number of immoral and irreligious works sold in Manchester', Manchester Statistical Society Papers, July 1835 (Manchester Central Library MS F310.6).

30. A. Fowler and T. Wyke, *Spindleopolis. Oldham in 1913*, Oldham: Oldham Council, 2013, p. 39.

31. D.A. Farnie, *The English Cotton Industry and the World Market 1815–1896*, Oxford: Clarendon Press, 1979, p. 158.

32. T.S. Ashton, 'The bill of exchange and private banks in Lancashire, 1790–1830', in T.S. Ashton and R.S. Sayers, eds, *Papers in English Monetary History*, Oxford: Clarendon Press, 1953, pp. 37–49.

33. W.H. Chaloner, *Vulcan. The History of One Hundred Years of Engineering Insurance 1859–1959*, Manchester: Vulcan Boiler and General Insurance Co., 1959.

34. A. Davies, 'Saturday night markets in Manchester and Salford 1840–1939', *Manchester Region History Review*, 1.2 (1987–88), pp. 3–12.

35. R. Nicholls, *Trafford Park. The First Hundred Years*, Chichester: Phillimore, 1996; E.T. Hooley, *Confessions*, Simpkin, Marshall, Hamilton [1925].

36. S. Inglis, *Played in Manchester. The Architectural Heritage of a City at Play*, London: English Heritage, 2004.

37. *Manchester Evening News*, 1 October 1880; *Memoirs of Madam Chester of Manchester*, London, 1868.

38. *The Letters of Virginia Woolf, Vol. II: 1912–1922*, ed. N. Nicolson and J. Trautmann, London: Hogarth Press, 1976, pp. 457–8.

39. Baedeker's *Guide to Great Britain*, 7th edn, Leipzig, 1910.

40. We need to imagine far more factory chimneys filling the Oldham skyline in 1914 than those captured in the dramatic photographic panorama taken by Squire Knott in 1876, http://www.galleryoldham.org.uk/collections/social-history-collection (accessed 2 January 2016).

41. E. Wilson, *Battles for the Standard: Bimetallism and the Spread of the Gold Standard in the Nineteenth Century*, Aldershot: Ashgate, 2001.

42. A. Fowler, *Lancashire Cotton Operatives and Work, 1900–1950*, London: Ashgate, 2003.

43. Phillips and Smith, *Lancashire and Cheshire since AD 1540*, p. 305.
44. R.S. Sayers, *The Bank of England 1891–1944*, vol. 1, Cambridge: Cambridge University Press, 1976, pp. 251–8.
45. M. Dupree, ed., *Lancashire and Whitehall: The Diary of Sir Raymond Streat*, Manchester: Manchester University Press, 1987, vol. 1.
46. See the entry on A.P. Wadsworth in *ODNB*. Wadsworth was joint author with Julia de Lacy Mann of *The Cotton Trade and Industrial Lancashire, 1600–1780*, Manchester: Manchester University Press, 1931.
47. Margaret Harkness's fiery 1890 novel of the sewing trades in Ancoats is a starting point to the literature. John Law (pseud.), *A Manchester Shirtmaker*, Brighouse: Northern Herald Books, 2002.
48. E.M. Sigsworth, *Montague Burton: The Tailor of Taste*, Manchester: Manchester University Press, 1990, pp. 57–9.
49. Walter Greenwood writing in his autobiography (*There Was a Time*, London: Cape, 1967), about those workers who walked around at dinner time having no money to buy food.
50. *Our Blitz: Red Sky over Manchester*, Manchester: Kemsley Newspapers, 1945.
51. D. Egerton, *Britain's War Machine: Weapons, Resources, and Experts in the Second World War*, Harmondsworth: Penguin, 2012, pp. 26–7.
52. *Manchester Guardian*, 8 July 1965.
53. Hansard, 23 April 1959.
54. D.A. Farnie, 'John Worrall of Oldham. Directory-publisher to Lancashire and to the world, 1868–1970', *Manchester Region History Review*, 4.1 (1990), p. 32.
55. *Manchester Guardian*, 9 May 1962; G. Moorhouse, *Britain in the Sixties. The Other England*, Harmondsworth: Penguin, 1966, p. 125.
56. J.A. Blackburn, 'The vanishing UK cotton industry', *National Westminster Quarterly Bank Review*, November 1982, pp. 42–52; J. Singleton, 'Showing the white flag: the Lancashire cotton industry, 1945–65', in M.B. Rose, ed., *International Competition and Strategic Response in the Textile Industries*, London: Routledge, 1991, pp. 129–49.
57. P. Scott, *The Property Masters: A History of the British Commercial Property Sector*, London: E and F.N. Spon, 1996.

Science, Technology and Medicine

JAMES SUMNER

The uniqueness of Manchester's scientific history is undoubtedly tied up with its relationship to industry: a much-loved local vision presents a radical new knowledge culture exploding out of the factories to reshape the world around it. Yet this is not where Manchester science began. In the late eighteenth century, as the industrial boom began to reshape the lives and landscapes of Lancashire, the knowledge-making activities which would soon be called 'science' were still conceptually far from the roaring mills. Locally, they were organized more than anything around the local medical culture, with contributions from a cluster of clerics, lawyers, landowners and occasional merchant-manufacturers such as might have been found in any large town in England. Manchester's distinctive scientific culture came later, in the mid-nineteenth century, as a generation of research-minded professionals tuned into the needs of an industrial city engaged in global competitive trade. Yet this culture, too, owed much to medicine, and to civic and religious politics besides. Mancunian science was a response not only to the work of manufacturing, but to the peculiar life of a manufacturing people, engaged with epidemic disease, urban planning, mechanized automation, mass technical education and hopes of a better world.

The roots of Manchester science

The fragmentary surviving history of early modern Manchester includes a handful of luminaries who have stood out to later generations for their scientific significance. John Dee (1527–1609), who was for a time warden of the Collegiate Church (later Manchester Cathedral), fascinates modern audiences for his writings

Line engraving by W.H. Worthington (1823) of Joseph William Allen, *John Dalton* (1814). Allen's portrait of Dalton hung in the Manchester Literary and Philosophical Society's rooms in George Street but became more widely known through the engraving. The atomic symbols are visible on the paper lying on the table. Further public recognition of Dalton in Manchester followed, including in 1833 the commissioning of a marble portrait statue by Francis Chantrey which was placed in the entrance hall of the Royal Manchester Institution.

Wellcome Images

CRABTREE WATCHING THE TRANSIT OF VENUS · A·D·1639

spanning mathematics, astrology, and communication with angels.[1] William Crabtree of Broughton (baptized 1610, died 1644) belonged to a correspondence network credited with establishing research astronomy in Britain: in 1639 he made the first recorded observation of the transit of Venus, an event immortalized in Ford Madox Brown's mural sequence for Manchester Town Hall in the 1880s.[2] Despite valiant Victorian efforts to read a long-standing scientific tradition into such achievements, however, there is little evidence of a self-aware and persistent community focused on natural knowledge until the founding of the Manchester Literary and Philosophical Society in 1781.[3]

The central organizer of the early 'Lit and Phil' was a physician, Thomas Percival (1740–1804), and more than half the founders were medical men. Their leaders included Charles White (1728–1813), a surgeon and key promoter of forceps-free delivery in his role as what was then called a 'man-midwife'. In 1752 White had set up the Manchester Infirmary in imitation of the voluntary hospitals established in other English towns, treating poor patients through donations from wealthy citizens keen to demonstrate their charitable credentials.[4] Another founder, Thomas Henry (1734–1816), demonstrates how boundaries were already beginning to shift in the growing industrial town. By profession, Henry was an apothecary, a rung below the physicians on the traditional status ladder. Yet what really defined his position – and made him far wealthier than most physicians – was his parallel career as a manufacturing chemist, with interests in industrial applications such as bleaching, and a patent on the process for 'Henry's Magnesia', a popular indigestion remedy.[5]

Soon after the Lit and Phil's foundation, Henry presented a manifesto for 'the consistency of literary and philosophical with commercial pursuits', making two key claims. First, a merchant or manufacturer could be as good a man as the traditional gentlemen and professionals, and could, like them, set aside leisure time for cultural refinement – artistic and scientific – without neglecting his business. Secondly, theoretical study of fields such as chemistry and mechanics could benefit masters and working men alike: a community in which 'few dyers are chemists, and few chemists dyers' would be much improved by educational reorganization.[6] The first claim served as a badge of Mancunian civic respectability into the mid-nineteenth century, and the second still resonates today. Both, however, took time to take hold. The Lit and Phil's leaders set up a College of Arts and Sciences in 1783, but the project petered out within five years, reputedly owing to their townsmen's 'superstitious dread of the tendency of science to unfit young men for the ordinary details of business'.[7]

Yet there were other reasons to invest in education. Percival, Henry and other early managers of the Lit and Phil were Unitarians, members of one of the 'Dissenting' religious communities barred from many conventional paths to social and professional success tied up with the established Church of England – including Oxford and Cambridge, then England's only universities. Dissenters who could afford to seek a professional career had usually studied in Scotland or the Netherlands instead (and, in important fields such as medicine, received a more up-to-date education into the bargain), but were now beginning to build local systems for learning and social advancement in the fast-growing industrial towns of the English north. In 1786 Percival and others created another teaching institution, the Manchester Academy (later called the 'New College'). The Academy was intended mainly as a theological college for young men training to be Dissenting ministers, but also taught mathematics and technical subjects, attracting some of the manufacturers' sons the 1783 college had failed to recruit.[8]

The rise of the Dissenters brought the risk of conflict with the Tory Anglican elite who had long controlled Manchester's local government under a system which had changed little since medieval times – and whose strongest allies included Charles White, an innovator in surgery but firmly traditional in his politics. Percival, in particular, sought reforms to meet the healthcare challenges of the growing industrial town, campaigning for improved sanitation, public baths and regulations to safeguard the health of factory workers.[9] Yet reformers such as Percival and Henry were usually able to collaborate with their political opponents in ventures such as the college of 1783; and the Lit and Phil sought stability by practising as far as possible a policy, long favoured by similar institutions, of requiring its members to leave religion, politics and other controversial topics at the door.[10]

The Infirmary, on the other hand, became a key battleground for Manchester's political direction. 1785 saw the arrival of another Unitarian physician, John Ferriar (1761–1815), who worked closely with Percival but was far more outspoken, allying himself with the leading local radicals who were to profess open admiration for

Samuel Austin, *The Infirmary, Dispensary and Lunatic Asylum, Manchester* (1829). By the 1820s Manchester Infirmary was one of the largest of the country's voluntary hospitals, and central to the town's reputation as an important provincial medical centre. Legacies of £10,000 each from Dauntsey Hulme and Frances Hall in 1829 enabled improvements to be made to the building, while the acquisition of royal patronage in 1830 further secured the hospital's public status and funding.

Courtesy of Manchester Libraries, Information and Archives, Manchester City Council

the goals of the French Revolution. Medical practice was increasingly a political issue in Manchester and nearby industrial towns, as the connection between the uncontrolled growth of poor-quality urban housing and lethal outbreaks of fever became too obvious to ignore. Social inequality, thought Ferriar, *caused* fever, as the 'effluvia' of those living in polluted and crowded conditions bred the agents of disease. His prescriptions were space, light and as much treatment as possible, to be achieved by withdrawing the established limits on the size of the Infirmary's staff, which had maintained it as something of a clique for White and his fellow Tories. In 1790, following a stormy public controversy against the background of a typhus epidemic, the reformers won the day. White resigned, transferring his efforts to a new 'Lying-In Charity' which in time became St Mary's Hospital, focusing on pregnancy care and midwifery.[11]

The reformers transformed the Infirmary with a new dispensary building and library, the cataloguing of the anatomical collection, and the recruitment of a greater number of non-local physicians and surgeons, mostly Scottish- or Dutch-trained. This was, in fact, the biggest achievement of the Manchester radicals before organized repression from 'Church and King' loyalists broke up their organization around 1792–93.[12] The hospital reforms endured, however, and cemented Manchester as a place which looked outwards for its scientific and medical direction. The controversy produced another major legacy: in 1792 the Infirmary's trustees asked Thomas Percival to suggest guidelines for professional behaviour which would avoid any repeat of the embarrassing public dispute. The result was a code of conduct which Percival expanded into an internationally influential treatise of 1803, *Medical Ethics*, coining the name for a branch of study which has become ever more important to professional practice.[13]

Soon after this controversy, the Academy brought to Manchester the man who would become its first public scientific hero. In a culture which came to thrive on the cliché of the humble man made good, John Dalton's (1766–1844) origins were apparently humbler than most: a weaver's son from the remote Cumberland village of Eaglesfield, he had worked on the land as a child.[14] Yet Dalton was also born into the Society of Friends, or Quakers, a Dissenting movement with a vigorous internal tradition of education. Aged 12, he was already working as a teacher in a village school for younger boys operating in a local barn. His abilities in mathematics, mechanics and particularly meteorology were encouraged by well-connected local Quakers, and through the wider Dissenting network he gained a teaching job at the Academy in 1793. Dalton was quickly elected to the Lit and Phil, which was to serve as the main base of his activities for the remaining half-century of his life. In his first paper to the Society, Dalton demonstrated the remarkable achievement of diagnosing his own colour-blindness.[15]

The innovation which would make Dalton famous, the 'new atomic theory', combined his interests in chemistry and meteorology. Recent discoveries had determined 'the air' to be in fact a mixture of gases with different properties: if some were lighter than others, wondered Dalton, why didn't they separate out into

Thomas Percival, *Medical Ethics*, title page of 1803 edition. Arising out of his experience as a physician at the Manchester Infirmary, Percival's examination of relations within the medical profession and their conduct towards patients was influential in establishing an agreed code of ethical conduct.

Courtesy of Chetham's Library

different layers? Dalton pondered the way water dispersed itself in the much lighter air, as his journeys between rainy Manchester and the rainy Lake District constantly reminded him; and he pondered also the recent work of his friend William Henry (1774–1836), Thomas's son and business partner. The family's many side-interests included bottling soda water, made fizzy by the addition of 'fixed air' (what we would call carbon dioxide), and William had discovered the principle that a gas will dissolve in liquids in proportion to the pressure of that gas above the liquid's surface.[16] In drawing these themes together, Dalton perhaps relied on his experience, through regular teaching to young pupils, in breaking down complex ideas into simple components. The result was a new way of understanding the universe.

All matter, Dalton decided, was made up of atoms – tiny, unbreakable particles, far too small to be seen. If the atoms were of different sizes, the small atoms could mingle among the big ones to provide this mixture. Atomic theories had been proposed now and then since ancient times, but Dalton combined the concept with new descriptions of the different forms of matter, or 'elements', and with the results of weight measurements in chemical reactions, which were becoming more and more precise in the nineteenth century. Chemists had found that a given weight of hydrogen, for instance, would combine with a particular weight of oxygen to make water, but not with more or less. Dalton proposed that all the atoms of an element weighed the same; that the particular weight could be different for different elements; and that atoms of different elements combined with each other in simple fixed proportions – two to one, for instance – to make what we would call molecules.

Manchester was not an ideal base from which to promote a new grand theory. Yet Dalton quickly won some powerful supporters, including Thomas Thomson (1773–1852) of Edinburgh, who promoted his theory through his *System of Chemistry*, the leading English-language chemistry textbook of its time. Some chemists, notably Humphry Davy (1778–1829), doubted the atomic approach at first, but Dalton's theory gained increasing experimental support and eventually became the dominant basis for explaining chemical composition, making Dalton an international chemical star. He continued, however, to earn his living almost entirely from teaching. After the Dissenters' Academy moved to York in 1803, Dalton carved out a freelance career in private tutoring and at medical and other colleges around the town. The Lit and Phil, of which he was for many years president, provided a room which served as his regular office and laboratory; a lifelong bachelor, Dalton lived nearby in rented accommodation. This was an unusually simple life for a living legend, and brought Dalton a public reputation for exemplary modesty and devotion to learning.

Manchester certainly made the most of its adopted son. Remarkably – and perhaps discomfortingly for a plain Quaker – a statue was raised to Dalton in his own lifetime, the cost of 2,000 guineas being met by public subscriptions. In 1842, when the British Association for the Advancement of Science brought its annual meeting to Manchester for the first time, Dalton's image appeared on the

John Dalton's lecture diagram of 1806 or 1807 showing his proposed symbols and atomic weights for various chemical elements. 'Azote' was soon more commonly known as 'nitrogen'. In the second part of his *A New System of Chemical Philosophy* (1810), Dalton extended the list to 36 elements. His pictorial symbols, though useful at first in explaining the theory, quickly gave way to the convenient alphabetic notation (H, N, C, etc).

Wellcome Images

membership tickets.[17] The reality was that Dalton had not kept pace with the development of chemistry for some twenty years, focusing on the routine collection of weather data to a degree the younger generation found tedious. On his death in 1844, however, the Manchester authorities honoured him as befitted a great statesman: 40,000 people, it was reported, filed past his coffin to pay their respects.

Manchester by this time boasted an unrivalled engineering culture, thanks largely to its tremendous industrial growth. There were the iconic textile mills themselves, of course: the Arkwright partnership's site near Shudehill, sometimes called the 'first factory', or the vast Murray's Mills complex at Ancoats, with its purpose-built canal basin and extensive use of steam.[18] But the business of making textiles required other industries: the 'finishing' processes of bleaching, dyeing and printing; the alkali and other chemical production which made this work possible; the metalworking and mechanical engineering behind the looms and spindles, engines and load-bearing structures of the mills themselves.[19] In their classic 1969 study, the historians Musson and Robinson trace the roots of Manchester engineering to a vigorous eighteenth-century skill base in precision clockmaking and tool production for metal- and woodworking, and to iron-founding firms such as Peel, Williams and Peel, which expanded into boilermaking and general steam engine production.[20] Manchester was an attractive base for precision engineers, including the most ambitious ex-pupils of the leading London

maker, Henry Maudslay. Richard Roberts (1789–1864) set up shop in 1816, developing their interests from screw- and wheel-cutting to power loom manufacture. He was followed in the 1830s by James Nasmyth (1808–90), famed for developing the awesomely powerful steam hammer which could forge huge iron pieces, and Joseph Whitworth (1803–87), whose specialisms included screw-cutting machines, lathes, and planing and dividing to extreme precision.[21]

The growth of Manchester's reputation in engineering and textile manufacture throws an interesting light on the posthumous honours heaped upon Dalton. Manchester was, by 1844, an icon of industrial, economic and political change, attracting visitors and commentators from around the world for its indications of a possible future.[22] Its *scientific* reputation, meanwhile, was strongly bound up with Dalton alone. The leading engineers were all active Lit and Phil members, publicly committed to the growth of natural knowledge, but this did not make them men of science in the public mind. Tellingly, when a bronze copy of the first Dalton statue was erected in front of the Infirmary in the 1850s, there were proposals to pair it with one of James Watt – iconically associated with Glasgow and Birmingham, but never Manchester – in view of the 'immense influence' of Watt's discoveries and 'the beneficial application of them in this community': the community, in other words, could not yet point to a home-grown lineage of scientific-industrial heroes.[23] This was very soon to change, however: Manchester's growth on the world stage had already laid the groundwork for several new modes of scientific life.

Devotee science and new institutions

The middle years of the nineteenth century were dominated by a generation Robert Kargon has called *devotees*: men who built their lives around science and engineering in a far more focused fashion than the gentleman-amateurs of earlier years, without being professional scientists in the modern sense. Most had professional or trade careers in other walks of life, which overlapped with their studies to varying degrees.[24] An early example was Eaton Hodgkinson (1789–1861), Cheshire farmer's son turned Salford pawnbroker, who devoted himself to materials science and structural engineering. Hodgkinson worked with professional engineers such as William Fairbairn (1789–1874), whose new machinery had transformed the cotton mills of the district, and who gave him space and materials to make experiments. Hodgkinson and Fairbairn's design collaborations included the cast-iron bridge which carried the railway of 1830 across Water Street to its terminus on Liverpool Road, connecting Manchester to Liverpool with the world's first steam-locomotive-driven passenger route.[25]

An influential devotee of the following generation was Edward Binney (1812–81), a lawyer by training, who spent much of his life working on geological surveys. After a Scottish chemist, James Young (1811–83), employed Binney in a successful patent litigation, the two became partners in a lucrative process for making paraffin from coal. Industrial connections similarly led the surgeon John Leigh (1812–88)

to develop his interest in chemistry, working on aniline dyestuffs and serving as analyst to the Manchester Gas Directors in the 1840s–50s, focusing on environmental questions of the condition of the air and the health problems caused by the constant pall of smoke from coal burning.[26] Not all devotees took their cues from industry: Joseph Baxendell (1815–87), an estate agent, was an enthusiastic astronomer and meteorologist.

One devotee achieved a fame as wide as Dalton's. James Prescott Joule (1818–89) was a prosperous brewer's son who fitted his early scientific investigations around a solid nine-hour working day at the family brewhouse on New Bailey Street, on the Salford side of the river. Although Joule published nothing on brewing in particular, his experiments focused very much on the concerns of mechanized industry – particularly on questions of economy and efficiency, as measured by industrially inspired tests such as raising a given weight to a given height. Around 1840 he adopted the contemporary fashion for electrical studies: Richard Roberts followed up his designs for electromagnets on a commercial scale, and Joule began developing an electric motor, fired by dreams of a low-cost alternative to steam engines. To his great disappointment, the discharging batteries used up zinc to a value several hundred times that of the coal burned in doing the same job by steam. Such experiences led the young Joule to a deep concern with the nature of heat and matter.[27]

What *was* heat? Most theorists understood it as a fluid, but Joule took the main alternative position, seeing it as a kind of motion. If particles or atoms of matter were moving in an organized way – in a weight being lifted on a pulley, for instance – useful work was being done; if they were instead milling around at random, as in steam, this was heat. Work and heat, Joule decided, were two forms of the same phenomenon, later named *energy*. Energy could not be created or destroyed, but could be converted from work to heat and back again – and the total quantities of the two would always add up to the same figure, if only it could be measured accurately. For engine users, this gave a new way to define efficiency: converting as much heat into productive work as possible.

Through the 1840s Joule developed a variety of experiments to prove the heat–work relationship, using electromagnetic coils, gas condensers and – most simply, but most famously – a set of spinning paddle-wheels in a canister of water, powered by a falling weight: the work done could be measured from the weight's drop, and the resulting heat from the tiny temperature rise in the water. Such experiments needed very precise attention to heat sources: Joule's training in the brewery, where temperature control is so crucial in mashing and fermentation, was probably helpful here, and the paddle-wheel apparatus, with its spinning axis, resembles in miniature an automated brewer's mash-tun. Certainly, some of Joule's experiments were conducted in the brewhouse cellar, which probably helped in providing stable temperature conditions.[28]

Today Joule is famed as one of the founders of thermodynamics. His statue faces Dalton's across the entranceway to Manchester Town Hall. In his youth,

Joule had been a pupil of Dalton's, and visitors often picture the two as master and disciple in a grand research lineage. In fact, Joule merely took an elementary course of private tuition around the age of 16, like many other gentlemen's sons of Manchester and Salford, covering standard topics which could have been covered equally well by less famous teachers, although Joule always credited Dalton's approach as inspirational. Manchester still, in the 1840s, had no formal system for university-level education or research, and Joule knew how hard it was to convince the national scientific elite that a fundamental physical theory had again been formed (as he later put it) in 'a town where they dine in the middle of the day': his first paper on the conservation-of-energy theory was rejected by the *Philosophical Transactions of the Royal Society*.[29]

Joule was also to follow Dalton, however, in receiving timely help from a well-connected source in Scotland. In 1847 the young University of Glasgow professor William Thomson (the future Lord Kelvin, 1824–1907) saw Joule's paddle-wheel demonstration and began a correspondence which first secured the validity of the mechanical equivalent of heat for a national audience, and then vigorously defended Joule's originality against the priority claims of the German Julius von Mayer. Away from Manchester, there are few statues to Joule, yet he is commemorated in a way so fundamental as to be practically invisible: in the standardized system that measures power in watts, and force in newtons, energy is measured in joules.

The devotee scientists of Joule's generation depended on a growing variety of social clubs, teaching institutions and public bodies to communicate and support their research. The centre of gravity remained the Lit and Phil – which was increasingly 'Literary' in name only, as the devotees took charge, with Eaton Hodgkinson as president, and reconstituted it as a society to foster original scientific research.[30] Meanwhile, a Natural History Society had formed in 1821, originally around the task of securing and preserving the collections left by John Leigh Phillips (1761–1814), a local manufacturer and antiquarian. By 1835 the society had established an impressive museum on Peter Street, initially on a members-only basis but soon opened to the paying public. A Manchester Geological Society followed in 1838, led by Edward Binney with hefty financial support from Lord Francis Egerton, of the archetypal landowning-turned-coalowning dynasty: geology, in industrial Britain, was automatically valued as economically important for its ability to point the way to coal seams and other exploitable resources. The gentlemen devotees of science were not always genteel in their relations: an attempt by these two societies to share premises, with geological specimens displayed alongside the natural history collections at Peter Street in the 1850s, led to arguments over admission fees and an extraordinary dispute about charges for the use of the naturalists' umbrella-stand. The British Association for the Advancement of Science's decision to return to Manchester for its annual meeting of 1861 eventually prompted the combatants to patch up their differences so as to present a united front to the increasingly international audience.[31]

Manchester Mechanics' Institution. Located in Cooper Street and opened in 1827, it was the first purpose-built mechanics' institution in the country. 'The delivery of lectures on the various sciences and their practical application to the arts' was foremost among its objectives.

Courtesy of Manchester Libraries, Information and Archives, Manchester City Council

Owenite Hall of Science. The hall was built and paid for by the followers of Robert Owen in Camp Field. Capable of accommodating some 3,000 people, it was an important centre of working-class radicalism in the city throughout the 1840s but closed in 1850. In 1852 the building reopened as the Manchester Free Library.

Courtesy of Manchester Libraries, Information and Archives, Manchester City Council

There were also new teaching colleges. The most important in the long term was the Mechanics' Institution, founded in 1824 to provide a basic education for working men. Its founders included engineers such as Fairbairn and Roberts and many of the leading commercial men of the town, building on the existing network of the Lit and Phil. In truth, as for many similar institutions nationwide, the elite proprietors did not altogether understand their audience. The cost of classes was far too high for labourers, and the rising generation of working-class radicals – those most likely to be interested in the opportunities of technical education – were suspicious of an initiative obviously controlled by the manufacturers. One result was a breakaway New Mechanics' Institution, run more democratically with input from its students, whose offerings included mathematics, astronomy and technical drawing. Its leading lecturer was the self-taught Rowland Detrosier (1800?–34), who also led a workmen's society for natural history. Detrosier campaigned vociferously for the political value of a combined technical and moral education, but could not, in the end, carry the support of workmen's groups more radical than himself. The original Mechanics' Institution made some moves to address the objections and effectively re-absorbed the breakaway in 1835. It never truly lived up to its name, however, instead finding an alternative niche in catering for skilled tradesmen and members of the lower middle classes, shopkeepers and clerks looking to better themselves.[32]

Very different was the Hall of Science on Byrom Street, established in 1840 by followers of the pioneer socialist Robert Owen: its exterior emblazoned with the motto 'Sacred to the Investigation of Truth', the imposing hall could hold an audience of 3,000. 'Science', to the Owenites, implied a generalized system of

rational enquiry, including social and political debate, which could serve as an alternative to conventional religion, but the Hall of Science's planners were equally keen to undercut the appeal of the Mechanics' Institution, and incorporated teaching in the physical sciences from the outset.[33] The leading lecturer, John Watts (1818–87), made regular use of scientific imagery in setting out his moral philosophy. Watts was an early friend of Friedrich Engels, the textile manufacturer's son who was to draw on his Manchester experiences as a co-founder of communism: it was probably Watts who first inspired Engels to bring scientific arguments into political debate, using the potential of agricultural chemistry to feed growing populations in countering conclusions drawn from Malthusian economics.[34]

The conservative end of the political spectrum showed its influence in the Royal Manchester Institution, founded in 1823, whose chief purpose was to demonstrate that the newly rich manufacturers and professional men could be men of culture. This, in practice, meant a focus on painting, sculpture and the decorative arts; initial plans to sponsor the productive arts and sciences – along the lines of the older Royal Institution in London – were unappealing to the governors, and quickly found an alternative home in the Mechanics' Institution.[35] Nonetheless, the Royal Manchester Institution accommodated some lectures in chemistry, physiology and natural history. Its chemistry professorship, unpaid but with laboratory facilities and the right to take paying students, provided a base for the brief Manchester career of the chemist Lyon Playfair (1818–98), who was soon to assume a leading role in British science policy.

Another kind of institutional basis for scientific and medical innovation came from alarm at the town's uncontrolled growth. Frequent fever epidemics had helped to make Manchester a national byword for the worst problems of urban-industrial life: the slum dwellings, whose spread outran all prospect of adequate sanitation; the tall factory chimneys, already a cliché of the industrial landscape, which filled the air by night and day with thick, black, sulphurous smoke; and the toxic outflow of dyeworks, bleaching houses and other manufactories discharging freely into rivers already filthy from organic waste. The situation inevitably troubled physicians such as James Phillips Kay (in later life Sir James Kay-Shuttleworth, 1804–77). Although Kay was suspicious of social welfare schemes, he increasingly recognized that the extremes of industrial life were beyond any individual's power to remedy, and promoted surveying and inspection in the general public interest. In 1833 Kay and similarly minded medical colleagues founded the Manchester Statistical Society, focused not on mathematics but on the systematic collection of data about the social conditions of the poor, including education, population density, diet and disease.[36]

Environmental and healthcare concerns combined in the work of the Manchester-born reformer Edwin Chadwick (1800–90), who coordinated an influential 1842 report into public health. Like many contemporary doctors, Chadwick worked on the basis of the miasma theory, which held that diseases such as cholera were generated by the decay of animal and vegetable matter. To the national and local authorities, this offered a palatable basis for reform: poor sanitation, not the

system which produced poverty, could be blamed for the worst of the city's ills. Although Chadwick argued for the public appointment of district medical officers to identify and track outbreaks, he urged that what was most needed was not better medicine but better civil engineering, to deliver clean streets, clean water and efficient sewerage.[37]

Chadwick's report was followed in 1843 by a Royal Commission to examine the state of public health in 'Large Towns and Populous Districts', with the above-mentioned Lyon Playfair among the commissioners. Playfair had trained at Giessen under Justus Liebig, the most influential chemist of his generation, and was the chief promoter in Britain of Liebig's adaptation of the miasma theory, which in its practical implications broadly supported Chadwick's sanitary agenda. The Commission drew strongly on Lit and Phil connections, interviewing doctors such as John Leigh and reformist manufacturers such as Thomas Ashton, who highlighted the importance of clean water. James Young, mentioned above as a paraffin producer, worked closely with Playfair and his colleagues on the chemical treatment of waste products to render them not only safe but productively useful as agricultural fertilizers. Such investigations led one manufacturer, Alexander McDougall, to a profitable sideline in disinfectant powder incorporating carbolic acid (phenol), ultimately inspiring Joseph Lister's practices in antiseptic surgery.[38]

For Robert Angus Smith (1817–84), who first came to Manchester as Playfair's assistant in 1843, the sanitary problems of the industrial city were to provide a lifelong career. Another Liebig-trained chemical analyst, Smith became consultant to a series of further government-sponsored inquiries and helped to define the identity of the 'civil scientist', using expert knowledge to uphold regulations

'Typical' and 'melanic' variants of the peppered moth (*Biston betularia*). Amateur Manchester entomologists such as Robert Edleston (1819-72) discovered the soot-black variant of this moth in the 1840s and later found its population to be growing dramatically compared to the original form, presumably because it was better camouflaged in the increasingly blackened industrial landscape. The variation later became a key case for directly observable evolutionary change according to the Darwinian theory of natural selection.

Images courtesy of Wikimedia Commons and Olaf Leillinger

enshrined in law. Concerns about air quality no longer focused only on the visible problems of smoke and soot, but had widened to the invisible yet dangerous carbonic, sulphuric and other acids belched forth by various industrial processes. In 1864 Smith became director of an Alkali Inspectorate designed to enforce technical modifications to cut out the worst of the pollutants. An active leader of the Lit and Phil, he was on good terms with local manufacturers and proved dextrous at ensuring their compliance through rigorous definition of the offences and their remedies. The work took Smith into new conceptual territory as he began to develop a theory of 'chemical climatology', assessing the effects of pollutants on vegetable growth and coining the term 'acid rain'.[39]

Amid the discord and disease, Manchester offered some remarkable amenities for scientific investigation. As one of the few centres outside London

John Collier, *James Prescott Joule* (1882). Collier's formal portrait provides no clues to Joule's achievements, omitting the visual accessories that had become the conventional way of establishing the public image of the scientist. In Manchester Joule was often associated with his one-time teacher, John Dalton – Alfred Gilbert's statue of Joule was placed opposite that of Dalton in the Town Hall. Both scientists also featured in Roger Oldham's *Manchester Alphabet* (1906).
© The Royal Society

that could sustain a market for high-quality precision instruments, it had attracted the instrument-maker John Benjamin Dancer (1812–87), a specialist in microscopy who set up shop on Cross Street in 1841. Dancer's instruments were crucial to James Joule's work on the mechanical equivalent of heat: his highly sensitive thermometers were calibrated to unrivalled accuracy (Joule claimed to discern to one 200th of a degree Fahrenheit) using a custom-designed moveable magnifying eyepiece. Dancer proved similarly valuable to Robert Angus Smith in his microscopic examination of air samples, and the local Field Naturalists' Society carried his portable microscope models on expeditions. Dancer also introduced photography to Manchester, made improvements to stereoscopic camera and magic-lantern display technology, and co-founded the Manchester Photographic Society in 1855. His best-known innovation, combining his interests, was to achieve the first successful microphotographs – tiny photographs developed through an adapted microscope lens – opening the path to the microfilm and microfiche of twentieth-century data storage, and the hidden microdots of espionage legend.[40]

Scientific life in Manchester, however, could be precarious. Dancer, forced to give up his business after his eyesight failed, died in near poverty, as did William Sturgeon (1783–1850), a leading public lecturer in the 1840s. Another scientific star who had raised himself through education from humble beginnings, Sturgeon had arrived from London, where he had been a leading light in the exciting electrical science which so captivated James Joule, inventing some of the first electromagnets. He was not, however, on good terms with elite London figures such as Michael Faraday, and sought the opportunity to build a new kind of career in the industrial north. In 1840 he became superintendent of the Royal Victoria Gallery, created to realize an unfulfilled goal of the early Mechanics' Institution project which many industrialists saw as an obvious opportunity for Manchester: to collect and display showpiece machinery and models, for both practical education and rational entertainment.[41] Despite forming close friendships with Joule, Binney and others, however, Sturgeon was evidently not able to build for electricity the same kind of industrial patronage that Eaton Hodgkinson had achieved for structural engineering. The gallery failed in 1842, a victim of economic downturn and the capriciousness of local patronage, and Sturgeon was reduced to scratching a living as an itinerant lecturer until his friends secured a civil list pension to rescue him from penury.[42]

Manchester, then, offered lucrative if chancy opportunities to commercialize discoveries, but little in the way of systematic support for research in itself. Institutional status was still tied strongly to teaching: one proposal following Dalton's death was a memorial professorship, which might have gone to Lyon Playfair, but the established chemical tutors of the town objected that this would create an unfair advantage in the scramble for paying pupils.[43] Playfair's brief appearance in Manchester was, however, symptomatic of a more lasting trend, one that would ultimately cement a lasting basis for a research community: the growth of a vigorous community of German-trained chemical experts, often PhDs trained

under Liebig at Giessen. Robert Angus Smith was one example; another was Henry Edward Schunck (1820–1903), Manchester-born to German emigrants, who managed his family's dyeworks near Rochdale while building a research career in colour chemistry and assuming a leading role in the Lit and Phil. In a similar mould, though French-trained, was Frederick Crace-Calvert (1819–73), Playfair's successor at the Royal Manchester Institution. Crace-Calvert worked with McDougall and Smith on disinfection; through his French contacts, he found a market for highly purified organic acids, which were useful in the increasingly lucrative synthetic dyestuffs industry, and was soon a flourishing manufacturer in his own right.[44] It was these scientific-industrial connections, particularly in chemistry, which shaped Manchester's path towards a truly distinctive knowledge culture.

The rise of the scientific professionals

As Manchester grew, so did the sentiment that the town – or city, as it became in 1853 – deserved a university of its own. In 1846 John Owens, a cotton goods manufacturer, died, leaving nearly £100,000 for a non-denominational college to teach 'such branches of learning and science as are … usually taught in the English universities', implying the broad curriculum provided for gentlemen's sons at Oxford or Cambridge. Owens College duly opened in 1851 in a house on Quay Street which had belonged to the leading Free Trade politician, Richard Cobden. The beginnings were small, with seven staff and 25 students, and the location was unpromising: reportedly, undergraduates were easily distracted by the nearby Dog public house. Despite recruiting some highly capable professors, the college initially failed to increase its student numbers, and was soon on the point of collapse. In an 1857 editorial, the *Manchester Guardian* saw a 'mortifying failure' in the attempt to rival the Oxbridge model in a city which had no inclination or need for it.[45]

This gloomy picture, however, overlooked promising changes which were most visible in Owens' approach to chemistry. The first chemistry professor was Edward Frankland (1825–99), the pioneer of the valency concept. Frankland made good use of the resources of local industrialists such as his friend, the engineer James Nasmyth, isolating new compounds using industrial techniques of heating under pressure, and introduced applied chemistry and consultancy work on a pattern which was largely new to English higher education.[46] These approaches were brought to the centre of the college's mission by Frankland's successor, Henry Roscoe (1833–1915). In partnership with his humanities colleague A.W. Ward, Roscoe emphasized the value of research on the German academic model: Roscoe himself had trained at Heidelberg with the influential Robert Bunsen (of burner fame). By establishing close training links with local industry, stressing the importance of a core understanding of principles, and writing the definitive textbooks which explained in English the newest German methods, Roscoe established Manchester as a credible centre of instruction, not only locally but in the international chemical community. By 1863 the college had over 100 students, 38 of them in chemistry.[47]

Unsurprisingly, industrial lobbying was soon extended to other fields, particularly engineering. A key benefactor was Joseph Whitworth, whose triumphs in precision machining had led to highly successful ventures in rifle and cannon manufacture in the 1850s and 1860s, with an equally lucrative process for hydraulically pressed steel to follow.[48] Whitworth and other prominent manufacturers endowed an engineering professorship in 1868: the first holder was the young civil engineer Osborne Reynolds (1842–1912), who spent his whole career in the post, making important contributions to fluid dynamics.[49] Other notables of this period included William Crawford Williamson (1816–95), a founding professor of Owens with the demanding brief of 'natural history, anatomy and physiology', who gradually specialized towards botany. Williamson gained an international

reputation for his work on plant fossils, a study supported by industrialists for its value in assessing coal deposits.[50]

The Quay Street house was soon a victim of its own success. Laboratories were overcrowded, and intensive chemical work in such a confined space became a health hazard. Roscoe and his colleagues again rallied support from industry and relocated to much larger, purpose-built premises on cheaper land to the south, along Oxford Road in what was then the neighbouring township of Chorlton-on-Medlock. The new Owens College, formally opened in 1873, unsurprisingly boasted excellent chemical facilities; Roscoe now had a handsome personal laboratory, but was long in the habit of making a daily round of the student labs in the manner of his mentor Bunsen.[51] Although primarily an inorganic chemist himself, Roscoe, as a good Germanophile, understood that industry would best respond to a massive expansion of provision on the more commercially valuable organic side. He brought to Manchester the Giessen-trained Carl Schorlemmer (1834–92) and secured his appointment, in 1874, as the first professor of organic chemistry in England. Schorlemmer was followed by William Perkin, Jr (1860–1929), whose interests followed those of his famous father, the creator of mauve aniline dye.[52]

Another showpiece building on the new campus housed the Faculty of Medicine, a new departure for Owens created from the former Royal School of Medicine which had absorbed the various competing medical colleges around the city. The founding

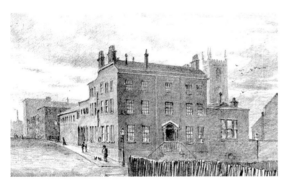

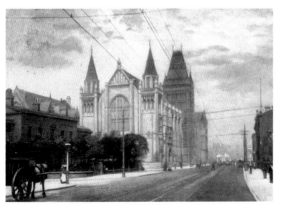

Owens College, corner of Byrom Street and Quay Street (top). When it opened in 1851 the college was housed in a large gentleman's residence – once the home of Richard Cobden – in what was a busy city-centre street. In 1865 it was decided to remove the college to a more suitable location, land being eventually acquired on Oxford Road. Owens moved into the first of its new buildings in 1873. By 1910 (bottom), the site had gained a frontage along Oxford Road, including the ceremonial Whitworth Hall, being in the revived Gothic style favoured by its architect, Alfred Waterhouse.

Courtesy of Manchester Libraries, Information and Archives, Manchester City Council

professor of physiology, Arthur Gamgee (1841–1909), set a pattern for combining teaching with internationally recognized research alongside colleagues in the Faculty of Science.[53] Correspondingly, the Infirmary at Piccadilly increasingly appointed physicians who could combine practice with specialist clinical research, sometimes through academic posts at Owens. One of the most influential was Julius Dreschfeld (1845–1907), another product of German-Mancunian merchant connections, born to a Bavarian Jewish family and educated at Owens and Würzburg. Informed by wide-ranging experience of facilities across Europe, Dreschfeld developed a pathology laboratory at Owens while teaching numerous medical students, and led the establishment of pathology in British medical curricula.[54]

Owens was further buoyed by a bequest of over £100,000 – more than the original endowment – from Charles Beyer (1813–76) of the Beyer Peacock locomotive engineering firm, and quickly expanded with dedicated facilities for the natural history disciplines of zoology, botany and geology. The geology professor, William Boyd Dawkins (1837–1929), embraced the applied side of his field, consulting on coal-measure determination and other commercial projects around the country.[55] Boyd Dawkins had formerly been curator of natural history at the museum on Peter Street. Like Owens, the museum had suffered from shortage of space in a city-centre location, and in 1868 Owens had acquired its collections, the plan being to create a more spacious museum on the Oxford Road site which could serve both public audiences and academic research. The Manchester Museum duly opened in 1900: its layout provided a main entranceway onto Oxford Road for visitors, and connecting corridors to the Owens buildings by which it effectively served as an extension of the laboratories.[56]

Calls were now growing to recognize Owens as a university in its own right. A peculiar compromise of the 1880s, with Owens the central college in a federal 'Victoria University' with sister colleges in Liverpool and Leeds – pioneering, at least, in opening full degrees to women on the same terms as for men – gave way in 1903–04 to full status as the Victoria University of Manchester.[57] The shifting centre of gravity was neatly symbolized in the patronage of the above-mentioned Edward Schunck, one of the public leaders of Manchester chemistry in the years after Dalton. In the 1870s Schunck used the family fortune to build a superb private laboratory and library of chemical literature at his home on Kersal Moor; he died in 1903, bequeathing the laboratory and library to the college. Not only were the contents of the library brought to the newly independent university: remarkably, the entire physical laboratory was removed from Kersal and reconstructed on the Oxford Road campus.[58]

The emergence of Owens prompted the established organizations, in particular the Literary and Philosophical Society, to re-evaluate their status. The Lit and Phil had already passed a significant watershed in 1862, when Leo Grindon, popular leader of the local amateur field naturalists' society, applied to join. Grindon's enthusiastic, non-expert approach was everything the devotee tendency was trying to get away from; in an awkwardly public wrangle, most of the Owens

professors weighed in with the devotees, finally affirming that the chief business of the Society was not to popularize, but to advance research.[59] In turn, however, friction arose between older devotees, such as Edward Binney, and the new professionals. In 1868, fearing that Owens would swallow up the entire scientific culture of the town, Binney made an impassioned plea for the fundamental contribution of 'amateurs and practical men': the true tradition of Dalton and the Lancashire engineers, he claimed, lay in devotee institutions such as the Manchester Geological Society. If Owens must conquer all, then its priorities should at least be rebalanced, with professorships focused on practical teaching.[60] Although Binney's appeal made little headway, developments elsewhere ensured that Owens was not the only vehicle for Manchester's scientific-industrial identity.

The Mechanics' Institution had flourished in the mid-century boom, opening a grand new building on Princess Street in 1856, but its activities more than ever belied its name. Needing to attract reliable local fee-payers, its main business was to provide basic education for school-age boys and girls, social club activities for young men, and white-collar skills such as shorthand: evening classes in fields such as mathematics and chemistry were sparsely attended. After 1870 the school-age classes dried up as publicly funded provision improved, and a farcical series of incidents involving incompetent or embezzling managers left the Institution rudderless. What saved it – or, rather, transformed it into something very different – was the national movement for technical education. Advocates such as Lyon Playfair had feared for the future of Britain's industrial supremacy since the 1850s, often stressing the superior ability of Continental education systems to bridge the gap between theory and practice. In the 1870s, as German industry began to eclipse the British on a variety of fronts, Manchester's civic leaders saw the case for a major regional centre for technical training. So did local industrialists such

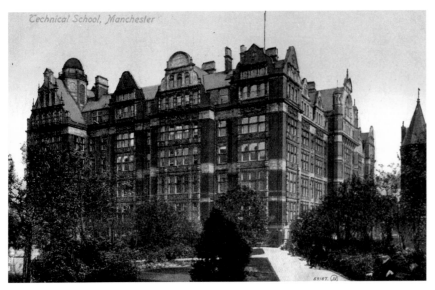

Manchester Municipal School of Technology, from Sackville Park, c.1912. Opening the School of Technology in 1902, the prime minister, A.J. Balfour, described it as 'perhaps the greatest fruit of its kind of municipal enterprise in this country'. The building had cost some £300,000, funding coming from the estate of Joseph Whitworth and profits made from the 1887 Royal Jubilee Exhibition.

Courtesy of Manchester Libraries, Information and Archives, Manchester City Council

as Ivan Levinstein (1845–1916), who knew the strength of the German training system at first hand.[61]

The man who harnessed the work of the Institution to this movement was John Henry Reynolds (1842–1927), himself a self-educated working man originally trained as a bootmaker, who took office as Superintendent in 1879. Using the new examinations framework of the City and Guilds Institute, Reynolds rebuilt the curriculum around industrial priorities, from workshop classes in bleaching and printing to the principles of workplace management.[62] A revitalized programme of evening classes, aimed at working men and particularly apprentices, accompanied expanded day classes for middle-class young men too commercially oriented for Owens. In 1883 the Institution was rechristened as the Manchester Technical

Adolphe Valette, *John Henry Reynolds* (1919). Between his appointment as secretary of the Mechanics' Institution in 1871 and his retirement as the principal of the School of Technology and Director of Higher Education for Manchester in 1912, Reynolds was a key figure in establishing and modernizing the city's system of advanced education. For Reynolds, as for the founders of the Mechanics' Institution in 1824, scientific and technical education and its relationship to industry and the threat of foreign competition remained central concerns.

Courtesy of Manchester Art Gallery

School, the first in a series of variant names conveniently abbreviated to 'the Tech'. Research was not formally part of the early Tech's responsibility, but the nature of the enterprise inevitably produced innovations. The claim for Manchester as the 'birthplace of chemical engineering' rests on a lecture series given at the Tech by George Davis (1850–1907), a former factory emissions inspector, on industrial chemical applications in 1887.[63]

The project's opportunities were transformed by two developments. Sir Joseph Whitworth died in 1887, leaving a vast bequest for public works, and a scheme emerged for a grand Whitworth Institute incorporating the Tech, the existing School of Art and a new Whitworth Park and Gallery: since the Tech had outgrown its existing building, it would be refounded on the site of Whitworth's former engineering works on Sackville Street. The second development, however, was the 1889 Technical Instruction Act, which promised what even the largest bequest could not: long-term stability through a regular commitment from local government taxation. This meant a rapid end to the Whitworth Institute as the Tech came under direct municipal control, but the project was allowed to retain the Sackville Street land. The new building formally opened in 1902. Designed after careful study of the grandest technical colleges of Europe, the structure was a defiant showpiece and the best equipped of its kind in Britain.[64] A distinctive oddity on its roofline was the papier-mâché dome of an astronomical observatory, handsomely fitted out by the cotton manufacturer Francis Godlee (1854–1928), and still used by the Manchester Astronomical Society today.[65]

The industrial production culture of the city and region was meanwhile embracing new opportunities. The Manchester Ship Canal opened in 1894, wide and deep enough to float ocean-going ships, which could now bypass Liverpool and pass through the manufacturing heartlands to the edge of the city centre.[66] The canal project was bolstered from 1896 by the development of Trafford Park, a former country estate along its banks, into the largest industrial estate in Europe. Activities included not only manufacturing but warehousing and tranship-ment, with an extensive private rail system; the Co-operative Wholesale Society developed a major food packing and distribution operation and operated a flour mill. The core, however, was manufacturing industry, including the growing field of electrical supply. Trafford Park was a key site for the importation of American industrial methods, particularly through the British subsidiary of the Westinghouse Electric Corporation of Pittsburgh, making turbines and genera-tors. Beside the British Westinghouse works stood a model township for workers, with its unmistakeably American grid layout – 'First Avenue', 'Second Street' and so on. The shift was cemented by the arrival of Ford Motors' plant in 1911, which imported assembly line methods to produce Model T cars.[67] The aviation boom had reached Manchester the previous year, when Alliott Verdon Roe (1877–1958) set up the firm later known as Avro to manufacture aircraft on Great Ancoats Street. The growing industrial complex provided extensive opportunities for academic collaboration.

Richard Copley Christie, academic, bibliophile and lawyer. Christie had a long connection with the university, beginning in the 1850s when he was professor of political economy, history and jurisprudence at Owens College. Other public offices that he held included Chancellor of the Diocese of Manchester. The university library was named in his honour, Christie having paid for the building and also gifted it a collection of rare books. A stained glass window on the library staircase shows him in academic dress flanked by Manchester Cathedral and Owens College, and the Renaissance scholars Erasmus and Aldus.

Reproduced with the kind permission of Nick Higham

The transformation of both Owens and the Tech after 1900 complicated their relationship. Formerly, the division of labour had been clear: the Tech taught elementary theory and applied industrial skills; Owens taught 'professional scientific men' to degree level. In traditional terms, the Tech's role was inferior, jarring uneasily with the cutting-edge facilities and the city government's ambitions. Briefly, it seemed that Manchester might have two major institutions in direct competition; but the leaders of both Owens and the Tech were too canny to foster any risk of instability. The new University of Manchester charter of 1904 established co-operation through a new Faculty of Technology, constitutionally part of the university but using the Sackville Street site and Tech staff; the Tech also continued in its primary business of applied teaching, the same facilities often serving degree classes by day and wage-earning students in the evenings.[68] The arrangement set a precedent for a century of Tech–Owens institutional crossover which often baffled outsiders while proving productive for those involved.

The Whitworth bequest also contributed to major changes in healthcare. The Medical School's absorption into Owens College had created a case for moving the Royal Infirmary from Piccadilly to join it: a cheaper site in the suburbs would answer the problems of a growing renovation bill, and sanitarian worries about the dangers of built-up city-centre sites had not entirely gone away. Yet such a move was opposed by many of the trustees, who stressed the Infirmary's role in the community surrounding it; some doctors insinuated that the academics were more concerned with expanding clinical teaching than with treating the sick.[69] Meanwhile, one of Whitworth's executors, Richard Copley Christie (1830–1901), professor of history at Owens, was developing plans for a 'Cancer Pavilion', inspired by his wife Helen's philanthropic concerns; this would be the first step in a gradual consolidation towards a general teaching hospital, for which the executors bought up a large site near the college, on the other side of Oxford Road.[70] As the scheme grew, the two principal women's and children's hospitals, St Mary's and the Manchester Southern Hospital, were quickly pulled in, merging and transferring their gynaecology and children's departments to the new site. Unable to expand at Piccadilly, the Infirmary's managers reluctantly agreed to join the exodus in 1903, the historic site being cleared and ultimately covered by Piccadilly Gardens. By 1911 the Infirmary was the largest in a coordinated group of hospitals fringing Oxford Road and tied firmly to the University Medical School.

The Medical School had expanded greatly in the 1880s and 90s. Slower than the rest of the university to accept women, it received its first female student in 1899: Catherine Chisholm (1878–1952), later an influential paediatrician and a prominent campaigner for infant welfare provision and for women in medicine. The Swiss pathologist Sheridan Delépine (1855–1921) combined teaching at Owens with consultancy to sanitary authorities in Manchester and across the region, developing a dedicated Public Health Laboratory on York Place, near the hospital complex, to apply bacteriological knowledge to urban disease prevention.[71] The Medical School was now one of the largest teaching facilities in the country,

although its research side did not approach the university's eminence in physics and chemistry. The anatomy department, however, witnessed in the 1910s the early careers of three doctors who went on to gain national reputations through local work: Harry Platt (1886–1986), one of the pioneers of orthopaedic surgery; Geoffrey Jefferson (1886–1961), a neurologist and neurosurgeon with a strong interest in the philosophy of mind; and the unforgettably named John Sebastian Bach Stopford (1888–1961), who considered himself a 'surgeon's anatomist', working closely with clinical colleagues, but is best known as a university administrator and medical policy advisor.[72]

The Australian researcher Grafton Elliot Smith (1871–1937) was professor of anatomy in this period, though his interests ranged widely across neurology, psychology, archaeology, anthropology and folklore. Smith combined several of these interests into the specialism of palaeopathology, diagnosing disease in human remains from burial sites in Nubia; he also developed the controversial theory that Egypt provided a central origin point for the spread and development of all human culture.[73] Egyptology was a fashionable field which attracted wealthy patrons in Manchester, most importantly the cotton merchant Jesse Haworth (1835–1920), who funded extensions to the Manchester Museum which pushed its focus beyond its natural-historical roots into the study of ancient human cultures.[74] Haworth also sponsored the archaeologist Flinders Petrie (1853–1942) of University College London, many of whose discoveries found their way to Manchester; Petrie's leading

Unwrapping of Khnum-nakht, Chemistry Theatre, May 1908. Manchester Museum's collection of Egyptian artefacts was one of the largest outside London, largely due to the financial support that the Manchester cotton merchant Jesse Haworth provided to the explorations undertaken by Flinders Petrie. Margaret Murray (bottom, second right) led the team that carried out the unwrapping. The occasion attracted a large audience, though not all stayed to observe what the *Manchester Guardian* described as 'on the whole a gruesome business'. Those who did remain to observe this scientifically conducted procedure were promised, on leaving their name and address, a memento in the form of a piece of the linen wrapping from the body.

Courtesy of Manchester Museum, University of Manchester

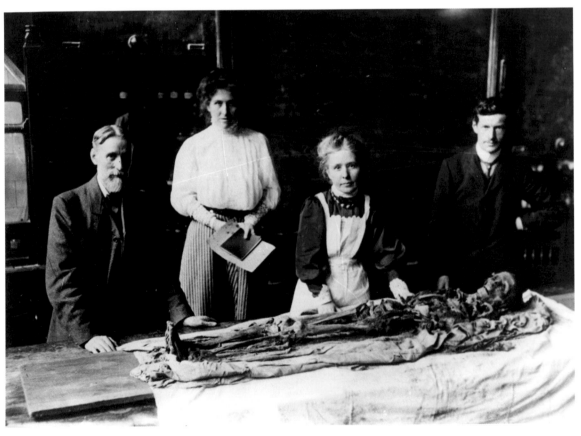

disciple, Margaret Murray (1863–1963), worked for a time at the museum, cataloguing and lecturing on the results. It was Murray, in 1908, who 'unwrapped' the mummified priest Khnum-nakht, excavated by Petrie the previous year, in a public demonstration at the museum.[75]

Physics provided the most striking developments in turn-of-the-century Manchester's scientific profile. The key figure was a protégé of Henry Roscoe, Arthur Schuster (1851–1934), the second holder of the Langworthy professorship in physics, the bequest of yet another philanthropic cotton magnate. Schuster, born in Frankfurt to a banking and merchant family with textile interests in Manchester, unusually combined the patronage opportunities and commercial connections of a wealthy nineteenth-century devotee with the institution-building agenda of a twentieth-century university leader. He designed and secured funding for a new physics laboratory, the fourth largest in the world on its inauguration in 1900. Physics research in Manchester benefited from a distinctive close engagement with electrochemistry, mechanical engineering and 'electrotechnics', the emerging field which would become electrical engineering.[76] Schuster effectively co-directed the university's shift to full independence alongside the historian T.F. Tout, in a partnership recalling the Roscoe–Ward alliance of the pre-university days.[77]

Schuster's other defining contribution was to engage the trailblazing New Zealander physicist Ernest Rutherford (1871–1937) to succeed him in the Langworthy chair in 1907. Rutherford had previously worked at McGill University in Canada, performing research on atomic disintegration which won him a Nobel Prize in 1908 (for chemistry, rather than physics: the new atomic specialisms were not yet disentangled). Uniquely, Rutherford made all of his best-known discoveries

Installation of skeleton of sperm whale calf, Manchester Museum, 1898. Owens College absorbed the Manchester Natural History Museum in 1868 but it was not until 1890 that the renamed Manchester Museum had its own purpose-built premises (designed by Alfred Waterhouse). The whale skeleton became one of its most popular exhibits. It came from the United States, a purchase rather than a donation; its articulation was carried out by the Stockport taxidermist Harry Brazenor (pictured).

Courtesy of Manchester Museum, University of Manchester

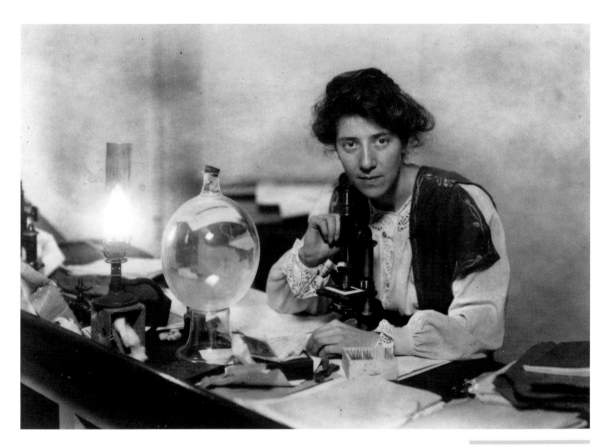

after his Nobel win. Manchester in Rutherford's time was a world centre for cutting-edge research in both theoretical and experimental physics and a magnet for international scholars such as Hans Geiger (1882–1945), who developed the first radiation counter there with Rutherford in 1908. Ernest Marsden (1889–1970) was still an undergraduate when he and Geiger performed one of the most famous experiments in the history of physics, firing a stream of alpha particles from a radioactive source at a thin sheet of gold foil and observing that the particles occasionally bounced back, as though powerfully repelled at particular points in the metal. Rutherford's explanation of this result gave the word *nuclear* to atomic science. Atoms, he decided, are composed mostly of empty space, with most of their mass packed into a tiny core or *nucleus* in the centre: the strong positive electrical charge on the nucleus repelled the particles if they happened to pass close to it. This picture was developed and revised by many researchers who spent time at Manchester in the 1910s, including Niels Bohr (1885–1962), who combined Rutherford's model with Max Planck's quantum theory to propose the orbital model of atomic structure, and James Chadwick (1891–1974), who years later made a major contribution to understanding the nucleus's structure with the discovery of the neutron.[78]

In 1904 the University of Manchester appointed its first female lecturer, Marie Stopes (1880–1958), who arrived with a PhD in palaeobotany from Munich

– completed in a single year, during which she was the sole woman among five hundred male students – and worked on coal deposits and seed ferns.[79] Stopes is better known, of course, for her activities in birth control and sex education, largely developed after she left Manchester. The early university had something of a habit of producing individuals with world-changing roles outside their fields of study. Chaim Weizmann (1874–1952), the Russian-Jewish, German- and Swiss-educated organic chemist, arrived in 1904 to work on fermentation and dyestuffs, later becoming reader in biochemistry; throughout his scientific studies, he was constantly active in the Zionist movement, and became, late in life, founding President of Israel.[80] Ludwig Wittgenstein (1889–1951), later one of the world's most influential philosophers, studied from 1908 to 1911 in aeronautical engineering, testing box kites at an atmospheric research station Schuster had developed in the hills above Glossop.[81]

The science of war and the struggles of industry

The First World War brought a tide of anti-German sentiment that ripped through Manchester's scientific culture. The German-born Arthur Schuster, who had been elected president of the British Association for the Advancement of Science for its upcoming meeting in Manchester in 1915, was attacked in the press and pressured by several high-profile scientists to resign his various positions, though most of the community supported him. Schuster was widely applauded when he delivered his presidential address on 'The common aims of science and humanity', championing the universal value of scientific inquiry against 'the spirit of evil that destroyed the sense of brotherhood among nations'; earlier that day, he had received the news that his son, an officer in the British Army, had been wounded in action.[82] Many scientists and engineers themselves went to war: Hans Geiger and Ernest Marsden, collaborators on the atomic deflection experiments, were at one point on active service on opposing sides of the same stretch of front line.

The iconic casualty was Henry Moseley (1887–1915), a rising star of Rutherford's lab, who fell to a sniper during the Gallipoli campaign aged 27. Moseley had established, on the basis of X-ray spectroscopy data, that the 'atomic number' assigned to chemical elements on the basis of their position in the periodic table could be taken as a direct indication of the nuclear charge, thus confirming Bohr's model of the atomic nucleus. It would have been 'far more useful,' wrote Rutherford in bitter frustration, to have employed his disciple 'in one of the numerous fields of scientific inquiry rendered necessary by the war than by exposure to the chances of a Turkish bullet'.[83] Moseley, in fact, had insisted on active service, but later governments adopted a tacit policy that such researchers should be saved from themselves.

The kind of inquiry Rutherford had in mind was typified by his own work for the wartime Admiralty's Board of Invention and Research, assessing proposals for submarines and related technologies including detection by acoustic sounding. With help on the theoretical side from his mathematical colleague Sir Horace Lamb

(1849–1934), whose specialisms included wave propagation, Rutherford spent much of the war testing potential devices, moving between an experimental tank of water in the laboratory basement and the naval test site at Aberdour in Fife, laying foundations for the ASDIC and sonar of later years.[84] The organic chemists found themselves in demand in explosives production, with Chaim Weizmann's fermentation processes yielding a crucial supply of the compound acetone. This brought Weizmann a national advisory role which had significant consequences for world history, as he deployed the resulting connections and goodwill in the Zionist cause, easing the path to the 1917 Balfour Declaration that favoured a Jewish national home in Palestine.[85] The Tech, meanwhile, put its engineering and material science expertise to work on projects ranging from gas shells to airship fabrics to cheaper wartime bread.[86]

With casualties from the war concentrated in temporary hospital facilities in the major urban centres, Manchester found itself treating over 200,000 soldiers. Grafton Elliot Smith, whose multifarious interests included brain morphology, worked on shell shock along with the young professor of psychology, Tom Hatherley Pear (1886–1972), arguing that severe cases were due to environment and experience rather than hereditary factors, and thus deserving of active intervention.[87] Harry Platt and Geoffrey Jefferson developed new surgical techniques, setting a course for peacetime approaches to injuries such as bone fractures.[88]

Post-war recovery was short-lived. With the downturn of the cotton trade, economic slump hit industrial Lancashire before it hit most of Europe, and lasted a brutally long time. Patronage opportunities dried up as the luckier of the region's magnates fled into retirement, taking their capital with them: in the words of John Pickstone, 'the epitaph of Lancashire cotton was written on the gravestones of

Hans Geiger (left) and Ernest Rutherford (right), University of Manchester, 1912. Rutherford had come to Manchester in 1907 to continue the research that was to establish atomic physics. In Manchester he worked with Geiger, and it was in 1913 that Geiger and Ernest Marsden concluded the gold foil experiments which proved essential in determining the nucleus nature of the atom.

Reproduced with permission from the University of Manchester

Bournemouth'.[89] The Tech, relying heavily on the ratepayers of Manchester, felt the strain particularly in this period, despite an overall growth in student numbers. Grand as it was, the Sackville Street building was overcrowded almost as soon as it was built, with courses and entire departments run from temporary outbuildings. A major planned extension, shelved for the duration of the First World War, was endlessly deferred through the Depression for want of funds: its steel skeleton finally went up just in time for war to halt the project again.[90]

Yet Manchester, with its diverse commercial and industrial base, was overall less hard-hit than the surrounding textile towns. Trafford Park survived, though Ford moved south to Dagenham in 1931. British Westinghouse had peeled away from its American parent, reconstituting around 1919 within the British-owned Vickers conglomerate under the new name Metropolitan–Vickers. 'Metrovicks' at Trafford Park was one of the foremost heavy engineering plants in the world, with international reputations in generators and turbines, transformers and railway electrification, later to be joined by electronics.[91] Chemical industry saw areas of growth: dyestuffs operations such as the British Alizarine Company, operating at Trafford Park from the 1920s, and Ivan Levinstein's works at Blackley in north Manchester, were progressively amalgamated into what became Imperial Chemical Industries (ICI) in 1926, aiding coordination with the alkali, pharmaceutical and synthetic textile sectors.[92] Industrial research for the textile trade was concentrated at the Shirley Institute in Didsbury, founded in 1920, which worked increasingly on synthetic fibres such as rayon.[93]

In chemical research, the university remained important through such researchers as Henry Roscoe's successor, H.B. Dixon (1852–1930), whose expertise on gas explosions found applications from mines to munitions; Arthur Lapworth (1872–1941), who succeeded William Perkin on the organic side, before switching to the inorganic and physical chair (remarkably, in what was already the era of the specialist) to succeed Dixon; and Lapworth's friend and assistant, Robert Robinson (1886–1975), who filled the organic vacancy, and was later to be president of the Royal Society. Robinson had been a postgraduate at Manchester alongside Gertrude Walsh (1886–1954), who was for a time Chaim Weizmann's research assistant; Robert and Gertrude married in 1912, and collaborated on research.[94]

In physics, the world reputation that had grown around Rutherford endured. Rutherford himself departed for Cambridge in 1919, though not before making the last of his famous subatomic discoveries, demonstrating the artificial disintegration of nitrogen by alpha-particle bombardment – an achievement memorialized as 'splitting the atom' in the city where the modern atomic theory had first taken hold. Rutherford's place as Langworthy professor passed to a crystallographer, Lawrence Bragg (1890–1971), whose X-ray diffraction techniques to reveal the atomic structures of crystals had made him the youngest-ever Nobel Physics prizewinner in 1915. Bragg's recruits included Arnold Beevers (1908–2001) and Henry Lipson (1910–91), creators of the Beevers–Lipson strip, the definitive 'paper technology' on which most crystallographers relied for calculations until electronic

computing power became cheaply available.[95] The university also boasted one of the country's most important specialists in automatic computation, the mathematician Douglas Hartree (1897–1958), who memorably built a differential analyser – a kind of analogue computer, using moving parts to solve equations – out of toy Meccano sets, proving the case for a more heavy-duty model which was manufactured by Metrovicks.[96]

In 1921 the University of Manchester hosted Albert Einstein, already world famous as the pioneer of relativity theory, for his first British lecture – a symbolic step in re-normalizing international scientific relations following the war. Einstein also addressed the university's Jewish Students' Society on the contemporary project for a Jerusalem University.[97] The academic community's internationalism and the strength of local Jewish networks were demonstrated in Manchester's response to the 1933 mass dismissal of Jewish and anti-Nazi scholars from German universities – although the chance to recruit some of Europe's most eminent and promising scientists was not merely a humanitarian matter. Physicists who were based temporarily in Manchester included Hans Bethe (1906–2005), Rudolf Peierls (1907–95) and, as anti-Jewish repression spread to Italy, Bruno Rossi (1905–93), all of whom went on to work on the atomic bomb project at Los Alamos and subsequently to campaign against nuclear proliferation. A permanent recruit was the physical chemist Michael Polanyi (1891–1976), known initially for his work on chemical dynamics.[98]

Patrick Blackett (1897–1974), a Rutherford disciple, succeeded Lawrence Bragg in the Langworthy chair in 1937. Blackett reoriented the Manchester department around cosmic ray physics, and was to receive the Physics Nobel Prize in 1948 for work developing the cloud chambers used to create visible evidence of cosmic rays and nuclear reactions. He was yet more influential, however, as a scientific administrator and policymaker promoting central research planning, a position closely tied to his left-wing politics. Blackett was to gain national importance in the Second World War, applying operational research (the applied science of decision making using systematic data collection) to radar and anti-aircraft strategy, though he would fall out with the post-war government over its decision to develop atomic weapons.

Remarkably, one of Blackett's closest friends in Manchester was his strongest theoretical opponent, the above-mentioned Michael Polanyi: spurred by his experience of totalitarianism, Polanyi wrote urgently against planned science as developed in the Soviet Union, and by non-Marxist leftists such as Blackett closer to home. In 1948 Polanyi exchanged his chemistry professorship for a personal chair in social studies, and spent most of the rest of his career preaching a philosophy of personal freedom in science, and the importance of 'tacit knowledge' – based on personally acquired contextual awareness and not reducible to formal evidence-handling rules – in all scientific innovation.[99]

Engineering remained strong at both Owens and the Tech. The new electrical applications found close links to industry through Miles Walker (1868–1941), a former designer at British Westinghouse, who took a professorship in the Faculty

Einstein visits Manchester, 1921

It was perhaps as a tribute to the intellectual independence of Manchester that Professor Einstein assumed, to all appearance, that the audience he was facing had its doubts about Relativity. He limited himself to demonstrating, by a close and strictly scientific argument, that Relativity was a true conception. Not in a single sentence did he allow himself to touch upon the philosophical implications of his discovery, though that would, no doubt, have been appreciated by his audience.

Dr Einstein began by explaining how the relation of geometry to physics had been modified by the development of the theory of Relativity. The first stone in the structure of that relationship was the fact that from the accepted propositions relating to the conduct of solid bodies in space certain other propositions could logically be deduced. The definition of this relationship almost reached finality with Euclid ... The truth of the axioms we had inherited from Euclid rested for a long time solely on what Dr Einstein called man's 'necessity to think'. They had become purely formal propositions, and the basis of a complex logical structure.

The whole development of physics had been founded on the acceptance of these axioms, but already the 'special' theory of Relativity ... had led to results that differed from the accepted axioms concerning the conduct of solids. That theory showed that length could not be an inherent property of matter, but that it had significance only in relation to a given observer ...

Manchester Guardian, 10 June 1921

Einstein's first lecture on his theory of relativity in Britain was given at the University of Manchester in 1921. He spoke in German with what the *Manchester Guardian* referred to as a 'kindly twinkle' in his eye. After leaving the lecture hall, he was cheered in the courtyard. Earlier in the day he had spoken to the University Jewish Students' Society about establishing a Jewish university in Jerusalem, a project for which he and Chaim Weizmann were among the leading proponents.

of Technology in 1912 and remained a consultant to Metrovicks. A similar hybrid role was played by the Burnley-born Willis Jackson (1904–70), who had spells at Owens, Metrovicks and the Tech before serving as Owens' professor of 'electro-technics' from 1938. Jackson was another strong advocate of technical education, and would later still be found at Metrovicks once again, directing the firm's apprentice school as well as its research department.[100] Notable inter-war graduates at Owens included Beatrice Shilling (1909–90), one of the electrical engineering programme's first two female students in 1929, who transferred to mechanical engineering for a Master's in 1932. Manifesting an impressively absolute disregard for conventional standards of middle-class womanhood, Shilling combined a career in aeronautics with a passion for high-performance motorbikes, lapping Brooklands at 106 miles per hour in 1934. She spent most of her career at the Royal Aeronautical Establishment, notably producing a modification to the Rolls-Royce Merlin carburettor (the 'RAE restrictor' or 'Tilly orifice') which greatly improved British aerial manoeuvrability in 1941.[101]

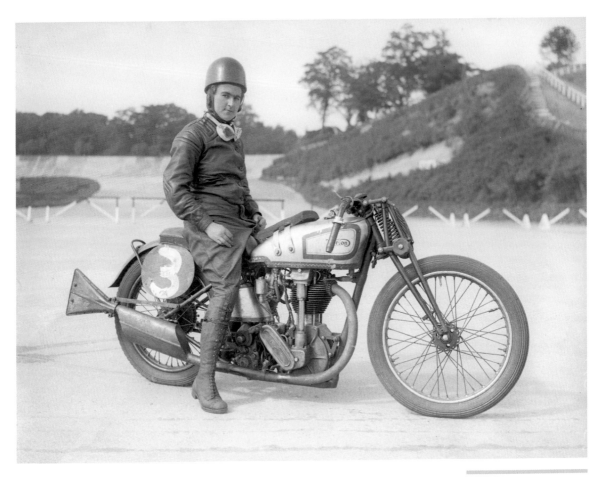

Among the many changes to medical technology in this period, radiation therapy stands out as uniquely Mancunian. Local specialists had been pushing since 1914 for a coordinated supply of medical radium; following a public appeal (with fundraising 'radium days'), and a substantial donation from the brewer Edward Holt, a Radium Institute was opened in 1921, merging in 1932 with the cancer hospital – now named the Christie Hospital, in honour of its founders – on a new site at Withington. The Holt Institute brought to Manchester a husband-and-wife pair of Edinburgh-trained specialists who were to influence cancer medicine internationally. Ralston Paterson (1897–1981), as director of the Institute, reorganized diagnosis and treatment on a regional basis and commissioned extensive clinical studies to determine the optimum doses of radiation for particular tumour cases, specifying them in a standardized form that could be exported to other facilities: institutions worldwide took up the 'Manchester system'. Concurrently, Edith Paterson (1900–95), initially working without salary at the Holt, became one of the founders of radiobiology, exploring the influence of radiation on human tissues: her original background in paediatrics proved particularly useful in developing local expertise in the treatment of childhood brain cancers.[102]

'Miss Beatrice Shilling sits astride her Norton motorcycle at the Brooklands race track', July 1935. Determined to pursue a career in engineering, Shilling was one of two female students who enrolled in 1929 to study electrical engineering at the University of Manchester, going on to complete a Master's degree in mechanical engineering. Her love of motorcycles led to her participating in many road and track races, making her a popular figure.

Fox Photos/Getty Images

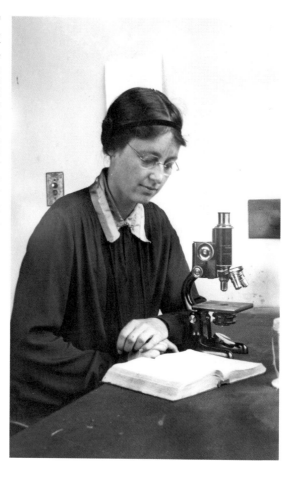

Perhaps the most unusual case of international recognition in this period was that of Kathleen Drew (1901–57), a star student in botany who became an assistant lecturer, specializing in red algae. In 1928 Drew married Henry Wright Baker (1893–1969), a mechanical engineer at Owens and later the Tech, who himself achieved passing fame for devising a means to open the fragile Copper Scroll found among the Dead Sea Scrolls in 1952. The university policy of the day prohibited the employment of spouses, so Drew-Baker continued her research unpaid as an honorary fellow, with aquaria built at the family home. In 1949 she published a key breakthrough in explaining the life cycle of *Porphyra*, a seaweed widely used for food in Japan. Building on her work, Japanese scientists developed new mass cultivation techniques which ended the often catastrophic problem of fluctuating harvests, allowing production on an industrial basis. In 1963 grateful farmers erected a memorial near Uto City, where an annual ceremony commemorates the 'Mother of the Sea'.[103]

Industrial production stepped up once more in the late 1930s as Britain prepared for the possibility of war. The Tech once again turned its laboratories to the supply effort, from the synthesis of desperately needed chemicals to the material properties of ropes and webbing.[104] The designers at Metrovicks underwent a

curious journey from generator turbines to turbojet engines for aviation, and the firm also produced bombers in association with A.V. Roe.[105] The old Ford factory at Trafford Park was refitted to produce Rolls-Royce aero-engines, and tank and gun parts poured out of the engineering shops of the region. The aircraft designer Roy Chadwick (1893–1947), who had been schooled in the drawing office of British Westinghouse and the night classes of the Tech before joining Avro, created the early long-range Manchester bomber and its iconic successor, the Lancaster.[106] Manchester and Salford's contributions to the war machine made them an obvious priority for German aerial attack. Among its other devastating effects, the 'Christmas Blitz' of 22–23 December 1940 had major consequences for the memorialization of Manchester science, as incendiaries completely burned out the Lit and Phil's premises on George Street. Among the wealth of historic materials lost were the carefully preserved room which had been Dalton's laboratory, and the majority of his papers, meaning that the most iconic Manchester scientist of all will never receive the detailed exploration afforded in later years to Newton and Darwin.[107]

Post-war renewal and white-heat visions

Manchester, like the country as a whole, was left battered and indebted by the war, with little to spend on new research and infrastructure; on the other hand, it enjoyed a powerful influx of expertise derived from wartime work. This was nowhere clearer than in Manchester's emergence at the forefront of electronic computing. The mathematician Max Newman (1897–1984) had developed top-secret codebreaking machines at Bletchley Park; in electrical engineering, Freddie Williams (1911–77) and Tom Kilburn (1921–2001) had worked together on radar, and had the idea of adapting the cathode ray tubes used for radar display into a data store. By mid-1948 the engineers had built a simple computer (the so-called 'Manchester Baby') around this principle: though only a prototype, this was the first machine ever to store instructions electronically in the same format as its data, thus demonstrating the essential properties of the architecture used for almost all computers ever since. The project evolved in close collaboration with the local engineering firm Ferranti, which in 1951 became the first organization to market and deliver an electronic computer, seeding short-lived but culturally resonant hopes of British dominance in a crucial new industry.[108]

A very different approach to computing came from Alan Turing (1912–54), another of Bletchley Park's silent heroes, and known publicly for his revolutionary 1930s work on computability theory. Appointed to the mathematics department in 1948, Turing was officially responsible for software on the Mark 1 stored-program computer project, but his restless mind quickly gravitated to the broader philosophical and scientific questions which the computer entailed. It was here that he prepared his famous 1950 contribution to the psychology journal *Mind*, on the question of whether machines in future might be defined as 'thinking': the answer, said Turing, was yes, if their responses to any given variety of questioning could not

The Manchester Mark 1. Here pictured in 1949, the Mark 1 grew out of the University of Manchester's 1948 'Baby', the first working prototype of an electronic digital stored-program computer. The original 'Baby' was essentially the left-hand half of the machine shown here: a working replica, built for the 1998 anniversary, is now on display at the Museum of Science and Industry. The original developers included, left to right: Dai Edwards, Frederic C. Williams, Tom Kilburn, Alec Robinson, G.E. ('Tommy') Thomas.

Courtesy of the School of Computer Science, University of Manchester

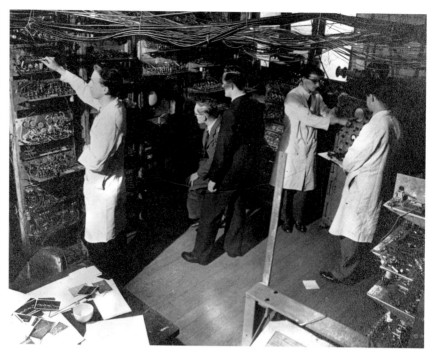

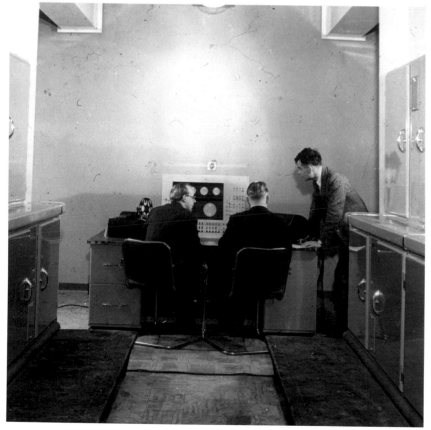

Alan Turing (standing) with two Ferranti engineers, Brian Pollard and Keith Lonsdale, at the console of the Ferranti Mark 1 in 1951. The first computer to be made commercially available, Ferranti's machine was based on the Manchester Mark 1 and produced in collaboration with the University. Turing was not closely involved in developing the hardware: his focus had shifted to the emerging new specialism of software design. A bronze statue in Sackville Park, unveiled in 2001, commemorates his wide-ranging significance as 'Father of Computer Science, Mathematician, Logician, Wartime Codebreaker, Victim of Prejudice'.

Courtesy of the School of Computer Science, University of Manchester

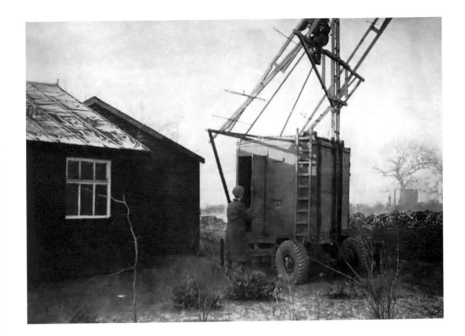

The first day at Jodrell Bank (right). The makeshift army-surplus equipment erected by Bernard Lovell and colleagues in December 1945, on a site then used by the university's botany department, gave way to highly sophisticated radio telescopes. The iconic 76-metre Mark I dish, built 1952–57 and later renamed in honour of Lovell, was joined in 1962 by the smaller, elliptical Mark II (below, with the Mark I in the background).

Reproduced with permission from the University of Manchester

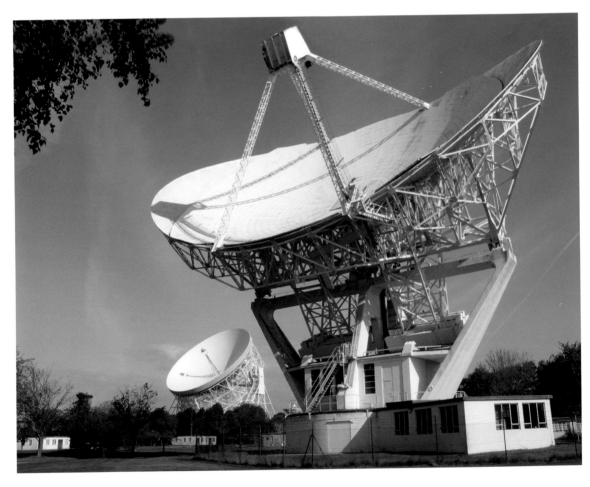

be convincingly distinguished from human responses. Turing's other focus in his final years was morphogenesis, the formation of asymmetry and patterns in biology, which he researched in collaboration with the botanist Claude Wardlaw (1901–85). Turing hoped to use the computer as a newly powerful tool to investigate how, given certain homogeneous conditions and rules, distinct patterns could emerge from apparently homogeneous starting materials. This remarkable sequence of investigations was cut short when Turing took his own life in 1954, two years after his conviction for 'gross indecency' and subjection to hormone injections intended to curb his homosexuality. Turing's death drew little attention outside his specialist subject community at first, but he has since gained an ever-growing reputation as an original thinker, national hero and victim of prejudice.[109]

The defining name in post-war Manchester science, as it turned out, belonged not to a person but to a place – and one which lay deliberately far from Manchester itself. Jodrell Bank owes its role in world history to the electric tramcars running up and down Oxford Road, a persistent source of interference for the cosmic ray detection experiments established by Patrick Blackett and managed by Bernard Lovell (1913–2012), another researcher with a wartime radar background. Enquiring after quieter university-owned properties led Lovell to a research outpost of the botany department, a little over 30 km away in the flat farming country of Cheshire.

Astrophysics soon became Jodrell Bank's main business. With the consulting engineer Charles Husband (1908–83), Lovell planned the vast, steerable Mark I radio telescope, 76 metres in diameter, which has towered incongruously over the plain since 1957. The assembly features one of the grandest cases of thriftily repurposed wartime surplus: two huge gun-turret bearings from battleships became its altitude rotators. The project's costs overran hugely but, with fairytale timing, the detector became operational just before the Soviet Union's launch of Sputnik 1, the first artificial satellite, and was the only radar device on earth that could track its carrier rocket. Building on this opportunity, Lovell showed great skill in handling both policymaking and public audiences to weave an integral role for the observatory in the national Cold War infrastructure and public consciousness, gaining powerful supporters such as Viscount Nuffield (1877–1963), the motor manufacturer, who personally ensured the clearance of the debt.[110]

Otherworldly visions were a useful tonic in a city with worldly problems. Though national standards of living were increasing, foreign competition had decisively undermined the textile base of Lancashire, and there seemed little chance of a return to manufacturing glory. Scientists less concerned with industrial applications unsurprisingly tended to seek greener spaces for contemplation in the south of England (or, preferably, in America, as the 'brain drain' took hold). Yet the Manchester ethic of inspiration amid toil retained some of its power. Anthony Sampson's state-of-the-nation study of 1962 emphasized that the 'blackened' buildings of the bleak Oxford Road site were lush territory for ideas, having spawned 'three Nobel Prize winners in a row' (the Langworthy succession

of Rutherford, Bragg and Blackett), while pleasanter campuses elsewhere were 'academic Siberia'.[111] The university certainly continued to produce significant achievements, particularly in the physical sciences. The mechanical engineering department under Jack Diamond (1912–90) in 1954 mounted the first nuclear engineering study programme in Europe, and from 1964 the university had a small-scale research reactor of its own, built at Risley near Warrington as a joint venture with the University of Liverpool.[112]

Manchester also remained at the forefront of British computing. A series of further collaborations between the university and Ferranti included Atlas, which on its inauguration in 1962 was the fastest and most powerful computer in the world. Only three Atlas machines were constructed (one for Manchester, one for the University of London and one for the Harwell/Chilton site housing the Atomic Energy Research Establishment), but the project spawned several important new technologies and conceptual innovations. A separate venture was the National Computing Centre of 1966, offering advice, training and advocacy for computer users from a modernist building on Oxford Road.[113]

The Tech, meanwhile, was to transform itself for a second time in response to national policy concerns. Vivian Bowden (1910–89) arrived as principal in 1953 following an engineering career which spanned wartime radar, the Atomic Energy Research Establishment and Ferranti, where he had been – as he realized only in hindsight – the world's first computer salesman, writing explanatory literature and lobbying firms that knew nothing of the new digital technology. Bowden was an early exemplar of the mood that new technologies were fundamentally trans-forming the world, economically and socially, and must be grasped to avoid ruin: under the banner of 'White Heat', the position was later picked up by Harold Wilson's Labour administration, in which Bowden would serve as Minister for Education and Science between 1964 and 1965. This was the sole interruption in a 23-year career devoted to remaking the College of Technology into what he termed 'industry's university', with research, rather than teaching, at the forefront.[114]

The long-awaited Sackville Street extension, finally completed in 1957 to a 1927 design (to the great mystification of architectural critics), was followed by a rapid swing to modernity. With remarkable speed the site expanded, deftly incorporating the railway viaduct to its south, and sweeping away slum housing and the former factories fringing the filthy river Medlock to erect a compact but well-ordered statement of white-tile, white-heat progress. In 1966 the Tech gained the last in its procession of variant names: UMIST, standing for University of Manchester Institute of Science and Technology – amplifying outsiders' confusion over its relationship to the established University of Manchester, from which it was now more separate than ever, being effectively a university in its own right.[115]

UMIST shifted rapidly to embrace international research agendas, yet its roots in local industrial training made it distinctive: the Tech's brewing chemistry group was the seed of a biochemistry department, while 'municipal engineering' was restructured into the modern civil and structural specialisms. Important

niches included corrosion science research and paper science, in the latter of which UMIST provided practically the entire national teaching capacity. In the 1970s these approaches were joined by new ventures including molecular biology and precision instrumentation.[116] The UMIST vision allowed from the outset that training scientists and engineers required some level of humanities and social-science skills: in industrial administration and labour organization theory (or 'management sciences', as it became); in marketing; in European studies; and in the history of science and technology, where Donald Cardwell (1919–98) developed an influential research group attuned to the international significance of the Manchester story. It was Cardwell's group that provided the initial impetus for the North Western Museum of Science and Industry which opened in 1969, finally fulfilling nineteenth-century aspirations for a showcase of industrial equipment.[117]

The evening classes and non-degree teaching which had once been the Tech's core mission, meanwhile, were gradually transferred to a variety of colleges still under municipal control. One of these was a new foundation, the John Dalton College of Technology, by means of which one of the world's most eminent school-masters finally gave his name to a teaching establishment. As a stand-alone institution it was short-lived, however, combining in 1970 with the city's existing College of Art and College of Commerce to form the multi-site Manchester Polytechnic. Focusing particularly on professional and vocational courses, the 'Poly' grew significantly over the following years, in part through the absorption of other colleges in the city. When the government decided to remove the binary divide in higher education in 1992, the polytechnic became Manchester Metropolitan University, and, like the Tech before it, began to look increasingly to research opportunities.[118] Yet the institution retains its teaching and local community focus, and the Faculty

North Western Museum of Science and Industry, Grosvenor Street, 1978. The long-discussed idea for a science and technology museum in Manchester was revived in the 1960s, a project in which Donald Cardwell and other historians of science and technology from UMIST were prominent. A museum was opened in 1969 in the former Manchester Unity Oddfellows building in Grosvenor Street. Its eye-catching mural was designed by Ken Billyard.

Copyright David Dixon

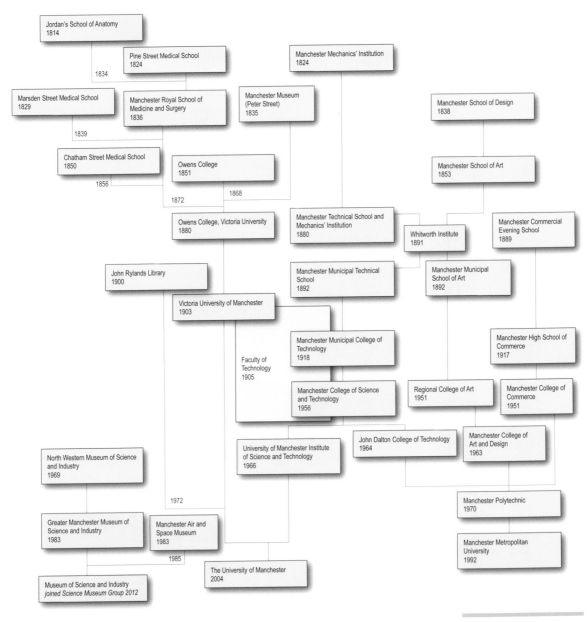

Jordan's School of Anatomy
1814

Pine Street Medical School
1824

Manchester Mechanics' Institution
1824

1834

Marsden Street Medical School
1829

Manchester Royal School of
Medicine and Surgery
1836

Manchester Museum
(Peter Street)
1835

Manchester School of Design
1838

1839

Chatham Street Medical School
1850

Owens College
1851

Manchester School of Art
1853

1856

1872

1868

Owens College, Victoria University
1880

Manchester Technical School and
Mechanics' Institution
1880

Whitworth Institute
1891

Manchester Commercial
Evening School
1889

John Rylands Library
1900

Manchester Municipal Technical
School
1892

Manchester Municipal
School of Art
1892

Victoria University of Manchester
1903

Manchester Municipal College of
Technology
1918

Manchester High School of
Commerce
1917

Faculty of
Technology
1905

Manchester College of Science
and Technology
1956

Regional College of Art
1951

Manchester College of
Commerce
1951

North Western Museum of Science
and Industry
1969

University of Manchester Institute
of Science and Technology
1966

John Dalton College of Technology
1964

Manchester College of
Art and Design
1963

1972

Greater Manchester Museum of
Science and Industry
1983

Manchester Air and
Space Museum
1983

Manchester Polytechnic
1970

1985

The University of Manchester
2004

Manchester Metropolitan
University
1992

Museum of Science and Industry
joined Science Museum Group 2012

Development of major
teaching and research
institutions in Manchester

of Science and Engineering remains headquartered in the John Dalton College building, with a bronze copy of the original Dalton statue keeping guard outside.

Quiet but momentous developments were meanwhile under way in medical and healthcare research. ICI's pharmaceutical division, based at Alderley Park in the Cheshire countryside between Macclesfield and Knutsford, had built a programme around the principle of 'rational drug design', targeting research efforts to particular disease problems, with a keen eye on international markets. In 1964 James Black (1924–2010) produced the first effective beta blockers, used to treat

conditions from angina to stage-fright; two years later, Dora Richardson (1919–98) synthesized tamoxifen, which – in a perfect demonstration of the limits of the 'rational' – was originally proposed as a morning-after contraceptive, but is familiar now as the most widely used drug for treating breast cancer, and the first drug to be approved as a cancer preventative.[119] At Wrightington, near Appley Bridge in west Lancashire, the local orthopaedic expertise that had grown up around Harry Platt had its legacy in the work of John Charnley (1911–82), pioneer of the hip replacement operation.[120] A much greater fanfare attended the birth of the world's first *in-vitro* fertilized ('test-tube') baby, Louise Brown, in 1978, through the work of Patrick Steptoe (1913–88) and Robert Edwards (1925–2013) at the Centre for Human Reproduction in Oldham. The university and hospital systems remained tightly meshed on Oxford Road. In 1974 Jean McFarlane (1926–2012) took up a professorship of nursing – the first in England – and oversaw the development of a research programme.[121]

Manchester's scientific-industrial complex was now more closely planned and integrated than ever; yet it remained at the mercy of national and international changes. The docklands and Ship Canal were the most high-profile casualties of the 1960s, as container standardization inspired a shift to larger ships that could not negotiate the channel; Trafford Park, correspondingly, declined as production diffused to the wider region.[122] Growing interest in industrial heritage had a double-edged significance: a key priority of the Museum of Science and Industry was to rescue plant and tools as the factories closed. Similarly, the North West Industrial Research Unit, set up by geographers at the university, did its most important work in establishing the scale and nature of job losses.[123] Academic researchers themselves experienced the same difficulty. In 1973 Vivian Bowden had characterized 1960s technical education as a peculiar process whereby around half of all British talent was exported to the USA and Canada, to be replaced by imported skills from India and Africa.[124] The sudden halting of the American research and development boom with the oil shock blocked this emigration route and generated a major scramble for jobs, at a time when universities were again going into downturn. The University of Manchester's Stopford Building, opened in 1973 and housing a new Medical School, represented the last gasp for major new laboratory and teaching projects for some considerable time.[125]

The 1980s onwards: new uncertainties, new opportunities

The Thatcher years saw the decline in status which was already under way through de-industrialization further heightened by increasing national-level policy control and the hollowing-out of regional planning. The post-Bowden UMIST, suffering internal strife and hit hard by the highly selective University Grants Committee cuts of 1981, wobbled dangerously. It was rescued by a shrewd programme of retrenchment and development under a new principal, Harold Hankins (1930–2009), a notable defender of union representation and another Metropolitan–Vickers

product who had taken evening classes at the Tech. Commercializing research was key to the revival; so was the recruitment of overseas students, mainly at postgraduate level. The survival strategy proved its worth from the mid-1980s as central government began to link funding explicitly to research output. From its roots in elementary teaching, UMIST had shifted, remarkably, to become one of the most research-focused institutions in the British system.[126]

The University of Manchester's biggest changes came in the life sciences. The prominent public successes of physics, astronomy and computer science, and the sustained expansion of chemistry and clinical medicine, had left biology as something of a poor relation. Nationally, the local culture was seen as old-fashioned, focusing heavily on comparative physiology as researchers found excitement increasingly in genetics and cell biology. Where these trends demanded cross-disciplinary working, the university's biologists were strongly compartmentalized into biology, zoology and *two* biochemistry departments, sprung separately from chemistry and medicine. These structures were abruptly replaced with a unified School of Biological Sciences, closely tuned to government funding priorities in molecular methods and medical applications. The approach was controversial, leading a number of specialists to move elsewhere, but was overall lucrative, particularly from the mid-1990s when the Wellcome Trust committed multi-million pound sponsorship to develop expertise on the properties and interactions of the cell matrix, the molecular 'glue' that holds cells together. In a significant reversal, it was the life sciences which ended up leading the University of Manchester's sally into the new breed of commercialization. What became known as spin-out companies, set up to exploit biotechnology and related research with commercial potential, were housed from 1999 in a dedicated 'Incubator Building', physically connected to the main bioscience core, which could shelter them through the years of trials and regulatory negotiation needed to secure investors' confidence.[127]

The vision of Manchester as ripe for renewal through an industrial revolution of a new kind remained powerful. Efforts in the 1990s focused on the idea of the 'information city', embracing such pioneer projects as the Manchester Host network, incorporating public email access; a Manchester Communities Information Network and 'electronic village halls' for community engagement; and the G-MING high-speed networking ring. The fiftieth anniversary of the 'Manchester Baby' computer in 1998 was marked by grand civic celebrations with keen support from International Computers Limited (ICL), the conglomerate formed as a national flag-carrier in a Wilsonian burst of optimism around 1968, which was still active at various sites around Manchester and proudly continued the heritage of the Ferranti collaborations.[128]

The vision struggled to take hold, however, as the internet rolled out with surprising rapidity as a mundane phenomenon internationally; suddenly, every city was an 'information city'. ICL, meanwhile, was in course of acquisition by Fujitsu of Japan, and soon ceased to trade on its history; the National Computing Centre, too, lost much of its purpose in a routinized and internationalized IT world. Even in

success areas, the ethic of the uniquely Mancunian was becoming harder to articulate: Jodrell Bank continued to operate its iconic telescope, no longer as a splendid Cold War exception, but alongside other sites running the full breadth of central England as part of the MERLIN array. The university's School of Computer Science has maintained its distinctive hardware design culture, however, with projects directed by the former microcomputer designer Steve Furber, including the Amulet processor series and SpiNNaker neural net architecture intended for experimental brain modelling.

Policy wisdom increasingly dictated that the future for post-industrial cities lay not in remaking industrial identity but in leisure, culture and services. This had consequences for higher education: as one journalist put it, 'students, not iron or coal or china clay, are the new natural resource'.[129] An expanding student base implied broad subject coverage, with strong provision for the arts and humanities – which the University of Manchester had, but UMIST did not. In research, on the other hand, it was UMIST, with its strong commercialization agenda, which best fitted the increasingly marketized national notion of what a university ought to be. Among the leaders of both institutions, support began to grow for the idea of a merger, the aim being to create one 'world-leading institution' which would finally banish the hovering question marks over Manchester's position on the international scientific stage.

The two universities formally dissolved in 2004 and reconstituted as a new foundation – inevitably christened the University of Manchester, though some had favoured a new name honouring Dalton. In a last gasp of the Tech–Owens tradition of befuddling outsiders, the institution's logo proclaimed it to be 'Est[ablished] 1824', commemorating both the Mechanics' Institution and the Pine Street Medical School, one of the roots of Owens. The university was in truth far more of a twenty-first-century foundation, headquartered on Oxford Road but departing from Owens traditions. The School of Biological Sciences' successes were rewarded with autonomous status as a Faculty of Life Sciences. A new building rose for mathematics, photon science and astrophysics, roofed by a vast photovoltaic array to reduce power consumption, and was named the Alan Turing Building.

The initial strategy was to affirm international status through widely understood markers such as an increased tally of Nobel prizewinners – somewhat awkwardly, as this amounted at first to hiring in talent. Some necessary reassurance came in 2010 with a home-grown accolade: Andre Geim and Konstantin Novoselov won the Physics Nobel jointly for their techniques to produce crystallites of graphene, a material consisting of carbon atoms arranged in a two-dimensional lattice: recent years have seen a 'gold rush' of investigations into the potential uses of graphene in applications as diverse as logic circuits, biofuel distillation, radioactive contamination cleanup and artificial bone tissue.

A National Graphene Institute opened in 2015, with a Graphene Engineering Innovation Centre scheduled to join it in 2017. The new focus draws on local strengths in chemistry, polymer science, nanomaterials, electronics and signalling,

but has particularly served to consolidate the historical reputation of physics – a field already riding high, at least in recruitment terms, thanks to the media profile of Brian Cox, particle physicist, ex-rock keyboardist and television personality. Novoselov succeeded Geim as Langworthy professor in 2013: the Langworthy chair has now been graced by five Nobel-winning physicists, and has understandably been used for promotional purposes by the university, much as Cambridge uses the Lucasian chair of Newton, Babbage and Hawking.

The future of Manchester's unique scientific, technological and medical culture is profoundly uncertain – but then, it always was. In the run-up to the university merger, *Nature* had dared to whisper that the 'golden triangle' of London, Oxford and Cambridge might be balanced by a new northern triangle, perhaps bounded by Liverpool, Sheffield and Newcastle, with Manchester its beating heart.[130] The succeeding years have seen little redistribution, however, and even some concentration of research funds in the south; and yet the national budget of 2015 boomed the prospect of a 'Northern powerhouse', again Manchester-centred and tied firmly to scientific-industrial prospects such as graphene. Designated European City of Science for 2016, Manchester continues to build on its legacy with prominent contributions to radioastronomy, logic circuitry, chemical engineering, biotechnology, community medicine and a host of other fields; and it continues to

National Graphene Institute. Andre Geim displays a cleanroom laboratory to Chinese president Xi Jinping during his state visit to the UK in October 2015, accompanied by chancellor of the exchequer George Osborne, president and vice-chancellor of the University of Manchester Dame Nancy Rothwell, and Geim's fellow Nobel laureate Kostya Novoselov. Work at the Institute focuses on developing and commercializing applications for graphene, promoted by the university as 'Manchester's revolutionary two-dimensional material'.

Reproduced with permission from the University of Manchester

seek technical and social fixes to the consequences of an industrial culture which for two centuries reached as far and as fast as possible.

One notable outcome has been reflexive: Manchester is a noted centre for the heritage, history and wider examination of science, technology and medicine. The North Western Museum, with its commitment to preserving heavy industrial machinery, quickly outgrew its original premises; increasingly a city council project, it moved in 1983 to the huge site of the abandoned Liverpool Road freight complex, where the Museum of Science and Industry continues as a popular visitor attraction. It has been the headquarters since 2007 of an annual Manchester Science Festival, part of a concerted science policy trend to engage with public audiences, and since 2012 has been part of the national Science Museum Group, allowing a greater focus on research.

At the University of Manchester, meanwhile, the biochemist Fred Jevons (1929–2012) had developed a programme in 'Liberal Studies in Science' from the 1960s. From this sprang a science policy research group and, in 1986, a Centre for the History of Science, Technology and Medicine (CHSTM). John Pickstone (1944–2014), the founder of CHSTM, had previously worked with Donald Cardwell at UMIST and developed an innovative programme to integrate the study of science, engineering, industry, medicine and healthcare under a common framework, guided particularly by insights from the history of medicine and social policy, and above all by the lessons of Manchester – an approach which has been widely adopted internationally and which, of course, informs the structure and coverage of this chapter.[131] CHSTM has recently developed a specialism in science communication studies, and works with the museum and with other local institutions to bring history to a wider audience.

Notes

1. J. Rampling, ed., 'John Dee and the sciences: early modern networks of knowledge', *Studies in History and Philosophy of Science Part A*, Special Issue, 43 (2012), pp. 432–549.

2. A. Chapman, 'Jeremiah Horrocks, William Crabtree, and the Lancashire observations of the transit of Venus of 1639', in D.W. Kurtz, ed., *Transits of Venus: New Views of the Solar System and Galaxy*, 196th colloquium of the International Astronomical Union, Cambridge: Cambridge University Press, 2004, pp. 3–26.

3. A. Thackray, 'Natural knowledge in cultural context: the Manchester model', *American Historical Review*, 79 (1974), p. 675.

4. S. Butler, 'White, Charles (1728–1813)', *Oxford Dictionary of National Biography* [hereafter *ODNB*].

5. W.V. Farrar et al., 'The Henrys of Manchester, part 1. Thomas Henry (1734–1816)', *Ambix*, 20 (1973), pp. 183–208.

6. T. Henry, 'On the advantages of literature and philosophy in general', *Memoirs of the Literary and Philosophical Society of Manchester*, 1 (2nd edn, 1789), pp. 7–29.

7. W. Henry, 'A tribute to the memory of the late president of the Literary and Philosophical Society of Manchester', *Quarterly Journal* (1819), pp. 1–21.

8. A. Musson and E. Robinson, *Science and Technology in the Industrial Revolution*, Manchester: Manchester University Press, 1969, pp. 93–6.

9. J. Pickstone and S. Butler, 'The politics of medicine in Manchester, 1788–1792: hospital reform and public health services in the early industrial city', *Medical History*, 28 (1984), pp. 227–49.

10. Farrar, 'Thomas Henry', p. 190.

11. Pickstone and Butler, 'Politics of medicine'; J. Young, *St Mary's Hospitals, Manchester, 1790–1963*, Edinburgh: Livingstone, 1964.

12. A. Booth, 'Popular loyalism and public violence in the north-west of England, 1790–1800', *Social History*, 8 (1983), pp. 295–313.

13. For the later appropriation of Percival's work, see R. Baker, 'Deciphering Percival's code', *Philosophy and Medicine*, 45 (1993), pp. 179–211.

14. For Dalton's life and work, see A. Thackray, *John Dalton: Critical Assessments of his Life and Science*, Cambridge, MA: Harvard University Press, 1972; F. Greenaway, *John Dalton and the Atom*, London: Heinemann, 1966.

15. J. Dalton, 'Extraordinary facts relating to the vision of colours', *Memoirs of the Literary and Philosophical Society of Manchester*, 5 (1798), pp. 28–43.

16. W.V. Farrar et al., 'The Henrys of Manchester, part 6. William Charles Henry: the magnesia factory', *Ambix*, 24 (1977), pp. 17–18.

17. R. Kargon, *Science in Victorian Manchester: Enterprise and Expertise*, Baltimore, MD: Johns Hopkins University Press, 1977, p. 32.

18. M. Nevell, *Manchester: The Hidden History*, Stroud: History Press, 2008, pp. 93–134.

19. R. Lloyd-Jones and M.J. Lewis, *Manchester and the Age of the Factory*, London: Croom Helm, 1988, pp. 155–91.

20. Musson and Robinson, *Science and Technology*, pp. 427–72.

21. A. Musson, 'Joseph Whitworth and the growth of mass-production engineering', *Business History*, 17 (1975), pp. 109–49; N. Atkinson, *Sir Joseph Whitworth: 'The World's Best Mechanician'*, Stroud: Sutton, 1997.

22. A. Briggs, *Victorian Cities*, New York: Harper and Row, 1965, pp. 92–4.

23. Quoted in T. Wyke with H. Cocks, *Public Sculpture of Greater Manchester*, Liverpool: Liverpool University Press, 2004, p. 118.

24. Kargon, *Science*, p. 35.

25. R.S. Fitzgerald, *Liverpool Road Station, Manchester: An Historical and Architectural Survey*, Manchester: Manchester University Press, 1980, pp. 22–4.

26. Kargon, *Science*, pp. 60–77, 94.

27. D. Cardwell, *James Joule: A Biography*, Manchester: Manchester University Press, 1991, is the source of this and the following paragraphs.

28. O. Sibum, 'Reworking the mechanical value of heat: instruments of precision and gestures of accuracy in early Victorian England', *Studies in History and Philosophy of Science Part A*, 26 (1995), pp. 73–106.

29. Quoted in Cardwell, *James Joule*, p. 41.

30. Kargon, *Science*, pp. 44–5.

31. S. Alberti, *Nature and Culture: Objects, Disciplines and the Manchester Museum*, Manchester: Manchester University Press, 2009, pp. 10–25; Kargon, *Science*, pp. 24–7, 61–3.

32. R.G. Kirby, 'An early experiment in workers' self-education: the Manchester New Mechanics' Institution, 1829–35', in D. Cardwell, ed., *Artisan to Graduate: Essays to Commemorate the Foundation in 1824 of the Manchester Mechanics' Institution*, Manchester: Manchester University Press, 1974, pp. 87–98.

33. *Supplement to the New Moral World*, 23 May 1840, p. 1245. My thanks to Erin Beeston for this reference.

34. *New Moral World*, 18 February 1843, p. 275; J. Watts, *Robert Owen: The Visionary*, Manchester: Abel Heywood, 1843, p. 8; and for his influence, G. Claeys, 'Engels' *Outlines of a Critique of Political Economy* (1843) and the origins of the Marxist critique of capitalism', *History of Political Economy*, 16 (1984), pp. 207–32. A translation of Engels's essay is available at the Marxists Internet Archive Library, https://www.marxists.org.

35. Kargon, *Science*, pp. 16–19; R. Bud, 'The Royal Manchester Institution', in D. Cardwell, ed., *Artisan to Graduate: Essays to Commemorate the Foundation in 1824 of the Manchester Mechanics' Institution*, Manchester: Manchester University Press, 1974, pp. 119–33.

36. J. Pickstone, 'Ferriar's fever to Kay's cholera: disease and social structure in Cottonopolis', *History of Science*, 22 (1984), pp. 401–19; R. Selleck, 'The Manchester Statistical Society and the foundation of social science research', *Critical Studies in Education*, 11 (2006), pp. 53–63.

37. C. Hamlin, *Public Health and Social Justice in the Age of Chadwick*, Cambridge: Cambridge University Press, 1998.

38. Kargon, *Science*, pp. 117–22.

39. P. Reed, *Acid Rain and the Rise of the Environmental Chemist in Nineteenth-Century Britain*, Farnham: Ashgate, 2014.

40. J. Wetton, 'John Benjamin Dancer: Manchester instrument maker', *Bulletin of the Scientific Instrument Society*, 29 (1991), pp. 4–8; Cardwell, *Joule*, p. 63.

41. M. Tylecote, 'The Manchester Mechanics' Institution, 1824–1850', in D. Cardwell, ed., *Artisan to Graduate: Essays to Commemorate the Foundation in 1824 of the Manchester Mechanics' Institution*, Manchester: Manchester University Press, 1974, p. 77.

42. W. Gee, rev. F. James, 'Sturgeon, William (1783–1850)', *ODNB*.

43. Kargon, *Science*, pp. 92–3.

44. Kargon, *Science*, pp. 141–3.

45. J. Thompson, *The Owens College: Its Foundation and Growth*, Manchester: J.E. Cornish, 1886, pp. 194–7; E. Fiddes, *Chapters in the History of Owens College and of Manchester University, 1851–1914*, Manchester: Manchester University Press, 1937, pp. 26–7.

46. C. Russell, *Edward Frankland: Chemistry, Controversy and Conspiracy in Victorian England*, Cambridge: Cambridge University Press, 1996.

47. Kargon, *Science*, pp. 167–82; H.B. Charlton, *Portrait of a University, 1851–1951*, Manchester: Manchester University Press, 1951, pp. 53–68.

48. T. Seccombe, rev. A. Buchanan, 'Whitworth, Sir Joseph (1803–1887)', *ODNB*.

49. Kargon, *Science*, pp. 182–90.

50. J. Pickstone, 'Williamson, William Crawford (1816–1895)', *ODNB*.

51. H. Roscoe, *Description of the Chemical Laboratories at the Owens College, Manchester*, Manchester: J.E. Cornish, 1878; Kargon, *Science*, p. 178.

52. Kargon, *Science*, pp. 195–6; J. Morrell, 'W.H. Perkin, junior, at Manchester and Oxford: from Irwell to Isis', *Osiris*, 2nd series, 8 (1993), pp. 104–26.

53. J. Pickstone, *Medicine and Industrial Society: A History of Hospital Development in Manchester and its Region, 1752–1946*, Manchester: Manchester University Press, 1985, pp. 186–7.

54. P. Mohr, 'Dreschfeld, Julius (1845–1907)', *ODNB*.

55. G. Tweedale, 'Geology and industrial consultancy: Sir William Boyd Dawkins (1837–1929) and the Kent coalfield', *British Society for the History of Science*, 24 (1991), pp. 435–51.

56. Alberti, *Nature and Culture*, pp. 20–38.

57. Charlton, *Portrait of a University*, p. 53.

58. W.V. Farrar, 'Edward Schunck, F.R.S., a pioneer of natural-product chemistry', *Notes and Records of the Royal Society*, 31 (1977), pp. 273–96; 'Opening of the Schunck Laboratory', *Manchester Guardian*, 2 July 1904, p. 6.

59. Kargon, *Science*, pp. 80–5.

60. Kargon, *Science*, pp. 64–6.

61. M.J. Cruickshank, 'From Mechanics' Institution to Technical School, 1850–92', in D. Cardwell, ed., *Artisan to Graduate: Essays to Commemorate the Foundation in 1824 of the Manchester Mechanics' Institution*, Manchester: Manchester University Press, 1974, pp. 134–56; Kargon, *Science*, p. 206.

62. J.D. Marshall, 'John Henry Reynolds: pioneer of technical education in Manchester', *Vocational Aspect*, 16 (1964), pp. 176–96.

63. C. Cohen, 'The early history of chemical engineering: a reassessment', *British Journal for the History of Science*, 29 (1996), pp. 171–94.

64. P.J. Short, 'The Municipal School of Technology and the university, 1890–1914', in D. Cardwell, ed., *Artisan to Graduate: Essays to Commemorate the Foundation in 1824 of the Manchester Mechanics' Institution*, Manchester: Manchester University Press, 1974, pp. 157–64; Cruickshank, 'From Mechanics' Institution', pp. 152–3.

65. K. Kilburn, 'The Godlee Observatory in Manchester, England', *Journal of the Antique Telescope Society*, 23 (2002), pp. 19–24.

66. D. Farnie, *The Manchester Ship Canal and the Rise of the Port of Manchester, 1894–1975*, Manchester: Manchester University Press, 1980.

67. R. Nicholls, *Trafford Park: The First Hundred Years*, Chichester: Phillimore, 1996.

68. Short, 'Municipal School', pp. 163–4; W.E. Morton, 'The Manchester College of Science and Technology, 1914–1956', in D. Cardwell, ed., *Artisan to Graduate: Essays to Commemorate the Foundation in 1824 of the Manchester Mechanics' Institution*, Manchester: Manchester University Press, 1974, pp. 167–207.

69. Pickstone, *Medicine and Industrial Society*, pp. 188–9.

70. E. Magnello, *A Centenary History of the Christie Hospital, Manchester*, Manchester: Christie Hospital NHS Trust, 2001, p. 17; Pickstone, *Medicine and Industrial Society*, pp. 193–4.

71. M. Worboys, 'Delépine, Auguste Sheridan (1855–1921)', *ODNB*.

72. S. Butler, 'Academic medicine in Manchester: the careers of Geoffrey Jefferson, Harry Platt and John Stopford, 1914–39', *Bulletin of the John Rylands University Library of Manchester*, 87 (2005), pp. 133–66.

73. W. Dawson, ed., *Sir Grafton Elliot Smith: A Biographical Record by his Colleagues*, London: Jonathan Cape, 1938.

74. Alberti, *Nature and Culture*, pp. 65–73.

75. K. Sheppard, 'Between spectacle and science: Margaret Murray and the Tomb of the Two Brothers', *Science in Context*, 25 (2012), pp. 525–49.

76. *The Physical Laboratories of the University of Manchester: A Record of 25 Years' Work*, Manchester: Manchester University Press, 1906; Kargon, *Science*, pp. 226–32; T.E. Broadbent, *Electrical Engineering at Manchester University: 125 Years of Achievement*, Manchester: University of Manchester School of Engineering, 1998, pp. 26–66.

77. Charlton, *Portrait of a University*, pp. 78–96.

78. Anecdotes of the Rutherford period, and several of the major papers, are collected in J.B. Birks, ed., *Rutherford at Manchester*, London: Heywood, 1962.

79. W. Chaloner, 'The palaeobotanical work of Marie Stopes', in A.J. Bowden et al., eds, *The History of Palaeobotany*, London: Geological Society, 2005, pp. 127–35.

80. C. Weizmann, *Trial and Error*, London: Hamish Hamilton, 1949.

81. I. Lemco, 'Wittgenstein's aeronautical investigation', *Notes and Records of the Royal Society*, 61 (2007), pp. 39–51.

82. L. Badash, 'British and American views of the German menace in World War I', *Notes and Records of the Royal Society*, 34 (1979), pp. 95–8; A. Schuster, 'The common aims of science and humanity', *Science*, new series, 42 (1915), pp. 397–413.

83. *Nature*, 9 September 1915, pp. 33–4; J. Heilbron, *H.G.J. Moseley: The Life and Letters of an English Physicist, 1887–1915*, Berkeley, CA: University of California Press, 1974, pp. 124–5.

84. J. Campbell, *Rutherford: Scientist Supreme*, Christchurch, New Zealand: AAS, 1999, pp. 360–74; S. Katzir, 'Who knew piezoelectricity? Rutherford and Langevin on submarine detection and the invention of sonar', *Notes and Records of the Royal Society*, 66 (2012), pp. 141–57.

85. G.B. Kauffman and I. Mayo, 'Chaim Weizmann (1874–1952): chemist, biotechnologist, and statesman', *Journal of Chemical Education*, 71 (1994), pp. 209–14.

86. H. Hankins and T. Yates, 'Tech and the two world wars, 1903–51', in B. Pullan et al., eds, *A Portrait of the University of Manchester*, London: Third Millennium, 2004, pp. 36–7.

87. E. Jones, 'Shell shock at Maghull and the Maudsley: models of psychological medicine in the UK', *Journal of the History of Medicine and Allied Sciences*, 65 (2010), pp. 384–5.

88. Pickstone, *Medicine and Industrial Society*, pp. 205, 207–8.

89. J. Pickstone, 'Before and after the Second World War', 2007, http://www.chstm.manchester.ac.uk/public/manchester/beforeandafterthe2ndww/ (accessed 2 January 2016).

90. A. Fowler and T. Wyke, *Many Arts, Many Skills: The Origins of the Manchester Metropolitan University*, Manchester: Manchester Metropolitan University, 1993, pp. 41–2.

91. J. Dummelow, *Metropolitan–Vickers Electrical Company, Ltd., 1899–1949*, Manchester: Metropolitan–Vickers, 1949; R. Jones and O. Marriott, *Anatomy of a Merger: A History of G.E.C., A.E.I. and English Electric*, London: Cape, 1970.

92. G. Timmins, *Made in Lancashire: A History of Regional Industrialisation*, Manchester: Manchester University Press, 1998, pp. 312–13.

93. M. Sawbridge, ed., *The Story of Shirley*, Manchester: Shirley Institute, 1988.

94. W. Cocker, 'Chemistry in Manchester in the twenties, and some personal recollections', *Natural Product Reports (Royal Society of Chemistry)*, 4 (1987), pp. 67–72; T. Williams, 'Robinson, Sir Robert (1886–1975), also including Gertrude Maud Robinson (1886–1954)', *ODNB*.

95. M.M. Woolfson, 'Henry Lipson (1910–1991)', *Acta Crystallographica Section A*, 47 (1991), pp. 635–6.

96. M. Croarken, *Early Scientific Computing in Britain*, Oxford: Clarendon Press, 1990, pp. 50–3.

97. *Manchester Guardian*, 10 June 1921, pp. 6–7; R. Clark, *Einstein: The Life and Times*, London: Hodder and Stoughton, 1973, pp. 262–4.

98. B. Williams, *'Jews and Other Foreigners': Manchester and the Rescue of the Victims of European Fascism, 1933–1940*, Manchester: Manchester University Press, 2011, pp. 34–57.

99. M.J. Nye, *Blackett: Physics, War, and Politics in the Twentieth Century*, Cambridge, MA: Harvard University Press, 2004; M.J. Nye, *Michael Polanyi and his Generation: Origins of the Social Construction of Science*, Chicago: University of Chicago Press, 2011.

100. T. Cooper, 'The science–industry relationship: the case of electrical engineering in Manchester, 1914–1960', PhD thesis, University of Manchester, 2003.

101. M. Freudenberg, *Negative Gravity: A Life of Beatrice Shilling*, Creech St Michael: Charlton, 2003.

102. E.H. Burrows, 'Paterson, (James) Ralston Kennedy (1897–1981), also including Edith Isabel Myfanwy Paterson (1900–1995)', *ODNB*.

103. J. Brodie, 'Drew, Kathleen Mary (1901–1957)', *ODNB*; 'The mother of the sea', radio broadcast, BBC Radio 4, 8 September 2014.

104. Hankins and Yates, 'Tech', p. 40.

105. J. Whitfield, 'Metropolitan Vickers, the gas turbine, and the state: a socio-technical history, 1935–1960', PhD thesis, University of Manchester, 2012.

106. M. Dove, 'Roy Chadwick', 1996, http://www.transporttrust.com/10065.html (accessed 2 January 2016).

107. Some manuscripts survived, however, and are now carefully preserved at the John Rylands Library. For details, see A. Smyth, *John Dalton, 1766–1844: A Bibliography of Works by and about Him*, Manchester: Manchester University Press, 1966; D. Leitch and A. Williamson, *The Dalton Tradition*, Manchester: John Rylands University Library, 1991.

108. S. Lavington, *A History of Manchester Computers*, 2nd edn, Swindon: British Computer Society, 1998; G. Tweedale, 'Marketing in the second industrial revolution: a case study of the Ferranti computer group, 1949–63', *Business History*, 34 (1992), pp. 96–127.

109. A. Hodges, *Alan Turing: The Enigma*, London: Vintage, 2012.

110. J. Agar, *Science and Spectacle: The Work of Jodrell Bank in Post-War British Culture*, Amsterdam: Harwood, 1998; M. Edmonds, '"When they come to model Heaven": big science and the monumental in post-war Britain', *Antiquity*, 84 (2010), pp. 774–95.

111. A. Sampson, *Anatomy of Britain*, London: Hodder and Stoughton, 1962, p. 207.

112. M. Razey, 'The universities research reactor', *Electronics and Power*, 10 (1964), pp. 372–3.

113. J.D. Humphries, 'Britain's National Computing Centre: a progress report', *Electronics and Power*, 14 (1968), pp. 141–3.

114. K.M. Entwhistle, 'Bowden, (Bertram) Vivian, Baron Bowden (1910–1989)', *ODNB*.

115. D.E. Hodgson, 'UMIST today', in D. Cardwell, ed., *Artisan to Graduate: Essays to Commemorate the Foundation in 1824 of the Manchester Mechanics' Institution*, Manchester: Manchester University Press, 1974, pp. 231–47.

116. H. Hankins, 'The creation and development of UMIST, 1951–2004', in B. Pullan et al., eds, *A Portrait of the University of Manchester*, London: Third Millennium, 2004, p. 63.

117. R. Hills, 'The North-Western Museum of Science and Industry: some reminiscences', 2013, http://www.chethams.org.uk/digital_resources/north_western_museum_of_science_and_industry.pdf (accessed 2 January 2016).

118. Fowler and Wyke, *Many Arts*, pp. 70–4.

119. V. Quirke, 'Targeting the American market for medicines, ca. 1950s–1970s: ICI and Rhône-Poulenc compared', *Bulletin of the History of Medicine*, 88 (2014), pp. 654–96.

120. J. Anderson, 'Innovation and locality: hip replacement in Manchester and the North West of England', *Bulletin of the John Rylands Library*, 87 (2005), pp. 155–66.

121. H. Valier, 'The Manchester Royal Infirmary, 1945–97: a microcosm of the National Health Service', *Bulletin of the John Rylands Library*, 87 (2005), pp. 167–92.

122. A. Kidd, *Manchester: A History*, 4th edn, Lancaster: Carnegie, 2006, p. 189.

123. B. Pullan, *A History of the University of Manchester, 1973–90*, Manchester: Manchester University Press, 2004, p. 7.

124. V. Bowden, 'The present situation', in D. Cardwell, ed., *Artisan to Graduate: Essays to Commemorate the Foundation in 1824 of the Manchester Mechanics' Institution*, Manchester: Manchester University Press, 1974, p. 253.

125. B. Pullan, 'The University of Manchester, 1951–92', in B. Pullan et al., eds, *A Portrait of the University of Manchester*, London: Third Millennium, 2004, p. 52.

126. Hankins, 'Creation', pp. 64–6.

127. D. Wilson, *Reconfiguring Biological Sciences in the Late Twentieth Century*, Manchester: University of Manchester Faculty of Life Sciences, 2008.

128. J. Agar, S. Green and P. Harvey, 'Cotton to computers: from industrial to information revolutions', in S. Woolgar, ed., *Virtual Society? Technology, Cyberbole, Reality*, Oxford: Oxford University Press, 2002.

129. P. Barker, 'The great McUniversity take-away', *Guardian*, 7 June 1994, p. 18.

130. P. Smaglik, 'Northern England: rising star', *Nature*, 425 (25 September 2003), pp. 430–3.

131. See, in particular, J. Pickstone, *Ways of Knowing: A New History of Science, Technology and Medicine*, Chicago: University of Chicago Press, 2001.

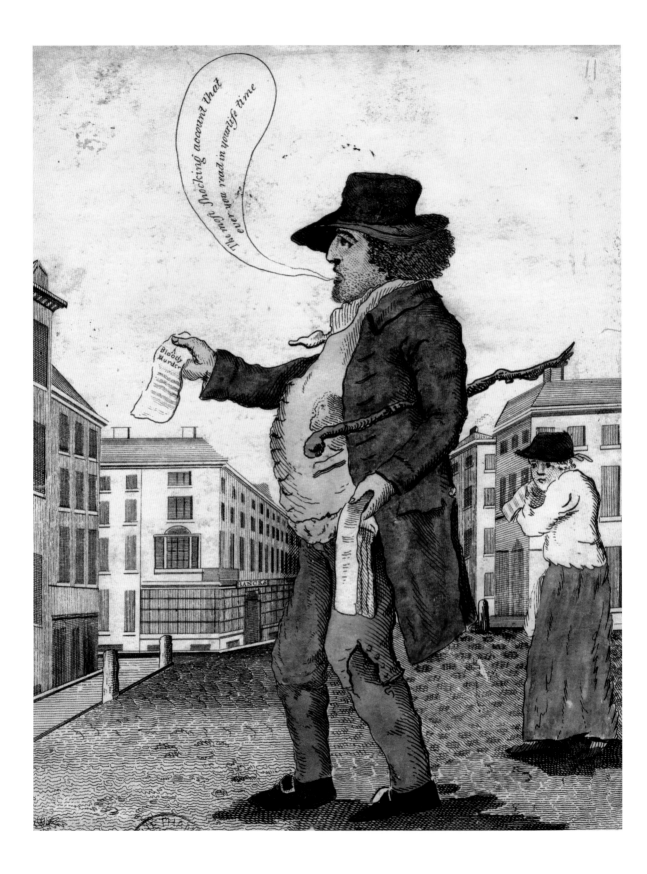

CHAPTER FOUR

Voices of the People

MICHAEL E. ROSE

Monday 16 August 1819 was arguably the single most important day in the history of Manchester. On that day a peaceful crowd of men and women in their tens of thousands who had gathered to support the cry for parliamentary representation were attacked by soldiers on horseback. The Peterloo Massacre not only caught the headlines of the moment but also captured the imagination of succeeding generations. Manchester continued to give voice to protest movements in the battle for the ballot, from Peterloo through the era of Chartism and on to the fight for women's suffrage at the beginning of the twentieth century. However, the city was also the ideological home of the middle-class radicalism of the free trade movement that sought to unite the classes against aristocratic privilege and in favour of the free market. As a result the association of Manchester with the philosophy of economic liberalism is inescapable, and its premier public hall was famously named after an intellectual proposition rather than the usual royal or religious figure. Less often acknowledged is Manchester's connection with the opposing ideology of revolutionary communism. This was the city studied by Friedrich Engels that provided the inspiration for Karl Marx's analysis of capitalism. In the event, Marx and Engels were to bemoan the reformist character of the British working class for working within the system rather than setting out to destroy it. Manchester symbolizes this as the home of the first ever Trades Union Congress in 1868.

Manchester was a city of contrasts. Despite the role of slave-produced cotton in creating much of Manchester's wealth, some of its citizens were at the forefront of the campaign against slavery and its voice was heard across the Atlantic during the American Civil War. The city was home to many radical voices, few more purposeful than those of Emmeline Pankhurst and her daughters as the Women's

Ballad seller, Manchester. Ballad sellers and singers were part of the street life of nineteenth-century Manchester, and whether they were regarded as an amusement or an aural nuisance would depend on the contents of the ballads as well as where they were selling them.

Courtesy of Chetham's Library

VOICES OF THE PEOPLE 171

Social and Political Union added civil disobedience and direct action to the armoury of the campaign for votes for women. In the twentieth-century era of universal suffrage, political action has focused on parliamentary and municipal campaigns. However, Manchester has also seen direct action and organized protest, from the unemployed workers' movement of the 1930s to the gay rights activists of the 1980s and after. These were all 'Manchester voices'.

Radical voices

An estimated 60,000 people gathered at St Peter's Field in Manchester on 16 August 1819 to hear the celebrated orator, Henry Hunt, speak on the necessity of parliamentary reform. The local magistrates, fearing an outbreak of violence, ordered constables to force their way through the crowd and arrest Hunt before he could begin his speech. When the constables proved unable to reach the platform, the amateur cavalry of the Lancashire and Cheshire Yeomanry were sent in to clear the way. Armed with sabres, they attempted to force a path through the crowd. This attempt led to chaos, so the professional troops of the 125th Hussars charged into the crowd. Amateur and professional soldiery alike used their sabres, some with the cutting edge. Estimates of the numbers killed and injured in the crowd have varied, but the most recent study of the casualty lists has found 18 deaths and 654 wounded, some seriously.[1]

The presence of newspaper reporters on the hustings, including John Tyas of *The Times*, meant that news of the event spread rapidly throughout the country. 'Peterloo Massacre' proclaimed a pamphlet advertised by James Wroe (1788–1844), editor of the radical *Manchester Observer*. This ironical name was based on the fact that some of the soldiers who charged into the crowd had taken part in the battle of Waterloo four years earlier. The name stuck. To have been present at Peterloo, or even to claim a relative who had been there, became a badge of popular radicalism. 'Think on lad', says the elderly workman, pointing to the blood-encrusted sabre hanging above his deathbed, to the young hero of Howard Spring's novel, *Fame is the Spur*.[2]

Historians have argued, often vehemently, over the affair. Robert Walmsley, in a lengthy study, has defended the decision to arrest Hunt and disperse the crowd.[3] In 1817 the authorities had successfully dispersed a gathering in St Peter's Field to support a march to London by distressed weavers, each carrying a blanket to sleep in en route. Most of these 'blanketeers', pursued by magistrates and militia, got no further than Stockport. A fortnight later a meeting in Ardwick was raided to prevent an attempt to 'make a Moscow of Manchester'. In 1818 a cotton spinners' strike led to an attack on a mill that was still working. Militia were called out and arrests made. Thus the orderly, almost military, manner in which workers from outside Manchester marched to St Peter's Field in 1819, together with reports that some were carrying clubs, led to fears of further violence and attacks on property.

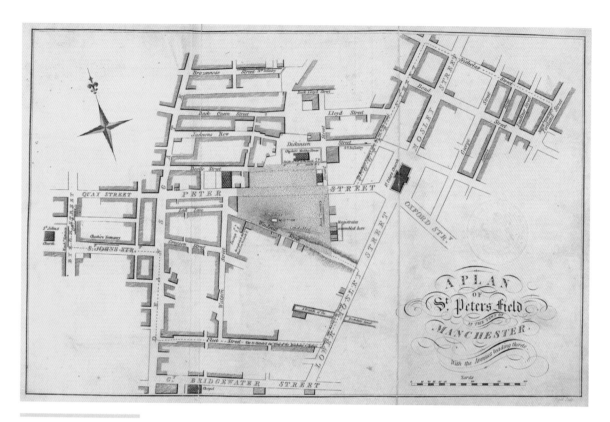

Plan of St Peter's Field, 1819. Peterloo took its name from the open space between Windmill Street and Peter Street on which the meeting was held. The land was subsequently built upon, becoming home to prominent public buildings including the Natural History Museum (1835), Free Trade Hall (1840) and Theatre Royal (1846).

A more neutral view by historians like Joyce Marlow and Donald Read was that, given the primitive state of Manchester's local government, the constables had no concept of crowd control.[4] Resort to the military was inevitable, causing panic in the crowd and death or injury from being crushed or trampled on. Left-wing historians, notably E.P. Thompson, will have none of this. Peterloo, Thompson wrote, was 'without exception a formative experience in British political and social history ... within two days all England knew of the event'.[5] Organized workers, especially those in the cotton mills of Manchester, were abandoning the old language of 'Church and King' loyalism and, inspired by writers and speakers such as William Cobbett, Richard Carlile and Henry Hunt, were seeing themselves as a class, exploited by their employers.

One of the best-known first-hand accounts of Peterloo is that contained in Samuel Bamford's *Passages in the Life of a Radical* (1844).[6] This has fostered the idea that many of those taking part came from communities outside Manchester, like Bamford's Middleton. Recent study of the casualty lists, however, indicates that the bulk of the crowd were from Manchester, particularly from the rapidly growing inner suburb of Ancoats where large steam-powered spinning mills had been established. This had been the site of unrest when strikes led employers to recruit non-unionized, often Irish, immigrant workers or 'knobsticks'. The young Friedrich Engels (1820–95), born in the year after Peterloo, came to Manchester in 1842 and

Remembering Peterloo

On the cavalry drawing up they were received with a shout of good-will, as I understood it. They shouted again, waving their sabres over their heads; and then, slackening rein, and striking spur into their steeds, they dashed forward and began cutting the people … On the breaking of the crowd the yeomanry wheeled, and, dashing whenever there was an opening, they followed, pressing and wounding. Many females appeared as the crowd opened; and striplings or mere youths also were found. Their cries were piteous and heart-rending; and would, one might have supposed, have disarmed any human resentment: but here their appeals were in vain. Women, white-vested maids, and tender youths, were indiscriminately sabred or trampled; and we have reason for believing that few were the instances in which that forbearance was vouchsafed which they so earnestly implored.

In ten minutes from the commencement of the havoc the field was an open and almost deserted space. The sun looked down through a sultry and motionless air. The curtains and blinds of the windows within view were all closed. A gentleman or two might occasionally be seen looking out from one of the new houses before mentioned, near the door of which a group of persons (special constables) were collected, and apparently in conversation; others were assisting the wounded or carrying off the dead. The hustings remained, with a few broken and hewed flag-staves erect, and a torn and gashed banner or two dropping; whilst over the whole field were strewed caps, bonnets, hats, shawls, and shoes, and other parts of male and female dress, trampled, torn, and bloody. The yeomanry had dismounted – some were easing their horses' girths, others adjusting their accoutrements, and some were wiping their sabres. Several mounds of human beings still remained where they had fallen, crushed down and smothered. Some of these still groaning, others with staring eyes, were gasping for breath, and others would never breathe more. All was silent save those low sounds, and the occasional snorting and pawing of steeds. Persons might sometimes be noticed peeping from attics and over the tall ridgings of houses, but they quickly withdrew, as if fearful of being observed, or unable to sustain the full gaze of a scene so hideous and abhorrent.

Samuel Bamford, *Passages in the Life of a Radical* (1844)

Of the many eyewitness accounts of the Peterloo Massacre, the most powerful and most frequently quoted was that provided by Sam Bamford (1788–1872) who led the Middleton contingent to the meeting, and was subsequently arrested, tried and imprisoned. Bamford's recollections of the day were written and published in the early 1840s, by which time he was distancing himself from the more radical ideas of his youth, and being lionized by members of Manchester's middle class such as Elizabeth Gaskell who was to find a place for him in her first novel, *Mary Barton. A Tale of Manchester Life* (1848). The photograph shows Bamford in later life, by then an essayist and poet, as well as retired political activist.

Courtesy of Chetham's Library

befriended a factory worker, Mary Burns (1823–63). She introduced him to Ancoats and the life of the workers. Engels came to read Manchester as an expression of the geography of social class. The proletariat were formed in the industrial suburbs of Ancoats, Chorlton-on-Medlock and Hulme. Their employers, the bourgeoisie, were separately housed in the pleasanter districts of Ardwick, Rusholme and the 'breezy heights of Cheetham Hill'.[7]

There was no repeat of Peterloo, but Manchester remained prone to violent protest. In 1832 the discovery, before burial, of a young cholera victim's headless body led to suspicion of body snatchers and an attack on the Ancoats cholera hospital. Soldiers at Hulme barracks were put on readiness to control an angry crowd, but the protestors were dispersed by the intervention of a Catholic priest.

Two sociopolitical issues which aroused popular protest in the 1830s were the Ten Hours Movement for factory reform and attempts to impose the Poor Law Amendment Act of 1834 on communities in the north of England. Both the South Lancashire Anti-Poor Law Association and the Factory Ten Hours Movement had bases in Manchester, but their campaigns, sometimes arousing violent protest, were in the smaller towns and communities of Lancashire and the West Riding of Yorkshire. Manchester, with its press and printing facilities, was a convenient base but little more. The anti-Poor Law campaign, however, soon dissolved into a movement in which Manchester's radical voice was clearly heard, that of Chartism.

The People's Charter, with its six demands for universal suffrage, annual parliaments, vote by ballot, payment for MPs, equal electoral districts and the abolition of property qualifications for electors and elected, struck a familiar note in the political radicalism of Manchester. The demands had been voiced at Peterloo. The Chartist leader, Feargus O'Connor (1794–1855), came to Manchester in the autumn of 1838 to attend a large demonstration on Kersal Moor, outside the town. Here Joseph Rayner Stephens (1805–79), a prominent agitator in the anti-Poor Law campaign, spoke of Chartist demands as being a 'knife and fork question, a bread and butter question', appealing to the hard-pressed workers of Manchester.[8] R.J. Richardson (1808–61) was chosen by the assembly as Manchester's delegate to the Chartist convention in London, the 'People's Parliament' of 1839. Its petition to the Westminster Parliament with over a million signatures was rejected.

In the following year a delegate meeting at the Griffin Inn, Ancoats, founded the National Charter Association 'to obtain a full and faithful representation of the entire people in the House of Commons'.[9] In August 1840 a rally was organized to welcome two Chartist leaders, John Collins (1802–52) and Peter McDouall (1814–54), on their release from prison. A procession starting in Stevenson Square wound its way through the town to the Crescent in Salford, then back to Carpenters' Hall and from there to a dinner at the recently opened Hall of Science in Campfield, whose 'socialist community' the young Friedrich Engels was soon to join.[10]

The rejection by Parliament of a second Chartist petition in 1842, together with a severe economic depression in the factory districts of Lancashire and Cheshire, brought Chartist-led demonstrations of protest. An open-air meeting on

Mottram Moor in August decreed that all labour should cease until the Charter became the law of the land. A similar resolution was carried a week later by the executive council of the National Charter Association meeting at Dr Scholefield's chapel in Ancoats.[11] Unemployment brought demonstrations of protest, much of it local and uncoordinated, although the authorities were alarmed by the so-called 'Plug Plot' in which dissatisfied workers were alleged to be going round factories withdrawing plugs from the boilers of steam engines, thus bringing production to a standstill. Troops were moved into the disaffected districts. *The Times* reported two thousand soldiers and six pieces of artillery on the streets of Manchester.[12] Two policemen were killed, but there was no repeat of Peterloo. Major General Napier (1782–1853), commander of the Northern District from 1839, regarded Manchester as the centre of the insurrectionary movement. However, he and his subordinate there, Colonel Wemyss, were content with a show of force rather than any rash intervention. Demonstrations, such as the welcome for McDouall and Collins, proceeded in an orderly fashion. Large demonstrations were held on the moors above the town, the sight of their torches as night fell doubtless worrying the Manchester bourgeoisie, but causing them no physical harm.

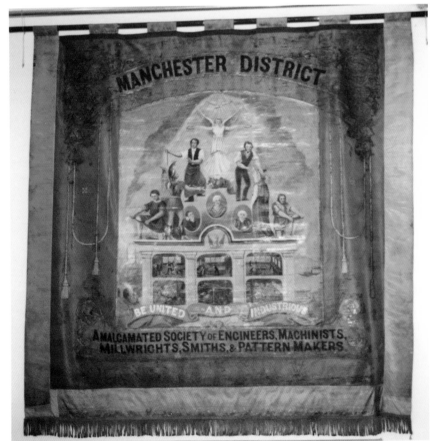

Amalgamated Society of Engineers, Manchester District banner. James Sharples's competition-winning design for an emblem for the Amalgamated Society of Engineers in 1851 combined classical and modern images and symbolism, including portraits of Arkwright, Crompton and Watt. It was reproduced on membership cards and certificates as well as banners.

By permission of the People's History Museum

With the rejection of the second Charter and O'Connor's move to London in 1843, Manchester ceased to be central to the Chartist movement. Another convention was held there in 1845. It agreed to cease its opposition to the repeal of the Corn Laws, a cause which had come to dominate Manchester's radicalism. In 1848, 'the year of revolutions', there were cannons in the street but a march on the town by factory workers and coalminers was persuaded to turn back. Chartism's last leader, Ernest Jones (1819–69), moved from Manchester to London. He agitated for reform, defended the Fenians accused of murdering a police sergeant in 1867, and stood (unsuccessfully) for a Manchester parliamentary seat in 1868. He died the following year with a large crowd attending his burial in Ardwick cemetery.[13] Chartism's last leader might have been dead but the radical voice was not silenced.

A voice increasingly heard in the industrializing Manchester of the early nineteenth century was that of the organized working class. Nowhere was this more distinct than in the growth of trade unionism. Repeal of the Combination Acts in 1824 gave trade unions the stamp of legality, but their origins pre-dated this. Two groups of skilled male workers in Manchester who best reflected the rise of organized labour were the cotton spinners and the mechanical engineers. Both were essential to the working of the complex machinery operating in the mills of Manchester's inner suburbs. Prominent in the spinners' organization was an Irish immigrant, John Doherty (1798–1854). Doherty arrived in Manchester in 1816 and found employment at Adam and George Murray's large spinning mill in Ancoats. From the first, Doherty became involved in union organization. Imprisoned for his activities in 1819, he resumed employment on his release and, in 1828, was elected secretary of the Manchester Cotton Spinners' Union. He attempted to form a Grand General Union of Spinners, and a National Association for the Protection of Labour. In 1830 he launched a newspaper, *The Voice of the People*, giving prominence to trades union activities, and to those of the factory movement and the anti-Poor Law campaign. He remained, however, his biographers argue, a trade unionist concerned with the improvement of working conditions in factories and the defence of the pay and status of his members.[14]

Doherty's arguments for a wider unionization of working people have led to his being seen as an advocate for the ideas of Robert Owen (1771–1858). Owen, in the early part of his life, was the manager of a Manchester cotton mill before moving to Scotland to manage and then own a large cotton manufactory at New Lanark. Distressed by the cut-throat nature and injustice of the capitalist system he had witnessed in Manchester, he not only devised more humane systems of work at New Lanark but also argued in his book, *A New View of Society*, for more communal, co-operative systems of production.[15] However, such ideals had little appeal to hard-headed, skilled workers intent on improving their place within a capitalist system. Doherty's Grand General Union of Cotton Operatives of the United Kingdom collapsed in 1830 after a call for a general strike failed. The attempt to found a general union of all trades, the National Association for the

Protection of Labour, lasted only two years. As a result, the Manchester Spinners' lost members and influence.

Another skill essential to the cotton industry and many others was mechanical engineering. The Journeymen Steam Engine and Machine Makers, the 'Old Mechanics', formed a union in 1826. Without Owenite ideals, they played an important part in the foundation of the Amalgamated Society of Engineers in 1851. Controlling entry to the trade through apprenticeships and negotiating with employers over wages and working conditions, they emphasized the essential respectability of trades unions, a 'new model', abhorring violence and striking only as a last resort. Together with other skilled workers, they formed a Manchester and Salford Trades Council in 1867 to bring together local unions, though with no radical or revolutionary aims. In 1868 they convened the first Trades Union Congress, which met in Manchester in June of that year at the Mechanics' Institution in Princess Street.[16] The importance of the skilled, male labour voice in the city was confirmed.

Another modification of the Owenite ideal of co-operation was launched in 1844, not in Manchester but in the nearby textile town of Rochdale. A store was opened where members of its co-operative society could purchase goods, especially groceries, of good quality and at a fair price. Members received an annual dividend on their purchases. Other industrial towns followed suit. A meeting room and, often, a library above the store gave an improving, educational element to commercial proceedings. In 1863 a Co-operative Wholesale Society (CWS) opened

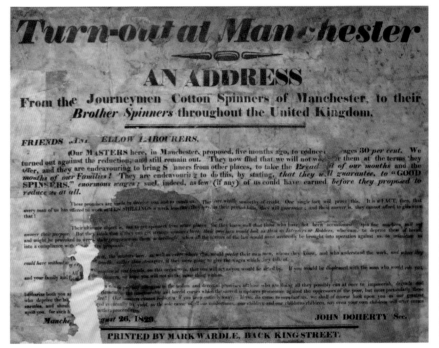

Address from the Journeymen Cotton Spinners of Manchester, 1829. John Doherty was the leading figure in the movement to establish trade unions in the factory-based cotton industry. The Manchester spinners' failure to resist wage cuts in 1829 spurred him on to establish a Grand General Spinners' Union and the National Association for the Protection of Labour.

By permission of the People's History Museum

in Balloon Street, Manchester, providing essential goods bought in bulk to its retail store members. It expanded into the manufacture of popular lines, like biscuits, and then into services such as insurance and banking. By the later nineteenth century its buildings dominated the eastern end of the city around Victoria railway station.[17] As with the trades unions, Manchester's radical voices adjusted their tone to the tenor of nineteenth-century capitalism.

Voices of the middle classes

The social structure of industrial Manchester had no landed aristocracy at its head. The town was surrounded by landed estates, but their wealthy owners preferred the society of rural Cheshire, Staffordshire or Derbyshire to the ferment of a growing manufacturing town. Although remaining lords of the manor until 1846, the Mosley family had by the 1780s left Ancoats Hall for their estate at Rolleston in Staffordshire, the hall later being acquired and rebuilt by a newly enriched cotton spinner, George Murray (1761–1855). By 1795 the only family of antiquity remaining close to the town was the de Traffords of Trafford Hall.

Divisions within the middle classes were religious and political rather than economic. Dominant in the government of the eighteenth-century town were the 'Church and King' Tories, worshippers at, and officers of, the parish church. Influential in the town's medieval organs of government such as its Court Leet and socializing together at John Shaw's Punch Club in Market Place, they regarded with horror the events of the French Revolution and the unrest of the post-Napoleonic

years, culminating in Peterloo. Those opposing them were men of similar occupations, merchants, manufacturers and professions, but often nonconformist or dissenting in religion and Whig/Radical in politics. Particularly influential were the Unitarians, based at Cross Street chapel. Many of them were professional men and women, critical of the establishment and of Manchester's antiquated system of government.

The old political system was not wholly incapable of reform. While an attempt in 1763 to make Manchester a municipal borough failed, 1792 saw the passage of the Manchester and Salford Police Act. This established an elected Police Commission charged with the duties of lighting, scavenging, drainage of the streets and the maintenance of public order. One of its most important achievements was the provision, in 1817, of a gasworks. An Act of 1824 gave the Police Commission's Gas Committee, a publicly funded body, power to trade in the open market.[18]

The Tory-controlled Police Commission struggled to keep pace with the rapid growth of a town whose population increased from 70,000 in 1801 to 142,000 at the census of 1831. As Peterloo showed, the Commission's powers of crowd control were severely tested by popular demonstrations, while the sanitary state of the town necessitated the establishment of a voluntary, doctor-led Board of Health to deal with the cholera epidemic of 1832.[19] That year saw the passage of a parliamentary reform act. This widened the franchise, although since it remained a propertied vote at the £10 householder level, it was far from achieving the universal suffrage demanded by the Peterloo demonstrators. It did, however, give separate parliamentary representation to Manchester, which hitherto had shared its MPs with the county of Lancashire. Manchester became a parliamentary borough returning two members to Westminster. One of those elected in 1832

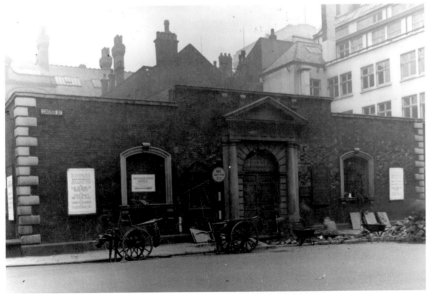

Cross Street chapel, 1940. The chapel, opened as the Dissenters Meeting House in 1694, became an important reference point in the religious and political history of Manchester. Bombed in 1940, it was demolished and a new chapel opened in 1959.

Courtesy of Manchester Libraries, Information and Archives, Manchester City Council

was Mark Phillips (1800–73), a worshipper at Cross Street chapel, who retained the seat until 1847.

This strengthening of the liberal/nonconformist position in Manchester politics brought with it a demand for reform of the town's 'medieval' system of local government. The Municipal Corporations Act of 1835 gave the opportunity for towns like Manchester to petition for inclusion under the Act as a municipal borough, with ratepayer-elected councillors. A young calico manufacturer, Richard Cobden (1804–65), led a group of middle-class reformers campaigning for change. In an influential pamphlet, *Incorporate Your Borough* (1837), Cobden lampooned the absurdities of the existing system.

> Is it that in this great town of Manchester, we are still living under the feudal system? Does Sir Oswald Mosley, living up in Derbyshire, send his mandate down for us to come into this dingy hole to elect a government for Manchester and then go and get a ticket for soup at his expense?

Cobden described his attendance at the Court Leet when summoned there as a juror. 'The atmosphere of the room was heavy and stale ... to the left of the door lay a heap of sawdust ... a filthy white dog with black spots had curled himself upon this tempting bed'. It was here that the jurors 'penned within a small enclosure at the furthest extremity of the room' chose the persons to fill the offices – borough-reeve and constables of Manchester – before seven spectators, the police constables and the dog.[20] In January 1838 a public meeting at the Thatched House Tavern called for a petition to the Queen in Council requesting a Charter of Incorporation under the Act of 1835. The campaign was hard fought. Not only did the Tories, who controlled the existing system, naturally oppose the idea, but so did working-class radicals, some of whom feared that a new body might introduce the rigours of the New Poor Law. The petition for incorporation got 11,830 signatures but a counter-petition from opponents was said to have 31,947 signatures. An inquiry by the Privy Council found many of the latter signatures invalid, though there was still a small majority opposed. However, when a second Privy Council inquiry was called, opponents refused to take part and a Charter of Incorporation was issued. Manchester became a municipal borough ruled by a mayor, 16 aldermen and 48 councillors elected from 15 wards. Municipal reform had been achieved, though only narrowly.

Toryism fought a rearguard campaign, denying the council access to the Town Hall on King Street and making various legal challenges for the next three years. The Police Commissioners only relinquished power in 1843, and the Court Leet met for the last time in 1845. A year later, Sir Oswald Mosley (1785–1871) sold his manorial rights to the borough council, giving it crucial control over the borough's markets. In 1853 Manchester acquired civic status. The voice of liberal nonconformity had triumphed.[21]

Manchester 'belonged definitely to the superior class of capital cities ... a city with a soul, it stood for an idea'.[22] That idea was free trade. The prominent target for those holding that idea were the Corn Laws, notably that of 1815. This prohibited the import of grain, especially wheat, from abroad until the domestic price had reached 80 shillings a quarter. This was seen as increasing the price of bread, the staple of a worker's diet. Banners at Peterloo had demanded the repeal of the 'bread tax' as well as universal suffrage. For the Manchester manufacturers and merchants, the Corn Laws were an improper interference in the free exchange of manufactured goods and raw materials. They were seen as a device by a landowner-dominated government to keep food prices high, tenant farmers prosperous and rent rolls in credit. Although the Act of 1815 was replaced in 1828 by a sliding scale of duties, the Corn Laws remained a target of protest. Anti-Corn Law associations were formed to generate protest against the system, but the real force for a national campaign came with the formation of the Manchester Anti-Corn Law Association in 1838. Many of those on its provisional committee had been involved in the successful campaign for incorporation. Thomas Potter (1774–1845), the first mayor of the new borough, J.B. Smith (1794–1879), George Wilson (1808–70), John

Bright (1811–89), a Rochdale manufacturer, later a Manchester MP, and Richard Cobden were members. In 1839 at a conference in Manchester, the rules for a national Anti-Corn Law League were drawn up. Smith was elected president, and Wilson, chair of the League Council. Under Wilson, Manchester became the headquarters of the League and supplied much of its funding.

'My hopes of agitation are anchored on Manchester', Cobden told Smith in February 1839, while another Manchester member found the climate of support in London 'like descending into an ice box compared to Manchester'.[23] From its headquarters in Newalls Buildings on Market Street, the League issued a stream of pamphlets arguing the case for repeal. It sent lecturers around the country, even into the less supportive countryside. Hostility at open-air meetings led to the organization of stewards, drilled in strong-arm tactics, to control them. For greater security in 1840 a large timber pavilion was erected in Manchester to hold public meetings, followed by a more permanent brick-built one.

While the League was influential in converting opinion, the actual repeal of the Corn Laws in 1846 was achieved in the face of a national catastrophe, the Irish potato famine of that year. Nevertheless League members remained convinced that their campaign, driven from Manchester, had achieved not merely the repeal of the Corn Laws but other measures issuing in an era of free trade. In 1856 a permanent building replaced the temporary meeting places. Edward Walters' Free Trade Hall took its place as one of Manchester's most distinguished and symbolic buildings. A monument to the voice of the liberal middle class, it provided a space for public meetings in which that voice, and many others, could be heard.

That voice was not solely a political one. Nonconformists, barred as they were from England's Anglican-dominated universities and public schools, founded their

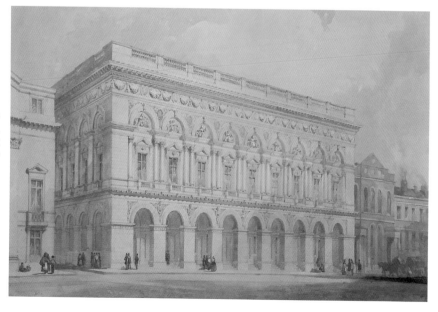

Free Trade Hall, Peter Street. Originally built in a great hurry in 1840 to hold the meetings of the Anti-Corn Law League, it was not until 1856 that a more substantial public hall was erected. The building, designed by Edward Walters, became an integral part of the political and cultural life of the city.

Courtesy of Manchester Libraries, Information and Archives, Manchester City Council

own institutions for social and cultural development. The earliest of these was the Literary and Philosophical Society (the 'Lit and Phil') of 1781. After the French wars, its members were prominent in the establishment of the Royal Manchester Institution for the Promotion of Literature, Science and Art in 1823. The young Charles Barry (1795–1860) designed and built its headquarters on Mosley Street. It housed an art collection and provided meeting rooms for the discussion of matters of cultural interest. In 1835 Barry was again chosen as the architect of the Manchester Athenaeum, a club for the Advancement and Diffusion of Knowledge. It announced itself as 'combining the several attractions of an extensive reading and newsroom with the advantages of a library and lectures, as well as the opportunity of pursuing in classes or sections, various literary and scientific studies'.[24] One of its aims was the better education of the sons of the middle classes, thought to be 'too widely exposed to the temptations of the town'. The next two decades saw the foundation of more specialist learned societies, a Natural History Society (1821) and a Botanical Society (1827), a Medical Society (1834) and a Geological Society (1838). In 1833 the first statistical society in the country was founded, a body more concerned with social investigations than with mathematics. Such organizations, many of them supported by Unitarians, made the town a centre of serious research-oriented science. In 1842 Manchester was chosen as the venue for the annual congress of the British Association for the Advancement of Science. In 1857 it staged the Art Treasures Exhibition in specially built premises at Old Trafford. An event of international importance, this was Manchester's response to the Great Exhibition of 1851. The middle-class voice was thus heard in areas other than those of trade and politics.

One such area, from as early as the late eighteenth century, was that of humanitarian protest against slavery and the slave trade. Groups within the town's rapidly growing population saw the slave trade as abhorrent to both the Christian faith and individual liberty. These included manufacturers, especially those in the fustian trade, merchants and professional men. Many were Quakers and also Unitarians, a faith embraced by many of the Manchester elite. A committee chaired by Thomas Walker (1749–1817), a prominent merchant, was formed to campaign for the abolition of the trade. Since Manchester at that time lacked both an MP and a corporation, the committee used a new method of protest, the mass petition to Parliament. Supportive newspapers like the *Manchester Mercury* and the *Manchester Chronicle* spread news of the campaign and gathered signatures. Advertisements were placed in other newspapers. In October 1787 Thomas Clarkson (1760–1846), the nationally famous abolitionist, visited Manchester and was persuaded to preach against the slave trade from the parish church pulpit. 'The church was so full I could scarcely get to my place', he recorded, and he was also surprised to find 40 or 50 black people standing around the pulpit. He preached on the text: 'Thou shalt not oppress a stranger, seeing ye were strangers in the land of Egypt.'[25] In the same year a petition with 10,639 signatures against the slave trade was presented in Parliament by the MP for Lancashire on behalf of his Manchester constituents.[26]

The slave trade became part of a national political agenda, and was abolished by the Act of 1807. Humanitarian attention then turned to the institution of slavery itself, particularly that being practised in the British West Indies. Unitarians, Quakers and Evangelical Anglicans campaigned against the practice. Boycotts of West Indian products such as rum and sugar were publicized. Abstention from these products, especially sugar, involved some change in household budgets. As a result women, many of whom already subscribed to the anti-slave trade and anti-slavery causes, became even more directly involved.

With slavery in Britain and its colonies abolished by an Act of 1833, attention turned against the institution as still practised in the southern plantations of the United States. A Manchester Ladies Anti-Slavery Society was formed in 1847, six years before Frederick Chesson launched the Manchester Anti-Slavery Union. The latter, in co-operation with the British and Foreign Anti-Slavery Society, became

Dissenting voices in the Free Trade Hall

The public anti-slavery meeting was held in the large room of the Free Trade Hall. The walls of the town had been placarded for several previous days with appeals addressed to the Manchester public signed by the 'Executive committee of the Southern Club', and with replies by the promoters of the meeting. The hall was densely crowded, and considerable excitement prevailed. At a very early period of the meeting manifestations of disorder, and disapprobation of the sentiments of the speakers were made; and as the evening wore on the dissentients became so vigorous and demonstrative that the oratory was lost in the general disorder that prevailed. Several fights occurred. Cheers were given for 'Jefferson Davis', 'General Lee', and 'the South', followed by similar demonstrations for 'President Lincoln' and 'the North'. The speakers one after another tried all the arts of rhetoric to gain a hearing; but the shafts of wit and the fires of sarcasm were equally ineffectual. In vain the Chairman appealed to sentiments of fair play, and even threatened the interference of the police, of whom there was a strong body in various parts of the Hall. Occasionally the police did interfere, but this was only the signal for still greater uproar.

Manchester Guardian, 4 June 1863

The first Free Trade Hall was built in a hurry by the Anti-Corn Law League in 1840 to provide an indoor venue for its public meetings, a space that also gave it greater control over those meetings. The irony that the site was that of the Peterloo Massacre was not lost to local radicals. It and the subsequent halls became the most important public venue in the city, most of the country's leading politicians speaking from its platform. However, controlling the behaviour of the audience was not necessarily any easier than at outdoor meetings, and one can trace voices of dissent from the reform meetings of the 1850s to those of Mosley's Blackshirts in the 1930s and beyond. Open public meetings, as this report during the American Civil War indicates, could and did slip out of the control of the organizers. Voices of protest were less evident at the musical and entertainment events held in the hall, though Oscar Wilde was made fun of in 1883, while in 1966 one protestor at a concert by Bob Dylan resulted in the event becoming a part of the cultural timeline of the twentieth century.

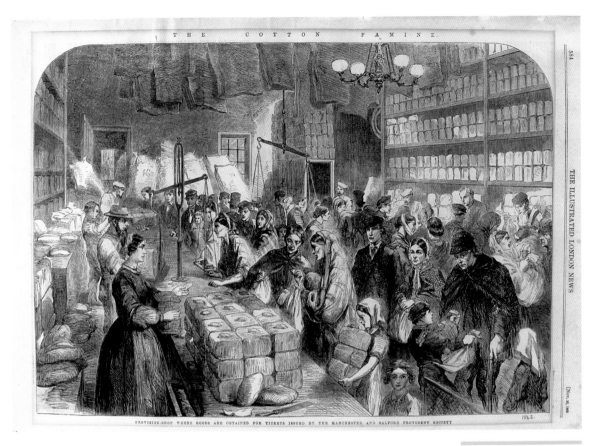

THE COTTON FAMINE.

584

THE ILLUSTRATED LONDON NEWS

[Nov. 29, 1862.

PROVISION-SHOP WHERE GOODS ARE OBTAINED FOR TICKETS ISSUED BY THE MANCHESTER AND SALFORD PROVIDENT SOCIETY.

'Lancashire Cotton Famine', *Illustrated London News*, 1862. The organization of famine relief in Manchester and Salford was delegated to a local charity, the Manchester and Salford District Provident Society. It doled out food, fuel and clothing to applicants who by 1862 were numbered in tens of thousands.

the Manchester Anti-Slavery League. A founder of the Ladies Society, Rebecca Moore, became the first female delegate to a British anti-slavery conference. The publication of Harriet Beecher Stowe's *Uncle Tom's Cabin* in 1852 and of Frances Kemble's *Journal of a Residence on a Georgian Plantation* in 1863, with their accounts of slavery's destructive effect on family life and morals, appealed especially to female readers. Emmeline Goulden (later Pankhurst) recalled her grandfather (a Peterloo veteran) reading *Uncle Tom's Cabin* to her as a bedtime story.

In December 1862 a meeting at the Free Trade Hall resolved to send an address to President Abraham Lincoln urging the abolition of slavery in the United States. Despite the cessation of imports of raw cotton from the southern states of the USA during the American Civil War, Manchester appeared to be putting humanitarian principles before the economic interests that had driven its growth. The resulting 'Cotton Famine' brought unemployment and near-starvation to many millworkers, although Manchester, with its more diversified economy, may have suffered less than smaller towns like Rochdale, Ashton or Stalybridge, where cotton spinning or weaving was the dominant form of employment. The victory of the Union over the Confederacy made Lincoln's Emancipation Proclamation of 1863 a reality, despite his assassination in April 1865. Manchester's (and Lancashire's) voice had been heard.

Abraham Lincoln, Platt Fields, 1943. George Grey Barnard's statue of Lincoln (controversial because of the way its subject was represented as a humble rather than a presidential figure) was presented to Manchester in 1919 because of the support its workers had shown towards the Union states in the Civil War, a link that was echoed in this press photograph of American servicemen admiring Manchester's Lincoln.

Courtesy of Manchester Libraries, Information and Archives, Manchester City Council

A memento of this came rather later. In 1919 the US President, Woodrow Wilson, visited Manchester and received the freedom of the city. In return a somewhat artistically controversial statue of Lincoln, copied from the original by George Grey Barnard in Cincinnati, Ohio, was presented to Manchester. It was intended to 'symbolise the way in which the English cotton spinners stood by us which enabled us to preserve the Union'. The statue was first installed in the relatively isolated suburban location of Platt Fields Park in Rusholme. In 1986 it was moved to a city-centre location in Brasenose Street, an area redeveloped as Lincoln Square. A new inscription on the plinth caused some controversy when an evening paper suggested that the wording had been changed from 'working men' to 'working people' as a sop to left-wing feminism. In fact, the inclusive word 'people' is historically correct, since not only had women been prominent in Manchester's anti-slavery campaigns, but female millworkers had suffered as a result of the Cotton Famine, both as workers experiencing unemployment and as wives facing the restriction of family income.[27]

Women's voices

'Will the Liberal government give women the vote?' Annie Kenney's interruption of a speech by the Foreign Secretary, Sir Edward Grey, at a meeting in the Free Trade Hall in October 1905 is one of the best-known voices in Manchester history. In its challenge to authority it has become perhaps the 'Peterloo' of the female suffrage campaign. It was, however, by no means the first time that female voices calling for social and political equality with men had been heard in Manchester. On St Peter's Field in 1819, Mary Fildes (1789–1875), chair of the Manchester Female Reform Society, had, with other women, mounted the platform with flags and prepared statements. Before these could be delivered, the charge of the military changed radical words to screams and cries as male and female demonstrators were attacked.

On a perhaps more acceptable level, the wives and daughters of Manchester's middle classes were, as has been seen, prominent in the campaigns against the slave trade and then against slavery itself. Movements like the Manchester Ladies Anti-Slavery Society provided experience in pamphlet writing, canvassing, fundraising and petitioning for another cause, that of female suffrage. As well as her anti-slavery activities, Rebecca Moore was also a member of the executive committee of the Manchester Society for Women's Suffrage. One historian of the anti-slavery movement has described the links in Manchester between anti-slavery and the demand for women's suffrage as 'striking'.[28] In the 1860s pressure for an extension of the franchise was renewed. John Stuart Mill, elected to Parliament in 1865, was persuaded to include women in the Reform Bill he drafted. A Manchester widow, Lily Maxwell, managed to register and cast her vote in the election of 1867. Despite these promising signs the 1867 Reform Act, while extending the vote to some working-class men, did nothing for women of any class. The loophole through which Lily Maxwell had squeezed was closed by the High Court in the case of Chorlton vs. Lings, despite the pleas of a young barrister, Richard Pankhurst.

The debate over the parliamentary franchise, however, had aroused interest in votes for women, especially in Manchester, one of whose MPs, Jacob Bright (1821–99), was an advocate for the cause, together with his wife Ursula

Lydia Becker's campaigns for women's rights included the parliamentary franchise. As this election cartoon of 1870 suggests, politicians like Jacob Bright, the radical Liberal MP for Manchester, who associated themselves with Becker presented an easy target for their misogynistic opponents.

Courtesy of Chetham's Library

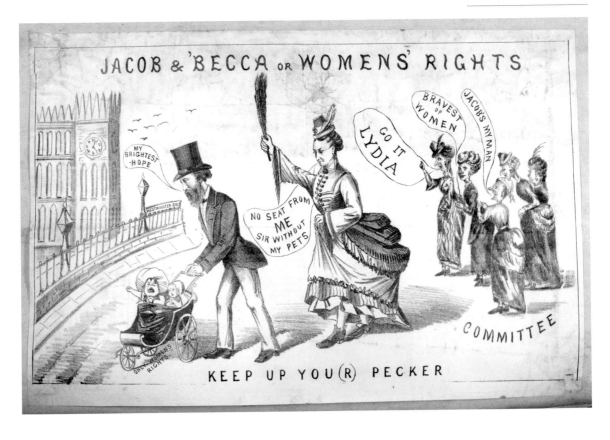

(1835–1915). A small committee of Liberal activists formed a Manchester Society for Women's Suffrage, with Elizabeth Wolstenholme (1833–1918), a schoolteacher and daughter of an Eccles minister, as its first secretary. Her post was soon taken over by Lydia Becker (1827–90), self-educated but a member, by 1864, of the British Association for the Advancement of Science and author of *Botany for Novices* (1864). Excluded by gender from most of Manchester's intellectual societies such as the Lit and Phil, she formed a Ladies Literary Society in 1869. She threw herself into the suffrage campaign, collecting signatures for a parliamentary petition in 1867, then attempting to place as many women ratepayers as possible on the new electoral registers in 1868. In April of that year the Manchester National Society for Women's Suffrage held its first public meeting in the Free Trade Hall, chaired by the mayor of Salford, with resolutions moved by women and seconded by men.

Although pressure for the parliamentary vote for women was to prove unsuccessful in the second half of the nineteenth century, important advances were made in the field of local government. Jacob Bright's amendment to the Municipal Corporations Act in 1869 gave women ratepayers the vote on the same basis as men. In the following year the Education Act of 1870 created directly elected school boards to fill the gaps in school provision where the voluntary system, mainly of a religious nature, had failed. Not only were women ratepayers qualified to vote but they were also able to stand as candidates for election. A complex voting system, together perhaps with the notion that the education of young children was a womanly responsibility, ensured the election of female school board members. Manchester, concerned at the poor educational standard of children in its inner-city areas, swiftly adopted the provisions of the Act. Among those elected to its first school board in 1870 was Lydia Becker, who retained her seat until her death in 1890. Her voice in school policy was clearly heard. She devised schemes of free admission for the children of poor families and for school meals, and criticized the city council for salting frozen roads in winter which made them uncomfortable for children walking to school barefoot. She served on subcommittees planning school building, organization and curriculum, demanding equality of girls and boys in the latter. 'Every boy in Manchester', she insisted, 'should be taught to darn his own socks and cook his own chops.'[29] By 1877 she was laying foundation stones. Admirers funded a scholarship in her name.

On Becker's death in 1890, her place was taken by other women with progressive ideas and voices. Rachel Scott (1848–1905), wife of the *Manchester Guardian*'s editor, served on the school board until 1896. She was followed by Mary Dendy (1859–1933), who campaigned on behalf of 'mentally defective' pupils. Dendy persuaded the school board to provide special schools for these children, and started a residential college at Sandlebridge, Cheshire.

The 1902 Education Act abolished school boards and placed responsibility for public education on borough, city and county councils. Pressure from bodies like the Women's Local Government Society forced an amendment requiring councils

to co-opt women on to their education committees, a recognition of the importance of women's voices in this area of local government.

An older local government body, the Poor Law Union, also found itself in need of a female presence. Its workhouses were becoming places of refuge for the chronically sick, the mentally infirm, the aged and the orphan child. Boards of Poor Law Guardians found themselves in need of women's expertise to deal with inmates of this nature. Florence Nightingale advised the Chorlton (South Manchester) Board of Guardians on the design of their new workhouse at Withington. Women working as visitors for charitable organizations such as the Manchester & Salford District

Margaret Ashton

Margaret Ashton (1856–1937) was the third of the six daughters and three sons of Thomas Ashton, a wealthy cotton manufacturer of the Ashton mills at Flowery Fields, Hyde. Her father, the major influence on her life, was a leading Manchester Liberal and Unitarian. Margaret Ashton never married and lived in the family home, Ford Bank, Didsbury. Her first involvement in politics came in 1888 when she helped to found the Manchester Women's Guardian Association, an organization that encouraged women to become Poor Law Guardians and to take a more active role in local politics. In 1895 she joined the Women's Liberal Association, and the following year became a founder member of the Women's Trade Union League.

In 1908 she was the first woman to be elected to Manchester City Council, sitting for Withington. As a councillor she campaigned to improve the wages and conditions of factory girls, to raise the age of employment of children, and to abolish the sweated system. Ashton House, a municipal women's refuge on Corporation Street, was named in tribute to her work in 1910. She was a member of Manchester's public health committee, and chaired its maternity and child welfare subcommittee. The fall in Manchester's notoriously high infant mortality rate was in part due to her implementation of health reforms,

especially her support for municipal mother and baby clinics, and the introduction of free milk for young children and nursing mothers. In 1914, with the paediatrician Catherine Chisholm, she founded the Manchester Babies Hospital, staffed entirely by women.

In 1906 she resigned from the Liberal Party because of the Liberal government's refusal to legislate on votes for women. She became chair of the North of England Society for Women's Suffrage, and financially supported its newspaper, the *Common Cause*. A constitutional suffragist, she did not approve of the militant tactics of the WSPU but expressed solidarity with released WSPU prisoners. Politically, she gradually moved to the left, and joined the Labour Party in 1913.

Her pacifism during the First World War caused her to be regarded as unpatriotic and castigated as 'pro-German'. After much opposition she resigned from the city council in 1921. She remained active in public life after the war, joining the National Council of Women and helping to found the Manchester Women's Citizens Association. She remained a pacifist for the rest of her life. She was an important figure in improving the health of the city in pre-NHS days, a noted campaigner for education, a strong supporter of women's rights and a pioneer peace activist.

Provident Society were co-opted on to subcommittees, sometimes paid, to provide first-hand experience of the living standards of the poor. A change in the franchise for election to Boards of Guardians in 1894 led women to seek and gain election. Emmeline Pankhurst (1858–1928) was elected to the Chorlton Board and Hannah Mitchell (1872–1956), a working-class feminist, to the Ashton-under-Lyne Board.

City councils proved more impervious to the presence of women, but, with four women on Manchester's Education Committee, a breach was made. In 1907 women ratepayers gained the right not only to vote in council elections but to be returned as members. Margaret Ashton (1856–1937), daughter of a wealthy mill owner and manager of Flowery Fields school, was elected to Withington Urban District Council. After an initial failure in 1907, she was elected to the city council for the Withington district in the following year. A member of both its education committee and its sanitary committee, she denounced sweated labour, advised on the design of new council housing and persuaded the council to build and manage a women's lodging house in the notorious Angel Meadow district of the city. Although a minority on all the local bodies they were elected or appointed to, women's voices in Manchester government were clear and effective.

Women's campaigns for the parliamentary franchise and their increasingly active role in local government went along with their improved position in secondary and higher education. Manchester Grammar School, founded in 1515, was for boys. Owens College of 1851 was, at the behest of its founder John Owens (1790–1846), to be 'the means of instructing and improving young persons of the male sex'.[30] In 1867 a Manchester Society for Promoting the Education of Women was formed to address the gender imbalance. In 1873 a Manchester High School for Girls was established, providing a female equivalent of the Grammar School. Four years later the association added 'the higher education of women' to its title. The governors of Owens College, somewhat reluctantly, established a Manchester and Salford College for Women close to their own building on Oxford Road. In 1880 Owens College became part of a federal university, the Victoria University, together with colleges in Leeds and Liverpool. Under its charter, male and female students were accepted. Progress was slow in Manchester, but the first women students graduated in 1887. In 1903 Manchester broke from its partners to form a single institution, the Victoria University of Manchester. Two of the early female graduates of the former federal body, Alice Crompton (1866–1958) and Mary Tout (1873–1960), became members of the First Court, the governing body of the new university.

Alice Crompton, a niece of Lydia Becker, had in 1898 been appointed joint warden of the Manchester University Settlement. Housed in Ancoats Hall, together with the Ancoats Art Museum, it ran a variety of programmes, talks, concerts, visits and outings, open to the working-class residents of Ancoats, still one of the city's most populous industrial suburbs. It attracted as residents or 'associates' educated young women who found many professions closed to them and who did not wish to enter a conventional marriage. Crompton was a suffragist and a firm believer in gender equality. Active in the Settlement's early activities were women who also

Ancoats Art Museum, 1890. Founded by Thomas 'German' Horsfall, the Art Museum was a Ruskin-inspired institution that took art into one of Manchester's poorest working-class districts. Its entry into 'Outcast Ancoats' was followed by other social and educational initiatives, including the Ancoats Brotherhood and the University Settlement.

Courtesy of Manchester Libraries, Information and Archives, Manchester City Council

became prominent in female suffrage campaigns such as Christabel Pankhurst (1880–1958), Teresa Billington (1877–1964), Esther Roper (1868–1938) and Eva Gore-Booth (1870–1926). Christabel Pankhurst and Esther Roper founded a drama club, the Elizabethan Society, which encouraged factory girls to read Shakespeare aloud and take part in productions of his plays. Such activities provided a sounding board for the voices of both middle- and working-class women, a link that was to prove of importance in early twentieth-century suffrage campaigns.

With the defeat of a women's suffrage amendment to the 1884 Parliamentary Reform Bill, the cause of parliamentary votes for women fell into the doldrums. Membership of women's suffrage societies declined. The liberal climate of Manchester's early nineteenth-century politics turned more conservative in the 1870s. Revival came in the 1890s with the rise of a new generation of female suffragists. Prominent among these, especially in the popular memory, was Emmeline Goulden. Born in Manchester in 1858 into a wealthy manufacturing family, she married the young socialist barrister, Richard Pankhurst (1835/6–98). After a spell in London, they returned to Manchester with their three daughters, Christabel, Sylvia (1882–1960) and Adela (1885–1961). Both Richard and Emmeline were members of the newly formed Independent Labour Party. 'Socialist first and suffragists afterwards', Emmeline found the socialist movements of late nineteenth-century Manchester stimulating.[31] The new socialist groups, the Independent Labour Party, the Social Democratic Federation and the Fabian Society, made no distinction between male and female members. The established political parties, by contrast, channelled female supporters into subsidiary organizations, the Conservatives' Primrose League and the Women's Liberal Federation.

The death of Richard Pankhurst in 1898 proved a severe disruption to the family. In straitened circumstances, they had to move to a smaller house in Nelson Street, Rusholme. Emmeline found paid employment and withdrew from political activity for two years. In 1901, together with Christabel, she joined the North of England Society for Women's Suffrage. Tiring of the society's slow progress, the Pankhursts formed a new organization, the Women's Social and Political Union (WSPU), at a meeting in their Nelson Street home in 1903. The WSPU believed in militant tactics to bring public attention to the issue of female suffrage, and members soon gained the title 'suffragette' from emerging popular newspapers like the *Daily Mail*. In 1906 the WSPU moved its headquarters from Manchester to London where they thought militant tactics would gain more immediate newspaper coverage.

A more moderate tone was set by Margaret Ashton as president of the North of England Society for Women's Suffrage. In 1908 she organized a large, peaceful demonstration in Manchester in support of votes for women. Like Pankhurst, however, she became frustrated at the inactivity of the Liberal government relative to the cause. She resigned her membership of the Liberal Party and her presidency of the North of England Society.

Perhaps the most important women's voices to be heard in Manchester were those of the radical suffragists. Esther Roper, whose father was an Ancoats factory worker turned Christian missioner, became secretary of the Manchester Society for Women's Suffrage and was joined by Eva Gore-Booth (1870–1926), the daughter of an Irish landowner. Living together in Victoria Park, they were both active 'associates' in the University Settlement. They recognized, not least through their involvement with the University Settlement Elizabethan Drama Group, the great potential of working-class women in supporting radical causes like female suffrage.

The Manchester society (later the North of England Society for Women's Suffrage) was supported by working women like Mrs Hannah Winbolt, a Stockport weaver, Annie Heaton, a Rochdale winder, Annie Kenney (1879–1953) and Cissy Foley, spinners and members of the Cardroom Association. Roper and Gore-Booth distributed leaflets and held meetings at factory gates when shifts ended. An aid to this was the Women's Co-operative Guild, founded in Manchester in 1892 to organize talks and events for its members. Manchester and the cotton towns of Lancashire had large numbers of women working together in spinning mills, weaving sheds and other places of employment in the cotton industry. Informal contact at work, and more organized association through the growing number and membership of trades unions, gave them a voice calling not only for improved wages and working conditions but also in the wider social and political aspects of women's roles. A Manchester and Salford Women's Trades Council, formed in 1895 with offices in Albert Square, coordinated some of this activity. When in 1904 the chair of the Council, Amy Bulley (1852–1939), a *Manchester Guardian* journalist, challenged the notion that the Council should promote female suffrage, Eva Gore-Booth and Christabel Pankhurst resigned from it and formed a rival Manchester and Salford Women's Trades and Labour Council. With premises in John Dalton

Street, it received support from several trades unions, the Women's Co-operative Guild and the Clarion cyclists. Its aim was 'to improve the working conditions of women by securing their parliamentary franchise'.[32] Gore-Booth and Sarah Dickenson (1868–1954) were joint secretaries of the new body, which began publication of a quarterly journal, *The Women's Labour News*.

The Council supported Gore-Booth's campaign against a Licensing Bill in 1907 which threatened to restrict the working hours of barmaids. Members took part in a spectacular by-election campaign in April 1908 leading to the defeat of a Liberal government minister, Winston Churchill. The Bill was amended in 1908, removing all restrictions on female employment in licensed premises. Close links with trades unions, the co-operative movement and the Independent Labour Party resulted in the new Parliamentary Labour Party of 1906 becoming sympathetic to the cause of women's suffrage. In 1912 its annual conference resolved that it would not contemplate any franchise reform which excluded women, a resolution not fully endorsed till 1929. By 1913 Gore-Booth and Roper had moved, as

the Pankhursts had done earlier, to London, though not for publicity reasons. 'The smog bound industrial quarters of Manchester', writes her biographer, 'had become too much for Gore-Booth's declining health.'[33]

Despite the Pankhursts' move to London, suffragette militancy in Manchester did not cease. 'Manchester Art Gallery Outrage' headlined a disapproving *Manchester Guardian* in April 1913.[34] Three WSPU members, Lillian Forrester, Annie Briggs and Evelyn Manesta, had smashed the glass of several paintings in the City Art Gallery, using a hammer decorated with the purple and green ribbons of the WSPU and leaving a card proclaiming 'No Forcible Feeding'.

With the outbreak of war in August 1914, Emmeline Pankhurst declared a suspension of WSPU hostilities. She and her daughter Christabel actively supported the war effort, persuading young men to register for active service. Margaret Ashton took a different approach. She resigned from the executive of the National Union of Women's Suffrage Societies and joined in efforts for a negotiated peace, She helped to found, and became chair of, a Women's International League. Her attempt with other British delegates to attend an International Congress on Peace in Amsterdam in 1915 was foiled by the British government, which prevented their crossing to the Continent. Her pacifism made her unpopular on the city council, which removed her from the education committee, leading to her resignation in 1921.

The First World War brought important changes in the lives of many Manchester women. The recruitment of men made for severe labour shortages in the engineering and munitions industries, which were essential to the war effort. Women workers were drafted in to fill the gaps. Feminists, like Ashton, were concerned that the new recruits would be discriminated against in terms of pay, hours and conditions of work as compared to the male workers whose jobs they were filling. A Women's War Interest Committee was formed in May 1915 to research gendered differences in pay and working conditions. Its final report, *Women in the Labour Market (Manchester and District) during the War* (1916), focused on equal pay and working conditions for women. It also advocated compensation for women workers made redundant after the war. Those involved were conscious that, even with the (very partial) granting of female suffrage in 1918, much remained to be done to improve Manchester women's conditions in both the political and in the economic and social spheres.

Political voices – old and new

By the mid-nineteenth century, the political and religious character of Manchester seemed set. It was Liberal and in favour of free trade, with John Bright, the hero of the Anti-Corn Law League struggle, as its MP and the Free Trade Hall, completed in 1856, its major public building. Nonconformity, notably Unitarianism at Cross Street chapel, was its rational faith. Thomas Worthington's Memorial Hall of 1866 commemorated those ministers expelled after the restoration of the monarchy in 1662. Yet these images were to change quite radically in the second half of the century.[35]

Manchester, which was divided into three parliamentary constituencies by the 1867 Reform Act and six in 1884, overall returned more Conservatives, many of them local businessmen, than Liberals until 1906, when there was a brief revival of Liberal fortunes due to Manchester free traders' distrust of Tory tariff reform policies. Manchester had been represented by Liberal MPs from 1832 to 1867. Between 1868 and 1880, however, four of the nine parliamentary seats in Manchester were Conservative held, and 21 of the 30 available between 1885 and 1900.

Nor did Liberals dominate at local government level. In the decade before the First World War, Conservatives controlled the city council. Between 1911 and 1913, local electors returned 55 Conservatives, 27 Liberals and 15 Labour councillors. Hostility to Catholic Irish immigrants strengthened the Tory vote in inner-city working-class areas. The growth of the Orange Order from its origins in the early nineteenth century, its lodges often meeting in public houses, inculcated Protestant working men with a fear of Catholic rituals and a hostility towards Irish labourers whom employers might use as 'knobsticks' or strike breakers.

A quite different voice challenging Liberalism electorally and culturally was that of Labour. An informal meeting of socialist groups at St James's Hall in Manchester in 1892 led, in the following year, to the creation of the Independent Labour Party in Bradford, West Yorkshire. While its early Manchester membership was relatively small compared to that in Lancashire's cotton towns, Labour won its first council seats in Bradford and Openshaw, then slowly increased their number.

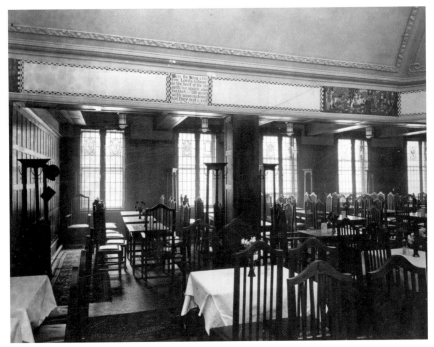

Clarion café, Market Street, 1908. Among the clubs and societies founded to support the socialism inspired by Robert Blatchford's writings in *The Clarion* newspaper was a café. Its design, inspired by William Morris, featured quotations from Shelley, while its menu included vegetarian meals. Opened by Blatchford in 1908, it was a popular meeting place for socialists and others until its closure in 1936.

Courtesy of Manchester Libraries, Information and Archives, Manchester City Council

In 1903, with the support of trades unions in the Trades Council, a branch of the new Labour Representative Committee (LRC) was formed. At the 1906 general election, three Manchester constituencies – South West, North East and Gorton – all returned LRC candidates, who with other LRC MPs renamed themselves the Labour Party.

The socialist voice was also heard beyond the ballot box. Young people from the skilled working class and, particularly, from the white-collar middle class – clerks, shop workers and schoolteachers – found an escape from the rather stereotyped views of their 'elders and betters'. Many were readers of the *Clarion* newspaper. First published in Manchester in 1891 by the journalist Robert Blatchford (1851–1943), the Clarion brand spread to many of the recreational interests of this group, who formed Clarion cycling clubs, rambling clubs, choirs and, in 1908, a Clarion café in Market Street, a centre for recreation and discussion.

Despite the intrusion of socialism, denominational religion retained its importance in Manchester. All three major Christian denominations – Anglican, nonconformist and Roman Catholic – demonstrated their public presence in Whit week, Manchester's 'wakes week'. On separate days of the week, churches and chapels, with their Sunday schools, paraded through the city centre, a rival attraction to the Manchester races held that same week.

The Church of England, the voice of 'Church and King' Tory reaction in the early part of the nineteenth century, widened its presence in the community. Manchester became a diocese in 1847, with the parish church as its cathedral. Its first two bishops, James Prince Lee (1804–69) and James Fraser (1818–85), though contrasting personalities, were both active in establishing new parishes and building new churches. The railway from the 1840s carried wealthy members of society – 'the cottontots' – to the outer suburbs where they became patrons of their parish churches. Unitarianism lost some of its social and political influence. Nonconformity remained strong, however, particularly the Methodists who were increasingly active in welfare work and provision in the inner city. Voices from the pulpit were not to be ignored.

Workers' voices

As the birthplace of the Trades Union Congress and the Co-operative Wholesale Society, Manchester's labour voice by the 1860s appeared to have a conciliatory tone, a readiness to discuss grievances and to work within the structures of capitalist society. Within the next few decades, however, labour voices became more challenging. The opening of the Manchester Ship Canal in 1894 made Manchester a port city, which created employment for dockworkers and greatly increased the numbers employed in transportation, both road and rail.

Workers in these sectors, many of them unskilled or semi-skilled, were beginning to form themselves into trades unions which tended to have a more militant attitude towards their employers. Following the success of strikes in

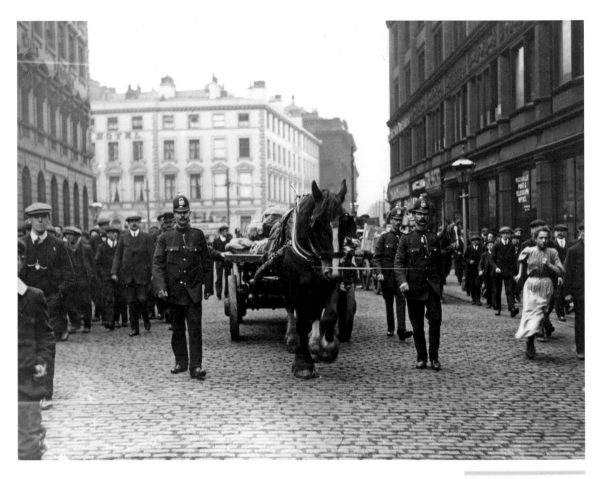

London by gas workers and dockers in 1889–90, a branch of the Gasworkers and General Labourers' Union was formed in Manchester. By 1900 it had been joined by branches of the Dock Labourers' Union and the tramway employees, and by the Manchester-based Quay and Railway Porters' Union. The voices of these so-called 'new unions' were important to the movement of goods and people on which a trading city like Manchester depended. The attitudes of many of the leaders of these new unions, though not necessarily those of their rank and file members, were influenced by the Social Democratic Federation (SDF), founded in London in 1884, and rapidly expanding into Lancashire. One of its largest branches (c.200 members) was that of South Salford, meeting at the Black Horse pub.

Perhaps the most striking instance of the 'new union' voice occurred during the disturbed years before the First World War. In June 1911 dockers at the Ship Canal quays withdrew their labour and were joined, on 3 July, by the city's carters. Manchester trade and transport came to a standstill, and the Lord Mayor asked the Board of Trade to send its arbitrator, George Askwith, to mediate in the strike. George Dangerfield, in his influential history of the period, describes Askwith passing through the corridors of Manchester Town Hall from one group to another

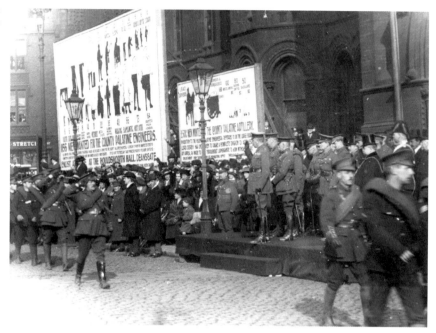

in an attempt to end the dispute.[36] After five days and nights, he was successful. Soldiers and police who had been sent to Manchester and Salford to guard against violent unrest were withdrawn.

The outbreak of war with Germany in 1914 changed the labour situation. Working-class voices were generally patriotic. Large numbers of men responded to calls to join up. Despite a trades union meeting in Alexandra Park that protested against Britain being 'dragged into war', men queued along Hyde Road and outside the Town Hall to volunteer.[37] This loss, particularly of skilled workers, to the armed forces created labour shortages in key industries like engineering. Employers had to take on and train unskilled workers to perform tasks previously the preserve of the skilled, a process known as 'dilution'. This created anxieties for trades unions especially in industries like engineering. The employment of unskilled workers, in some cases women, aroused suspicions that this might lead to wage reductions and increased working hours.

Further tensions were aroused by increased food and fuel prices. In 1916 a dockworkers' claim for a one penny an hour wage increase brought 40,000 out on strike. Their claim was hastily settled, along with those of engineers and railway workers. 1917 brought further demands. Cotton spinners called for a 30 per cent pay rise, and carters threatened to strike. The arrest of two Manchester engineering trade union leaders on a charge of 'impeding the supply of weapons' brought the threat of an all-out strike, which was only averted by shop stewards appealing to a mass meeting of their members to return to work pending a settlement of the case. Charges were withdrawn following the intervention of the men's union, the

Amalgamated Society of Engineers. In June 1917 tram workers began a work to rule, and only the award of a bonus in the face of the threat of a strike led to a resumption of normal working. The doubling of food prices since 1914 and restrictions on alcohol consumption added to workers' complaints. Street cleaners and rubbish collectors threatened action in 1918 and even CWS employees at its Crumpsall biscuit factory walked out and joined a march of disgruntled workers through the streets of Manchester city centre. Cotton spinners and railway workers added their voices to those threatening a withdrawal of labour.

Peace in 1919 calmed the situation with a brief economic boom as wartime shortages were made up. Fierce competition in world markets very soon affected industries like cotton textiles. Employers tried to increase the number of machines per operative to combat overseas competitors. Threats of redundancy revived labour hostility. Manchester engineering workers were locked out by employers in 1922, and returned to work 13 weeks later on the employers' terms. This period of labour unrest in Manchester and other industrial centres culminated in the so-called 'General Strike' of 1926.

With the call for a national cessation of labour on 4 May 1926, transport workers, dockers and other workers on Manchester docks and the Ship Canal came out on strike. Manchester and Salford Trades Council formed a 'council of action' to organize strikers. Open-air meetings were held in Platt Fields, Gorton and Blackley, and a Manchester edition of the strikers' newspaper, the *British Worker*, was published on 7 May. The city council formed an emergency committee to maintain food supplies, while central government provided accommodation for strike breakers at the docks and sent a Royal Navy destroyer in support of this action. Manchester, however, was not central to the dispute. Workers in what was now its major industry, engineering, were not called out on strike until 11 May, the day before the General Strike was called off. Another related voice, before and after the First World War, was to prove more disruptive.

Although the Labour Party increased its political influence in Manchester after the war, its voice was not always greeted with enthusiasm by working people. Hannah Mitchell remarked that Labour councillors in Manchester wanted 'lower rates and more social services and would not be convinced that both were not possible at one and the same time'.[38] Such disillusion strengthened the voice of the SDF, whose members believed in direct militant action rather than the verdict of the ballot box. The unemployed, whose numbers had increased prior to the war, were likely to respond to such a strategy. In 1905 the SDF had called a mass meeting in Albert Square to protest against the Conservative government's unemployment policy. This led to a march, blocking Market Street, with the police using baton charges to disperse the crowd. The event was described by the *Manchester Evening Chronicle* as having 'no parallel in the history of the city since the dreadful days of Peterloo'.[39] In 1908 a similar demonstration followed a meeting at the Town Hall on the unemployed question. The Town Hall was barricaded against invasion by demonstrators but attacks were made on the cathedral and the Midland Hotel. Windows in Cross

Street and Deansgate were smashed. Eventually removed from Albert Square, the crowds regrouped in Stevenson Square, the site of many protest meetings at this time, to hear a speech by Leopold Fleetwood, an engineer and SDF activist.

Although never as high in Manchester as in its neighbouring cotton towns, unemployment again became a problem after the war. Given the apparent passivity of the existing political parties on the subject, the voice of the unemployed was expressed by the National Unemployed Workers Movement, inspired by the Communist Party of Great Britain into which the SDF, known after 1911 as the British Socialist Party, had merged with other left-wing groups in 1920. The introduction of a 'means test' for unemployment benefit and the reduction of this benefit in 1931 brought two major demonstrations in Manchester and Salford. A march on Salford Town Hall on 1 October 1931 was broken up by police in the so-called 'Battle of Bexley Square'. This is the episode described by the Salford writer Walter Greenwood (1903–74) in his 1933 novel *Love on the Dole*.[40] A week later an even larger demonstration in Manchester involved a march from Ardwick Green to petition the city council with a request not to implement benefit cuts and the means test. Police barred the route of the march at the junction of Whitworth Street and London Road. The marchers, several thousand strong, were dispersed by police baton charges and the use of hoses from the nearby fire station. More than a century after the events of Peterloo, the voice of popular protest found public, contested expression.

Religious voices. Roman Catholics were quick to protest over the religious and financial implications of government plans to reform education in 1943. Here, demonstrators gather on the blitzed Mosley Street corner of Piccadilly Gardens for a meeting addressed by the Bishop of Salford, October 1943.

Courtesy of Salford Diocesan Archive

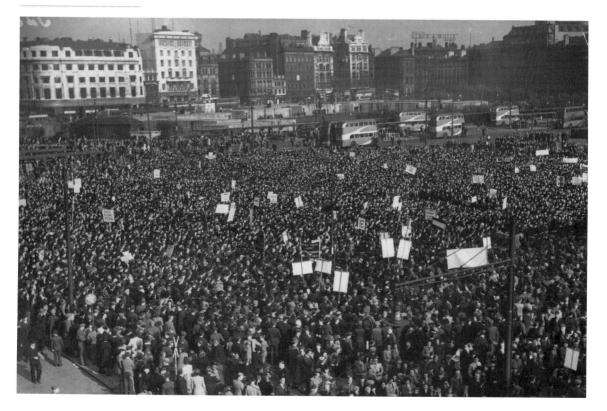

A popular pastime of employed and unemployed working people in Manchester was that of walking in the nearby Derbyshire countryside. In 1932 it was estimated that up to 15,000 people left Manchester every Sunday to go walking. One of their favourite destinations was Kinder Scout, a high area of moorland in the Dark Peak, easily reached from either Hayfield or Edale. A problem was that there were very few public footpaths in this area. One of the most popular was the Hayfield-Snake path which had been negotiated by the Peak Forest and Northern Counties Footpaths Preservation Society in the mid-1890s, providing what Richard Pankhurst described as a hunger among the urban masses to enjoy the countryside. The moorland of Kinder was owned by the Duke of Devonshire. It was used for a few months of the year by the duke's grouse shooting parties but guarded throughout the year by his gamekeepers, who denied public access lest the game birds be disturbed. While many ramblers resented this symbol of class oppression, it was not directly challenged until 1932. Its challengers were members of the communist-inspired British Workers' Sports Federation.[41] Established with the help of the Clarion Cycling Club and trade unionists in 1923, the Federation campaigned for better provision of sporting facilities for working people. In April 1932, inspired by a young activist Benny Rothman (1911–2002), an engineer from Cheetham Hill, the Federation advertised a 'mass trespass' on Kinder Scout in the Derbyshire Peak District.

On Sunday 24 April, a group of some 400 men and women set off from Hayfield to walk over Kinder Scout and meet up with another group ascending from Hope. They were met by gamekeepers and a scuffle ensued involving fists and sticks, from which the heavily outnumbered gamekeepers retreated. The victorious trespassers continued their ramble to meet up with a smaller group from Sheffield at Ashop Head. Here tea was taken and the 'Red Flag' sung. On their return to Hayfield, however, they were met by police. Five men were detained and later fined or given short prison sentences.[42] While other walking groups disowned the protest and the villagers of Hayfield were described as 'jubilant' to see the police triumph over a group of rather scruffily dressed ramblers, the event remained in the public memory and paved the way for the 1949 National Parks and Access to the Countryside Act (the Peak District was made Britain's first National Park in April 1951) and Labour's 'Right to Roam' policy of 1997.

Gay voices

A voice heard only in whispers before the 1970s was that of Manchester's gay community. Meeting in semi-secrecy in a number of pubs and clubs such as the Rembrandt and the Union, along the by then little-used Rochdale canal and close to a 'red light' district around Chorlton Street, they faced not only public hostility but also a very real legal threat. The pioneer computer scientist Alan Turing (1912–54) had come to Manchester from Cambridge in 1948 as deputy director of the Computing Laboratory at Manchester University. In 1952 he was prosecuted

for 'gross indecency', found guilty and ordered to undergo 'chemical castration'. This led him to take his own life.[43] But attitudes were changing. The Wolfenden Committee recommended in 1957 that sexual acts between consenting adults in private should be decriminalized. A decade later this came into effect with the 1967 Sexual Offences Act, which made same-sex activity between consenting adults over 21 years of age no longer a criminal offence, although public activity and the involvement of men under 21 remained subject to police harassment and prosecution.

In Manchester, support for the decriminalization of homosexual acts, and for a greater understanding of homosexuality, came with the formation in 1964 of the North West Homosexual Law Reform Committee. One of its founders was Allan Horsfall (1927–2012), an employee of the National Coal Board, from Atherton in Lancashire. He had been raised by God-fearing grandparents, but recognized his sexual orientation during his military service in the RAF. He became secretary to the North West Committee at its inaugural public meeting in Church House, Deansgate.[44]

Recognizing that the 1967 Act would not end prejudice against, and prosecution of, homosexuals, the committee continued its activities. It renamed itself the Committee for Homosexual Equality, and then, in 1971, the Campaign for Homosexual Equality (CHE). An office was rented in Manchester, and by 1972 it was one of the leading gay rights organizations in the country, with 2,800 members and 60 local groups. Highly respectable, its vice-presidents included the Dean of Manchester, Alfred Jowett (1914–2004), and the Bishop of Middleton, Ted Wickham (1911–94). Its aims were educational, advisory and political. It tried to counter prejudice and to press for improvements to the Sexual Offences Act. The Manchester branch of the CHE held monthly meetings at the Friends Meeting House and organized theatre, cinema and countryside visits.

Prejudice remained strong, exacerbated by the outbreak of AIDS in the 1980s. Police raided gay clubs such as Napoleons ('Naps') in Bloom Street using (in 1978) a nineteenth-century byelaw that prohibited men from dancing together. 'We've been trying to close these queer places for years' remarked a police officer after another raid on the club in 1984.[45] Such police action had the support of Manchester's chief constable, James Anderton, an evangelical Christian who, at times, claimed to be 'the voice of God'. In a speech in 1986 he described AIDS sufferers as 'swirling around in a human cesspool of their own making'.[46]

By the mid-1980s, however, attitudes were changing. In 1983 the radical left gained control of Manchester Labour Party, and under its new leader, Graham Stringer, won a decisive victory in the 1984 local elections. The new council restored the Urban Aid Grant which the Gay Centre in Bloom Street had lost. It publicized the centre's work and allowed it to have a stall at the Manchester Show. In October 1984 it organized a public meeting at the Archway Club in Whitworth Street. At this seven men were elected to a new gay men's subcommittee of the city council's new equal opportunities committee. The grant to the Gay Centre was

increased and money given for a Lesbian Link. In 1987 a rally was held at the Town Hall to celebrate the twentieth anniversary of the 1967 Act, a gathering addressed by the Labour MP Ken Livingstone.

Manchester's 'gay voice', now officially recognized, was coming out in a more 'in your face' manner than that of the quietly influential Campaign for Homosexual Equality. A new club, Manto, opened on Canal Street in 1990. It had a glass wall frontage enabling customers to see and be seen. A magazine, the *Mancunian Gay*, advertised and reported on Manchester's gay scene. In 1985 it publicized a 'gay day' on August Bank Holiday Monday. This included a Gay Pub and Club Olympics and a Gay Centre Fun Day, which made Bloom Street and Sackville Street 'awash with people, beer, fun and plenty of water'.[47] The event became the 'Mardi Gras' and, by 2006, Manchester Pride, a festival with its own director. A parade was organized through the city centre to the Canal Street area, or the 'Gay Village' as it had become known. The festival ended in Sackville Park with a candlelit vigil round the statue of a seated figure of Alan Turing.[48]

The previously semi-derelict warehouses and offices along the Rochdale canal proved attractive to entrepreneurs for renting out as bars, clubs and restaurants.

Stop Clause 28 rally. Organized by the North West Campaign for Lesbian and Gay Equality, one of the major protests against the amendment of the 1986 Local Government Act took place in Albert Square in February 1988. Thousands voiced their opposition to legislation that aimed to curb 'the promotion and teaching of homosexuality'.

Courtesy of Manchester Libraries, Information and Archives, Manchester City Council

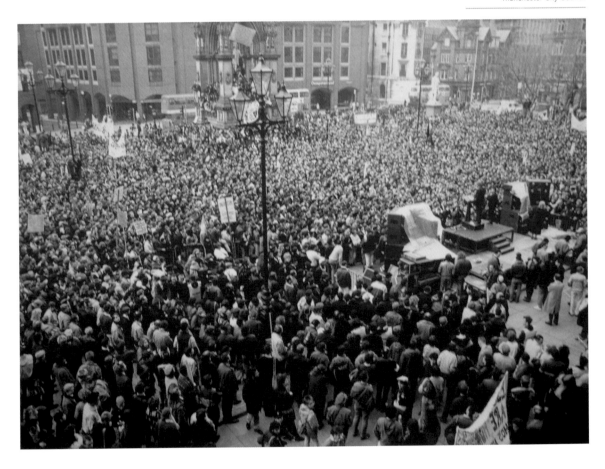

Nationwide publicity was increased by the Granada Television series *Queer as Folk* in 1999. By now there was little doubt that gay 'voices' were being heard in the city. Official recognition assisted acceptance as Manchester City Council came to view the Gay Village as an asset. As well as the desire for equality, the power of the 'pink pound' in attracting visitors to Manchester was inescapable. By the early twenty-first century the village had become the focal point for the lesbian, gay, bisexual and transgender community. It makes a significant contribution to the local economy, attracting between 15,000 and 20,000 visitors each weekend. Manchester Pride each year also attracts thousands of visitors, and is regarded as one of the lynchpins of the city's 'event-based visitor programme'.[49]

Manchester voices

A new and rapidly growing town from the mid-eighteenth century, Manchester, through the next two hundred years and more, voiced many expressions of argument and protest. A city of many races and creeds, its mix of peoples created ideas and movements still familiar in the twenty-first century. Some of the voices heard in Manchester reverberated across the country and even around the globe. Those raised in protest on St Peter's Field in August 1819 echoed down the years. The Peterloo Massacre became one of those iconic events that stand for something beyond their initial impact. It remains a central moment in the struggle for the vote in Britain and a landmark in British history. It is also one of the key events on the road to democracy elsewhere in the world, a herald of those other innumerable battles for the ballot. Eventually, the aspirations of those many thousands gathered on St Peter's Field bore fruit, although it took a century and more for them to become reality. Whenever newly enfranchised peoples queue to vote wherever they may be in the world they are the heirs of the protesters at Peterloo. It is an anomaly that only now, almost two hundred years after that fateful day, has a fitting memorial been commissioned to commemorate the martyrs of Peterloo.

The voice of the working-class radicals was suppressed in 1819, but another radical voice emerged in Manchester that was to be given much freer expression. The ideal of free trade arose from the city's influential merchant and manufacturing community, especially those engaged in the cotton trade. The victory over the old, restrictive mercantile system, popularly expressed in the campaign to repeal the Corn Laws, was voiced in this new ideology. It even gave its name to one of the city's most impressive buildings. To contemporaries, what was sometimes called the 'Manchester School of Economics' epitomized the town's contribution to the political ideology of liberalism. This school of thought supported the proposition that unfettered commerce would ultimately be to the benefit of all mankind. This view of free market economics gained international currency through the Anti-Corn Law League. It was characterized by German critics in the abstract noun *das Manchestertum* to symbolize what they saw as the British ideology of economic

'Manchester Heroes' (published by S.W. Fores, September 1819). Visual images and language played an important part in shaping public attitudes towards Peterloo both at the time and for later generations. This print, attributed to George Cruickshank, shows the Manchester Yeomanry with their swords drawn riding into the crowd. Henry Hunt, hat in hand, is shown on the platform. A young boy cries out: 'Oh pray Sir, doan't Kill Mammy, she only came to see Mr Hunt.'

Courtesy of Chetham's Library

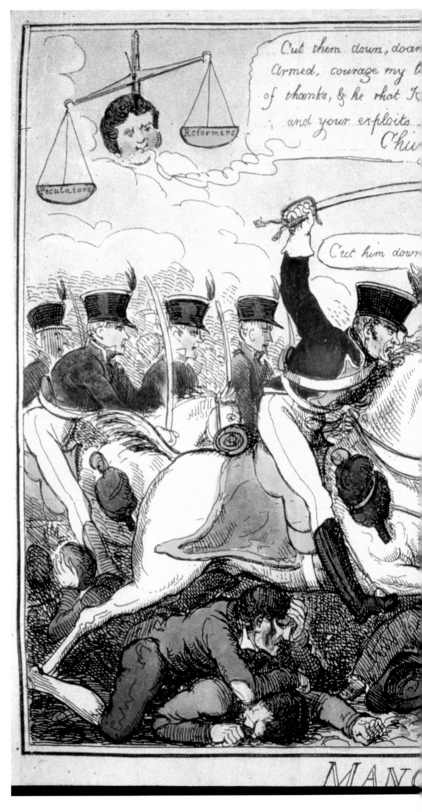

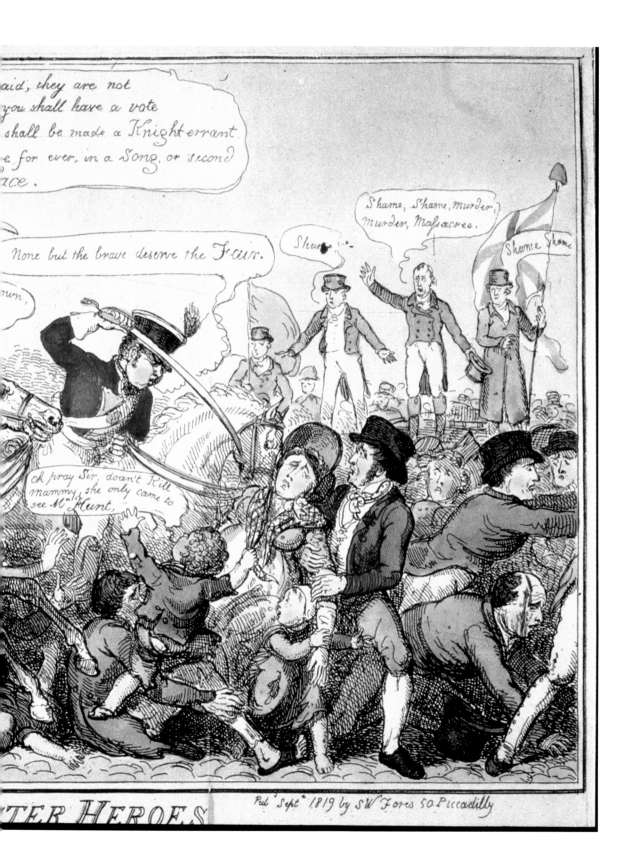

individualism. Thus 'Manchester' itself became abstracted as the free trade symbol of Britain's economic power and of the British middle class.

Manchester has an important place in the history of the political ideology of free market capitalism. Yet ironically it also provided a key moment in the evolution of an entirely opposed ideology that was itself to reverberate around the world. From a member of the same manufacturing and commercial community that produced the likes of Richard Cobden came an alternative voice that contributed to an opposing ideology, Marxism. It was Engels's experience of life in the world's most advanced industrial city that assisted Marx in his analysis of capitalism. Engels wrote of his impressions of Manchester in *Die Lage der arbeitenden Klasse in England (The Condition of the Working Class in England)*, published in Leipzig in 1845, an influential study that was not widely known in Britain until the end of the century.[50] Marx and Engels expected the communist revolution to occur first in the most advanced nations, like Britain. Eventually they came to despair of the 'bourgeois' character of the English proletariat. In the post-Chartist era the working class appeared to accept the economics of industrial capitalism. They joined trade unions rather than revolutionary parties and it was in Manchester that the first Trades Union Congress was held. The Chartist Ernest Jones, whom Engels and Marx hoped might become a revolutionary leader, became ever more moderate

Ernest Jones, image on commemorative jug. Ernest Jones's funeral in Manchester in 1868 was on a scale not seen since that of John Dalton, testimony to the high public regard for a man who had become a leading figure in promoting and defending working-class causes in the post-Chartist years.

By permission of the People's History Museum

in his views. During the Cotton Famine of the 1860s the relative quiescence of Lancashire's millworkers became a potent symbol of this accommodation with the new economic system.

One Manchester voice that could be heard in far distant places was that of the friendly society to which it gave its name, the Manchester Unity of Oddfellows. Founded in 1810, it became the largest society of its type in the country and eventually lodges of the society could be found throughout the Empire. The huge Manchester Unity Building in Melbourne, Australia, is a symbol of the reach of the principle of mutual aid that originated with the English working class during the early industrial revolution. Another ideal, which this time appeared, though not deliberately, to be a compromise between capitalism and revolutionary socialism, was that of co-operation. Although the co-operative consumer movement was founded in Rochdale, Manchester became the national headquarters of the Co-operative Wholesale Society and its increasingly impressive buildings came to dominate the northern stretch of Corporation Street.

Women speakers were on the platform at Peterloo but it was not until the later nineteenth century that a distinct and separate woman's voice was heard. As in 1819 it was in the cause of suffrage, this time the campaign for votes for women. The pioneering work of suffragists like Lydia Becker has been overshadowed in popular memory by the activities of the suffragettes. Emmeline Pankhurst and the Women's Social and Political Union will forever be associated with Manchester. Their campaign of civil disobedience and violence united women of differing social classes, caught the public imagination and kept the issue of votes for women at the forefront of debate. The repressive policy of the government towards individual suffragettes added a moral dimension to their cause. The eventual enfranchisement of women in the Acts of 1918 and 1928 was seen by many as just the beginning of the campaign to improve the conditions of women in society.

Manchester's twentieth-century voices were often vociferous and sometimes listened to. The campaigning spirit of the likes of Wal Hannington (1896–1966), Benny Rothman and Allan Horsfall enjoyed mixed fortunes. The unemployed protests of the 1930s were treated as problems of public order rather than issues of justice and equality. The pioneering activities of those who sought to make the countryside open and free to all was later to achieve expression in the country's national parks. The struggle for equal civil rights for homosexuals has achieved much since the 1950s and Manchester has provided an example of how society can go some way towards making amends for the cruel treatment meted out to individuals like Alan Turing not so very long ago. In all of this it is the voices emanating from below, from the people, rather than from officials and rulers that have made their mark. While it is true that of the cities of any nation it will be the capital city that has most impact on the public life of the country, among the provincial cities of Britain few have had such a distinctive voice as Manchester.

Notes

1. M. Bush, *The Casualities of Peterloo*, Lancaster: Carnegie, 2005, p. 10.
2. H. Spring, *Fame is the Spur*, 8th edn, 1944, p. 20.
3. R. Walmsley, *Peterloo. The Case Re-opened*, Manchester: Manchester University Press, 1969.
4. J. Marlow, *The Peterloo Massacre*, London: Rapp and Whiting, 1969; D. Read, *Peterloo: The 'Massacre' and its Background*, Manchester: Manchester University Press, 1958.
5. E.P. Thompson, *The Making of the English Working Class*, Harmondsworth: Penguin, 1968, p. 754.
6. S. Bamford, *Passages in the Life of a Radical*, Oxford: Oxford University Press, 1984, chs. 35, 36; *Manchester Region History Review*, 3.1 (1989); *Manchester Region History Review*, 23 (2012).
7. F. Engels, *The Condition of the Working Class in England*, Harmondsworth: Penguin, 1987, p. 86.
8. M. Hovell, *The Chartist Movement*, 2nd edn, Manchester: Manchester University Press, 1925, p. 118.
9. 'Account of a Chartist rally in Manchester', *Northern Star*, 22 August 1840', in D. Thompson, ed., *The Early Chartists*, London: Macmillan, 1971, pp. 139-74.
10. On the Campfield Hall of Science, see T. Hunt, *The Frock-Coated Communist: The Revolutionary Life of Friedrich Engels*, Harmondsworth: Penguin, 2010.
11. Known as the 'Round House' in Every Street, Ancoats, the chapel was founded in 1821 by James Scholefield, a Bible Christian minister. It was later taken over and restored in the 1920s by the Manchester University Settlement, before being demolished in 1988. See E. and R. Frow, 'The Round House in Ancoats', *North West Labour History*, 18 (1993–94), pp. 59-64.
12. *The Times*, 17 August 1842; Hovell, *Chartist Movement*, p. 262.
13. *Manchester Guardian*, 1 February 1869.
14. R.G. Kirby and A.E. Musson, *The Voice of the People. John Doherty 1798-1854. Trade Unionist, Radical and Factory Reformer*, Manchester: Manchester University Press, 1975.
15. R. Owen, *A New View of Society* (1817), reprinted with an introduction by J. Saville, London: Macmillan, 1972.
16. Although seen to be of 'a preliminary character' by one delegate (George Howell), the holding of a second congress in Birmingham in 1869 confirmed its status as an annual event. A.E. Musson, *Trade Union and Social History*, London: Cass, 1974.
17. J.K. Walton, *Lancashire: A Social History*, Manchester: Manchester University Press, 1987, p. 245; G.D.H. Cole, *A Century of Co-operation*, London: Allen & Unwin, 1944.
18. A. Redford and I.S. Russell, *The History of Local Government in Manchester*, London: Longman, 1939, vol. I, pt. II.
19. H. Gaulter, *The Origin and Progress of the Malignant Cholera in Manchester*, Manchester, 1833; J.P. Kay, *The Moral and Physical Condition of the Working Classes ...*, London: J. Ridgway, 1832. For the Board of Health, see A. Kidd and T. Wyke, eds, *The Challenge of Cholera: Proceedings of the Manchester Special Board of Health 1831–1833*, Record Society of Lancashire & Cheshire, 2010.
20. Redford and Russell, *History of Local Government*, vol. II, pp. 12–13.
21. A. Kidd, *Manchester: A History*, 4th edn, Lancaster: Carnegie, 2006, ch. 4.
22. A.J.P. Taylor, 'The world's great cities: I, Manchester', *Encounter*, 8 (1957), p. 9. The observation was not original to Taylor; see W. Haslam Mills, *Sir Charles Macara, Bart: A Study of Modern Lancashire*, Manchester: Sherratt & Hughes, 1917, pp. 28-9.
23. A. Briggs, *Victorian Cities*, Harmondsworth: Penguin, 1968, ch. 3.
24. Report of the Proceedings of a Public Meeting for the Purpose of Establishing the Athenaeum. Manchester Central Reference Library Historical Tracts H.329/4. M.E. Rose, 'Culture, philanthropy and the middle classes', in A.J. Kidd and K.W. Roberts, eds, *City, Class and Culture*, Manchester: Manchester University Press, 1985, pp. 103-17.
25. T. Clarkson, *History of the Rise, Progress, and Accomplishment of the Abolition of the African Slave-Trade ...* (1808), London: Frank Cass, 1968, vol. I, pp. 418-25.
26. J.R. Oldfield, *Popular Politics and British Anti-Slavery. The Mobilization of Public Opinion against the Slave Trade, 1787–1807*, London: Routledge, 1998, p. 47.
27. T. Wyke and H. Cocks, *Public Sculpture of Greater Manchester*, Liverpool: Liverpool University Press, 2004, p. 91.
28. C. Medley, *Women against Slavery. The British Campaigns 1780–1870*, London: Routledge, 1995.
29. J. Parker, 'Lydia Becker: pioneer orator of the women's movement', *Manchester Region History Review*, 5.2 (1991–92), p. 16.
30. H.B. Charlton, *Portrait of a University 1851-1951*, Manchester: Manchester University Press, 1951, p. 26.
31. J. Liddington and J. Norris, *One Hand Tied behind Us: The Rise of the Women's Suffrage Movement*, London: Virago, 1978, ch. 10.
32. S. Tiernan, *Eva Gore-Booth: An Image of Such Politics*, Manchester: Manchester University Press, 2012, p. 81.
33. Tiernan, *Eva Gore-Booth*, p. 146.
34. *Manchester Guardian*, 4 April 1913; *Guardian*, Review, 30 March 2013.
35. A. Kidd, *Manchester*, pp. 157-8.
36. G. Dangerfield, *The Strange Death of Liberal England*, New York: G.P. Putnam, 1961, pp. 253-5.
37. J. O'Neill, *Manchester in the Great War*, Barnsley: Pen & Sword Military, 2014, p. 18.
38. H. Mitchell, *The Hard Way Up*, London: Faber, 1968.
39. *Manchester Evening Chronicle*, 31 July 1905, cited in Kidd, *Manchester*, p. 178.
40. W. Greenwood, *Love on the Dole* (1933), Harmondsworth: Penguin, 1969, ch. 10.

41. S.G. Jones, 'Sport, politics and the labour movement: the British Workers' Sports Federation, 1923–1935', *International Journal of the History of Sport*, 2 (1985), pp. 154–78.

42. *Manchester Guardian*, 25 April 1932; *Guardian Archive*, 6 February 2014; B. Rothman, *The Battle for Kinder Scout*, Timperley: Willow, 2012. See also M. Tebbutt, 'Rambling and manly identity in Derbyshire's Dark Peak, 1880s–1920s', *Historical Journal*, 49 (2006), pp. 1125–53.

43. A. Hodges, *Alan Turing: The Enigma*, London: Unwin, 1985.

44. Obituary, 11 September 2012. Memorial Celebration of Life in Horsfall Papers, Manchester Central Library Archives, GB124 G.HOR./1. See also P. Scott-Presland, *Amiable Warriors. A History of the Campaign for Homosexual Equality and its Times, Volume 1, A Space to Breathe 1954–1973*, London: Paradise Press, 2015.

45. *Mancunian Gay*, 17 November 1984.

46. Copy of letter from James E. Edgell, CHE, London, to Rt. Hon. Douglas Hurd. Horsfall papers, 29 December 1986, Manchester Central Library Archives, GB124 G.HOR./1.

47. *Manchester Evening News*, 7 August 1987; *Mancunian Gay*, September 1985.

48. *Out North West*, 59 (August 2006).

49. *A strategic plan for Manchester City Centre 2009–2012*, Manchester City Council, 2009, pp. 44–5.

50. It was not translated into English until 1886 by Florence Kelley, an American social worker. More recent translations are those by W.O. Henderson and W.H. Chaloner, Oxford: Blackwell, 1958, and V. Kiernan, Harmondsworth: Penguin, 1987.

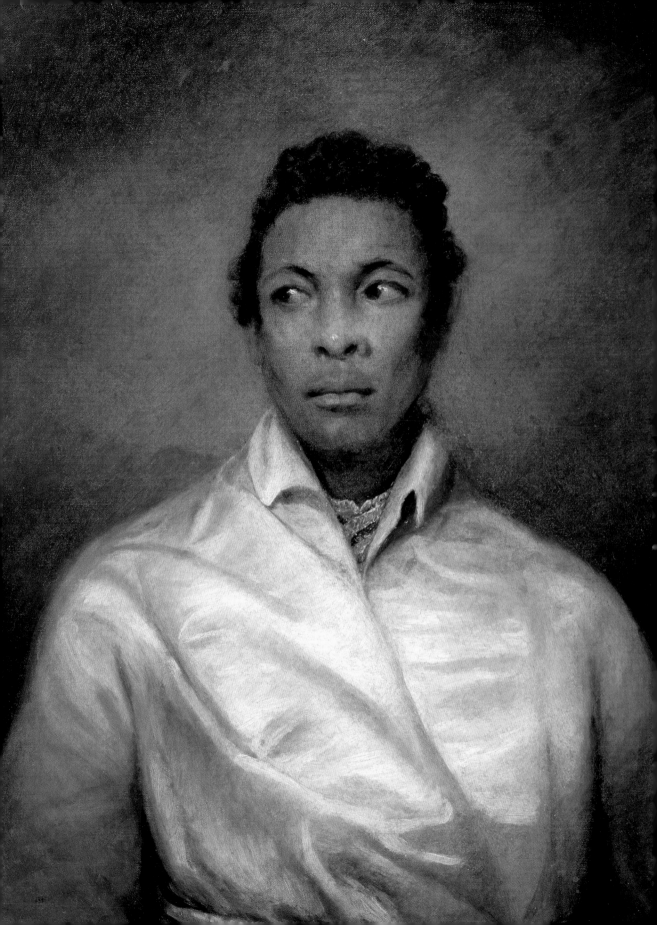

A Cosmopolitan City

MERVYN BUSTEED

Manchester was never a monochrome city. From the mid-eighteenth century the accelerating growth of its industry and its commercial connections attracted a diverse population from the surrounding counties and more distant regions of Britain and Ireland. But the steady development of overseas trade also drew growing numbers from the rest of Europe, the Caribbean and Asia. By 1856 agents from 12 different nationalities were running merchant trading houses in the city.[1] In October 1872, at a time when Japan was beginning to emerge from centuries of self-imposed isolation, the mayor of Tokyo and a 40-strong delegation visited the city, presumably attracted by its international reputation for pioneering modern economic development. Other visitors noticed not only the heterogeneity of the population, but also the downside of this migration experience. In 1844 the German commentator Johann Kohl visited the Night Asylum for travelling visitors. As well as the Irish he noted:

> I saw one black negro face among the white ones lit up by the friendly blaze, and I was told that a short time ago there were seven negroes here at once. Sometimes a poor, brown hindoo or Malay, knocked at the Asylum door, and in one of those rooms Africans, Asiatics and Europeans often creep together for shelter from the chilling blasts of an English winter's night.[2]

When he walked down Market Street he passed a man dressed in white muslin and a turban. He had noticed the first indications of the creation of a multi-cultural city. The 2011 census recorded that 25.2 per cent of the city's total population of 503,127 had been born outside the United Kingdom (Table 5.1). When it came to

Place of birth	(percentage)		Ethnicity	(percentage)
England	71.6		White British	59.3
Northern Ireland	0.9		Other white	7.4
Scotland	1.3		Asian	14.4
Wales	0.9		Black	6.7
Ireland	1.7		Mixed race	4.7
Other EU	4.5			
Other countries	19.0			

Table 5.1 Manchester: cultural diversity in 2011 (Census)

Main language	(percentage)		Religious belief	(percentage)
English	83.4		Christian	48.7
Polish	1.3		No religion	25.3
French	0.5		Muslim	15.8
Spanish	0.4		Hindu	1.1
Portuguese	0.3		Buddhist	0.8
Greek	0.3		Jewish	0.5
Other	0.9		Not stated	6.9

Table 5.2 Languages and religion in Manchester in 2011 (Census)

ethnicity the picture was even more diverse: only 59.3 per cent described themselves as 'White British'.[3]

The linguistic picture was both simpler and more complex. The 2011 census found that of 480,738 residents aged three years and over, 83.4 per cent cited English as their main language (Table 5.2). However, a 2013 survey of 531 children in two primary and two secondary schools who had English as an additional language identified 48 languages in use, of which ten had at least ten speakers. In the home situation 80 per cent of children stated they used a language other than English with their mother, 75 per cent with their father and 46 per cent with siblings. Some received instruction in these languages in supplementary schools.[4] The situation was reflected in the city's public services. In 2012 approximately 20,000 books and other media items in languages other than English were available in the city's public libraries and in 2012–13 over 70,000 non-English books were borrowed, with Urdu items the most frequently requested.[5] In September 1989 Manchester Royal Infirmary set up a translation service – in 2012 the most frequently requested interpreter requests in the Central Manchester Hospitals group were for Urdu, Arabic, Cantonese, Bengali and Vietnamese.[6]

Diversity is further reflected in religious belief. In the 2011 census, 48.7 per cent returned themselves as Christian, the first time in the history of the city that Christians were in a minority. A total of 25.3 per cent declared they had no religion

and 15.8 per cent were Muslim.[7] In reality the city has always been diverse in religion. In addition to the established Church of England, there had long been a Protestant nonconformist tradition reinforced by Welsh migrants, Scots Presbyterians and German Lutherans, and there was a tiny native Catholic element which was to be massively reinforced by the Irish influx and the arrival of the Italians.

In the early twenty-first century Manchester was being portrayed in the popular press as one of the most ethnically diverse cities in Europe.[8] The purpose of the present chapter is to outline the processes whereby this notably heterogeneous population evolved, the economic and spatial niches they occupied and the ways in which they have coped with latent, and occasionally overt, anti-immigrant sentiment, while interacting with the city as a whole and striving to retain their distinctive traditions.

Local and regional migrants

Between 1801 and 1851 the Manchester population grew from 76,788 to 316,213. Some of this was due to natural increase, but the greater part was due to immigration. The 1851 census noted that a considerable part of this inward movement had come from the surrounding counties of Lancashire and Cheshire, with notable numbers also drawn from Yorkshire and other parts of England (Table 5.3). Contemporary observers were somewhat conflicted by this influx. It was noted that while welcoming to friends and co-religionists, locals were deeply suspicious of strangers, defined as anyone outside their immediate locality, and bigoted towards those who did not share their religious outlook. Their speech was marked by strong accents and dialects which one observer described as difficult for others to understand, describing it as 'a sort of bastard Saxon ...'[9]

Place of birth	Number	Percentage
Manchester–Salford	182,195	45.4
Elsewhere		
Lancashire	75,537	18.8
Cheshire	20,231	5.0
Yorkshire	17,274	4.3
Rest of England	37,034	9.2
Wales	6,850	1.7
Scotland	6, 551	1.6
Overseas	3,145	0.8
Ireland	52,504	13.1
Elsewhere subtotal	219,126	54.6

Table 5.3 Places of birth of Manchester-Salford population in 1851 (Census)

Welsh in Manchester

Migrants were not only attracted by employment opportunities but actively encouraged to move by Manchester entrepreneurs who sent their agents throughout the United Kingdom, especially at times when specific skills were in short supply. Thus from quite early on people from North Wales had migrated to the city and by 1851 the Welsh constituted 1.7 per cent of the population (Table 5.3). Sources are scarce, but useful data can be gathered from the organizations and associations they formed. Given the enduring strength of the nonconformist tradition and the language in nineteenth-century North Wales, it is not surprising that from quite early on Welsh-speaking groups gathered regularly for worship. There are traces of informal meetings as early as 1788, sometimes in private homes, but also in whatever premises were available. A Sunday school was opened in 1795 and numbers of worshippers grew to the point where a purpose-built chapel was opened in late 1799 in Shudehill on the north-eastern side of the city. As numbers grew, so too did the number of chapels, until by 1880 there were six.[10] Their geography had also changed. Originally the chapels had been concentrated in the inner areas of the city, but as the Welsh prospered, upward mobility took them into the suburbs. A Welsh group had been worshipping in temporary premises in Altrincham since at least 1850, but a purpose-built chapel was finally opened in 1903 with a service, a tea party and a speech by David Lloyd George (1863–1945).

The man and the location nicely sum up the varied reasons for Welsh movement into the Manchester region. His father William (1820–64) had originally migrated in 1861 to take up a teaching post, and the future prime minister was born in the city in 1863. However, William contracted tuberculosis and the family moved back to Wales in the hope that his health would improve, though he died in May 1864. In many ways he personified the educated, literate professionals in the Welsh inflow. Analysis of the background of 121 men of Welsh birth or descent who were present in the city in the nineteenth century suggests that the most notable inflow took place in the period from the early 1830s to the late 1860s. Of the 71 main occupations cited, 15 were clergy, 13 were related to the textile trade and there were three doctors and three engineers. A number were active in community and chapel affairs, including the cotton merchant Absalom Watkin (1787–1861). Others were notable in civic life, such as Edward Edwards (1812–86), appointed Manchester public librarian in 1851, the first such post in the United Kingdom, and John Owens (1790–1846), second-generation founder of Owens College, later Manchester University.[11] Robert Owen (1771–1858), born in Newtown, Montgomeryshire, quickly became active in local affairs as a member of the Literary and Philosophical Society and the Board of Health. His experience working in and managing a local mill contributed to the development of his radical ideas on factory life and workers' living conditions which underlay the New Lanark mills he developed when he moved to Scotland.

But there were also considerable numbers of working-class people attracted by the great variety of employment openings. Significant numbers of Welsh women entered domestic service, especially in the more prosperous suburbs, and the Welsh servant girl was a notable feature of many wealthy households. They were a very visible presence in the chapels, notable for their personal spirituality, catering skills and energy in cleaning and embellishing the premises. Those who did not live in were often to be found in small cottage-style houses nearby.

Some families held open house for fellow Welsh arrivals, but there was clearly a feeling that something more formal was needed. By 1837 a Cambrian Institute and Society for Diffusion of Useful Knowledge Among the Welsh existed.[12] There was a thriving Cambrian Society by 1842 which organized annual dinners, and the first mention of a St David's Day celebration is in 1881.[13] Such organizations and events were important for the atmosphere of relaxed nostalgic fellowship they created.

Links with North Wales remained strong. Clergy were usually trained at Bala, several Manchester Welsh won Eisteddfod awards and others contributed regularly to Welsh-language publications. The year 1906 probably saw the Welsh community in the Manchester and Salford region at its peak, with officers from 17 chapels gathering for regular monthly meetings.[14] But thereafter there was a steady decline as migration patterns altered, subsequent generations abandoned their distinctive cultural traditions and chapel-going declined. From 1950 onwards the rate of chapel closure accelerated until by 2015 there was only one chapel in Manchester and another in Altrincham.

Scots in Manchester

There are traces of temporary and seasonal Scottish migrants in north-west England from the later middle ages, mostly as harvesters or drovers, but from the early eighteenth century onwards there was a steady build-up of more highly skilled permanent residents, particularly from south-western Scotland.[15] They reached a peak of 1.9 per cent of the city's total population in 1871. The newer Scots were notable for their high level of education and their technical skills, attributed to the fact that the curricula in Scottish colleges and universities had a notably practical and applied emphasis and they trained more people than the Scots economy could absorb on the assumption that many would emigrate. Men were in a small majority and many of them were skilled tradesmen and craftsmen employed in engineering and textiles. Of the first 43 baptisms at the 'Scotch Church' in St Peter's Square, opened in February 1833, eleven of the fathers were employed as either surgeon, teacher, engineer, mechanic or watchmaker and a further ten as metal moulder, engraver, coachmaker, cabinet maker or smith. Only four could be classed as involved in the textile industry but seven were described as merchants or salesmen.[16] Data on women is difficult to unearth but there is some evidence that many entered domestic service and the textile mills.

Notable efforts were made to preserve links with Scotland. By the mid-nineteenth century there were two Scottish Presbyterian churches in the city, with clergy trained in Scotland. The 'Scotch Church' archives declare that their basic statement of faith was that approved by the General Assembly of the Church of Scotland and ratified by law in 1690.[17] Later the same year they decided to launch a Sunday school and library, contacted Edinburgh to inquire about a 'suitable person' to teach in the day school and sent £50 to support the Gaelic School Society. In 1834 the Young Men's Society prepared an address to 'Scotchmen residing in Manchester who are in the habit of not attending any Church whatsoever'. They took great care over those who did attend. The list of those able to take communion was regularly revised, the city was divided into eight districts and a ruling elder was appointed to the pastoral and spiritual oversight of each district.[18]

Some Scots came to play prominent roles in city life. The firms of Adam and George Murray and McConnel and Kennedy built in Ancoats two of the earliest steam-powered mill complexes. The chemist James 'Paraffin' Young (1811–83) arrived in 1844, developed new oils and dyes, was active in the Literary and Philosophical Society and helped to found the *Manchester Examiner* newspaper in 1846. Sir Frank Forbes Adam (1846–1926), merchant and banker, served as president of the Chamber of Commerce from 1894 to 1905 and chaired the governing boards of both the Royal Infirmary and St Mary's Hospital.

Grosvenor Square Presbyterian Church, All Saints, 1972. The church and its day school were founded in 1850, members of its congregation having been expelled from the Scottish Presbyterian church in Mount Street. The congregation, which included some of Manchester's wealthiest Scottish families, declined with the suburban diaspora. The church closed in 1940 and the building was demolished in 1974.

Courtesy of Manchester Libraries, Information and Archives, Manchester City Council

There were also informal organizations and gatherings. By 1880 a St Andrew's Society was organizing annual dinners and by 1890 the Manchester and Salford Caledonian Society was organizing an annual concert and there were regular Burns Suppers. In 1914 the Caledonian Society was prominent in the campaign to recruit Manchester Scots into the Scottish regiments and it is estimated that half the strength of the 15th Royal Scots came from the city. During the twentieth century the Scots gradually blended into the generality of the population, though there were still annual St Andrew's Day dinners and Burns Suppers. There was also a continued movement of Scots talent into the city at all levels. Among many Scottish-born academics was Morrison Watson (1846–85), professor of anatomy at Owens, and the biblical scholar F.F. Bruce (1910–90) who was appointed to a chair at the university in 1959. In the second half of the twentieth century Manchester United was notable for the number of Scottish management staff and players it recruited.

Irish in Manchester

It is the Irish who have proved the most numerous and enduring of all the city's immigrant groups. There were commercial and military connections with Ireland from at least the sixteenth century, when Irish linen yarn was imported and supplies and men were raised in the city for campaigning in Ireland. Subsequently, Manchester imported steadily increasing amounts of Irish goods, notably pastoral produce, live animals, meat and pork.[19] By the late eighteenth century growing numbers of Irish were travelling through the city on the way to help with the annual harvest in the north-west, and the resident Irish population steadily increased. From the early nineteenth century the outflow from Ireland grew and by 1841 there were 32,490 in the city, or 11.6 per cent of the population. They were quitting Ireland because of the deteriorating economic situation and attracted to Manchester by the varied opportunities in the rapidly expanding economy. Numbers were further boosted by the flight from the Great Famine of 1845–52, and by 1861 the Irish population had reached its peak, with 52,076 people (15.4 per cent). Subsequent numbers declined fairly steadily into the twentieth century, with occasional upturns depending on the relative fortunes of the Irish and British economies. From the mid-1930s until the early 1960s there was a steady rise in the numbers of Irish coming to Britain, with further upsurges in the early 1980s and the early years of the twenty-first century.[20] Like most of north-west England, Manchester saw a growing Irish population in the early stages of this upsurge but by the late 1950s the regional economy was entering a long period of decline and the city was no longer as attractive as it once was. By the 2011 census 1.7 per cent of the population of the city had been born in the Republic of Ireland and 0.9 per cent in Northern Ireland.

Employment patterns also underwent notable changes. The great majority of nineteenth-century Irish migrants were from deeply rural backgrounds and could only offer physical strength, stamina or domestic skills to the labour market, though

Little Ireland

Gentlemen, the undersigned having been deputed by the Special Board of Health to inquire into the state of Little Ireland beg to report that in the main street & courts abutting, the sewers are all in a most wretched state and quite inadequate to carry off the surface water, not to mention the slops thrown down by the inhabitants in about 200 houses.

The privies are in a most disgraceful state, inaccessible from filth, and too few for the accommodation of the number of people – the average number being <u>two</u> to 250 people. The upper rooms are with few exceptions very dirty and the cellars much worse, all damp, and some occasionally overflowed. The cellars consist of two rooms on a floor each 9 to 10ft square some inhabited by 10 persons, others by more: in many the people have no beds and keep each other warm by close stowage on shavings, straw &c.; a change of linen or clothes is an exception to the common practice. Many of the back rooms where they sleep, have no other means of ventilation than from the front rooms. Some of the cellars on the lower ground were once filled up as uninhabitable but one is now occupied by a weaver and he has stopped up the drain with clay to prevent the water flowing from it into his cellar and mops up the water every morning ...

In conclusion we are decidedly of opinion that should cholera visit this neighbourhood a more suitable soil and situation for its malignant development cannot be found than that described and commonly known by the name of Little Ireland.

Edmund Lyon M.D., Frederick Fincham, William Johns M.D., Peter Ewart junr.

Members of the Board of Health in Manchester

Extract from the proceedings of the Special
Board of Health, dated 19 December 1831

The threat of cholera in 1831 led to the establishment of a Special Board of Health in Manchester. Its investigations brought the living conditions of Irish migrants to the attention of a wider public. Some of the worst conditions reported were in the streets by the river Medlock to the west of Oxford Road. James Phillips Kay's influential essay *The moral and physical condition of the working classes employed in the cotton manufacture in Manchester* (1832) was based on the findings of the Special Board, making this particular 'Little Ireland' a byword for the habits and destitution of the 'low Irish' long after the slum itself was demolished.

'Come Back To Erin'. Broadside ballads with Irish themes were a staple of ballad publishers, of whom Thomas Pearson was the most prolific in mid-Victorian Manchester. Their subjects ranged from the sentimental to the political, evocations of the homeland contributing to maintaining Irish identity.

Courtesy of Chetham's Library

there were always some skilled, middle-class and professional people in the mix. By the late nineteenth century there were definite signs of upward mobility and as the twentieth century wore on increasing numbers of men were to be found in light engineering and transport and women in the health and welfare services, teaching and part-time occupations. Subsequently it was notable that the educational level of Irish immigrants was rising and the average age falling with increased personal mobility.

One of the most distinctive features of the nineteenth-century Irish influx was the tendency towards residential clustering in certain districts of the city. The notably poor living conditions in 'Little Ireland' on the south-western edge of the township came to be regarded as the 'typical' Irish district despite its limited area, small population and brief duration, largely thanks to the writings of the local sanitary reformer James Phillips Kay (1804–77) and Friedrich Engels (1820–95).[21] The enduring Irish neighbourhoods were to be found in Angel Meadow and Ancoats on the north-eastern side and Hulme on the south-western fringes. Relative poverty encouraged concentration in the poorer working-class districts and within these, communal solidarity, family links, alienation from the novel urban and industrial environment and occasional outbreaks of anti-Irish and anti-Catholic sentiment led to multiple occupation and a degree of residential segregation. This pattern was reinforced by the fact that the overwhelming majority of the Irish were Catholic and local churches, with the associated parochial halls and schools and a network of parish-based religious, social and cultural organizations, both followed and consolidated the pattern of spatial clustering. As the anti-Catholic sentiment which underlay much historic English popular nationalism gradually faded, Catholic churches become more numerous and grander in size and architecture. Following the restoration of a full Catholic hierarchy in England and Wales in 1851, St John's church, Salford was designated the cathedral of the new diocese.

Residential concentration facilitated political activity. The Irish retained a keen interest in the affairs of Ireland, and once politically organized they developed a working relationship with the local Liberal Party in the late nineteenth and early twentieth centuries which enabled them to rally their voters in these districts and elect a group of councillors on the Liberal ticket, some of whom went on to occupy prominent positions in the civic life of the city. The most notable was probably the immensely popular Daniel McCabe (1853–1919), second-generation Irish, devout Catholic and keen supporter of Irish Home Rule. He was the first Catholic to become Lord Mayor, serving two terms (1913–15), and was knighted by both King George V and the Vatican. But by no means all those of Irish descent were at ease with their roots. Many quietly focused on making a living and rearing a family. Others ostentatiously eschewed their background. The distinguished author, critic and composer Anthony Burgess (1917–93) was the lower middle-class son of Irish migrants. Born in the strongly Irish working-class Harpurhey district and educated in church schools, he nevertheless distanced himself from the claims of both religion and nationalism.

Alongside democratic politics, the clandestine tradition of revolutionary violence was represented in the city, as shown in the rescue of two Irish Republican Brotherhood prisoners from a police van in September 1867. Two months later this resulted in the execution of three Irishmen for the murder of a policeman during the rescue, thereby supplying the Irish nationalist movement with the 'Manchester Martyrs', a ballad 'God Save Ireland' which virtually became a national anthem, and the longest running commemorative tradition in Irish nationalism. The city also saw a brief IRA campaign in 1920–21, but with the establishment of the Irish Free State in early 1922, most politically conscious Irish drifted towards the Labour Party on the basis of class and union links. Several Irish-born councillors were elected to the city council for all three main parties, but their interests tended to focus on local rather than specifically Irish issues. The troubles in Northern Ireland from 1968 onwards revived some of the more politically conscious, but the general trend was a cautious distancing from the situation. The IRA campaign came to the city in the form of a large bomb explosion in 1996 which, while causing extensive damage, many injuries and provoking some anti-Irish sentiment, did no lasting damage to the position of the Irish.

A network of often parish-based organizations had grown up from early times. Some focused on aspects of spiritual life and Catholic doctrine, others addressed social problems such as alcohol abuse, and there were reading and debating groups and sports clubs. These organizations enabled women to find a key

Manchester Martyrs: letter (dated 27 October 1867) from William Allen to his mother before his execution in November 1867. One of the defining episodes in the Irish nationalist narrative is the rescue of two leading members of the Fenian Brotherhood from a police van in Manchester in September 1867. The prisoners escaped but a police sergeant was killed and the later public hanging of three Irishmen – William Allen, Michael Larkin and Michael O'Brien – saw them elevated into the nationalist pantheon as 'The Manchester Martyrs'. Since the event took place in the diaspora, it resonated with the Irish abroad, becoming the oldest continuous commemorative event in the Irish nationalist calendar.

Reproduced with kind permission from the Working Class Movement Library

role in Irish migrant life. In a pattern duplicated by many migrant groups, the initial influx of Irish had been strongly male dominated, but with time the gender ratios evened out. The roles assigned to women varied, but, as with so many migrant groups where religion played a central role in community life and identity, there was a notable tendency to assume that women would be preoccupied with roles in home-making, child-rearing, food preparation and moral instruction. Some did find employment as mill hands, milliners, dressmakers and domestic servants. The diocesan newsletter *The Harvest* occasionally carried advertisements such as that which appeared in September 1898 announcing the availability of 'Irish girls just over, well trained and with good references'. In the dense thicket of organizations and clubs which grew up, women took on particular responsibility for charitable work involving the welfare of the poor, sick and young. The Catholic Needlework Guild was led and administered by women, and had as its objects 'to provide useful articles of clothing for the poor, and to offer to girls and women of all classes the means of organising charity'. The Protection and Rescue Society set up by Bishop Herbert Vaughan (1832–1903) in 1886 and placed under the special protection of St Patrick was designed to rescue Catholic children who appeared in the courts and workhouse from Protestantism and neglectful parents. Although the executive committee was clerically dominated, in 1901 its 25 members included five women and the nine-person committee which oversaw the homes run by the Society included three women. When women did enter the public realm, it was again in a child-centred welfare role. By the early twentieth century increasing numbers were teachers in church schools. In 1899 Rose Hyland (1843–1911) was the first woman elected to the Manchester Board of Poor Law Guardians, where she was prominent in the care of the old, the infirm and women and children who had fallen on hard times, a role she also played in the various church-based charities she supported. Subsequent generations of Irish women followed similar paths, but increasingly as full-time employees in the state sector, and as time went on it was notable that improved education opportunities in Ireland led to increasing numbers moving into senior positions in both the state and private sector.

One of the most notable developments in this Irish associational culture in the nineteenth century shadowed the Victorian trend to self-help and mutual aid in the form of the Irish National Foresters, founded in Ireland in 1877 with the aim of encouraging saving against sickness, unemployment and funeral expenses. Donegal-born Dan Boyle (1859–1925), later a Manchester alderman and MP for North Mayo, was one of the most energetic organizers in Britain. In the early years of the twentieth century the Irish cultural revival was reflected when branches of Conradh na Gaeilge, which nurtured Gaelic linguistic and literary traditions, and the Gaelic Athletic Association were founded in the city. Community social life also thrived, with concerts of Irish music and dancing, annual dinners and public celebration of St Patrick's Day, a tradition traceable to the 1840s. Certain pubs and dance halls catered for the Irish in particular, and from the 1950s onwards Irish clubs and associations multiplied and the music scene became increasingly lively

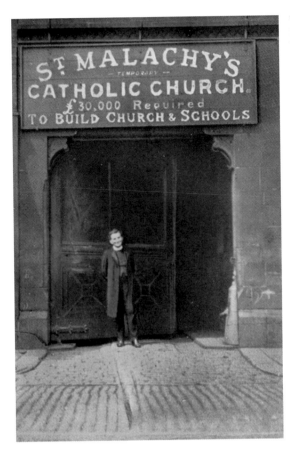

St Malachy's. The struggle to provide churches for Irish Catholics continued into the inter-war years, especially in the poorest areas of the city. St Malachy's opened in a former blacking works on Rochdale Road in 1922 and suffered three arson attacks in the following year. Money was eventually raised to build a new church, school and presbytery in Collyhurst, which opened in 1931.

Courtesy of Salford Diocesan Archives

and creative, not merely retaining traditional Irish music and dance under the aegis of a local branch of Comhaltas Ceoltóirí Éireann, but diversifying into often hybrid forms of rock, punk and rap.

Clearance and demolition from the 1930s onwards began to erode the traditional Irish neighbourhoods, but on moving out the Irish still tended to relocate to districts with family links and a Catholic church and school. The 1980s saw a notable quickening of Irish community activity. In 1981 the Irish World Heritage Centre was opened on the northern side of the city, providing a venue for a wide variety of social and cultural events for all ethnic groups, and there was a rapid growth of County Associations which organized social events and annual dinners. A radio programme dedicated to Irish interests was launched in 1983. Recognizing the needs of a population that was ageing, in 1985 Irish Community Care was founded to provide a variety of services, including advice, counselling and support for those suffering isolation, abuse and bereavement.

There was also a growing interest in the history and traditions of the community. Support for the Gaelic language and sports persisted and increasing attention was devoted to community history and traditions. The first modern St Patrick's Day parade was held in 1990, and the Manchester Irish Education

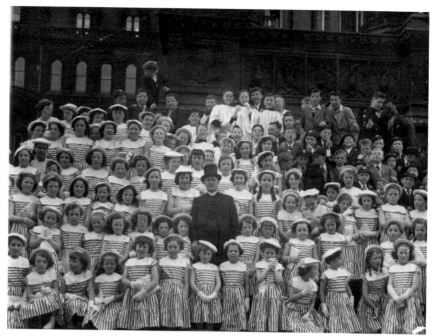

Group was founded in 1996, became a registered charity in 1998 and went on to produce material for schools and to organize lectures, study groups and an annual conference.[22] This became part of an annual Manchester Irish Festival, launched in March 1996, which brought together many of the strands of Irish life in the city.

By the early twenty-first century the Manchester Irish were well integrated into the life of the city while also managing to maintain a more distinct sense of group awareness than either the Welsh or Scots. This might be attributed to greater numbers, their distinctive religion, history and cultural traditions, the generosity of successful Irish businessmen and some notable community leaders.

International migrants

Greeks in Manchester

By the late eighteenth century representatives of European firms eager to trade in textiles were established in the city. Among the most notable were a group generally referred to as 'Levantine merchants'. This was a generic term covering businessmen from Syria, Lebanon, Turkey and, most notably, Greece. The first record of a Greek trader in the city dates from 1834 and by the late 1840s there were 33 Greek merchants, mostly living in Upper Broughton. The community was sufficiently numerous and prosperous to consecrate a Greek Orthodox church in 1843 and open a purpose-built church with resident priest and manse in 1860. The church became a centre of community life, along with a 'Learned Mercury Club' where people met for social events, reading and discussion. A fund for poor relief

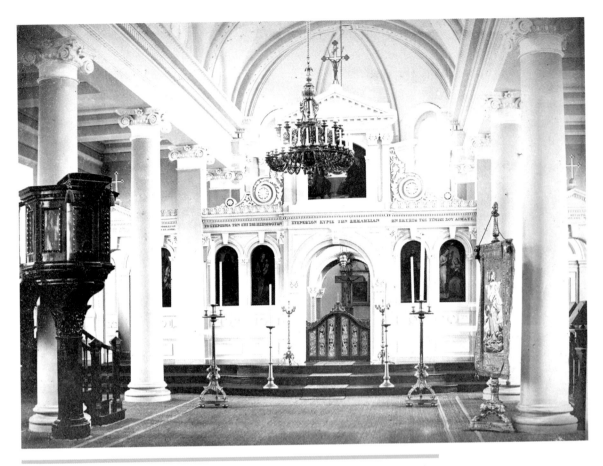

Greek Orthodox Church of the Annunciation, Higher Broughton. A Greek merchant community flourished for a time during the nineteenth century when a treaty of 1834 opened the Ottoman Empire to trade with Britain. But numbers declined sharply following the declaration of war in October 1914 and the defeat of Turkey and dissolution of the empire in 1918. Opened in 1861, the church is still active, patronized by descendants of the original community and students from the universities.

Courtesy of Manchester Libraries, Information and Archives, Manchester City Council

was set up in 1866 and periodic collections taken up for disaster relief in Greece. Some members were also participants in broader civic life, most notably Sotiros Hazzopulo (1839?–1916), friend of the Liberal Prime Minister W.E. Gladstone, elected councillor for Salford's St John's ward 1888–91. A small influx continued into the early twentieth century and a branch of the Bank of Athens was set up in 1921 in Mosley Street, but numbers were drifting downwards until the early twenty-first century, with Greek entry into the European Union and a small influx of Greek students into the local universities. Manchester University benefited notably from the benevolence of Sir John Zochonis (1929–2013), a successful businessman descended from a family trading in the city from the 1870s.

Germans in Manchester

In 1781 the first German merchant was established and by 1870 there were 420 foreign firms in the city owned by at least 14 different nationalities. At first most relied on Manchester merchants to select and package the cotton goods they ordered, but impatience with the fees charged and inappropriate selection and packaging led many to set up their own warehouses.[23] One such was the German Jew Nathan Meyer Rothschild (1777–1836), who arrived with £20,000 capital in 1799 which he used to purchase a large warehouse for the storage and export of goods destined for the great trading fairs of north Germany. On his departure for London in 1810 he had trebled his original capital and went on to found the great banking dynasty.[24] By 1870 there were 153 German firms at work, some of which had expanded into engineering, chemicals, banking and the retail trades.[25] Down to 1891 Germans were the city's largest single foreign element, numbering 1,318 by 1911, the second largest German community in the United Kingdom.[26] As with the Greek, Armenian, Syrian and Moroccan communities, by the 1930s they had virtually disappeared, but nonetheless the German contribution to Manchester was in its time substantial and welcome.

As they became established, some became 'merchant entrepreneurs', branching out into textile manufacturing and allied industries such as engineering and chemicals. Some firms based in Germany set up branches in the region and dispatched representatives to oversee their interests. This was one motivation of the Engels family of Barmen in the Prussian Rhineland when they sent their son Friedrich to England in 1842 to learn the trade and look after the family share in the textile firm of Ermen and Engels and its mills in Salford. His devoutly Christian parents also hoped to separate him from the radical political company he had been keeping. As with all migrant communities, there were internal variations in wealth and status, with many clerks, tailors, shopkeepers, and café and restaurant owners of modest means. While the majority of this early German influx was Jewish in background, they varied in their adherence to the faith: some defected to Unitarianism, but others reinforced the tiny existing Jewish community.

From quite early on Germans participated energetically in local society. Some contributed generously to local causes and organizations, such as the merchant entrepreneur Solomon Levi Behrens (1787–1873) from Hamburg who gave 10 guineas to a collection for the poor in 1816. Others took up places in financial life, including in the Manchester and Salford Savings Bank.[27] There was strong German input into the Foreign Library founded in 1830, and the Society for the Relief of Really Deserving Foreigners, founded in 1847, was largely financed and patronized by Germans. There was also a growing tendency to set up their own organizations and clubs which achieved the remarkable dual role of both preserving German cultural traditions while gaining broad local acceptance and respect. In 1841 the Liedertafel, a choral society, was founded, and in 1845 the Kegel Club, for a German version of skittles. The Albert Club, founded in 1842 and open to all, was rather more serious

Friedrich Engels was sent to Manchester in 1842 to oversee the family interest in cotton mills in Weaste, Salford, and in the forlorn hope that this would divert him from radical political ideas. His expeditions into Manchester's working-class districts, often accompanied by his Irish partner, the millworker Mary Burns, merely confirmed his outlook and provided some of the most vivid passages in his *Condition of the Working Class in England* (1845). He returned to live in Manchester during the 1850s and 1860s, where his visitors included Karl Marx.

Courtesy of Chetham's Library

in outlook, with its library, newsroom, dining and committee rooms, but like so many gentlemen's clubs of the time, it mixed sociability with business. Manchester's Schiller Anstalt has been described as possibly the most famous German club in Britain. Founded in 1860, following the previous year's celebrations of the centenary of Schiller's birth, it came to occupy a prominent role in the broader cultural and social life of the city. Engels was chairman from 1864 to 1868. With its extensive library, reading and dining rooms, it hosted public lectures, recitals and concerts, supported victims of the Franco-Prussian War of 1870–71 and celebrated the Kaiser's birthday, but there was a fair smattering of English and other nationalities among the members, who numbered 300 by 1866. In 1860 the Turnverein was founded, its combination of facilities for gymnastics and fitness, cultural and social activities and excursions reflecting current German thinking on the all-encompassing nature of education.[28] In 1910 the only German-language newspaper outside London, the *Manchester Nachrichten*, was launched, but only lasted two years.

Spiritual life was not neglected. The majority of German gentile immigrants were Lutheran Protestants, and there were gatherings for regular worship by 1853 and in 1854 a Lutheran pastor was appointed. By 1871 they had moved into their own building and by the early twentieth century the church had 300–350 members. A second church opened in 1896 and a German Seaman's Home was opened in 1906. Distinct from these two churches was the Mission Church, opened in 1853 on the north side of the city to reach out to the poorer classes of Germans,

providing not only spiritual and pastoral support but a primary school. Under the leadership of the charismatic Revd Joseph Steinthal (c.1824–77) this acquired its own premises in 1874.

Germans contributed notably to the cultural life of the city. The most enduring heritage is the orchestra, founded in 1858 by Charles Hallé (1819–77), who had been born in Westphalia. He went on to help found the Royal Manchester College of Music and was succeeded in turn by Hans Richter. Education at all levels benefited from the German presence. The churches ran Sunday and day schools which were much appreciated and German ideas on child development influenced the growth of kindergartens in the city. In higher education the departments of chemistry, languages and particularly physics at Owens College benefited greatly from the German presence. (Sir) Arthur Schuster (1851–1937) had been born in Frankfurt-am-Main in 1854 into a family that had a textile business in Manchester as early as 1811 and finally came to live in the city in 1869. Schuster became successively professor of mathematics (1881), physics (1888) and Dean of the Science Faculty when university status was granted in 1903. At a humbler level, German restaurants and a delicatessen had appeared in the city by the early 1860s; Germans were notable as pork butchers and German waiters were a marked presence in hotels and cafés.

In politics Germans participated fully in local affairs as magistrates, Poor Law Guardians, councillors and aldermen.[29] The most notable was probably Philip Goldschmidt (?–1899), a non-practising Jew from Oldenburg who arrived in Manchester in 1846, was elected to the council in 1868, and in August 1883 became the city's first foreign-born mayor, receiving the rare accolade of a second term in 1885–86.[30] Enduring interest in German affairs led to the formation of the Deutsches National Verein in 1848 to express solidarity with the liberal revolutions of that year in Berlin and Vienna. In late March 1848 13 German firms contributed £500 for the relief of families who had lost relatives in the fighting. A public meeting was held on 30 March in the city's Athenaeum at which speeches entirely in German were made in support of the revolutionaries, the liberal tricolour of black, red and gold was displayed, and the proceedings concluded with nine members of the Liedertafel leading the assembly in patriotic songs.[31] The increasingly militaristic and autocratic ethos of the new German Empire after 1870 grated on the generally liberal instincts of many Manchester Germans.

These political sympathies were one of the reasons why for much of the nineteenth century the Germans were comfortable and accepted in Manchester, since their outlook converged nicely with the inclusive civic ethos of the city. Moreover, middle-class Germans, with their emphasis on serious-minded hard work, civic duty, active involvement in cultural and charitable activities and domestic respectability, moved easily into bourgeois social circles. This sense of solidarity was reinforced by the circulation of pseudo-scientific racist ideas which elevated 'Anglo-Saxons' to the top of the racial hierarchy, with the British and Germans at the very peak.

But this was not to last. By the 1880s there was a growing awareness that the German Empire was expanding steadily in economic and political significance

and by the opening decade of the next century this had developed into deep alarm, especially over German naval strength. This occasionally erupted into outbreaks of 'spy mania', reflected in popular novels and newspapers, and was exacerbated by a series of diplomatic crises. Consequently the outbreak of war in August 1914 saw public opinion turn quickly against the local German population, who became targets of both popular anger and official sanction. The peak was reached when 1,457 people were killed following the torpedoing of the *Lusitania* off the southern Irish coast on 7 May 1915. Riots broke out across the country, including three days of disturbances in Manchester over 10–12 May, when business premises and houses owned by Germans or those related to Germans were attacked, and there was also opportunist looting of other shops. A total of 122 people appeared in court, mostly on charges of riotous behaviour and theft or receipt of stolen goods. At national level tabloid hysteria reached almost paranoid levels: in Manchester and elsewhere local institutions banned or sacked Germans and increasingly severe official restrictions were introduced, culminating in the internment of all German males aged 17 to 55 and the repatriation of all females. Many Manchester Germans were interned on the Isle of Man and the German institutions in the city withered and died. Movement to the suburbs had already weakened many, notably the Albert Club which closed in 1888, followed by the Schiller in 1911, and the Society for Relief of Foreigners, despite widening its scope, ceased operations in 1927. The German community in Manchester had been destroyed and for a long period its history was written out of the city's story.

Jews in Manchester

Clearly many of the earliest Jewish migrants to Manchester were of German origin. In 1290 England was the first European country to order the total expulsion of Jews, and they were only readmitted by Oliver Cromwell in 1657. Small numbers of Sephardic merchants, descended from Jews who had been expelled from Iberia in 1492 and had settled in ports around the Mediterranean trading in cotton goods, settled in London and port cities. Some traded with ships' crews, while others became familiar figures as pedlars on the roads and at fairs and festivals, selling or repairing small household items such as umbrellas, brushes or combs.[32] By the early eighteenth century Jews in Liverpool had discerned opportunities in Manchester and a map of 1741 notes the presence of 'Synagogue Alley' in the city centre, derived from the use of a warehouse for worship. By the 1780s some had accumulated sufficient capital to set up small shops dealing in pens, pencils, old clothes and watch parts and there is also evidence of a pawnbroker and optician.[33] In 1794 land was purchased for a Jewish cemetery, a 'Hebrew Academy' for religious instruction was established in 1802 and new premises for worship obtained in 1806. In 1811 there were approximately 140 Jews in the city; a full-time Reader for the conduct of services was appointed in 1813 and the first kosher restaurant opened in 1819. Some early immigrants had abandoned the faith entirely and others had been attracted by the inclusive universalism of Cross Street Unitarian chapel, but by now

the observant community was sufficiently numerous to open the first purpose-built synagogue, costing £1,700.

The community was now well established, but the launch of the Hebrew Philanthropic Society in 1826 for the relief of those who had fallen on hard times acknowledged an internal division. There was clearly an upwardly mobile element making their way into the broader business and professional life of the city, acquiring premises in Deansgate, Market Street and St Ann's Square and homes in the growing suburbs. But there was also a poorer element still involved in the peripatetic lifestyle of the travelling salesman and the small shop in the older parts of the city. Leadership definitely lay with the first group. Anxious to prove themselves patriotic and worthy citizens, they adopted a strategy which involved retention of their faith while being simultaneously active in local and national affairs. Jews were involved in supporting the Mechanics' Institution, the School of Design, the Athenaeum, the District Provident Society and the Anti-Corn Law League and many gave generously to local charities. There was also strong support for the campaign to allow Jews to enter Parliament, which was finally achieved in 1858. In 1851 Philip Lucas (1797–1865) was returned unopposed as Liberal councillor for Cheetham ward, and by then there were about 1,000 Jews in the city, making it the second largest Jewish community in Britain outside London.

The year 1851 also saw the appointment of Dr Schiller-Szinessy as Manchester's first fully qualified rabbi and in 1858 what became known as the Great Synagogue was opened off Cheetham Hill Road. But that same year saw latent fissures come into the open. For some time more liberal elements in the leadership cadre had been attracted towards the idea of modernizing aspects of synagogue

services and religious instruction, with greater use of English alongside Hebrew. In Germany a modernizing reform movement had emerged in the years immediately following the end of the Napoleonic wars and immigrants brought some of its ideas to Manchester. These resonated with some local Jews and the result was a schism in the community, with a Reform synagogue, to which Schiller-Szinessy later gravitated, also opened on Cheetham Hill Road in 1858.

A further source of differentiation had been building up almost unnoticed since the 1840s with the growing immigration of Jews from eastern Europe, especially Russian Poland. Economic adversity played a part, but increasing discrimination and eventually outright persecution were the dominant reasons as the imperial government rescinded the favourable conditions under which those areas known as the Pale of Settlement had originally been settled by Jews. They proceeded to impose all the discriminatory measures long endured by Jews in the rest of the Russian Empire. The climax came with a series of vicious pogroms in parts of Poland and Ukraine in the early 1880s.

The result was that by 1889 the Jewish population of Manchester had risen to about 14,000, the great majority of East European origin. To the consternation of the existing Jewish population they were characterized by poverty, lack of skills and education, use of Yiddish as their everyday language and entrenched conservatism in religious observance. Given their poverty, it is hardly surprising that they clustered densely in the poorer residential district known as Red Bank between Cheetham Hill Road and the river Irk. There they worked long hours in the tiny crowded workshops or 'sweatshops' run by fellow Jews, employed in making cheap clothing, footwear, caps and tassels, while some set up one- or two-person firms specializing in glazing and watchmaking and repairs.[34] Ill at ease in the existing places of worship, they gathered at informal prayer groups and eventually by 1900 had three distinctive synagogues.

Partly in response to this inflow of immigrants, some elements in British public life began to campaign against what was described as the 'alien flood', expressing themselves in terms which combined varying degrees of xenophobia, racism and anti-Semitism. The result was the Aliens Act of 1905 which denied entry to those with a criminal record or suffering from disease or unable to prove they could support themselves. There was a variety of responses from local Jews. Some preferred to retain the traditional low-profile strategy of quiet integration, exemplified in the plethora of charitable organizations for education and support of the poor and sporting and leisure clubs based on standard Edwardian models, emphasizing good citizenship and patriotism. Other avenues were also explored, most notably leftist politics and trades unions, though these can also be seen as routes to integration.[35]

But perhaps the most significant development was the growth of Zionism, with its aspiration of a return to Palestine and the establishment of a Jewish state. The idea seems to have arrived in Manchester with some of the Russian refugees but can also be seen as a distinctive Jewish version of the burgeoning nationalisms of contemporary Europe which so frequently focused on Jews as 'other'. In

'Sweated labour': the interior of Mandelberg's waterproof clothing factory, probably taken during the celebrations of the coronation of George V with women workers at their sewing machines. By the 1890s the influx of refugees from the pogroms in central and eastern Europe had created a notable concentration of impoverished Jews, many of whom worked in overcrowded conditions in tiny workshops specializing in cheap textiles, glassware and watch repairs. They lived in a small, densely populated district off the lower end of Cheetham Hill Road known as 'Red Bank'.
Image courtesy of the Manchester Jewish Museum

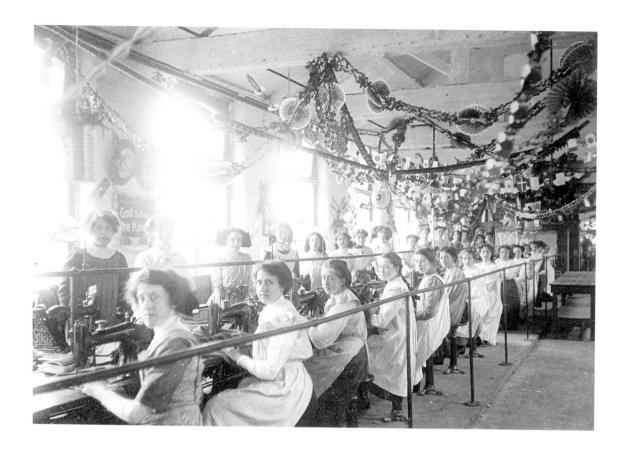

September 1885 the Society for the Promotion of the Colonisation of Palestine was founded, to be followed by a plethora of frequently short-lived small groups, and it was not until 1902 that Manchester Zionism took coherent organizational form in the shape of the Manchester Zionist Association, one of the most active in Britain. This prominence was due in no small measure to the arrival in the city of the energetic and charismatic Chaim Weizmann (1874–1952), an industrial chemist and Reader at the University of Manchester who developed close contacts with the local political establishment. During the First World War he energetically advocated Jewish support for the Allied cause and was influential in the issuing of the Balfour Declaration in November 1917. Its pledge of support for a Jewish homeland in Palestine strongly resonated in Manchester, especially since the wartime campaigns on the eastern front had been in territories with significant Jewish populations who had suffered heavily.[36]

In the years immediately after the war one of the most notable developments in Manchester Jewry was the accelerating drift from the traditional residential concentrations in the Cheetham and Red Bank areas as upward mobility among the Ashkenazi was marked by a move into the northern and southern suburbs. It was also notable that the earlier well-anglicized leadership had been replaced by a subsequent generation whose children were now making their way into the top schools,

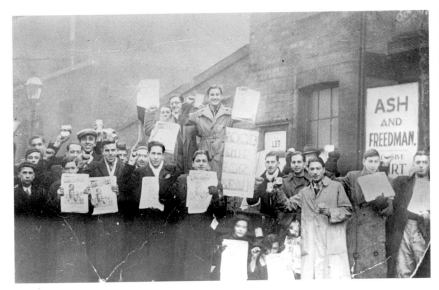

professions and higher echelons of the business and civic life of the city. The network of organizations and associations continued to proliferate, in Jewish musical, sporting, literary and friendly societies. In local politics there were some notable advances, with Samuel Finburgh (1867–1935) serving as Conservative MP for Salford North, 1924–29, the first Manchester Jew to enter the House of Commons. In 1929 Abraham Moss (1889–1964) joined the council as a Liberal (later Labour) councillor, crowning what became a notable civic career by serving as Lord Mayor in 1953.

For Zionism there was something of a quiet period from the end of the war until the early 1930s. From that point onwards there was growing anxiety and self-awareness among Jewish communities in Britain as they watched the outbreak of riots between Arabs and Jews in Palestine, the rise of Nazism in Germany, the establishment of quasi-fascist regimes in central and eastern Europe and the activities of Oswald Mosley's Blackshirts in Britain. Mosley deliberately held a series of meetings in the city, sometimes in the heart of Jewish neighbourhoods, and some politically aware young Jews responded with protests, counter-demonstrations, rallies and leaflets, spearheaded by a strongly Jewish branch of the Young Communist League in Cheetham Hill. Under the leadership of the dominant community leader Nathan Laski others were more comfortable in joining with sympathetic gentiles to campaign for the admission of approximately 8,000 German, Austrian and Czech Jewish refugees from Nazism who made their way to the city between 1933 and 1940. After the war, in 1948 the state of Israel was founded and immediately became involved in conflict with neighbouring Arab states. Jewish opinion in Manchester was strongly sympathetic towards the new state and approximately 40 local men and women emigrated to become involved in the fighting. Support meetings and fund-raising efforts were organized, a pattern repeated during subsequent conflicts between Israel and Arab states.

But conventional local politics were by no means neglected. The general elections of 1945 and 1964 in particular saw the election of some notable Jewish personalities who would play significant roles on the national stage. In 1945 Leslie Lever (1905–77) and his younger brother Harold (1914–95) were elected for Manchester seats, Harold going on to serve in the governments of Harold Wilson. Both became life peers, Leslie being the first Manchester Jew to enter the House of Lords. He was succeeded in his Ardwick seat by Gerald Kaufman. In 1964 the Levers were joined in the Commons by Robert Sheldon, Paul Rose and Joel Barnett, who all had strong Manchester links. Barnett and Sheldon also served in a Wilson government and entered the Lords.

Within the Jewish community there were two significant trends in the late twentieth and early twenty-first centuries. The move from the city to the suburbs and into surrounding council areas accelerated. The 2011 census revealed that the Greater Manchester Jewish population had risen by 15.4 per cent from 2001, with the largest number now in Bury district with 10,302, followed by Salford with 7,687, leaving Manchester with 2,613. Another notable internal trend was the growth of the Haredin, the ultra-Orthodox. A number of rabbis of this persuasion had arrived from Germany in the 1930s and by the early twenty-first century they were probably the largest single element in the Jewish population. In early 2014 in north Manchester they inaugurated an Eruv, with a symbolic 13-mile boundary using roads, walls and wires to delineate the area within which people could move and carry out certain specified tasks during the Sabbath without breaching traditional prohibitions.

By this time the Manchester Jewish population, with all its varied forms and customs, was truly well established, sustained by an intense community life based on extended family, synagogue and a close network of organizations while functioning as an integral and yet distinctive element of the city's population. The characteristically keen awareness of its history, its roots and the enduring challenges it faced was expressed in the opening of the Jewish Museum in the former Spanish and Portuguese synagogue on Cheetham Hill Road in 1984, a project in which Bill Williams, author of a fine history of nineteenth-century Manchester Jewry, played a leading role. But for all its deep roots in the city and its contribution to civic life over the decades, the community was still well aware of the latent anti-Semitism which lingered and sporadically erupted in verbal abuse and desecration of cemeteries, especially when Middle Eastern affairs flared up.

Italians in Manchester

The Italian element in Manchester's population was nothing like as large as the Jewish and like the Germans they were to suffer wartime reaction, but traces of their community have been preserved. The first indications of settlement come with the firm of C.G. Alberti in 1781 and by the 1830s there was a small colony of itinerant craftsmen and cotton merchants in the city, some of whom were involved in the setting up of the Foreign Library in 1830.[37] The crafts practised

were the making and selling of statues, mirrors and precision instruments, picture framing, carving, gilding and the import and selling of fruit and food. Some were itinerant pedlars, the most visible being street musicians with barrel organs and small performing animals. By the early 1830s there was a cluster of lodging houses catering for Italians on the edge of the Ancoats district.

The greatest influx of Italians came in the period 1881–1901 and by the latter date there were 1,605 Italians in north-west England, with some 1,250 in Manchester. Of these about half were to be found in a small interlocking group of streets in Ancoats, north-west of Piccadilly Station, known locally as 'Little Italy'. Emigration from Italy was triggered by structural changes in the north Italian economy and land shortage in the south, and this influx differed from their predecessors in being largely peasant farmers or landless labourers. A significant proportion of the new arrivals migrated under the *padrone* system. The *padrone* functioned as a broker between the would-be migrant and a potential employer, overseeing the process of migration, often accommodating the migrants in lodging houses they owned and making contact with prospective employers. For many migrants he was a helpful guide through a complex and frightening experience, but the system was open to abuse and some migrants were ruthlessly exploited.[38]

Some of the traditional occupations persisted but there were subtle changes. Street musicians almost disappeared, though in some cases the musical

entertainment was now combined with the sale of ice cream. In the second half of the nineteenth century Italians were employed in asphalt laying, the construction of the Ship Canal, and the laying of the elaborate floors in the new Town Hall and the growing number of hospitals. By the early twentieth century some were drifting into the textile mills. The food and catering trades employed increasing numbers, with the first Italian restaurant in the city opening in 1893. The manufacture and sale of ice cream became almost totally dominated by Italians and from this grew firms manufacturing wafers and biscuits. These were owned and staffed by tight-knit, patriarchal, extended families that employed young and old, and meant that women in particular were multi-tasking, with both domestic and business duties. Others made their way into the public life of the city, such as Andrea Crestadoro (1808–79) who became the second city librarian in 1864, and Jerome Caminada (1844–1914), second-generation son of an Italian father and an Irish mother who established a national reputation as a police officer in the 1890s and is seen as one of the founders of modern British detective work. The scholarly Louis Casartelli (1852–1925), fifth Catholic Bishop of Salford, was the second-generation son of a manufacturer of specialist optical instruments.

The Italian population was notable for the intensity of its community bonds. A key element in this bonding was the extended family – the 1891 census suggests that 30 families made up half of the Italian population in Little Italy. Regional birth-place was also a significant element in identity. The great majority of Manchester's Italians came from the southern province of Campania and, in a country which had only come to unified statehood in 1870 and where national identity was as yet weakly developed, this was an important marker, as indeed was the village or town of birth. Little Italy came into St Michael's and St Alban's Catholic parishes and both had sympathetic priests, most notably the Irish-born Father Tynan, and his Italian successors Father Pappalardo and Father Fracassi at St Michael's. The parish provided the basis of a lively community and social life. Italians first took part in the annual Catholic Whit Walks in 1890 and always attracted attention by the elaborate statue of the Virgin Mary which they carried.

Participation in this very public event was symptomatic of a trend in the community to organize themselves in a network of interlocking organizations. The earliest was the Manchester Italian Catholic Society set up by Father Tynan in 1888. It provided language classes, social events and celebrated the 'Festa of the Madonna of St Carmel'. In the early years of the twentieth century the Mutual Aid Society was set up to support those who had fallen on hard times, along with the Italian Benefit Society and the Italian Working Men's Club, which provided lectures and entertainment.[39] For those of refined taste the Dante Society was launched at a gathering in the university in 1906 with Bishop Casartelli (1852–1925) as president, while the 'Star of Italy' musical society formed in 1913 catered for the popular market.

The relatively small Manchester Italian community had never been seen as much of a threat and its craftsmanship and food had been much appreciated,

Bishop Louis Charles Casartelli with family, 1895. Louis Charles Casartelli was the Catholic bishop of Salford from 1903 to 1925. He was the son of an Italian immigrant family which, like several others, specialized in the manufacture of optical instruments, lenses and spectacles. Scholarly and very much at home among the city intelligentsia, he lacked the common touch or any sympathy with the Irish who made up the great majority of the Catholic population.

Courtesy of Manchester Libraries, Information and Archives, Manchester City Council

though there had been occasional irritation at the activities of the now fast-disappearing street musicians. When Italy joined the Allied cause in May 1915 acceptance seemed complete. Over 200 men left to join the Italian army and in the next three years a branch of the Italian Red Cross, a Benevolent Society for refugee support and a British-Italian League were set up. Nine Manchester Italians were killed on active service and 14 decorated, and in 1924 a bronze commemorative plaque was added to the cenotaph in the city centre. The establishment of the first professorship of Italian Studies at the university in October 1920 seemed to set the seal on the place of Italians in civic life.[40]

In the inter-war period there was little further migration to Britain because the fascist government which came to power in Italy in October 1922 directed would-be migrants to the colonies in Africa, and by 1936 it was estimated that numbers had dwindled to about 800 in Manchester. Although there were few outright fascists among the Manchester Italians, the sense of national grievance that Italy's territorial gains from the First World War had been much less than its due was widely shared. In 1924 a local branch of the Fascist Italian League was founded. Funded by the Italian government, it emphasized Italian language, culture and patriotism and organized sports events and trips to Italy.

Entry into the Second World War on the Axis side in June 1940 was a disaster for the Italian community. All Italian men aged 17 to 60 years were interned on the Isle of Man, children were evacuated to Lytham St Annes, a curfew was imposed in Little Italy and community life withered. In mid-1940 several hundred Italian and German internees sailed for Canada on the liner *Arandora Star*, but it was torpedoed on 2 July with the loss of 470 Italians, including Father Fracassi and others from Manchester. In the post-war years a growing tendency to marry out, together with

large-scale house demolition and redevelopment in Ancoats and movement to the suburbs, spelled the end of Little Italy. Nevertheless, elements of community awareness survived and began to revive in the 1980s, when the Mutual Aid Society and the Catholic Society merged to form the Manchester Italian Association, which organizes social and cultural events and keeps up the tradition of the procession of the Madonna of the Rosary each summer. The bronze plaque which had been removed from the cenotaph in wartime was restored in 1990 and Requiem Mass for the *Arandora Star* casualties was regularly celebrated. The community also found its chroniclers, who began collecting oral history and memorabilia, writing up and sharing its experiences in talks and exhibitions, thereby ensuring that the contribution of Italians to the human mosaic of the city was acknowledged.[41]

Poles in Manchester

While economic factors have traditionally been the strongest motivation for migration, politics has also been a consideration and this is particularly notable in the case of the Poles. Poland vanished from the map of Europe in 1795 when it was partitioned out of existence by Prussia, imperial Austria and Russia, the latter gaining by far the largest slice of territory. But Polish national sentiment, deeply rooted in Catholicism, remained vibrant. A series of unsuccessful insurrections in the nineteenth century which were severely repressed by the Russian authorities led to periodic migrations. Following the rising of November 1830 a group of Polish families settled in Manchester, later reinforced by refugees from the suppression of a rising in Austrian Poland in 1846, migrants fleeing after the revolt of 1860 and others escaping the persecution of minorities throughout Russia in the 1880s. Most settled on the fringes of Angel Meadow and were employed in the low-paid

Polish Church of Divine Mercy, Moss Side. Polish refugees in Britain are notable for the significance of the political imperative in their flight abroad. The extinction of the Polish state in the late eighteenth century failed to extinguish a tenacious sense of nationhood, closely associated with the Catholic faith. Entry into the European Union in 2004 triggered further migration, now motivated by economic forces.

Courtesy of Manchester Libraries, Information and Archives, Manchester City Council

'sweatshops' manufacturing cheap footwear. In 1891 a Polish contingent was first noted in the Whit Walks and by 1901 they had their first church, dedicated to St Casimir. Independence after the First World War checked the inflow but the defeat of Poland in August 1939 led to an influx of Polish servicemen fleeing German and Russian occupation. Many chose to remain after 1945 following Russian occupation of their country and the imposition of a communist government. Some found their way to Manchester, where they opened a new church in Moss Side in 1958.[42] The collapse of the communist regime in 1989 and entry into the European Union in 2004 produced a new influx, this time attracted by employment opportunities. They renewed local Polish community life, reflected in church attendance and the appearance of shops selling traditional Polish foodstuffs.

Chinese in Manchester

The earliest Chinese living in Britain were seafarers who settled in London in the late eighteenth century, and similar small maritime communities grew in most large ports in the next century. By 1902 it is estimated there were about 200–300 Chinese resident in Manchester and the first Chinese laundry had appeared. By 1912 they were sufficiently numerous for the Methodist Revd Samuel Collier to organize regular Sunday services in Chinese and an English-language school on Monday evenings in Oldham Street Central Hall. The great majority were employed in the 39 Chinese laundries.[43] These small-scale businesses required minimal skill, equipment and capital and employed male members of the extended family, who worked long hours in demanding conditions and lived on the premises, which were usually disused shops or warehouses. The majority of the families were Cantonese speakers from the southern province of Guangxi. In terms of religion, most probably shared the characteristic Chinese blend of Buddhism, Taoism and Confucianism, but there was clearly a Christian element. It was a small, inward-looking community serving a largely working-class clientele.

The inter-war years were difficult for the Chinese in Britain, who saw their numbers decline. They suffered from considerable public prejudice during the economically troubled times after 1919. To some extent this was due to the economic instability of the period, but it was stoked by popular fears of 'the yellow peril' as exemplified by what has been described as the 'Dr Fu Manchu' syndrome centred on the myth of the inscrutable, unknowable, conspiratorial oriental.[44] The Second World War saw a revival in numbers as many were employed in British merchant and naval vessels and stayed on after 1945. Public attitudes also became marginally more favourable out of respect for the considerable Chinese casualties during the long-drawn-out conflict between China and Japan. By the early 1950s Chinese communities in Britain had recovered and surpassed their earlier numbers and there was a notable change in both origins and employment patterns. The advent of a communist government in China in October 1949 closed off immigration for several decades but there were increasing numbers from Hong Kong and the associated New Territories.[45] There was also a trend for the Chinese to enter

the catering trade by opening takeaways and restaurants – they were benefiting from the rise in real incomes in Britain and a greater public readiness to sample new foods and flavours after the austerity of wartime fare in the armed services and the subsequent years of rationing.

The Chinese who arrived in Manchester, like many in Britain, came after a sojourn elsewhere in the country. Liverpool had traditionally had the largest Chinese community in the north-west, but as the city's economic prospects darkened, increasing numbers of concerns transferred to Manchester. Takeaways began to multiply in the 1960s, usually replacing English chip shops, though often incorporating traditional fish and chips in their menus. Once again these were quite small family-based concerns with accommodation in the same building. The first Chinese restaurant appeared in Manchester in 1948, but numbers really took off in the 1980s. In terms of both the size of premises and turnover these were much larger concerns, usually devoted to business alone, with the proprietors living elsewhere.[46]

The significance of Manchester as a centre of Chinese settlement and business was acknowledged by the setting up of branches of the Hong Kong and Shanghai Banking Corporation, the Bank of China and the Bank of East Asia and the decision of the Chinese government to establish a consulate in the city in the early 1980s. In 1986 Manchester was twinned with the Chinese city of Wuhan and in December 2014 Cathay Pacific opened its only direct link to China outside London when it launched flights from Manchester International Airport. A Chinese arch was erected in the city in 1987 in what became known as the Manchester 'Chinatown', because of the concentration of Chinese restaurants, takeaways and supermarkets. The area also became a site for processions marking the Chinese New Year and a

convenient place for the Chinese to gather, eat and socialize together. In 1966 a Chinese Christian Church had opened and by 2014 there were services in English, Mandarin or Cantonese at three locations, together with a youth group, Sunday school and weekday study and prayer meetings.[47] From 1905 until the mid-1930s there had been Chinese students at Manchester University, but numbers dried up with the advent of the Second World War and the establishment of the communist government. However, with the evolution of a more outward-looking policy, increasing numbers of Chinese came to study at the city's institutions of higher education in the last two decades of the twentieth century.

Many of the younger generation of Chinese became notable for their upward mobility and progress in the professions and business. This has led to some dilemmas concerning traditional cultural identity markers. Research has revealed that younger Chinese adopt a fluid and eclectic attitude, blending aspects of both traditional Chinese and local British society, especially in their leisure pursuits. It is also true that the very different history of the various groups of Chinese who have arrived in the city and the absence of a common religion have bequeathed sharply contrasting outlooks and inhibited a sense of group solidarity. However, efforts have been made to ensure that historic shared values and pursuits are not lost. In 2005 the Manchester Chinese Centre opened in the Ardwick area to encourage and expound Chinese culture. It runs an advice centre and hosts a regular poetry festival, opera classes, tai chi and traditional dance sessions, and organizes courses in English, Mandarin, maths and Chinese arts and provides tutoring in Mandarin to A level. A primary school with Mandarin as the second language has been planned.[48] Wider recognition of the significance of the community came with the establishment of the Chinese section in the city's Central Library in the late 1980s.

Overall, the Chinese community in Manchester thrived after a slow start and though they were the object of some of the common prejudices of the 1930s and still experience occasional animosity, there has also been a considerable degree of respect for a small, colourful, hard-working community whose contribution to the food sector of the service industry is much appreciated. With the emergence of China as an increasingly significant player on the world economic stage it may become an even greater asset to the city. In 2013 the Beijing Construction Engineering Group became a major partner in the project to build an Airport City while the visit of Chinese President Xi Jinping in 2015 and the launch by Hainan Airlines of flights from Manchester to China were further indications of growing links.

Afro-Caribbeans in Manchester

The first indications of an Afro-Caribbean population in Manchester come in the late eighteenth century. Some may have been so-called 'Lascar' seamen discharged and abandoned by ship captains in Liverpool who found their way inland. Others may have been personal slaves of sea captains who took the opportunity to abscond. Some may have been demobbed former slaves from the American colonies enticed

by the promise of emancipation to side with the British in the American War of Independence. Still others may have been servants in aristocratic households, where it was fashionable for ladies to have a black servant. One of the few traces of their presence is found in parish registers of funerals and baptisms.

Like most growing urban centres, Manchester had close links with the slave trade. In 1788 it was estimated that the town supplied £500,000 worth of cloth to be traded for slaves in West Africa or sold as clothing for slaves in the Caribbean, and there was a similar trade with Brazil and Cuba. Several families prominent in the civic and commercial life of the city had direct links with the slave trade or owned slave-worked plantations in the West Indies, and it is highly likely that the capital generated by such enterprises was invested in the early stages of the city's manufacturing industries.[49]

However, Manchester also participated in the growing campaign against the slave trade. When Thomas Clarkson (1760–1846), the leading abolitionist, gave an address in the Collegiate Church on 8 October 1787, he remarked on the presence of a large group of black people around the pulpit. His visit inspired a petition in favour of abolition, which by 1792 had attracted 20,000 signatures, and also the launch of a cluster of abolitionist groups. The trade was abolished within the British Empire in 1807, though it was not until 1834 that slaves within British territories were freed. Groups originally formed for abolition switched their attention to the education and spiritual and material welfare of the freed slaves. In August 1834 a meeting held in the Exchange heard accounts of the situation in the USA and hopes were expressed that £1,000 could be raised for a scheme to present each freed slave with a Bible. In 1847 when the renowned freed slave Frederick Douglass (1818–95) lectured in Manchester on behalf of the Anti-Slavery League, the campaign for abolition in countries outside the British Empire was attracting far less interest.[50] But it is clear that there were still some for whom trade was more significant than humanity. When there were proposals in 1849 to authorize naval vessels to check the continued involvement of Brazil in the trade, the Chamber of Commerce voiced its opposition. The American Civil War of 1861–65 found local opinion divided. Export of the raw cotton on which the textile industry depended fell away drastically and while there was considerable support for the Union cause on the basis of sympathy with slaves, there was also strong support for recognition of the Confederacy in the hope this might bring them victory and restore cotton exports.

In Manchester itself there are only very faint traces of a resident black population. In March 1834 it was reported that the platform for speakers at a meeting was provided by 'a *gentleman* of colour known by the cognomen of "Black Joe" and used by him for the exhibition of pugilistic feats'.[51] There were occasional performances by black entertainment groups and lectures by black clergy raising funds for missionary and educational work. By the late 1890s there was a small colony of black people in the Greengate district of Salford, mostly former labourers on the Ship Canal and discharged seamen. Numbers of the latter were boosted by

the First World War until by 1919 there was an almost entirely male community
of about 250. That year there were serious race riots, especially in Cardiff and
Liverpool, caused by unemployment and returning servicemen who alleged that
the newcomers had taken jobs. In Manchester there was a notable increase in racial
prejudice, tension, fist fights and verbal abuse in both casual conversation and the
press. The Greengate area was demolished for redevelopment in the late 1930s and
local black residents moved into nearby areas of cheap housing and hostels where
prejudice was less entrenched, most notably Moss Side and Whalley Range.[52]

The Second World War and its aftermath saw far-reaching developments for
the black population of the city. Numbers of black seamen and servicemen grew.
Faced with the labour shortages created by conscription and the rapid expansion
of the wartime economy, the Ministry of Labour recruited skilled men from the
West Indies to work in munitions, engineering and forestry. A further boost came
with the arrival of increasing numbers of black seamen and units of black American

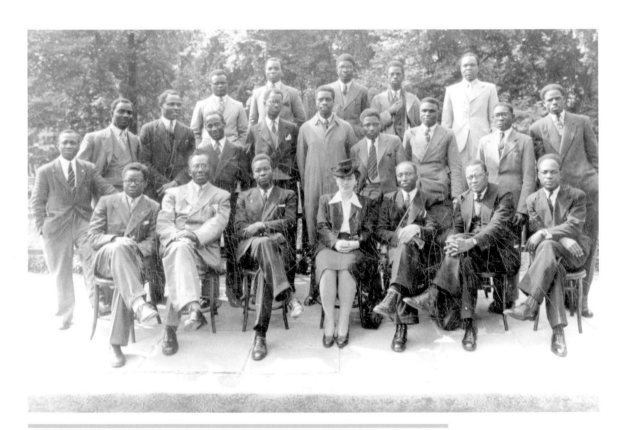

Fifth Pan-African Congress, 1945. The long term Guyana-born resident Dr Peter Milliard may well
have been instrumental in the Congress meeting in Manchester in October 1945. Delegates
included not only local residents such as Len Johnson, boxer and local civil rights activist, and
Jomo Kenyatta, later President of Kenya, but many others who would become prominent in
African nationalist politics. Kwame Nkrumah, subsequently first prime minister and president of
Ghana, is seated in the front row on the far right.

Courtesy of Manchester Libraries, Information and Archives, Manchester City Council

School children from Webster Street school, Moss Side, 1951. Schools in Moss Side became more multi-cultural in the post-war period as Caribbean and Sikh immigrants settled in the community. Webster Street has since disappeared under the Royal Brewery, and Webster primary school has moved a few streets away.

Courtesy of Documentary Photography Archive

servicemen who, based locally, came into the city for relaxation. They were relatively well paid but encountered a colour bar in many pubs and dance halls. During the 1930s there had been a few such premises owned by black people, but now some local black entrepreneurs saw an opportunity and a network of clubs, cafés and teashops began to develop.

There had been some stirring of political awareness in the 1930s with occasional visits by advocates of pan-Africanism under the tutelage of local personalities such as the Guyana-born Dr Peter Milliard (1882–1953), and it was possibly through his local standing and connections that the Fifth Pan-African Congress was held in the city between 15–20 October 1945, attended by over 90 delegates from 50 organizations. Among those present were several personalities who were to become prominent in the political life of their home countries. These included the American intellectual W.E.F. Du Bois, Jomo Kenyatta, then a Manchester resident, who later became President of Kenya, Hastings Banda of Malawi, Kwame Nkrumah of Ghana and Obafemi Awolowo, later a prominent Nigerian politician. They argued strongly for self-determination but received minimal and notably patronizing attention from the press.[53] From the small local black population one of the most notable delegates was Len Johnson (1902–74), former middleweight professional boxer who had been banned from championship contests because of his colour. A member of the Communist Party, after war service he became a bus and lorry driver and a noted civil rights activist in Moss Side, where he stood unsuccessfully for the local council on six occasions. He was active in the small network of sometimes short-lived black organizations in the city in the late 1940s and early 1950s.

Caribbean carnival, 1977. Started in the early 1970s by West Indian immigrants living mainly in Moss Side, the carnival expanded to become an annual celebration of Caribbean music, dance and art, its centrepiece being the parade with its flamboyantly dressed dancers.

Courtesy of Manchester Libraries, Information and Archives, Manchester City Council

Numbers were considerably boosted in the 1950s. In 1952 the McCarran-Walter Act in the USA imposed a new ceiling on West Indian immigration, reducing the annual quota from 65,000 to 800. With this exit closed off, increasing numbers turned to the United Kingdom, to which they had a right of entry as Commonwealth citizens. In 1951 there had been 351 West Indians in Manchester and by 1961 this had grown to 2,502, the great majority from Jamaica. The Commonwealth Immigration Act of 1962 restricted further migration to relatives of those already present and by 1981 the total in the city was 6,263.[54] Moss Side, which already had a small black population, became the centre of a growing community. In the early days this was largely a replacement population, occupying accommodation and jobs that the local white population preferred to avoid. Consequently there was an initial concentration in the poorly paid parts of the service industries such as transport, catering and cleaning, where they experienced unsocial hours and poor working conditions. Discrimination often barred them from higher grade occupations, regardless of the fact that many were ex-servicemen or were highly skilled. Almost no West Indians were to be found in the professions, an exception being W. Arthur Lewis (1915–91), who was appointed professor of economics at the University of Manchester in 1947. Some mainstream Christian churches were welcoming, but many migrants preferred locally organized gatherings with a lively neo-pentecostal style of worship. Community life also centred around a growing network of black-owned and organized clubs, dance halls, sports clubs and pubs.

But by the late 1970s the combination of racial prejudice, insensitive policing, youth unemployment and the slow disintegration of the extended family which

had been such a mainstay of West Indian life created a well of alienation which led to enduring problems with gang culture, petty crime and the trading and use of drugs. On 2 April 1981 rioting had occurred in the largely black St Paul's district of Bristol. This sparked similar outbreaks elsewhere, including in Moss Side on 8–10 July, after which 241 mostly black people aged 17 to 24 were arrested.[55] Partly as a result of the problems which this threw up, there was a growing awareness among civic leaders of the need for a policy that formally recognized the existence of ethnic groups in the population, the validity of their distinctive cultural traditions and an education system that adapted accordingly. As early as the 1970s there had been efforts to organize a carnival in Moss Side to celebrate local life and culture, and with time this evolved into a city-wide event with an established place in the civic cultural calendar. Local oral history projects were organized from which grew exhibitions, lectures and media events. There was increased entry into formal politics, with generally Labour black councillors elected. The Sierra Leone-born Yombi Mambu became Lord Mayor in 1989–90 and the Jamaica-born Roy Walters in 2002–03, while the Jamaican Witt Stennett was mayor of neighbouring Trafford in 2003–04. Others made their way into prominent places in the commercial and administrative life of the city.

By the early twenty-first century the Afro-Caribbean population had become deeply rooted in many areas of city life, with some notably high-achieving personalities in commercial, political and sporting life, but relative deprivation and prejudice remained, especially among unemployed younger people in some of the long-established residential areas where traditional sources of authority and values had disintegrated.

Indians and Pakistanis in Manchester

Johann Kohl's remark quoted at the opening of this chapter on the presence of a 'Hindoo' in the city in 1844 hints at the growing global links of the city economy, but it was not until the second half of the twentieth century that significant numbers of migrants from India and Pakistan began to appear. By 2011 there were 60,758 Manchester residents who had been born in the Indian subcontinent. Of these 70 per cent had been born in Pakistan, 18.8 per cent in India and 10.6 per cent in Bangladesh.[56] They made a notable impact on the religious landscape, with the result that 15.8 per cent of all those who returned a religious affiliation were Muslim, 1.1 per cent Hindu and 0.5 per cent Sikh (Table 5.2). As so often with migrant flows, the reasons for the influx were a mix of employment opportunities and high politics in the original homeland.

From the 1960s onwards the British economy went through a series of sectoral shifts which involved the gradual decline of manufacturing and the growth of a notably varied service sector. At one level this was characterized by professional services which were located in information-rich environments and employed a highly qualified and well-paid labour force. But many of these new industries required a less qualified, lower-paid labour force working unsocial hours

in unpleasant environments. The native labour force tended to avoid these areas and they were often filled by what was, initially at least, an overwhelmingly male immigrant labour force. The last remnants of the cotton industry saw Indians and Pakistanis willing to work the most awkward shifts in the more demanding stages of cloth processing and dyeing. Others found their way into transport as bus drivers, conductors and taxi drivers and into cleaning and catering. In residential terms they were also a replacement population, renting or eventually buying into the rows of cheap terraced housing in the Moss Side, Cheetham Hill, Whalley Range, Longsight and Levenshulme areas of the city that were being steadily abandoned by earlier residents. As they became established, they were joined by family members whose passage they often financed through remittances in the classic sequence of 'chain migration'.

The great majority of the newcomers were Muslim and the mosque often became a centre not only of spiritual but also a lively community life. There had been traces of Islam in nineteenth-century Manchester. 'Syrian' merchants who in reality originated from both modern Syria and Lebanon had set up trading houses to deal in cotton goods with the Ottoman Empire, and Muslims among them had gathered for prayer in private homes, but by the 1930s almost all had departed. However, Muslim students attending the University of Manchester in the late 1940s came together with some local families to purchase a house in Victoria Park for use as a mosque and in subsequent years a group of mosques evolved, catering for the variety of emphases within Islam, together with a network of charitable and cultural organizations. The Victoria Park premises were rebuilt and extended in

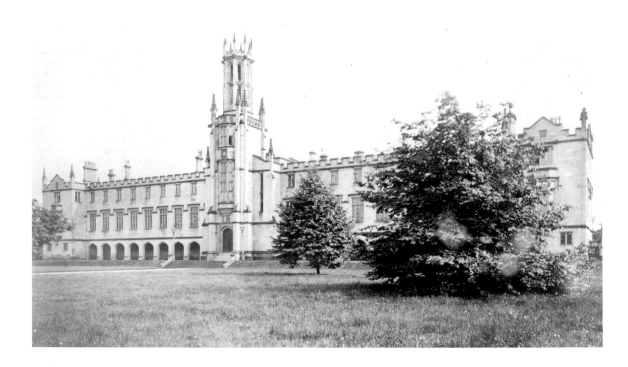

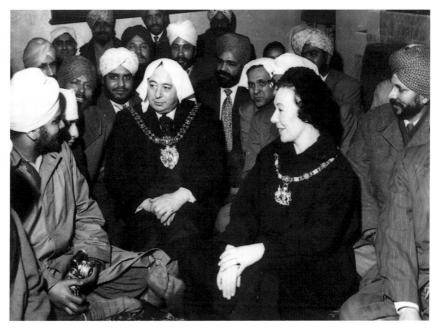

Bhil Singh was one of the earliest and most active Sikh community leaders. His Moss Side home was used as a temporary place of worship until a gurdwara was formally consecrated in a nearby house. Here, in around 1958, he is being visited in his home by the Lord Mayor, Leslie Lever.

Courtesy of Manchester Libraries, Information and Archives, Manchester City Council

British Muslim Heritage Centre, Whalley Range. Opened in 2011, the Heritage Centre aims to increase understanding between the Muslim religion and other faiths. The buildings and grounds, originally built as the Lancashire Independent College for the training of ministers of the Congregational Church, were purchased with the assistance of the Saudi royal family.

Courtesy of Manchester Libraries, Information and Archives, Manchester City Council

1970 and developed into Manchester Central Mosque and Islamic Cultural Centre, hosting a range of social, cultural and educational activities.

In 1969 the city's first Hindu temple was opened and here too worship was accompanied by a range of social and cultural events. The same pattern emerged with the development of the Sikh community, but in this case the politics of the Indian subcontinent were a significant factor impelling emigration. Partition in 1948 involved the imposition of an international boundary across the Punjab, the historic territorial core of the Sikh faith, triggering large-scale movement of peoples into what they regarded as safe havens. For some the answer was emigration to Britain and some found their way to Manchester where they settled in a small area of Moss Side where there was already a cluster of Sikh families who had used the home of prominent local leader Bhil Singh as an impromptu gurdwara or temple. In April 1953 a nearby house was dedicated as a gurdwara, the first of several, all of which practise the Sikh custom of offering free hospitality to worshippers, a key feature of community life. Immigration from India fell away in the mid-1960s, but in the early 1970s a significant number of Sikhs expelled from Uganda settled in the city.[57] Like so many other migrants, Sikhs often found they initially had to take up jobs below their qualifications and this led some to set up in business, some as travelling salesmen but quite a few as shopkeepers. The timing was apt, since they were able to take advantage of legislative changes in the 1970s and 1980s which abolished retail price maintenance and allowed local authorities to relax the regulations on opening hours.

The same period also saw changes in British food tastes noted in the development of the Chinese catering industry. Indian food became increasingly popular

James A. Laycock's *The Moss Side Riots* (1981). Riots occurred in several of Britain's major cities in 1981, triggered by many years of relative deprivation, racism and high unemployment. Insensitive policing added to the discontent, but this was merely symptomatic of the latent institutional racism which subsequent investigation found in many public bodies. The outbreak in Moss Side in early July led to serious rethinking by the agencies that delivered local government services.

Courtesy of Greater Manchester Police Museum and Archives

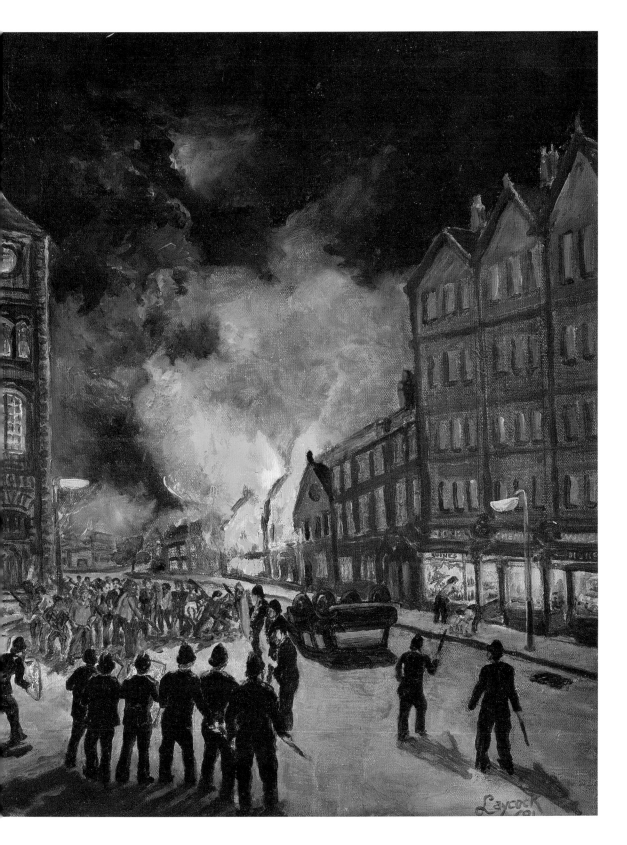

and Wilmslow Road on the southern side of the city became nationally known as the 'Curry Mile', hosting several award-winning restaurants and notable for its colourful celebration of Eid al-Fitr at the end of Ramadhan. There was also an increasing impact on the professions, especially law and accountancy, and on formal politics. By the early twenty-first century the wards of Cheetham, Levenshulme, Longsight, Rusholme, Whalley Range and Burnage regularly elected councillors of south Asian background and the first Sikh magistrate had been appointed in 2002. Mohammed Afzal Khan set a number of precedents, becoming not only the city's youngest Lord Mayor in 2005, but the first Pakistani-born and first Muslim to hold the post, before going on to become a Labour Member of the European Parliament for north-west England in 2014.

Overview and retrospect

Outside observers looking in on immigrant groups are apt to view them as solidly homogeneous, especially if they are centred round a faith tradition and sufficiently numerous to form distinct residential clusters. In reality, they are as internally diverse as any human group. From the outset there are cleavages related to district of origin, as shown in the Irish tradition of county-based faction fighting among early nineteenth-century immigrants and the strong Italian emphasis on locality and province of origin. Other groups can be divided over aspects of religious observance, notably the Jewish and Muslim communities. With the passage of time there are also stresses rooted in time of arrival and the development of second and subsequent generations. Class divisions, always latent, are exacerbated by upward social mobility. The low level of formal religious observance among the British population and the growing variety of ideas within British society on what is acceptable in terms of sexual identities, relationships, the nature of marriage and gender roles, especially for women, are particularly strong challenges to groups whose outlook is rooted in a faith tradition. Many younger people, products of the local school system, are attracted by the dress styles, cultural tastes and behaviour patterns of their peers in the general population and often develop a hybrid set of values and different patterns of speech for the public sphere and the domestic space. The result can be a clash between traditional values and the practices and expectations adopted by younger and more open-minded elements, though any sense of outside threat can reinforce group solidarity.

Discussion of immigrant groups frequently focuses on their distinctive nature while overlooking the fact that they develop links not only with the host society but also with other migrant communities. They have a common experience as newcomers faced with a periodically uncomprehending and anxious host society. Although they sometimes compete in the labour market and for the allocation of public funding, they have faced a common challenge of devising coping strategies to fend off local ignorance and prejudice, retain distinctive cultural traditions and simply make a living. From quite early on there are indications of linkages

between the various groups in Manchester. The Italians and the Irish were to be found concentrated in the dense working-class housing of the Ancoats district on the northern side of the city and the great majority shared a common Catholic faith, though there was a tendency to favour different parish churches. Attired in their Sunday best, both joined the Catholic Whit Walks, anxious to demonstrate not only faith, but respectability. The German Liedertafel raised money for Irish famine relief in 1847. The left-wing Irish nationalist Michael Davitt (1846–1908), reared and schooled in Haslingden, north of Manchester, wrote a book in 1902 exposing the atrocities in Russian Poland and his keen Zionism was shared by David Lloyd George. When Leslie Lever first campaigned for election to the city council he was actively encouraged by the local Catholic priest Father Henry Marshall, later Bishop of Salford, who helped rally the Irish vote.

Such linkages, together with the contribution to the civic and commercial life of the city by generations of migrants, led to the comforting and sometimes complacent notion that Manchester has always been a notably open-minded and tolerant city. Certainly in the nineteenth century migrants were attracted by the novel nature and dynamism of the local economy, the unprecedented number and range of employment opportunities and a distinctive ethos of open, confident economic optimism. This led to the elaboration of the set of self-consciously 'modern' ideas on economic development which became known as 'The Manchester School', stressing the free flow of goods, finance, ideas and labour. The *Manchester Guardian* was a significant mouthpiece of this outlook. By association this was taken to mean that the city was an open-minded, liberal and tolerant host to all peoples, valuing them for their skills and their potential contribution to the common good. When Oldenburg-born Jew Philip Goldschmidt was installed as mayor in 1883–84 the *Manchester City News* hailed his elevation as proof that 'no prejudice of race can dim recognition of merit'.

But this was at best a flattering and self-serving half-truth. The city has shared in the sometimes adverse attitudes that have periodically characterized British society. In the nineteenth century openness extended only to those such as the Germans, Jews anxious to anglicize and Protestant Irish who shared the assumptions of the ruling bourgeois elite on what constituted respectability in terms of both domestic and civic life. There has always been a darker side to Manchester's relations with its immigrant populations, particularly if they were marked out by distinctive cultural features such as religion or dress or by skin colour. Those traditional features of popular English and later British nationalism, namely anti-Irish and anti-Catholic prejudice, were certainly on display throughout the nineteenth and into the twentieth century. Like all popular prejudices, they waxed and waned in response to broader economic and political circumstances. The *Manchester Guardian*, whatever its later outlook, was notably contemptuous of both Catholicism and the Irish into the early 1870s, as was the *Manchester Courier* throughout its existence (1825–1915). The Jewish population was always aware of the long tradition of anti-Semitism in British society, hence the readiness of

some to anglicize and their nervousness over the influx of impoverished refugees from Russian Poland towards the end of the nineteenth century, when the local magazine *Spy* (1890–98) made a point of persistent denigration of everything Jewish. Throughout the period, verbal abuse and desecration of Jewish buildings and graves has recurred. Germans, Italians and Irish all experienced hostility when relationships between Britain and their original home country deteriorated, to the point when the considerable German contribution to the history of the city was virtually erased, and many Irish have deliberately kept a low profile when Anglo-Irish relations have entered particularly fraught periods.

The latent racism towards black people came strongly to the surface in the period after the Second World War when numbers increased notably, and probably reached its nadir with the 1981 riots, which among other things expressed the frustrations of the second generation with the ingrained, often unconscious, prejudice of so many public institutions. From the late twentieth century onwards the increased involvement of Western powers in the politics of Muslim countries such as Afghanistan and Iraq led to growing anti-Islamic prejudice in some sections of British society. These were further heightened by the attacks mounted by Muslim extremists in New York in September 2001 and London in July 2005 and the departure of some young Muslims to join militant groups fighting for an Islamic

Viraj Mendis demonstration outside Manchester Town Hall, 1988. A vigorous campaign was organized to try to stop the deportation of Mendis back to Sri Lanka where his life was in danger. Mendis was, however, deported in 1989, having claimed sanctuary in the Church of the Ascension, Hulme for over two years.

Courtesy of Manchester Libraries, Information and Archives, Manchester City Council

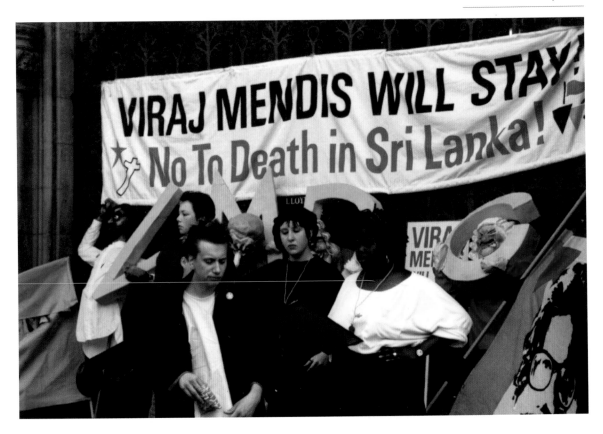

caliphate in the Middle East. Efforts by the authorities to locate and detain likely recruits meant that the entire Muslim population was in danger of becoming a suspect community.

The nineteenth century saw the launch of the first wave of economic globalization and Manchester was at the pioneering edge of the transformation, attracting people not merely from the north-west and other parts of the British state, but from around the world. As the various groups settled into the city they experienced a broadly similar set of experiences. If sufficiently numerous they tended to form distinct and dense residential clusters in the poorer parts of the city infrastructure. Originally male-dominated, transmission of funds and information back home led to the arrival of other family members. The development of organizations and clubs for socializing and leisure pursuits led to the build-up of social capital, often based around places of worship, thereby confirming the distinctive nature of the neighbourhood. At some periods the inner-city residential areas of the city have resembled a confederation of ethnic villages with porous, fuzzy edges.

Since the prime motivation for immigration was economic, immigrants quickly developed linkages with the local economy at a variety of levels. Many found their skills inappropriate to the demands of the local economy and others encountered discrimination, with the result that it was a common experience for the first generation to take up the less-skilled jobs. With the passage of time some found a distinctive niche, serving their own community or turning outwards to offer services and goods appreciated by the wider population. Another route to gradual acceptance was via the leisure and entertainment industries, most notably sport, music and theatre.

Following the riots of 1981 the more inclusive outlook adopted by the city council encouraged migrant communities to develop a greater sense of the value of their history and cultural traditions and to practise and display them in a public fashion. Classes were held, often in places of worship, to transmit and share aspects of traditional culture, including language, food, dance, prose and poetry. Informal groups gathered to record their personal experiences of emigration to and life in Britain. Efforts were made to raise awareness and appreciation of these narratives in the general population. The results of the oral history projects were deposited with the Ahmed Iqbal Ullah Race Relations Resource Centre in the Central Library. Displays, processions, exhibitions, conferences and events such as local Black History Month and the Irish Festival became regular features of the city's cultural calendar and efforts were made to incorporate aspects of the immigrant experience into the school curriculum.

From quite early some migrants, most notably the Germans, Jews and Irish, had participated in the formal politics of the city. Some in the political establishment occasionally exploited anti-immigrant feeling for political gain, especially in the second half of the nineteenth century where the Irish were concerned, but the parties quickly realized that the residential clustering of migrant groups made them an electoral force and increasingly opened their ranks. The migrant groups for their

The appointment of immigrants to prominent public positions in Manchester, particularly that of Lord Mayor, was long regarded as a significant indicator of acceptance. Philip Goldschmidt was the first Jewish mayor (1883–84, 1885–86) and Daniel McCabe the first Irish Catholic Lord Mayor (1913–15). The first and second Asian Lord Mayors of Manchester, Afzal Khan (2005–06, second left) and Naeem ul Hassan (2013–14, second right), are shown here at a reception promoting the Mayors for Peace vision, November 2013.

Reproduced with permission from Manchester City Council

part realized that this was a means of defending their communities, ensuring their share of public resources and a path to wider acceptance.

By the early decades of the twenty-first century Manchester was a truly multi-cultural city in which the various groups were still facing the multi-dimensional challenge of combining cultural distinctiveness with full civic participation. Their historic contributions to the development of the city were finally being documented and publicized but their contemporary value was also increasingly recognized. Against this, historic prejudices periodically resurfaced, most notably anti-Semitic and anti-Islamic sentiment. In a period when Britain's large urban centres were seriously reconsidering their relationship with central government and simultaneously competing for inward foreign investment, the varied history and cultural traditions of all the elements in Manchester's population had the potential to create a stimulating, creative and exciting environment sparked off by a long history of cultural encounter. But this would only occur if all the communities concerned were convinced that their distinctive traditions and practices were respected and they were not regarded as potential suspects but unquestionably accepted as full citizens.

Notes

1. B. Williams, 'Foreign merchants in Manchester 1781-1840' (unpublished notes). I am deeply indebted to Bill Williams for sending me his notes on ethnic groups in Manchester in the form of email attachments along with permission to use them in this chapter.
2. J. Kohl, *England and Wales* (1844), London: Cass, 1968, p. 112.
3. *Manchester City Council Public Intelligence 2011 Census QO5E Census Summary Country of Birth I 330.85KB, PDF* (accessed 8 July 2014).
4. *Mapping Community Language Skills: The School Language Survey in Manchester: Multilingual Manchester, 2013.* School of Arts, Languages and Culture, University of Manchester, mlm. humanities.manchester.ac.uk (accessed 5 November 2014).
5. 'Language Provision in the public sector, library resources', in *Multilingual Manchester. A Digest*, University of Manchester, 2013.
6. 'Central Manchester hospitals interpretation requests', in *Multilingual Manchester. A Digest*, University of Manchester, 2013, pp. 3-5.
7. *City of Manchester Religious Belief 2011. manchester.gov.uk QO5c2011Census_Summary_Religion* (accessed 8 July 2014).
8. *Mail Online*, 15 February 2013 (accessed 8 July 2014).
9. J.H. Smith, 'The North-West: magnet for migrants 1750-1914', *Manchester Genealogist*, 28.1 (1992), p. 74.
10. *Jubilee of the Welsh Calvinistic Methodist Church at Moss Side, Manchester* (1925), translation by Margaret Hughes, Archives Department, Manchester Central Library (henceforth ADMCL), Q285.235 WEL (030), pp. 1, 3.
11. I. Williams, *Byr Haves Cymry Manceinion* (1896), translation by Margaret Hughes, ADMCL, Q942.733004 WIL (975).
12. *Manchester Guardian*, 16 December 1837.
13. *Manchester City News*, 5 March 1881.
14. A. Hunt and L. Bury, *Manchester Welsh Presbytery, Past and Present* (2002), ADMCL, 262.985.24 HUN (606), p. 39.
15. J.A. Galloway and I. Murray, 'Scottish migration to England, 1400-1560', *Scottish Geographical Magazine*, 112.1 (1996), pp. 29-38; I. Whyte, 'Invisible migrants: the migration of Scots to Manchester in the eighteenth and nineteenth centuries', *Manchester Genealogist*, 24.4 (1991), pp. 48-54.
16. *Copy of Register of Births & Baptisms Scotch National Church, St. Peter's Square, Manchester 1830-1837*, ADMCL, M641/24/1/1/1.
17. *Manchester Presbytery and its Constituent Churches, Confession of Faith, Copy of Trust Deed &c., Scotch Church, Manchester*, ADMCL, GB127.M641/24, p. 18.
18. *Minutes of Session, Scotch Church, St. Peter's Square Manchester 1832 to1845*, ADMCL, M641/24.
19. R. Scola, *Feeding the Victorian City: The Food Supply of Manchester 1770-1870*, Manchester: Manchester University Press, 1992.
20. E. Delaney, *The Irish in Post-War Britain*, Oxford: Oxford University Press, 2013.
21. M.A. Busteed, '"The most horrible spot"? The legend of Manchester's Little Ireland', *Irish Studies Review*, 13 (1995-96), pp. 12-20.
22. Information from Joe Flynn, founder and chair.
23. B. Williams, 'Foreign merchants' (unpublished notes).
24. B. Williams, 'The first Germans, 1783-1841' (unpublished notes).
25. B. Williams, 'Foreign merchants' (unpublished notes).
26. P. Panayi, 'German immigrants in Britain, 1815-1914', in P. Panayi, ed., *Germans in Britain Since 1500*, London: Hambledon Press, 1996, p. 78.
27. B. Williams, 'The first Germans' (unpublished notes).
28. S. Coates, 'Manchester's German gentlemen: immigrant institutions in a provincial city 1840-1920', *Manchester Region History Review*, 5.2 (1991-92), p. 21.
29. B. Williams, 'The first Germans' (unpublished notes).
30. B. Williams, 'The German colony, 1841-1883' (unpublished notes).
31. *Manchester Guardian*, 1 April 1848.
32. B. Williams, *The Making of Manchester Jewry 1740-1875*, Manchester: Manchester University Press, 1985, pp. 2-13.
33. B. Williams, 'The First Jews' (unpublished notes).
34. B. Williams, 'The Jews of Eastern Europe' (unpublished notes); L. Vaughan and A. Penn, 'Jewish immigrant settlement patterns in Manchester and Leeds 1881', *Urban Studies*, 43.3 (2006), pp. 653-71.
35. B. Williams, 'The immigrant response' (unpublished notes).
36. Much of the material on Zionism is derived from www. manchesterjewishstudies.org/Resources/Manchester and Zionism (accessed 10 January 2015).
37. B. Williams, 'The first Italians' (unpublished notes).
38. P. DiFelice, 'Italians in Manchester 1891-1939: settlement and occupations', *The Local Historian*, 30.2 (2000), pp. 88-104.
39. DiFelice, 'Italians', pp. 100-2.
40. B. Williams, 'Immigrants in war and peace, 1914-1920: the Italians' (unpublished notes).
41. A. Rea, *Manchester's Little Italy: Memories of the Italian Colony of Ancoats*, Radcliffe: Neil Richardson, 1988, p. 31.
42. B. Williams, 'Poles 1830; Eastern European Christians' (unpublished notes).
43. B. Williams, 'The Chinese 1894-1930' (unpublished notes).
44. *The Guardian Review*, 1 November 2014.
45. G. Yeung, 'The Chinese in Manchester, 1960-2010', paper read to the annual conference of the Society for Folklore Studies, Manchester, 13 September 2012. I am indebted to Mr Yeung for providing a copy of this paper.
46. Yi Liao, 'The geography of the Chinese catering trade in Greater Manchester', *Manchester Geographer*, 14 (1993), pp. 54-65.
47. wwwmanchester.ccc.org.uk (accessed 15 October 2014).
48. www.mchinesecentre.org.uk/content/community (accessed 15 October 2014).
49. M. Sherwood, *After Abolition: Britain and the Slave Trade since 1807*, London: I.B. Tauris, 2007, pp. 45-6.
50. *Manchester Guardian*, 20 January 1847.
51. *Manchester Guardian*, 22 March 1834.
52. B. Williams, 'The Black Community 1894-1907'; 'Riotous Negroes: Greengate 1914-1938' (unpublished notes).
53. *The Observer*, 21 October 1945.
54. J. Stanley, 'Mangoes to Moss Side: Caribbean migration to Manchester in the 1950s and 1960s', *Manchester Region History Review*, 16 (2002-03), pp. 40-1.
55. B. Williams, 'Riots in Moss Side July 1981' (unpublished notes).
56. www.ethnicity.ac.uk/dynamicsofdiversity (accessed 16 February 2015).
57. B. Williams, 'The Sikh diaspora' (unpublished notes).

Culture, Media and Sport

DAVE RUSSELL

For much of the last two hundred years, Manchester has been one of the country's major cultural centres. Indeed, in many senses it has long served, after London, as England's second 'city of culture'. Salford Art Gallery (1849) and Manchester Free Library (1852) were England's first rate-supported buildings of their type. The 1857 Manchester Art Treasures Exhibition remains probably the largest art show ever held and the orchestra organized by German émigré Charles Hallé (1819–95) to furnish it with weekly concerts was placed on a permanent footing the next year. In 1893 Hallé further enriched musical life by establishing the Royal Manchester College of Music (now the Royal Northern College of Music), staffed largely by members of his orchestra. In the 1860s and 1870s Charles Calvert's Shakespearean revivals at the Prince's Theatre defined a theatrical management 'unrivalled in the provinces and not consistently matched in the metropolis', while in 1907, Annie Horniman (1860–1937) established Britain's first permanent provincial repertory company at the Gaiety Theatre. From the early 1900s the city, already home to the *Manchester Guardian* and a publishing industry 'far in excess of other provincial cities', was adopted by London daily papers as production centre for their northern editions. By 1935 England's 'second Fleet Street' was responsible for one-sixth of English and Welsh newspaper output and the city's role as a major media centre was further enhanced on becoming the headquarters of the BBC's Northern Region in 1931 and Granada Television in 1956.[1] Its pop and rock bands placed it at the heart of national popular musical culture for much of the 1980s and early 1990s, while Manchester United dominated English domestic football for two decades from the early 1990s, becoming in the process a leading global sporting

'brand'. The early twenty-first century, in its turn, has seen a striking growth in the city's cultural infrastructure and a significantly enhanced role for cultural activity as an engine for economic regeneration. Its reputation for cultural dynamism, skilfully promoted by internal agencies but often reinforced by external observers, has rarely been higher.

Such a listing and conflation of highlights is problematic, obscuring both the more prosaic fare that constituted the city's standard daily cultural life and those periods when its reputation in various elements was rather more modest. Moreover, Birmingham might well dispute claims of Mancunian cultural superiority and Liverpool, never reticent where Manchester's 'absurd and harmful pretensions' are concerned, most certainly would; both cities could find much in their favour.[2] Nevertheless, beyond the entirely exceptional case of London – and occasionally, even the capital has had to cede ground – it remains difficult to posit a cumulative record of cultural achievement across such a variety of fields that matches Manchester's.

Especially in recent discussions of popular culture, Manchester's cultural strength is frequently viewed as the outcome of a distinctive marriage between widespread hardship and an openness to new influences. Its comedians laugh in the face of difficulty, its boxers are hardened by their physical and economic environment, its musicians are energized by what Dave Haslam terms 'the trauma of the city'. 'Maybe if Manchester was less of a shit-hole', he muses, 'then creativity in

Theatre Royal playbill, 11 October 1780. Richard Brinsley Sheridan's *School for Scandal* heads a typically packed bill at the city's first Theatre Royal, sharing the stage with a pantomime. Local and regional settings are clearly being used with the intention of enhancing audience numbers.

Courtesy of Manchester Libraries, Information and Archives, Manchester City Council

the city would die.' He also describes Manchester as 'one of the least insular music cities in the world' and many others emphasize the city's tolerant and cosmopolitan outlook. A contributor to a 1996 Manchester United fanzine, for example, claimed Manchester as 'the least English city in the country' (a neat borrowing of great rival Liverpool's self-image) peopled by those 'who refuse to accept the boundaries of the mind' and draw influences 'from all over the world'.[3] Manchester, however, has had a monopoly of neither open-mindedness nor urban harshness, even if it might be empowering to believe otherwise. Certainly, the impact of successive generations of energetic immigrant groups on the city cannot be denied; working-class writers, artists, performers and sports stars have a secure place in the city's history; and much of its popular culture has been underpinned and shaped by working-class taste, commitment and interest. Nevertheless, rather than poverty, it has been the wealth of a small minority allied to the modest but growing real incomes of the majority which has exerted the greater impact on local cultural life. Individual acts of patronage and philanthropy by the very wealthy were not infrequent, especially in the period to 1914, while middle- and upper-middle-class spending power – always higher in cities like Manchester with a large commercial sector – helped sustain a substantial cultural infrastructure. The city recorded the largest population of both professional artists and musicians of any English provincial community for much of the nineteenth century and enjoyed an unusually well-developed service industry, exemplified by the presence from 1817 of nationally important art dealers, Thomas Agnew and Sons. Generalizations about working-class expenditure are notoriously difficult, but, as disposable incomes grew from the mid-nineteenth century, Manchester clearly sustained a strong habit of 'going out', recording Britain's highest density of public houses per head of population in Britain in the 1890s, the highest level of cinema provision in 1914, and probably the largest provision of working men's and other social clubs in the 1950s and 1960s.[4]

Manchester's cultural life has also benefited from a substantial body of advantages stemming from site and location. As the organizers of the 1857 Exhibition stressed, the city was 'in the centre of the kingdom, in the midst of a dense surrounding population, with railway facilities admirably adapted for bringing and returning visitors within one day to their own residences'.[5] The combination of central location and transport links certainly attracted London newspaper proprietors, appreciative that Manchester could service most of England north of Birmingham (and eventually Wales, Scotland and Ireland) rapidly and effectively. Manchester's demographic advantage has flowed not from the size of the city itself, but from that of its hinterland. In 2011 some 2.5 million people lived within a radius of roughly 15 miles from the city centre, a situation that only Birmingham could come close to matching. If the radius is extended to some 50 miles, a perfectly manageable distance for visitors even in the mid-nineteenth century, then the city's sphere of influence embraced effectively the whole of the urban-industrial north midlands and 'near' north; in 2011 just over 11 million people, approximately 20 per cent of the population of England, lived within this compass. While Manchester

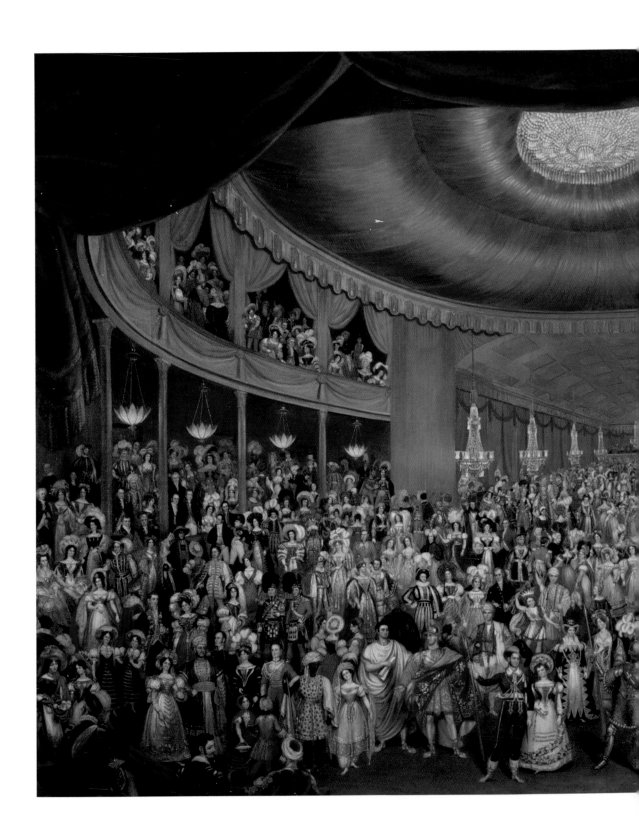

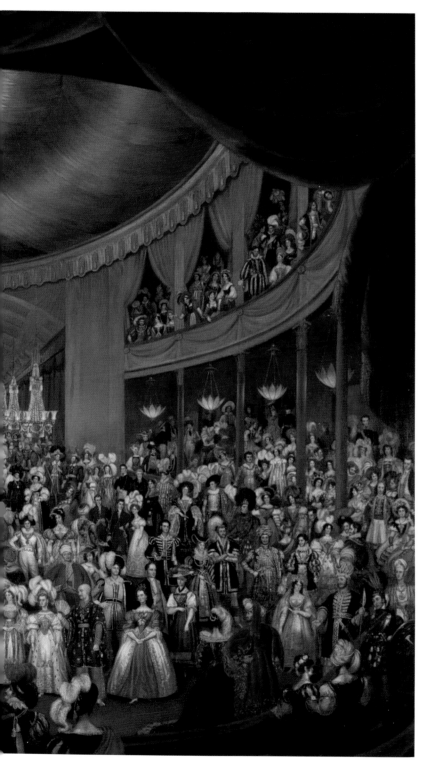

Arthur Perigal, *A Fancy Dress Ball* (1828). Fancy dress balls were a popular entertainment for the urban middle class, and were often associated with raising money for local charities. One of the earliest in Manchester took place in 1828 as part of its first music festival, an occasion that drew support from across the region. The names and costumes of those attending were reported in detail in the local press, allowing one to identify some of the figures in Perigal's painting.

events have been mainly enjoyed by those living in relatively close proximity, the Thursday night Hallé trains taking concert-goers to and from the suburbs and Cheshire, the 'coachloads, having sometimes booked months in advance', bringing strip club patrons from Stoke, Preston and Liverpool in the 1960s, or the cars carrying fans along the motorway network to watch City or United have made a critical difference to Manchester's cultural viability.[6] In no sense can Manchester's drawing power be seen as evidence of the city exercising any formal control over its region, however that may be defined: towns in close proximity saw Manchester as a place to be consumed, rather than one to be consumed by. Nevertheless, even some of the city's greatest rivals had reason to be grateful for its proximity.

Culture

While this chapter is hardly the place for detailed discussion of 'culture', it is useful to clarify how the term is used here. If defined as a broad body of artistic and social practices embodying the values and beliefs of a particular society, then it clearly embraces every topic in this chapter. Nevertheless, for the sake of clarity, and in acknowledgement of autonomous elements within their individual histories, culture, media and sport are treated separately. In this section culture is used largely as shorthand for music, fine art and theatre (the city's universities, long providing expertise for innumerable cultural institutions and a large marketplace for cultural goods, and its many learned societies from the Literary and Philosophical Society (1781) onward, would have featured in a longer study) with the focus falling on public and quasi-public institutional settings rather than upon individuals and their creative outputs. Elizabeth Gaskell (1810–65), L.S. Lowry (1887–1976), Peter Maxwell Davies (1934–2016) and numerous others must, therefore, await another treatment, although their very mention further emphasizes Manchester's cultural depth. Any discussion of culture involves categorization and the use of such labels as 'high', 'middlebrow', 'popular' and their many variants, undeniably generative of numerous simplifications and value judgements, but carrying certain common-sense meanings rooted in broadly understood patterns of cultural differentiation. 'High' and 'popular' are, therefore, adopted here as useful organizational devices and the process by which 'high' culture has gradually seen its role as purveyor of civic status and individual *kudos* challenged by 'popular' culture forms a narrative thread. Finally, it should be noted that here and throughout the chapter, the city of Manchester and its immediate environs (including Salford where appropriate), rather than the greater conurbation, provide the core subject matter.

Throughout the nineteenth century, sustained interest in high culture was most closely associated with the city's middle classes, and, indeed, only a minority within this group; the Royal Manchester Institution (1823) and the Athenaeum (1836) were established to enhance the intellectual horizons of, respectively, the upper middle class and middle classes but became prized ultimately as social and sporting institutions.[7] It is important to note, however, that high culture has

The Manchester Art Treasures Exhibition, 1857. Designed by Edward Salomons, the central span contained the Great Hall, the two smaller ones the main picture galleries. A specially constructed railway station adjoining the exhibition encouraged excursionists, as well as providing competition for the local omnibus companies.

Courtesy of Manchester Libraries, Information and Archives, Manchester City Council

always enjoyed a wider purchase within local society. This stemmed partly from the existence of engaged constituencies beyond the social elite, exemplified by the city's artisan poets, the broad-based popularity of Shakespeare with Victorian audiences and, above all, the widely diffused interest in classical music in the nineteenth century and beyond. More generally, serious culture was understood to bear a heavy responsibility for the city's image and self-projection, a powerful weapon to be deployed against external assertions (frequently emanating from an Anglican, Tory and southerly direction) of the city's workaday and generally 'philistine' nature. The 1857 Exhibition was clearly intended to lift Manchester beyond such criticism. Opened by Prince Albert and held over a five-and-a-half-month period from May until October 1857 in a purpose-built glass and iron structure at Old Trafford (styled the 'Art Treasures Palace' and heavily influenced by Paxton's design for the Great Exhibition in London just six years earlier), it contained 16,000 items of fine and decorative art and attracted 1.3 million visitors. Its organizing committee, chaired by local art collector and patron Thomas Fairbairn (1823–91), sought to combine a collective personal interest in art and belief in its educative powers with a desire to reconfigure Manchester's image, an early and dramatic

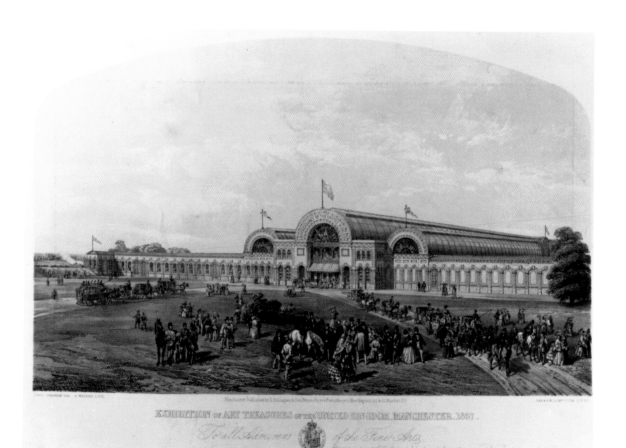

EXHIBITION OF ART TREASURES OF THE UNITED KINGDOM, MANCHESTER, 1857.

example of the 'selling' of the city through the medium of cultural display. Softening the city's image was a thankless task. The *Art-Journal*, highly critical of what it saw as fundamental curatorial flaws, stated that 'the great lesson which Manchester has taught, is the total unfitness of Manchester for such an exhibition, and of such an exhibition for Manchester'. Some seventy years later, an official publication could still complain that the city was 'labouring under a great deal of prejudice as being wholly commercial and material in spirit'.[8] Nevertheless, pride in cultural heritage formed an important civic narrative, capable of connecting many Mancunians to a world, in actuality, beyond their normal experience; tellingly, Charles Calvert's funeral in 1879 and Hallé's in 1895 drew enormous crowds on to Manchester's streets. Moreover, as in the cultural field more widely, no opportunity has been lost to challenge London's assumed dominance or to bemoan its capacity to draw away local talent.

Much nineteenth-century high cultural activity took place in a private or semi-private environment. The traditions of fine art collection and patronage beginning in the eighteenth century and continued by Thomas Fairbairn, brewer Henry Boddington (1813–86) and others; the Gentlemen's Concerts, established in 1770, and requiring a five-guinea annual subscription in 1849; the Manchester Academy of Fine Art's *conversaziones* and annual exhibitions at the Royal Manchester Institution (public events from 1874) – all were variously designed to generate a superior social tone. Even where serious efforts were made to create an open market, the results were often modest. Although when Hallé began his concerts in 1858, his lowest price of one shilling allowed limited levels of lower-middle and working-class attendance, between 1861 and 1883 the proportion of subscribers rose from 33 per

Whitworth Art Gallery, 1930. Formally established in 1889, the Whitworth Institute of Art and the adjoining park were part of a wider project to promote art and technical education in Manchester, financed principally from the bequest left by Sir Joseph Whitworth. The main gallery building was completed in 1908, the park having been opened in 1890. The gallery's collection policy included world textiles, in line with the Institute's aim of supporting the region's industries.

Courtesy of Manchester Libraries, Information and Archives, Manchester City Council

cent to 60 per cent while that of shilling ticket-holders fell from 39 to 18 per cent. The winter season of Thursday-night Hallé concerts at the Free Trade Hall came to stand at the apex of bourgeois cultural life as subscribers, clad in evening dress, demonstrated the 'collective refinement, decorum and self-discipline' of their class, 'a living symbol of the power of art and the art of power'.[9] Significantly, although middle-class women found more space within the high cultural sphere (not least at Hallé concerts) than in many other arenas of contemporary life, it often carried a decidedly masculine flavour. Institutions such as the all-male Brasenose Club, for example, a centre of 'cultured bohemianism' founded in 1869, where visiting actors held court and Hallé members gave informal concerts amidst cigarette smoke and lively drinking, provided a distinctively gendered element to elite culture.[10]

Some democratization certainly occurred as the century progressed. A variety of motives, from a political desire to control the working class to a genuine wish to widen cultural access, were catalysts for the many philanthropic initiatives that marked Victorian Manchester, from the mechanics' institution movement of the 1820s and onwards, to the 'people's' concerts of the 1840s and 1850s, the establishment of the Manchester Art Museum by Thomas Coglan Horsfall (1841–1932) in 1884 in the heart of proletarian Ancoats, and the opening of the Whitworth Art Gallery in 1890, funded by a charitable bequest from engineer and armaments manufacturer Sir Joseph Whitworth (1803–87). Such ventures rarely penetrated working-class culture to any great extent, but they provided a significant legacy of bricks and mortar as well as establishing important principles about the wider role of education and culture.[11] In similar philanthropic spirit, although many private art collections remained precisely that, some found their way into the public arena, most notably Thomas Agnew's extensive gift to Salford Art Gallery in 1851, and *Manchester Guardian* proprietor John Edward Taylor's donation of some 150 watercolours to the Whitworth in 1892.[12] Crucially, the voluntary principle was supplemented by tentative provision from the local state. The public library (all books were initially purchased from public subscription and 'gifts' rather than the rates) opened in Campfield in 1852 and, although it was closed in 1877 when the weight of stock threatened it with collapse, by the late 1890s the city boasted a central reference library, 12 branch libraries and 47,000 individuals with active cards.[13] In a move that cemented Manchester's already strong association with the Pre-Raphaelite movement, the city commissioned Ford Madox Brown's murals for the Town Hall, executed between 1879 and 1893 (albeit at a modest cost), while Manchester City Art Gallery was opened in 1882 after terminal financial problems saw the Royal Manchester Institution pass its Mosley Street building and art collection to the corporation.

In many senses, the greatest level of cultural democratization came through the marketplace. In music, Hallé's exceptional achievements must not obscure the importance of others. His flautist, Edward de Jong (1837–1920), formed his own orchestra in 1871 to service promenade concerts that survived into the 1890s, and three other concert series existed in the late nineteenth century founded,

Sir Charles Hallé. Born Karl Halle in Westphalia, he arrived in England in 1848, altered his forename to Charles and accented his surname. Invited in 1849 to take charge of Manchester's Gentlemen's Concert Society, he decided to remain in the city. Following success in providing music at the Art Treasures Exhibition in 1857, Hallé went on to form the orchestra named after him, establishing an annual series of concerts at the Free Trade Hall. Knighted in 1888, he was founder of the Royal Manchester (later Northern) College of Music and served as Professor of Piano.

Courtesy of Manchester Libraries, Information and Archives, Manchester City Council

Flautist Edward de Jong was born in Holland in 1837 and, after working in London, became a founder member of the Hallé Orchestra. In 1871 he left the Hallé to form his own orchestra which presented a successful series of concerts at the Free Trade Hall for over twenty years.

Courtesy of Manchester Libraries, Information and Archives, Manchester City Council

respectively, by music dealer and founder of the Manchester School of Music, J. Albert Cross (1845–1926); Thomas A. Barrett (1863–1928), one-time organist of Salford Cathedral (and, as Leslie Stuart, a leading popular songwriter of the age); and businessman and musical enthusiast George William Brand Lane (1854–1927). With programmes offering a miscellany of ballads and (although not always) familiar classical and choral works at 'popular' prices – Lane's Wednesday concerts at the Free Trade Hall were partially aimed at shop workers and programmes carried the injunction 'Do not shop on Wednesday afternoon, for that is the shop assistants' half-day' – they added much to the process of musical education and dissemination.[14] Although opera was too closely associated with both the theatre and Italianate passion for some tastes, it maintained a notable element in the city's theatrical repertoire throughout the nineteenth century and had lost much of its taint by its close; in 1895 no fewer than five different opera companies played for a total of 17 weeks at three separate Manchester venues.[15]

The theatre had always been entirely of the marketplace and its significant levels of working-class patronage and the powerful religious and moral objections

Alfred Darbyshire

Architect Alfred Darbyshire (1839–1908) was a central figure within Victorian Manchester's theatrical and wider cultural life. Born into a middle-class family in Salford in 1839, a visit to the 1851 Great Exhibition with his uncle, George Bradshaw of railway guide fame, is believed to have inspired his interest in art and design. He became a leading theatrical architect in the later nineteenth century and was responsible for Manchester's Comedy (later Gaiety) Theatre in 1884 and the Palace Theatre of Varieties in 1891. Darbyshire was a nationally recognized expert in safety measures, a much-needed specialism given the dangers inherent in the theatrical environment. On 31 July 1868, for example, a (false) fire alarm led to 23 patrons being crushed to death at the Victoria Saloon in Manchester; as many as 2,000 people may have been present in a building seating only half that number. By contrast, Darbyshire's design for the Palace allowed safe exit for a full house of 3,000 in minutes. He was a talented amateur actor, once playing Polonius to Henry Irving's Hamlet during Irving's time as a young actor in Manchester, and he designed many of the spectacular sets that adorned Charles Calvert's Prince's Theatre Shakespeare productions. He also published theatrical history and art criticism, was a local historian of some note and, in 1869, was a founder member of the Brasenose Club, a modestly Bohemian, male-only organization in which cultural worlds that might have been thought of as largely separate collided in fruitful ways; other founders included figures as diverse as Charles Hallé, Calvert and the dialect poet, Edwin Waugh. Darbyshire's theatrical activities are all the more remarkable because he was a practising Quaker at a time when many of his co-religionists were far from sympathetic to the stage.

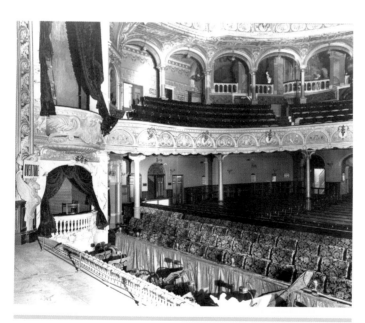

The Palace Theatre of Varieties in 1900, view from stage left. Comfort, style and safety.
Courtesy of Manchester Libraries, Information and Archives, Manchester City Council

Alfred Darbyshire
Courtesy of Manchester Libraries, Information and Archives, Manchester City Council

that it attracted somewhat restricted its earlier growth. In the last quarter of the nineteenth century, however, religious prejudices were increasingly overcome and Manchester's theatrical trade prospered. In 1870 the city possessed three major venues, the Theatre Royal (1844, and the third so-named building in the city's history), Prince's Theatre (1864) and Queen's Theatre (1870). By 1891 it recorded the largest numbers of actors in provincial England, and by 1900 seven houses advertised regularly in the theatrical trade press. Manchester was to host two important and distinctive theatrical projects in the period before 1914. In October 1864 actor-manager Charles Calvert's *The Tempest* at the Prince's formed the first of his highly regarded Shakespearean revivals, in which painstaking recreations of the play's historical settings resulted in the design of spectacular costumes and scenery and drew large and appreciative audiences.[16] Miss Horniman's Gaiety Theatre venture was an even greater theatrical landmark. The daughter of a London tea merchant and the founder of Dublin's Abbey Theatre in 1904, from her arrival in 1907 she assembled a highly talented group of young directors and actors who had staged some 200 plays by 1916 in Manchester, London and North America. Over a hundred of these were new works, including a small but significant number by local writers such as Harold Brighouse (1882–1958), Stanley Houghton (1881–1913) and Allan Monkhouse (1858–1936); Houghton's *Hindle Wakes*, which opened at London's Aldwych in 1912 and Brighouse's *Hobson's Choice*, premiered in New York in 1915, were especially successful. Audiences were not always plentiful,

Edyth Goodall as Fanny and Jack V. Bryant as Alan in the London premiere of Stanley Houghton's *Hindle Wakes*. The sexual morality explored in this play, in which Fanny, a female millworker, describes her sexual liaison with the mill owner's son as 'a bit of fun' and rejects his offer of marriage, made it a highly controversial work.

Courtesy of University of Salford University Archive, Stanley Houghton Collection

Pomona Palace public house. Located at the junction of Cornbrook Road and Runcorn Street, when it first opened its customers included those visiting the nearby Pomona Gardens, while from 1910 until the present day it has been a favourite of football supporters making their way to and from Old Trafford.

Courtesy of Manchester Libraries, Information and Archives, Manchester City Council

however, and starved of capital in the difficult environment of the First World War, Horniman disbanded the company in 1917 and sold the theatre in 1920.[17]

Theatre has been treated here as a 'high cultural' form but it would be seriously misleading if it were seen exclusively in that light. Many in the audience would have viewed Shakespeare (and opera) as part of a wider shared culture, while much theatrical entertainment consisted of a range of lighter genres. Calvert's pantomimes were a major feature of the dramatic landscape as were, for a shorter period, the operettas devised by Alfred Cellier (1844–91), his musical director from 1872–77; his *The Sultan of Mocha* (1874) saw, in a typical Calvert flourish, the Sultan enter on a live camel. Theatre, then, was very much part of the commercial popular culture that grew so significantly over the course of the nineteenth century, and especially in its later decades as working hours were shortened or restructured and real wages rose. Sport, explored later, formed a major element but innumerable others developed. Manchester was unusually well-served by amusement gardens, with Belle Vue, opened by John Jennison (1793–1869) in 1836, growing to become the site of England's largest provincial zoological garden, home to all manner of permanent attractions from bowling greens to an open-air dancing arena, and events such the pyrodramas in which fireworks and spectacular scenery were used to depict historical events. Pomona Gardens, opened in 1845, increasingly threatened Belle Vue's dominance, but its position on the line of the proposed Ship Canal forced its closure in 1888.[18]

It was music hall, however, that was urban Britain's most important popular cultural innovation. Public house 'singing saloons' of the 1830s and 1840s, offering entertainment in return for redeemable beer tokens, swiftly evolved into music halls charging admission for the entertainment provided. By 1852 Manchester's

The Manchester Hippodrome and Ardwick Empire were two of the city's Edwardian variety theatres, both designed by Frank Matcham. As these advertisements of 1915 suggest, these theatres saw themselves as part of the war effort, appealing directly to women and offering a variety show twice nightly for as little as threepence.

three largest pub halls, the Casino, Victoria Saloon and Polytechnic Hall, were thought to be attracting a combined weekly attendance of some 25,000, drawn mainly from a young, working-class constituency, with girls and young women comprising between a quarter and a third of patrons. By the early 1860s some Manchester halls were seeking a broader-based audience, with both the London Music Hall (1862) and the Alexandra (1865) attracting a number of clerks, shopmen and others from within the lower middle class.[19] The most lucrative potential market, however, lay in the middle class and those in lower social classes who had previously rejected the halls as morally unacceptable; women, whose attendance conferred respectability, were especially sought after. Thus began the process whereby, from the 1880s, 'music hall' evolved into 'variety', sited in increasingly luxurious venues, with alcohol consigned to designated bars beyond the auditorium and the notoriously suggestive comic singers increasingly replaced by circus-style performers. Temperance and moral reform lobbies were not easily convinced and the management of the city's first such venture, the Palace Theatre of Varieties, had to apply three times for a music-hall licence before finally opening in March 1891; a drink licence was never secured. Nevertheless, by 1910 some ten variety theatres existed within Manchester and its immediate suburbs, with several owned by William Henry Broadhead (1849–1931), whose theatrical and variety circuit grew to become one of the most important in the north-west. The working and lower middle classes remained the core audience: the Palace's prices, rising from a minimum sixpence to five shillings in the 1890s, with boxes at one and two guineas, were not the norm.[20] However, the long-term 'popular culturization' of society had begun in earnest, with a once disreputable popular entertainment reinvented for mass audiences in a manner which became a blueprint within the twentieth-century popular entertainment industry.

From the end of the nineteenth century, music hall was first joined and then increasingly challenged by cinema. The city's first public shows at the St James's Theatre and the YMCA occurred on 4 May 1896, and by the early twentieth century moving pictures frequently featured in public halls, fairground booths and music halls. The public safety clauses of the 1909 Cinematograph Act generated a rapid growth of purpose-built cinemas and the council had granted 41 licences by December 1910 and 111 by the end of 1914, although some of these were for church halls and other public buildings. Audiences were again largely young and working class but, in a novel shift, increasingly dominated by women. Many cinemas offered only basic amenities, but the Deansgate Picture Palace, opened in 1914 in the presence of the Lord Mayor and featuring a Jacobean-style entry hall with panelled oak and tapestries, hinted at the wider ambition that surfaced in the inter-war period.[21]

The scale of the city's commercial entertainment industry should not detract attention from the existence of a rich voluntary culture, a salutary reminder of the extent to which local populations have always entertained themselves. Amateur choral societies emerged in the 1840s, drawing on a wide social constituency and dedicated to the public performance of sacred art music, while choirs performing secular music flourished from the late nineteenth century, often performing in a

Annie Horniman (1860–1937) bought the Gaiety Theatre, Peter Street in 1908, establishing it as one of the first repertory theatres. Its fame came from performing plays by new playwrights including Stanley Houghton and Harold Brighouse. Horniman sold the theatre in 1920, following which it was converted into a cinema.

competitive format; the Manchester Orpheus Glee Society (1896) became one of the nation's finest male voice choirs within this environment. Here were forms of high art entirely dependent for their existence upon the community. Amateur theatrical and operatic groups, often suburban-based, emerged in increasing numbers from the late century, adding a powerful and growing middlebrow element to the city's culture.

Writing in 1960, Michael Kennedy (1926–2014) suggested that 'Manchester was at its cultural peak' from the late 1890s to about 1914. Cultural peaks and golden ages are highly subjective phenomena, but in terms of the 'serious' culture Kennedy was considering, with the Hallé under the conductorship of Hans Richter (1843–1916), Miss Horniman at the Gaiety and the array of journalistic talent displayed at the *Manchester Guardian*, the suggestion is far from unreasonable. (It would be interesting to see how Kennedy might have judged that 'peak' against the cultural developments of recent decades.) Moreover, two remarkable seasons of opera under Thomas Beecham (1879–1961) in 1916–17 lay in the immediate future.[22] Underneath this impressive superstructure, however, deep changes were at work resulting in a much altered and in some ways reduced place for institutions of high culture, and a much enhanced one for the popular and middlebrow. This is not to minimize the continuing role of high culture in local life. However, as the influence of the nineteenth-century patrician elite declined and the disciplines of both the marketplace and public funding grew, fundamental changes took place in regard to what high art stood for and how it had to be organized.

In many ways, classical music survived the challenges of the twentieth century extremely well. Certainly opera, increasingly expensive to stage, increasingly gaining a reputation for elitism entirely belied by its earlier history and losing out in popular taste to musicals, was infrequently staged from the 1930s; performances in Salford by Opera North in recent decades have reversed that trend slightly. However, a city housing a world-leading conservatoire (the Royal Manchester

Walter Carroll's success in encouraging music in Manchester Education Committee schools was being recognized some time before the Manchester Children's Choir and the Hallé Orchestra recorded Purcell's 'Nymphs and Shepherds' in 1929. The gramophone record proved popular, selling over one million copies.

Courtesy of Manchester Libraries, Information and Archives, Manchester City Council

College of Music merged with the Northern School of Music, a music-teacher training college, to form the Royal Northern College of Music in 1973) was never going to lack musical performance, while new ensembles have emerged to supplement the musical landscape. The orchestras associated with the BBC, discussed later, proved important here, as has the Manchester Camerata (1972), one of the rare freelance chamber orchestras outside London. For all the problems that any major institution will inevitably experience, the Hallé has continued to serve as the city's cultural flagship, although with changed social connotations. Audience and subscription numbers fell from the 1890s as Manchester's *haute bourgeoisie* found other leisure pursuits through which to exhibit status (for males, sport was crucial here) while increasingly disengaging from the city and its institutions in the 'flight' to Cheshire.[23] Hallé audiences probably remained ultimately 'middle-class' in a broad sense, but the concerts were increasingly less rituals that underlined the authority of the local ruling class. In the, albeit untypical, years of the Second World War when the Free Trade Hall was commandeered by the government, the orchestra performed in a variety of locations, with Sunday afternoon concerts at Belle Vue drawing audiences of 6,000–7,000. The charismatic Sir John Barbirolli (1899–1970), conductor from 1943 to 1968 and extraordinarily popular with the Manchester public, did much to enhance this rather more democratic flavour. From 1996 the Hallé has been resident in the 2,400-seat Bridgewater Hall, a concert hall blessed with a revolutionary noise insulation system and central to the city's aspiration to economic regeneration through culture. Despite an 80 per cent occupancy rate for its concerts, it came within days of financial collapse in February 1998 as it struggled to deal with a lengthy freeze in Arts Council subsidy and problems of

The Corona Cinema/Southern Sporting Club/Mayflower

As leisure entrepreneurs have sought to adapt to rapid shifts in popular taste, many of Manchester's cultural venues have frequently undergone a process of reinvention, and few demonstrate this more strikingly than the Corona cinema in Birch Street, West Gorton. With its showy façade in green and white faience, topped with twin towers reminiscent of a medieval cathedral, the 1,000-seat building opened in April 1915 as an excellent example of the contemporary attempt to improve the image and appeal of cinema. Originally operated by New Century Pictures, its ownership transferred to Gaumont in 1928 before finally passing to the Snape circuit in 1950. The Corona was one of many cinemas to fall victim to the rise of television, finally closing in October 1958 with a double bill featuring Johnny Desmond in *Escape from San Quentin* and Deborah Kerr in *Bonjour Tristesse*. After a short spell in which it was probably used as a dance hall, it was reopened as the Southern Sporting Club in December 1959 by Syd Elgar, a variety agent and a pioneer of the region's cabaret club industry. By the early 1960s it offered (along with wrestling bouts) casino facilities and a nightly cabaret programme often headed by major figures within the British and American entertainment industry, including singers Johnny Ray, Guy Mitchell and Alma Cogan and jazz trumpeter Nat Gonella. On 13 June 1963 the Beatles appeared there, although some oral testimony suggests that this was not a particularly successful event. By the early 1970s, with cabaret and variety clubs fast losing popularity, it transformed into Stoneground, a major local rock venue, before finally becoming, as the Mayflower, a centre for the city's reggae, punk and post-punk scenes in the late 1970s and early 1980s. By this stage, parts of the structure were condemned and the remainder was blessed with an erratic and dangerous electricity supply, carpets sticky with beer and cider, and toilets the stuff of nightmares. Nevertheless, this almost gothic ruin hosted a number of important gigs and some of Kevin Cummings's iconic photographs of Joy Division were taken here. Unsurprisingly, the building was effectively destroyed by fire in 1984 and demolished the next year, its journey from show-business glitz to polar opposite fully completed.

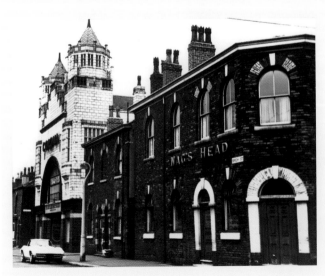

The Corona building, *c.*1964, during its period as the Southern Sporting Club.

Courtesy of Manchester Libraries, Information and Archives, Manchester City Council

internal management. Further council support (the city council and the Central Manchester Development Corporation had funded the original Bridgewater Hall project), a public appeal and an injection of funds from the Hallé Trust rescued it, too potent a symbol of Mancunian cultural ambition and status to be allowed to fail.

The city's theatrical life enjoyed a decidedly erratic twentieth-century journey. The Edwardian high point was followed by an especially difficult period as cinema absorbed both premises (the Gaiety and Theatre Royal both succumbed in 1921) and audiences. Of the theatres operative in 1900, only two survived until 1939. The 3,000-seat Opera House, opened as the New Theatre in 1912, showed that the trend could be resisted, with impresario C.B. Cochran (1872–1951) using it expertly for pre-London runs, and the Rusholme Theatre Company extending the Horniman legacy; Robert Donat (1905–58) and Wendy Hiller (1912–2003) were among those learning their trade there. Amateur drama grew during the inter-war period when Manchester also become a centre of the socialist theatre movement, with Salford-born Jimmie Millar, later known as Ewan MacColl (1915–89), prominent within the Red Megaphones agit-prop company.[24] The Opera House was nationally renowned in the post-war period for its staging of Broadway shows including the pre-West End run of *Oklahoma* in April 1947 and the European premiere of *West Side Story* in 1958, but the arrival of television coupled with rising costs saw commercial theatre decline alarmingly in the 1960s and 1970s, with the Opera House serving as a bingo hall from 1979 to 1984. The opening of the Royal Exchange Theatre in 1976 heralded a major renewal of live theatre in the city.

Arguably the most important change within the ecology of serious art has been the growth of subsidy since 1945, with various local and national state grants, supplemented increasingly from the 1990s by support from business, taking the role once filled by wealthy patrons. This has resulted in both new physical provision, beginning with the Library Theatre in 1947, and the support of exhibitions and live performance. Public subsidies have usually provided some 40–50 per cent of the Hallé's annual operational turnover from the mid-1960s and, while box-office receipts provided the biggest single share of the Royal Exchange's revenue in 2008–09, government grants provided almost 40 per cent of income.[25] The vagaries of public funding have caused problems, especially for smaller and more vulnerable organizations. The Forum Theatre, opened in Wythenshawe Civic Centre in 1971, was closed in 1999, and the highly regarded experimental performance venue, the Green Room, in Whitworth Street West, similarly fell victim in 2011.

Over the course of the twentieth century, the rapidly expanding and constantly evolving field of popular entertainment played an ever greater role in defining Manchester's cultural life, both internally and externally. Until the 1960s this was largely a matter of increased provision and a higher profile within the city's built environment. Some genres declined, with variety suffering as badly as the legitimate theatre from cinematic competition; others, notably the dance hall, became quintessential modern leisure pursuits. Public dancing had been popular within working-class communities from the 1840s, but, outside of Belle Vue and

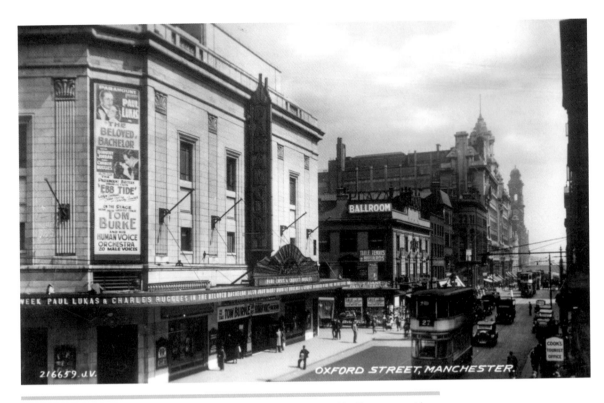

Paramount Cinema and neighbouring Plaza Ballroom, Oxford Street, 1932. The Paramount, with a capacity of almost 3,000, was opened in October 1930 and was probably the most luxurious cinema in Manchester at that time; a minimum evening admission price of 1s. 3d. was designed to maintain a certain social tone. The Plaza, along with the Ritz on Whitworth Street West, occupied a similar position in the city's dance hall hierarchy. The proximity of the Paramount and Plaza draws attention to the importance of this part of the city centre to the local pleasure economy.

Courtesy of Manchester Libraries, Information and Archives, Manchester City Council

Pomona, little effort was made to claim a morally suspect activity for the mainstream. This changed rapidly in the 1920s with a mushrooming of venues ranging from halls such as the Ritz in Whitworth Street West, Plaza in Oxford Street and Embassy at Whalley Range that featured leading local dance bands and boasted excellent facilities, to the dozens of church halls and other spaces that were called upon to service the craze. Dance halls provided another important avenue for women's leisure, although in Salford, at least, some closed on Friday nights on the assumption that young female patrons would be assisting with family chores.[26]

By the late 1950s cinema and dance halls were under pressure, with television mounting the key challenge; by the mid-1960s, only 33 cinemas remained within the city. From the late 1950s, and stimulated by rising living standards and the liberalization of licensing and gambling laws at national level, a range of late-night club venues became the leading sector within the city's leisure culture. They ranged in type from the so-called 'coffee clubs' aimed at a youth market and very important to the dissemination of popular music, to the shebeens and clubs that

grew up among the Afro-Caribbean communities of Moss Side and Hulme, strip clubs such as the Arthur Fox Revue Bar, and nightclubs and casinos such as the Garden of Eden in Whitworth Street. Here (along with small alligators swimming in a channel around the dance floor) could be found an all-night hairdressing salon and a shop where 'members can buy a shirt before going to the office after a night at the casino tables'.[27] Particularly prominent were the 'cabaret' or 'theatre' clubs aimed at a popular audience and capable of bringing leading national and international light entertainment stars to the city; Shirley Bassey played the Talk of the North, Pendleton, in 1965, Eartha Kitt, the Golden Garter at Wythenshawe, in 1970. In 1967 when numbers reached their peak, some 25 such clubs were operating within a four-mile radius of Manchester city centre in comparison with just four in Liverpool and three in Leeds.[28] 'Clubland' declined rapidly in the 1970s as new licensing regimes and the introduction of the breathalyser undermined profitability, but at its height, and in a period when the city is often cast as being in decline and backward-looking, it lent a veneer of glitzy modernity. Perhaps for the first time, popular culture played a significant part in defining the city's image. Some constituencies were pleased by this, with the *Manchester Evening News* greeting readers on 6 February 1964 with the headline 'Manchester at Midnight. The verdict ... it's SWINGING!' and citing various expert testimonies deeming the city the 'club centre of Britain'. Others were far less comfortable, and the police closed down the coffee clubs in a concerted campaign in 1966 and waged a guerrilla war against illegal gaming and after-hours drinking at cabaret clubs. Nevertheless, there is a strong sense of a new note being struck within civic discourses.

Golden Garter, Wythenshawe. The frontage of the Golden Garter, Wythenshawe, in the early 1970s, with singer Lulu and comedian Jim Bowen the headline acts. A product of the 1960s cabaret club boom, the Golden Garter opened as 'Britain's first showbar restaurant' in October 1968. Holding up to 1,400 patrons, it became one of the nation's leading light entertainment venues, despite attempts by the police to close it for licensing violations.

Courtesy of Manchester Libraries, Information and Archives, Manchester City Council

In similar vein, the 1960s saw the national and sometimes international success of pop groups either born or based in the city. Although Manchester never matched Merseybeat's place within the national imagination, Freddie and Dreamers, The Hollies, Herman's Hermits and Wayne Fontana and the Mindbenders were among the leading contemporary acts. The city was, too, a key centre for jazz and folk, mainly performed within a network of small clubs, although star names were drawn to major venues, particularly the Free Trade Hall. Bob Dylan was to perform there in 1965 and 1966 and, at the second concert, his use of electric guitars sparked enormous controversy.[29] For much of the period from the late 1970s to the mid-1990s, Manchester moved to the very centre of British popular music, with Factory Records, initially founded in 1978 by Granada TV presenter Tony Wilson (1950–2007) and band manager Alan Erasmus, critical in this process. Home to a number of influential Manchester bands including Joy Division/New Order and the Happy Mondays, the company also promoted live performances and dance events, with its most famous venue, the Haçienda (1982), at the heart of a dance culture which peaked in the 'Madchester' moment of the late 1980s and early 1990s. The Happy Mondays and other local bands including the Stone Roses and Inspiral Carpets, along with clothing fashions often pioneered in the city, placed Manchester firmly in the national gaze, albeit one that sometimes too easily resorted to traditional stereotypes positing sophisticated London against a brash, untutored north.

Factory went bankrupt in 1992 and the Haçienda closed five years later, but subsequent media interest, including the films *Twenty-four Hour Party People* (2002) and *Control* (2007), rendered Factory a powerful presence (some would argue too much so) within cultural representations of late twentieth-century Manchester. The Smiths, founded in 1982 by vocalist (Steven Patrick) Morrissey and guitarist Johnny Marr, were seen by many critics as the most influential product of the British 'independent' rock scene of the 1980s and Morrissey continues to epitomize a certain 'miserablist' Mancunian persona to the outside world. Oasis, fronted by the Gallagher brothers, Noel and Liam, was to be, at least in terms of chart success, Britain's most successful band from the mid-1990s to the early twenty-first century. From about 1980, then, popular music (along with football and popular television) became central to internal and external understandings of Manchester and gave the city a prominence and reach that high art could simply never have achieved.[30] At the same time, boundaries between 'high' and 'low' became increasingly blurred, something well demonstrated by the range of programming featured in the biennial Manchester International Festivals which began in 2007, and the recent collaborations between rock band Elbow and the Hallé.

Media

It is Manchester's history as a media centre that most justifies any claim to provincial cultural superiority. Although the MediaCity complex that opened on the banks of the Ship Canal in 2011 is actually located in Salford, its name is an apt reflection

of the area's long record of achievement in this field. The city's first newspaper, the *Manchester News-Letter* (1719–25), was short-lived, but other early titles, notably the *Manchester Mercury* (1752–1830), enjoyed considerable longevity. It was, however, the highly charged political context of the Peterloo era that truly stimulated local newspaper growth, and by the mid-1820s most shades of Manchester's political opinion had a journalistic mouthpiece, with the *Manchester Guardian* the most striking product.[31] Founded in 1821 by Unitarian cotton merchant and radical reformer John Edward Taylor (1791–1844), the paper swiftly moderated its tone and became strongly supportive of the interests of the Lancashire cotton manufacturers. Under the guidance of C.P. Scott (1846–1932), editor from 1872 until 1929 and owner from 1907 until his death in 1932, it took on a more radical demeanour, supporting Irish Home Rule, strongly opposing the Boer War and, in the process, becoming increasingly perceived, nationally and internationally, as the representative voice of progressive British Liberalism. Especially under Scott, the paper also treated the arts with a seriousness previously only devoted to business and politics – the strength of Manchester's cultural life encouraged this – and its specialist critics and writers helped build and inform audiences both within the north-west and further afield. Over the course of the nineteenth century, the paper became Britain's only regional newspaper to attain national and international significance. For all this remarkable record, the *Guardian*'s history must not be allowed to stand proxy for that of the city's wider newspaper industry. Although it was the largest selling Manchester daily (from 1855) for much of the nineteenth century, its circulation was frequently smaller than that of its rivals in combination, while, from late in the century, its sales were dwarfed by those of the rapidly emerging popular press. Sunday and evening papers, notably the *Manchester Evening News* (1868–) and *Manchester Evening Chronicle* (1897–1963), were crucial, but new dailies also exerted a powerful influence. By 1912, when the *Guardian* was selling just under 50,000 copies a day, sales of the *Daily Dispatch* (1900), a Manchester-published daily for Lancashire and the north-west published by Edward Hulton (1838–1904), reached 270,000.

The richness of Manchester's press and related publishing history beyond Cross Street is well demonstrated by Frederick Leary's identification of some 661 locally published titles between 1720 and 1888, with 206, including 34 newspapers, current at the latter date. An especially significant chapter in this wider history is provided by Edward Hulton, described on his death in 1904 as 'the most original and potent force in provincial journalism in the last quarter of the nineteenth century'. A journeyman printer and horse-racing devotee, Hulton built his Withy Grove empire on the rapidly expanding world of commercial sport, with his first venture, the weekly horse-racing tipster *The Prophetic Bell* (1871), swiftly evolving to become the *Sporting Chronicle*, published daily from 1880. He saw its circulation reach 150,000 by 1900 and become Manchester's first (some would argue, only) national daily newspaper. Its success, replicated by the weekly *Athletic News* (1875), allowed the company to move beyond sport and launch the *Sunday Chronicle* in 1884 and the *Evening Chronicle* in the next decade: circulation of the Sunday title

reached 650,000 by the First World War.[32] Although the *Manchester City News*, launched as a penny weekly in 1864, could never match Hulton's circulation figures or the *Guardian*'s status, it made an important and distinctive contribution to local intellectual life, especially during John H. Nodal's editorship from 1871 to 1904. Using his many connections in the influential Manchester Literary Club (1862), he made the paper a key forum for discussion of literature, the arts and science. He also edited two of the city's satirical papers, the *Freelance* and the *Sphinx*, titles capturing yet another aspect of a periodical publication industry that also embraced 'improving' household journals, dialect publications, trade papers and even the early years of *Tit-Bits*, founded in Manchester in 1881 by George Newnes (1851–1910) and funded from the proceeds of a vegetarian restaurant.[33]

Manchester's involvement with national titles began in 1900 with the production of a northern edition of the *Daily Mail*. The concept of a 'national' daily newspaper then barely existed, the market comprising simply London titles, of which only *The Times* penetrated the whole country, and provincial dailies. Distance from the capital, preventing the arrival of all but early editions to the breakfast table, combined with the lack of relevant local news in London papers gave local titles a powerful market advantage. The arrival of the *Mail* changed this, beginning the process by which 'national papers became truly national'; the paper was producing Liverpool, Lancashire and Yorkshire editions from its Manchester base by 1912.[34] By 1940, when the *Daily Telegraph* and *Sunday Times* began publishing in the city, seven dailies and four Sundays were printing locally and Withy Grove, with some 3,000 staff, was probably Europe's single biggest print hub.

The 1950s perhaps represented the city's high point as a press centre: from then, closures, amalgamations and relocations impacted significantly and largely detrimentally. Of the national titles printing locally, the *News Chronicle* closed in 1960 and the *Daily Sketch*, founded as a joint Manchester and London paper in 1909, in 1971. Among Manchester papers, and despite sales of 500,000, the *Daily Dispatch* closed in 1955, the leasing of its presses to the *Daily Mirror* deemed a more profitable course. The *Guardian*'s abandonment of the city was, however, the highest profile and most symbolically important of all these upheavals. A move to simultaneous London and Manchester production as a mechanism for attaining nationwide circulation had been considered as early as 1884, but a desire to seek out younger, more socially aware constituencies beyond the paper's north-west heartland finally brought the idea to fruition. 'Manchester' disappeared from the masthead on 24 August 1959, London printing began in 1961 and, contrary to original intentions, the editor, Alistair Hetherington (1919–99), moved his desk to London in 1964. This was a crucial moment, for it undermined the original intention that the paper should continue to be shaped in Manchester. By 1970 the *Guardian* was undeniably a national, but one unrecognizable to many of its readers from even just a quarter of a century earlier.[35]

There were inevitably counter-trends, including the launch of the *Daily Star* at the *Daily Express*'s Great Ancoats Street plant in 1978, while a lively alternative

The *Athletic News* and the rise of professional football

The sporting press was one of the most characteristic products of Manchester's newspaper industry and the *Athletic News* was one of its most original and influential titles. A weekly, first published in 1875 by Edward Hulton, it provided a counterbalance to his hugely successful *Sporting Chronicle* by ignoring gambling and racing news and instead focusing on the team sports that were becoming such a significant part of the sporting landscape. It became the premier media voice for association football and played an important role in reporting, debating and encouraging the spread of the game. Closely allied to the Football League – League president John J. Bentley edited the paper from 1895 to 1900 – the 'footballer's bible' became an enthusiastic champion of the professional game at a crucial moment in its development. The paper's sales rose from about 25,000 in 1883 to 170,000 just after the First World War, but during the 1920s competition from the burgeoning Sunday press forced its eventual absorption into the *Sporting Chronicle* in 1931.

The extracts below from the paper's report of the Manchester derby of September 1898 capture the moment when it was clear that 'socker' had become a central part of the city's sporting culture. Interestingly, the legendary Billy Meredith, then of City but later of United, is compared very unfavourably here with Newton Heath's Joe Cassidy. Although the 'Heathens' won this Second Division home game by three goals to nil, City were eventually promoted as champions. In December 1906 Manchester finally enjoyed its first ever First Division derby.

Newton Heath v Manchester City

With such a vast crowd as we had at Clayton on Saturday in mind it makes one wonder why we do not possess a First Division club in Manchester, and a successful one at that [...] As a proof of the enthusiasm of Mancunians for the game, I need only mention the fact that there would be fully 18,000 on the Clayton enclosure on the occasion of the first meeting of the old rivals.

There have been great improvements effected in the Heathen's enclosure since last season, a fine uncovered stand having been erected on the Clayton side in place of the one which stood at the opposite end, while the apology for covered stand has also received attention.

Cassidy was the star of the afternoon, and played a really first class game. He fairly did as he wanted with his opponents, and fed his partner to the latter's heart's content, while as a 'shootist' he was a terror. Meredith was like a bull in a china-shop, rushing about without much good intent.

Athletic News, 12 September 1898

Edward Hulton in 1885.
Courtesy of Manchester Libraries, Information and Archives, Manchester City Council

press, exemplified by *New Manchester Review* (1975) and *City Life* (1984), blended a radical political agenda with extensive coverage of the local arts and popular music scenes. Similarly, the late 1970s and early 1980s saw the emergence of the music and soccer fanzines that helped shape dynamic new aspects of popular culture. Within the mainstream, however, Manchester had only ever been viewed as a branch plant economy suited to a particular set of working practices. Once printing unions were forced to accept new technologies, it was only a matter of time before northern editions could be replaced by facsimile editions sent from London to a network of print centres. Between 1985 and 1989 the remaining components of the second Fleet Street were swept away, with publishing finally ceasing at Withy Grove in 1988; it reopened as the Printworks leisure complex in 2000.

Manchester's broadcasting history began modestly on 17 May 1922 when the Old Trafford-based Metropolitan–Vickers Company, seeking to advertise its manufacture of wireless receivers, made its first, short transmission. Along with other pioneers, it was absorbed into the British Broadcasting Company (Corporation from 1927) in November 1922, and its 2ZY station became one of the nine local providers that formed the initial core of BBC programming. Although popular

Interior of *Daily Herald* office, Manchester, 1930. Manchester's importance in the battle for readers among national papers was underlined when the *Daily Herald* (owned by Odhams Press and the TUC) opened offices in the city in 1930, a decision that helped it become the first daily newspaper to have a circulation of over 2 million.

Courtesy of Manchester Libraries, Information and Archives, Manchester City Council

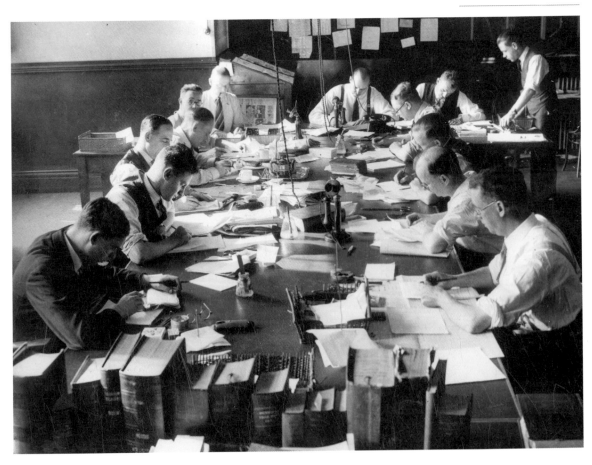

with listeners, local radio was never more than a stopgap designed to circumvent early limitations to transmitter capacity and, by the early 1930s, it had been effectively replaced by a national service supported by five (eventually seven) 'regional' stations. Seemingly without much deliberation, Manchester was chosen as the headquarters for the North Region, for the first time in its history awarded a role that formally rendered it capital of the north. Regional stations were always subservient to the London-based National Programme, and, rather than match its output, they were intended to capture characteristics supposedly distinctive to their territories. The problem for the Manchester management was that the sheer size of the 'North' as defined for them, stretching at one stage from the Potteries to the Scottish border, almost guaranteed tensions within, and criticisms from, its myriad constituent parts. Nevertheless, tremendous efforts were made to capture the widest possible sense of northern life, as key Manchester staff such as Archie Harding (1903–53), programme director from 1933–36 and an Oxbridge-educated Marxist who developed a passionate attachment to the region, sought interesting ways through which to explore it. Above all, the station developed a reputation for documentary programmes that put 'ordinary', often working-class voices, on air. Blending these with music and dramatized readings, writers and producers such as Sheffield poet D.G. Bridson (1910–80) and another southern-born, left-thinking Oxbridge graduate, Olive Shapley (1910–99), came close to inventing a new art form. The North Region, like Horniman's 'Manchester School' plays before it and certain Granada TV productions after it, thereby did much to equate Manchester and the North more widely with a social realism that both played to stereotypes many locals wished to challenge but also opened opportunities for new avenues of cultural engagement.

The station also played a major role in local and regional musical life. The tiny 2ZY orchestra gradually evolved into the BBC Philharmonic, reorganized as a national orchestra in 1982, but continuing to be based locally. The Northern Variety Orchestra, founded in 1951, became the Northern Dance Orchestra in 1956 and, until its abolition in 1985, remained one of the country's leading dance bands. Although radio was rapidly superseded by television during the 1950s, it has continued to hold an important place in local culture, especially in the commercial sector, finally legalized in 1972. Piccadilly Radio (1974), originally located in Piccadilly Plaza, was the city's first commercial station and remained highly popular into the late 1990s; it became part of the Magic Radio network in 1999 and currently broadcasts as Key 2. Alongside BBC national and local services, a wide range of commercial and community stations operate in the early twenty-first century, often aiming at highly specific social or ethnic groups and musical taste publics.[36]

Television only became available to northern audiences in 1951 and its administration inevitably passed to Manchester. The city was to be home to numerous important programmes, including the first three series of *Top of the Pops* from 1964 to 1967 (filmed at Rusholme, site of the BBC's first TV studio

beyond London), the long-running *Question of Sport* (1968–) and, more recently, *Dragon's Den* (2005–). For all the importance of the BBC's contribution, however, it is commercial television that arguably looms largest in the city's history. The BBC had been criticized for what one government committee had termed the excessive 'Londonization' of its output and, when commercial television was legalized in 1954, ITV franchises were created for three regions of which the North (originally comprising Lancashire, Yorkshire, the North Midlands, Cumbria and North Wales) was one. ABC Television, based in the Capitol Theatre in Didsbury, won the northern weekend contract, with Granada awarded weekday schedules. Granada did consider establishing its headquarters in either Leeds or Liverpool but, with a certain inevitability, settled on the Quay Street location that the company occupied until moving, as ITV Manchester, to MediaCity in 2013. Both companies began broadcasting in May 1956 and while ABC produced some significant programmes (early productions of the highly regarded *Armchair Theatre* emanated from Didsbury), it was Granada's wide-ranging and considered regionalism that was to make it Britain's most successful and critically regarded independent franchise.[37]

The company became synonymous with *Coronation Street*, first broadcast on 9 December 1960 and, within a year, heading the national television ratings. Its continuing popularity (the programme's set became an important tourist feature in the later twentieth century) contributed strongly to the elevation of the place allotted to popular culture within Manchester's overall cultural status. The studio's output was, however, far wider than this one programme. It celebrated the city's cultural heritage with revivals of Gaiety Theatre dramas in 1958 and 1959 and developed a strong reputation for locally rooted comedy, from titles such as Jack Rosenthal's *The Dustbinmen* in 1969–70, through to the romantic comedy drama *Cold Feet* in 1998–2003. It also produced a number of high-profile titles unrelated to the region including the current affairs programme *World in Action* (1963–98). Granada's output did not always meet with local approval; some were excited that, for example, *Coronation Street* 'was showing ordinary people doing ordinary things', but others were dismayed by its being 'all back alleys and booze'.[38] Whatever the response, there can be no denying the critical role the station played in placing powerful and thought-provoking versions of the north-west (changes to the franchise system saw 'Granadaland' shrink from the late 1960s) into the national culture. A restructuring of ITV in the early twenty-first century resulted in the absorption of Granada into a single network from 2004 and the name now only survives in local news programmes. The complex media environment emerging from the late twentieth century as a result of increased competition and technological change has opened opportunities for smaller-scale media outlets. Channel M, initially rooted in a partnership between Guardian Media Group and Salford University, enjoyed some success as a regional news, discussion and popular music network before falling victim to financial pressures and closing in 2012. A number of TV production companies have been established, with Red Production Company (1998), creators of Channel 4's *Queer as Folk*, set in the city's Gay Village, proving notably successful.

Ena Sharples (Violet Carson) surveys the Manchester skyline with a suitably caustic eye. First broadcast by Granada in December 1960, *Coronation Street* became, in ways both positive and negative, the most significant media representation of the Manchester region and the north more widely.

© Rex Shutterstock

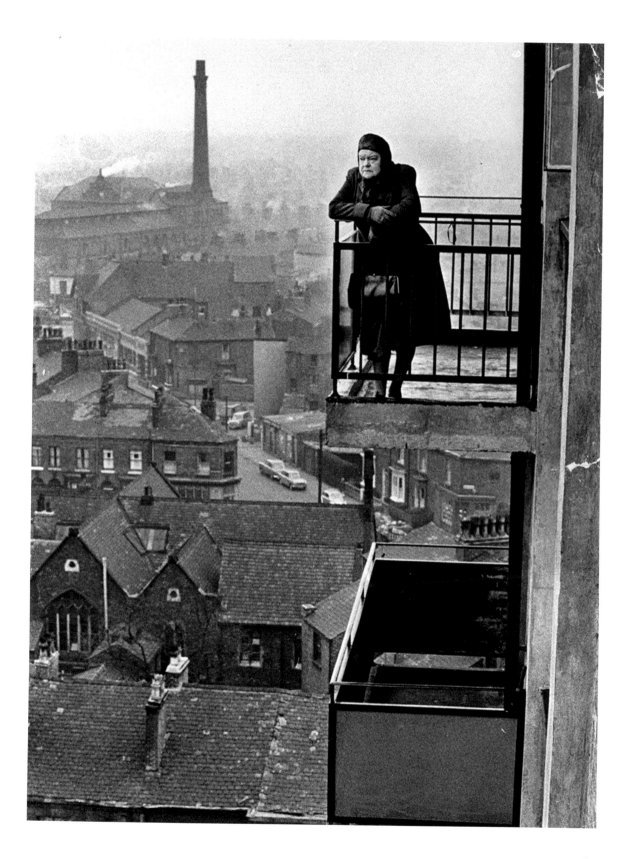

Sport

Sport has long been an important feature of Manchester's cultural life.[39] Hunting dates back to at least the fourteenth century, race meetings began on Kersal Moor in the 1680s, eighteenth-century Manchester was a major centre of competitive archery, and animal baiting and fighting sports drew adherents from a wide social spectrum into the 1830s. As sport has grown to become a central facet of British culture from the late nineteenth century, the city has developed a body of sporting institutions and facilities that, cumulatively, have at least equalled and often surpassed those of other provincial cities. Once again, locational and demographic advantages have encouraged the growth of a highly developed service sector. Only London surpassed Manchester as a centre for the betting industry in the nineteenth century (Liverpool usurped this position from the 1920s), the city's not unrelated role as a focus for the sporting press has already been noted and it is has long been a major centre for sporting retail: *Slater's Directory* for 1912 listed 18 athletic outfitters.[40] The city's role as transport hub has led to it hosting numerous significant meetings, most notably the one that founded the Football League in April 1888, and it serves as headquarters to a number of national bodies including the Professional Footballers' Association, founded in Manchester in 1907.

Although the city's sporting reputation has been largely made by professionals, the world of the amateur should be the starting point for discussion: the 'typical' sportsman (and the sportswoman almost without exception) has always been an amateur. Voluntary sports clubs became increasingly common from the 1820s, before expanding hugely in number across almost all levels of society beyond the poorer working class from the late nineteenth century. Manchester Golf Club, only England's second, was founded around 1814 by Scottish merchant William Mitchell, and the sport maintained a distinctively Scottish flavour until late in the nineteenth century, when it took hold among the suburban middle class. By 1912 over 70 clubs enjoyed by some 20,000 golfers existed within a 20-mile radius of the city. Manchester Cricket Club, founded as Aurora CC between 1818 and 1823, was the city's first, eventually moving to the current Old Trafford ground in 1857 and reforming itself as the basis of Lancashire County Cricket Club in 1864. Old Trafford was the site of the first ever Ashes Test match in England in July 1884 and remained one of England's leading Test match venues from that point. (It has been the site of many key cricketing events, perhaps most importantly Jim Laker's capturing of 19 Australian wickets in the 1956 Test match.) Manchester Rugby Club formed in 1860, 1867 saw lacrosse clubs established at both Old Trafford and Broughton Cricket Clubs, and Manchester Polo Club, the first such provincial organization, was founded five years later.[41]

These institutions were mainly founded by middle- and upper-middle-class male elites who policed membership requirements rigorously. Class was always the major concern, but it was not the only one; in 1932 the country's second-only Jewish golf club opened at Whitefield in response to significant levels of

discrimination.[42] By the 1880s, however, the national codification and bureaucratization of sport, rising real wage rates, reductions in working hours, improvements in public transport and the growth of the sports press were combining to generate a much more broadly based culture, albeit one still marked by class distinction. Although women's participation was largely restricted to 'respectable' and decorously executed middle-class sports such as croquet, tennis and golf, for many men, Saturday afternoons became the time for a wide array of activities, with association football, cricket and bowls the most popular. The inter-war period saw further growth in participation and by the late 1930s Manchester and its immediate environs boasted some 400 football and hockey and 150 cricket teams alone.[43]

An important factor in this expansion was the substantial level of municipal support, with the council maintaining around 800 sporting facilities, including 398 tennis courts, 79 bowling greens and 35 swimming baths by 1938. A number of leading companies also contributed impressive resources, as exemplified by the Co-operative Wholesale Society's grounds, opened in Moston in 1928. The growth of the outdoor movement, particularly rambling, was a striking feature of the inter-war years. Its most iconic moment came with the Kinder Scout mass trespass on 24 April 1932, when some 400 walkers, many from Manchester, sought access to private land in the Derbyshire Peak District. Its long-term significance in campaigns for the right to roam remains a matter of debate, but it symbolizes the powerful appeal of moorland walking to urban dwellers.[44] Participation rates in voluntary sport possibly peaked around the 1960s (a decade that saw the effective acceptance of Sunday sport) although data is elusive. Increasingly from the last quarter of the twentieth century, changing lifestyles have both threatened sport by offering new, sometimes sedentary alternatives, and stimulated new avenues for its pursuance, exemplified by the emergence of squash. The decline of manufacturing has effectively ended works-sponsored provision and, although the picture

Manchester and Salford regatta, 1844. Although it took place on a river renowned for its pollution, the regatta established itself as a popular annual event. As at the Manchester races, temporary stands were erected for spectators, drinking and gambling adding to the excitement of the day.

Courtesy of Chetham's Library

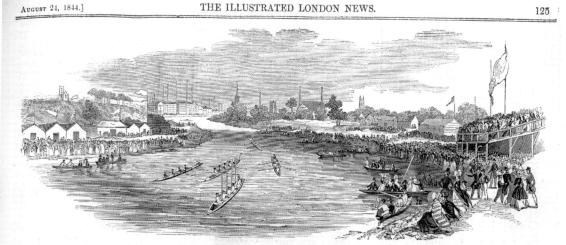

MANCHESTER REGATTA—FROM A SKETCH BY MR. HAYES.

is complex, many municipal services have declined as a result of cuts in, or refocusing of, central government funding. By 2004, for example, the city retained only 50 per cent of the bowling greens that it possessed in 1927 and just under 20 per cent of its tennis courts.

The greatest cultural impact on the city's physical and, crucially, mental landscapes have been exerted by professional sport. No other aspect of cultural life has allowed such scope for the expression of individual and collective loyalties to Manchester or certain sections of it, and of the city's contribution to larger units such as county and nation. The presence of local players has always enhanced interest in the national cricket and football teams and their absence has been a source of aggrieved local pride. Although the take-off of professional sport was ultimately a late Victorian phenomenon, powerful prototypes existed much earlier. As so often, the public house proved a fertile springboard for new ventures and not least in the development of athletics, or 'pedestrianism' as it was frequently termed. A number of publicans, possibly beginning with Betty Berry of the Snipe Inn, Audenshaw around 1840, built cinder tracks adjacent to their properties, often accompanied by bowls greens or other sporting facilities. By the late 1850s a network of these proto-sports stadia existed in and around the city, drawing crowds that could occasionally exceed 10,000 and hosting events of sufficient importance to allow the world record for the mile to be lowered six times at local tracks between 1857 and 1865.[45]

The annual Manchester and Salford Regatta, founded in 1841 and promoted by Pomona Gardens, grew to become a three-day event attracting large crowds to the banks of the Irwell and some of the country's leading oarsmen. Horse racing prospered, drawing spectators and gamblers from across the social spectrum to courses sited at Kersal Moor until 1846 – uncorroborated estimates suggest attendances of over 100,000 in the 1820s – Castle Irwell from 1847 to 1867 and again from 1902, and at New Barns from 1876 to 1901. As a mass spectator culture developed from the 1880s, association football and rugby drew the largest numbers on a regular basis, although Saturday and bank holiday county and Test matches at Old Trafford could also draw large and boisterous cricket crowds. Both football codes began as amateur sports but were swiftly riven by conflicts over incipient professionalism. The Football Association allowed payment to players from 1885 but the Rugby Football Union remained rigidly amateur, resulting in the establishment of the breakaway Northern Union (Rugby Football League from 1922) in 1895. Broughton Rangers was a founder member, winning the league championship in 1902, while Salford and Swinton joined in 1896; both were to be extremely successful in the inter-war period and had further periods of success in the 1960s and 1970s.

Manchester had initially shown a clear preference for rugby and it was claimed as late as 1892 that it 'was probably more popular amongst the working classes of this great city than any other branch of national sport'.[46] However, soccer quickly came to predominate, perhaps because of its comparative simplicity and

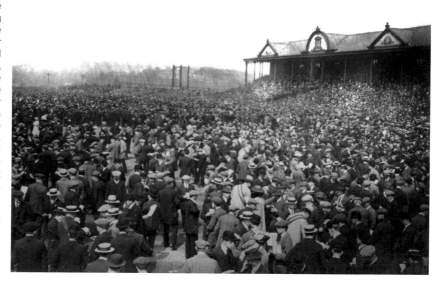

its growing promotion in schools, boys' clubs and similar agencies for moral and physical self-improvement. Both Manchester United and Manchester City emerged from within the traditions of rational recreation, with United's roots traceable to the team started by the dining room committee of the Newton Heath Lancashire and Yorkshire Railway in 1878, and City's to a young men's improvement society at St Mark's church, West Gorton, in 1880. They grew to become professional clubs representing specific areas of the city, entering the Football League in 1892 as Newton Heath and Ardwick respectively, with Ardwick finally reforming as City in 1894, and Newton Heath as United in 1902. Soccer's rapid rise to prominence was well demonstrated on Christmas Day 1902 when some 35,000 saw the United–City Football League match while only 17,000 saw Broughton play Salford in the equivalent Northern Union derby match. The 'working classes of this great city', and some within the social classes above them, had a new passion.[47]

With sport drastically curtailed between 1914 and 1918, the immediate post-war years saw a boom in attendance and interest that set the tone for another strong period of growth in the inter-war period. Unemployment and short-time working undeniably truncated the sporting opportunities of some, but increases in real wages, especially from the early 1930s, coupled with further reductions in working hours expanded those of many others. Despite serious falls in attendance during the worst years of the Depression, association football continued to enjoy a powerful place in the city's sporting culture: both League clubs finished the 1930s with average crowds some 15 per cent higher than in 1913–14. Other sports also experienced rising patronage, not least professional boxing. The Free Trade Hall and Belle Vue's King's Hall were its major venues, with the latter regarded

by some as the sport's leading European location. Perhaps 200 professional and semi-professional fighters were based in Manchester and Salford in the 1930s, with leading figures such as Jackie Brown (1909–71), Johnny King (1912–63) and Jock McAvoy (1908–71) becoming major sporting celebrities. When Brown, the city's first ever world champion of the post-prize fight era, was married in 1931, crowds 'filled the churchyard and climbed on to the surrounding walls … policemen had to clear the roadway to allow cars bringing the wedding party to get to the church gate'. Many expert commentators firmly believed that Manchester would have had another champion in the shape of black middleweight Len Johnson (1902–74), but a British Boxing Board colour bar which stood until 1948 prevented him from ever having the opportunity.[48]

Especially striking was the emergence of new forms of spectator sport, most notably greyhound racing and speedway, consciously modern and seeking audiences through excitement, spectacle and improved facilities (Salford Albion greyhound track offered women both reduced entry prices and a pram park). Although greyhound racing had its roots in coursing and whippet racing, its modern incarnation had begun in the USA in 1912. The ever-rich soil of Belle Vue was the site of Britain's first track in July 1926, and attendances reached 25,000 by the next

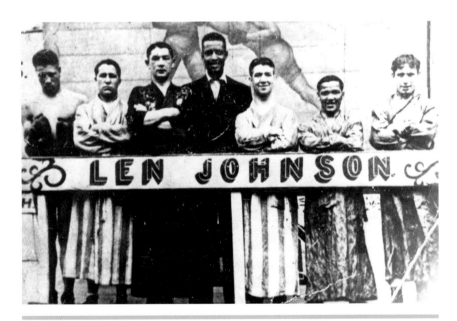

Len Johnson. Born in 1902 to a West African seaman and his Mancunian wife, Johnson was a leading British boxer in the late 1920s and early 1930s but was prevented from fighting for British titles by the colour bar then operated by the National Sporting Club and its successor, the British Board of Boxing Control. Following his retirement from boxing, he organized a boxing booth that toured fairgrounds. Johnson joined the Communist Party in the 1940s, becoming an active figure in the party and also playing a significant role in anti-racist politics in the city. Johnson is shown here with boxers at his boxing booth.

Courtesy of Manchester Libraries, Information and Archives, Manchester City Council

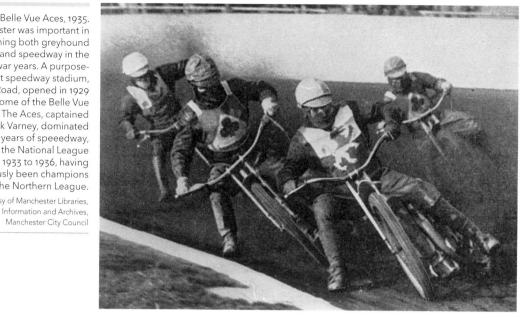

spring. Tracks were opened at the Albion Ground, Salford, and the revamped White City Amusement Park in 1928 and by 1931 annual attendances at the three venues reached 1.7 million.[49] Speedway, derived from American and Australian grass and dirt-track racing, probably had its first local exposure at Droylsden's Moorside Trotting Stadium in June 1927 but it emerged fully in 1928, with tracks established at Kirkmanshulme Lane, Salford Albion Greyhound Stadium, Audenshaw Racecourse and White City. High expenses and a shortage of top-quality riders meant that all were extremely short-lived and only a new track at Belle Vue, opened in March 1929, survived the 1930s. With a capacity of 34,000, it was home to the Belle Vue Aces, Britain's most successful speedway team of the inter-war period.[50]

Although sport was played with greater frequency between 1939 and 1945 than had been the case during the First World War, the public were only too anxious to welcome back regular, high-level fare on the cessation of hostilities and the immediate post-war period saw attendance at professional sport in the city, as elsewhere in the nation, reach its zenith. From the early 1950s attendances began to fall as post-war novelty faded and rising real wages, historically a key engine of sporting growth, now led to a rise in consumption of televisions, cars, foreign holidays and a variety of other activities rivalling or diluting the attraction of sport. By the 1970s and 1980s declining revenues and a resultant lack of reinvestment in infrastructure led to a spiral of decline in which often poorly attended stadia fell into ever greater disrepair. New safety regulations introduced in response to the Bradford City football ground fire in 1985 forced the closure of a number of historic local sporting sites including the White City greyhound track in 1981, Belle Vue's King's Hall in 1982 and its speedway stadium five years later.[51]

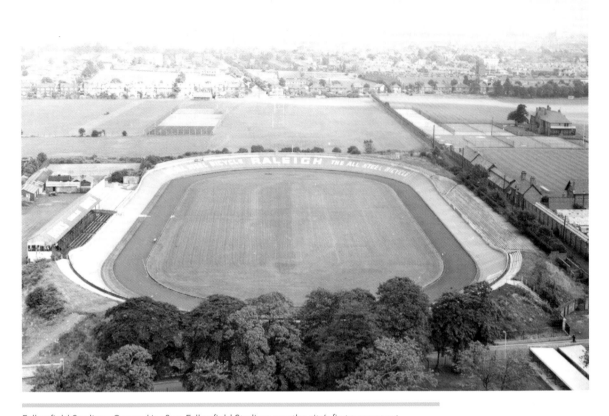

Fallowfield Stadium. Opened in 1892, Fallowfield Stadium was the city's first permanent home for cycling and athletics. It hosted innumerable events in these two sports, including the cycling races for the 1934 British Empire Games. Although hopelessly inadequate for the task – some 45,000 fans turned up to a stadium accommodating perhaps 15,000 – it was also home to the 1893 FA Cup Final. Photographed here in the 1950s when it was a commercial stadium owned by Manchester cyclist Reg Harris, it was demolished to make way for student halls of residence in 1994.

Courtesy of Manchester Libraries, Information and Archives, Manchester City Council

As always, there were counter-narratives and Manchester United provided the most important. Between 1964 and 1986 the club experienced a fall in attendance of just 1 per cent against a First Division average of 29 per cent and, despite a modest playing record in the 1970s and 1980s, it was the country's best-supported football club for 19 of those 22 seasons. It was clearly becoming a 'super-club', a beneficiary perhaps of the aura generated by the 1958 Munich air disaster, but more so from the interest generated by England's 1966 World Cup success, growing television coverage and United's victory in the 1968 European Cup Final.[52] As football gradually recovered its place in society from the late 1980s, the club, under the remarkably successful management of Sir Alex Ferguson, was outstandingly well placed to benefit from the globalization of the game stimulated by the founding of the FA Premier League in 1992 and its penetration of world markets via digital TV. The global 'neo-tribe' that has been drawn to United by its success and its star

names, particularly David Beckham, has been estimated at over 300 million. Both Manchester football clubs have exemplified the global flows of capital, goods and labour that have been such a feature of elite sport in the twenty-first century. Of the 22 players starting the Premier League derby game in September 2013, fifteen, including ten City players, were non-British. United was bought by American businessman Malcolm Glazer in 2005, while City was purchased first by the ex-prime minister of Thailand, Dr Thaksin Shinawatra, in 2007 and then by an Abu Dhabi private equity company in 2008. There are clear signs that the Abu Dhabi investment has finally begun to tilt the balance of football power away from United, with City winning the Premiership title in 2011–12 and 2013–14, although sporting prediction can be a foolish enterprise. Not all fans have been enamoured of these financial developments, and 2005 saw the founding of supporter-run FC United of Manchester by United fans anxious about the practical and moral implications of the new ownership.

While new or radically modernized sporting venues exist throughout the country, Manchester's enthusiastic embrace of sport as a major element of economic regeneration has led to the city enjoying an unusually rich crop of new facilities. Although bids in 1985 and 1989 to host future Olympic Games were unsuccessful, the city was finally successful in attracting the 2002 Commonwealth Games. This resulted in the building of the 146-hectare Sportcity, a complex of six sports arenas (one of these, the highly successful cycling velodrome, had actually opened in 1994) in combination with commercial outlets and housing on an industrial wasteland in the east Manchester district of Bradford.[53] The key issue was to ensure that the athletic stadium had long-term viability and, in August 2003, Manchester City moved into the stadium on a 250-year council lease. The Manchester Arena, opened in 1995 and briefly home to the short-lived Manchester Storm ice hockey and Manchester Giants basketball teams in the 1990s, and the Manchester Aquatics Centre (2000) are further important products of the 'Games effect'.

If this book had been published some fifty years ago, many of the topics covered in the current chapter, especially those relating to popular culture, would have been excluded, deemed beneath the dignity of the historian's gaze. It is also likely that any cultural survey that was included would have come last in the running order, the light at the end of the tunnel of seriousness. Historians are now far more attuned to the central role played by leisure and culture in people's lives and not even the greatest sceptic can fail to see culture's ever-growing role in the process of economic regeneration. When twenty-first-century Manchester's history is written, the cultural sphere, broadly defined, will surely loom large indeed.

Notes

1. R. Foulkes, *The Calverts. Actors of Some Importance*, London: Society for Theatre Research, 1992, p. 92; L. Brake and M. Demoor, eds, *Dictionary of Nineteenth-century Journalism in Great Britain and Ireland*, Gent: Academia Press, 2009, p. 395; PEP, *Report on the British Press*, London: Political and Economic Planning, 1938, p. 47.

2. *Liverpool Daily Post*, 20 April 1964.

3. D. Haslam, *Manchester, England*, London: Fourth Estate, 2000, pp. xxx, xxvii; quoted in A. King, *The European Ritual. Football in the New Europe*, Aldershot: Ashgate, 2003, pp. 215–16.

4. J. Seed, '"Commerce and the liberal arts": the political economy of art in Manchester, 1775–1860', in J. Wolff and J. Seed, eds, *The Culture of Capital. Art, Power and the Nineteenth-century Middle Class*, Manchester: Manchester University Press, 1988, pp. 56–7; D. Russell, 'Musicians in the English provincial city: Manchester, c.1860–1914', in C. Bashford and L. Langley, eds, *Music and British Culture, 1785–1914*, Oxford: Oxford University Press, 2000, p. 235; B. Harrison, 'Pubs', in H.J. Dyos and M. Wolff, eds, *The Victorian City: Image and Reality*, London: Routledge and Kegan Paul, 1973, p. 162; R. Low, *The History of the British Film, 1906–1914*, London: George Allen and Unwin, 1946, pp. 22–3, 50; 'Lancashire's hot spot', *The Guardian*, 9 July 1966.

5. E.A. Pergam, *The Manchester Art Treasures Exhibition of 1857. Entrepreneurs, Connoisseurs and the Public*, Farnham: Ashgate, 2011, p. 21.

6. 'Lancashire's hot spot', *The Guardian*, 9 July 1966.

7. H. Wach, 'Culture and the middle classes: popular knowledge in industrial Manchester', *Journal of British Studies*, 27 (1988), pp. 375–404.

8. U. Finke, 'The Art Treasures Exhibition', in J.H.G. Archer, ed., *Art and Architecture in Victorian Manchester*, Manchester: Manchester University Press, 1985, pp. 102–26; Pergam, *Art Treasures Exhibition*, p. 206; J.A. Cuming Walters, 'The story of Manchester', in *A guide to Manchester*, Manchester: Manchester City News for Manchester Development Committee, 1937, p. 11.

9. M. Kennedy, *The Hallé, 1858–1983. A History of the Orchestra*, Manchester: Manchester University Press, 1982; R. Beale, *Charles Hallé: A Musical Life*, Farnham: Ashgate, 2007; S. Gunn, *The Public Culture of the Victorian Middle Classes. Ritual and Authority and the English Industrial City*, Manchester: Manchester University Press, 2000, pp. 143, 154.

10. The Lion [Alfred Darbyshire], *A Chronicle of the Brasenose Club*, Manchester: Brasenose Club, 1892, pp. 93–6.

11. M. Tylecote, 'The Manchester Mechanics' Institution, 1824–1850', in D.S.L. Cardwell, ed., *Artisan to Graduate: Essays to Commemorate the Foundation in 1824 of the Manchester Mechanics' Institution*, Manchester: Manchester University Press, 1974, pp. 55–86; D. Russell, *Popular Music in England, 1840–1914*, Manchester: Manchester University Press, 1997, pp. 32, 43; M. Harrison, 'Art and philanthropy: T.C. Horsfall and the Manchester Art Museum', in A. Kidd and K.W. Roberts, eds, *City, Class and Culture. Studies of Social Policy and Cultural Production in Victorian Manchester*, Manchester: Manchester University Press, 1988, pp. 1–25.

12. E. Conran, 'Art collections', in J.H.G. Archer, ed., *Art and Architecture in Victorian Manchester*, Manchester: Manchester University Press, 1985, pp. 71, 75; F.W. Hawcroft, 'The Whitworth Art Gallery', in Archer, ed., *Art and Architecture*, pp. 208–29.

13. W.R. Credland, *The Manchester Public Free Libraries*, Manchester, 1899, pp. 116, 218.

14. Russell, 'Musicians in the English provincial city', pp. 236–7; R. Beale, 'Not just the Hallé', *Manchester Sounds*, 9 (2011–13), pp. 23–44; A. Lamb, *Leslie Stuart*, London: Routledge, 2002; miscellaneous programmes collection, Manchester Central Library, R780 69 Py 87; *Manchester Faces and Places*, November 1905, pp. 345–68.

15. *Musical Times*, July 1911, p. 468; J. Ward, 'Carl Rosa comes to town: the opera season of 1873', *Manchester Sounds*, 5 (2004–05), pp. 5–24; R. Beale, 'Opera in Manchester, 1848–1899', *Manchester Sounds*, 6 (2005–06), p. 83.

16. Foulkes, *The Calverts*, pp. 44–58, 92; R.J. Walker, 'A Manchester connection: Alfred Cellier (1844–91), composer and conductor', *Manchester Sounds*, 5 (2004–05), pp. 89–104.

17. R. Pogson, *Miss Horniman and the Gaiety Theatre*, Manchester: Rockliff, 1952; S. Goodie, *Annie Horniman: A Pioneer in the Theatre*, London: Methuen, 1990. The company performed in the Midland Hotel theatre from 1907–08 before moving to the Gaiety.

18. R. Nicholls, *The Belle Vue Story*, Swinton: Neil Richardson, 1992; T. Wyke and M. Powell, 'Counting the coppers: John Jennison and the Belle Vue zoological gardens', in M. Savage and J. Wolff, eds, *Culture in Manchester. Institutions and Urban Change since 1850*, Manchester: Manchester University Press, 2013, pp. 33–60; D. Mayer, 'The world on fire … pyrodramas at Belle Vue Gardens, Manchester, c.1850–1950', in J. MacKenzie, ed., *Popular Imperialism and the Military, 1850–1950*, Manchester: Manchester University Press, 1992, pp. 179–97.

19. D. Kift, *The Victorian Music Hall. Culture, Class and Conflict*, Cambridge: Cambridge University Press, 1996, pp. 1, 65, 66–7.

20. C. Waters, 'Manchester morality and London capital: the battles over the Palace of Varieties', in P. Bailey, ed., *Music Hall. The Business of Pleasure*, Milton Keynes: Open University Press, 1986, pp. 141–61, 149.

21. W. Shenton, 'Manchester's first cinemas, 1896–1914', *Manchester Region History Review*, 4.2 (1990–91), pp. 3–11; D.J. Southall, *The Golden Years of Manchester Picture Houses*, Stroud: History Press, 2010.

22. M. Kennedy, *The Hallé Tradition. A Century of Music*, Manchester: Manchester University Press, 1960, p. 131.

23. Beale, *Charles Hallé*, pp. 219–20; Gunn, *Public Culture*, pp. 155–6.

24. H. Gooney and E. MacColl, eds, *Agit-prop to Theatre Workshop*, Manchester: Manchester University Press, 1986, pp. ix–lvii.

25. R. Beale, 'Paying the piper. The Hallé and the City of Manchester', *Manchester Sounds*, 1 (2000), pp. 71–91.

26. F. Pritchard, *Dance Band Days around Manchester*, Swinton; Neil Richardson, 1988; R. Roberts, *The Classic Slum*, Harmondsworth: Pelican, 1973, p. 37.

27. G. Turner, *The North Country*, London: Eyre and Spottiswoode, 1967, pp. 74–6; *Manchester Evening News*, 17 March 1965.

28. D. Russell, 'Going with the mainstream: Manchester cabaret clubs and popular music in the 1960s', *Manchester Region History Review*, 25 (2014), pp. 1–19.

29. L.A. Jackson, '"The coffee club menace". Policing youth, leisure and sexuality in post-war Manchester', *Cultural and Social History*, 5.3 (2008), pp. 289–308; A. Lawson, *It Happened in Manchester*, Unsworth, Bury: Multimedia, 1990, pp. 25–6; C.P. Lee, 'Bob Dylan, folk music and Manchester', *Manchester Region History Review*, 25 (2014), pp. 35–52.

30. Haslam, *Manchester, England*; J. Nice, *Shadowplayers. The Rise and Fall of Factory Records*, London: Aurum, 2010; G. Gregory, 'Madchester and the representations of the North–South divide in the 1980s and 1990s', *Manchester Region History Review*, 25 (2014), pp. 71–92; S. Campbell and C. Coulter, eds, *Why Pamper Life's Complexities? Essays on The Smiths*, Manchester: Manchester University Press, 2011.

31. D. Read, *Press and People, 1790–1850. Opinion in Three English Cities*, London: Arnold, 1961, pp. 59–62; D. Ayerst, *Guardian. Biography of a Newspaper*, London: Collins, 1971.

32. M. Powell and T. Wyke, 'Manchester periodicals: some new readings. Charting the Manchester tributary of the golden stream: Leary's history of the Manchester periodical press', *Manchester Region History Review*, 17 (2006), p. 55; S. Tate, 'Edward Hulton and sports journalism in late-Victorian Manchester', *Manchester Region History Review*, 20 (2009), pp. 46–67; Mitchell and Co., *The Newspaper Press Directory*, 1912, pp. 431–2.

33. M. Beetham, '"Healthy reading": the periodical press in late Victorian Manchester', in A. Kidd and K.W. Roberts, eds, *City, Class and Culture. Studies of Social Policy and Cultural Production in Victorian Manchester*, Manchester: Manchester University Press, 1988, pp. 167–92.

34. R. Waterhouse, *The Other Fleet Street*, Altrincham: First Edition, 2004, p. 7.

35. G. Taylor, *Changing Faces. A History of the Guardian, 1956–88*, London: Fourth Estate, 1988.

36. P. Scannell and D. Cardiff, *A Social History of British Broadcasting, 1922–1939: Serving the Nation*, Oxford: Basil Blackwell, 1991, pp. 308, 311–12, 333–55; I. Hartley, *2ZY to NBH. An Informal History of the BBC in Manchester*, Timperley: Willow, 1987; P. Radcliffe, *The Piccadilly Story*, London: Blond and Briggs, 1979.

37. D. Forman, *Persona Granada. Some Memories of Sydney Bernstein and the Early Years of Independent Television*, London: André Deutsch, 1997.

38. *The Guardian*, 16 December 1974; *Liverpool Daily Post*, 19 December 1967.

39. S. Inglis, *Played in Manchester*, London: English Heritage, 2004; D. Russell, 'Sporting Manchester, from c.1800 to the present: an introduction', *Manchester Region History Review*, 20 (2009), pp. 1–23.

40. M. Huggins, 'Betting capital of the provinces: Manchester, 1800–1900', *Manchester Region History Review*, 20 (2009), pp. 24–45.

41. M.W. Peers, *A History of Manchester Golf Club Limited, 1882–1982*, Manchester: Manchester Golf Club, 1982; Inglis, *Played in Manchester*, pp. 25, 90, 24.

42. D. Dee, *Sport and British Jewry: Integration, Ethnicity and Anti-Semitism, 1890–1970*, Manchester: Manchester University Press, 2013, pp. 183–4, 189.

43. S.G. Jones, 'Working-class sport in Manchester between the wars', in R. Holt, ed., *Sport and the Working Class in Modern Britain*, Manchester: Manchester University Press, 1990, p. 75.

44. A. Kidd, *Manchester*, 4th ed., Lancaster: Carnegie, 2006, p. 231; Inglis, *Played in Manchester*, p. 73; J.K. Walton, 'The Northern Rambler: recreational walking and the popular politics of industrial England, from Peterloo to the 1930s', *Labour History Review*, 78.3 (2013), pp. 243–68.

45. B. Phillips, *'The Iron in his Soul'. Bill Roberts and Manchester's Sporting Heritage*, Manchester: Parrs Wood, 2002, pp. 30–41; P. Swain, 'Pedestrianism, the public house and gambling in nineteenth-century south-east Lancashire', *Sport in History*, 32.3 (2012), pp. 393–9.

46. Revd F. Marshall, ed., *Football: The Rugby Union Game*, London: Cassell, 1892, p. 387.

47. C.E.B. Russell, *Manchester Boys. Sketches of Manchester Lads at Work and Play*, Manchester: Manchester University Press, 1905, pp. 61–72; G. James and D. Day, 'The emergence of an Association Football culture in Manchester, 1840–1880', *Sport in History*, 34.1 (2014), pp. 49–74; G. James, *Manchester. A Football History*, Halifax: James Ward, 2008.

48. B. Hughes, *Jackie Brown … The Man, the Myth, the Legend*, Manchester: Collyhurst and Moston Lads Club, 1996; B. Hughes, *For King and Country*, Manchester: Collyhurst and Moston Lads Club, 1999; *Manchester Evening News*, 19 October 1931; M. Herbert, *Never Counted Out*, Manchester: Dropped Aitches Press, 1992.

49. M. Clapson, *A Bit of a Flutter*, Manchester: Manchester University Press, 1992, pp. 138–44, 146.

50. J. Williams, '"A wild orgy of speed". Responses to speedway in Britain before the Second World War', *The Sports Historian*, 19.1 (1999), pp. 1–15; T. Jones and B. Stephenson, *Speedway in Manchester, 1927–1945*, Stroud: Tempus, 2003.

51. Inglis, *Played in Manchester*, pp. 28, 49, 62, 58–9, 119–23.

52. G. Mellor, 'The genesis of Manchester United as a national and international "super-club", 1958–68', *Soccer and Society*, 1.2 (2000), pp. 151–66.

53. Inglis, *Played in Manchester*, pp. 52–7.

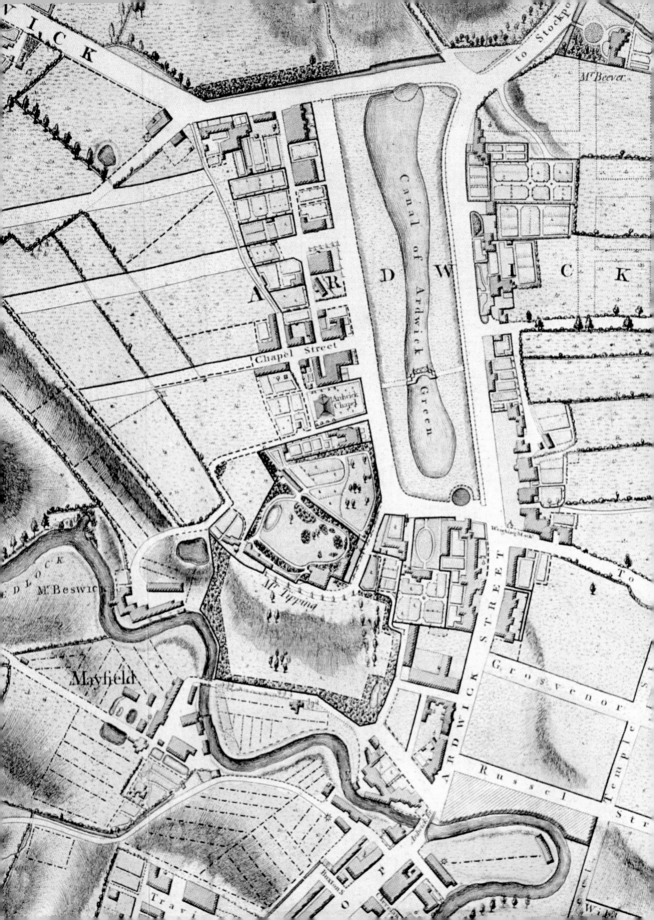

From Township to Metropolis

Suburbs and the Shaping of the Modern City

ALAN KIDD

If suburbia originated in London ... Only when the London suburb was transplanted to Manchester and the other cities of northern England did suburbia demonstrate its revolutionary power to dominate middle-class residential patterns and to transform urban structure.[1]

Where is modern Manchester? Where does it begin and where does it end? How did it grow and can it be confined to the boundary lines on the map? These are some of the questions posed in this chapter. Attention will focus on the districts surrounding the city (the suburbs, the conurbation, 'Greater Manchester') rather than the buildings and the streets of the urban core. Indeed, while the economic dynamism of central Manchester provided the impetus for the modern city region that takes its name, it was the suburbs that provided that city region with its physical shape, defining its territorial limits and giving it much of its character.

Suburbs are as old as urban living but the modern residential suburb is a creation of the last two hundred or so years. Up until the eighteenth century the most sought-after residential location in any town had been the streets of the central area, in easy reach of its chief attractions and major facilities. Yet by the mid-nineteenth century the suburb had become the most desirable place to live and the city centre was becoming a 'dead heart' of work not residence, occupied by fewer people and containing places of business and the dwellings of the poor unable to move elsewhere. This process transformed the character of most cities in Britain and North America and continues to do so in many cities around the world, although it has had less impact on urban living in mainland Europe.

Ardwick Green, Manchester's first suburb, as shown on Laurent's *Topographical Plan of Manchester and Salford* (1793). 'This is, perhaps, one of the best built and most pleasant suburbs in the kingdom; to which its elegant houses – its expanded green – and the lake in its centre all contribute.' Joseph Aston, *The Manchester Guide: a brief historical description of the towns of Manchester & Salford* (1804).

For centuries before the industrial era the space on the ground occupied by the township of Manchester remained confined to limits dictated by political circumstances (the separate political existence of Salford), natural features, market forces and transportation limits. Until the eighteenth century Manchester grew slowly from the huddle of buildings around the Collegiate Church and Chetham's College and as late as 1800 its dusty streets were never far from green fields. It was a 'walking city' in the sense that journeys could easily be undertaken on foot and generally were. Yet during the nineteenth century the town experienced a building boom that saw it burst free of its ancient boundaries and eat up the surrounding countryside at a sometimes alarming rate, absorbing and remaking existing settlements and creating whole new districts almost from nothing. Suburbanization had begun earlier in London but it was in Manchester that the process first reshaped the entire urban environment into its modern form.

From the late eighteenth century onwards, residential suburbs grew up around the urban core, initially close by due to limited transport facilities, later more distant, assisted by the explosion in railway development after the 1830s. The expansion of omnibus and later of tram routes enabled the growth of inner suburbs, absorbing once independent villages and townships and filling in the gaps between the centre and the periphery. In the twentieth century public and private motor transport further liberated the suburb dweller and stimulated extensive development that extends down to the present. Today the process of suburbanization continues to incorporate surrounding towns, making them in part dormitories to the economic powerhouse that is Manchester, the wealth generator for a region. In all this the modern metropolis has a real existence regardless of any political recognition of the fact from Westminster. In fact, today we can speak of different relationships within this metropolis in which the city–suburb, core–periphery dichotomy no longer dominates. This is a new urban world with its interconnection of suburban locales with multiple urban cores within the metropolitan area and a car-dependent decentralization of services (shopping malls, entertainment complexes, business parks, industrial estates). This is the present modernity and raises the ultimate question: if we know where Manchester was in the past, where is it today? But this is to get ahead of ourselves. We first need to understand how this modern urban shape evolved.

The first suburbs

Over the centuries since medieval times, the rich and the poor had often inhabited the same crowded Manchester streets, albeit in very different domestic circumstances. During the eighteenth century, however, the move towards the edges of the built-up area began, as the town's more prosperous inhabitants sought to put distance between themselves and their less well-off neighbours. They wanted modern houses, a cleaner atmosphere and a less congested environment. Fields and country lanes on the outskirts were laid out as streets and given urban names.

Some of this extended the development beyond the older, medieval limits of the town (see Chapter 1). However, despite this rapid urban expansion the countryside was still in sight and although the town's shape was changing, most places were still a short walk from agricultural land and there were no separate suburbs. Between the Infirmary at Piccadilly and Great Ancoats Lane lay meadowland, soon to be developed by its owner, Sir Ashton Lever. A population census conducted in 1773 recorded only 12 houses on Great Ancoats Lane and to the north of this thoroughfare the world's first modern industrial suburb was not yet dreamed of. Mosley Street and Portland Street were yet to be laid out.

By the 1790s much development had taken place, as Laurent's map and Green's map both show. Yet as late as 1794 when St Peter's church was completed (on the site of the present-day St Peter's Square), it marked the southern edge of the town. A windmill stood nearby (hence Windmill Street behind the later Free Trade Hall) and it was on St Peter's Field that in 1819 the great reform meeting assembled that was to be so mercilessly dispersed. In the 1790s one could still walk from St Peter's church to Castlefield across fields, passing hedges and stepping over stiles. Only the newly marked out (but not yet built-up) Oxford Street suggested the southward march of the urban area.

Population figures show how rapidly the town expanded. The number of inhabitants multiplied threefold between 1801 and 1841. But urban growth can be measured by means other than population figures. Land values increased with the prosperity of trade and the later decades of the eighteenth century witnessed the beginnings of the seventy-year 'building boom' that was to construct the first industrial city. Between 1773 and 1821 the total number of houses in Manchester rose from 3,402 to 17,257. While population density increased, the town expanded physically, but only a small proportion of the population was responsible for the major part of this spatial growth. By 1850 the built-up area of 'Greater Manchester' extended to about seven square miles. Of this, over half was occupied by prosperous suburbs, and only one-fifth by artisan housing. It was the rich and powerful who did most to determine the early shape of modern Manchester. It was they who created its built environment.

By the end of the eighteenth century distinct patrician quarters had emerged for the wealthier inhabitants. Plush Georgian houses for the well-to-do had been erected on Mosley Street, King Street and Princess Street, and Quay Street/St John's was a fashionable residential area. Some had already taken to more rural surroundings at Ardwick Green, Manchester's first suburb, or on the Crescent in Salford. Travel time largely determined place of residence for those with carriages of their own. Good roads made distance less of a problem: Ardwick Green and the Crescent were served by turnpike trusts, and anyway in an age when walking was a commonplace means of travel even for the wealthy, neither was more than a short stroll from town.

When the age of the steam-powered factory emerged, from the 1790s onwards, industry was soon extending the built-up area. Ancoats to the north

was an industrial suburb comprising factories and workers' housing and (by 1804) bisected by the Rochdale canal. Industry was also pushing the urban area south and eastwards following the meandering line of the river Medlock, extending the urban footprint into the adjacent (and hitherto largely rural) townships of Chorlton Row (later Chorlton-on-Medlock), Hulme and Ardwick. The spread of the Medlock industrial belt made Mosley Street much less fashionable and denied such status entirely to an Oxford Road development like Grosvenor Square (All Saints). It also encroached upon the rural seclusion of Ardwick Green.

Ardwick Green, situated on slightly elevated ground south-east of Manchester just across the Medlock valley, had become a fashionable retreat for the wealthy by the late eighteenth century. St Thomas's church (Ardwick Chapel) dates from 1741 when Ardwick was a 'a detached village, cut off from Manchester by nearly a mile of cultivated fields'.[2] The church was later enlarged to cater for the increased numbers living in its vicinity. Elegant houses grew up around a large green with its leech-shaped lake known as 'the canal'. This was probably the original village green landscaped to provide a suitable setting for 'gentlemen's residences'. Ardwick Green became Manchester's first residential suburb, with the warehouses and workshops of the town accessible by carriage (crossing the Medlock at Ardwick Bridge on the London road) or by a brisk walk across fields. Once this must have been an idyllic setting. However, Aikin writing in 1795 tells us that while 'Some years ago it was regarded as a rural situation ... the buildings of Manchester have extended in that direction so far as completely to connect it with the town.' Nonetheless, Ardwick Green was still 'principally inhabited by the more opulent classes, so as to resemble, though on a small scale, the west end of the city of London'.[3] Laurent's map of 1793 shows a footbridge across the 'canal' to allow ease of access to the church. As the country between Ardwick Green and Manchester became built up, the Green became a privately owned open space reserved for the use of residents: exclusivity was sought by installing a chain fence and later on railings and a gate, each household possessing a key for access and paying an annual fee that covered the cost of maintaining the grounds. Ardwick Green and its immediate vicinity remained a desirable address until the middle of the nineteenth century. Several local residents were well-known names in Manchester life. John Kennedy (1769–1855) and James McConnel (1762–1831), partners in the famous firm of cotton spinners from Ancoats, lived here. Kennedy moved into one of the grandest houses, Ardwick Hall, at the south end of the Green. McConnel had a large house built in 1806 at the Polygon, a select development facing the nearby Stockport Road. From here he rode on horseback to his Ancoats mill. Later inhabitants included the eminent engineer William Fairbairn (1789–1874) and leading Manchester merchants Alexander Henry (1784–1862) and John Rylands (1801–88). Rylands was Manchester's foremost cotton merchant in a city noted for its merchant princes.

Another early suburb grew up on a further stretch of high ground, this time overlooking a curve in the river Irwell beyond the built-up area of Salford. The Crescent, the adjoining Albion Place and other streets in the vicinity were laid out

and the first leases issued in 1793. In 1804 Aston described the Crescent as 'almost unrivalled for a beautiful and commanding prospect, which from the nature of the situation can never be interrupted by buildings, and the inhabitants of this charming elevation will always be sure of rich country scenery in view of their front windows'.[4] However, as with Ardwick Green and innumerable suburbs ever since, the lifespan of this paradise was limited. Within little more than a generation the encroaching urban area had stolen its exclusivity and the view from the plush Georgian terraces lining the Crescent took in factories and the smoke from their chimneys as well as the natural charms of the river and the hills beyond. In 1841 *Bradshaw's Manchester Journal* reported that the Crescent was still 'one of the most picturesque landscapes in the suburbs of Manchester' yet it was 'deeply to be regretted' that nothing had been done 'to prevent the erection of the numerous manufactures on the banks of the river'.[5] These included the Adelphi Bleach Works, which the magazine illustrated in its engraving of the scene. Sixty years later the journalist Thomas Swindells (1859–1929) could tell the readers of his column in the *Manchester Evening News* that the early twentieth-century resident of Salford Crescent would 'rub his eyes with wonderment' at Aston's description when he saw 'the pall of smoke that hangs over the valley today'.[6] The housing on

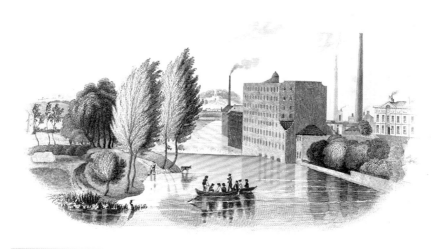

An engraving of the view from Salford Crescent. 'One of the most picturesque landscapes in the suburbs of Manchester ... occupied by the beautiful plain formed by an immense tortuosity of the Irwell, studded with a windmill, a farm, straggling cottages, and numerous trees. In the distance are seen the rising grounds of Kersall and Broughton, adorned with castellated chateaus, the Priory, and many a Gothic and Grecian villa ... whilst on the right hand the river dashing over the weir, and the gardens in front of Adelphi Terrace, all conspire to arrest the attention of the passing stranger, and amply justify the selection of the site of the extensive range of mansions stiled the Crescent, the windows of which command this delightful prospect ... It is deeply to be regretted, that the same degree of public spirit did not at an earlier period interpose to prevent the erection of the numerous manufactures on the banks of the river ... Considerable prominence has been given in the engraving, to what at first sight appears to be a cotton mill, but is in reality a bleach works ...' *Bradshaw's Manchester Journal*, 16, 14 August 1841.

the Crescent was not the only example of how the entrepreneurial success of its wealthy neighbour influenced the built environment of Salford. Indeed, a striking feature of mid-nineteenth-century Salford was the amount of land given over to high-status villa housing and private parkland. Pendleton, Broughton and Buile Hill were favoured locations for early villa estates. However, by the time Swindells wrote, this early suburban landscape had been severely eroded by late nineteenth-century redevelopment and suburban infill. Villas with gardens were demolished to make way for street upon street of terraced houses that formed a concentric ring around Salford's urban core.

The move to a suburban environment was not the first thought of all the wealthy citizens. Many had sought to maintain residence in the urban core, albeit outside the overcrowded 'Old Town'. Thus Mosley Street, laid out in the 1780s, was soon lined with fine houses for some of the town's leading merchants and professional gentlemen. In 1823 James Butterworth described it as 'without exception the most elegant street in Manchester'.[7] On Mosley Street or nearby were important institutions of respectable middle-class society including the Assembly Rooms, the Portico Library and Newsroom, and the Royal Manchester Institution (designed by Charles Barry (1795–1860) in 1824). There were various places of worship: the Independent chapel and Unitarian chapel, and at the south end of Mosley Street, St Peter's church. This was a purpose-built patrician district for the town's elite. Bearing in mind that this was a business elite, it was important to many merchants to retain close physical contact with their trade. This reflects what had been the traditional urban pattern whereby merchants traded from their own houses or were only a short stride away from the warehouses and the commercial world.

This old pattern of fashionable town-centre living was not to survive the second quarter of the nineteenth century. The fate of Mosley Street is emblematic of the process. A decade after Butterworth had written, Mosley Street began its transformation from elegant residential address to busy commercial throng. As a guidebook of 1839 notes: 'Mosley Street ... is now converted almost entirely into warehouses; and the increasing business of the town is rapidly converting all the principal dwelling-houses ... into mercantile establishments, and is driving most of the respectable inhabitants into the suburbs.'[8]

There are many explanations for the attraction of suburban living to the middle classes created by the industrial revolution: the aspiration for a gentleman's lifestyle in emulation of the aristocratic ideal; the desire to escape the pollution and disease of the industrial city not to mention association with its burgeoning working class; new emphases on the refinements of privacy; the perceived immorality and criminality of the profane metropolis; and the sacred need to protect women and children from contact with strangers (a combination of evangelical zeal and the theory of separate spheres). In various ways any combination of these factors could account for the initial shift to the suburbs, but they cannot provide the explanation for the successive waves of suburban development over the nearly two hundred years since. In the case of Mosley Street in the 1830s a more prosaic factor

may have been involved. The sheer expansion of the cotton trade placed distinct pressures on the land market in Manchester and values rocketed. The demand for warehouse space became an economic driver, persuading many that the value of a town-centre property lay more in its commercial applications than in its residential uses. This fact added to the impulse to remove to the suburbs.

Richard Cobden (1804–65), the successful calico printer, later to be co-founder of the Anti-Corn Law League and leading light of Manchester School liberalism, who bought a house in Mosley Street in 1832, wrote to his brother in the same year about what was happening around him:

> My next door neighbour, Brooks, of the firm of Cunliffe and Brooks, bankers, has sold his house to be converted into a warehouse. The owner of the house on the other side has given his tenant notice for the same purpose. The house immediately opposite to me has been announced for sale, ... they want 8000 for what they paid 4500 only five years ago ... if I were to put up my house to-morrow, I might have 6000 guineas for it. So as I gave but 3000, and all the world is talking of the bargain here, and there being but one opinion or criterion of a man's ability – the making of money – I am already thought a clever fellow.[9]

As Mosley Street residents moved out, warehouses and banks moved in. Initially private dwellings were converted into commercial premises but very soon new multi-storey warehouses were being erected, and this and other former residential streets took on the shape and function of what we would now call a central business district. In 1839 Cobden himself commissioned the young architect Edward Walters (1808–72) to design the first of Manchester's notable palazzo-inspired warehouses at what is today 16 Mosley Street (Harvest House). Earlier, in 1836, the Manchester and Salford Bank had erected new premises (today 10 Mosley Street) in what was rapidly becoming the commercial heart of the town. Imposing business premises now lined this once-fashionable street. The banker Samuel Brooks (1793–1864), who as Cobden noted had converted his Mosley Street home into his warehouse, subsequently bought a tract of mossy farmland two miles south of the town that he renamed Whalley Range. Here he drained the land and laid out roads, built his own villa and subdivided the rest to create a purpose-built suburb complete with houses and gardens to attract Manchester's rich merchants.

The move to the suburbs around Manchester was becoming so well established that it had become an object of satire. In 1833 a local author published a collection entitled *Gimcrackiana* that included a poem, 'Surburban Sortie', in which he lampooned the aspirations of those 'town-bred merchants' who chose to:

> leave the smoky town some time to range,/ A mile or two from that *trade mill* the 'Change'!/ Bent to survey those pleasant snug retreats,/ Term'd *country boxes, villas, genmen's seats* .../ Large houses now to *cottages* they change .../ A gig or coach-house and a stable fair,/ For one Bucephalus, mayhap a pair,/ As it may chance to suit his purse,/ or meet the style and splendour of his country seat.

Waterloo Place, nos. 176–188 Oxford Road, near the Manchester Museum. 'Along the level Oxford-road you'll view/ Th'exalted Terrace, Exmouth, Waterloo'. This is a surviving example of an early nineteenth-century suburban terrace comprising seven two-storey houses with arched entrances embellished with inset Doric columns and intricate fanlight glazing. Grosvenor Square (All Saints) had been planned as an elegant suburb but as the Medlock industrial belt encroached, development moved farther south along Oxford Road and into nearby Plymouth Grove.

The poem ruthlessly satires the suburban merchant who, seeking the landed life, 'talks of his *estate*' and 'Thinks ...'tis time to *rusticate*'. But if the agricultural predilections of the richest were ripe for satire, so were the pretensions of the newest wave of suburban dwellers, those with less full purses who rented more modest suburban dwellings. 'As around our suburbs you may chance to go,/ Consider well each Terrace, Place and Row,/ Nor be surpris'd or squeamishly too nice,/ If some dull, dirty street's call'd Paradise!/ Along the level Oxford-road you'll view/ Th' exalted Terrace, Exmouth, Waterloo.'[10]

As the satirist observed, the process of suburban growth operated on several levels within the Manchester middle class, according to status and aspirations. Many sought to escape from the city's environs as the industrial grime spread outwards and the working class encroached on former suburbs like Ardwick Green in Manchester and the Crescent in Salford. The pioneer suburbanites were pushed farther and farther out in their search for the bourgeois utopia. Speculative builders erected villas and terraces for the middle classes along the main routes south of the city, Oxford Road and Upper Brook Street. Examples of these can still be seen. It may well have been Waterloo Place, to be found near the University of Manchester between Tuer and Bridgeford streets, that the author of *Gimcrackiana* had in his sights. Today it appears as a terrace of modest two-storey houses with wide arched entrances embellished with Doric columns. Slightly more prestigious is a pair of early nineteenth-century villas at 60–62 Nelson Street, of which no. 62 was later to be the home of Emmeline Pankhurst (1858–1928) and the birthplace of the Suffragette movement. Grander still was (what is now) 84 Plymouth Grove, the

mid-century home of the famous novelist Elizabeth Gaskell (1810–65), author of *Mary Barton*, *North and South* and *Cranford*. Detached in its own grounds and with a main entrance enhanced with pilasters and columns, all with capitals based on a detail from the Tower of the Winds in Athens, this was an altogether more aspirational dwelling.[11]

Plymouth Grove was first developed as a residential retreat in the early 1820s. Over the next couple of decades it became an exclusive suburb for the city's merchant and professional classes, replete with detached and semi-detached villas. This was at that time a rural setting abutting fields and farmland. Elizabeth Gaskell relished this environment. Here she kept pigs and poultry and rented an adjacent field for her cow. Yet she was little more than a mile and a half from Manchester where her husband was the minister at the Cross Street chapel. The Gaskells did not move in until 1850, having removed from nearby Rumford Street. Like many other suburban dwellers of that era, regardless of status, they rented their property,

Elizabeth Gaskell's house in Plymouth Grove was built around 1838 and is a rare example of the elegant Regency-style villas once popular in Manchester's early suburbs. William Gaskell, minister at Cross Street Unitarian chapel, and his wife Elizabeth, the famous writer, together with their four daughters and five servants moved into the house in 1850. It was here that Elizabeth wrote *Cranford*, *Ruth*, *North and South* and *Wives and Daughters* as well as the biography of her friend Charlotte Brontë, who frequently visited the house. Other guests included Charles Dickens, John Ruskin, Charles Hallé and Harriet Beecher Stowe. After Elizabeth's death in 1865, members of the family occupied the house until 1913. This tree-lined road with its elegant detached and semi-detached houses abutting fields and farmland attracted several of Manchester's wealthier families who mostly rented their properties. Elizabeth Gaskell's house is Grade II* listed and after a major restoration is open to the public. Managed by the Manchester Historic Buildings Trust, it is furnished and decorated as it would have been while Elizabeth was living there.

Wikimedia Commons

and this enhanced their mobility. Charlotte Brontë, who visited three times in the early 1850s, described it as 'a large, cheerful, airy house, quite out of the Manchester smoke'.[12] The Crewdsons were another eminent family already living on Plymouth Grove when the Gaskells moved in. Wilson Crewdson (1790–1871) and his brother Joseph (1787–1844) founded the Dacca Twist Mills on Fleet Street, Manchester in 1814. Initially the family had preferred Ardwick Green as a place to live but moved out to Plymouth Grove in the early 1840s. The advance of the smoky city and the houses of its lower-class citizens were the probable driving forces. As Plymouth Grove itself inevitably declined in status the Crewdsons made their final escape to Alderley Edge, a move only made possible by the railway. The Behrens, a family of eminent cotton merchants, followed a similar path. In 1814 Solomon Behrens (c.1787–1873) acquired a house on Mosley Street and traded from his warehouse in Back George Street. In 1832 he left Mosley Street for Nelson Street and within two years had moved further out to Plymouth Grove, eventually joining the charge to Alderley Edge by the mid-century.

Before the full potential of railway travel and the advent of the first suburban lines by the mid-century, one solution to the problem of exclusiveness that did not require great distance from the city was to build gated residential estates with tollbars and estate police to keep out intruders. Victoria Park, Rusholme, begun in 1837, set a fashion for such enclosures. Planned from the outset as a walled ornamental park with plots for villas and mansions, it was intentionally exclusive. The owner of a 'gentleman's residence' in Victoria Park could combine the advantages of proximity to town life with the privacy of a 'country seat'. The very use of the term 'Park' was evocative of an aristocratic estate. The architect Richard Lane designed the layout of crescents and curving tree-lined thoroughfares. He was also responsible for some of the earliest houses, one of which he occupied. Richard Cobden, an original investor, lived in Victoria Park for three years in the 1840s. His neighbours at that time numbered several among Manchester's business elite such as the cotton merchant William Romaine Callender, (1794–1872) one of the first aldermen of the city; James Kershaw (1795–1864), calico printer, mayor of Manchester 1842–43 and Liberal MP for Stockport 1847–59; and the cotton spinner Edward Riley Langworthy (1797–1874), owner of Greengate Mills, who was mayor of Salford 1848–50. Occupying one of the more modest dwellings was Charles Hallé (1819–95) who rented a house in Addison Terrace, Daisy Bank Road, when he first arrived in Manchester in 1848.[13]

A trust was formed in 1845 with the objective of preserving Victoria Park's status as a private estate and to maintain the roadways, lodges and tollgates. Only 19 houses had been erected by this stage and building continued up to the 1880s when the estate was complete. The Park contained some of Manchester's grandest domestic residences. The *Manchester Guardian* journalist Neville Cardus (1888–1975), who grew up in humble circumstances in Rusholme 'without the gates', knew Victoria Park in the early 1900s as 'a sequestered purlieu – not more than a half an hour's drive in a carriage from Manchester'. Once through the

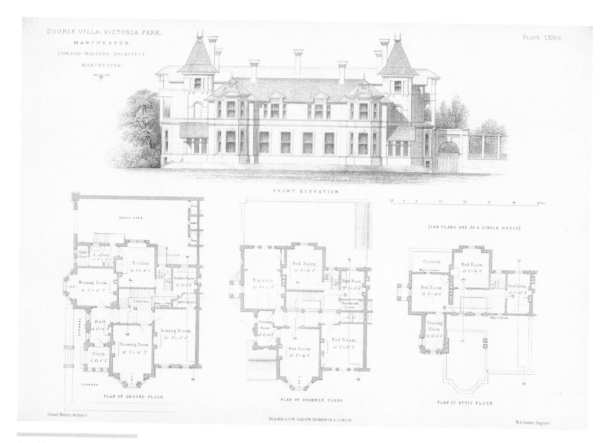

'Double Villa, Victoria Park', architect's plan from *Villa and Cottage Architecture: Select examples of country and suburban residences recently erected* (Blackie & Son, 1868), Plate LXXVI opposite page 104. This villa was designed by Edward Walters and built in 1854 on a plot at the corner of Upper Park Road and Denison Road at an approximate cost of £2,000.

Copyright of the University of Manchester

The house prior to its demolition in 1971.

Courtesy of Manchester Libraries, Information and Archives, Manchester City Council

tollgates, 'carriages swung by iron gates and pillars, and curved along drives to massive turreted stone houses, at the base of them broad steps leading up to the portals, flanked by lions *couchant*'.[14] Victoria Park remained an attractive option until around 1914, although its encirclement by the growth of Rusholme meant that new building became progressively more modest. Despite the departure of its once-affluent population, twentieth-century decay and the demolition of some of the early houses, a number of large properties still stand (often converted for educational use) and the original street pattern remains. Consequently, a stroll round Victoria Park can still convey faint echoes of its former glory.

Nearby Rusholme and Fallowfield were separate villages when Victoria Park was planned but later in the century their populations grew as they evolved into suburbs, as was the case in so many other rural locations around Manchester. An early attempt in 1836 to establish an exclusive gated settlement at Brighton Grove failed and only four houses were completed. Nonetheless the pull of Manchester was sufficient in time to see the erection elsewhere in Rusholme and Fallowfield of numerous substantial villas and mansions complete with stables, gardens and servants. Almost as a marker of this process, later in the century both of these new

Victoria Park. This aerial view from 1930 shows the large houses, generous sized gardens and tree-lined thoroughfares characteristic of the upper middle-class suburban environment. St Chrysostom's church (consecrated 1877), sitting between Conyngham Road and Anson Road, can be seen at the top left. Victoria Park was designated a conservation area in 1972.

Courtesy of Manchester Libraries, Information and Archives, Manchester City Council

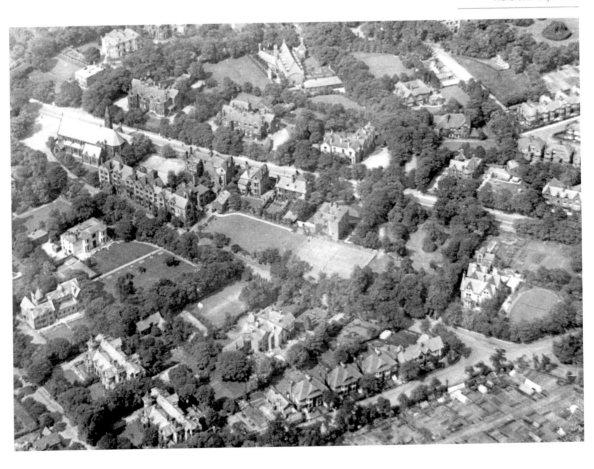

suburbs acquired their own local histories in which the authors wrote nostalgically about the lost rural worlds of their respective communities.[15]

Fallowfield in particular attracted several notable residents. It was here that Alfred Waterhouse (1830–1905), already eminent as architect of the Assize Courts in Manchester, designed and built his own home in 1861. He left Fallowfield in 1865 when he moved his architectural practice from Manchester to London. Later buildings he designed included Manchester Town Hall, Owens College and the Natural History Museum, Kensington. Sir Joseph Whitworth (1803–87), the world-famous engineer and inventor, bought a large house and commissioned the architect Edward Walters to turn it into a mansion, which Whitworth named 'The Firs'. Set in 52 acres of land this was the grandest house in the suburb. On his death, Whitworth left the freehold of the house and land to the trustees of Manchester University. C.P. Scott (1846–1932), journalist, Liberal MP, owner and for fifty years editor of the *Manchester Guardian*, later rented the same house. Scott lived in 'The Firs' from 1882 until his death in 1932 and could be seen daily riding his bicycle on the three-mile journey to the *Guardian* offices in Manchester. Scott's grand-daughter, Rachel Ryan (1901–78), gives a spirited account of her childhood in Fallowfield and the faded grandeur of 'The Firs' by the early years of the twentieth century.[16]

Writing in the 1930s Ryan lamented the decay of this upper-middle-class idyll as it experienced 'the second stage of the suburban cycle ... with the building of more middle-class houses, still with gardens but without stables, a few streets of very small semi-detached houses each darkly and defensively withdrawn behind a low brick wall and a stout palisade of privet, and some blank rows of working-class cottages'.[17] Ryan bemoaned the passing of an era, that of the first suburban dwellers with their mansions and grand villas. She conceived the city as a rapacious monster consuming all in its path.

> Manchester, like a mouth gaping enormously, swallowed up village after village. After Fallowfield went Withington, then Didsbury. Soon the great jaws were mumbling at the edge of Cheshire. The engulfed villages lay only half digested in the monster's stomach. Each of them still preserved some resemblance to what it had been once, though some were more decayed than others.[18]

What was a loss for some was an opportunity for others lower down the social scale. However, for the majority the prospect of such a suburban life was beyond ambition. As the suburbs of the rich took shape and themselves changed and grew, the burgeoning industrial working class of Manchester occupied much more congested quarters in the town's rapidly expanding inner residential belt, living in the meanest streets, generally within a short walk of work. Row upon row of densely packed housing rapidly covered the open spaces between mills and workshops. Most of this housing was constructed by the speculative builder with little capital, himself recently risen from the working class. These 'jerry builders' usually did

not work to any set of building standards and were often desperately inefficient. Some districts grew to the proportions of a medium-sized town. Hulme (apart from Salford, the largest of the townships in the immediate vicinity of Manchester), which had 1,677 inhabitants in 1801, was developed for artisan dwellings and had a population of over 53,000 by 1851. To all intents and purposes this was a residential suburb but minus the desirable accoutrements of the middle-class enclaves and far from the rural idyll desired by the richest.

The arrangement of living in the first industrial city separated class from class. The Revd Richard Parkinson (1797–1858), canon of Manchester, claimed in 1841: 'there is no town in the world where the distance between the rich and the poor is so great or the barrier between them so difficult to be crossed'.[19] The French commentator Leon Faucher (1803–54) described the effects of the exodus of the rich more graphically:

> at the very moment when the engines are stopped, and the counting-houses closed, everything which was the thought – the authority – the impulsive force – the moral order of this immense industrial combination, flies from the town and disappears in an instant. The rich man spreads his couch amidst the beauties of the surrounding country, and abandons the town to the operatives, publicans, mendicants, thieves and prostitutes.[20]

The effect of this spatial segregation was to create a residential pattern of concentric circles noticed by others but first analysed in 1844 by Friedrich Engels (1820–95) in *The Condition of the Working Class in England*. At the core, where the spread of the commercial district contributed greatly to overcrowding, lived the very poorest in some of the nation's worst housing, surrounded by a solid mass of working-class terraces and at the periphery a less densely populated ring of middle-class suburban villas. As the city expanded so the suburbs grew and multiplied. By the 1840s the 'breezy heights' of Cheetham Hill and Higher Broughton or the seclusion of Buile Hill, Pendleton, were better prospects for the very rich, while the ring of inner suburbs housed the mass of workers required in the great manufacturing and commercial metropolis. Until the advent of cheap tram journeys in the later nineteenth century, the journey to work for residents of these inner suburbs was mostly on foot. For areas of mixed land use such as Ancoats and Ardwick, the factories and workshops might be round the corner. The sections of Chorlton-on-Medlock closest to Manchester, along Cambridge Street for example, also contained numerous large mills. By contrast Hulme was mostly residential and the walk to work would be longer. But whether housed in largely residential or in mixed industrial and residential districts, this ring of working-class suburbs is as much part of the story of the shaping of the city as are the retreats of the wealthy.

The history of suburban living usually evokes images of leisure and ease, the perquisites of the more comfortable classes. But the contours of the emerging city also reflected the growth of the more densely packed living quarters of its poorer

Engels on Manchester

Manchester contains, at its heart, a rather extended commercial district, perhaps half a mile long and about as broad, and consisting almost wholly of offices and warehouses. Nearly the whole district is abandoned by dwellers, and is lonely and deserted at night; only watchmen and policemen traverse its narrow lanes with their dark lanterns. This district is cut through by certain main thoroughfares upon which the vast traffic concentrates, and in which the ground level is lined with brilliant shops. In these streets the upper floors are occupied, here and there, and there is a good deal of life upon them until late at night. With the exception of this commercial district, all Manchester proper, all Salford and Hulme, a great part of Pendleton and Chorlton, two-thirds of Ardwick, and single stretches of Cheetham Hill and Broughton are all unmixed working-people's quarters, stretching like a girdle, averaging a mile and a half in breadth, around the commercial district. Outside, beyond this girdle, lives the upper and middle bourgeoisie, the middle bourgeoisie in regularly laid out streets in the vicinity of the working quarters, especially in Chorlton and the lower lying portions of Cheetham Hill; the upper bourgeoisie in remoter villas with gardens in Chorlton and Ardwick, or on the breezy heights of Cheetham Hill, Broughton, and Pendleton, in free, wholesome country air, in fine, comfortable homes, passed once every half or quarter hour by omnibuses going into the city. And the finest part of the arrangement is this, that the members of this money aristocracy can take the shortest road through the middle of all the labouring districts to their places of business without ever seeing that they are in the midst of the grimy misery that lurks to the right and the left. For the thoroughfares leading from the Exchange in all directions out of the city are lined, on both sides, with an almost unbroken series of shops ... True, these shops bear some relation to the districts which lie behind them, and are more elegant in the commercial and residential quarters than when they hide grimy working-men's dwellings; but they suffice to conceal from the eyes of the wealthy men and women of strong stomachs and weak nerves the misery and grime which form the complement of their wealth. ... I have never seen so systematic a shutting out of the working-class from the thoroughfares, so tender a concealment of everything which might affront the eye and the nerves of the bourgeoisie, as in Manchester.

Friedrich Engels, *The Condition of the Working Class in England* (1845), English edition published New York, 1887, and London, 1891

denizens, the mass of workers without whom its wealth would not have been made. Their neighbourhoods were congested and polluted, their treeless streets narrow, and their outside space limited or communal. Housing in Hulme varied enormously from the multi-occupied and squalid, situated around dark courts or in rows of back-to-backs, to some streets of modest houses with gardens. (It was in one of these, in a row named Mount Pleasant on Boundary Street, that Patrick Brontë lodged for several weeks in 1846 while he endured and recovered from cataract surgery under the watchful eye of his daughter Charlotte, who spent her spare time on the early stages of writing *Jane Eyre*.) Between these two extremes there were streets lined with little terraced houses, each with their own privies in their own back yard. For the families occupying houses such as these suburban living offered a greater degree of privacy in self-contained dwellings, with boundaries albeit cursory in the case of the modest terraced house, but distinct from the more public use of space that had prevailed even for the wealthy in the pre-industrial town.

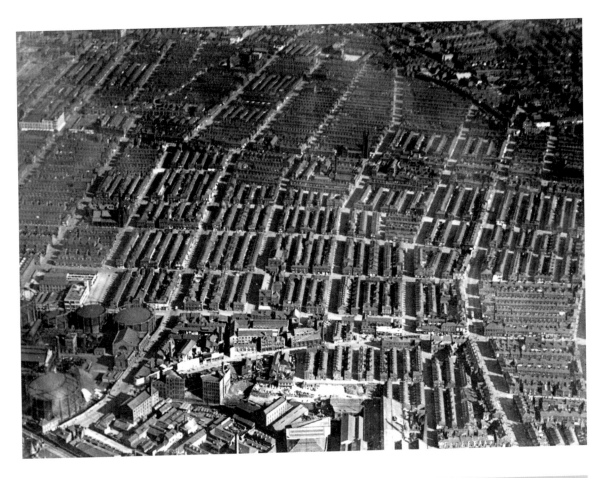

Hulme, 1922. 'With the exception of this commercial district, all Manchester proper, all Salford and Hulme, a great part of Pendleton and Chorlton, two-thirds of Ardwick, and single stretches of Cheetham Hill and Broughton are all unmixed working-people's quarters, stretching like a girdle, averaging a mile and a half in breadth, around the commercial district' (Engels). The history of suburban living usually evokes images of leisure and ease, the perquisites of the more comfortable classes. But the emerging shape of the city had as much to with the growth of more densely packed suburbs such as Hulme. The aerial view shows the gridiron pattern of street layout characteristic of working-class districts. Compare this with the more fluid layout and generous plots of Victoria Park. The second view is of Caroline Street. Hulme has been made over more than once since these photographs were taken.

Courtesy of Manchester Libraries, Information and Archives, Manchester City Council

Housing quality and facilities in these inner suburbs may have been lacking by later standards but they were a step up from the squalor of central Manchester's back streets, alleyways and courts. For example, a report on conditions in Chorlton-on-Medlock reported that two-thirds of the houses had their own 'necessaries with middens or cess pools attached', the contents of which were removed by cart. Several newly finished streets had been paved and sewered at the owner's expense. The paved streets were swept by Whitworth's patent street-cleansing machine. However, the quality of housing in Chorlton-on-Medlock varied and some unpaved streets and courts were very dirty. About one-third of inhabitants lived in back-to-backs, although cellar dwelling was uncommon.[21] These were undoubtedly better conditions than in the back streets and courts of the central area, but it was the latter that captured the attention of contemporaries. A first fruit of official anxiety about sanitary conditions was an 1844 byelaw to ban the erection of further back-to-back dwellings in Manchester and later in the century many were converted to 'through' houses. By the beginning of the twentieth century, expectations about the quality of life had changed and the mean streets of the working-class suburbs themselves became subjects for reform as slum-clearance programmes started to be formulated and the impact of planned rehousing on the urban form began. The rehousing of the residents of Hulme was to perplex more than one generation of city councillors during the twentieth century.

Transport and the suburbs

As we have seen, the middle-class residential suburb pre-dated the dramatic transport advances of the nineteenth century. It was the carriage-owning classes who moved out first. But as the suburban ideal began to permeate down the social ranks, the possibilities offered by new forms of transport became crucial and ultimately determined the shape of the 'greater Manchester' that emerged. Without the transport revolution in road and rail, the contours of suburbia would have been much more confined. Before the railway age, stagecoaches provided inter-city travel across long distances. For shorter journeys within town sedan chairs could be hired, although most simply walked. Hackney carriages plied their trade and carriage ranks stood in St Ann's Square and at the top of Market Street. Hackney carriages were convenient but expensive. With the advent of the early suburbs the demand for a more economical form of transport over short distances grew steadily.

We will speak later of the mixed relationship between the railway and suburban growth, but prior to the introduction of the passenger railway and a quarter of a century before the first suburban routes ran regular rail services, the journeys of the business class from their suburban homes into the city centre stimulated a pioneering venture in public transport on the road. The horse-drawn omnibus could be found operating in several cities on both sides of the Atlantic by the early 1830s. Although this new mode of conveyance acquired the epithet

'omnibus' from a service originating in 1826 in Nantes in north-west France, it is most likely that the first practical example was in Manchester. As early as 1824, John Greenwood (1788–1851), collector of the tolls on the Pendleton turnpike, took the opportunity to start a horse-drawn omnibus service between the village green at Pendleton and Market Street, Manchester. Greenwood's service pre-dated those established in Paris (1828), London (1829) and New York (1831). Unlike the stage-coach, the horse-drawn omnibus allowed passengers to climb aboard and alight at any point. Greenwood's first vehicle was little more than a large hackney carriage drawn by a single horse. As he became profitable he progressed to two-horse omnibuses that carried eight or nine passengers inside and up to three outside. A flat rate of sixpence for the journey (fourpence if you sat outside next to the driver) was cheaper than the hire of a hackney carriage, but costly enough to exclude all but the wealthier commuter. Greenwood later introduced further services along other routes into the city and other providers soon entered the field.

By the 1830s omnibuses had reached most of Manchester's new suburbs.[22] In 1834 the writer of a local guide to the town observed presciently that in consequence of these new 'accommodation coaches or omnibuses':

> persons are constantly removing ... to the outskirts of the town and the surrounding villages, leaving those parts that were once occupied as dwelling-houses to be converted into warehouses or offices for business ... let the present fashion of emigration from the centre of the town go onwards a few years and all that was once called 'Mancunium' will claim the appellation of a 'town of warehouses'.[23]

The commercial possibilities of this new form of transport were evident and rival companies set up omnibus services on most suburban routes. Most notable were the vehicles of G. McEwen's City Omnibus Company, painted in the tartan plaid of the McEwen clan, and first seen on the streets of Manchester in the 1850s. These spacious, three-horse double-decker omnibuses could carry up to 42 passengers, thus enabling cheaper fares of threepence inside and twopence on top. The City Omnibus Timetable for 1851 lists several suburban routes including an hourly service between Plymouth Grove and Victoria Station and a half-hourly service between Ardwick Green and Great Ducie Street.[24] Greenwood's (now run by the son of the founder) responded to the challenge with new, larger buses and reduced fares. By the mid-1850s 10,000 passenger journeys per week were being made in Greenwood's omnibuses alone and the firm's workforce totalled some 200 coachmen, guards and stable boys.[25]

The amalgamation of several businesses to form the Manchester Carriage Company in 1865 was intended to bring some unity to a complicated set of rival services. The Carriage Company's buses ran on 'city routes' covering inner suburbs such as Cheetham Hill, Plymouth Grove and the like and 'country routes' extending to Didsbury, Prestwich and as far afield as Stockport and Bolton. Most buses

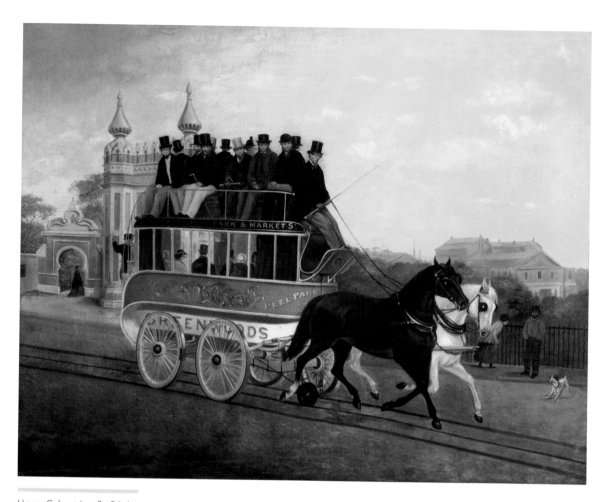

Henry Calvert (1798–1869),
*The Five-Wheeled
Omnibus* (date unknown).
In 1824 John Greenwood
began what was possibly
the world's first horse-
drawn 'accommodation
coach' or omnibus
service carrying suburban
travellers into central
Manchester. Greenwood's
service pre-dated those
established in Paris
(1828), London (1829)
and New York (1831).

departed from the Carriage Company's offices in Market Street. By this date the
stock of horses required to pull Manchester's buses totalled over 500. However, the
Carriage Company's dominant position was not a monopoly and rival companies
continued to exploit the ever-increasing demand. For example, in the 1870s
Manchester Carriage Company buses faced competition on certain routes from
the Cheadle Omnibus Company, and there were reports of Carriage Company
buses in their distinctive red livery racing the blue buses of the Cheadle Omnibus:
'Side by side they would chase along from Didsbury, the passengers ... consisting of
Manchester merchants and their sons, standing up and cheering their own driver
as he galloped along.'[26]

By this time the railway was the chief rival of the omnibus and the first
suburban train routes had been laid down around the middle of the century.
Following the opening of the Liverpool and Manchester Railway in 1830, the rail
routes established in the first two decades of the 'Railway Age' were designed to
connect towns and cities. It was only as an afterthought that some of these became
suburban lines. In the event the railway greatly extended the reach of suburbia,

although its chief impact came after 1850. An early illustration was the colonization of Alderley Edge, also an instance of the contribution made by tourism to the growth of the commuter belt. The Manchester and Birmingham Railway, opened in 1842, stopped at Alderley and soon attracted sightseers to the wooded Edge. The placing of a station barely two miles down the line from the more important stop at Wilmslow was undoubtedly intended to exploit the day-excursion market from Manchester. The day-trippers soon arrived. The resident gentry, the Stanleys at Park House, found these tourists a great nuisance, though Lady Stanley complained that Manchester's 'cottontot grandees' were more annoying than the operatives 'as one can neither hand cuff nor great dog them if they are intrusive'.[27] The Stanleys must have been alarmed when the 'cottontots' began building their villas on the hill approaching the Edge. Passenger traffic receipts at Alderley rose from £359 in 1843 to £3,379 in 1852, but this remained a select service for a small number of well-to-do passengers. Alderley Edge remained an exclusive suburb for the rest of the century and Katharine Chorley's account of life in this upper-middle-class village in the years before the First World War is justly famous.[28]

A further line of advance was created when the Manchester South Junction and Altrincham Railway (MSJ&AR) was opened in 1849 with a terminus in Altrincham at the foot of Bowdon Downs. In the first year of operations of the new line, 13 trains a day departed for the 30-minute journey from Altrincham to Manchester Oxford Road. After ten years of operation the line was well established and for the second half of 1858 a total of 692,000 passenger journeys were undertaken on the Altrincham branch line, of which 132,000 were first class with 957 season ticket holders.[29] The MSJ&AR stimulated the building of many grand villas, chiefly to the south-west of the old town centre on land owned by the Earl of Stamford, then within the township of Dunham Massey. Altrincham is an example of an established settlement that grew because of the railway. In 1851 it was already a small market town with a socially mixed population of 4,500 that increased by almost 50 per cent in the following decade. The railway attracted incomers at all social levels, with significant numbers of railway workers in its early years. However, it was the conversion of the town into a middle-class suburb of Manchester between the 1850s and the 1880s that transformed its character forever. As well as the grand mansions of the rich, streets of more modest suburban houses grew up near the station. To the south of Altrincham, the coming of the railway secured the future of the tiny hamlet of Bowdon as an exclusive suburb, and the addition of the Cheshire Midland Railway in 1862, linking Altrincham to Northwich with a station at Hale, although not deliberately intended as a suburban line, further extended the suburban belt around Altrincham. The advent of suburban railways like the MSJ&AR marked the beginning of the regular commute by train that was to become such a central feature of daily life around Britain's cities before the end of Victoria's reign.[30]

Alderley and Altrincham marked the limits of the suburban invasion of Cheshire. It is notable how the southern limits of the later conurbation were

already laid out as early as the mid-nineteenth century. Once these outposts were established, other residential developments followed. By 1900 there were strings of dormitory suburbs along the rail routes to the south. Suburban clusters surrounded the stations of the London line at Wilmslow, Cheadle Hulme, Bramhall and Heaton Moor. Sale and Stretford grew up on the Altrincham line. Closer to Manchester, Withington and Didsbury had developed on the Wilmslow Road horse omnibus route since the 1830s, but the Midland line from Central Station ensured their future in the 1880s. In the 1890s Withington and Didsbury stations together were booking around 1,250 passengers each working day. With season ticket holders this rose to 2,500. The opening of an electric tram route in 1904 cut into rail passenger traffic but only added to the appeal of living in these suburbs. By this time the social mix of the suburbs included better-off artisans, warehousemen and clerks. An example of this is the development of Chorlton-cum-Hardy, four miles south-west of the city centre and in the mid-nineteenth century sufficiently remote to retain its agricultural character (the nearest station was at Stretford, a mile and a half away). Suburban growth was already underway by the 1870s, but when the Midland Railway Company opened a station at Chorlton in 1880 it was to prove instrumental in changing the nature of the village forever. The siting of the station where the line crossed Wilbraham Road created a new residential cluster away from the older village centre. The new 'village' that grew up near the junction of Barlow Moor and Wilbraham roads was served by tram as well as train and soon attracted shops and other services. Most of this new housing was aimed at the families of professionals and better-off artisans and clerks rather than the upper-middle-class occupations characteristic of the earlier suburbs.[31] The suburban ideal was making inexorable progress down the social scale.

Sale, five miles from Manchester, is an example of a Victorian suburb that grew because of the railway. The adjacent villages of Sale and Ashton-upon-Mersey were small agricultural communities in 1841 with comparable populations (Ashton, 1,105; Sale, 1,309). While the populations of both grew during the nineteenth century, it was the opening of the railway station at Sale on the MSJ&AR line in 1849 that marked out a contrasting pace of development for the two settlements. While the population of Ashton had multiplied threefold to 3,326 between 1841 and 1881, that of Sale at 7,915 was more than six times larger than it had been in 1841. The transformation of Sale from a rural environment to a dormitory suburb was remarkably swift. While the census of 1841 recorded 50 per cent of occupations as agricultural, thirty years later in the census of 1871 that figure had fallen to 16 per cent. By contrast, in 1841 only 4 per cent of occupations of Sale residents were classified as 'professional'. By 1871 this proportion had risen to 28 per cent, constituting the largest occupational category in what by now had become a suburb of Manchester. In 1841 there had been 254 houses in Sale; by 1881 the number had risen to 1,503. Several of these early suburban houses were substantial villas mostly built within easy walking distance of the railway station. The poor-quality soil of Sale Moor rapidly acquired a value it would never have achieved as

Sale railway station. Sale, five miles from Manchester, is an example of a suburb that grew because of the railway. Sale station was on the Manchester South Junction and Altrincham line, opened in 1849. Sale did not remain a socially exclusive suburb like Bowdon or Alderley Edge, and later development involved the building of semi-detached and terraced houses mostly rented by clerks and artisans. The arrival of the tramline in the first decade of the twentieth century and later the motor bus ensured the future of what had started out as a railway suburb for the affluent few. This photograph taken on a sleepy afternoon in 1903 shows the station master resplendent in his top hat with the station clock standing at five to three and crates and parcels waiting on the up platform for a Manchester train.

Courtesy of Manchester Libraries, Information and Archives, Manchester City Council

agricultural land. The suitability of this land for housing development pushed the rateable value of property up almost sixfold between 1841 and 1871. Those who had houses built or paid rent to live in those constructed by speculative builders were chiefly merchants and professionals from Manchester, although Sale's most famous resident was James Prescott Joule (1818–89), the celebrated scientist, who spent the last seventeen years of his life in a detached house on Wardle Road. Several of these early villas can still be seen.

On the south-east edge of Sale an entirely new suburb developed that became known as Brooklands. This was the creation of the wealthy Manchester banker Samuel Brooks, who had earlier in the 1830s created the suburb of Whalley Range. In the 1850s Brooks made substantial purchases of agricultural land on which he built a speculative development of large houses along a new road (Brooklands Road). In order to ensure the future of this speculation he underwrote a deal with the MSJ&AR to open a new station, known as Brooklands, in 1859. Brooks wanted his

new suburb to have a fine church and commissioned the up-and-coming architect Alfred Waterhouse to build it. Despite Brooks's initiative, Sale was never a socially exclusive suburb like Bowdon or Alderley Edge, and later development involved the building of semi-detached and terraced houses mostly rented by clerks and artisans. The arrival of the tramline in the first decade of the twentieth century and later the motor bus ensured the future of what had started out as a railway suburb for the affluent few. Like several larger suburbs, Sale acquired its own newspaper, the *Sale and Stretford Guardian*, which began publishing in 1879. Community life found expression in various local societies and clubs including that staple of suburbia, the amateur theatrical. Sale Amateur Dramatic Club was founded as early as 1869, while later the Brooklands Amateur Thespians concentrated on light opera. Sporting activities included Sale Cricket Club, which launched what later became Sale Rugby Union Club in 1861.[32]

A further example of railways opening up new areas for suburban development was the construction of the so-called 'Styal loop', a branch line between Levenshulme and Wilmslow opened by the London & North Western Railway Company in 1909. This route passed through already suburbanized Withington at Mauldeth Road, planted a new station at Didsbury (later East Didsbury & Parrs Wood), and traversed the still rural locations of Gatley, Heald Green and Styal before rejoining the main line at Wilmslow. A further station opened in 1910 to serve the newly created Burnage Garden Village.[33] Manchester was spreading southwards into the rural hinterland of Cheshire. The girdle of middle-class residential suburbs was thinner elsewhere around the city. Significant exceptions were the suburban developments along the Bury line at Prestwich and Crumpsall and astride the Warrington line at Urmston and Flixton.

The relatively flat lands to the south and west were more conducive to the creation of a rural idyll than the foothills of the Pennines to the north and east. Weather systems played their part in this. The prevailing winds from the west and south refreshed by the almost constant succession of Atlantic weather systems blew the smoke pollution of domestic and industrial chimneys northwards over the city centre towards the foothills of the Pennines. The resultant micro-climates created were remarked on at the time. A study conducted in 1891 and 1892 revealed that in winter, as a result of air pollution, the city centre enjoyed only half the sunlight of the suburban areas of Didsbury and Davyhulme. The link between health and smoke pollution was understood at the time, including its link to some of the most common diseases of the age. Smoke pollution directly affected respiratory illnesses such as pulmonary tuberculosis and sunlight deprivation played a part in reducing resistance to diseases such as rickets.[34] Significant among the attractions of suburban living was the opportunity for a healthier family lifestyle. As is ever the case, this was something the better-off could buy that was denied to those on lower incomes. Employed in the factories, workshops and warehouses of the central and northern districts of the city, Manchester's working classes lived close to their workplace or but a short walk or tram ride away. This generally meant rented

A suburban house, Bramhall, architect's plans, 1909. Bramhall was linked to Manchester by the Macclesfield branch line of the Manchester and Birmingham Railway (London & North Western Railway). The plans shown here were for a house within walking distance of the station. There was to be much building in the inter-war years and a promotional publication of this time spoke of Bramhall as a 'delightful residential spot … with a pure bracing air and … the reputation of being one of the healthiest parts of the country … [with] one of the lowest death rates. The locality is entirely residential - absolutely free from factories and is easy of access, splendidly connected by both 'bus and train with Manchester, Stockport.' F. Green and S. Wolff, *Manchester and District Old and New*, Souvenir Magazines, London (c.1930).

accommodation in Manchester's inner residential belt. Although the more distant suburbs represented Manchester's encroachment on its rural hinterland, those living the suburban dream were outnumbered by their less well-off brethren inhabiting the closely packed streets that stretched like a girdle around the commercial heart of the city, or living in the blackened brick terraces that by the later nineteenth century had spread 'Manchester' deep into south Lancashire. Although many still walked to work, the inner suburbs that encircled the late Victorian and Edwardian city and spread their tentacles northwards were tram-dependent.

The railway may have influenced the geographical extent of Manchester's suburban outreach, but it was the tramway that did more to assist the development

Houses designed by Edgar Wood, Mount Road, Alkrington Garden Village. An example of a suburb north of the city that did not depend on the railway was Alkrington Garden Village, near Middleton. Although never completed as envisaged by its designer, Thomas Adams, 40 houses were erected before 1914, including those designed by the local architect Edgar Wood. Burnage, to the south of the city, was a more complete example of a pre-1914 garden suburb.

Image supplied and reproduced with kind permission from David Morris

of the inner residential belt where most people lived, especially the impact of electric trams after 1900. The idea of a street tramway gained credence in the 1860s and the Tramways Act of 1870 gave local authorities the power to lay tramways within their respective boundaries but not to operate tram services themselves. Both Manchester and Salford built tramlines and then leased them to a private company. The Manchester Suburban Tramways Company was formed to exploit the potential of this new public transport technology. The company also gained powers to lay its own lines outside the Manchester boundary, and in 1877 it ran the first horse-drawn tram between the Grove Inn, Bury New Road, and Deansgate. The intention was that this line should eventually reach the suburb of Higher Broughton. After a merger with the Manchester Carriage Company the two businesses became the Manchester Carriage and Tramways Company. In the 1880s it was busy laying tramlines in the inner suburbs. At its peak in the mid-1890s this company ran the largest unified tramway system in the country, with over 500 tramcars and 5,000 horses (with corresponding depots and stables). It continued to operate horse omnibuses in more outlying districts served by neither tramway nor railway. Together the Company ran tram and omnibus routes extending to 143 miles. The legal terms of the Company's operations were constrained by a 21-year

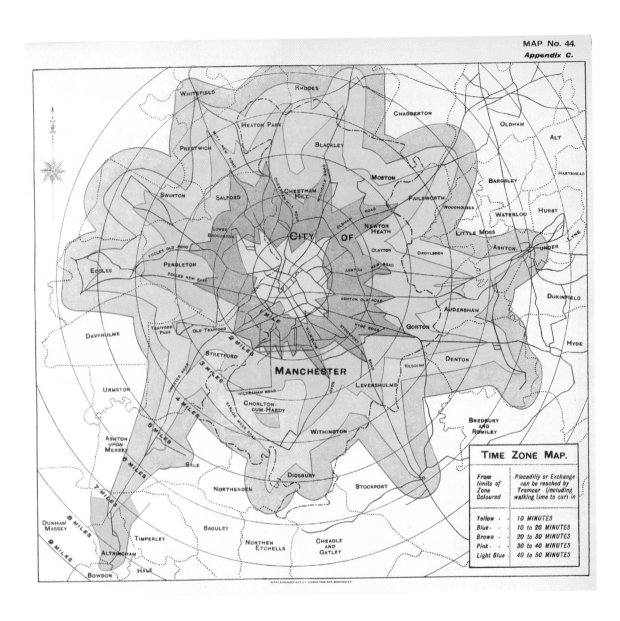

TIME ZONE MAP.

From limits of Zone Coloured	Piccadilly or Exchange can be reached by Tramcar (including walking time to car) in
Yellow - -	10 MINUTES
Blue - - -	10 to 20 MINUTES
Brown - -	20 to 30 MINUTES
Pink - -	30 to 40 MINUTES
Light Blue -	40 to 50 MINUTES

lease that expired in 1898. By then electric motive power for trams offered new possibilities and Parliament's opposition to municipal tramway enterprise had been removed. Manchester and Salford councils duly moved into tramway operation using battery-powered electric trams.

In 1901 both Manchester and Salford corporations took over the services of the Manchester Carriage and Tramways Company, electrified them and began operating their own systems. Other municipal authorities followed suit and a network of electric tramways across 'Greater Manchester' linked the disparate towns and suburbs of the emerging conurbation. A constant stream of slow-moving but frequent and cheap double-decker trams processed through the main

streets, while single-decker trams and a less frequent service were sufficient for more outlying districts. Reciprocal agreements between local authorities secured a more coordinated transport system and by 1911 around a thousand tramcars were in daily service in the region. Over half of these were owned, leased or operated by Manchester Corporation and ran as far as Stockport and Altrincham in the south and Middleton and Failsworth in the north.[35] The electrified tramways system expanded remarkably quickly and new routes were opened in rapid succession. Between 1902 and 1906 passenger journeys multiplied more than fivefold (from 23.5 million a year to 134 million a year). Manchester relied more on the tram than most other British cities. In 1905 it was estimated that it had four times as many miles of tramway per head of population as London and twice as many as Glasgow. Moreover, it was possible to ride farther for a penny on a Manchester tram than on the tramway of any other UK city.[36]

More significant than the numbers was the social impact of the electric tram. It enabled cheap, convenient and reliable journeys to be made to travel to work or to visit the shops and other attractions of the metropolis. It encouraged the spread and growth of suburbs, and extended suburban living lower down the social scale. It especially benefited the skilled working class. In many cases house building followed the new tram routes. Trams did not just reflect suburban demand, they were often laid in advance of house building and as with some rail routes in the mid-nineteenth century (and again in the inter-war years), the existence of a new transport connection stimulated suburban development. As John M. McElroy, the general manager of Manchester Corporation Tramways, observed in 1906 'cheap and rapid transit under commodious conditions tends to spread the population'; electric tramways, he averred, had 'revolutionized the whole means of transit. The habits and social customs of the people are being affected ... There is a general tendency all round the city towards growth and development, and I think it safe to say that housing accommodation is increasing.'[37] However, unlike the railway, the tram was mostly used as a short-distance mode of transport. It was also never going to be a fast service, since the speed along the tramway was that of the slowest car stopping at all the stops, which increased in number as the city-centre streets were reached. Short-distance travel predominated. Figures for 1907 show that almost 70 per cent of passengers paid fares of one penny and travelled no more than two miles. Although there were longer routes to outer suburbs such as Altrincham, through traffic on these routes was more limited. The electric tram did most to help the growth of the inner suburbs within a two-mile radius of the city centre. This was the sphere of the penny fare with journeys generally taking no more than twenty to thirty minutes.[38]

Tramways extended like tentacles, reaching out from the centre, with new housing clustering near the major arterial roads. The electric tram did much to generate the characteristic star-shaped pattern of residential expansion and especially stimulated the growth of inner suburbs. These were the British version of the streetcar suburbs of US cities like Boston. But the tram became obsolete even

before the end of the 1930s, and ultimately did less to determine the outer boundaries of the modern conurbation than the invention of the internal combustion engine. During the twentieth century, the motor bus and the motor car became a convenient mode of travel especially for the commuter in more distant suburbs. Together with the advent of electric railways they stimulated the growth of new suburbs farther from the urban core.

For those living in the inner suburbs, walking to work was the most common commute before the First World War, but declined dramatically during the inter-war years to be replaced by tram and then bus travel, but also by more individualized forms of transport, chiefly the bicycle, motorbike and only belatedly the motor car. The car was a growing element in inter-war travel arrangements but it did not become the dominant mode of transport until the 1960s.[39]

The inter-war years saw the replacement of tramways by motor bus services and the last trams ran soon after the Second World War was over. Although bus routes operated before 1914 they complemented rather than competed with the tramways. It was in the 1920s that their potential was realized first by private bus companies and then by the municipal authorities. The writing was on the wall for the tram and from 1929 Manchester Corporation pursued a policy of replacing trams with buses. Tramways were ripped up and became bus routes instead. A decade later Manchester Corporation's tramcar fleet had drastically reduced and the number of passengers carried had more than halved. Meanwhile the number of bus passengers had increased sevenfold. Travel by double-decker buses, now fitted with pneumatic tyres and featuring covered-in top decks, became the norm even for shorter journeys. It was not until the 1950s that the use of private cars began to reduce the numbers travelling by public transport.

A further transport stimulus to suburban growth came in the form of the electrification of certain railway routes. The line to Bury was electrified as early as 1916, reducing the journey time by a quarter. En route the line served the residential suburbs of Crumpsall and Prestwich and the 1930s saw the opening of new stations at Besses o' the Barn (in Whitefield) and Bowker Vale (in Prestwich), where semi-detached housing had sprung up close to the line. The next to be electrified was the Altrincham line where electric services started in 1931. The faster trains on this route competed successfully with existing tram and bus operations. As on the Bury line, new stations were opened, Dane Road (between Stretford and Sale)

Bacon's *Plan of Manchester & Salford* (1907). This map of the city, divided into half-mile squares, was drawn prior to the extensive private and public building programmes of the twentieth century. It encompasses the southern suburbs of Rusholme, Withington and Levenshulme and extends northwards to Crumpsall, Prestwich and the city's new acquisition, Heaton Park. The map shows roads, railways and canals including the newly constructed docks of the Manchester Ship Canal.

MCL Local Image Collection

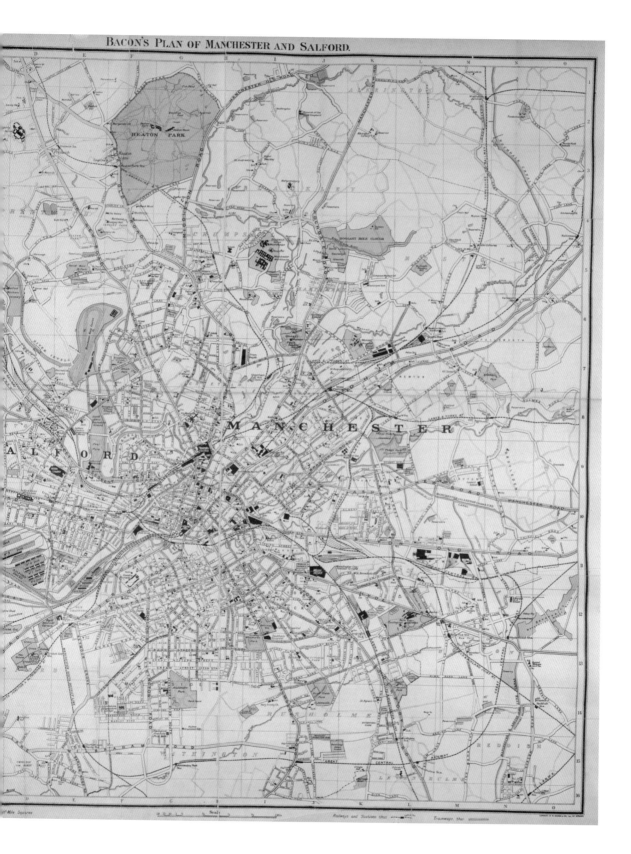

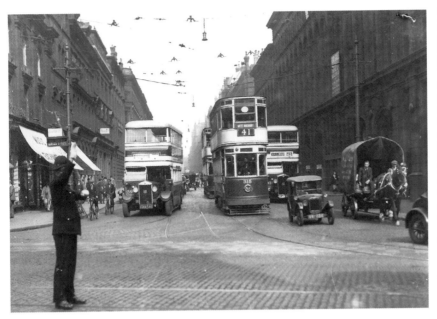

City centre traffic in 1933 at the junction of Portland Street and Oxford Street, looking up Portland Street. The photograph shows the various forms of public and private transport to be seen on Manchester's streets by this date. Electric tram No. 41 was en route from Victoria Street to West Didsbury. Of the two buses, one is the No. 28 bound for Sale Moor. Completing the range of traffic are a horse-drawn lorry, an Austin 7 motor car and a couple of travellers on the ubiquitous safety bicycle. Note the policeman on point duty.

Image supplied and reproduced with kind permission from Chris Makepeace

and Navigation Road (between Timperley and Altrincham). Although interrupted by the Second World War, the next electrification scheme was for the Manchester to Sheffield line. Completed by 1954, this provided local services to Hadfield and Glossop, again helping to build up commuter traffic flow into Manchester.

Motorized suburbia first emerged between the wars. Its chief impact was in the Home Counties around London.[40] However, although garages or at least the space for a car can be found in suburban houses put up in the building boom of the 1930s, most were constructed without such concessions to this new mode of travel. It was chiefly after the war that garages appeared in the spaces between pairs of semi-detached houses and it was post-war suburban development that was to be most influenced by the motor car revolution. The numbers of motor vehicles on Britain's increasingly congested roads multiplied fivefold in the twenty years after 1950. The proportion of these that were privately driven cars rather than commercial vehicles or buses rose steadily. By 1970 it was estimated that 52 per cent of households in Britain possessed a car, although that clearly meant that almost half of households were without one. By then the car had overtaken the bus as the preferred mode of commuting according to research on travel habits in Manchester. However, car ownership was disproportionately higher in more affluent areas.[41] Evidence from Manchester's suburbs supports this contention.

The 1971 Census included data on the availability of cars that provide statistics of car ownership for individual boroughs and urban districts. This allows us to make comparisons between the suburbs around Manchester. Of the 1,600 households in Alderley Edge, 1,095 or 68 per cent possessed a car. The figure was similar for Bowdon, another wealthy suburb, with car ownership at 71 per cent of the

1,580 households. This indicated a degree of car ownership well above the national average. Indeed the car was already a marker of affluence. According to the 1971 census, 31 per cent of households in Bowdon had two or more cars. The figure for Alderley Edge was 24 per cent. Both Alderley Edge and Bowdon were socially exclusive and small suburbs. However, the census data for a much larger and more socially mixed suburban district such as Sale reveals lower but still comparable figures: 60 per cent of Sale households were recorded as possessing a car. North of the city the proportion of households with a car in suburban Prestwich was almost exactly the national average at 50 per cent, and in the former industrial town of Middleton now rapidly being suburbanized the figure was 40 per cent. This compares with the figure of 32 per cent car ownership per household for the county borough of Manchester (the census does not provide data for districts within the borough).[42] Commuting to work by car, while increasingly common by the early 1970s, was still more likely from higher income areas and for many public transport by road and rail, or on the ubiquitous bicycle, remained essential. Nonetheless, the 'motor revolution' was underway and the future shape of the city and its suburbs was now intertwined with the social demographics of car ownership.

Suburbs and the conurbation: Manchester and 'Greater Manchester'

As the suburbs grew generation by generation, the observer might have asked, where is Manchester now? Certainly the city of Manchester could not be confined to the municipal boundaries of 1838 (themselves an amalgamation of the township of Manchester with Ardwick, Beswick, Cheetham, Chorlton-on-Medlock and Hulme). As the built-up urban area grew in the later nineteenth and early twentieth centuries, a series of further boundary extensions between 1885 and 1913 incorporated several adjoining authorities and increased the physical extent of the city (Manchester was created a city in 1853) from 4,293 acres to 21,690 acres. This absorbed formerly distinct townships such as Rusholme, Crumpsall, Moss Side, Withington, Chorlton-cum-Hardy and Didsbury into the borough of Manchester. In 1931 the addition of Wythenshawe meant the city now extended to 27,255 acres and gave it its peculiar elongated shape, stretching some 12 miles from north to south but only 4 miles or so from east to west. Given the intractability of relations with neighbouring Salford, itself created a city in 1926, boundary extensions beyond the Irwell were not possible. As a consequence, Manchester Cathedral and the old medieval core of the city today remain the shortest of strolls from another city altogether. However, the lines on a map rarely convey a complete description of a place and Manchester is no exception.

Even as the city expanded, the notion of a 'greater Manchester' beyond its municipal boundaries was gaining currency and from the early twentieth century proponents of urbanization such as Patrick Geddes, who coined the term 'conurbation', promoted the idea of the 'city region' of which Manchester was a

prime example. The reality of what was happening was inescapable. The older Manchester of the Victorian era and earlier, surrounded by fields and looking only across the Irwell to Salford as a neighbour, was now submerged in a much greater entity. This left W. Haslam Mills (1873–1930), chief reporter on the *Manchester Guardian*, writing in 1915 with nostalgia for a lost 'Manchester': 'As a residential address "Manchester" may mean anything, and does in fact mean nothing. "Fallowfield, Manchester" means something definite, and so does "Cheetham Hill, Manchester"...' To Mills, in the daily commute

> the spirit of the old authentic Manchester is diffused every night and, though it collects again the next morning ... much of it evaporates on the double journey of going out and coming back; it travels further even than the radius of these suburbs – far into Derbyshire and Cheshire. Residential Manchester is grafted like a new social surface over many miles of territorial Cheshire.

Yet what he found even more striking was the endless miles of terraces that characterized the urban landscape of the northern and eastern suburbs: 'From Manchester to Bolton or to Rochdale', he wrote, 'is all of a piece and towns are carried into one another by gas lamps and pavements without the interval of as much as a hedge or ditch. From Manchester to Oldham it is one street, and very nearly one row or one terrace – the continuation of the same idea along seven paved and sewered miles ...'[43]

Writing in his book *English Journey* almost twenty years later, J.B. Priestley (1894–1984) was similarly struck by the continuous ribbon development along the Rochdale and Oldham roads that extended working-class Manchester deep into Lancashire. This caused him to reflect on the city region that had emerged and that was 'Manchester' in all but name:

> On paper, in official returns, Manchester has a population of about three-quarters of a million. In actual fact, it is much larger than that. All manner of towns pretend to be independent, and produce separate population figures of their own, when for nearly all practical purposes they have been part of Manchester for years. The city sprawls all over South Lancashire. It is an Amazonian jungle of blackened bricks. You could take a tram in it for hours and hours, never losing it and arriving into broad daylight. The real population of Manchester must be getting on for two millions. You seem as long getting at the heart of the city as you are when driving into London itself.[44]

Priestley's estimate of the population of 'greater Manchester' was if anything short of the mark. This was despite the fact that the vigorous population growth of the Victorian era had come to an end and population increase in what was to become in 1974 the metropolitan county of Greater Manchester slowed virtually to a halt after 1914.[45] The figure for 1911 was 2.6 million, rising slightly to reach a shade over 2.7 million by 1931, a figure that remained relatively stable for the following forty

years. From 1971 to 2001 population decline was the trend, followed by a striking upturn in the first ten years of the twenty-first century that restored the population of Greater Manchester to approaching 2.7 million once more.[46] Ironically, despite stagnating population figures, the decades between 1921 and 1951 saw rapid and substantial expansion of the built-up area of the city region. While the pressure of numbers eased, the character of the population altered in the new age of the smaller family with rising expectations of adequate living space. Thus the number of households in the region grew by 22 per cent between 1931 and 1951 despite zero population growth. Correspondingly, the housing stock rose by 24 per cent over the same period.

Within this overall picture there was a submerged pattern of decentralization, suburban growth paralleling inner-city decline. After reaching a peak of 766,300 in 1931, the population of the borough of Manchester fell by 8 per cent between 1931 and 1951, and a further drop of 6 per cent to 661,800 by 1961 meant a loss of over 100,000 in thirty years. The decline intensified over the next twenty years due to manufacturing decay and a policy of rehousing outside the municipal boundary. The figure of 404,861 for 1991 was little more than half the 1931 peak. Along with Liverpool and Glasgow, Manchester had sustained the greatest population loss since 1951 of any of the large cities in the UK (although the trend has been reversed since the 1990s).

By contrast, the populations of several neighbouring districts were hugely increased during the second quarter of the century. Between 1921 and 1951 the population of Prestwich had risen by 82 per cent, Wilmslow by 90 per cent, Hazel Grove and Bramhall by 100 per cent, Urmston by 156 per cent and Cheadle by 186 per cent. Such figures represent, in part, the trend towards owner-occupation, which came to characterize residential tenure in twentieth-century Britain, but also the advent of the council-owned suburban housing estate. Both developments, in different ways, extended further down the social scale a pattern of suburban living pioneered by the Victorian upper middle class. Between 1919 and 1939, 4 million new houses (or one-third of the total housing stock in 1939) were built across the country, of which 2.5 million were private and 1.5 million were government subsidized (1.1 million council-owned and 400,000 in private ownership). The voluntary resettlement of the better-off in the private sector after 1914 was accompanied by growth in public-sector housing stock, largely got under way by Addison's Housing Act of 1919 and only brought to a serious halt, sixty years later, by the decision to sell off council houses after 1979. The outflow to the suburbs since the early nineteenth century had left behind generation after generation of inner-city poor, ill-housed and poorly supplied with amenities. Successive rehousing schemes have, sometimes imaginatively, sometimes inadequately, relocated some of those who could not afford entry to the owner-occupier 'club'. The growth in the number of council house tenants paralleled the rise of the mortgage holder, but perpetuated a social geography inherited from the Victorians.

QUALITY *plus* ECONOMY.

For Attractive WELL BUILT
HOUSES OF DISTINCTION
INSPECT THOSE ERECTED BY

Telephone:
URMSTON
2777
ALBERT LOCKE, LTD., BUILDERS,
AT
Lostock Road, **DAVYHULME,** Manchester.
(Few minutes walk from Urmston Station).

A specimen pair of Houses.

3 BEDROOMS, 2 RECEPTION ROOMS, BATHROOM,
Scullery, W.C. Hall approximately 6 ft. 5 in. by
11 ft. 9 in.; Dining Room, 12 ft. by 11 ft. 9 in.; Front
Bedroom, 13 ft. by 10 ft. 9 in.

Approximate Frontage—19 ft. 10 in. Depth: 24 ft. 6 ins.
LONG GARDENS.

Price **£400** REPAYMENTS **17/-** WEEKLY
Inclusive of Rates and Ground Rent
NO EXTRAS.
NO ROAD CHARGES — STAMP DUTIES
OR LEGAL CHARGES.
☞ *See following page for further Particulars.*

SUPERIOR DETACHED HOUSES

of **Character** *and* **Distinction**
IN
FOWNHOPE ROAD, SALE, CHESHIRE

in an ideal position—
close to Bus route,
Station, shops and
schools. ATTRACTIVE
ELEVATIONS Modern
design. Superior in-
teriors fitted with up-
to-date labour saving
devices.

Built with
Best Materials
and a
FIVE YEARS
GUARANTEE
GIVEN WITH
EVERY HOUSE.

Accommodation :—
2 Reception 3 and 4
Bedrooms—Tiled Bath
room and Kitchen—
Separate W.C. —
Room for Garage.
Your inspection is
cordially invited.

PRICES FROM
£750
Mortgage up to 90%.
Easy re-payments.

Office on Site or full particulars from

W. ROBERTSON,
Building Contractor,
875, CHESTER RD., STRETFORD
Tel. : LONGFORD 1995

House builders' adverts, Davyhulme and Sale, c.1932. A combination of low interest rates and falling building costs made house-ownership more affordable by the early 1930s. Many houses were built by local speculative builders, like these in the Manchester suburbs of Davyhulme and Sale. Builders catered mostly for buyers with annual incomes of between £200 and £600 and house prices ranged from around £300 to £800. This extended the possibility of home-ownership to those lower down the scale of professional and commercial occupations and even to higher paid manual workers.

Manchester's suburban increase after 1914 continued the nineteenth-century pattern of southwards expansion into Cheshire. The private housing boom of the 1920s and 1930s refashioned villages and fields into residential suburbs. Existing towns and settlements contributed to an expansion that was more than a mere growth outwards from the centre. Falling house prices – around £400 in the 1930s bought a three-bedroom semi-detached house – created a revolution in home ownership. The suburban frontier at Altrincham, Alderley Edge and Wilmslow had been established as early as the 1850s. House building in the inter-war years was to fill in the green spaces left between these early residential outposts and the pre-1914 'tramway' suburbs closer to the city centre. Thus the infill of bricks and mortar in Brooklands and Timperley physically joined the towns of Altrincham and Sale. Cheshire villages like Gatley, Cheadle and Cheadle Hulme were each incorporated into the continuous suburban belt of South Manchester. Stockport was absorbed in the process, forming part of an almost uninterrupted townscape that had taken on most of its present dimensions by 1939. There were those in the 1930s who thought this expansion of the built-up area should be followed by the political extension of the city boundaries. Ernest Simon (1879–1960) wrote in 1935 that it was 'a calamity for Manchester that almost the whole of its well-to-do

citizens live outside its borders. From the point of view both of the efficient govern-ment of Manchester and of the good development of the land on its borders, the area of Manchester ought to cover the whole of these rich suburbs.' Despite his advocacy of political expansion Simon acknowledged that due to vested interests this was unlikely to happen.[47]

Although the political boundaries of the borough of Manchester have remained unchanged since 1931, no other modern British conurbation is so dominated by its core city. It has taken two centuries for the conurbation to acquire its current shape and it is remarkable how much the urban area of Greater Manchester has been fashioned by suburban growth chiefly emanating from its core city. The historic development of the built-up area in and around Manchester is revealed by a series of sequential maps (Figures 7.1–7.4), based on the modern metropolitan county of Greater Manchester that offer a snapshot view of residential patterns at specific moments in time (1852, 1912, 1967 and 2006).[48] The map for 1852 (Figure 7.1) demonstrates the early prominence of residential development around the historic urban cores of the municipal boroughs of Manchester and Salford but also the existence of smaller but discrete residential clusters connected to the surrounding urban centres (Bolton, Bury, Rochdale, Oldham, Ashton-under-Lyne, Stockport, Altrincham and Wigan).[49] Nonetheless, the overwhelmingly rural character of the landscape is clear. By 1912 (Figure 7.2), on to this existing pattern has been overlaid the characteristic 'starfish' shape of Manchester's outward suburban expansion along arterial roads (tram routes) and railway lines. However, across the emerging city region, 'enclosed land' (fields and farms) remains the predominant character type. By 1967 (Figure 7.3) the suburban drift southward has become domi-nating. While there is evidence of residential growth around all the urban cores (including even the smaller ones), the influence of the economic powerhouse that was Manchester is demonstrated in the evolving shape of the suburban landscape. This reflects the building boom of the inter-war years, especially the 1930s, and the combination of private and public development in the 1950s and 1960s. The urban form is taking on its modern character. If we move forward to the mapping for 2006 (Figure 7.4) we see clearly demonstrated the extent to which residential land use now characterizes the landscape. This is has become a fully urban morphology. The borough of Manchester is the most completely urbanized while the boroughs of Salford, Trafford, Tameside and the territories of the other municipal authorities retain reduced but noticeable areas of enclosed land. Only Wigan and Rochdale show any degree of separation by enclosed land from the rest of the urban mass. From the 2006 map it becomes evident that a simple suburb–city dichotomy no longer accounts for the shape of the modern conurbation. The southern suburbs do not stand out so markedly as they did before. The 'starfish' shape is still discern-ible, but infilling over the twentieth century has been intense both to the north and to the south of Manchester and Salford. Moreover, development has become more complex, with each urban core of what is by now the metropolitan county

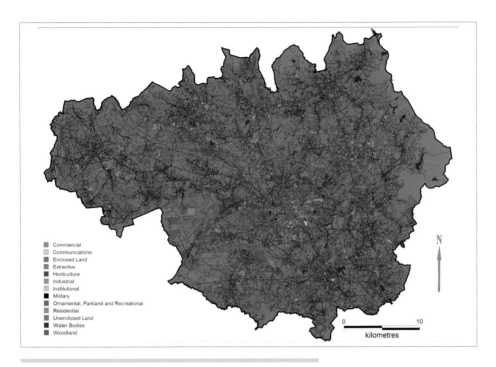

Figure 7.1 Greater Manchester residential development, 1852.
GMAU archive, courtesy of the Greater Manchester Archaeological Advisory Service

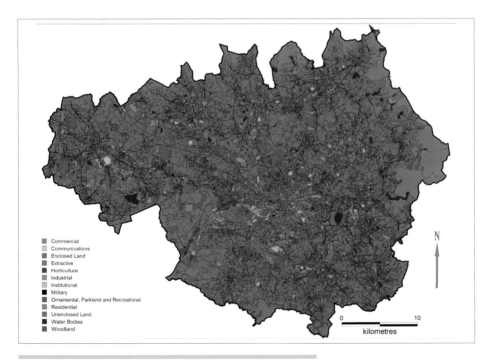

Figure 7.2 Greater Manchester residential development, 1912.
GMAU archive, courtesy of the Greater Manchester Archaeological Advisory Service

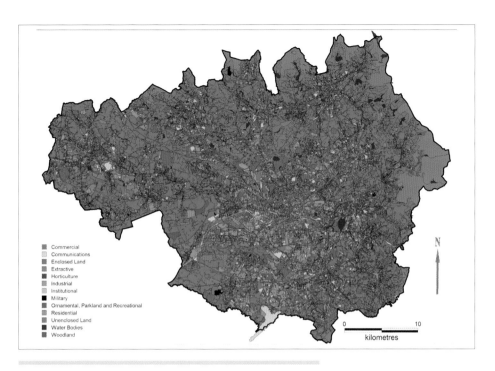

Figure 7.3 Greater Manchester residential development, 1967.
GMAU archive, courtesy of the Greater Manchester Archaeological Advisory Service

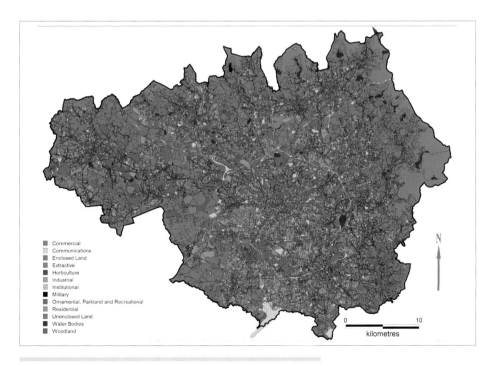

Figure 7.4 Greater Manchester residential development, 2006.
GMAU archive, courtesy of the Greater Manchester Archaeological Advisory Service

assuming an overwhelmingly residential character, although differing in shape and in apparent relationship to the Manchester core at the heart of the conurbation.

The maps illustrate the impact on residential development of changes in transport types. This is clearest when we look at the pattern for the area south of Manchester (mostly in the present-day metropolitan boroughs of Trafford and Stockport). In 1852 the urban cores of Stockport and Altrincham are noticeable as is some residential presence along the route through Stretford to Manchester (the present A56). The next map, for 1912, confirms the pattern established over half a century before. That for 1967, however, reveals a quite different picture. The early 'starfish' shape of residential development south of Manchester is now overlaid by a much denser configuration in which the relevance of the main lines of communication by road and rail is less transparent. The personalization of transport in the automobile age was contributing to the extension of the suburban belt, which the 2006 map shows has culminated in a continuous residential band from Stockport through Cheadle and Gatley to Timperley and Altrincham.

In this process of urban expansion the extent to which suburban social housing constitutes a significant element in the built environment of the modern city is often underestimated. A central feature of suburban growth between the 1930s and the 1970s was the building of council housing to rent. The rehousing of inner-city residents in greener and healthier surroundings was the aim, and the chief influence was the garden city movement inspired by Ebenezer Howard. New housing legislation following the First World War paved the way for local authorities to become town planners. Manchester City Council was among the first to respond positively to the 1919 Housing Act. The next twenty years saw the construction of corporation estates, mainly on suburban sites, and the planning, on a visionary scale, of Manchester's own 'garden town' at Wythenshawe, which has been described as 'perhaps the most ambitious programme of civic restructuring that any British city has ever undertaken'.[50] Manchester Corporation planned Wythenshawe Garden City in the early years after the First World War. By 1926 farmland was being cheaply purchased on a grand scale eight miles to the south of the city, and in 1931 Wythenshawe was incorporated within the municipal boundary. It was not the size of Wythenshawe that made it exceptional (Becontree in Essex was much larger, with a population of 90,000 by 1934) but the original conception behind it. It was conceived as a 'satellite garden town ... deliberately planned ... to cover a large district including not only houses and parks but also a factory area ... the population working partly in the area and partly in the mother city'.[51] This was a new town before its time, planned from scratch around the focal point of Wythenshawe Hall and Park, a gift to the city from Ernest and Shena Simon (1883–1972) who had so much to do with the early development of Wythenshawe. Bisected by the breadth of Princess Parkway, it was to include industrial zones and civic amenities and to house a target population of 100,000.

Although factories for the production of electrical goods, embroidery, hosiery, biscuits and other products were established early on, the economic depression

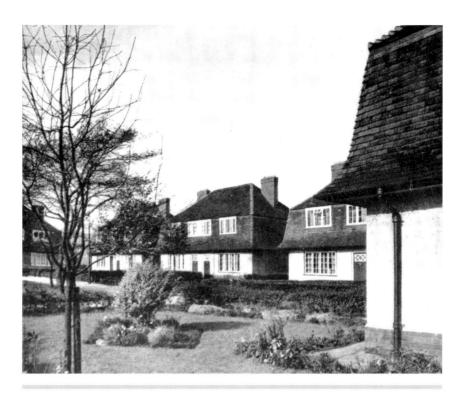

Wythenshawe housing, 1935. Houses built by Manchester Corporation in Wythenshawe Garden City in the 1930s were of good quality with front and back gardens, set in a verdant landscape of spacious green verges generously planted with trees and bushes. Designed by the City Housing Department, they were cottage style, often semi-detached with hipped roofs of slate or red tile and rendered brick walls colourwashed cream. Accommodation comprised living room, kitchen and scullery, plus two or three bedrooms. Upstairs bathrooms were standard. Weekly rents ranged from 9s. to 15s. 9d. This was at a time when a skilled factory worker would expect to earn around £2 15s. a week. In the 1930s most Wythenshawe tenants came from the better-off working class, not from the slums. Of new tenants, only one in five households had previously paid less than 10s. rent. Few slum properties had cost that much.

Courtesy of Manchester Libraries, Information and Archives, Manchester City Council

of the 1930s was not the most propitious time for expanding new businesses. A survey in 1935 revealed that around two-thirds of workers who had moved to Wythenshawe still worked in Manchester or at Trafford Park, the majority of them cycling to work despite the provision of subsidized bus transport.[52] It was not until the 1950s that Wythenshawe's three industrial zones (at Sharston, Roundthorn and Moss Nook) took proper shape. Equally the much-awaited civic centre was not completed till the 1960s. In the event Wythenshawe became a garden suburb rather than a satellite town. It was too close to its parent to be independent, and residential priorities meant the proportion of industry to housing was too low for a self-contained community to develop. Nonetheless it had been a brave conception.

Wythenshawe was the main offspring of a publicly funded house-building programme entered into with zeal by Manchester Corporation. Between 1920 and 1938 a total of 27,447 council houses were erected, plus a further 8,315 built by

private contractors with subsidies or loans from the corporation. These numbers exceeded by far the 15,845 private houses built locally without subsidy between 1925 and 1938, a ratio of public to private construction well above the national average.[53] Manchester's council houses of the inter-war years were planned to meet the latest requirements in health and convenience, and with considerable attention to detail. House styles varied, but the most common corporation home consisted of a living room, kitchen and scullery, plus two or three bedrooms. Upstairs bathrooms were to be standard, and instructions were even given that mouldings and skirtings were to be without ledges to prevent the accumulation of dust.

The foundations of modern slum clearance were laid in the 1930s. The Greenwood Act of 1930 (the implementation of which was delayed two years by the economic crisis of 1931) gave a central government subsidy to each local authority that developed schemes of demolition and rehousing. But disappointingly few properties were replaced under this legislation up to 1939. The Manchester authorities were able to condemn only 15,000 houses out of a total stock of around 180,000. In 1942 the city's medical officer of health estimated that Manchester still had approaching 69,000 unfit properties, and over one-third of all houses remained below 'reasonable' standards of sanitation. Manchester was one of the provincial cities targeted by the Luftwaffe in the wake of the Battle of Britain. Although not among the worst affected cities, the bombing of Manchester was intensive in the central area. There were several raids on the city for twelve months or so from late

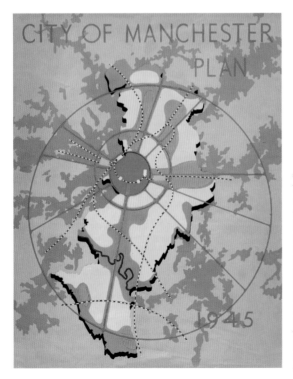

The *City of Manchester Plan 1945* offered a blueprint for post-war reconstruction that sought to deal not only with the impact of wartime bombing but also the Victorian inheritance of decaying housing stock that characterized the built environment of central Manchester and the inner residential areas. As the cover illustration implied, the city had a plan that transcended its political boundaries. 'The main object of the Plan outlined in these pages is to enable every inhabitant of this city to enjoy real health of body and health of mind. For most of us in Manchester this must remain an unattainable ideal until radical improvements have been made in our living and working conditions … nearly a quarter of a million of us are huddled together in terrace houses completely lacking in modern internal amenities – often indeed in a state of decay approaching structural collapse.' *City of Manchester Plan 1945*, p. 1.

1940 but it was the so-called Christmas Blitz of 22/23 and 23/24 December that did most damage. On those two nights the Luftwaffe dropped thousands of incendiary devices and high-explosive bombs on Manchester, Salford and Stretford. Over 1,300 people were killed or seriously injured and around 1,500 buildings were destroyed or seriously damaged. At the end of the Second World War the *City of Manchester Plan 1945* was published by Manchester Corporation. Produced in the midst of 'total war' it offered a blueprint for reconstruction that sought to deal not only with the impact of wartime destruction but also the Victorian inheritance and decaying housing stock that characterized the built environment of central Manchester and the inner residential areas.

Central to the *City of Manchester Plan 1945* was the need to rationalize roads and rehouse the population – both those people made homeless by the bombing, and the much larger number living in substandard housing inherited from the Victorian era. The housing programme outlined in the Plan determined that no more than one-fifth of family accommodation provided in any part of the city should be in the form of flats. This was accompanied by a pledge to build no more than 12 houses per acre. Such low-density planning led logically to the need for overspill (i.e. the rehousing of up to 150,000 people outside the municipal boundary). Since the inter-war period Manchester had resisted inner-city high-rise housing as the chief instrument in housing policy (unlike Liverpool, which pioneered such developments). The consequence was the search for overspill sites outside the municipal area, with all that that was to entail in the later 1940s through to the 1960s. Despite some flat building within the municipal area, the priority remained the need for more overspill land. The main aim was to build what might have amounted to two more 'Wythenshawes' in Cheshire, at Mobberley and at Lymm. This would have greatly extended the geographical reach of the city and the shape of the 'greater Manchester' that would have emerged. However, the strong objections of Cheshire County Council found support in Whitehall and lack of central government interest put paid to this plan.[54]

Manchester entered the second half of the twentieth century with its housing problems still not solved. By the 1960s it had become clear that the solution lay not with the preferred policy of rehousing people in one or two large new towns, but in the more piecemeal approach of building several smaller, less well-provisioned overspill council housing estates within the boundaries of surrounding authorities. Although a second-best solution for the city, this policy had a cumulative effect on surrounding communities, transplanting many families and households from inner-city districts to new housing estates. Between 1953 and 1973 almost 23,500 new dwellings were built on 22 sites, the largest of which were at Langley in Middleton and Hattersley in Hyde.[55] These were not mini-Wythenshawes. It was not just a question of size; there was no planned industry to accompany these residential estates and when they were first built social amenities were meagre. The fact that the 1947 Town Planning Act undermined the tradition of regional planning

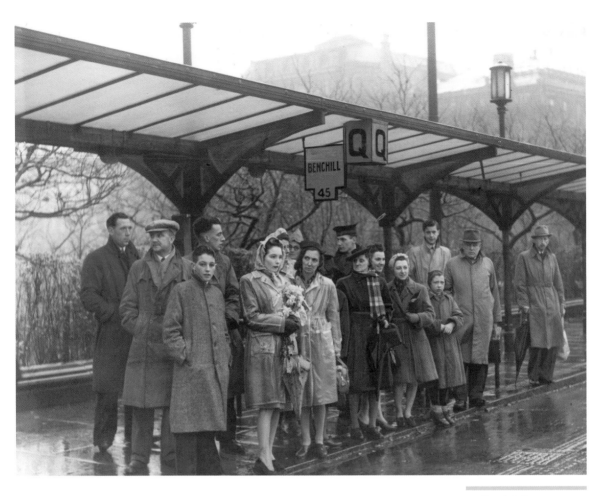

The daily bus commute.
Passengers queuing
in the rain at Piccadilly
for a bus to Benchill,
Wythenshawe in 1946.

Courtesy of Manchester Libraries,
Information and Archives,
Manchester City Council

was to be blamed by some for the failure to develop a comprehensive housing strategy for what had become by the 1950s a *de facto* metropolitan region.[56]

The historic significance of some social housing is well understood. For example, within Greater Manchester the planning and building of Wythenshawe Garden City in the 1930s attracted national attention. Less well known is the impact of the 'neighbourhood unit' idea on post-war planned social housing. Town planners and sociologists sought to develop model home neighbourhoods in the suburbs as part of the reconstruction of the bombed cities. In doing so they drew on planning ideas developed in Europe and the USA earlier in the century. Both the *County of London Plan* of 1943 and the *City of Manchester Plan 1945* had proposed low-rise suburban public housing organized in neighbourhood units with appropriate facilities as the ideal solution to the housing problems of the inner city with its decaying inheritance of nineteenth-century industrial housing exacerbated by the devastation of aerial bombardment. In the event, when massive slum-clearance programmes were carried out in British cities during the 1960s and 1970s, inner-city high-rise solutions were preferred, which in some cases have become notorious

for their very lack of neighbourhood environments. Although Manchester had experimented with high-rise dwellings as early as the 1890s (Victoria Square Buildings, Oldham Road) and had constructed 9,000 low-rise council flats between the wars, it was not until the late 1960s that the corporation turned to the system-built tower blocks so popular with other metropolitan authorities. When it did, the results, although sometimes architecturally innovative as in the 'Crescents' in Hulme, more often proved socially disastrous. The living problems created by some designs were so severe that demolition was considered the only solution less than two decades after construction. Despite these problems, by the late 1970s approaching half of the borough of Manchester's inhabitants lived in accommodation rented from the city council, well above the national average of 29 per cent. However, the era of massive public rehousing programmes may be over for good. At any rate, government policy after 1979 acted as a restraint. Cutbacks in local authority housing finance reduced the number of new properties built by the city from 2,200 in 1977/78 to just 77 in 1986/87.

Metropolis

The shaping of the modern metropolis of Manchester began over two centuries ago. Over time the township became a city and the city has become a region. This chapter has not been a political history of the growth of a 'greater Manchester' but the story of how residential patterns have transcended municipal boundaries and determined the footprint made by the modern city. We have seen how the first suburbs emerged before the advent of new transport technologies on road and rail. However, it is also evident that it was these new forms of transport that enabled the city to grow and spread in the manner it has. We have noticed the class-based character of residential patterns inherited from the Victorian era and perpetuated in much of the suburban development of the twentieth century. We have witnessed the continuing geographical spread of Manchester unconstrained by administrative borders. In conclusion it is worth considering where we are today and what it means to speak of 'Manchester' in the twenty-first century.

In terms of identity and sense of place, metropolitan areas like Greater Manchester encompass many varied local identities that are not diminished by inclusion in the metropolis any more than the districts of Greater London are less marked because of their absorption within the generalized epithet 'London'. The suburbs generated by the wealth and economic vitality of Manchester acquired their own identities and histories. They may have seemed uniform and lacking in individuality from the outside but their communities found expression through such things as churches, clubs and societies, and local newspapers. Those identities may be lessened today in the era of mass media and the information revolution, but that is not a fate peculiar to the suburban dweller and his or her sense of place. The house with a garden is still a key ambition for many and the appeal of the suburbs remains strong despite the constraints of the modern UK housing market,

although house-ownership is now considered more desirable than the Victorian preference for renting.

Perhaps the strongest urban identities within modern Greater Manchester are those relating to traditional urban areas from Salford to Oldham, from Wigan to Stockport. Although the economies of these towns are as much dependent upon that of Manchester as any of the suburbs within and beyond its boundaries, they retain distinct identities, although these may be weakening with time and less forcibly expressed than in the past. Nonetheless those living today in these former industrial towns are part of a metropolis that takes the name Manchester. Does that make them all citizens of Manchester? Few in those towns would accept that designation. But equally, few would deny the reality of interdependence within a metropolitan region, which has its historic roots and present reality in the strength of the dominant economy that has given its name to the entire region. Furthermore, reflection on the history of urban growth in what is now Greater Manchester would support the contention that in this process these towns have, in part, themselves become suburbs of Manchester, reflected in commuting patterns by road, rail and metrolink tram.

A key issue in understanding the modern metropolitan area is the relationship of the suburbs to the city. Because of their history, the suburbs are generally defined as being dependent upon the urban core – residential or 'dormitory' districts physically located outside or on the edge of the central urban area and distinct from the latter with its predominantly commercial, retail, administrative and industrial functions. They generally display lower housing density than the residential quarters of the urban core; the characteristic housing type is the single family dwelling with garden; and there is usually a commuting relationship to the urban core linked to the development of transport systems. However, in recent times the distinction between the suburbs and the 'core' has become blurred as successive waves of suburban growth have been subsumed within the expansion of the metropolitan area. The impact of mass motoring on the functionality and appearance of the emerging metropolis has been crucial. The car changes the way people use the city, making (sub)urban areas increasingly interdependent. The road network itself has been transformed. Although the arterial routes inherited from an earlier age have largely survived, bypasses, flyovers and car parks add a doubtful degree of interest to the urban landscape. Fortunately, Manchester city centre has largely escaped the intrusions of the motorway network that scarred Birmingham and Glasgow, and the M6 takes a route to the west of the metropolitan area, although the necessary orbital route of the M60 cuts a swathe through surrounding districts. 'Out-of-town' shopping malls and retail parks, imported from America since the 1970s, have complicated the pattern of road use from the simple suburb–city–suburb commute and further extended the built-up area. The relocation of offices and the creation of business parks away from the city centre added to the mix. The result has been a decentralization of services and the interconnection of intra-urban locales within a broader metropolitan area with its several urban

centres. While the simple dichotomy between urban core and suburban districts may help explain historic forms of residential growth around cities like Manchester, to understand the dimensions and character of our present-day urban structure it is more appropriate to view it as a diverse yet integrated metropolitan complex that incorporates several urban centres, including older towns and modern suburbs. Yet it is also important to restate that historically the suburbs were the dynamic element in this process, expanding the core area and extending physical links to surrounding towns, filling up the land with bricks and mortar and in the process creating the extensive metropolis of today.

Finally, the expansion of the built-up area over the last sixty years or so has been at a greater pace and more extensive in scope than at any time since the region's suburban development began two centuries ago. This has involved an explosion of new building in the private and social housing sectors and extensive infill development as well as outward expansion. Accompanying this has been a dramatic shift in the balance of the housing stock, with a sharp decline in the proportion of nineteenth-century housing of all types and quality. These are changes unprecedented in scope and significance that along with the decentralization of urban services and functions is producing a revolution in our midst. We may argue about where Manchester begins and ends today. We can be less certain about where the city will begin and end tomorrow.

Notes

1. R. Fishman, *Bourgeois Utopias: The Rise and Fall of Suburbia*, New York: Basic Books, 1987, p. 73.

2. J. Aston, *The Manchester Guide*, Manchester, 1804, p. 119.

3. J. Aikin, *A Description of the Country from Thirty to Forty Miles Round Manchester*, London, 1795, p. 206. See also Aston, *Manchester Guide*, p. 274.

4. Aston, *Manchester Guide*, p. 275. The celebrated scientist James Prescott Joule grew up and lived his early life in a large house at the Acton Square end of the Crescent. The house survives today as part of the University of Salford.

5. *Bradshaw's Manchester Journal*, 16 (14 August 1841), p. 241.

6. T. Swindells, *Manchester Streets and Manchester Men, First Series,* Manchester: J.E. Cornish, 1903, p. 3.

7. J. Butterworth, *A Complete History of the Cotton Trade*, Manchester, 1823, p. 258.

8. *Manchester As It Is: Or, Notices of the Institutions, Manufactures, Commerce, Railways, Etc of the Metropolis of Manufactures*, Manchester: Love & Barton, 1839, pp. 200–1.

9. Letter to Frederick Cobden, September 1832. Quoted in J. Morley, *The Life of Richard Cobden*, London: Macmillan, 1908, vol. I, p. 24.

10. J.S. Gregson, *Gimcrackiana or Fugitive Pieces on Manchester Men and Manners Ten Years Ago*, Manchester, 1833, pp. 88–98.

11. Today this house is open to the public.

12. J. Uglow, *Elizabeth Gaskell: A Habit of Stories*, London: Faber & Faber, 1993, p. 272.

13. M. Spiers, *Victoria Park Manchester: A Nineteenth-century Suburb in its Social and Administrative Context*, Manchester: Chetham Society, 1976, has a list of prominent residents of Victoria Park in Appendix 3.

14. N. Cardus, *Second Innings*, London: Collins, 1950, p. 7.

15. Mrs W.C. Williamson, *Sketches of Fallowfield and the surrounding manors past and present*, Manchester, 1888; William Royle, *History of Rusholme with a gossipy talk of men and things*, Manchester, 1914 [1905].

16. The house survives today as Chancellors, a University of Manchester hotel and conference centre.

17. R. Ryan, *A Biography of Manchester*, London: Methuen, 1937, pp. 71–2.

18. Ibid., p. 72.

19. Revd R. Parkinson, *On the Present Condition of the Labouring Poor in Manchester* (1841), reprinted in *Focal Aspects of the Industrial Revolution 1825–1842*, Shannon: Irish University Press, 1971, p. 114.

20. L. Faucher, *Manchester in 1844: Its Present Condition and Future Prospects*, London: Simpkin, Marshall & Co. and Manchester: Abel Heywood, 1844, p. 26.

21. British Parliamentary Papers, *Commissioners for Inquiring into the State of Large and Populous Districts, First Report*, XVII, 1844, Appendix, pp. 58–70.

22. James Pigot & Son, *General and Classified Directory of Manchester*, 1832, records services to Ardwick, Broughton, Cheetham Hill, Eccles, Greenheys, Pendleton, Rusholme etc. 'several times a day'.

23. *Panorama of Manchester and Railway Companion*, published J. Everett, Market Street, Manchester, 1834.

24. E. Gray, *The Manchester Carriage and Tramways Company*, Rochdale: Manchester Transport Museum Society, 1977, p. 12.

25. D. Brumhead and T. Wyke, eds, *Moving Manchester: Aspects of the History of Transport in the City and Region since 1700*, Manchester: Lancashire & Cheshire Antiquarian Society, 2004, p. 163.

26. Royle, *History of Rusholme*, 1914 edn, p. 64. Although the omnibus assisted the commute of those in the early suburbs we must not forget that this was an age when even the wealthy were prepared to walk the few miles into town from their suburban homes. This is evident from two valuable diaries of Manchester men in the 1840s. See D. Hogkins, ed., *The Diary of Edward Watkin*, Manchester: Chetham Society, 2013, p. 62, and M. McBride, ed., 'Thomas Leech Diary 1839–40' (entries for 6 January 1840) [http://www.leechdiaries.com]. Watkin lived in Northenden and Leech lived in Urmston.

27. N. Mitford, *The Ladies of Alderley*, London: Hamish Hamilton, 1967, p. 62.

28. K. Chorley, *Manchester Made Them* (1950), Hale: Silk Press Books, 2001. See also M. Hyde, *The Villas of Alderley Edge*, Altrincham: Silk Press, 1999. For passenger traffic receipts at Alderley, see J. Simmons, *The Railway in Town and Country 1830–1914*, Newton Abbott: David & Charles, 1986, p. 113.

29. F. Dixon, *The Manchester South Junction & Altrincham Railway*, Oxford: Oakwood Press, 1994, p. 158.

30. J. Simmons, *The Victorian Railway*, New York: Thames & Hudson, 1991, pp. 324–32; F. Bamford, *The Making of Altrincham 1850–1991*, Altrincham: privately published, 1991; F. Bamford, *Mansions and Men of Dunham Massey*, Altrincham: privately published, 1991; R.N. Dore, *A History of Hale, Cheshire*, Altrincham: John Sherratt, 1971.

31. T. Kennedy, 'Who built Chorlton? The development of a late Victorian suburb', *Manchester Geographer*, New Series, 10 (1989), pp. 2–19.

32. For Sale, see J. Newhill, *The Story of Sale from 1806 to 1876: A 'House Detective' Book*, Ashton & Sale History Society, 2011; J. Newhill, *Sale, Cheshire in 1841*, Ashton & Sale History Society, 2007; N.V. Swain, *A History of Sale*, Wilmslow: Sigma, 1987. For Brooklands, see L. Grindon, *Manchester Banks and Bankers*, Manchester: Palmer & Howe, 1878; I. Collins, ed., *Chapters in Parish History: The First Hundred Years of the Church of St John the Divine, Brooklands*, Brooklands: privately published, 1968; A. Brackenbury, 'The road from Brooklands Station', *Journal of the Railway and Canal Historical Society*, 31 (1993), pp. 170–4.

33. See M. Harrison, 'Burnage Garden Village: an ideal for life in Manchester', *Town Planning Review*, 47 (1976), pp. 256–68.

34. S. Mosley, *The Chimney of the World: A History of Smoke Pollution in Manchester*, Cambridge: White Horse Press, 2001, pp. 54, 65, 205.

35. See the map at the back of A.K. Kirby, *Dan Boyle's Railway: A Record of Manchester Corporation Tramways 1901 to 1906*, Manchester Transport Museum Society, 1974.

36. H.C., 1905, XXX, 587, cited in J.R. Kellett, *The Impact of Railways on Victorian Cities*, London: Routledge & Kegan Paul, 1969, p. 359; C. Divall and W. Bond, eds, *Suburbanizing the Masses: Public Transport and Urban Development in Historical Perspective*, Aldershot: Ashgate, 2003, p. 77.

37. Quoted in J. Joyce, *Roads and Rails of Manchester 1900–1950*, Shepperton: Ian Allan, 1982, p. 50.

38. Ibid., pp. 52–6; J.P. McKay, *Tramways and Trolleys: The Rise of Mass Urban Transport in Europe*, Princeton, NJ: Princeton University Press, 1976, pp. 217–19.

39. See statistics in C. Pooley and J. Turnbull, 'Commuting, transport and urban form: Manchester and Glasgow in the mid-twentieth century', *Urban History*, 27 (2000), pp. 367–8, tables 3 & 4.

40. See M.J. Law, *The Experience of Suburban Modernity: How Private Transport Changed Interwar London*, Manchester: Manchester University Press, 2014.

41. Pooley and Turnbull, 'Commuting, transport and urban form', p. 368, table 4; S. Gunn, 'People and the car: the expansion of automobility in urban Britain, c.1955–70', *Social History*, 38 (2013), pp. 220–37.

42. Office of Population Census and Surveys, *Census 1971. England and Wales. Availability of Cars*, London: HMSO, 1973.

43. W.H. Mills, 'Manchester of to-day', in H.M. McKechnie, ed., *Manchester in 1915: being the handbook for the eighty-fifth meeting of the British Association for the Advancement of Science*, Manchester: Manchester University Press, 1915, pp. 10–11.

44. J.B. Priestley, *English Journey*, London: William Heinemann, 1934, p. 252. Rachel Ryan made much the same point in *A Biography of Manchester*, ch. 2.

45. The Metropolitan County of Greater Manchester was created by the Local Government Act of 1972.

46. GB Historical GIS / University of Portsmouth, Historical Statistics on Population for the Modern (post 1974) County, *A Vision of Britain through Time*, http://www.visionofbritain.org.uk/unit/10056925/rate/POP_CH_10 (accessed 8 January 2016).

47. E.D. Simon and J. Inman, *The Rebuilding of Manchester*, London: Longmans, Green, 1935, p. 149.

48. These 'timeslice' maps were created as part of the Greater Manchester Historic Urban Landscape Characterization Project funded by English Heritage and are reproduced courtesy of Greater Manchester Archaeology Advisory Service, University of Salford.

49. In 1844 Leon Faucher had described how Manchester, 'like a diligent spider, is placed at the centre of the web, and sends forth roads and railways towards its auxiliaries … which serve as outposts to the grand centre of industry.' *Manchester in 1844*, p. 15.

50. B. Rodgers, 'Manchester: metropolitan planning by collaboration and consent; or civic hope frustrated', in G. Gordon, ed., *Regional Cities in the United Kingdom 1890–1980*, London: Harper & Row, 1986, p. 44.

51. Simon and Inman, *Rebuilding*, p. 36.

52. See *Wythenshawe: The Report of an Investigation made by Manchester and Salford Better Housing Council*, Manchester, 1935, pp. 10–11.

53. A. Redford and I. Russell, *The History of Local Government in Manchester*, vol. III, London: Longman, 1939–40, p. 246.

54. This story has often been told, but for a reassessment, see P. Shapely, *The Politics of Housing*, Manchester: Manchester University Press, 2007, pp. 132–57.

55. *Manchester: 50 Years of Change. Post-War Planning in Manchester*, London: HMSO, 1995, p. 24.

56. See, for example, L.P. Green, *Provincial Metropolis: The Future of Local Government in South-East Lancashire*, London: George Allen & Unwin, 1959, esp. p. 201.

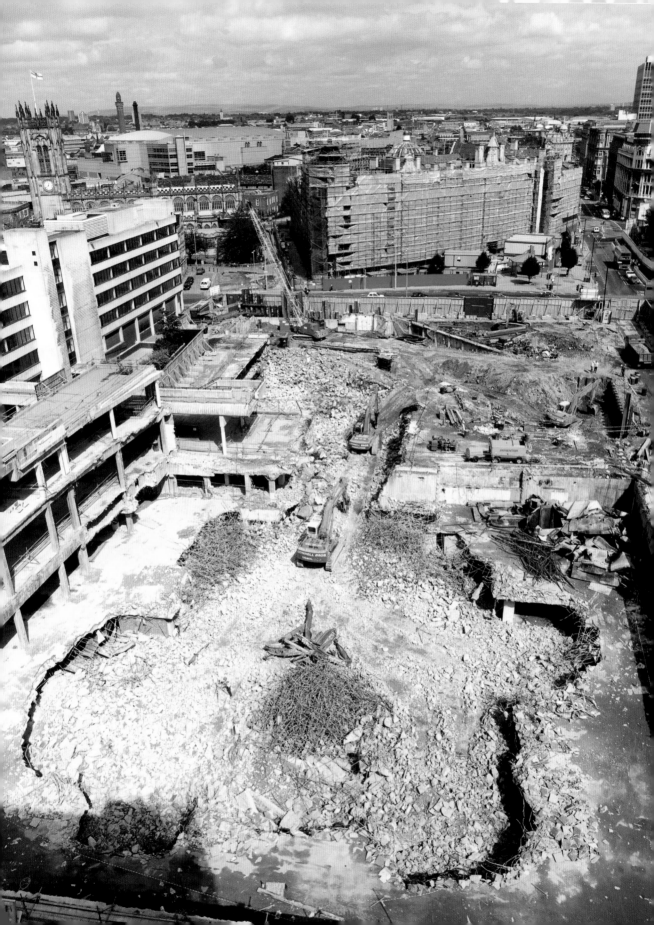

The Resurgent Entrepreneurial City

BRIAN ROBSON

Manchester can claim to be the first big industrial city to have successfully rein-vented itself in response to the evolution of a post-industrial consumer-based world. This chapter traces the history of the journey that it has fashioned from catastrophic economic decline in the three decades from the 1960s to the 1980s to a new-found resilience and confidence. This has underlain the regeneration of some of its most deprived areas and the development of the city's new post-industrial economy. If it is a pioneer in this process, much of the credit can be attributed to the astute leadership and drive of the city council and its chief executive, and also to the work of the many individuals who played significant roles in turning around the city's fortunes from the 1990s. Manchester still faces challenges in tackling deprivation in some fringe areas outside the city centre and in improving the skills of its residents, but the saga of the renaissance of Manchester's city region is an impressive achievement.

Manchester's rollercoaster economy

Manchester's economy suffered a prolonged post-war collapse.[1] The successive recessions of the early 1970s, 1980s and 1990s left the city's economy in a parlous state. The collapse mirrored developments elsewhere as industrial towns and cities experienced the effects of the twin processes of de-industrialization and globali-zation which impacted most strongly on the big northern cities that had relied disproportionately on heavy manufacturing and exports. There was some recovery

IRA bomb, 15 June 1996. There were no fatalities but over 200 people were injured when the IRA exploded a bomb concealed in a van that was parked by Marks and Spencer and the Arndale Centre in Corporation Street. The damage to the city centre was extensive. Collaborative partnerships between the city council and business resulted in an ambitious programme of redevelopment that was to revitalize the city centre in a remarkably short period of time.

Reproduced with the kind permission of Len Grant

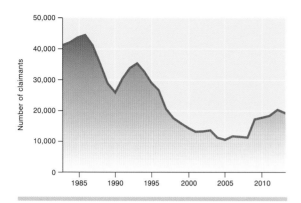

Figure 8.1 Unemployment in Manchester, 1983–2013, JSA
claimant numbers

Source: Nomis

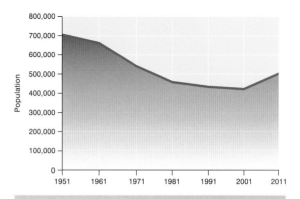

Figure 8.2 Manchester's population, 1951–2011

Source: Censuses

	Number employed (000s)		% change
	1981	1989	1981–89
Textiles	31.3	21.1	–32.5
Mechanical engineering	56.6	43.7	–22.8
Electrical engineering	36.0	29.5	–18.1
Clothing and footwear	32.4	28.1	–13.2
Paper, printing, publishing	33.7	22.0	–34.8
Total	190.0	144.4	–24.0
Total conurbation employment	1,041.8	1,038.2	–0.3

Table 8.1 The demise of manufacturing, Greater Manchester, 1981–89

Source: Calculated from J. Peck and M. Emmerich, 'Recession, restructuring and the Greater Manchester
labour market', SPA Working Paper 17, School of Geography, Manchester University, 1992

	Number employed (000s)				Absolute change (000s)			% change
	1981	1984	1987	1989	1981–84	1984–87	1987–89	1981–89
Primary	27	23	21	17	–4	–2	–4	–37.0
Manufacturing	346	291	292	283	–55	1	–9	–18.2
Construction	53	49	52	54	–4	3	2	1.9
Services	617	614	653	684	–3	39	31	10.9
TOTAL	1,042	977	1,017	1,038	–65	40	21	–0.4

Table 8.2 Employment change in Greater Manchester, 1981–89

Source: J. Peck and M. Emmerich, 'Recession, restructuring and the Greater Manchester labour market', SPA Working
Paper 17, School of Geography, Manchester University, 1992

from the mid-1990s, contraction after the 2008 recession, and then a recent upturn in the city's fortunes.

Three sets of indicators paint a picture of this economic switchback: unemployment, the sectoral composition of the workforce and population.

Unemployment. Manchester's unemployed numbers peaked in the three recessions, but were then followed by continuous improvement from 1993 until the crash of 2008 (Figure 8.1). This was an identical pattern to the national trend, but the city's unemployment rate was consistently 30–40 per cent higher than that for England and Wales.

Sectoral composition. Accounts of the manufacturing collapse in the 1970s spell a bleak picture. Lloyd concluded that Greater Manchester 'remains a conurbation in the process of slow and painful transition where the forces for decline currently far outweigh new sources of industrial and employment growth'.[2] Between 1966 and 1975 the conurbation lost almost a quarter of its manufacturing jobs, the great bulk of which came from plant closures. The service sector failed to replace this massive loss of jobs.

The recession of the early 1980s had a similarly dramatic impact on manufacturing.[3] More than 65,000 jobs were lost overall across the conurbation, with losses spread across all sectors. By the end of the 1980s the five manufacturing stalwarts had been reduced to a mere 14 per cent of overall employment. Textiles, which had been the largest employer in the 1960s and 1970s, had already fallen to the lowest of the five by 1981 (Table 8.1). However, unlike the 1970s, service employment in the second half of the 1980s made a relatively strong recovery after the recession (Table 8.2).

It is now quite difficult to recall the general gloom that characterized most opinions about cities in the 1970s and 1980s. Commentators talked about 'triage' and rehearsed arguments for closing down Glasgow and Liverpool. Cities and big towns were seen as problems. Few voices argued the merits and potential of cities.[4] It may now be generally accepted that cities are the solution not the problem – it is they that drive regional and national economies – but to most commentators it did not look that way from the perspective of the 1980s.

For Manchester itself, manufacturing fell from over one-third of employment in 1961 to a mere 5.5 per cent by 2011, but over the same period employment in services doubled from 42 per cent to 83 per cent (Table 8.3). The breakdown of service employment in 2011 shows that 40 per cent was in the health and education sectors and that employment in finance was a surprisingly low 6.6 per cent. The employment pattern shows a marked contrast between the southern and northern halves of the conurbation. For example, in 1961 six of the seven (old) northern boroughs had 20 per cent or more of their total female employees working in textiles, with Rochdale (47 per cent) and Bolton (35 per cent) having the largest percentages. Contrariwise, four of the five central and southern boroughs

Year		Primary	Manufacturing	Construction	Utilities/Transport	Services
1961	Manchester	0.8	39.1	9.6	8.8	41.8
	England & Wales	6.1	31.3	8.1	7.1	47.3
1971	Manchester	0.2	36.7	7.4	9.0	46.8
	England & Wales	4.2	34.8	7.0	8.2	45.9
1981	Manchester	0.2	26.9	7.7	9.6	55.7
	rest of GM	0.4	34.0	7.0	8.3	50.2
	England & Wales	2.2	27.6	6.9	9.7	53.7
1991	Manchester	2.3	15.9	7.7	8.9	65.2
	rest of GM	3.5	22.6	7.6	7.9	58.5
	England & Wales	4.8	18.1	7.4	8.3	61.5
2001	Manchester	0.5	11.3	5.5	9.3	73.5
	rest of GM	0.6	18.3	7.3	8.3	65.5
	England & Wales	1.9	15.8	7.1	8.2	67.1
2011	Manchester	0.1	5.5	4.9	6.5	82.9
	rest of GM	0.2	10.6	8.4	7.1	73.7
	England & Wales	1.1	9.4	8.1	6.6	74.9

Table 8.3 Employment (%) by sector, 1961–2011

Source: Censuses

		Female employees in textiles	% of female workforce	Total textile employees as % of total workforce
Northern boroughs	Bolton CB	12,360	35.4	23.0
	Bury CB	3,330	25.3	21.0
	Oldham CB	6,300	24.9	16.8
	Rochdale CB	8,970	46.8	34.0
	Wigan CB	3,180	18.9	10.9
	Ashton MB	2,230	20.8	12.8
	Middleton MB	1,590	24.6	16.9
Central & southern boroughs	Manchester CB	6,180	3.7	2.8
	Salford CB	1,250	4.3	3.4
	Stockport CB	2,460	10.2	6.6
	Sale MB	0	0.0	0.2
	Stretford MB	130	1.0	0.8

Table 8.4 Employment in textiles, the old county boroughs and metropolitan boroughs in 1961

Source: Census

	1951	1961	1971	1981	1991	2001	2011
Manchester	703,082	661,791	543,650	459,200	432,700	422,900	502,900
Greater Manchester	2,688,987	2,699,711	2,729,741	2,575,441	2,569,700	2,482,352	2,682,500
% change	**1951–61**	**1961–71**	**1971–81**	**1981–91**	**1991–2001**	**2001–11**	
Manchester	−5.9	−17.9	−15.5	−5.8	−2.3	18.9	
Greater Manchester	0.4	1.1	−5.7	−0.2	−3.4	8.1	

Table 8.5 Population totals, Manchester and Greater Manchester, 1951–2011

Source: Censuses

had significantly less than 5 per cent (Table 8.4). The contrast was equally true for the total workforce of the northern and southern boroughs. However, in a remarkably short period, overseas competition dealt near fatal blows to the textile mills of the northern boroughs and the legacy is painfully clear in their still empty or underused carcasses.

Population. Population changes have been equally dramatic (Table 8.5 and Figure 8.2). The city's population of just over 700,000 in 1951 fell precipitously to 423,000 by 2001, but in the decade 2001–11 this pattern dramatically reversed, the population growing to over 500,000, an astonishing increase of 19 per cent, markedly faster than any other of the big cities (and indeed on a scale unmatched since Victorian times). Growth has continued in the years since 2011.

Hence, de-industrialization and recession drove a profound restructuring of the city. Its loss of heavy industry was eventually compensated by growth in advanced services, high-end research-based manufacturing and consumer-based activities such as sport, music, medicine and tourism. Manchester is now widely seen as the first ex-industrial city in Britain to have reinvented itself. If, as the economic and demographic statistics suggest, Manchester can justifiably claim to have transformed itself into a post-industrial city and to have achieved this before other places, why should Manchester have been in the vanguard? It certainly had solid strengths on which to build. It sits in the middle of a densely populated area with 7 or 8 million people within easy commuting distance, hence it did not suffer from the smaller half-moon catchments of coastal cities like Liverpool, Hull or Sunderland. The conurbation is unambiguously monocentric and did not suffer the kinds of rivalry experienced between Birmingham and the Black Country, or Leeds and Bradford. It had big research-active universities. It had professional services in law, finance and accounting. It had a successful international airport. To varying degrees other of the conurbations had similar assets, but none had so broad a set of potential strengths as Manchester.

Yet it was not just the fact of these potential assets that helped Manchester to reinvent itself. Assets have to be made to work. The magic bullets that really helped to propel Manchester's transformation seem of a softer, less tangible nature, tied up essentially with strategy, pragmatism, leadership and self-belief. It is these attributes that have translated potential into solid achievements.

Local leadership

Much of the city's success in reinventing itself has reflected the pragmatic astuteness of its leaders, and in particular its current chief executive, Howard Bernstein, the city's *eminence grise*, who has worked in tandem with two successive heavyweight council leaders, first Graham Stringer who became leader in 1984 and then Richard Leese who took over from Stringer in 1996 and has been leader ever since. Over the past three decades this triumvirate has given the city a sense of its strengths, weaknesses and potential, a series of goals to guide its priorities, and an operational model through which to deliver regeneration. This has given Manchester a new sense of direction and a new image both to itself and to the outside world. While this has been underlain by more than a dash of urban boosterism, there are many undoubted achievements that have set the city on the road to living easily with its post-industrial present. The recurring evidence of the leadership given by the city council runs counter to academic arguments about the 'hollowing-out' of the state. Here is a city in which, over the post-war decades, it has consistently been the council that has guided and implemented change. Undoubtedly there have been a multitude of quangos and other bodies that have played roles in the governance of the city, but it has been the city council that has taken an unambiguous lead and spelled out the vision of how the city should best develop.

What has characterized Manchester's refashioning has been its readiness to work with governments of whatever political complexion if, pragmatically, this has been seen as in the city's best interests; early development of genuine partnerships across the public and private sectors; an arm's-length model to involve the private sector in task forces to tackle large regeneration projects; a series of 'visions'

Graham Stringer (right) went to Moston Brook High School and read chemistry at Sheffield University. After working as an analytical chemist he became a Manchester councillor in 1979 and was leader of the city from 1984 to 1996 before becoming an MP, representing Blackley and Broughton. He is shown here laying the foundation stone of a building at the Manchester Science Park.

Howard Bernstein and Richard Leese at the Manchester Aquatics Centre. Howard Bernstein joined the council as a junior clerk, rose to become deputy chief executive and has been chief executive since 1998. His business shrewdness and ability to create partnerships with key players have been critical to Manchester's resurgence as an international city. He was knighted in 2003 and named European Personality of 2004 by the *Financial Times*. Richard Leese read mathematics at Warwick University and taught in Coventry and the USA. He moved to Manchester as a youth worker. He became a local councillor in 1984 and has been leader of the city council since 1996. He was knighted in 2006 after overseeing the city centre's reconstruction after the IRA bomb.

that have in part guided policy and in part capitalized on positive changes outside the council's control; and impressing funders with a can-do approach, reflected in the success of staging the Commonwealth Games, the speed of recovery from the IRA bombing of the city centre, the scale and ambition of the regeneration of East Manchester, and the council's readiness to take an informed stock of its weakness and potential, for example in its decision to commission the warts-and-all Manchester Independent Economic Review.[5]

Much of this was initially embodied in Manchester's approach to City Pride, launched by the government in November 1993. Birmingham, London and Manchester were each invited to produce 'visions' of what they wanted to become and to identify projects to move them in that direction. No specific funding was attached, but it was clear that this represented an opportunity to encourage government to support their ambitions. Manchester took the invitation seriously.[6] It was the first to submit a City Pride prospectus, which embodied some of the most significant and enduring elements of the city's approach to regeneration. First, the leadership of City Pride in Manchester was a public–private partnership (albeit led by the city council itself). Secondly, Manchester opted to incorporate neighbouring

authorities and organizations into its proposals, so that rather than coming solely from Manchester it included Salford and Trafford. It is not too fanciful to see this as dipping a toe into what eventually was to become the wider Manchester city region. Thirdly, stress was placed on the partnership principle, since two Urban Development Corporations and an impressive range of some 150 business, public sector and voluntary bodies were involved. These formed task forces coordinated by Howard Bernstein (then deputy chief executive of Manchester), and with an advisory panel chaired by Graham Stringer.

The resulting document was a glossy pamphlet with the usual aspirational statements about becoming an international city of outstanding potential, together with a series of more specific aims: repopulating the city centre, reducing dereliction and attracting key decision-makers and international investors.[7] In reality, the document was in large part irrelevant. It was the *process* that was important: creating dialogue and partnership across a wide range of bodies and individuals; eroding some of the suspicion between local authorities in the balkanized conurbation; and showing government that this was a city that could deliver. Some commentators sneered at what they saw as a 'development-led vision with overtones of "trickle down" [that] justified unbridled entrepreneurialism',[8] but this was a process-driven

The Town Hall emblazoned with the Olympic rings during the Olympic bid, 1996. Manchester's successive bids for the Olympic Games of 1996 and 2000 may have been unsuccessful but they raised the international profile of the city and laid the groundwork for the successful bid to host the Commonwealth Games in 2002.

Courtesy of Manchester Libraries, Information and Archives, Manchester City Council

blueprint from a city that recognized that economic growth was fundamental to tackling its social problems and that support (and funds) from central government were a critical part of lubricating effective regeneration. Anticipating a possible change of government, Manchester produced a second version of City Pride in 1997, with the three earlier authorities now joined by Tameside.[9]

A strong element of self-belief underlay much of this. Manchester has long thought much of itself, hence the old adage that what the city thinks today will be followed by London tomorrow. In a different sense, the fact that the textile history of the area produced an atypically high proportion of women in the labour force gave them a degree of independence and muscularity lacking in some other industrial districts. It may be unfashionable (and probably unrealistic) to try to characterize what 'a city' collectively thinks, but there was a telling and poignant moment when an expectant audience from Manchester heard that it had been unsuccessful in its bid for the Olympic Games. Many cities would have greeted the outcome with a surly 'we-wuz-robbed': instead, the Manchester audience, unprompted, broke into song with a rendition of 'Always look on the bright side of life'. And this wasn't a touch of Monty Python irony, it was a genuine sense that the city could not fail to triumph ultimately.

This combination of attributes has delivered a city that has been remarkably successful in attracting central government and European Union funding, as well as private investment from big business. Since the late 1980s virtually every regeneration programme from central government has included Manchester – the long list of programmes includes City Challenge, Single Regeneration Budgets, Urban Development Corporations, Urban Regeneration Companies, New Deal for Communities, Enterprise Zones, Housing Market Renewal and a welter of other area-based initiatives and action zones.

The five most high-profile regeneration schemes have been the work of the Central Manchester Development Corporation (CMDC), Hulme, city-centre reconstruction, East Manchester and Salford Quays. Each is worth outlining to illustrate the principles that have motivated and driven the city's trio of Bernstein, Stringer and Leese.

Central Manchester Development Corporation

The Central Manchester Development Corporation was established by government as a private-sector-led Urban Development Corporation with a boundary wrapped tightly round the southern fringe of the central business district. It was initially viewed with some hostility by the city, which had spent the early part of the 1980s making noises opposing central government. However, Graham Stringer managed Janus-faced to keep his backbenchers happy and yet sit on the board of CMDC, recognizing pragmatically that its resources and leverage could benefit the city. CMDC operated from 1988 to 1996 and introduced some dramatic developments to an area one-quarter of which had been derelict or underused. Its initial aims emphasized commercial development. This proved more difficult than

expected since most of its lifespan coincided with the downturn of the early 1990s when rental values plummeted. However, housing, which had been a relatively small element of CMDC's initial aims, played an increasingly important part in its operations and it was residential and leisure developments that proved the most important of its achievements.

It operated in six sectors (Figure 8.3).[10] One was Castlefield, the historic birthplace of the city with the original Roman fort and subsequent industrial overlay of canal basins and massive railway viaducts. Regeneration had started in the 1970s following archaeological investigation and the area's designation as a conservation area in 1979. It was the site of the world's first passenger railway station and when the Liverpool Road rail depot closed in 1975 Greater Manchester Council bought the site as the new home of the Museum of Science and Industry which opened in 1983. Castlefield had been a rather inaccessible – and certainly a largely derelict – part of the city until CMDC opened up the canal complex, made high-quality environmental improvements to the basins and introduced leisure, tourism and residential developments. It proved one of the Corporation's undoubted successes.[11] One of the most entrepreneurial of the city's local developers, Jim Ramsbottom, was centrally

Figure 8.3 CMDC expenditure (£) in its six sectors
Source: Robson et al. (1998)

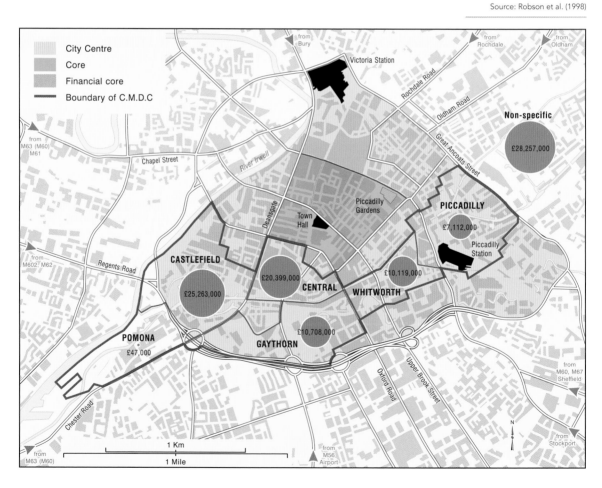

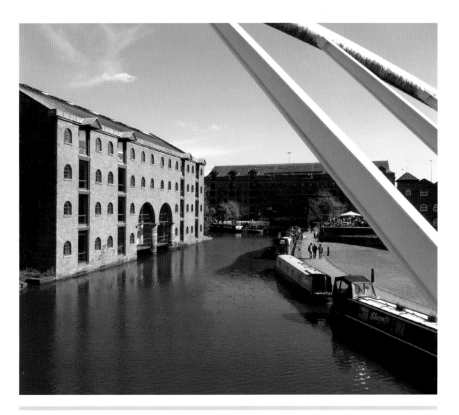

Restored Merchants' Warehouse and Middle Warehouse, Castlefield. Having played a key role in the history of the city in both Roman times and the industrial revolution, Castlefield took on a new significance in the 1970s with a regeneration programme that capitalized on its past, particularly its industrial heritage. Its potential as a leisure and tourist attraction saw the restoration and rebuilding of warehouses around the Bridgewater Canal basin, while the long-neglected terminus of the Liverpool and Manchester Railway became the principal exhibit in the Greater Manchester Museum of Science and Industry.

Courtesy of Brian Webb

involved through his Castlefield Estates Company, through which he bought derelict properties such as Merchants' Warehouse which he converted into offices and apartments, and Dukes 92 (a popular pub, with an adjacent restaurant, Albert's Shed – named after his uncle's tool shed). Other developments included Knott Mill (a complex of small commercial and industrial companies, to which many of the local architects moved their practices), and the refurbishment of other historic warehouses converted into handsome apartment complexes or offices.[12] One of the most iconic is the 1831 Middle Warehouse which became a restaurant, offices and flats. Another is Eastgate, converted into 'studio offices' for creative businesses and designed by the local architectural practice Stephenson Bell. As developer confidence in the area grew, new developments were subsequently undertaken without subsidy and the area is now a bustling mix of refurbished and new buildings.

A second sector was the Whitworth Street area, once the centre of Manchester's cotton trade, with a collection of listed buildings such as the former

Age	Population	% of total	% males
0–4	213	1.2	45.1
5–9	27	0.2	40.7
10–14	84	0.5	53.6
15–19	2,215	12.4	43.7
20–24	6,228	34.9	53.5
25–29	3,936	22.1	57.5
30–34	2,199	12.3	62.3
35–39	980	5.5	67.6
40–49	992	5.6	72.8
50–59	517	2.9	70.4
60–69	233	1.3	68.1
70+	224	1.3	38.4
Total	**17,848**	**100.0**	**56.3**

Table 8.6 Population in the City Centre ward, 2011
Source: Mid-year estimates

headquarters of Refuge Assurance and a number of large ornate textile warehouses. Most were empty or underused, and attracted no commercial interest. CMDC used gap funding to refurbish and re-use the buildings. Most were converted to apartments: Granby House with 238 new apartments; Lancaster House with 71; Orient House with 170. Subsequently, sufficient confidence was generated for the area to develop without gap funding. The huge former Refuge Assurance building became a major hotel, restaurant, casino and offices. All the listed buildings now have productive uses and Whitworth Street is a resilient part of the city centre. Other neighbouring historic warehouse buildings such as Churchgate House and Lee House were subsequently refurbished as offices without CMDC grant assistance.

Of the other areas, the central sector saw two major developments: the construction of a dramatic concert venue, the Bridgewater Hall, which replaced the rather gloomy Free Trade Hall and provided a new home for the Hallé and BBC Philharmonic orchestras; and, adjacent to the concert hall, a large new office complex into which some of the major local law firms moved. Earlier, the area had seen the conversion of the old Central Station into a conference centre and a major exhibition venue, GMEX (now renamed 'Manchester Central'), which was developed by Greater Manchester Council and opened in 1986.

The other sectors attracted somewhat less development. Gaythorn saw the construction of a new office building to which the British Council moved (for what proved an unexpectedly short tenure), and also the conversion of a historic mill complex for student accommodation. Piccadilly saw housing investment in Piccadilly Village which sat (and still sits) slightly forlornly in an area that is

otherwise still awaiting significant physical redevelopment. Pomona had virtually no investment.

The work of CMDC has been spelled out in some detail since it marked the city's first large-scale physical regeneration. It also spelled out some significant messages for future strategy. First, there was clearly market potential for housing in the central area to cater for young professional households and the growing student market. Residents in the burgeoning city-centre apartments were overwhelmingly unmarried and professional. A survey in 1998 found no one under the age of 16.[13] By 2011 there were almost 20,000 people living in the City Centre ward alone, and the central apartment market now spreads well beyond the bounds of that ward (Table 8.6). The market potential for housing and offices was a highly significant lesson for a city that had inherited a huge number of warehouses whose only fate appeared to have been demolition. Secondly, it was clear that scale was important: improve a sufficiently large compact area and the private sector is more likely to invest. Across CMDC's area it was notable that the least successful sectors were its extreme ends, Pomona and Piccadilly. Creating a sufficient mass of environmental and physical improvements was clearly important in bringing market confidence to an area and ultimately achieving non-subsidized development. Thirdly, it was clear that effective regeneration was unlikely to be achieved in a few years. Even for an initiative with a lifespan of eight years, many developments would only be completed long after the closure of CMDC. Fourthly, it was clear that a key element in achieving regeneration was the combination of the public sector (with land holdings, planning powers and potential access to significant public resources) and the private sector (with its technical skills and resource base).

Hulme

One question that CMDC could not address was how best to incorporate local communities in the regeneration process since, prior to its establishment, there were hardly any residents in its area. However, it was in Hulme that the city faced the often sensitive issue of responding to local residents. Hulme's major redevelopment in the 1960s had swept away its earlier dense terraced housing, replacing it with tower blocks and deck-access developments – the notorious Hulme Crescents. The concept – 'streets in the sky' with flats linked by walkways – rapidly proved a design and construction disaster. Concrete spalled, communal waste chutes clogged, lifts broke down, walkways turned into noisy play areas, poor insulation and high energy costs generated health problems. Crime and graffiti abounded. From the 1980s the council began to rehouse families elsewhere and their place was largely taken by young single households and students from the adjacent universities. Squatting became increasingly prevalent. The population was highly polarized with 35 per cent having no qualifications alongside 25 per cent with degrees. Throughout the 1980s there was a stand-off, with an impasse between the council, the then Department of the Environment and the often very articulate residents. A comprehensive solution eventually came in the form of City Challenge, in which

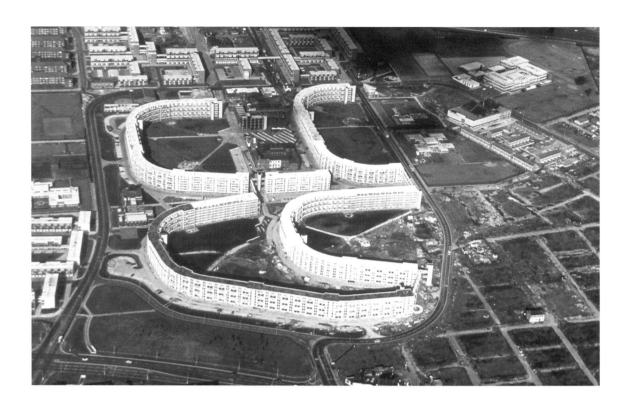

Hulme Crescents. Life in the high-rise deck-access flats in Hulme bore little resemblance to the politicians' and planners' hyperbole of communities living in traffic-free spaces – the 'streets in the sky'. By 1975, the Crescents (named, without irony, in honour of famous British architects) were problem-ridden, expensive to heat and inadequately maintained, leading to many tenants wanting to move out of the poorly constructed buildings. A long and challenging struggle to find a response to Hulme's problems followed, culminating in the launch of the Hulme City Challenge.

Aerial view, courtesy of Manchester Libraries, Information and Archives, Manchester City Council; man sitting on the parapet of Charles Barry Crescent, 1989, reproduced with kind permission from Ian Robinson.

government changed tack by acknowledging the positive role that local authorities could play in tackling regeneration. The programme ran from 1992 to 1997 and injected £35 million into a comprehensive regeneration which was subsequently followed by work on the broader Moss Side and Hulme area over a five-year period with funding from the government's Single Regeneration Budget and the European Commission. Since the ending of City Challenge some £400 million is estimated to have been targeted at the area, resulting in over 2,000 new homes, regeneration of the shops fronting the major thoroughfare of Princess Road, the Hulme Arch straddling the major southern approach into the city (with its flavour of flamboyant *grand projet*) and the business-park of Birley Fields.[14]

Dealing with residents has never come easily to an authority characterized by its *d'haut en bas* approach. However, in Hulme it had to come to terms with one very forceful and coherent resident group, the Homes for Change Co-operative, who were able to negotiate with the Guinness Housing Trust to identify a site at the heart of Hulme on which some 75 flats were built with strong input from the residents themselves and with provision for workspaces within the block of homes.

Two aspects of the regeneration of Hulme subsequently proved significant. First was a 'design guide' developed by the city to determine the nature of redevelopment.[15] This incorporated aspects of architectural determinism: that houses should front on to pavements to generate 'eyes on the street' and discourage street crime, burglary and casual vandalism; and a stress on the permeability of townscape design using significant buildings at street corners to imprint a clear interpretable geometry on to new developments. The Hulme Design Guide left a very distinctive townscape, although the subsequent attempt to roll out the principles to cover new

Hulme Arch. The Hulme City Challenge initiative aimed to bring about the economic, social and physical regeneration of a district that had become defined by its problems. Kick-started by a £37.5 million award from central government, the programme ran for five years, and helped to confirm the importance of partnerships between the public, private and voluntary sectors in community regeneration. A prominent symbol of the regeneration was the Hulme Arch Bridge over Princess Road, a major approach to the city centre from the south, opened in 1997.

development across the whole city proved both more difficult and less effective.[16] What the guide did betoken was an emerging interest in the quality of the city's new architecture and the increasing scope for local architects to expand their practices in the city.[17]

The second aspect was that Hulme was the first real example of the emergence of a 'Manchester model' for tackling regeneration.[18] Hulme's regeneration was overseen by an arm's-length company, Hulme Regeneration Ltd, on which secondees from the city were joined by private-sector developers such as AMEC and Bellway Homes. This was how the city managed to generate commercial confidence to reassure the private sector and yet maintain a firm oversight from the council itself. The model has proved highly successful, not least in the subsequent response to the IRA bombing of the city centre.

Despite some unpersuaded voices,[19] the general view is that the redevelopment of Hulme was a considerable success and a feather in the cap of the authority.[20] Certainly there was a good take-up of new housing, and the value of Hulme housing increased at a faster rate than elsewhere in the city.

Hulme street design. The Hulme Design Guide, describing itself as 'a working tool that will enable Hulme to grow into a successful urban neighbourhood once more', identified among its aspirations the importance of providing a variety of streets to define its urban structure, streets that 'serve equitably the needs of all pedestrians, cyclists, public transport and the private car without being dominated by the motor vehicle'.

City centre

An IRA bomb exploded in the heart of the city on 15 June 1996. No one was killed but many were injured, and there was extensive damage to property, with over 1,000 properties affected. Half a dozen buildings of historic significance had to be demolished.[21] The speed of response to the explosion was impressive.[22] Within a week the bomb-damaged area had been reduced to only five principal sites, focused on the major landowners: Marks and Spencer, close to whose store the bomb had been detonated; P&O, which owned the Arndale Centre; Royal Insurance; Prudential Insurance; and Frogmore Estates. The complexity of a major redevelopment in the heart of a city, allied with the need to maintain the commercial competitiveness of its shops and offices, was a formidable challenge. It was overseen by the second example of an arm's-length task force, a public–private partnership company limited by guarantee. It was headed by Howard Bernstein and comprised secondees from the private sector, the local authority and central government. The earlier development of partnerships meant that the organizations had already worked with each other and this proved important in ensuring speed in getting development off the ground. Again, this arm's-length model was a way of ensuring that, while the council was in the driving seat, the task force had a strong commercial flavour with development expertise that could give confidence both to the affected land- and property-owners and the development industry.

New Cathedral Street. Five months after the IRA bomb, EDAW was announced as the winner of the international design competition to provide a masterplan for the renewal of the city centre, furthering the City Pride goals of making the city a place in which people would want to work and live. High-quality design was a priority, in contrast to the disparaged brutalist architecture of the 1960s. It was a radical plan which included the creation of new public spaces (Exchange Square) and the construction of a new street linking St Ann's Square with the cathedral and the Corn Exchange.

Courtesy of Brian Webb

Encouraged by the then First Secretary of State, Michael Heseltine, the city launched an International Design Competition in mid-July, rapidly narrowed the contestants to five teams, and announced the winner, EDAW, in early November. The redesign was imaginative. It entailed driving a new street – New Cathedral Street – through the original site of Marks and Spencer to link the retail area of St Ann's Square with the cathedral and the heart of medieval Manchester, an area that had previously been effectively cut off from the main circulation flows in the city centre. The new street succeeded in attracting high-profile retailers, including Harvey Nichols, whose only other store in the north had been in Leeds. A new public space was created in front of the Corn Exchange, which had suffered major structural damage. Its previous tenants – small independent stallholders in an indoor market – were displaced, with many moving to the Northern Quarter, while the market itself was replaced by high-end retail businesses. Opening a link to the city's medieval core also had the effect of prompting substantial refurbishment of the area around the cathedral and Chetham's School of Music – the so-called Millennium Quarter.[23]

East Manchester

East Manchester was by far the biggest and most ambitious redevelopment.[24] Once the metal-bashing heart of Manchester's manufacturing, in the decade 1975–85 East Manchester lost more than 20,000 jobs, 60 per cent of its employment.[25] Between 1981 and 1989 the East Manchester Initiative, funded through the government's Urban Programme, tackled a variety of small environmental improvement schemes, especially along the river valleys.[26] However, the essence of the city's subsequent approach was all about scale and comprehensiveness. In 1998 Manchester adventurously and imaginatively bid for resources from two separate government initiatives, New Deal for Communities (NDC) and the 5th Round Single Regeneration Budget (SRB) programme. It targeted both at East Manchester, won funding from both and effectively regarded the two as a single resource pot. In October 1999 the Urban Regeneration Company, New East Manchester Ltd (NEM), was also launched. Like the city's earlier programmes, it used a formal arm's-length company with a mix of private- and public-sector representatives on its board: Marianne Neville-Rolfe, previously director of the NW Government Office, was its first CEO; Alan Cockshaw of AMEC and English Partnerships was chair; Richard Leese was deputy chair; Howard Bernstein was company secretary.[27] These two major programmes joined a welter of existing government-funded initiatives already operating in the area – earlier SRBs, Sure Start and zonal programmes including Health Action, Sport Action and Education Action zones (Figure 8.4). The NDC and NEM complemented each other, although their different foci created some awkward interfaces: NDC was at heart a social programme with heavy involvement of local communities; NEM was much more concerned with physical and economic development.

The challenges facing East Manchester were huge. The area for which NEM was eventually responsible covered some 2,000 hectares. Lacking substantial direct funding, its brief did not entail direct involvement in regeneration but the development of strategic plans and partnerships to deliver physical improvement. It was involved in a number of major developments. The first was Sportcity, the heart of the redevelopment that built on the construction of a cycling velodrome and the stadium for the Commonwealth Games in 2002 (subsequently home to Manchester City FC). A second was the creation of Central Business Park with Fujitsu as the main tenant, where land assembly and reclamation created a large IT complex involving the local universities and FE college as well as private-sector companies. A third key site was the Millennium Community of New Islington, where Urban Splash was the lead developer, capitalizing on the potential of the Rochdale and Ashton canals and attracting novel housing designs by architects like Will Alsop. Apartments, new housing, a free school and a medical centre now form an innovative complex grouped around refurbished canal developments. A fourth was the redevelopment of Beswick, where major housing developers such as Gleeson and Lovells were involved. NEM was also one of the partners involved in developments in Ancoats Urban Village, a major complex of historic listed textile mills fronting the Rochdale canal. One very recent development in Ancoats that illustrates the link between culture and regeneration is the re-use of the nineteenth-century church of St Peter's. This is now used by the Hallé as a rehearsal venue, thereby preserving its superb interior, with slender iron pillars, innovative roof ventilation and huge windows that flood the space with light.

Figure 8.4 East Manchester regeneration programmes

Source: New East Manchester

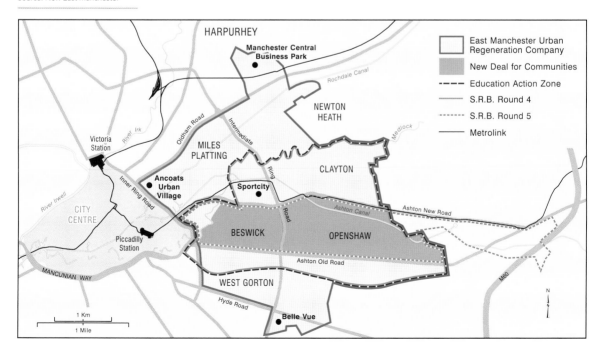

	2003	2004	2005	2006	2007	2008
Average house price (£000)	36.5	50.7	98.0	88.6	127.0	115.9
House price as % of Greater Manchester	36.4	41.7	72.9	60.4	81.6	77.2
Population	3,019	3,009	2,980	2,974	3,171	3,445
Working-age population	2,384	2,395	2,447	2,487	2,721	3,061

Table 8.7 Beswick Housing Market Renewal impacts
Source: Manchester HMR Programme

NEM was also involved in the Housing Market Renewal programme (HMR) which included large swathes of northern and eastern Manchester as well as other of the local authorities in the conurbation. Beswick provides an example of the impact of HMR, showing that over time its house prices grew more in line with those across the city and that its working-age population grew by more than a quarter (Table 8.7). Over 500 new houses were built with HMR resources and the area's house prices rose from about one-third of the Greater Manchester average in 2003 to over three-quarters by 2008.

The other major 'player' in the area was the NDC, officially named by residents as 'New Beacons'. It was able to draw on the 'single pot' of £25 million from an SRB programme and £51 million from NDC resources. Beacons initially faced some daunting challenges, not merely the area's social deprivation but also the disillusionment of residents suspicious of yet another regeneration programme being 'done to them'. It was hugely to the credit of the NDC staff – and in particular its CEO Sean McGonigle – that their dedication to the area and sensitivity to the needs and awareness of the strengths of the local population won over the often spirited residents and contributed hugely to the success of its many initiatives.[28] A telling quote from one active resident speaks volumes: 'Trust and honesty. That's what's needed. I've never known residents believe anyone before, but they did believe in Sean. And the people he brought in from other agencies. They didn't think themselves something they weren't.'[29] Even initially sceptical commentators agreed, sometimes grudgingly, that Beacons had been an outstanding success in the difficult field of community engagement.

The very scale and ambition of regeneration in East Manchester gave the area a high political profile as well as the potential for individual programmes to benefit from proximity to each other and to capitalize on the comprehensiveness of the suites of initiatives. East Manchester was a prime example of the city's belief in tackling large areas and big schemes that had the potential to create the momentum and synergy to bring more impact and more sustainable change than would be achieved by spreading resources widely and thinly.

Salford Quays

While not in the city of Manchester, Salford Quays has become a key element of the conurbation. The quays sat at the end of the Ship Canal, and when they closed in 1982 Salford City Council bought the dock site from the Ship Canal Company, won a rolling grant of £25 million from the government's Derelict Land Grant scheme and began the long process of improving water quality and decontaminating the land on which the quays sat.[30] On what was a bleak and unpromising site Salford attracted investment for a hotel and new apartments, and won a major National Lottery grant for the iconic Lowry Centre with its two theatres and permanent exhibition of paintings by L.S. Lowry.[31] This was complemented by the regeneration of Trafford Park on the Trafford side of the Ship Canal. This was the world's first industrial park, started in 1896 and attracting investment from major American companies such as Westinghouse and Ford Motors. During the war Rolls-Royce engines were made for Spitfires, Hurricanes and other aircraft, and employment reached a peak of 75,000. However, in the post-war years it lost most of its major companies and by the 1980s it was virtually an employment desert. An area along the line of the Ship Canal straddling Trafford and Salford had been declared an Enterprise Zone in 1981, but during the ten years of its existence it attracted relatively few firms, mostly in warehousing and distribution, some of which were merely relocations from the wider area.[32] However, in 1987 the Trafford Park Development Corporation was established and in its eleven years it focused on environmental improvements, new infrastructure and land assembly (Figure 8.5). It succeeded in attracting over 1,000 new firms and generated some 30,000 jobs. It also benefited from the construction of the Imperial War Museum of the North with its iconic building designed by Daniel Libeskind.

Figure 8.5 Trafford and Salford regeneration programmes
Source: Robson (1988)

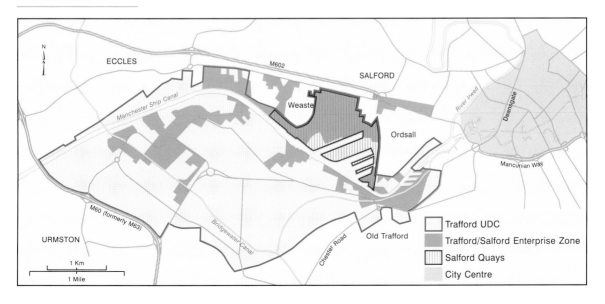

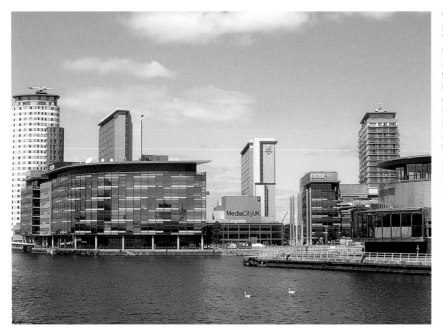

The story of the quays has taken a dramatic new turn in the last decade with the development of MediaCity, the site of the BBC's relocation of five of its production departments. The competing site proposals were reduced by the BBC to two in Manchester and two in Salford, one of which was the last remaining undeveloped site on Salford Quays which, to the chagrin of Manchester, was chosen in 2006. The Peel Group, as site owner, began construction in 2007. The principal tenants include the BBC, media-related organizations and Salford University. ITV had initially resisted a move from its Manchester location, but later changed its mind and completed the first phase of its move to MediaCity in 2013. The whole development comprises new apartments, a hotel, retail and office space and a branch of Metrolink to a new terminus serving MediaCity.

MediaCity has begun to bring huge benefits to Greater Manchester; 3,800 people now work on the site, 2,300 of whom are BBC staff. It is estimated that the various companies generate £190 million per year in gross value added (GVA). The early impact assessment calculated that some 15,000 people would eventually be employed there, adding £750 million per year to the local economy.[33] Manchester's New Economy estimated that the £573 million cost of relocating the BBC would result in £7.6 billion of GVA by 2030 – a return of £13 for every £1 spent. The relocation also reaffirmed Greater Manchester's position as the largest cultural, creative and digital venue outside London. The site sits adjacent to the Lowry and has greatly enhanced the tourist attraction of the wider Salford Quays area, with entertainment spaces as well as venues for conferences and events. There has also been real benefit from the publicity given to Manchester, since many BBC news and current affairs reports now draw on local examples and local participants.

Physical transformation

Most of the early developments relied on public funding. Increasingly, new developments have been largely commercial ventures. Examples include not only numerous individual office, retail and hotel buildings, but also some major sites. Spinningfields, between Deansgate and the river Irwell, is one. Allied London began buying buildings around the John Rylands Library from 1997 and led the major redevelopment of the area. The city council was keen to encourage this, not least to reinvigorate the city centre after the IRA bomb. Indeed it facilitated the sale of Manchester College of Arts and Technology (then one of the city's two FE colleges) and helped the college to relocate to East Manchester. Spinningfields now comprises residential apartments fronting the river, the People's Museum relocated to the historic pumping house (which had provided water pressure to operate lifts in the city centre), new magistrates' courts, the Civil Justice Centre (designed with projecting floors that justify its nickname of 'the filing cabinet') and a cluster of restaurants and fast-food outlets. The heart of the development, The Avenue, aimed to attract prestigious stores and now features Emporio Armani.

The most recent large-scale development is NOMA (denoting 'North Manchester') now being developed by the Co-operative Group on a large site opposite the CIS Tower and stretching to the historic Irish quarter of Angel Meadow. It claims to be the largest redevelopment site outside the south-east. It will comprise office, residential, retail and hotel space, together with the new home of the Co-operative Group. The city council contributed £20 million to its development as an incentive to regenerate an area that had not previously seen any of the refurbishment targeted at other parts of the city. At its heart is One Angel Square, the new headquarters of the Co-operative Group, with its striking design and green credentials.[34]

New developments have fundamentally changed the look of the central area. Manchester was never an especially handsome town. The lack of a significant water frontage, the absence of topography and the sheer speed with which the nineteenth-century city had developed ensured that what visual interest it offered was in individual buildings rather than a whole townscape. Physical regeneration has added an impressive array of new and refurbished buildings to the city's stock. Thirty years ago there was a despairing sense that with so many apparently outmoded warehouses and terraced properties with no obvious potential for re-use, demolition was the only option. However, regeneration has preserved much of the characteristic Venetian Gothic and the handsome detailing of the brickwork of Manchester's textile warehouses. It has brought some striking new and often innovative architecture to add to the townscape. Critics rightly point to the random geometry of the resulting city – a tall Beetham Tower to the south of the centre, a tall refurbished CIS Tower to the north, with odd interesting buildings scattered around in a randomly punctiform fashion – but taken individually there are some architectural stars.

Three outcomes flowed from this physical make-over. First, it generated a healthy cadre of local architects and designers. Ian Simpson has been widely lauded for some of his dramatic buildings, not least the Beetham Tower – a 47-storey tower with the Hilton Hotel occupying space up to level 22, a cantilever projecting out from level 23 where the Cloud 23 bar is located, and apartments rising from level 25 to the penthouse apartment which Simpson himself occupies, along with his own private arboretum. Equally impressive is the Siemens Building on the route from the town centre to the airport. Designed by another local architect, George Mills of Mills, Beaumont & Levy, it has a subtle grey/white textured surface that radiates bright-ness even in the gloomiest Manchester weather. A third local company is Urban Splash, jointly founded by the celebrated entrepreneur Tom Bloxham together with the designer Jonathan Falkingham. They have given both a national and local lead to the re-use of old buildings. The hand of Urban Splash can be seen widely across Manchester. Two developments led by the company have been architectur-ally revolutionary. First are some of the striking developments in New Islington, not least the Chips Building with colourful slabs of 'chips' forming a set of apartments. Second are the 'upside-down' houses on the Chimney Pot Estate in Langworthy in Salford. Just as the plethora of old warehouses had presented headaches, so the acres of nineteenth-century byelaw terraced housing presented quandaries about how to combat their failing market potential. The Chimney Pot development tackled the problem by turning the insides of the houses upside down while keeping the

best bits of the classic Victorian terrace facades. Living space and kitchens are on the upper floors; balconies and private roof terraces have been added and the rear alleyways have been converted into parking and communal gardens.

The second outcome of the physical changes has been the huge expansion in urban tourism and the growth of visitor numbers. Serious tourism started in the 1990s.[35] By 2012 Marketing Manchester estimated that conference and business events attracted over 5 million delegates to Greater Manchester, with an economic benefit of over £800 million and almost 22,000 full-time-equivalent jobs. Manchester has become Britain's third most popular destination after London and Edinburgh. Foreign visitors made 936,000 overnight stays in the city in 2011. Much of this is driven by shopping, drawn by the increasing number of luxury and boutique stores, but also by sport with the attraction of Manchester's two football teams. Manchester United's museum, for example, attracted more than 300,000 visitors. Other top attractions include the Lowry, the Museum of Science and Industry and the Imperial War Museum North. Many visitors are drawn simply by interest in the townscape of the world's first industrial city and evidence of its success in reinventing itself; to cultural events such as concerts at the Bridgewater

Chips Building, New Islington. The architectural practice Urban Splash, founded in 1993 by Tom Bloxham and Jonathan Falkingham, established a national reputation by demonstrating the value of re-using rather than demolishing old buildings in the regeneration of inner-city districts. Their work can be seen widely across Manchester and Salford. The distinctive and colourful Chips Building, designed by Will Alsop, was a landmark new building establishing the identity of New Islington, formerly the Cardroom Estate in Ancoats.

Hall, the Royal Northern College of Music, or MEN Arena; to theatrical performances at the Royal Exchange, Opera House, Lowry or Palace; or to specific events such as the now biennial Manchester International Festival (which in 2013 boasted Kenneth Branagh in a performance of *Macbeth*). The 'reach' of such cultural events can be very extensive, with patrons drawn from a wide area (Figure 8.6). More esoteric and specialized venues include the neo-Gothic splendours of the John Rylands Library, revitalized as part of the Spinningfields development; the city's art gallery; the University Museum; the medieval Chetham's Library with its chained books and alcove where Engels and Marx read and wrote; and the undeservedly overlooked misericords in the cathedral, second only to Ripon in their quality.

The third outcome is the demographic transformation of the central areas. The five wards with the highest population growth show this dramatically. The City Centre ward has outstripped any other area of the city (at least until the post-2008 recession), reflecting the phenomenal growth of apartments. The other four wards with high growth have each been the target of regeneration programmes: Hulme has grown consistently, Moss Side and Ardwick grew in the first half of the period and Ancoats grew impressively in the latter half (Table 8.8).

The city's impressive record has, of course, been tempered by less successful developments. The Urbis Building, for example, was intended to be a celebration of urbanism, but no one seemed to have thought what that might mean and its rather tired and random contents attracted little interest.[36] It has since been refurbished to house the National Museum of Football, which may prove rather more

Figure 8.6 Tickets sold for a concert at the Bridgewater Hall, 2005 (per 10,000 population of origin district)

Source: Robson et al. (2006)

Table 8.8 Wards with the highest (%) population growth, 2001–07 Source: Manchester City Council		2001-04	2004-07
	City Centre	27.4	23.4
	Ardwick	12.6	0.4
	Hulme	12.1	15.7
	Moss Side	11.7	5.4
	Ancoats	4.2	17.1

enticing to visitors. The city has also had rather mixed fortunes with its city-centre shopping. It unsuccessfully opposed the development of the major Peel Holdings' retail development of Dumplington (now called the Trafford Centre) housed in a huge pastiche version of the Brighton Pavilion.[37] It clearly represented a major threat to Manchester, opening as it did in 1998 when the city was recovering from the IRA bomb. The much earlier city-centre construction of the Arndale Centre had had a disastrous impact on the retail fortunes of Oldham Street. More recently, the development of luxury shops in Spinningfields has not helped the prospects of King Street, the erstwhile centre of high-end retail, which now has many empty premises.

One of Manchester's deprived areas, Wythenshawe – the large ex-council estate at the southern boundary of the city – was also somewhat overlooked in the city's regeneration priorities. It never had the slew of major funded programmes that focused on Hulme/Moss Side and East Manchester. It benefited from some smaller programmes, for example to reconfigure its Civic Centre, with new stores and gates locked at night to prevent vandalism. The Forum Centre – with library, leisure centre and café – has also been renovated. However, the major change has been the impact of the transfer of housing stock. From the 1990s ex-council houses were transferred to housing associations, Willow Park in east Wythenshawe and Parkway Green in west Wythenshawe. These two associations merged in 2013 to form the Wythenshawe Community Housing Group, now responsible for around 14,000 homes in Wythenshawe. Stock transfers across the city (for example Eastlands Homes in East Manchester) have transformed the city's tenure so that whereas in 1981 47 per cent of Manchester's housing stock was in local authority tenure, by 2011 this had fallen to 13 per cent and housing association stock had grown from 4 per cent to 32 per cent (Table 8.9).

The 2008 downturn saw an abrupt halt to many physical developments: some half-completed or proposed projects were mothballed and developers faced grave financial problems (Urban Splash, for example, had to cut its workforce dramatically and draw in its horns on various projects). The effect was particularly clear on the city-centre residential market, where numerous proposed apartment developments were in the pipeline.[38] Inevitably the impact on office and retail companies was also severe. One consequence was the near collapse of developments in Spinningfields, the timing of whose coming on stream proved unfortunate. The large local law firm

| | 1981 | | | 2011 | | |
	Owner-occupied	Local authority	Housing association	Owner-occupied	Local authority	Housing association
Bolton	66.0	26.8	2.1	63.7	14.2	20.5
Bury	71.2	21.7	1.8	69.6	9.4	15.0
Manchester	36.0	47.1	3.9	37.8	13.5	31.6
Oldham	61.5	31.1	1.7	64.9	9.7	21.1
Rochdale	55.8	36.8	1.3	61.8	15.6	23.1
Salford	42.0	46.8	3.3	50.3	17.8	28.8
Stockport	71.4	18.6	2.6	73.2	8.7	13.6
Tameside	58.6	33.4	1.2	63.8	5.2	21.5
Trafford	65.7	22.1	2.2	69.3	4.6	16.4
Wigan	61.2	32.6	0.5	67.9	16.2	18.9

Halliwells went into administration in 2010 partly as a result of its role as an anchor tenant. Allied London almost withdrew from the whole project. However, the city council bought some of the freeholds to allow development to proceed, and in 2013 Allied London was able to announce a start on a five-storey office block with an agreed tenant. Further evidence of the recent upturn in the economic fortunes of the city and of its close relationship with Allied London came later in 2013 when – as Manchester Quays Ltd – the two jointly bought the nearby site of Granada Studios following ITV's decision to move to MediaCity. The intention is that the site will be redeveloped with apartments, retail and office space.

Table 8.9 Housing tenure in Greater Manchester districts Note: Percentages do not sum to 100 since other tenures (e.g. private rented) are not included.
Source: Censuses

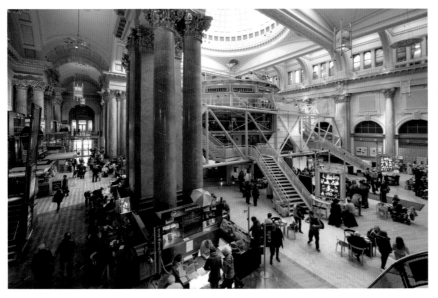

Royal Exchange Theatre. The theatre opened in 1976, at a time when architecturally distinctive buildings with historical associations were frequently regarded as obstacles rather than catalysts for regeneration. Richard Negri's free-standing capsule on the trading floor of the former Cotton Exchange quickly became a vital and much-photographed symbol of the city.
Image courtesy of Wikimedia Commons

Beetham Tower, seen from Castlefield. Located on Deansgate, the slender 47-storey Beetham Tower was completed in 2006. The architect was Ian Simpson, whose previous Manchester buildings included Urbis and Number One Deansgate. It is the tallest building in Manchester and has become a symbol of the post-industrial city, though its location, close to the historic district of Castlefield, and its design have not been without their critics. The first 23 storeys are occupied by the Hilton Hotel, which has resulted in it also being called the Hilton Tower.

Recent statistics suggest that the city is starting to mirror the national recovery, although very unevenly across Greater Manchester. House prices are one indication. Land Registry data for the ten districts show that in 2012–13 Manchester house prices rose impressively by 7.5 per cent, Tameside by 2.3 per cent, Trafford by 2.1 per cent, Oldham by 1.6 per cent and Stockport by 1.2 per cent; but that Salford fell by 2.9 per cent, Rochdale by 2.7 per cent, Bolton by 2.5 per cent and Wigan and Bury by 0.5 per cent.

City assets

The city's success in reinventing itself has, of course, built in part on its obvious assets. Three are especially significant: the airport, the universities and sport.

Manchester Airport

The airport, the third busiest in the country after Heathrow and Gatwick, is an undoubted jewel. Initially owned by the ten districts (with Manchester itself having a 51 per cent stake), it has not only acted as a vital attraction for international investment to the area, but also as a piggy-bank, with finance from its profits being used to support a variety of local projects. Under the imaginative stewardship of

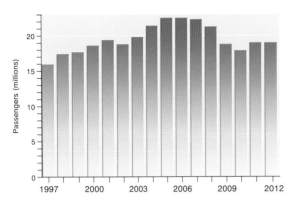

Figure 8.7 Manchester airport passenger numbers, 1997-2012 (millions)

Source: Civil Aviation Authority

its long-standing chief executive, Gil Thompson, it built a second runway and a third terminal. In 1986 the airport was converted from a purely municipal amenity into a commercial company operated at arm's length from the ten local authorities. Manchester Airports Group (MAG) has proved highly entrepreneurial, buying up further airports so that it now operates three others – East Midlands, Bournemouth and Stansted. Manchester has a 35 per cent stake in MAG and the other nine districts share 29 per cent. This currently generates some £14 million for the ten districts. After an inevitable fall in passenger numbers after 2008, the airport has largely recovered its custom, with over 20 million passengers in 2013 (Figure 8.7).

The latest development is the construction of a new business district, Airport City, adjacent to the airport and Wythenshawe. The concept of a business park on the site had long been discussed. It is now coming into being through having been declared an Enterprise Zone in 2011 under the government's new approach to EZs, which are targeted at large compact sites in areas with growth potential rather than at derelict areas. In 2013 it was announced that the Beijing Construction Engineering Group would invest £800 million in the project – one of the largest single Chinese investments in Britain. Airport City will be the third major current development in Manchester alongside MediaCity and NOMA.

The universities

The major universities give Manchester a strong claim to research excellence. Their student populations, totalling over 100,000, have a double significance, injecting spending power and boosting demand for city-centre housing, but also, through their international nature, creating valuable potential links to countries with which Manchester can do business.

Manchester University aspires to be in the top 25 in world research rankings. For a long time it rather ostentatiously turned its back on the city, claiming to be international rather than local. Increasingly, however, it has recognized the two-way benefit of closer collaboration with the city and community. Its financial impact is clearly very considerable. In 2011–12 its overall spend was over £800 million, it directly generated GVA of £521 million and a further £526 million

through multiplier effects (over £400 million in the north-west), creating 19,000 full-time-equivalent jobs.[39] Its research has brought tangible benefit to Manchester. The recent development of graphene by Andre Geim and Konstantin Novoselov made a huge international impact that recognized the potentially wide-ranging applications of the new material. The National Graphene Institute, established to explore the commercialization of the discovery, opened in 2015 with financial support from central government, the Engineering and Physical Sciences Research Council, and the European Regional Development Fund. Bluestone Global Tech has already become a partner, moving into university laboratories, and it expects to open its European headquarters in Manchester. Over the last two decades, the university has established a succession of incubation facilities, spawning innovative companies especially in bio-science. Two of its vice chancellors have played important roles in this. Mark Richmond, himself a micro-biologist, restructured the university's science faculty to create a separate Faculty of Biological Science; and Nancy Rothwell, also an internationally respected bio-scientist, has projected the university's scientific achievements nationally and internationally and garnered substantial investment to support new scientific initiatives.

Until 1992 the University of Manchester Institute of Science and Technology (UMIST) was formally a faculty of the university, before becoming an independent university. It merged once more with Manchester University in 2004 to create a single institution in joint manoeuvres that would have impressed the Grand Old Duke of York. UMIST's reputation had gone through something of a slump, but under the unassuming leadership of Harold Hankins (a communications engineer who had worked in Metropolitan–Vickers in Trafford Park and became UMIST's principal in 1984), its research reputation soared and at the time of the merger it added great strength to the combined university. The merger was used creatively to market the 'new' university and attract substantial resources to build laboratories and research and teaching facilities in one of the largest physical make-overs of any British university.

The other two universities have capitalized on different strengths that have also contributed to the local area. Salford University rightly prides itself on its close links with industry, commerce and the arts. The university's Technology House provides accommodation for a range of small businesses, and Salford has its own science park as an offshoot of the Manchester Science Park. It has long had expertise in popular music and film. Until 2012 it ran the regional TV station Channel M which made it the only UK university with its own TV station broadcasting on a terrestrial signal. This expertise persuaded the university to play a leading role in MediaCity, to where it moved its media-related teaching and research in 2011.

Manchester Metropolitan University, the fifth largest UK university in terms of student numbers, has particular strengths in teaching and the application of research. For example, its Centre for Enterprise mounts entrepreneurial training programmes to help SME companies. The university offers an innovative para-legal course in conjunction with a local law firm, giving a qualification that

allows students to qualify as para-legals with the possibility of eventually becoming lawyers. The university's Institute for Popular Culture was a good example of the link between the university and the city's creative industries sector.[40] In 2009 Carol Ann Duffy, the university's professor of contemporary poetry, was appointed as the Poet Laureate, the first woman to hold the post.

All four universities, in partnership with the city council, established the Manchester Science Park (MSP) in 1984 on a brownfield site adjacent to Manchester University. It has grown impressively, with over 100 high-tech companies as tenants, mostly in bio-related healthcare, telecoms, business services and digital media. In addition to the original site, it now operates in Salford Innovation Park (adjacent to Salford University), CityLabs (the refurbishment of Manchester's former Royal Eye Hospital), and its latest venture, the 2014 purchase from AstraZeneca of the 400-acre site of Alderley Park. It has rebranded itself as Manchester Science Partnerships and can claim to be one of the most successful of the UK's science parks. Indeed, two of its longest-serving chief executives, John Allen and Jane Davies, each served as chair of the UK Science Park Association and established an international profile for MSP.[41] The park began with a single building, but by 1995 there were four on the site. One of its especial attractions was that as early as 1993 it was the first science park connected to broadband via fibre optic cable. By 2000 two further buildings had been opened (the Williams and the Kilburn buildings, named after the two Manchester scientists who invented the world's first programmable computer). The park has proved continuously successful, hence its successive moves to expand to new sites.

The science park has seen some university spin-offs. One of the first tenants was a UMIST spin-off, Textile Computer Systems. One of the most successful of the tenant companies has been Medeval, founded in 1983 and owned by Manchester University until 1998. Specializing in drug evaluation trials, it has developed new treatments for HIV and heart disease. It was bought out in 2004 for £14.75 million and still operates from the science park. A prime example of access to researchers was Colgate Palmolive's move of its dental health unit to MSP in 1989 to be close to the university's dental hospital. However, as with most science parks, proximity to the universities is as much a matter of perception as of direct accommodation for university-based research – not least since Manchester, like many universities, has developed in-house incubation facilities.

Manchester was one of six 'Science Cities' designated in 2005 to encourage deeper links between business and science to stimulate economic growth. A variety of other related organizations have been established in partnerships between the universities, local authorities, hospitals and airport, aimed at capitalizing on the concentration of research activity in south Manchester.[42] They include Manchester Knowledge Capital and Corridor Manchester – the route stretching south from the city centre along Oxford Road which has a significant concentration of knowledge- and science-based businesses, although now with a large hole where the erstwhile BBC studios sat. The health sector is inevitably closely linked to the

area's universities. Two major teaching hospitals in Manchester, one adjacent to the university's medical school and the other in Wythenshawe, are large employers whose significant budgets feed into the local economy. To that can be added the specialist cancer expertise of the Christie Hospital. The strength and scale of medical science have generated significant investments in the area; for example, the Medical Research Council recently invested £20 million to establish the Farr Institute, a UK health informatics research institute with centres in Manchester, Durham, Dundee and Swansea.

Sport

Manchester's third asset is its sporting prowess. Its two premier football teams generate resources that boost local expenditure; they also bolster the expensive ends of the housing, retail and entertainment markets. They have given Manchester an international cachet second to none. Not only have they generated international investment, but they draw on a wide footprint of patronage. For example, season ticket holders for Manchester City FC in 2004–05 could be found in almost every district across England and Wales (even before the team's rise to stardom) (Figure 8.8). Manchester United has an even greater following, not least in the Far East.

The legacy of the Olympic bids and of the 2002 Commonwealth Games endowed the city with an Olympic-sized swimming pool, a cycling velodrome, a football stadium and a national squash centre.[43] The country's recent success in competitive cycling is due in no small part to the training facilities at the velodrome.

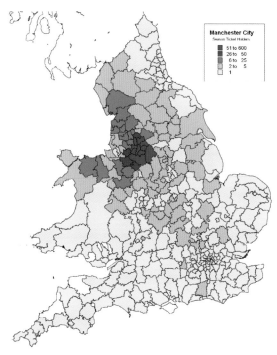

Figure 8.8 Manchester City FC season ticket holders, 2004-05 (per 10,000 population of origin district)
Source: Robson et al. (2006)

Little wonder that the council's 'visions' for the city have consistently presented it as a sporting mecca. The successive bids for the Olympic Games of 1996 and 2000 were unsuccessful; the first was premature, but the second was impressive and attracted central government support of £55 million for the stadium and velodrome and £20 million for the purchase of the Eastlands site.[44] To many it seemed that the city's ambition had over-reached itself. However, the bids clearly laid the groundwork to win the bid for the Commonwealth Games in 2002, which, to universal acclaim, were seen as an outstanding success, mounted with flair and panache. Ten thousand local volunteers acted as guides, the city was again shown as a place that could deliver big projects, and the involvement of the private sector, the community and the council reinforced the strength of the partnership principle that Manchester has made its own.

Evolving governance structures

These strengths were, of course, mere potential. The catalysts that transformed them into active assets were the perceptive governance and leadership from which the city has benefited over three decades. This was the softer, but essential, chemistry that propelled the city into its post-industrial transformation.

One of the strengths that Manchester has enjoyed has been the stability of its political control. It has long been an unchallengeable Labour authority. Indeed, the 2015 local elections saw all of its 96 council seats held by Labour. There have inevitably been internal disputes over the years, the most striking of which was the palace revolution that resulted in Graham Stringer's becoming leader in 1984. Many commentators have made much of this, seeing the period from 1984 as one of municipal socialism that subsequently switched dramatically to entrepreneurialism following the Conservative victory in the 1987 general election.[45] However, this suggestion of a road-to-Damascus transformation seems overdrawn. The 'revolution' was less a fundamental philosophical schism than a generational issue – a group of younger councillors taking control. There was a huge difference between the then Militant-led stance of Lambeth, Liverpool and Sheffield, and the much frothier and milder version that characterized Manchester. The deputy leader, John Nicholson, may have been in the Lambeth mould; Graham Stringer certainly was not. Manchester never developed an alternative hard-left economic model; it contented itself with creating a rainbow coalition of ethnic and sexual equality committees, and with proclaiming itself a nuclear-free city. Stringer always seems simply to have had the best interests of his city at heart. It was pragmatism that consistently dominated.

The 'entrepreneurialism' that supposedly followed 1987 was thus simply a matter of continuing to do whatever it took to attract resources to the city, and using the city's planning power, land holdings and financial resources to assist developments that promised jobs and inward investment. Its success in winning government resources was one aspect of this; another was its readiness to use its

own resources to ensure further commercial development. Some examples of the latter have already been noted in major developments such as Spinningfields and NOMA. Individual instances of the city's role in attracting new inward investment include Siemens's establishment of a northern headquarters for its automation and drive technology division in a new building on Princess Parkway. Ted Kitchen, then assistant planning officer, saw four main reasons for the company's decision: the location of the site midway between the city and the airport close to a motorway junction; the attractive residential neighbourhood; proximity to the local universities; and, probably most significant, the fact that the council went out of its way to assist the project, including acquiring the site which the city itself owned.[46] A second example is the Bank of New York Mellon which opened its Manchester headquarters in 2005 in Piccadilly Gardens and now employs over 1,000 people. Its move was facilitated by the city's inward investment agency, MIDAS. A strong factor underlying the move was said by the bank to be access to the large pool of graduates. Indeed the bank now works with Manchester University's Alliance Business School to put some of its employees through MBA courses, and has also set up a BA programme in investment management at MMU.

While the city has offered a favourable context in which businesses can thrive, created improved physical environments, helped with land assembly and established a variety of organizations to market Manchester, facilitated inward investment and broadcast its visions and aspirations, all of this is essentially contextual rather than direct entrepreneurialism. And, of course, much of the city's vision is simply a matter of capitalizing on and proselytizing for positive things that happen outside its control. The development of the Northern Quarter is one example. The area had suffered commercially from the building of the Arndale Shopping Centre in the 1970s. It was given a boost by some of the small independent businesses displaced from the Corn Exchange after the 1996 bomb. Now it houses a lively mix of small businesses, with a strong focus on popular music, and with bars, cafés and a mix of music and clothes shops. It has become a centre of alternative and bohemian culture which the city can add to its list of 'successes'. Another example is the growth of the Gay Village which was largely the creation of the local developer Carol Ainscow. This developed from the late 1980s with the transformation of old warehouses along the Rochdale canal providing facilities catering for gays and lesbians.[47] Ainscow opened a gay bar, Manto, in 1990 which triggered additional development. By 1995 it had 15 gay or mixed pubs and clubs. The annual Manchester Pride festival, focused on Canal Street, attracts large attendances from within the city and a wide area outside. A third example is Chinatown whose growth was initiated by the Chinese community itself and led to the construction (by Chinese builders) of an impressive arch, the provision of accommodation for elderly Chinese and an explosion in the number of high-quality Chinese restaurants with national reputations. Chinatown acts as a magnet for Chinese people drawn from across the north-west to come to Manchester on Sundays to eat and fraternize.

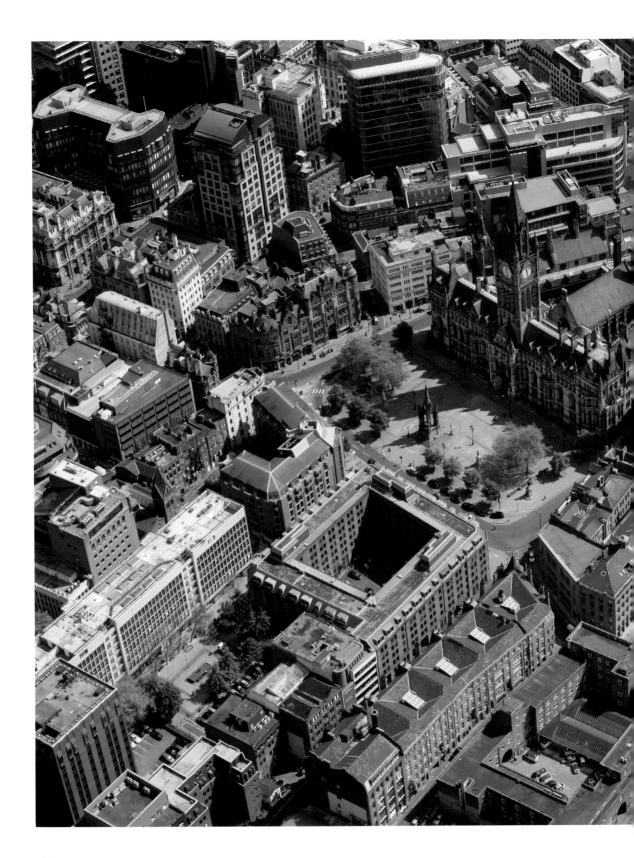

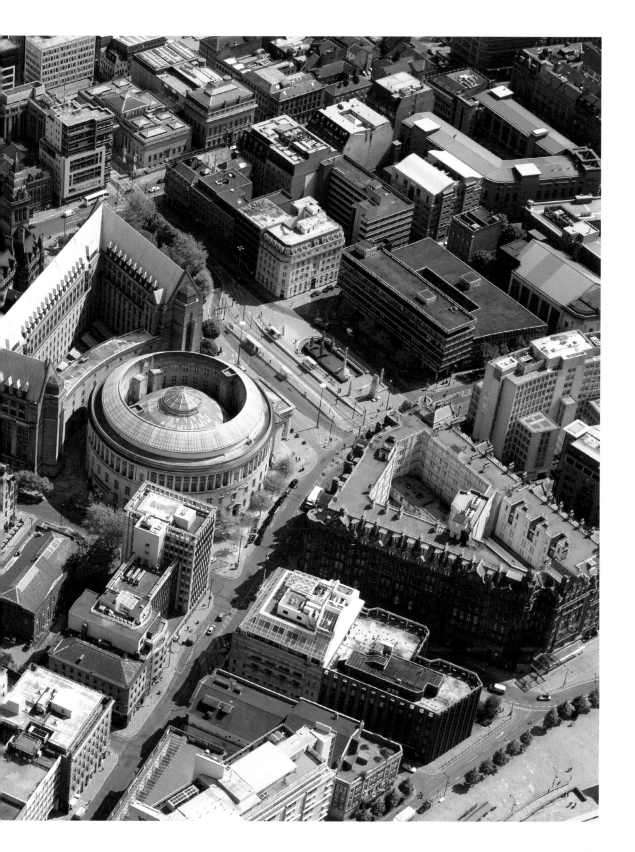

It is through the density of partnerships – in which City Pride played so important an initial role – that the city has been able to exert influence on all such developments. As Howard Bernstein said of the City Pride process, 'One of the biggest surprises for me was that many of the people we brought together did not previously know each other, notwithstanding their leadership in their own fields.'[48] The process has been helped by the proactive role of some of the big local companies, not least Kellogg's with its UK headquarters in Trafford Park. From the early 1980s Kellogg's developed a widely admired strategy of community social responsibility and was a founding member of the national 'Per-Cent Club', aiming to distribute 1 per cent of its pre-tax profits. It developed links with schools, work experience placements and a leading role in the Moss Side and Hulme Business Support Group, which it persuaded companies such as British Telecom, Norweb and Amec to join. Other businesses, such as the locally headquartered Co-operative Bank, have played similar roles in contributing to the well-being of deprived local communities.

However, while business involvement and the variety of quangos established by central government have introduced a plethora of voices into the governance of the city and conurbation, it has nevertheless been the council itself that has played the major role in articulating policy and priorities. Its initial decision not to opt for a city mayor reflected the city's strong leadership, which was argued to make a city mayor inappropriate. Salford's slightly perverse decision to elect its own mayor sits oddly in the wider context of local authority collaboration across the conurbation. In encouraging cross-authority collaboration, one of the challenges that Manchester has faced is the extraordinarily high degree of balkanization of the conurbation. The comparison with other provincial conurbations is striking. Greater Manchester is split between ten districts, far more than any other English conurbation. Manchester's population is only 19 per cent of its wider conurbation, whereas Newcastle's is 25 per cent of its conurbation, Liverpool and Leeds have 34 per cent of theirs, Birmingham 39 per cent and Sheffield 41 per cent. There has been a long history of suspicion of Manchester on the part of the surrounding districts, and to an extent this has been exacerbated by Manchester's successful commercial drive. That said, balkanization has encouraged the authorities, *faute de mieux*, to work together in many policy areas. It was significant that, following the abolition of the Greater Manchester Council, the ten districts established the Association of Greater Manchester Authorities (AGMA) in 1986, which has been an important body representing the collective views of the ten. Balkanization can also be said to have encouraged the districts to recognize – and to capitalize on – the concept of the 'city region', the functional definition of the wider conurbation which, in Greater Manchester's case, is demonstrably monocentric, focused on Manchester itself.

In this light, the new belated salience that government now gives to the concept of city regions has proved a particular boon for the conurbation. Manchester's footprints of the flows of people to the conurbation centre (for

example to travel to work, to shop, for entertainment, to look for housing) paint a clear picture of the large scale of its city region.[49] Commuting flows show the extent of the functional city region, but also its asymmetry, with strong flows from the south (from deep within Cheshire and parts of High Peak) but far fewer from the old textile towns to the north and virtually none from northern areas such as Blackburn, Rossendale and Burnley.

The Labour government began the process of giving formal recognition to city regions, recognizing Leeds and Manchester as the first two formal city regions. The coalition government of 2010 changed the governance jigsaw more dramatically, abolishing the Regional Development Agencies (RDAs) and creating cross-authority collaboration through Local Economic Partnerships (LEPs), which represent a somewhat haphazard bottom-up approach to identifying city regions. Manchester can claim to have anticipated this, not only with AGMA but also with its proposal that the ten districts should form the area's LEP. Most significantly, it persuaded government to recognize the ten as the first formal 'Combined Authority' in the country. This represents a genuine devolution of power from central government since the Combined Authority has direct responsibility for some expenditures and services which now rest jointly in the hands of the ten districts. The advent of the Combined Authority, working in tandem with the LEP and AGMA, should help to resolve some of the inherent tensions in an otherwise administratively fragmented conurbation. Typically, Manchester was quick to capitalize on these new arrangements, not least in the innovative agreement that it negotiated with government in response to the City Deal initiative announced in March 2012. This represented a major step in empowering the region to make its own decisions on economic growth and skills.[50] The most radical and innovative element of Manchester's deal was its 'earn-back model' through which the Combined Authority could claw back finance arising from new developments in the area. The government agreed that up to £1.2 billion invested by Greater Manchester in infrastructure improvements would be 'paid back' if demonstrable economic growth was fostered by its investments. 'Earned-back' funds will be reinvested in further infrastructure improvements in Greater Manchester. The initial plans focus on transport investment such as the extension of Metrolink to Trafford Park. This was the first tax-increment financing scheme in England outside London. In the face of the inevitable cuts in funding following the 2008 crisis, City Deal is a real opportunity for Manchester (and other cities) to generate resources to stimulate economic growth. That, together with the Regional Growth Fund and the new style of Enterprise Zones, may be small substitute for the large resources that had been channelled through RDAs, but this package has given the more imaginative and alert authorities scope to develop locally tailor-made approaches to encourage economic growth. Manchester has been at the forefront in capitalizing on this potential.

The most far-reaching development, however, is Chancellor George Osborne's continuing devolution of powers to Manchester's Combined Authority as part of his promise to create a 'Northern powerhouse'.[51] In return for the agreement

to elect a conurbation-wide mayor in 2017, the Combined Authority has been rewarded with 'Devo Manc', the city region's devolution package which gives it powers over transport, housing, planning, policing, skills and employment, worth some £1 billion of public expenditure. Most dramatically, it also gives it control over its £6 billion health and social care budgets, which will be integrated across the city region. These are genuinely revolutionary steps towards local devolution.[52]

Investments in transport have now begun to help weave closer physical links across the city region. Metrolink has gradually extended its reach and now forms a genuine network building on the initial single line between Altrincham and Bury that opened in 1992. The network now extends to termini at Eccles, MediaCity, Rochdale, Ashton-under-Lyne and East Didsbury (Figure 8.9). A further link was opened in 2014 through Wythenshawe to the airport. These linkages should prove a potent way of addressing the under-performance of the northern part of the conurbation, since the economic future of ex-textile towns like Oldham and Ashton rests not on trying to reinvent an industrial past but on drawing more of their populations to commute to work in the conurbation core.

Figure 8.9 The Metrolink network as of 2015

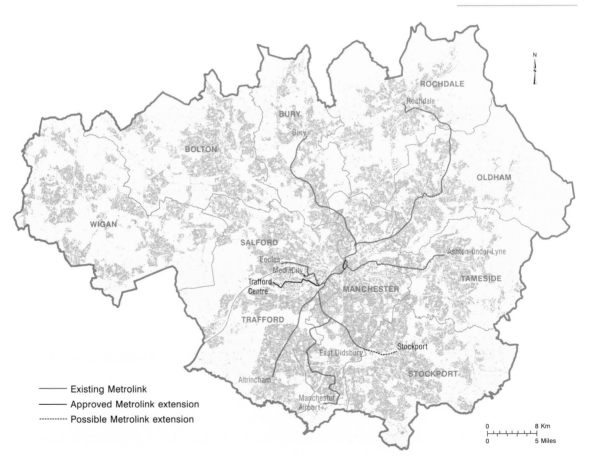

Metrolink's plans suffered a temporary glitch in 2007 when the government agreed to fund further extensions but only subject to an agreement that the city would introduce congestion charges. Richard Leese and Graham Stringer were on opposite sides of the argument over congestion charges and a referendum in 2008 comprehensively defeated the city's proposals, which had advocated two pricing bands, with an outer cordon formed by the M60 orbital motorway (an area of 80 square miles, ten times greater than London's original congestion charge area). The funding impasse after the referendum defeat was eventually resolved by the establishment of the Greater Manchester Transport Fund, with £1.5 billion raised through local council tax, government grant and resources from Manchester Airport Group. The expansion of the network has inevitably placed increasing pressure on the city-centre lines and a 'second city crossing' has now been designed, from St Peter's Square to Victoria, to relieve the city-centre bottlenecks.

Metrolink has proved very successful. In 2012–13 it generated 25 million passenger trips. Its greatest significance is its role in binding the conurbation together and reinforcing the cohesion of the city region. The Manchester Independent Economic Review argued that, outside London, Manchester was the city region best placed to take advantage of agglomeration economies, but that the conurbation punched below its weight.[53] One of the ways in which it could better capitalize on its potential would be to ensure the effective articulation of the city region as a whole, hence the significance of Metrolink. Here the comparison with London is instructive. The capital has a dense network of rail and underground lines that bind much of the wider south-east and Greater London into a huge competitive polycentric whole that will be massively enhanced by the enormous

investment in Crossrail. In comparison, Manchester's city region is still poorly linked and government investment in its transport massively less than London's. However, one encouraging development was the Treasury's agreement to fund the Northern Hub initiative which includes developing the 'Ordsall chord' linking Victoria, Oxford Road and Piccadilly stations to relieve bottlenecks on the cross-Manchester rail lines. Allied to this is the Chancellor's enthusiasm for an east–west high-speed rail line – HS3 – initially linking Leeds and Manchester, thus positioning Manchester as the key driver in a potential future complex of linked trans-Pennine cities. If implemented, this could provide the scale and diversity to create a polycentric economic powerhouse to complement the London mega-region. The plans of the newly created Transport for the North (TfN) also promise to make dramatic improvements to a variety of connections between the cities of the north. Such plans are much in line with the argument that priority should focus on transport improvements that boost inter-urban links.[54] To many observers, encouraging better connectivity within the city region and improving links between the economies of Manchester and Leeds would be key components in fostering growth in northern England – and far more significant than high-speed links to London.

Continuing urban challenges

Despite regeneration, the conurbation continues to be highly polarized, with a strong contrast between its southern and northern halves and even greater neighbourhood contrasts between areas of poverty and affluence. Glossy new buildings in the centre are often seen by poorer households as creating a hostile environment to which they are not welcome. Crime and gangs have featured prominently, not least in the perception of the outside world. Gun-related crime became a serious problem in the 1990s with rival gangs in Moss Side and Cheetham Hill.[55] The number of incidents led to the unwelcome soubriquet of 'Gunchester'. The most notorious of the gangs – the Gooch gang – was broken up with the jailing of its leaders in 2009. Nevertheless, crime statistics do not suggest that Manchester is the most crime-ridden city in Britain; equally, neighbourhoods that popular belief sees as the most criminal, such as Moss Side, in fact have lower crime levels than elsewhere in the city. Moreover, with its long history of immigration, ethnic relations in Manchester have generally been good. Likewise, wider social unrest has not featured highly. For example, the two main riots – focused on Hulme in 1981, and the centres of Salford and Manchester in 2011 – caused extensive damage, but were essentially copycat events prompted by the more severe outbreaks in Liverpool and London, rather than having been generated from within Manchester itself.[56]

However, deprivation and social polarization continue to be a feature of the city. Measures of deprivation between the early 1990s and 2010 show little change in Manchester's ranking (Table 8.10).[57] Of the ten districts, only Stockport and Trafford approach anywhere near being in the less deprived half of English local authorities. The more detailed patterns, measuring deprivation for Lower Super

	ILD rank of district score		IMD rank of average ward score	IMD rank of average score		
	1991	1998	2000	2004	2007	2010
Bolton	49	47	65	50	51	36
Bury	161	116	130	97	122	114
Manchester	3	3	6	2	4	4
Oldham	39	33	38	43	42	37
Rochdale	50	29	25	25	25	23
Salford	28	23	21	12	15	18
Stockport	213	177	189	159	161	151
Tameside	65	53	57	49	56	42
Trafford	146	129	177	136	178	167
Wigan	74	85	63	53	67	65

Table 8.10 Deprivation
rankings, Greater
Manchester districts
Note: The lower the
number, the higher the
level of deprivation.

Source: Government publications

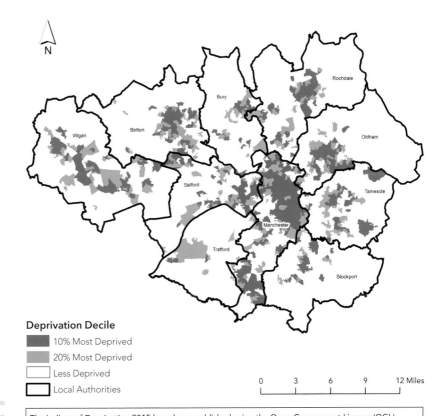

Figure 8.10 IMD 2010:
nationally most deprived
10% and 20% LSOAs

Source: Steven Hicks

The Indices of Deprivation 2015 have been published using the Open Government Licence (OGL)
version 3.0, see www.nationalarchives.gov.uk/doc/open-government-licence/version/3/
The Indices of Deprivation 2015 have been constructed for the Department of Communities and Local
Government (DCLG) by Oxford Consultants for Social Inclusion (OCS).

Output Areas (LSOAs), show large swathes of north and east Manchester and parts of Wythenshawe with very high levels of deprivation. Only in some of the southern neighbourhoods, focused on Didsbury, Chorlton and Withington, do deprivation scores fall into the less deprived upper half of English LSOAs. Elsewhere across the conurbation it is largely in or near the centres of the old industrial towns to the north that deprivation is concentrated (Figure 8.10). With the exception of Hulme, these detailed patterns of deprivation have hardly altered over time.

These are essentially static cross-sectional measures and take no account of the fact that 'deprived' areas can differ fundamentally in terms of the roles that they play in the dynamic churn of the housing market. Some provide cheap housing for new households who move out as they prosper. Others may be in the process of being gentrified. The deprived neighbourhoods that present real challenges are those where, if poor households move, it is only to similarly deprived areas, and they are replaced in turn by similarly deprived households; in effect, neighbourhoods where poor households are trapped in poverty. These have been called 'isolate' neighbourhoods.[58] The map of these genuinely problematic neighbourhoods shows that there are more in Manchester than in London, but fewer than in Liverpool. The pattern (Figure 8.11) reinforces the evidence that the really problematic areas are concentrated in north and east Manchester, in parts of Wythenshawe

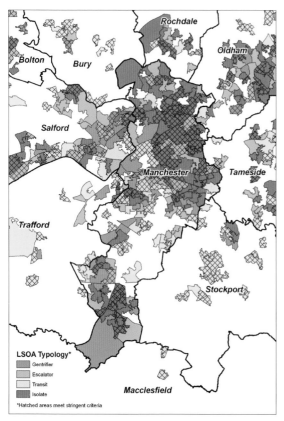

Figure 8.11 Types of deprived neighbourhoods in Manchester, 2001 The coloured LSOAs fall within the worst 20% of LSOAs in England.
Source: Robson et al. (2008)

and small parts of Moss Side. It also shows that many of the 'deprived' areas play positive roles in the housing market, acting as springboards for the socially mobile (transit and escalator areas) or as areas being colonized by more affluent households (gentrifier areas, such as the city centre and, most interestingly, Hulme).

Thus, despite the successful regeneration programmes in areas like East Manchester, the pattern of relative deprivation largely remains obdurately unchanged. There is no particular surprise in this. Social regeneration is a much more difficult challenge than physical and economic regeneration. There are no quick solutions likely to change the prospects of the poor overnight. Creating jobs clearly helps those who are job-ready, but many people in deprived areas lack the skills or the confidence or the readiness to benefit. Moreover, residential churn often means that those whose circumstances are improved by regeneration move out of their deprived area only to be replaced by new deprived households. Regeneration tends to be targeted at areas rather than at individuals and (as with Hulme) many areas that show marked improvement achieve this through the in-movement of new households as much as improvements to existing residents. None of this is to gainsay the benefits of regeneration, but it does suggest that the challenges require prolonged and dedicated commitment.

The starkest evidence of the problems faced by the city is its dismal record in educational achievement. Secondary school performance in particular has consistently fallen below national averages. This clearly presents particular challenges, since skills are increasingly important for post-industrial economies. The standard measures of good GCSE scores show the marked contrast between boroughs in the conurbation: the four-year averages for 2004–07 show that against an English average of 44.6 per cent, Bury and Stockport were better (48.8 and 47.6 respectively) whereas Salford and Manchester fell well below (32.1 and 28.1 respectively). Since deprived pupils tend to go disproportionately to poor-performing schools, the flows of pupils act as significant drivers of social polarization.[59]

There have, however, been recent improvements (Table 8.11). In 2013 eight of Manchester's 24 state-funded schools had better results than the English average. This may reflect a new determination by the city to address the skills deficit, not least through the active encouragement of specialized academies, of which there are now 11 across the city, supported by a range of organizations such as the Co-operative Group and Manchester United FC. Their future performance will be critical. The role of the new city-wide FE college has also been significant

	Percentage achieving 5+ A*-C GCSEs including English and maths			
State-funded schools	2010	2011	2012	2013
England	55	58	59	61
Manchester	48	54	55	54

Table 8.11 School GCSE performance, 2010–13
Source: DFES

in addressing the needs of young people who had dropped out of education. The Manchester College was created in 2008 through a merger of the Manchester College of Arts and Technology and City College to create a 'super-college' of 80,000 students. It works with some 3,000 employers and has developed an impressive range of apprenticeship schemes as well as liaison with local universities. There is now a sense that some of the educational challenges across the city are beginning to be tackled more imaginatively. However, this remains a critical issue since it is the medium-level skills that FE colleges and secondary schools address that the new post-industrial labour markets find most difficult to fill.

Conclusion

The Manchester saga of reinventing itself over the last thirty years has been impressive. The city even has adulatory coffee-table books.[60] Such exposure would have been unthinkable before the 1990s. More substantively, Manchester's experience is now widely used as an exemplar of regeneration in numerous comparisons with cities elsewhere in Europe.[61] It has also prompted academic commentators to do much head-scratching to try to reconcile the evidence of the city's impressive reinvention with their impulse to be critically or cynically unimpressed.[62]

Most of the criticisms of Manchester's regeneration have focused on condemnation of the city's 'entrepreneurialism' and its stress on physical redevelopment at the expense of social.[63] Here, without offering too one-sided a paean of praise for its achievements, the argument has been that it would be churlish to criticize the city too fiercely for the fact that its greatest successes have been in economic rather than in social regeneration. Creating the context in which new investment has been attracted into Manchester has generated new jobs and this, in the longer term, is by far the most likely way in which deprived households might benefit – but only so long as the skills agenda is tackled more successfully.

Which returns us to the initial question, why Manchester? The switch from manufacturing to a service-based economy catering to consumption and knowledge-based enterprise was always going to give big cities new opportunities as size density and variety generated agglomeration economies. Manchester was not the only conurbation with the potential to capitalize on this. Merseyside and Tyne and Wear may have been at something of a disadvantage with their relatively small size and catchments reduced by coastal locations. But the West Midlands, West Yorkshire, even possibly South Yorkshire possessed many of the same advantages as Greater Manchester. Birmingham perhaps sits too close to London and has increasingly had some of its economic independence sucked into the ambit of the Great Wen; Leeds has perhaps suffered from rivalry with Bradford. Nevertheless, both of these core cities had potential not dissimilar to Manchester. It may be unfashionable, but there is overwhelming evidence that what made the difference for Manchester in turning itself around in the late 1980s and the 1990s was 'agency' – the rather clunky term that academics give to the impact of people

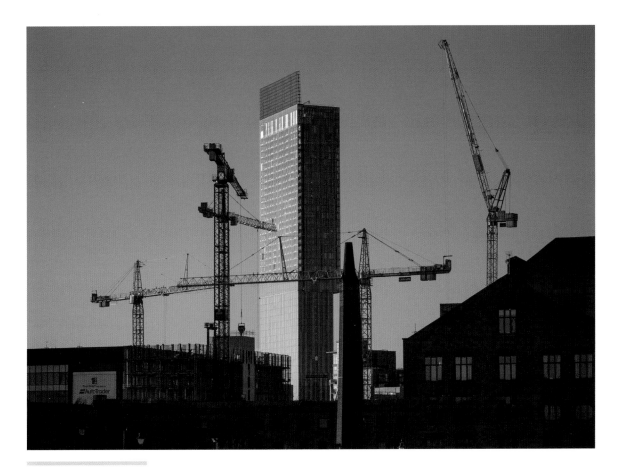

and organizations. The resourcefulness and intelligence of the trio of Bernstein, Stringer and Leese was hugely influential. Moreover, just as Michael Heseltine was so potent in giving new life to regeneration nationally, so in the 1980s and 1990s Manchester had many 'big beasts' who drove the transformation of the conurbation: Alan Cockshaw of AMEC who chaired many of the big regeneration initiatives; Bob Scott, the impresario who led the Olympic and Commonwealth bids; John Glester, chief executive, and James Grigor, the chair of CMDC; Mike Shields, chief executive of Trafford's Development Corporation; Felicity Goodey, champion of Salford Quays and chair of the Central Salford URC; John Zochonis, chair of PZ Cussons and philanthropist who supported numerous regeneration schemes through his Zochonis Trust; Marianne Neville-Rolfe who ran the Government Office and NEM; Anthony Wilson, creator of the Haçienda; Terry Thomas, chief executive of the Co-operative Bank; Robert Hough of Peel Holdings who chaired NEM; Peter Smith, leader of Wigan and AGMA; the developers Jim Ramsbottom and Tom Bloxham who saw potential for regeneration where others saw only dereliction; David Plowright of Granada TV; David Trippier, politician and chair of Marketing Manchester. Many of these have been honoured with knighthoods or lordships. The point is that their commitment and contacts were critical to

achieving Manchester's renaissance. They did the really heavy lifting. By the mid-2000s Manchester's renaissance had developed its own momentum.

It seems appropriate to end with a forecast made by Richard Leese in 2000. He suggested:

> And so what will Manchester be like in 10 years' time? We will have a thriving economy based in the industries of the future. We will have the research and educational facilities to keep us there. We will have a population with the skills to maintain those industries. Our bustling city centre will have a population of 20,000 and the sound infrastructure to support that population. East Manchester will be in the process of physical and social transformation and its population will be increasing towards 60,000 from the current 30,000. The city's population will be stabilising at around 450,000 people. The Manchester City-region will have its own government, and will be at the heart of social and economic revival of the North West. We will have the country's first integrated public transport system. Quality of life and the environment will have improved in every part of the city. Manchester City will be the second English football club to celebrate the treble.[64]

Second-guessing the future is always a risky business but he scored an impressive 8 out of 10. Most of his claims have either been achieved or exceeded, although Manchester still lacks a truly integrated transport system and it is difficult to argue that the quality of life has improved everywhere across the city. And both he and Howard Bernstein would deeply regret that Manchester City FC has not stuck to his timetable!

Acknowledgements

I am very grateful to Graham Bowden for drawing most of the maps and diagrams with his customary skill; and to Brian Webb for letting me use two of his photographs of Manchester.

Notes

1. 'Manchester' is an ambiguous concept. Various terms are used here: 'Manchester', 'city', or 'city council' refer to the metropolitan borough of Manchester; 'core' means the conurbation centre (Manchester, Salford and Trafford); and 'conurbation' or 'Greater Manchester' refer to all ten districts.

2. P. Lloyd, 'Manchester: a study in industrial decline and economic restructuring', in H.P. White, ed., *The Continuing Conurbation: Change and Development in Greater Manchester*, Farnborough: Gower, 1980, p. 74.

3. J. Peck and M. Emmerich, 'Recession, restructuring and the Greater Manchester labour market', SPA Working Paper 17, School of Geography, Manchester University, 1992.

4. B. Robson, 'Premature obituaries: change and adaptation in the great cities', in R. Lawton, ed., *The Rise and Fall of Great Cities*, London: Belhaven, 1989, pp. 45–54.

5. Manchester Independent Economic Review, *The Case for Agglomeration Economies*, Manchester: Manchester City Council, 2009.

6. G. Williams, 'City vision and strategic regeneration: the role of City Pride', in N. Oakley, ed., *Cities, Economic Competition and Urban Policy*, London: Paul Chapman, 1998; G. Williams, 'Prospecting for gold: Manchester's City Pride experience', *Planning Practice & Research*, 10 (1995), pp. 345–8.

7. City Pride, *A Focus for the Future: Manchester, Salford & Trafford from the Present into the Twenty-first Century*, Manchester: Manchester City Council, 1994.

8. S. Randal, 'City Pride: from "municipal socialism" to "municipal capitalism"', *Critical Social Policy*, 43 (1995), pp. 40–59.

9. City Pride, *Partnerships: Manchester, Salford, Trafford & Tameside from the Present into the Twenty-first Century*, Manchester: Manchester City Council, 1997.

10. B. Robson, M. Bradford, I. Deas et al., *The Impact of Urban Development Corporations in Leeds, Bristol and Central Manchester*, London: DETR, 1998; I. Deas et al., 'Re-thinking the Urban Development Corporation "experiment"', *Progress in Planning*, 54 (2000), pp. 1–72.

11. J. Grigor, 'The Castlefield renaissance', *Manchester Memoirs 1993–94*, 132 (1995), pp. 61–70.

12. J.J. Parkinson-Bailey, *Manchester: An Architectural History*, Manchester: Manchester University Press, 2000, pp. 288–91.

13. G. Williams, *The Enterprising City Centre,* London: E. & F.N. Spon, 2003, pp. 256–9.

14. SURF, *Hulme City Challenge: Ten Years On*, Salford: Salford University, 2002.

15. Hulme City Challenge, *Rebuilding the City: A Guide to Development*, Manchester: Hulme Regeneration, 1994.

16. *Guide to Development in Manchester*, Manchester: Manchester City Council, 1996; D. Rudlin, 'The Hulme and Manchester Design Guides', *Built Environment*, 25 (1999), pp. 317–24.

17. Parkinson-Bailey, *Manchester*; C. Hartwell, *Manchester*, Harmondsworth: Penguin, 2001.

18. B. Robson, 'Mancunian ways: the politics of regeneration', in J. Peck and K. Ward, eds, *City of Revolution*, Manchester: Manchester University Press, 2002, pp. 34–49.

19. R. Ramwell and H. Saltburn, *Trick or Treat? City Challenge and the Regeneration of Hulme*, High Wycombe: North British Housing Association, 1998.

20. A. Harding, *Hulme City Challenge: Did It Work?*, Manchester: Manchester City Council, 1998.

21. G. Williams, 'Rebuilding the entrepreneurial city: the master planning response to the bombing of Manchester city centre', *Environment and Planning B*, 27 (2000), pp. 485–505; A. Holden, 'Bomb sites: the politics of opportunity', in J. Peck and K. Ward, eds, *City of Revolution*, Manchester: Manchester University Press, 2002, pp. 133–54.

22. A. Sandford, 'Bombed but not bowed: 15 June 1996', *Manchester Memoirs 1997–98*, 136 (1999), pp. 50–9.

23. Williams, *The Enterprising City Centre*, pp. 261–7.

24. G. Blakeley and B. Evans, *The Regeneration of East Manchester*, Manchester: Manchester University Press, 2013.

25. EIUA, *New Evaluated Manchester*, Manchester: New East Manchester, 2006.

26. R. Tye and G. Williams, 'Urban regeneration and central-local government relations: the case of East Manchester', *Progress in Planning*, 42 (1994), pp. 1–97.

27. M. Parkinson and B. Robson, *Urban Regeneration Companies*, London: DETR, 2000.

28. L. Grant, *Reclaiming East Manchester: Ten Years of Resident-led Regeneration*, Manchester: New East Manchester, 2010, pp. 9–16; Blakeley and Evans, *The Regeneration of East Manchester*.

29. Grant, *Reclaiming East Manchester*, p. 182.

30. T. Struthers, 'The redevelopment of Salford Quays, Greater Manchester', *The Planning Review*, 38 (2003), pp. 11–18; C. Law, 'From Manchester docks to Salford quay', *Manchester Geographer*, 9 (1988), pp. 2–15; M. Raco et al., 'Delivering brownfield regeneration', in T. Dixon et al., eds, *Sustainable Brownfield Regeneration*, Oxford: Blackwell, 2007, pp. 119–40.

31. F. Goodey, 'The sexiest building in the North', *Manchester Memoirs 2000–01*, 139 (2002), pp. 22–7.

32. R. Tym, *Monitoring Enterprise Zones*, London: Department of the Environment, 1984; B. Robson, *Those Inner Cities*, Oxford: Oxford University Press, 1988.

33. Amion, 'The impact of MediaCity UK', conference presentation, Liverpool: Amion Consulting, 20 June 2011.

34. L. Grant, *1 Angel Square*, Manchester: Manchester University Press, 2013.

35. G. Williams, 'Tourism in Manchester', *North West Geographer*, 14 (1993), pp. 38–55.

36. K. Hetherington, 'Manchester's Urbis: urban regeneration, museums and symbolic economies', *Cultural Studies*, 21 (2007), pp. 630–49.

37. R. Hough, 'The Trafford Centre development', *Manchester Memoirs 1997–98*, 136 (1999), pp. 69–77.

38. G. Norwood, *The Housing Downturn*, London: Taylor & Francis, 2009.

39. Viewforth Consulting, *Measuring the Difference: The Economic and Social Impact of the University of Manchester*, Manchester: Manchester University, 2013.

40. J. O'Connor and Xin Gu, 'Developing a creative cluster in a postindustrial city: CIDS and Manchester', *The Information Society*, 26 (2010), pp. 124-36.

41. J. Davies, 'The English experience', in C.W. Wessner, ed., *Understanding Research, Science and Technology Parks*, Washington, DC: National Research Council, 2009, pp. 70-4.

42. A. Westwood and M. Nathan, *Manchester: Ideopolis?*, London: The Work Foundation, 2003.

43. C. Gratton et al., 'Sport and economic regeneration in cities', *Urban Studies*, 42 (2005), pp. 985-99.

44. C. Law, 'Manchester's bid for the Millennium Olympic Games', *Geography*, 79 (1994), pp. 222-31; C.R. Hill, *Olympic Politics*, Manchester: Manchester University Press, 1992.

45. S. Quilley, 'Manchester first: from municipal socialism to the entrepreneurial city', *International Journal of Urban and Regional Research*, 24 (2000), pp. 601-15.

46. T. Kitchen, *People, Politics, Policies and Plans*, London: Paul Chapman, 1997, p. 118.

47. I. Taylor et al., *A Tale of Two Cities*, London: Routledge, 1996; B. Skeggs and J. Binnie, 'Cosmopolitan knowledge and the production and consumption of sexualised space: Manchester's gay village', *Sociological Review*, 52 (2004), p. 69.

48. H. Bernstein, 'The future of UK cities and the quest for growth', *Manchester Memoirs 1995-96*, 134 (1997), pp. 65-71.

49. B. Robson, R. Barr et al., *Mapping City Regions*, London: Office of the Deputy Prime Minister, 2006.

50. *Unlocking Growth in Cities*, London: HM Treasury, 2011; Cabinet Office, *City Deals - Wave 1*, London: HM Government, 2012.

51. George Osborne, speaking in the Power Hall of the Museum of Science and Industry in Manchester in June 2014, said, 'The cities of the North are individually strong, but collectively not strong enough. The whole is less than the sum of its parts. So the powerhouse of London dominates more and more. And that's not healthy for our economy. It's not good for our country. We need a Northern powerhouse too. Not one city but a collection of Northern cities - sufficiently close to each other that combined they can take on the world ... You need a big place, with lots of people', https://www.gov.uk/government/speeches/chancellor-we-need-a-northern-powerhouse.

52. S. Jenkins, 'The secret negotiations to restore Manchester's greatness', *The Guardian*, 12 February 2015.

53. Manchester Independent Economic Review, *The Case for Agglomeration Economies*; M. Emmerich et al., 'Urban growth in the UK: a Mancunian call to action', *Transactions of the Manchester Statistical Society 2011-2012* (2013), pp. 7-28.

54. R. Eddington, *Transport's Role in Sustaining UK's Productivity and Competitiveness*, London: Department for Transport, 2006.

55. J. Aldridge et al., 'Collateral damage: territory and policing in an English gang city', in B. Goldson, ed., *Youth in Crisis?*, Oxford: Routledge, 2011; D. Mares, 'Gangstas or lager louts? Working class street gangs in Manchester', in D. Mares, ed., *The Eurogang Paradox*, New York: Springer, 2001.

56. S. Hylton, *A History of Manchester*, Chichester: Phillimore, 2003.

57. M. Noble et al., 'Measuring multiple deprivation at the small-area level', *Environment and Planning A*, 38 (2006), pp. 169-85; B. Robson, M. Bradford and R. Tye, *The Index of Local Conditions*, London: HMSO, 1995.

58. B. Robson, K. Lymperopoulou and A. Rae, 'People on the move: exploring the functional roles of deprived neighbourhoods', *Environment and Planning A*, 40 (2008), pp. 2693-714.

59. Manchester Independent Economic Review, *Sustainable Communities*, Manchester: Manchester City Council, 2009.

60. B. Redhead, *Manchester: A Celebration*, London: André Deutsch, 1993; P. Bamford, *Manchester: 50 Years of Change*, London: HMSO, 1995.

61. For example, M. Bontje et al., *Inventive City-regions*, Farnham: Ashgate, 2011; A. Mace et al., *Shrinking to Grow? The Urban Regeneration Challenge in Leipzig and Manchester*, London: Institute of Community Studies, 2004.

62. J. Peck and K. Ward, eds, *City of Revolution: Restructuring Manchester*, Manchester: Manchester University Press, 2002.

63. R. Imrie and H. Thomas, 'The limits to property-led regeneration', *Environment and Planning C*, 11 (1993), pp. 87-102; P. Loftman and B. Nevin, 'Going for growth: prestige projects in three British cities', *Urban Studies*, 33 (1996), pp. 991-1019; R. Mellor, 'Hypocritical city: cycles of urban exclusion', in J. Peck and K. Ward, eds, *City of Revolution: Restructuring Manchester*, Manchester: Manchester University Press, 2002, pp. 214-35; S. Quilley, 'Entrepreneurial turns: municipal socialism and after', in Peck and Ward, eds, *City of Revolution*, pp. 76-94.

64. R. Leese, 'Manchester: the next decade', *Manchester Memoirs 1999-2000*, 138 (2001), p. 59.

Manchester Timeline

Early and Medieval History

c.77–78 Romans establish a camp (Mamucium) near junction of Medlock and Irwell. Wooden fort later rebuilt in stone. A civil settlement (*vicus*) grew up outside the fortress walls.

c.400 Romans abandon Mamucium.

923 Anglo-Saxon Chronicle refers to the 'repairing' of the fort at Manchester by Edward, King of Wessex, as a defence against the Vikings.

1086 Mamecestre (Manchester) recorded in Domesday Book: unclear whether this refers to the manor or the parish. Manor in possession of Albert de Gresle. Domesday Book records two churches: St Mary's and St Michael's.

1215 Robert de Gresle is one of the barons who demand Magna Carta from King John at Runnymede.

1223 Manchester granted right to hold annual fair lasting two days at request of Robert de Gresle, baron of Manchester.

1301 Manchester granted a charter by Thomas de Gresle.

1351 Henry of Grosmont created first Duke of Lancaster, Lancashire being made a County Palatine.

1359 It is judicially determined that the charter of 1301 had not granted free borough status and that Manchester should be regarded as a 'manorial borough'. The town remained under the control of the lord of the manor and was governed by a manorial court until the nineteenth century.

1368 Earliest record of bridge over Irwell connecting Manchester and Salford (Old Salford Bridge).

1421 Thomas de la Warre, lord of the manor of Manchester, given licence to convert the parish church of St Mary into a collegiate foundation. John Huntington appointed first warden.

1505	Chapel on Salford Bridge repaired.
1506	James Stanley, warden of Collegiate Church, made Bishop of Ely. He died in 1515 and was buried in a chapel adjoining the Derby Chapel in the Collegiate Church.
1515	Founding of Manchester Free Grammar School by Hugh Oldham, Bishop of Exeter. School built on land adjoining Collegiate Church college buildings.
1538	John Leland visits Manchester, describing it as 'the fairest, best buildid, quickest, and most populus Tounne of al Lancastreshire ... Ther be divers Stone Bridgis in the Toune, but the best of iii arches is over Irwel. This Bridge devidith Manchestre from Salford, the wich is as a large Suburbe to Manchestre.'
1547	Collegiate Church dissolved.
1552	Parliamentary Act specifies the length, breadth and weight of piece of woollen cloths called 'Manchester, Lancashire and Cheshire cottons'.
1557	Collegiate Church re-founded by Queen Mary.
1573	Parish registers of Collegiate Church begin.
1578	New charter for Collegiate Church.
1585	William Camden visits Manchester and writes: 'This town excels the towns immediately around it in handsomeness, populousness, woollen manufacture, market-place, church and college, but did much more excel them in the last age, as well as by the glory of its woollen cloths, which they call Manchester Cottons.'
1595	John Dee, mathematician and astronomer, appointed warden of Collegiate Church. He left Manchester in 1605.
1596	Sir Nicholas Mosley, textile merchant, becomes Lord of the Manor. He died in 1612 and was buried in Didsbury church.

1600-1699

1600	Court Leet directs that 'yarn or other stuff' must be weighed using the standard weights of the town.
1605	Outbreak of plague. Sick were removed to Collyhurst where there was also a burial ground.
1634	Textile merchant Humphrey Booth the Elder lays foundation stone of Trinity Chapel, Salford.
1635	New charter of foundation granted to Collegiate Church. Population of parish asserted to be 20,000.
1639	William Crabtree and Jeremiah Horrocks observe the transit of Venus.

1642	Royalist forces commanded by Lord Strange besiege but fail to capture Manchester. The first skirmish reported in Parliament as 'the beginning of the Civil warres in England'.
1645	Money raised in London for relief of plague in Manchester.
1649	Collegiate Church college buildings used as military store and prison.
1653	Humphrey Chetham, textile merchant, dies. Under the terms of his will he left property to establish and operate a charity school and free library. These occupied buildings that had been the Lord of the Manor's house in medieval times and later accommodation for the clergy of the Collegiate Church.
1654	Charles Worsley of Platt appointed by Cromwell to represent Manchester in Parliament.
1661	Manchester celebrates coronation of Charles II.
1662	Manchester becomes an important centre in Lancashire for Dissenters following Act of Uniformity.
1665	Outbreak of plague.
1680	Alms-houses built in Miller's Lane.
1694	Henry Newcombe preaches at opening of new meeting house built by Presbyterians in Plungeon's Meadow (Cross Street).

1700-1749

1712	St Ann's church consecrated by Bishop of Chester.
1715	Dissenters' Meeting House (Cross Street chapel) damaged during Jacobite disturbances.
1719	*Manchester Weekly Journal*, Manchester's first newspaper, printed by Roger Adams. First book printed in Manchester: John Jackson, *Mathematical Lectures*, 'Printed by Roger Adams in the Parsonage, and sold by William Clayton, Bookseller at the Conduit'.
1721	Act passed to improve navigation on the Mersey and Irwell between the Mersey estuary and Manchester. Work completed by around 1734.
1722	First post office opened in Manchester.
1726	Referring to its form of local government, Daniel Defoe describes Manchester as 'the greatest mere village in England'.
1729	Exchange built by Lord of the Manor, Sir Oswald Mosley.
1730	First number of *Manchester Gazette* published by Henry Whitworth.
1733	John Wesley visits and preaches in Manchester.
1736	'Manchester Act' promotes production of fustian cloths (linen warps and cotton weft).
1737	Cross Street Presbyterian chapel rebuilt.
1740	Baptist chapel in Withy Grove built.

1741 First edition of 'A Plan of the Towns of Manchester and Salford' published by Russel Casson and John Berry.

1745 Jacobite army led by Charles Edward Stuart occupies Manchester.

1746 Trial and execution of officers of the 'Manchester Regiment' following defeat of Jacobite rising. The heads of two of them were sent up to Manchester and fixed on poles on the Exchange. John Marchant in *History of the Present Rebellion* (1746) noted that 'As The Hague in Holland is deservedly called the most magnificent village in Europe, Manchester, with equal propriety, may be styled the greatest mere village in England, for 'tis not so much as a town, strictly speaking, the highest magistrate being a constable or headborough; yet it is more populous than York, Norwich, or most cities in England, and as big as two or three of the lesser ones put together.'

1750–1799

1752 Joseph Harrop begins publication of *Manchester Mercury*, weekly newspaper.

1752 Manchester Infirmary opens in Garden Street, Shudehill, later moving to Piccadilly.

1753 Opening of Manchester's first theatre in Marsden Street.

1756 St Mary's church consecrated.

1757 Riot against high food prices suppressed by soldiers who fire on the crowd, killing three. Became known as the 'Shudehill Fight' after a satirical pamphlet by John Collier (Tim Bobbin).

1761 Opening of first section of Bridgewater Canal from Worsley to Manchester, including Barton Aqueduct.

1767 Manchester Agricultural Society founded.

1772 First issue of *Manchester Directory*, compiled by Elizabeth Raffald.

1775 First Theatre Royal opened at junction of York Street and Spring Gardens.

1776 Act of Parliament passed to enable widening of streets in centre of town.

1777 Gentlemen's Concert Society establish concert hall, Fountain Street. Old Salford Bridge widened.

1781 Manchester Literary and Philosophical Society established. Its *Memoirs and Proceedings* were first published in 1783.

1783 Richard Arkwright builds one of the first cotton factories in Manchester.

1785 New Bailey bridge opened.

1786 Founding of Manchester Academy. Repeal of fustian tax.

1787 Thomas Clarkson's sermon at Collegiate Church inspires anti-slavery movement in Manchester.

1788	Heywood's Bank established, St Ann's Square.
1792	Riots in Manchester, offices of *Manchester Herald* destroyed. Passing of Manchester Police Act.
1793	New Manchester workhouse opened, Strangeways.
1798	House of Recovery for treatment of infectious diseases opened, Aytoun Street.

1800-1849

1801	Population of Manchester township in first national census, 70,409.
1805	Rochdale canal fully opened.
1806	Portico Library, Mosley Street, opened.
1809	Opening of new Exchange, Market Street.
1818	Manchester gasworks erected in Water Street.
1819	Mounted troops disperse meeting calling for political and economic reform at St Peter's Field; 18 people killed and several hundred injured.
1820	Manchester Chamber of Commerce established to promote and protect trade of Manchester.
1821	*Manchester Guardian* first published.
1824	Manchester Mechanics' Institution founded. It built premises in Cooper Street.
1825	Opening of Town Hall, King Street. Construction of Royal Manchester Institution, Mosley Street, begun.
1830	Manchester and Liverpool Railway opened.
1832	Charles Poulett Thomson and Mark Philips elected as MPs for the new parliamentary borough of Manchester. Cholera epidemic.
1833	Manchester Statistical Society established.
1836	Second Manchester Music Festival marred by death of Maria Malibran. John Jennison opens Belle Vue Zoological Gardens.
1838	Incorporation of Manchester municipal borough: Manchester, Cheetham, Beswick, Ardwick, Chorlton-on-Medlock and Hulme. Establishment of Manchester Anti-Corn Law Association. Chartist meeting at Kersal Moor.
1839	Opening of Victoria Bridge which replaced the old Salford bridge, first built in the fourteenth century.
1840	First Free Trade Hall erected in Peter Street.
1842	Industrial disturbances in Manchester and cotton towns. Opening of London Road railway station.
1845	Friedrich Engels describes Manchester as the archetypal industrial city. Theatre Royal opened in Peter Street.

1846	Opening of first public parks in Manchester: Queens Park (Harpurhey) and Philips Park (Bradford). Manchester celebrates repeal of Corn Laws.
1847	Manchester diocese established. James Prince Lee appointed as first bishop.
1848	Publication of Elizabeth Gaskell's novel *Mary Barton. A Tale of Manchester Life.*
1849	Second cholera epidemic in Manchester.

1850-1899

1851	Manchester supplied with water from Longdendale reservoirs, engineer John Frederick Bateman. Owens College opened. Queen Victoria's first visit to Manchester. Manchester borough population, 303,382.
1852	Manchester Free Library opened in former Owenite Hall of Science, Tonman Street.
1853	Manchester designated a city.
1857	Manchester Art Treasures Exhibition at Old Trafford attracts 1.3 million visitors.
1858	Hallé Orchestra perform first season of concerts in new Free Trade Hall.
1861–65	Lancashire Cotton Famine.
1864	Manchester Assize Courts, Great Ducie Street, opened.
1867	Unveiling of Albert Memorial, Albert Square.
1868	First Trades Union Congress held in Mechanics' Institution, David Street. Opening of Strangeways prison. New Bailey prison closed. *Manchester Evening News* first published.
1870	Lydia Becker elected first female member of Manchester School Board.
1877	Abel Heywood opens new Town Hall, Albert Square.
1878	Newton Heath Lancashire & Yorkshire Railway Football Club formed, later renamed Manchester United FC.
1880	Owens College becomes the first constituent in the federal Victoria University, England's first civic university. St Mark's (West Gorton) church football team founded, forerunner of Manchester City FC.
1882	Manchester Municipal Art Gallery, Mosley Street, opened, occupying the premises built by the Manchester Royal Institution.
1885	Harpurhey, Bradford-with-Beswick and Rusholme become part of City of Manchester.
1887	Royal Jubilee Exhibition at Old Trafford attracts 4.5 million visitors.
1890	Blackley, Crumpsall, Clayton, Moston, Newton Heath, Openshaw and West Gorton become part of City of Manchester.
1893	Royal Manchester College of Music established by Sir Charles Hallé.

| 1894 | Official opening of Manchester Ship Canal by Queen Victoria. This makes the city a seaport with its own docks. Manchester supplied with water from Thirlmere reservoir. |
| 1896 | Opening of Trafford Park industrial estate. |

1900-1949

1900	Opening of John Rylands Library, Deansgate. Built by Enriqueta Rylands as memorial to her husband. E.G. Hulton launches *Daily Dispatch*, printed at Withy Grove works.
1901	Population of City of Manchester is 543,872.
1902	The Prime Minister, Arthur Balfour, opens the Municipal School of Technology, Sackville Street.
1903	Women's Social and Political Union is founded in Emmeline Pankhurst's house in Nelson Street, Chorlton-on-Medlock. Owens College reconstituted as the Victoria University of Manchester. Opening of Midland Hotel, luxury railway hotel serving Central Station.
1904	Burnage, Chorlton-cum-Hardy, Didsbury, Moss Side and Withington become part of City of Manchester. Founding of Manchester University Press.
1909	Edward VII opens Manchester Royal Infirmary, which had relocated from Piccadilly to Oxford Road in 1908. Gorton and Levenshulme become part of City of Manchester.
1910	Manchester United open new football stadium at Old Trafford.
1913	On the brink of the First World War, 65% of world's total cotton fabric is manufactured in Lancashire and a majority of the world's cotton is traded in Manchester's Royal Exchange. 80% of cotton cloth is exported, 45% to India.
1919	Civic reception to celebrate the achievement of John Alcock and Arthur Whitten Brown, first men to fly across the Atlantic.
1920	Indian National Congress starts a boycott of British goods in passive resistance to colonial rule.
1921	George V opens new Manchester Royal Exchange.
1923	Manchester City FC move from Ardwick to new stadium at Maine Road, Moss Side.
1924	Manchester cenotaph, St Peter's Square, unveiled.
1929–31	World economic depression accelerates decline of cotton industry.
1930	Barton Aerodrome opened.
1931	Demonstrations by the unemployed in Manchester and Salford. Wythenshawe (parishes of Baguley, Northenden and Northen Etchells) becomes part of City of Manchester.
1934	George V opens Manchester Central Library.

1935	Construction of Haweswater dam, Westmorland, to supply water to Manchester.
1937	First stage of new municipal airport at Ringway completed.
1938	Manchester celebrates centenary of municipal government. Completion of Town Hall extension.
1940	Manchester blitz.
1945	Publication of *City of Manchester Plan.*

1950-1999

1951	Population of city of Manchester is 703,082. Opening of new Free Trade Hall, Peter Street.
1958	Munich air disaster, 24 killed including eight Manchester United players.
1959	*Manchester Guardian* renamed *The Guardian*. It moved to London in 1964.
1960	London Road Station reopened and renamed Piccadilly Station.
1962	New terminal opened at Ringway airport.
1966–72	'Container revolution', decline of rail freight-carrying and growth of suburban trading estates causes rapid economic decline in central area.
1968	Cotton trading at Manchester Royal Exchange takes place for the last time. Manchester United becomes the first English football club to win the European Cup.
1969	Opening of North Western Museum of Science and Industry in Grosvenor Street. It moved to Liverpool Road station site in 1983.
1970	Manchester Polytechnic established.
1974	Metropolitan County of Greater Manchester formed.
1976	Royal Exchange Theatre opened by Laurence Olivier.
1978	*Daily Star*, tabloid newspaper, launched by Express newspapers in Manchester. Factory Records founded by Tony Wilson.
1980	Manchester declares itself to be the world's first nuclear-free city.
1981	Two days of rioting in Moss Side.
1982	Manchester docks finally closed. Bernard Manning opens Haçienda club, in a disused warehouse on Whitworth Street West.
1983	Salford City Council acquires part of former Manchester docks from Ship Canal Company. Subsequently developed as Salford Quays.
1984	Opening of Manchester Jewish Museum in former Spanish and Portuguese synagogue, Cheetham Hill Road.
1986	G-Mex opened in former Central Station.
1990	Serious disturbances at Strangeways prison, the longest prison riot in British history.

1992	Metrolink light rail system begins operating between Bury and Manchester Victoria. Manchester Polytechnic granted university status.
1993	Manchester comes third in bid to host the summer 2000 Olympics. It had previously been fifth of six cities competing to stage the 1996 Olympics.
1994	National Museum of Labour History (People's History Museum) opens new premises at the Pump House, Bridge Street. The museum had moved from London to Manchester in 1990.
1996	IRA bomb devastates Manchester city centre.
1998	Peel Holdings open Trafford shopping centre, Dumplington.

2000-

2000	The Printworks, Withy Grove, an entertainment centre in the former newspaper printing works, opened. The Lowry art gallery and theatre complex, Salford Quays opened.
2001	The official census figure of 392,800 persons living in the City of Manchester is challenged by the city council as a serious underestimate and revised by 21,200.
2002	Manchester hosts the Commonwealth Games.
2003	Manchester City Football Club moves from Moss Side to City of Manchester Stadium, Bradford.
2004	Merger of University of Manchester and UMIST. Labour Party holds its spring political conference in G-Mex centre.
2006	Opening of Beetham Tower, Deansgate, hotel and residential skyscraper. Tallest building in Manchester, 554 feet. Manchester International Airport carries a record 22.4 million passengers.
2007	First Manchester International Festival, a biennial arts festival featuring commissioned works.
2008	Queen Elizabeth officially opens the Manchester Civil Justice Centre, Spinningfields. Abu Dhabi United Group purchase Manchester City FC.
2010	Granada Studios is venue for the first televised general election debate of leaders of the main political parties.
2011	Population of City of Manchester is 503,127, an increase of 28.1 per cent since 2001.
2012	National Football Museum opened in Urbis building. Alan Turing centenary conference held in Manchester.
2013	Irish World Heritage Centre, Cheetham Hill, opened.
2015	Whitworth Art Gallery reopened following £15 million redevelopment. This follows extensive refurbishments of Manchester Art Gallery and Manchester Central Library. 'Home' opens as purpose-built premises on First Street for Library Theatre Company and Cornerhouse.

Further Reading

Roots of Industrial Revolution

Borsay, P., *The Eighteenth-Century Town: A Reader in English Urban History, 1688–1820*, London: Longman, 1990.

Chalklin, C., *The Provincial Towns of Georgian England: A Study of the Building Process, 1740–1820*, London: Arnold, 1974.

The Court Leet Records of the Manor of Manchester from the Year 1552, vol. I, Manchester, 1884.

Crosby, A.G., ed., *Leading The Way: A History of Lancashire's Roads*, Preston: Lancashire County Books, 1998.

Daniels, G.W., *The Early English Cotton Industry*, Manchester: Manchester University Press, 1920.

Darbyshire, A., *A Booke of Olde Manchester and Salford*, Manchester: Heywood, 1887.

Farrer, W., and J. Brownhill, *Victoria History of the County of Lancaster*, vol. IV, London: Constable, 1911.

Guscott, S.J., *Humphrey Chetham, 1580–1653: Fortune, Politics, and Mercantile Culture in Seventeenth-century England*, Chetham Society, 2003.

Hartwell, C, *Manchester*, New Haven, CT: Yale University Press, 2001.

Healey, J., 'Socially selective mortality during the population crisis of 1727–1739: evidence from Lancashire', *Local Population Studies*, 81 (2008), pp. 58–74.

Horner, C., ed., *Early Modern Manchester*, Manchester: Manchester Centre for Regional History, 2008.

Hoskins, W.G., *Local History in England*, London: Longman, 1959.

Lemire, B., *Fashion's Favourite: The Cotton Trade and the Consumer in Britain, 1660–1800*, Oxford: Oxford University Press, 1991.

Mason, M., 'Manchester in 1645: the effects and social consequences of plague', *Transactions of the Lancashire and Cheshire Antiquarian Society*, 94 (1998), pp. 1–30.

Nevell, M., and T. Wyke, eds, *Bridgewater 250: The Archaeology of the World's First Industrial Canal*, Salford: University of Salford Centre for Applied Archaeology, 2012.

O'Brien, P., T. Griffiths and P. Hunt, 'Political components of the industrial
 revolution: Parliament and the English cotton textile industry, 1660–1774',
 Economic History Review, 44.3 (1991), pp. 395–423.
Redford, A., *The History of Local Government in Manchester, vol. 1 Manor and
 Township*, London: Longman, 1939.
Roeder, C., 'Maps and views of Manchester', *Transactions of the Lancashire and
 Cheshire Antiquarian Society*, 21 (1903), pp. 152–71.
Rose, M.B., ed., *The Lancashire Cotton Industry: A History Since 1700*, Preston:
 Lancashire County Books, 1996.
Sharpe France, R., 'A history of plague in Lancashire', *Transactions of the Historic
 Society of Lancashire and Cheshire*, 90 (1938), pp. 1–175.
Stobart, J., *The First Industrial Region, North-West England 1700–60*, Manchester:
 Manchester University Press, 2004.
Stobart, J., 'Manchester and its regions: networks and boundaries in the eighteenth
 century', in C. Horner, ed., *Early Modern Manchester*, Manchester: Centre for
 Regional History, 2008.
Timmins, G., *Four Centuries of Lancashire Cotton*, Preston: Lancashire County
 Books, 1996.
Timmins, G., *Made in Lancashire: A History of Regional Industrialisation*,
 Manchester: Manchester University Press, 1998.
Tupling, G.H., 'Medieval and Early Modern Manchester', in C.F. Carter, ed.,
 Manchester and its Region, Manchester: Manchester University Press for the
 British Association, 1962.
Turnbull, G.L., *Traffic and Transport: An Economic History of Pickfords*, London:
 Allen & Unwin, 1979.
Wadsworth, A.P., and J. De Lacy Mann, *The Cotton Trade and Industrial Lancashire,
 1660–1780*, Manchester: Manchester University Press, 1931.
Willan, T.S., *Elizabethan Manchester*, Manchester: Manchester University Press,
 1980.
Willan, T.S., 'Plague in perspective: the case of Manchester in 1605', *Transactions of
 the Historic Society of Lancashire and Cheshire*, 132 (1982), pp. 29–40.
Wrigley, E.A., and R.S. Schofield, *The Population History of England, 1541–1871: A
 Reconstruction*, London: Edward Arnold, 1981.

Rise and Decline of Cottonopolis

Aldcroft, D.A., and M.J. Freeman, eds, *Transport in the Industrial Revolution*,
 Manchester: Manchester University Press, 1983.
Ashmore, O., *The Industrial Archaeology of Lancashire*, Newton Abbot: David &
 Charles, 1969.
Aspin, C., *Lancashire. The First Industrial Society*, Helmshore: Helmshore Local
 History Society, 1969.
Briggs, A., *Victorian Cities*, Harmondsworth: Penguin, 1990.

Brumhead, D., and T. Wyke, eds, *Moving Manchester: Aspects of History of Transport in the Manchester Region*, Manchester: Lancashire and Cheshire Antiquarian Society, 2004.

Chaloner, W.H., 'The birth of modern Manchester', in C.F. Carter, ed., *Manchester and its Region*, Manchester: Manchester University Press for the British Association, 1962.

Daunton, M., ed., *Cambridge Urban History of Britain, vol. 3 1840–1950*, Cambridge: Cambridge University Press, 2000.

Farnie, D.A., *The English Cotton Industry and the World Market 1815–1896*, Oxford: Clarendon Press, 1979.

Farnie, D.A., *The Manchester Ship Canal and the Rise of the Port of Manchester 1894–1975*, Manchester: Manchester University Press, 1980.

Farnie, D.A., and D.J. Jeremy, eds, *The Fibre that Changed the World. The Cotton Industry in International Perspective, 1600–1990s*, Oxford: Oxford University Press, 2004.

Kellett, J.R., *The Impact of Railways on Victorian Cities*, London: Routledge and Kegan Paul, 1969.

Kidd, A., *Manchester*, 4th edn, Lancaster: Carnegie, 2006.

King, S., and G. Timmins, *Making Sense of the Industrial Revolution*, Manchester: Manchester University Press, 2001.

Lee, C.H., *A Cotton Enterprise 1795–1840. A History of McConnel and Kennedy, Fine Cotton Spinners*, Manchester: Manchester University Press, 1972.

Lloyd-Jones, R., and M.J. Lewis, *Manchester and the Age of the Factory*, London: Croom Helm, 1988.

Maw, P., *Transport and the Industrial City. Manchester and the Canal Age 1750–1850*, Manchester: Manchester University Press, 2013.

Messinger, G.S., *Manchester in the Victorian Age. The Half-Known City*, Manchester: Manchester University Press, 1985.

Musson, A.E., and E. Robinson, *Science and Technology in the Industrial Revolution*, Manchester: Manchester University Press, 1969.

Nevell, M., *Manchester. The Hidden History,* Stroud: History Press, 2008.

Nicholls, R., *Trafford Park. The First Hundred Years*, Chichester: Phillimore, 1996.

Phillips, C.B., and J.H. Smith, *Lancashire and Cheshire since AD 1540*, London: Longman, 1994.

Rose, M.B., ed., *The Lancashire Cotton Industry. A History since 1700*, Preston: Lancashire County Books, 1996.

Scola, R., *Feeding the Victorian City. The Food Supply of Manchester, 1770–1870*, Manchester: Manchester University Press, 1992.

Singleton, J., *Lancashire on the Scrapheap: The Cotton Industry 1945–1970*, Oxford: Oxford University Press, 1991.

Smith, J.H., ed., *The Great Human Exploit. Historic Industries of the North West*, Chichester: Phillimore, 1973.

Taylor, S., M. Cooper et al., *Manchester: The Warehouse Legacy*, London: English
 Heritage, 2002.
Timmins, G., *Four Centuries of Lancashire Cotton*, Preston: Lancashire County
 Books, 1996.
Vigier, F., *Change and Apathy. Liverpool and Manchester during the Industrial
 Revolution*, Cambridge, MA: MIT Press, 1970.
Walton, J.K., *Lancashire. A Social History, 1558–1939*, Manchester: Manchester
 University Press, 1987.
Walton, J.K., 'The North West', in F.M.L. Thompson, ed., *The Cambridge Social
 History of Britain, 1750–1950*, Vol. 1, Cambridge: Cambridge University
 Press, 1990.

Science, Technology and Medicine

Agar, J., *Science and Spectacle: The Work of Jodrell Bank in Post-War British Culture*,
 Amsterdam: Harwood, 1998.
Alberti, S., *Nature and Culture: Objects, Disciplines and the Manchester Museum*,
 Manchester: Manchester University Press, 2009.
Broadbent, T.E., *Electrical Engineering at Manchester University: 125 Years of
 Achievement*, Manchester: University of Manchester School of Engineering,
 1998.
Campbell, J., *Rutherford: Scientist Supreme*, Christchurch, New Zealand: AAS, 1999.
Cardwell, D., ed., *Artisan to Graduate: Essays to Commemorate the Foundation in
 1824 of the Manchester Mechanics' Institution*, Manchester: Manchester
 University Press, 1974.
Cardwell, D., *James Joule: a Biography*, Manchester: Manchester University Press,
 1991.
Charlton, H.B., *Portrait of a University, 1851–1951*, Manchester: Manchester
 University Press, 1951.
Dummelow, J., *Metropolitan–Vickers Electrical Company, Ltd., 1899–1949*,
 Manchester: Metropolitan–Vickers, 1949.
Fiddes, E., *Chapters in the History of Owens College and of Manchester University,
 1851–1914*, Manchester: Manchester University Press, 1937.
Fowler, A., and T. Wyke, *Many Arts, Many Skills: The Origins of the Manchester
 Metropolitan University*, Manchester: Manchester Metropolitan University,
 1993.
Greenaway, F., *John Dalton and the Atom*, London: Heinemann, 1966.
Hamlin, C., *Public Health and Social Justice in the Age of Chadwick*, Cambridge:
 Cambridge University Press, 1998.
Hodges, A., *Alan Turing: The Enigma*, London: Vintage, 2012.
Kargon, R., *Science in Victorian Manchester: Enterprise and Expertise*, Baltimore, MD:
 Johns Hopkins University Press, 1977.

Lavington, S., *A History of Manchester Computers*, 2nd edn, Swindon: British Computer Society, 1998.

Magnello, E., *A Centenary History of the Christie Hospital, Manchester*, Manchester: Christie Hospital NHS Trust, 2001.

Musson, A.E., and E. Robinson, *Science and Technology in the Industrial Revolution*, Manchester: Manchester University Press, 1969.

Nye, M.J., *Blackett: Physics, War, and Politics in the Twentieth Century*, Cambridge, MA: Harvard University Press, 2004.

Nye, M.J., *Michael Polanyi and his Generation: Origins of the Social Construction of Science*, Chicago: University of Chicago Press, 2011.

Pickstone, J., *Medicine and Industrial Society: A History of Hospital Development in Manchester and its Region, 1752–1946*, Manchester: Manchester University Press, 1985.

Pullan, B., *A History of the University of Manchester, 1973–90*, Manchester: Manchester University Press, 2004.

Reed, P., *Acid Rain and the Rise of the Environmental Chemist in Nineteenth-Century Britain*, Farnham: Ashgate, 2014.

Sawbridge, M., ed., *The Story of Shirley*, Manchester: Shirley Institute, 1988.

Thackray, A., *John Dalton: Critical Assessments of his Life and Science*, Cambridge, MA: Harvard University Press, 1972.

Thompson, J., *The Owens College: Its Foundation and Growth*, Manchester: J.E. Cornish, 1886.

Williams, B., *'Jews and Other Foreigners': Manchester and the Rescue of the Victims of European Fascism, 1933–1940*, Manchester: Manchester University Press, 2011.

Voices of the People

Adi, H., and M. Sherwood, *The 1945 Manchester Pan-African Congress Revisited*, London: New Beacon, 1995.

Briggs, A., *Victorian Cities*, Harmondsworth: Penguin, 1990.

Bush, M.L., *The Casualties of Peterloo*, Lancaster: Carnegie, 2005.

Frow, E., and R. Frow, *Frederick Engels in Manchester*, Salford: Working Class Movement Library, 1997.

Hodges, A., *Alan Turing*, London: Burnett Books, 1983.

Hovell, M., *The Chartist Movement*, Manchester: Manchester University Press, 1966.

Hunt, T., *The Frock-Coated Communist: The Revolutionary Life of Friedrich Engels*, Harmondsworth: Penguin, 2010.

Kidd, A., *Manchester*, Lancaster: Carnegie, 2006.

Kidd, A., and K. Roberts, eds, *City, Class and Culture. Studies of Social Policy and Cultural Production in Victorian Manchester*, Manchester: Manchester University Press, 1985.

Liddington, J., and J. Norris, *One Hand Tied Behind Us. The Rise of the Women's Suffrage Movement*, London: Virago, 1978.

McCord, N., *The Anti-Corn Law League 1838–1846*, London: Unwin, 1958.

Midgley, C., *Women against Slavery. The British Campaigns 1780–1870*, London: Routledge, 1992.

Musson, A.E., *Trade Union and Social History*, London: Cass, 1974.

O'Neill, J., *Manchester in the Great War*, Barnsley: Pen & Sword Military, 2014.

Peterloo Special Issue, *Manchester Region History Review*, 3.1 (1989).

Pickering, P.A., *Chartism and the Chartists in Manchester and Salford*, Basingstoke: Macmillan, 1995.

Poole, R., ed., *Return to Peterloo, Manchester Region History Review*, 23 (2014).

Read, D., *Peterloo: The 'Massacre' and its Background*, Manchester: Manchester University Press, 1958.

Rothman, B., *The Battle for Kinder Scout*, Timperley: Willow, 2012.

Scott-Presland, P., *Amiable Warriors. A Space to Breathe, 1954–1973. A History of the Campaign for Homosexual Equality and its Times*, London: Paradise Press, 2015.

Tiernan, S., *Eva Gore-Booth. An Image of Such Politics*, Manchester: Manchester University Press, 2012.

Ward, J.T., ed., *Popular Movements c.1830–1850*, London: Macmillan, 1970.

Williams, B., *'Jews and other Foreigners'. Manchester and the Rescue of the Victims of European Fascism, 1933–1940*, Manchester: Manchester University Press, 2011.

Cosmopolitan City

Ashton, R., *Little Germany: Exile and Asylum in Victorian England*, Oxford: Oxford University Press, 1986.

Benton, G., and E.T. Gomez, *The Chinese in Britain, 1800–Present: Economy, Transnationalism, Identity*, Basingstoke: Palgrave Macmillan, 2008.

Bueltmann, T., A. Hinson and G. Norton, *The Scottish Diaspora*, Edinburgh: Edinburgh University Press, 2013.

Delaney, E., *Demography, State and Society: Irish Migration to Britain, 1921–1971*, Liverpool: Liverpool University Press, 2000.

Delaney, E., *The Irish in Post-War Britain*, Oxford: Oxford University Press, 2013.

Endelman, T.M., *The Jews of Britain*, Berkeley, CA: University of California Press, 2002.

Fryer, P., *Staying Power: The History of Black People in Britain*, London: Pluto Press, 2010.

Holmes, C., *John Bull's Island: Immigration and British Society, 1871–1971*, Basingstoke: Macmillan, 1988.

Hunt, T., *The Frock-Coated Communist: The Revolutionary Life of Friedrich Engels*, London: Allen Lane, 2009.

MacRaild, D., *The Irish Diaspora in Britain, 1750-1939*, Basingstoke: Macmillan, 2010.

Singh, G., and D.S.T. Tatla, *Sikhs in Britain: The Making of a Community*, London: Zed Books, 2006.

Sponza, L., *Italian Immigrants in Nineteenth-Century Britain: Realities and Images*, Leicester: Leicester University Press, 1988.

Stachura, P.D., ed., *The Poles in Britain 1940-2000: From Betrayal to Assimilation*, London: Cass, 2004.

Visram, R., *Asians in Britain: 400 Years of History*, London: Pluto Press, 2000.

Winder, R., *Bloody Foreigners: The Story of Immigration to Britain*, London: Little, Brown, 2004.

These references provide more detail on Manchester:

Buckley, A., *The Real Sherlock Holmes: The Hidden Story of Jerome Caminada*, Barnsley: Pen & Sword History, 2014.

Busteed, M., *The Irish in Manchester, c.1750-1921: Resistance, Adaptation and Identity*, Manchester: Manchester University Press, 2016.

Dobkin, M., *More Tales of Manchester Jewry*, Radcliffe: Neil Richardson, 1994.

George, J., *Merchants in Exile: The Armenians of Manchester 1835-1935*, London: Gomidas Institute, 2002.

Keegan, A., and D. Claffey, *More Irish Manchester*, Stroud: Sutton Publishing, 2006.

Sherwood, M., *Manchester and the 1945 Pan-African Congress*, London: Savannah Press, 1995.

Werbner, P., *Imagined Diasporas among Manchester Muslims: The Public Performance of Pakistani Transnational Identity Politics*, Oxford: James Currey, 2002.

Williams, B., *Jewish Manchester: An Illustrated History*, Derby: Breedon Books, 2008.

Williams, B., *The Making of Manchester Jewry 1740-1875*, Manchester: Manchester University Press, 1976.

Culture, Media and Sport

Andrews, D.L., ed., *Manchester United. A Thematic Study*, London: Routledge, 2004.

Ayerst, D., *Guardian. Biography of a Newspaper*, London: Collins, 1971.

Beale, R., *Charles Hallé: A Musical Life*, Farnham: Ashgate, 2007.

Cardwell, D.S.L., ed., *Artisan to Graduate*, Manchester: Manchester University Press, 1974.

Forman, D., *Persona Granada. Some Memories of Sydney Bernstein and the Early Years of Independent Television*, London: André Deutsch, 1997.

Goodie, S., *Annie Horniman: A Pioneer in the Theatre*, London: Methuen, 1990.

Gunn, S., *The Public Culture of the Victorian Middle Classes. Ritual and Authority and the English Industrial City*, Manchester: Manchester University Press, 2000.

Harrison, M., 'Art and philanthropy: T.C. Horsfall and the Manchester Art Museum', in A. Kidd and K.W. Roberts, eds, *City, Class and Culture. Studies*

of *Social Policy and Cultural Production in Victorian Manchester*, Manchester: Manchester University Press, 1985.

Hartley, I., *2ZY to NBH. An Informal History of the BBC in Manchester*, Timperley: Willow, 1987.

Haslam, D., *Manchester, England*, London: Fourth Estate, 1999.

Inglis, S., *Played in Manchester*, London: English Heritage, 2004.

Jackson, L.A., '"The coffee club menace". Policing youth, leisure and sexuality in post-war Manchester', *Cultural and Social History*, 5.3 (2008), pp. 289–308.

James, G., *Manchester. A Football History,* Halifax: James Ward, 2008.

Jones, S.G., 'Working-class sport in Manchester between the wars', in R. Holt, ed., *Sport and the Working Class in Modern Britain*, Manchester: Manchester University Press, 1990.

Jones, T., and B. Stephenson, *Speedway in Manchester, 1927–1945*, Stroud: Tempus, 2003.

Lee, C.P., *Shake, Rattle and Rain. Popular Music Making in Manchester, 1955–1995*, Ottery St Mary: Hardinge and Simpole, 2002.

Pergam, E.A., *The Manchester Art Treasures Exhibition of 1857. Entrepreneurs, Connoisseurs and the Public*, Farnham: Ashgate, 2011.

Read, D., *Press and People, 1790–1850. Opinion in Three English Cities*, London: Arnold, 1961.

Russell, D., ed., 'Popular music in the Manchester region since 1950', *Manchester Region History Review*, 25 (2014).

Russell, D., ed., 'Sport in Manchester', *Manchester Region History Review*, 20 (2009).

Savage, M., and J. Wolff, eds, *Culture in Manchester. Institutions and Urban Change since 1850*, Manchester: Manchester University Press, 2013.

Southall, D.J., *The Golden Years of Manchester Picture Houses*, Stroud: History Press, 2010.

Tate, S., 'Edward Hulton and sports journalism in late Victorian Manchester', *Manchester Region History Review*, 20 (2009), pp. 46–57.

Waterhouse, R., *The Other Fleet Street*, Altrincham: First Edition, 2004.

Waters, C., 'Manchester morality and London capital: the battles over the Palace of Varieties', in P. Bailey, ed., *Music Hall. The Business of Pleasure*, Milton Keynes: Open University Press, 1986.

Wyke, T., and N. Rudyard, *Manchester Theatres*, Manchester: Bibliography of North West England, 1994.

From Township to Metropolis

Archer, J.H.G., 'Edgar Wood: a notable Manchester architect', *Transactions of the Lancashire & Cheshire Antiquarian Society*, 73–74 (1963–64), pp. 153–87.

Barker, P., *Freedoms of Suburbia*, London: Frances Lincoln, 2009.

Burnett, J., *A Social History of Housing 1815–1985*, 2nd edn, London: Methuen, 1986.

Chalklin, C.W., *The Provincial Towns of Georgian England: A Study of the Building Process 1740–1820*, London: Edward Arnold, 1974.

Cherry, G., *Town Planning in Britain since 1900*, Oxford: Blackwell, 1996.

Clapson, M., *Invincible Green Suburbs, Brave New Towns: Social Change and Urban Dispersal in Post-war England*, Manchester: Manchester University Press, 1998.

Daunton, M., ed., *The Cambridge Urban History of Britain Volume III, 1840–1950*, Cambridge: Cambridge University Press, 2000.

Dodge, M., and R. Brook, eds, *The Making of Post-War Manchester: Plans and Projects*, Manchester: Bauprint, forthcoming.

Dore, R.N., 'Manchester's discovery of Cheshire: excursionism and commuting in the 19th century', *Transactions of the Lancashire & Cheshire Antiquarian Society*, 82 (1983), pp. 1–20.

Fishman, R., *Bourgeois Utopias: The Rise and Fall of Suburbia*, New York: Basic Books, 1987.

Gunn, S., and R. Bell, *Middle Classes: Their Rise and Sprawl*, London: Cassell, 2002.

Harris, R., and P.J. Larkham, eds, *Changing Suburbs: Foundation, Form and Function*, London: E. & F.N. Spon, 1999.

Hartwell, C., M. Hyde and N. Pevsner, *The Buildings of England: Lancashire: Manchester and the South-East*, New Haven, CT: Yale University Press, 2004.

Hartwell, C., M. Hyde and N. Pevsner, *The Buildings of England: Cheshire*, 2nd edn, New Haven, CT: Yale University Press, 2011.

McKellar, E., *Landscapes of London: The City, the Country and the Suburbs 1660–1840*, New Haven, CT: Yale University Press, 2013.

McManus, R., and P.J. Ethington, 'Suburbs in transition: new approaches to suburban history', *Urban History*, 34 (2007), pp. 317–37.

Nevell, M., *The Archaeology of Trafford: A Study of the Origins of Community in North West England Before 1900*, Manchester: Trafford Metropolitan Borough Council and Greater Manchester Archaeology Unit, 1997.

Redhead, N., *Greater Manchester Urban Historic Landscape Characterisation Project*, 2012, http://archaeologydataservice.ac.uk/archives/view/gmanchester_hlc_2012.

Rodgers, H.B., 'The suburban growth of Victorian Manchester', *Journal of the Manchester Geographical Society*, 58 (1962), pp. 1–12.

Rusholme and Victoria Park Archive, http://rusholmearchive.org.

Thompson, F.M.L., ed., *The Rise of Suburbia*, Leicester: Leicester University Press, 1982.

University of Manchester Online Map Collection, 'Maps of Manchester', http://www.library.manchester.ac.uk/search-resources/guide-to-special-collections/map-collection/online-map-collection/.

Whitehand, J.W.R., and C.M.H. Carr, eds, *Twentieth-Century Suburbs: A Morphological Approach*, London: Routledge, 2001.

Bailey, N., *Partnership Agencies in British Urban Policy*, London: UCL Press, 1995.

Blakeley, G., and B. Evans, *The Regeneration of East Manchester: A Political Analysis*, Manchester: Manchester University Press, 2013.

Blond, P., and M. Morris, *Devo Max–Devo Manc: Place-based Public Services*, London: ResPublica, 2014.

Bontje, M., S. Musterd and P. Pelzer, *Inventive City-regions: Path Dependence and Creative Knowledge Strategies*, Farnham: Ashgate, 2011.

Brook, R., and M. Dodge, eds, *The Making of Post-war Manchester, 1945–74: Plans and Projects*, Manchester: Bauprint, forthcoming.

Centre for Cities, *Cities Outlook 2015*, London: Centre for Cities, 2015.

City Growth Commission, *Unleashing Metropolitan Growth*, London: Royal Society of Arts, 2014.

Deas, I., B. Robson and M. Bradford, 'Re-thinking the Urban Development Corporation "experiment": the case of Central Manchester, Leeds and Bristol', *Progress in Planning*, 54 (2000), pp. 1–72.

Emmerich, M., J. Holden and R. Rios, 'Urban growth in the UK: a Mancunian call to action', *Transactions of the Manchester Statistical Society 2011–2012* (2013), pp. 7–28.

HM Treasury, *Unlocking Growth in Cities*, London: HM Treasury, 2011.

Jenkins, S., 'The secret negotiations to restore Manchester's greatness', *The Guardian*, 12 February 2015.

Martin, R., A. Pike, P. Tyler and B. Gardiner, *Spatially Rebalancing the UK Economy: The Need for a New Policy Model*, London: Regional Studies Association, 2015.

Martin, R., and B. Rowthorn, eds, *The Geography of Deindustrialisation*, London, Macmillan, 1986.

MIER, *The Case for Agglomeration Economies, Manchester Independent Economic Review*, Manchester: Manchester City Council, 2009.

Office of the Deputy Prime Minister, *State of the English Cities*, 2 volumes, London: ODPM, 2006.

Peck, J., and K. Ward, eds, *City of Revolution: Restructuring Manchester*, Manchester: Manchester University Press, 2002.

Robson, B., *Those Inner Cities*, Oxford: Oxford University Press, 1988.

Robson, B., R. Barr, K. Lymperopoulou and J. Rees, *Mapping City Regions: A Framework for City Regions*, London: Office of the Deputy Prime Minister, 2006.

Thomas, E., I. Serwicka and P. Swinney, *Urban Demographics: Where People Live and Work*, London: Centre for Cities, 2015.

Transport for the North, *The Northern Powerhouse: One Agenda, One Economy, One North*, London: Department for Transport, 2015.

Westwood, A., and M. Nathan, *Manchester: Ideopolis? Developing a Knowledge Capital*, London: The Work Foundation, 2003.

Williams, G., 'City vision and strategic regeneration: the role of City Pride', in N. Oakley, ed., *Cities, Economic Competition and Urban Policy*, London: Paul Chapman, 1998.

Williams, G., *The Enterprising City Centre: Manchester's Development Challenge*, London: E & F.N. Spon, 2003.

Wray, I., 'The future of urban policy', *Town and Country Planning*, 84 (2015), pp. 320–52.

Notes on Contributors

Mervyn Busteed was born in Belfast and graduated from Queen's University. From 1975 to 2002 he lectured in geography at Manchester University. He is a past chair of the British Association for Irish Studies. His research interests are life in late eighteenth-century Ireland and the Irish in nineteenth-century Manchester. Among his publications are *Irish Protestant Identities* (Manchester University Press, 2008) of which he is a contributing editor and *The Irish in Manchester c.1750–1921: Resistance, Adaptation and Identity* (Manchester University Press, 2016). He is married and lives in Liverpool, where he is an Honorary Research Fellow of the Institute of Irish Studies at Liverpool University.

Alan Kidd is Emeritus Professor at Manchester Metropolitan University. He has published numerous books and articles on various aspects of British social history, including the history of Manchester. Among his publications are *Manchester: From Roman Fort to 21st Century City* (Carnegie, 2016); *Manchester: A History* (4th edn, Carnegie, 2006); *State, Society and the Poor in Nineteenth-Century England* (Palgrave, 1999); *Gender, Civic Culture and Consumerism: Middle-class Identity in Britain 1800–1940* (Manchester University Press, 1999, ed. with D. Nicholls); *City, Class and Culture: Social Policy and Cultural Production in Victorian Manchester* (Manchester University Press, 1985, ed. with K.W. Roberts). He was one of the founding editors of the *Manchester Region History Review.*

Michael E. Rose taught nineteenth- and twentieth-century British social history in the Department of History, University of Manchester, 1962–2001. He is currently Professor Emeritus, University of Manchester and Visiting Senior Fellow, Centre for Regional History, Manchester Metropolitan University. He is historical adviser to the Ancoats Buildings Preservation Trust. His publications include articles and books on the English Poor Law and on the Settlement House Movement in Britain and the USA. Titles on Manchester include *It All Happened at the Round House: A Centenary History of the Manchester University (Ancoats) Settlement* (with Anne Woods, 1995) and *Ancoats: Cradle of Industrialisation* (with Keith Falconer and Julian Holder, English Heritage, 2011). His hobbies include theatre, coarse gardening and watching non-league football.

Brian Robson is Emeritus Professor at Manchester University. He was a student and postgraduate at Cambridge and returned to teach there for ten years before being invited to a chair in Manchester in 1977. At Manchester he founded the Centre for Urban Policy Studies through which he and his collaborators have produced a wide range of research projects commissioned by the Department of the Environment and its various successor bodies and by local government and regional agencies. He has published eight books and well over 100 articles on urban and regional issues.

Dave Russell's major interests are in the history of leisure with particular reference to music, sport and the construction of regional identities. He is the author of *Popular Music in England, 1840–1914. A Social History* (1997, 2nd edn), *Football and the English* (1997) and *Looking North. Northern England and the National Imagination* (2004), as well as numerous essays and articles on the history of popular culture. He taught in schools in Bradford and Leeds, at the University of Central Lancashire and at Leeds Metropolitan University from which he retired in 2010.

James Sumner is Lecturer in the history of technology at the University of Manchester. His research covers a variety of fields including the development of brewing science, the social history of computer use, and the growth of local technical and scientific culture. He is closely involved in developing public talks, guided walks and science festival events in the Manchester area and beyond. His personal website is www.jbsumner.com.

Geoff Timmins is Emeritus Professor in the School of Humanities and Social Science at the University of Central Lancashire. His research interests are mainly concerned with regional history and his publications include *The Last Shift: The Decline of Handloom Weaving in Nineteenth Century Lancashire* (Manchester University Press, 1993) and *Made in Lancashire: A History of Regional Industrialisation* (Manchester University Press, 1998). He has also published several works dealing with history teaching and is the lead author of *Teaching and Learning History* (Sage, 2005).

Terry Wyke teaches social and economic history at Manchester Metropolitan University and was one of the founder editors of the *Manchester Region History Review*. He has researched and written on different aspects of the history of the Manchester region including maps, transport, public sculpture, bookselling and bibliography. He has also curated exhibitions on Peterloo and cartoons of the cotton industry.

Index

Note: Page numbers in *italics* indicate illustrations; the letter 'f' following a page number indicates a figure and 't' a table.

Subscribers to the Limited Edition

ARUP

Bruntwood

Central Manchester University Hospitals NHS Foundation Trust

Corridor Manchester

Kaiser Trust Foundation

Manchester City Council

Manchester, European City of Science 2016

Manchester Metropolitan University

Manchester Science Partnerships

Royal Northern College of Music

The University of Manchester